THE
anime!
MOVIE GUIDE

First published in the United States in 1997 by
The Overlook Press, Peter Mayer Publishers, Inc.
Lewis Hollow Road
Woodstock, New York 12498

Library of Congress Cataloging-in-Publications Data

McCarthy, Helen.
The anime movie guide : movie-by-movie guide to Japanese animation / Helen McCarthy.
Includes bibliographical references and index. 1. Animated films—Japan—Catalogs. I. Title
NC1766.J3M33 1997 791.43'3—dc21 96-49034

ISBN 0-87951-781-6
Manufactured in the United States of America
10 9 8 7 6 5 4 3 2 1

PICTURE CREDITS

We have received kind assistance from many quarters in obtaining illustrations. All illustrations used in this book are copyright the rights holders and used with permission of the companies and individuals listed below. All video sleeves reproduced are copyright the individual companies producing the videos in the UK and USA, and are reproduced only for purposes of information and promotion.

The following illustrations are all used by kind permission of Kodansha and copyright as indicated: *Gun Smith Cats* © Sonoda, Kodansha, TBS, VAP. *Oh My Goddess!* © Fujishima, Kodansha, KSS, TBS. *You're Under Arrest!* © Fujishima, Kodansha, Bandai Visual, Marubeni.

The following illustrations are all used by kind permission of KSS and copyright as indicated: *Catgirl Nuku-Nuku* © Takada, SME, MOVIC, Futabasha, KSS. *Fairy Princess Rain* © KSS.

The following illustrations are all used by kind pemission of Pioneer and copyright as indicated: *Green Legend Ran* © Pioneer. *Kishin Corps* © Yamada, Chuokoronsha, Pioneer. *Moldiver* © Pioneer. *Tenchi Muyo! Ryo Oh Ki* © Pioneer.

The author and publishers would like to acknowledge the gracious and generous assistance provided by the following companies and individuals in providing illustrations, which are copyright as indicated.

By permission of AD Vision UK with kind assistance from Ms Glenda Morgan: *Burn Up W!* © NCS, AIC Media Ring. *Dragon Half* © Mita, Kadokawa, Victor Entertainment. *801 TTS Airbats* © Shinizu, Tokuma Shoten, JVC. *Princess Minerva* © Maisaka, Ishida, Red, Toho, Group Tack. *Shutendoji* © Dynamic Planning, Japan Columbia. *Sukeban Deka* © JVD, JH Project. *Super Atragon* © Toho.

By permission of Anime Projects with kind assistance from Mr Nigel Fisher: *Bubblegum Crisis 1-7* © Artmic, Youmex. *Bubblegum Crisis 8* © Toshiba EMI. *Genesis Surviver Gaiarth* © AK, Artmic. *Oh My Goddess!* © Fujishima, Kodansha, KSS, TBS. *Riding Bean* © Sonoda, Toshiba EMI. *Scramble Wars* © Toshiba EMI. *Ten Little Gall Force* © MOVIC, CBS Sony. *Urusei Yatsura* © Takahashi, Shogakukan, Kitty, Fuji.

By permission of East2West with kind assistance from Mr Chris Smith: *Kekko Kamen* © Dynamic Planning, Japan Columbia.

By permission of Kiseki Films with kind assistance from Mr Simon Gale: *Ambassador Magma* © Tezuka Pro, Bandai Visual. *The Cockpit* © Tokuma. *Plastic Little* © MOVIC, SME. *Star Blazers* © Voyager Entertainment.

By permission of Manga Entertainment with kind assistance from Ms Amanda Tolworthy: *AD Police* © Bandai. *Akira* © Akira Committee. *Angel Cop* © Itano, Soeishinsha, Japan Home Video. *Appleseed* © Shirow, Soeishinsha, AIC, Bandai. *Bounty Dog* © Zero-G Room, Starchild, Toho. *Crying Freeman* © Toei Doga, Toei Video. *Cyber City Oedo 808* © Japan Home Video. *Dangaio* © AIC, Bandai. *Ghost in the Shell* © Shirow, Kodansha, Bandai Visual, Manga Entertainment. *Giant Robo* © Yokoyama, Hikari Pro, Amuse Video, Plex, Atlantis. *Goshogun the Time Etranger* © Ashi, Tokuma Shoten. *The Guyver* © Takaya Pro, KSS, Bandai, MOVIC, Tokuma Shoten. *Legend of the Overfiend* © Maeda, JAVN. *Lensman* © E.E. 'Doc' Smith, Kodansha, MK Company. *Macross Plus 1* © Big West, Macross Plus Project, Hero Co Ltd. *Ninja Scroll* © Kawajiri, Madhouse, JVC. *Patlabor the Movie* © Headgear, Emotion, TFC. *Vampire Hunter 'D'* © Ashi, Epic. *Venus Wars* © Kugatsusha, Gakken, Shogakukan, Bandai. *Violence Jack* © Dynamic Planning, JHV. *Wings of Honneamise* © Gainax, Bandai Visual.

By permission of Western Connection with kind assistance from Mr Sasha Cipkalo: *Devil Hunter Yoko* © Madhouse, Toho. *Grey Digital Target* © Tagami, Tokuma Shoten. *Hummingbirds* © Toho. *Ladius* © Toho. *Love City* © Toho, MOVIC. *Lupin III: The Gold of Babylon* © Monkey Punch, Sotsu Agency, TMS. *Samurai Gold* © Toei Doga, Tokuma Shoten. *Slow Step* © Adachi, Toho Video. *Ushio & Tora* © Fujita, Shogakukan, Toho Video, Toshiba EMI, OB Planning.

Video sleeves: *Akai Hayate* © Soeishinsha, Plan, O. Yamazaki, sleeve design © Central Park Media Corp. *Bomber Bikers of Shonan* © Yoshida, Shonen Gohosha, Toei, sleeve design © AnimEigo Inc. *Dragon Knight: Another Knight On The Town* © elf, All product, sleeve design © AD Vision. *Dirty Pair: Project Eden* © Takachiho, Studio Nue, Sunrise, Bandai, sleeve design © Streamline Pictures, Orion Home Video. *Little Nemo* promo sleeve © TMS, McCay. *Warriors of the Wind* © Nibariki, Tokuma Shoten, Hakuhodo, Toei, sleeve design © Vestron.

Front cover picture: *Moldiver* © Pioneer.
Back cover pictures: *Catgirl Nuku-Nuku* © Takada, SME, MOVIC, Futabasha, KSS. *Ghost in the Shell* © Shirow, Kodansha, Bandai Visual, Manga Entertainment. *Legend of the Overfiend* © Maeda, JAVN, used by kind permission of Manga Entertainment. *You're Under Arrest!* © Fujishima, Kodansha, Bandai Visual, Marubeni.

THE

anime!

MOVIE GUIDE

HELEN McCARTHY

THE OVERLOOK PRESS

WOODSTOCK • NEW YORK

DEDICATION

For Steve

THANKS

I would like to extend special thanks to Fred Patten for his unfailing generosity and scholarship; to Jonathan Clements for his assistance in too many areas to list; to Youri Foster for help with translation; to my editor at Titan, David Barraclough, the kindest and cleverest editor a writer could wish for; to Adam Newell, for his painstaking work and his enthusiasm for my chaotic manuscript; to Peter Goll for constant encouragement and support; to Fred Schodt for writing his inspirational book on manga; Robert Fenelon, Beverley Headley Moriarty and Luke Menichelli for their example; and of course to my partner Steve Kyte, without whom none of this would ever have happened.

The author and publishers would like to extend their special thanks to KSS Inc, who very generously agreed to permit the use of materials relating to their productions through the good offices of Mr Peter Evans of Sakura Studio; to Kodansha Ltd, who generously agreed to permit the use of materials relating to their productions through the good offices of Mr Peter Evans of Sakura Studio and of Mr Robert Woodhead of AnimEigo; and to Pioneer LDC and their UK representative Mr Keiichi Onodera, who very generously agreed to permit the use of materials relating to their productions.

Contents

English titles alphabetically within each year, and movies and OAVs listed separately.

The title may seem a bit misleading since OAVs as well as movies are featured, but it was a deliberate choice. Most of the anime available in the English-speaking West consists of titles made for video release, with theatrical releases next in prominence, so it was logical to feature both formats. By using a similar title format as for Titan's other Movie Guides — Vampire, Werewolf and so on — both my editor and I wanted to send out a signal that anime isn't just some odd little bit of esoterica but a mainstream, mass-market moving picture format, with a wide general audience in its country of origin and a great deal to offer film-lovers in the West.

Why did made-for-video anime first begin to appear in 1983? Obviously the availability of video hardware in Japan was the deciding factor — there's no point launching a major new format until the hardware to play it is widely available. Other factors were the increase in TV and movie production costs and the segmentation of the market, with growing demand for more specialised programming from different customer groups. In the West, anime is overwhelmingly perceived as a youth medium and science fiction as the major subject area. In Japan, the most popular anime series on TV is the long-running soap opera *Sazae-San* and the first OAV, *Dallos*, was a science fiction story; the producers can't have considered it mainstream enough to command a TV audience and didn't have the budget to devote to the production standards required for a theatrical release.

WHAT IT'S FOR

Several reviewers of my first book, *Anime! A Beginner's Guide to Japanese Animation*, foresaw the need for another, more detailed book in the future. In the three years since it was published, the anime scene in the UK, Europe and USA has expanded, and interest from journalists, academics and fans has continued to grow. However, the general perception of Japanese animation in the English-speaking world is still distorted by the very limited range of material released in the West and by a continuing lack of information about all but a tiny fraction of the anime released in Japan. This book is an attempt to start redressing the balance.

The first book gave a brief history and an introduction to some of the major subject areas of anime, along with pointers for more information. It was intended to entice and empower, to persuade readers that anime was worth exploring and give them the means to do it themselves. Hopefully this book will build on that aim by providing more raw data for study and further exploration.

WHAT IT IS

This book lists a number of the movies and OAVs (Original Animation Videos) produced from the beginning of 1983, the first year in which original made-for-video animation was released, to the beginning of 1996. This period covers many of the titles and directors becoming popular in the West, but hopefully will also introduce some less familiar but interesting new ones. It lists as much information as I have been able to find on each title, and gives highly subjective synopses, subject categorisations and ratings. It is arranged year by year, with

WHAT IT ISN'T

This isn't a complete listing of movies and OAVs produced in its period, mostly because such a listing would have taken far longer to research and I wanted to get the book out in time to be of use to the growing number of non-linguists whose view of anime is distorted by the scarcity of English lang-uage information. It excludes several categories either partly or wholly — most anime for very young children is not featured, and satire and social comment likely to be relevant only to a Japanese audience is excluded, as is most pornography. The exclusions are partly subjective, and partly due to a lack of complete information, though I have tried to show the breadth of material available.

It isn't a complete history of anime outside Japan, either. The English language is so widespread that we native English speakers can forget that there are

other tongues as widely understood, if not more so. Anime and manga have long and vital histories as popular, mass-market entertainment in France and Italy, Hong Kong and South-East Asia; their popularity is established and growing in Spain, South America, Germany and the Benelux countries, and even in Eastern Europe, where Hayao Miyazaki and *Sailor Moon* are spreading the anime gospel via satellite TV. There have been many, many releases of Japanese material outside Japan which are not included here; but the history of anime in France, Italy or elsewhere is for native speakers to write.

In addition, the listings themselves are not complete. In some cases I have been able to find out a good deal even about titles not yet released or widely known in the West; in others I have nothing but the title, production house and rights holders. However, I have listed many such titles because others may be able to add something about them from their own knowledge, or may be encouraged to go and seek them out. I welcome any and all additions, corrections and extensions to the information contained in this book. It's a map, not a Bible. Like all maps, it needs to be constantly updated as the terrain, and our familiarity with it, changes.

If you know anything more about *Cynical Hystery Hour* or *Bakabon: 19000 Miles Looking for Osamatsu's Curry*, please write and tell me. Furthermore, I'm aware that there may be inaccuracies in the listings-despite my own care, the brilliance of my editor,

the excellence of my sources and the generous help I have received from many quarters. If you find one, please let me know your source for the accurate information, so that future editions can be updated.

WHAT I HOPE

I hope readers will find in this book the incentive to track down more anime and give it fairer consideration than has been usual in the mass media. As yet, we in the West have seen only the tip of the anime iceberg. This book delves a little way below the waterline; but there are wonderful things in the uncharted depths, things we'll never see unless we dive for them.

I hope to update this book to cover future years; I also hope that if there is sufficient demand a similar volume on TV shows, a huge and almost entirely unexplored area of anime, might be published sometime in the future.

I hope that before too long other researchers will begin to publish works on anime which are not narrowly focused on the material available in the West and the distortions imposed on it by our own translations and perceptions. The diversity of the medium is only just beginning to be appreciated; let's not stop here.

Helen McCarthy, London, 1996

Ambassador Magma

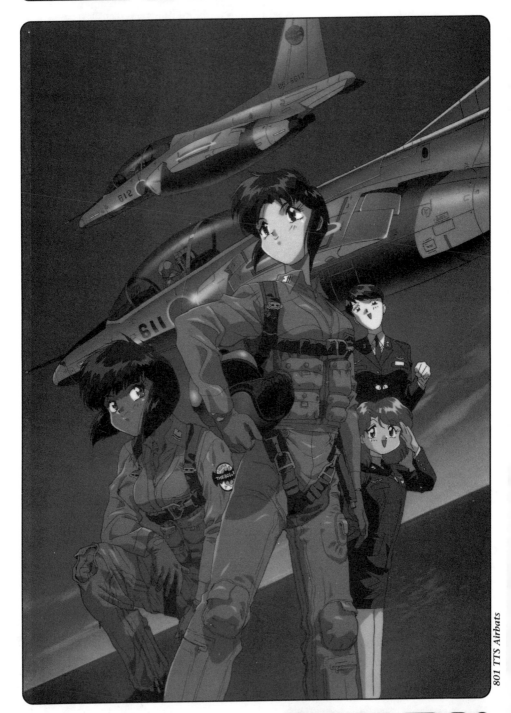

801 TTS Airbats

A few points in the listings may cause some puzzlement, especially for newcomers to the anime field. The following paragraphs will hopefully clarify them.

CREDITS

What do the various job titles mean and who does what?

The anime industry is a huge, complex organism, driven by a vast and diverse range of creative and administrative talents. The finer shades of distinction, of cell specialisation within the organism, as it were, are so complex as to appear almost arcane to an outsider without an intimate knowledge of the industry, the language and the relationships. There are, for example, a wide range of different words which all translate as 'director', a number of different ways of describing a designer (and that's *before* we get on to his or her actual design speciality), and many, many instances where it's hard to be sure exactly what a description means. Someone described as, say, a 'sound director' may be either involved in the composition and orchestration of the soundtrack or purely in its engineering. Add to this the hierarchical complexity of an industry which, just like Hollywood, has its esteemed old guard and its legendary giants who must be given proper respect, even if their actual physical input on a production has been limited, and you have a very confusing situation.

Let us take, for example, an imaginary six-part OAV series. There may be a single director for all six parts, or there may be a 'general director' or 'executive director' supervising the overall movement of the series and individual directors for some or all episodes. A distinguished industry figure who worked on an earlier version of the series may also lend his experience — and his prestige — to the production and become, perhaps, 'supervising director'. A large cast or a particularly demanding dub script may lead to the appointment of a separate 'voice director', and of course there is also the director of photography, the interface between the director and camera team. If the producer is a hands-on member of the creative team as well he may get an 'executive producer' credit. There could be a scriptwriter or screenplay writer, plus someone who thought up the original story of each episode and/or the whole series concept; if the series is based on a manga, the manga writer may also be credited. The manga artist or another well-known artist who has contributed to aspects of the show's overall 'look' may be credited with 'design works', as well as there possibly being a separate character designer, mecha designer and even, on some specialised shows, a gun or vehicle designer. Special characters or mecha which only pop up in one or two episodes may be done by a guest character or mecha designer. Background paintings, often complex works of art in themselves, may be done (or supervised) by an artist of high enough standing to merit a conspicuous individual credit.

In this book I've tried to describe everyone's role in their various productions as clearly as possible. I have used published English, French and Italian sources from video companies, publicity handouts and reviews, cross-checking these wherever possible against each other and fan sources, and have used the work of reliable translators to check Japanese source materials. However, it is inevitable that some of this information may still be confusing or inaccurate; no denigration of anyone's role or misrepresentation of their work is intended.

Why is there more than one person doing the same job?

There are many instances in the listings where two, three or even more people share the same credit on a title. This is usually for one of three reasons. Each artist may have a particular skill to contribute — for instance, three chara designers may each have a special talent for a certain character type required by the script; or perhaps each artist is very busy, either in general or at that time, and can only carry part of the workload required to produce the whole film or OAV; or else a talented but less experienced colleague may be working alongside an established team member, assisting and learning from them.

What does 'Eng Rewrite' mean?

Just that — the person credited rewrote the English script after it had been translated. This can be done for lots of reasons — maybe the original translator is a fine linguist but a leaden dialogue writer; maybe

the translation had to be rewritten for lipsync purposes; maybe the script contained too much profanity, or not enough profanity, for the tastes of the video company releasing it in the West. The difficulty here is that some translators perform these rewriting functions without being credited for them. Where you see separate translation and rewriting credits you know that at least two hands have been at work on the English script; but the fact that there's no rewrite credit is no guarantee that the original script has been translated into good English without any deviation from the Japanese original, and this applies as much to subtitling scripts as to dubbing scripts. This is a very important point, particularly if you are a student hoping to draw any conclusions about the writer, director or Japanese culture in general from a Western anime release.

TITLES

Why do some titles have translations and some not?
I have listed the UK or US release title first, then the Japanese title, marked 'Eng trans for' where it is a more-or-less direct translation. For instance, we have:

AURA BATTLER DUNBINE
(Eng trans for SEISENSHI DUNBINE)

But sometimes the Japanese title is the same in English. *Moldiver*, for instance, has English titles for each episode; *Idol Project* has its title rendered in katakana, which tells a Japanese person that these are foreign — in this case English — words. Since I know all of you readers are intelligent enough to recognise your own language, I'm not going to insult you by listing *Idol Project* as 'Eng trans for Idoru Purojekuto'; so you'll just read *Idol Project*, followed by the Japanese credits.

Sometimes, though, the Japanese title is very different from the English. There are a couple of cases where the Japanese production company have decided this; *Ozakani Dungeon* is described as *Virago in Dungeon* on all TMS' English language sales material, and *Fushigi No Umi No Nadia*'s English title, *The Secret of Blue Water*, was devised by its Japanese creators at a very early stage in production planning. In these cases you will find the UK or US release title first, then the Japanese title, then the literal translation of the Japanese title, thus:

THE SECRET OF BLUE WATER: NADIA THE MOVIE
(Eng title for FUSHIGI NO UMI NO NADIA THE

MOVIE FUZZY NO HIMITSU, lit Nadia of the Mysterious Seas: The Movie, The Secret of Fuzzy)

In most cases, though, where there is a difference it's because the Western company translating the material for domestic release has decided that a different title will sell better in their home market. These are described in the same way; eg

NINJA SCROLL
(Eng title for JUBEI NINPOCHO, lit Jubei the Wind Ninja)

Lastly, some titles, such as *Kekko Kamen*, just can't be translated. They may be proper names, puns or gags, references back to an earlier show, or just have no English equivalent words. In these cases there is usually an explanatory note in the listings, under 'Points of Interest', to give you an idea of what the title is trying to convey.

What's an aka title?
There are a number of entries with alternate titles, listed as an 'aka' title. These are variants from a wide range of sources. Sometimes a title has been released by different UK and US companies under more than one title; sometimes it has been widely known in fandom by a different title before its Western release. *Monster City* was widely known to fans as *Hell City Shinjuku* or *Demon City Shinjuku* for a couple of years before its release in English. You might need this information if you are reading an old fanzine, looking the title up in the index of a book or buying a second-hand tape from a now-defunct label; for example, you might pass up a tape labelled *The Legend of Shin Lon* if you didn't know that this was Harmony Gold's US release title for the first *Dragonball* movie, *Legend of the Divine Dragon*.

I hope that this has helped clear up any confusion; but if you can think of a way to simplify or amplify this information so that other readers will find it easier to follow, please let me know!

STAR RATING SYSTEM

This is a crude attempt to give the bewildered newcomer some guidance as to what they might or might not enjoy. It is, of course, heavily biased to my own tastes.

There are a number of cases where, although I haven't seen a work myself, or saw it so long ago that I can't make a fair assessment, I have access to the opinions of other writers or sources I trust, and to artwork which helps me form a view about the

art and design. In these cases I have rated the items according to this information, but followed the rating with a '?'.

I have only allocated no rating — and no star — in the very rare cases where I did not have enough information to form any kind of opinion.

★★★★★	Absolutely must see (though the reasons may vary!).
★★★★☆	Just short of perfection.
★★★★	A very, very good film/OAV.
★★★☆	A very good film/OAV.
★★★	A good film/OAV.
★★☆	An average, acceptably entertaining film/OAV; the midpoint of the scale.
★★	Below average (though it may still have specific merits).
★☆	Not quite the pits, but...
★	The edge of the pits.
☆	The pits.

CATEGORIES

Another crude attempt, this time to give an idea of what the subject is and what kind of content to look for. The abbreviations indicate the following categories:

SCIENCE FICTION	SF	
FANTASY/RPG TYPE	DD	
ROMANCE	R	
HORROR	H	
HISTORICAL	P	
NINJA/MARTIAL ARTS	SH	
COMEDY	C	
CRIME/THRILLER	M	
SOAP/EVERYDAY LIFE	N	
TRUE STORY	T	
ADULTS ONLY	X	(Because of sex or violence content)
ULTRAVIOLENCE	V	(Not for the sensitive of any age!)
WAR	W	
ADVENTURE	A	
SUITABLE FOR KIDS	U	(by which I mean under-twelves)

ORDER OF LISTING

I do not have all the information I'd like on many

titles, and on some there are only snippets. However, this is the order in which a full listing is presented.

Title most commonly used in English, or nearest English translation of the Japanese if no English title is commonly used, or English title as given by the Japanese, where this occurs.

Japanese title in Roman lettering, unless the original Japanese title is already in Romaji.
NOTE: Where katakana are used to render approximations of English words in Japanese I will give the English word rather than an exact transliteration of the katakana syllables. For example, the syllables Orenji Rodo are meant to convey the English words *Orange Road*; to transliterate them exactly seems to me unhelpful and pretentious.

Any other titles or translations used in English language releases.

JAPANESE CREDITS: Director. Writer or Screenplay. Chara designer. Mecha designer. Anime director. Art director. Photography director. Supervisor. Backgrounds. Music. Producer and/or Production company. Copyright holders. Length in minutes. (As explained above, there may be many variations on these credits, as well as occasionally additional credits.)

WESTERN CREDITS: English language releases in UK and US, with variant titles where applicable, year, releasing label, and director and translator where known.

ORIGINS: any manga, novels, previous films and/or OAVs or other sources.

SPINOFFS: manga, games, merchandise, other productions or publications, in Japan or in the West, inspired by this title. Since almost all anime have some effort devoted to merchandising this doesn't attempt to list all the related material, but simply highlights outstanding or unusual spinoffs to demonstrate a show's popularity or influence.

POINTS OF INTEREST: snippets of information likely to be of interest to the general reader.

CATEGORIES: The type of story/content as defined above.

Synopsis: a short breakdown of story and related information.

Star rating.

ADR — AUTOMATED DIALOGUE RECORDING: The process of making an English language soundtrack which (as far as possible) fits the mouth movements on the screen. This can sometimes involve retiming or 'stretching' some lines, either mechanically or simply by the actor redubbing them, or rewriting to replace a set of words that don't fit with ones that do.

ANIME: The loanword for animation borrowed by Japan from the Western word, and now used by Western fans to distinguish the Japanese version from that of any other nation.

ANIPARO: ANIme PAROdy, a popular manga genre in which anime charas and situations are used in comic stories or skits.

ARCADE GAME: The original computer game, played on machines in public arcades.

BGM: BackGround Music — the music from an anime soundtrack.

BISHOJO/BISHONEN: Japanese for beautiful young girl/boy.

-CHAN: Suffix meaning darling or little one, a term of affection usually reserved for romantic partners, young female friends, small animals or children. Also used in the eighties to describe the 'squashed' versions of charas now generally known as CB.

CHARA: Loanword for CHARActer.

CHIBI aka CB: The Japanese word for small, also for Child Body. Generally used as a prefix, eg CB Devilman.

CITY GOTHIC: An anime genre set in a con-temporary or future city, with cyberpunk styling and elements of traditional Gothic horror. Notable examples occur in the works of the Madhouse studio. Yoshiaki Kawajiri is the best known director of the genre in the West.

CONSOLE GAME: Another term for computer game.

DOJINSHI: Japanese for fanzine. A cottage industry of staggering proportions, the dojinshi market is huge.

ECCHI: The Japanese pronunciation of the initial sound of *hentai*, or pervert, ecchi is a term used to describe lust-crazed teenage boys, panty fans or otherwise 'pervy' types. It's milder than *hentai* — more disparaging than condemnatory in most circumstances.

ESPER: Another word for psychic, popular in the seventies and early eighties. You are most likely to run across it in American fanzines, synopses and critical writing of the early to mid eighties, where characters like Locke (*Locke The Superman*) and Justy (*Cosmo Police Justy*) are often referred to as 'espers'.

GACHAPON TOY: Small, cheap but often very attractive toys sold via vending machines.

GAIKOKUJIN or GAIJIN: Gaijin is the term normally used for foreigner; it means 'strange person', whereas gaikokujin is 'person from another country'. Gaijin was popularised by William Gibson and other Western cyberpunk novelists in the eighties.

GARAGE KIT: Model kit produced by fans working from home (hence the term) in small quantities and very basic packaging. Garage kits have now become an industry in their own right and some producers have become large and well-organised companies.

GEKIGA: Japanese word for graphic novel.

HIRAGANA: One of the three Japanese scripts, consisting of 46 basic syllables and variations on these. Any Japanese word which is normally written in kanji can also be written and understood in hiragana. It is the first script children learn and is characterised by graceful, flowing characters. See also kanji, katakana.

IDOL: Japanese term for young, cute, manufactured starlet in any field, idol singers being among the most popular. Both anime charas and the voice actors who portray them can be idols. They usual-

ly have short, hectic and intense careers.

KAIJU: Japanese for monster. Kaiju eiga (monster pictures) are a popular Japanese genre. A related term is YOKAI; this also indicates a monster, but where the term kaiju implies a 'monster beast', ie a naturally based monster or creature of this world, yokai indicates a supernatural-type, extraterrestrial or extra-dimensional monster.

KANJI: The Chinese characters which make up the bulk of the written Japanese language, with over 2000 pictograms required for basic communication and many thousands in use at an everyday level. Readings of kanji — and therefore the sounds they represent — can vary enormously according to their context and function in the sentence. Japanese school children begin to learn kanji at around ten years of age. See also hiragana, katakana.

KAMI: God or goddess, applied as a term of greatest respect, eg the great artist Osamu Tezuka, often referred to as 'manga no kami', the manga god. Even greater respect implied by the suffix '-sama'.

KATAKANA: A more angular form of the hiragana syllabary, it was devised to write foreign loanwords, foreigners' personal names and non-human nouns and terms (such as biological or mechanical terms). Like hiragana it is fast and easy to learn and is the second script taught to schoolchildren. Words like 'Gundam', 'project' and 'terebi' (a shortform of television) are written in katakana. See also hiragana, kanji.

KAWAII: Japanese for cute. Cuteness is a characteristic of great importance in some anime.

MANGA: Japanese for comic, though 'comic' is also in use in Japan.

MECHA: Loanword for MECHAnical, any kind of mechanism from a simple gun to a giant robot.

MOBILE SUIT/MOBILE ARMOUR: A humanoid fighting machine cum protective shell; not a true robot, in that it requires one or more operators to function. Sometimes abbreviated to MS.

NEWTYPE: Term used in *Gundam* universe for individuals naturally or artificially created with a special aptitude for technology and remarkable paranormal powers.

OAV/OVA: Original Animation Video or Original Video Animation, a work made specially for release onto video rather than for TV or cinema.

OST: Original SoundTrack, ie the music of an anime production, including all the songs.

OTAKU: Japanese word meaning an obsessive fan of anything, in the sense of being narrow, selfish and putting your interest or hobby above social duty. Westerners sometimes use the term without derogatory connotations to describe a dedicated anime or manga fan.

RPG: Role Playing Game. A board-based RPG is usually called a 'tabletalk' RPG; there are also console RPGs.

SD: Super Deformed, another version of CB or -chan, but usually more mischievous.

SEIYUU: Japanese term for voice actor or actress.

SENSEI: Another term of respect, meaning 'teacher' or 'master'; used either alone or as a suffix to the subject's surname, eg Miyazaki-sensei.

SENTAI: Japanese for team. Many shows use the term, or the shorter suffix 'tai' to indicate that there is a team of heroes.

SETTEI: The line art which is made up at the start of a project, used by the animators for reference, and often sent to magazines for advance publicity use.

SHOJO: Japanese for girl. Shojo manga are manga drawn in a very flowery, pretty, romantic style and deal with mainly romantic or emotional subjects.

SHONEN: Japanese for boy. Shonen manga are often more action-adventure oriented, with the notable exception of 'shonen ai' — boys' love — manga, homoerotic stories usually done for a female audience.

SIDE STORY: A story set in the same universe as a well known group of characters, but focusing on other, perhaps minor, charas, or introducing new ones, showing another 'side' of the title.

YAOI: A term for intense, emotional stories in which women usually figure as onlookers or observers while the intense emotional (and usually doomed) relationships are between men.

YAKUZA: Literally 'useless, worthless, good-for-nothing' (adj) or 'a ne'er-do-well' (noun), applied to a gangster or member of an organised crime syndicate — the Japanese equivalent of the Mafia.

YOMA: A term used for demons or supernatural entities of evil intent.

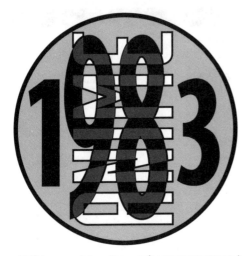

1983

This was an interesting year for many reasons; at the time, few foresaw that *Dallos* would turn out to be one of them. This otherwise wholly unremarkable SF tale was the first of a new wave in anime, the Original Animation Video or OAV, also known as Original Video Animation or OVA. A combination of the increasing availability of video hardware and the punishing demands of TV anime scheduling — weekly time slots, the absolute need for a sponsor, and therefore the absolute requirement to sell the sponsor's product — would make the new format a major force. Many fans have since hailed the far subtler and more complex *World of the Talisman* (1984), as the first 'true' OAV, but despite this wish to elevate the genre's origins, *Dallos'* claim to primogeniture can't be challenged.

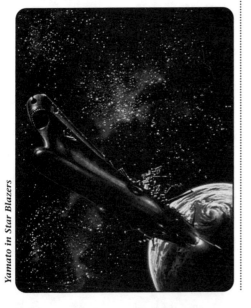

Yamato in Star Blazers

MOVIES

BAREFOOT GEN
(Eng trans for HADASHI NO GEN)

JAPANESE CREDITS: Dir: Masaki Mori. Chara des: Kazuo Tomizawa. Backgrounds: Kazuo Okija. Prod: Takenori Yoshimoto & Yasuieru Iwase. Prod co: Madhouse. © Madhouse, Gen Productions. 110 mins. WESTERN CREDITS: US video release 1995 on Streamline Pictures, dub, Eng dialogue Ardwight Chamberlain. ORIGINS: Manga by Keiji Nakazawa. POINTS OF INTEREST: Manga trans into Eng for Project Gen, pub New Society (USA) and Penguin (UK); the first manga to be trans into Eng and the first manga eyewitness account of the Hiroshima tragedy. CATEGORIES: T, X

Even if this film's production values were basic, it would still be an immensely important milestone in the history of anime. Based on the true story of a young boy who survived the bombing of Hiroshima and its terrible aftermath, both the manga and the film are imaginative and sensitive, yet unflinching in their depiction of the physical and emotional horrors of nuclear disaster. Gen's whole family survive the bombing, but he and his pregnant mother are not strong enough to lift the rubble of their house and free his father, brother and sister, and are forced to leave them to burn alive. His new sister is born in the devastation of the bombed and burning city. Surrounded by almost incomprehensible terrors, how does a child survive? *Barefoot Gen* is a record of the best and worst in the human spirit, by someone who was there to witness it. The film filters his testimony through the sensibilities of a generation unborn, or very young, when the bombing occurred, and throughout there is a strong sense of mission and of warning. A must-see. ★★★★★

CRUSHERS
(Eng title for CRUSHER JOE)

JAPANESE CREDITS: Dir & chara des: Yoshikazu Yasuhiko. Script: Haruka Takachiho & Yoshikazu Yasuhiko. Mecha des: Shoji Kawamori. Music: Koichi Chiba & Sadayoshi Fujino. Prod: Nippon Sunrise. © Takachiho, Studio Nue, Sunrise. 125 mins. WESTERN CREDITS: 1988 UK video release on MY-TV label, dub, Eng version © Enoki

Films USA, Nippon Sunrise.
ORIGINS: Series of SF novels by Haruka Takachiho.
POINTS OF INTEREST: First screen appearance of the Dirty Pair. Many future industry greats contributed 'guest' designs or assistance, including Akira Toriyama (Dragonball), Katsuhiro Otomo (Akira) and Rumiko Takahashi (Ranma 1/2).
CATEGORIES: SF

Crusher Joe is a team leader with the Crushers, galactic mercenaries who will take on almost any job within the law. He's a bit of a rebel, hot-tempered and brave, and has a stormy relationship with his father, Crusher Dan, who as head of the Crusher Conference is also his boss. (There is nothing in this story to support the fan thesis that Yuri, one of the Dirty Pair, is Joe's mother.) Between jobs, Joe and his team agree to transport a deep-frozen heiress to a medical facility on another planet, but on the way she disappears and they are in deep trouble with the police, embroiled in a web of cross and double-cross with pirates and politicians, and with only a few hours to save the galaxy from a doomsday weapon currently in the hands of a crazy pirate and his goons. This enjoyable space opera is distinguished by the first screen appearance of the Dirty Pair in a movie showing in the background of one scene — sadly edited out of the 1988 UK release. The four fifteen-second clips caused such a stir that Takachiho yielded to fan pressure and brought these two girls back to the screen in their own right. That claim to notoriety aside, Crushers is one of the most enjoyable space operas ever, with nary a trace of demons, tentacles or buckets of gore. ★★★☆

DOCUMENT OF SUN FANG DOUGRAM
(Eng trans for TAIYO NO KIBA DOUGRAM DOCUMENT)

JAPANESE CREDITS: Dir & mecha des: Ryosuke Takahashi. © Nippon Sunrise. 90 mins.
ORIGINS: 1981 TV series.
POINTS OF INTEREST: On triple bill with Xabungle Graffiti and Choro Q Dougram
CATEGORIES: SF

Also:
CHORO Q DOUGRAM

CREDITS, CATEGORIES: As above except: 10 minute comic parody.

Nippon Sunrise were on a robot roll in the eighties,

creating many series now regarded as classics. This film is a remake of the TV series Sun Fan Dougram from two years earlier. It closely follows the original story of a team of young people on the planet Deloyer resisting the alien invasion of their homeworld by forming a revolutionary army called Peloyer 7 and using advanced military technology in the form of giant robots, the title mech Dougram being one of them. The mecha design is gritty and powerful; Dougram is considered one of Takahashi's 'real robot' works, representing mecha as they would be used in a real war situation rather than the high-tech fantasies in primary colours found in the giant robot shows of the seventies. ★★★?

DR SLUMP AND ARALE-CHAN: THE GREAT ROUND-THE-WORLD RACE
(Eng trans for DR SLUMP AND ARALECHAN: HOYOYO! SEKAI ISSHU DAI RACE)

JAPANESE CREDITS: © Bird Studio, Toei Doga. 75 mins.
ORIGINS: Based on Akira Toriyama's manga & TV series.
CATEGORIES: C

Like all the Slump films, this is a wacky and completely over-the-top fantasy about the lecherous Doctor, his robot 'daughter' Arale and the people of their home town, Penguin Village. The round-the-world race is in pursuit of the Doctor's usual goals — wealth and women, especially the lovely Midori. ★★★?

FINAL YAMATO
(Eng title for UCHU SENKAN YAMATO KANKETSUHEN, lit Space Battleship Yamato Final Chapter, aka FAREWELL TO SPACE BATTLESHIP YAMATO — IN THE NAME OF LOVE)

JAPANESE CREDITS: Dir & prod: Yoshinobu Nishizaki & Leiji Matsumoto. © Westcape, Toei Doga. 160 mins.
WESTERN CREDITS: US video release 1994 as Farewell to Space Battleship Yamato — In the Name of Love, on Voyager Entertainment Inc. US edit of TV series released as Star Blazers in the UK on Kiseki Films, 1995.
ORIGINS: Manga by Matsumoto; 1974 TV series.
CATEGORIES: SF

The water-planet Aquarius is wandering through the galaxy, and the disruption it causes brings mas-

CINEMA INFLUENCES

Time and again, watching anime, you'll see something that strikes a chord in your memory. If you're watching an SF story done since the early eighties, chances are that the origin of that feeling is either *Alien*, *Blade Runner* or *The Terminator*. The style of these three movies had a huge impact on the look of eighties anime. Below are just a few of the references made to each film. (There are many more — look out for them.) But these are far from being the only Western films to influence anime creators, as you'll see if you read on and watch more anime.

ALIEN

Lily-C.A.T. is a direct takeoff of the film — except that the cat is the key to the mother computer and two young lovers survive.

Sybell, the spunky reporter in *Black Magic M-66*, is directly modelled on Sigourney Weaver's Ripley. There's even a voyeuristic scene where Sybelle picks up all her kit and leaves her flat without her clothes, echoing the famous changing-in-the-closet scene at the end of *Alien*.

The Paranoid impregnation of Patty in *Gall Force — Eternal Story* has a strong *Alien* influence.

The Superbuma at the end of *Bubblegum Crisis I* is an *Alien* on a much bigger scale; ugly, deadly and utterly unstoppable without total destruction. And in *Mad Bull 4 - Cop Killer* there's an unmistakeable appearance by a criminal who's wrapped himself in a bullet-proof carapace based on Giger's creation.

BLADE RUNNER

The most obvious reference is in the lead chara in *Bubblegum Crisis*, Priss, and her band, the Replicants. It's also notable in *Bubblegum Crisis* that the main villain is a mighty corporation out to use its influence to secure its own position, and that the lower levels of earthquake-devastated MegaTokyo are populated by a hopeless underclass, just like the city in Scott's masterpiece.

The glittering towers and dank sewers of *Blade Runner* also inspired Otomo's Neo Tokyo in *Akira* and the Martian city in *Armitage III*.

A less obvious nod occurs in the original 1987 *Guyver* OAV, where the woman who eventually transforms into Guyver 2 — eight feet of spiky, muscled death — starts

out with the elegant pseudo-forties hairstyle and distinctive beige-banded tailored suit of Deckard's replicant love Rachael, complete with power shoulders.

In Kia Asamiya's manga *Silent Möbius* and the two films based on it, Tokyo is protected from the invasion of nasty, icky monsters from Out There (an echo of *Alien* in their spiky, elongated forms and oozing corrosion) by an elite police unit which doesn't only have weaponry and cars which are direct lift-offs of those in Scott's film, even down to calling the cars 'spinners', but much the same methods of recruitment by subtle and not-so-subtle pressure.

And look out for the contextual reference in the opening scenes of *Cyber City Oedo 808 File-2*, with the setting echoing the faded deco grandeur of the building where Deckard and Batty play out their final game, and even white doves to recall the film's beautiful analogy for freedom.

THE TERMINATOR

Probably the closest thing to Arnie's steel-cored killing machine is the delicate-looking marionette after which *Black Magic M-66* was named. Masamune Shirow's intelligent action-adventure centres around this deadly doll, which has been designed to kill to order and to be unstoppable, just like Big T.

The Buma in *Bubblegum Crisis* and *Bubblegum Crash* are also obvious echoes, in particular those of *Crash*, like the pathetic reprogrammed cyborg of part one, trying desperately to find a reason for the strange memories left hiding in her artificial brain.

ROBOCOP

Since the original *Robocop* was, in fact, Japanese — a murdered detective whose brain was placed in an android body in the 1960s manga *8 Man* — the influences are coming full circle. *Eight Man After* is a nineties reincarnation of both the classic manga and anime series and the American live-action movie, though this time the subject is a private detective rather than a proper cop.

The monster fought off by Gogol in *Cyber City Oedo 808 File-2* obviously bought most of his gear at the Robocop Lookalike Emporium.

In *AD Police File 3: The Man Who Bites His Tongue*, metal-cased cop Billy Fanword is a darker take on Peter Weller's hero; he doesn't make the adjustment to living in a box nearly so well. The scientists have their own agenda and nothing can prevent the final tragedy.

VAMPIRE MOVIES

Where to start? Well, *Vampire Hunter 'D'* is the offspring of Count Dracula, and his arch-adversary is named Count Lee, an obvious tribute to the greatest modern exponent of the role of the bloodsucking Count. Look again at *Bubblegum Crisis*, where the Sexaroid Bumas Sylvie and Anri can't heal properly without taking in fresh human blood, and at *Cyber City Oedo 808 File-3*, where vampires are now being genetically engineered but retain many of the old powers. And in one episode of the OAV series *Phantom Quest Corp*, a spate of bloodsucking murders start in Tokyo when Transylvania's national treasure, Dracula's coffin, is sold to Japan... you just can't keep a good vampire down!

WEST SIDE STORY

No, I'm not joking, though this is not a visual reference but an aural one. Listen closely to Jo Hisaishi's ravishing score as the camera moves in on Nausicäa's body lying amid the vast herd of Ohmu in *Warriors of the Wind*, and tell me that's not two bars of 'Somewhere'... perfectly in context and heart-wrenching every time.

sive destruction as another galaxy emerges in its wake and begins to cover ours. From space, the battleship *Yamato* watches as Aquarius drowns the planet Dangiland and is itself disabled by the Aquarian fleet. Priest-king Lugar of Aquarius has a sinister agenda — he plans to warp the planet to Earth, from which his forefathers fled during Noah's flood, and take over the ancestral home of his people. Then Captain Okita mysteriously returns from the dead to lead his young crew and sacrifice his beloved *Yamato* to save the Earth he has served so well. You think you cried when Jim Kirk trashed the *Enterprise*? See the original, made years before *Star Trek III: The Search For Spock*. Despite the obvious creakiness of its outdated style and animation technique⌐, *Final Yamato* still has a powerful pull; classics may date but they always have something worth saying. ★★★☆

HARMAGEDDON
(Eng title for GENMA TAISEN, lit The Great War of the Demon Illusion)

JAPANESE CREDITS: Dir: Taro Rin. Script: Shotaro Ishinomori. Chara des: Katsuhiro Otomo. Music: Keith Emerson. Prod: Project Team Argos, Madhouse, Magic Capsule. © Haruki Kadokawa. 125 mins.
WESTERN CREDITS: US video release

1992 on US Manga Corps, sub, Eng rewrite Jay Parks.
ORIGINS: Manga by Shotaro Ishinomori.
POINTS OF INTEREST: First work produced by Haruki Kadokawa with Madhouse; Katsuhiro Otomo's anime début. Taro Rin makes a guest appearance in the story — as a drunken animator!
CATEGORIES: DD

Princess Luna of Transylvania, a powerful psychic, is involved in an aeroplane explosion. Her life is saved by Floi, an energy being who has battled the evil King Genma for more than 10 billion years. The cyborg soldier Vega shows her a vision of how his world, 3,800,000 light years from our galaxy, was destroyed by Genma, who now plans to invade Earth. Luna and Vega gather a team of psychics, the Psionic Warriors, to oppose him. But Genma has already turned Tokyo to desert; can a cyborg soldier, a Native American, a failed student and the rest of her motley crew stop him, and his powerful warriors like the demon dog Zombie and the terrifying Samedi? ★★★

LIGHTHEARTED TALES OF PRO BASEBALL
(Eng trans for PROYAKYU O JUBAI TANOSHIKI MIRU HOHO)

JAPANESE CREDITS: Prod: Tokyo Movie Shinsha. © Filmlink, Tokyo Movie Shinsha. 95 mins.
ORIGIN: Emoto Takenori's baseball books.
CATEGORIES: N, C

One of Japan's most renowned baseball pros, Takenori of the Tigers, relates humorous anecdotes from his own career and the game in general. For baseball completists only. ★★?

PATALIRO! STARDUST PROJECT
(Eng trans for PATALIRO! STARDUST KEIKAKU)

JAPANESE CREDITS: Writer: Mineo Maya. © Toei Doga. 48 mins.
ORIGINS: Mineo Maya's manga, pub Shueisha in Flowers & Dreams magazine, 1979; 1982 TV series.
POINTS OF INTEREST: The 1982 TV series is credited with introducing homosexual themes to TV anime.
CATEGORIES: DD, C

The tiny realm of Marinella, located in the South Seas, has two main exports — orchids and dia-

monds. It is ruled by a tiny Prince — Pataliro, a ten-year-old despotic genius, a master of disguise with a penchant for time travel and bad jokes. His bodyguard is Jack Barbarossa Bankolan, a top agent seconded from MI6 in London, complete with double-O prefix, Walther PPK Special and licence to kill. Bankolan is twenty-seven, a bishonen god with long black hair and bedroom eyes, and he has a fatal weakness — he just can't resist good-looking guys. Off-duty he lives in a London penthouse with the ravishing fourteen-year-old Mariahi, a redheaded German assassin, and on-duty he runs into terrible problems because the evildoers sent to carry out wicked schemes against Pataliro and his people tend to be absolutely gorgeous, whereas the Prince is a royal pain in the butt. The main adversary of our heroes is the criminal organisation Tarantula, which controls the International Diamond Syndicate and is trying to get control of Marinella's diamonds. In this film, scientists have determined that a meteor heading for Earth will shower the planet with diamonds. The Prince wants them, and so does Tarantula, and one of Bankolan's ex-lovers is embroiled in the plot. The humour is accessible enough to make the series and its spinoffs a favourite among many older fans in the USA and a staple of Western fan fiction. ★★★?

THE PROFESSIONAL: GOLGO 13
(Eng title for GOLGO 13)

JAPANESE CREDITS: Dir: Osamu Dezaki & Akio Sugino. Screenplay: Hideyoshi Nagasaka. Chara des, anime dir & art dir: Shichiro Kobayashi. Music: Toshiyuki Omori. © Takao Saito, Saito Pro, Tokyo Movie Shinsha. 95 mins.
WESTERN CREDITS: US video release 1992 on Streamline Pictures, dub, Eng dialogue Greg Snegoff; UK video release 1993 on Manga Video.
ORIGINS: Manga by Takao Saito, running since 1969, much praised for its accuracy and plausibility in depicting the life and activities of the criminal world. Eng trans versions, edited and coloured, pub Viz Communications, and in black and white graphic novel format, Lead Publishing Co.
POINTS OF INTEREST: Early use of computer animation sequences in the helicopter chase scenes looks limited now, but was state-of-the-art at the time.
CATEGORIES: M, X

A film derided by many Western audiences (I have been in the theatre on two occasions when a showing has provoked howls of mockery), this was, in fact, made specifically to appeal to Western tastes. In other words, this is the kind of film the Japanese think we like and it's a damning indictment of our tastes as viewed from the outside. *The Professional: Golgo 13* is a brutal, vicious and completely self-centred film in which any idea of loyalty, morality or social order is only there to be exploited when convenient. Duke, a professional hitman, accepts a contract to kill the son of a businessman powerful enough to subvert sections of the US government. The father is so bent on revenge that he offers his widowed daughter-in-law to a psychotic killer as down payment on a contract on Duke, and the hunted gunman becomes determined to find out who set the whole thing in motion. A very Japanese surprise ending reveals the originator to be the murdered son himself. The translation is stilted and the film has no redeeming features, although it's salutary to see ourselves as others see us. ☆

UNICO
(Eng title for UNICO: MAHO NO SHINAI E, lit Unico: To the Isle of Magic, aka FANTASTIC ADVENTURES OF UNICO 2: UNICO IN THE LAND OF MAGIC)

JAPANESE CREDITS: Dir & writer: Osamu Tezuka. Prod: Madhouse for Sanrio. © Tezuka, Sanrio. 90 mins.
WESTERN CREDITS: US video release on RCA/Columbia Magic Window children's label as Fantastic Adventures of Unico 2: Unico in the Land of Magic.
ORIGINS: Manga by Osamu Tezuka; 1981 movie.
POINTS OF INTEREST: Shown at London's Institute of Contemporary Arts in the mid-eighties.
CATEGORIES: DD, U

Unico is a little white unicorn with a special magical power — to grant people's wishes wherever he goes; but he has no control over whether these wishes will turn out well or badly. The film received considerable critical acclaim in Japan and was well received at what was, so far as I can ascertain, its only UK showing. ★★★

URUSEI YATSURA — ONLY YOU

JAPANESE CREDITS: Dir & screenplay: Mamoru Oshii. Chara des: Kazuo Yamazaki. Anime dir: Kazuo Yamazaki & Yuji Moriyama. Art dir: Shichiro Kobayashi.

Urusei Yatsura

© Takahashi, Kitty Film. 101 mins.
WESTERN CREDITS: *US video release 1993 on AnimEigo; UK video release 1994 on Anime Projects, sub.*
ORIGINS: *Manga by Rumiko Takahashi, pub Shogakukan, Eng trans pub Viz Communications; 1981 TV series.*
CATEGORIES: *C, R*

Ataru Moroboshi is getting married to a beautiful alien Princess, but it's not his affianced 'wife' Lum, Princess of the Oni. Elle rules a world with decor straight out of a Mills and Boon novel, with excessive use of pink and roses everywhere; there's also a mostly-female, mostly-babe population, and a very big freezer full of red-hot but deep-frozen studs for those late-night 'snacking' sessions no red-blooded girl can resist. Ataru is slated for a big wedding, followed by the Big Freeze, but Lum has other ideas, and her super-powered girlfriends, Princess Oyuki, the Goddess Benten and Ran-chan, decide to help her get her man back. The silliness, slapstick and visual sophistication of the battles that rage for possession of Ataru's person will keep most audiences smiling. Note the glorious character work, softening up and glamorising Takahashi's manga creations without changing the mood or lessening the appeal of this classic series. ★★★★

XABUNGLE GRAFFITI

JAPANESE CREDITS: *© Nippon Sunrise. 90 mins.*
ORIGINS: *Based on 1982 TV series Sento Mecha Xabungle from Nippon Animation.*
POINTS OF INTEREST: *Shared triple bill with Document of Sun Fang Dougram and Choro Q Dougram.*
CATEGORIES: *SF, C*

Episode compilation from the series about young Earthman Jiron Amons and his crew on the landship Iron Gear, fighting alien invasion and seeking the murderer of his father. The worker (sometimes rendered as walker) machines in *Xabungle* are a good deal less sleek and serious than the war mecha of *Gundam* and the story pokes gentle fun at the giant robot concept by making the title mech and its pilot good-hearted buffoons — hence the name, which is Japlish for 'The Bungler'. There's a strong cowboy influence in the series, right down to a Clint Eastwood clone. ★★☆

OAVS

DALLOS
(Eng title for DALLOS: DALLOS HAKAI SHIREI, lit Dallos: Order to Destroy Dallos)

JAPANESE CREDITS: *Dir: Mamoru Oshii. Writer: Hisaishi Toriumi. Prod: Studio Pierrot. © Studio Pierrot, Network, Bandai. 30 mins.*
POINTS OF INTEREST: *Although the first OAV to go on sale, on 21 December 1983, this is in fact the second part of the Dallos story. Part one, Remember Bartholomew, didn't go on sale until 21 January 1984.*
CATEGORIES: *SF*

At the end of the twenty-first century, the over-populated and exhausted Earth colonises the Moon. The planet prospers, but at the expense of the suppression and exploitation of the colonists by powerful military and commercial forces. A guerrilla force co-ordinates attacks on the governing body and demands Lunar independence; the ancient monument known as Dallos becomes the focus for the resistance and, realising this, the Earth government orders it to be destroyed. Guerrilla leaders Dog McCoy and Shun Nomura struggle for power, while commandant Alex Riger tries to control them and the rebels using his force of armed heavies and robot dogs. ★★

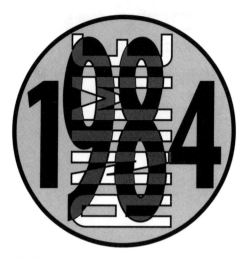

This was a year distinguished by cinema versions of two wonderful TV works from Hayao Miyazaki, plus his second feature film; by the *Macross* movie *Do You Remember Love?*; and by the OAV's first incursions into the realm of erotica. Of the OAVs released in 1984 almost a dozen fell into this category, including the first three of the famous Fairy Dust/Soeishinsha *Cream Lemon* series. Japanese animated erotica baffles many Western critics, who can't see how a cartoon character could seriously be considered sexy. But how much less 'real' or 'approachable' is a cel painting than a live-action screen goddess to the average fan? Whatever your verdict, the popularity of anime erotica endures to the present and shows no signs of an early decline. That, however, is another book...

MOVIES

DORAEMON

JAPANESE CREDITS: © Fujiko-Fujio, Shin'ei Doga. 99 mins.
ORIGINS: Manga by Fujiko-Fujio, pub Shin'ei Doga; 1979 TV series.
POINTS OF INTEREST: Released on a triple bill with kids' comedy films Paman and Ninja Hattori-kun.
CATEGORIES: C, U

Doraemon is a robot cat — and not a very expensive or high-grade one, but he's all his purchasers could afford. They are the descendants of Nobita, who lives in mid-twentieth-century Tokyo and is a typical dozy, lazy ten-year-old schoolboy. Unfortunately he's not going to grow out of his doziness, and so his descendants send Doraemon back from the future to try and make sure he doesn't leave them

with a pile of debt and disgrace that will take generations to pay off. The TV series is still running and regularly gets 18% or more of the ratings; in 1994 the fifteenth movie out-earned both *The Pelican Brief* and *Sleepless in Seattle* in Japanese cinemas, and the series is popular all over Asia, in Europe and in South America. The two-man team who worked as Fujiko-Fujio split amicably in 1988, but one of them, Hiroshi Fujimoto, still produces a new *Doraemon* manga book every year, and every summer the new *Doraemon* movie is based on the latest manga. I haven't seen this film, but the series provides a whimsical yet basically accurate picture of a Tokyo childhood in the 1960s.

DR SLUMP AND ARALE-CHAN: THE SECRET TREASURE OF NANABA CASTLE
(Eng trans for DR SLUMP AND ARALECHAN: HOYOYO! NANABAJO NO HIJO)

JAPANESE CREDITS: © Bird Studio, Shueisha, Toei Doga. 48 mins.
ORIGINS: Manga by Akira Toriyama; TV series; 1983 movie.
CATEGORIES: C

The story this time revolves around lechery, greed and time-travel. The insane inventor and his robot 'daughter' arrive back in 1929 at Nanaba, whose mysterious castle is said to conceal a great treasure. They tangle with pirates, the castle's defences and the crazy folk from Penguin Village in their attempts to get back to the future safe, sound and richer. ★★★?

FUTURE BOY CONAN: RETURN OF THE BIG PLANE GIGANT
(Eng trans for MIRAI SHONEN CONAN — KYODAIKAI GIGANT NO FUKKATSU)

JAPANESE CREDITS: Dir: Hayao Miyazaki, Isao Takahata & T. Ayukawa. Writer: K. Yoshikawa, T. Nakano & T. Muramomo. Chara des: Yasuo Otsuka. Prod & © Nippon animation. 47 mins.
ORIGINS: 1978 TV series.
POINTS OF INTEREST: Miyazaki is said to have based the hero on his own son. This is the only series to have been repeated in its entirety as a scheduled run on Japanese TV, in 1980.
CATEGORIES: SF, U

Theatrical compilation of the last three episodes of the future fantasy series. Conan, sole survivor of

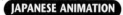

one of the scattered groups left by the war which destroyed the world, has left his lonely island to find Lana, the mysterious girl washed up on the beach and later kidnapped by soldiers from the despotic city of Industria. The pair and their friends manage to free the Industrian slaves and escape the final destruction of the city before coming full circle to re-colonise Conan's old home. The series is better because it's longer, but that's a minor quibble. ★★★

GREAT DETECTIVE HOLMES: THE BLUE RUBY, THE UNDERWATER TREASURE

(Eng trans for MEITANTEI HOLMES — AOI KOGYOKU NO MAKI, KAITEI NO ZAIHO NO MAKI; series alt title SHERLOCK HOUND)

JAPANESE CREDITS: Dir: Hayao Miyazaki. Chara des: Yoshifumi Kondo. Prod: Tokyo Movie Shinsha, RAI. © Tokyo Movie Shinsha, RAI, M. Pagott. 50 mins.
WESTERN CREDITS: TV series screened in Italy and the UK.
ORIGINS: The great detective created by Sir Arthur Conan Doyle; 1984 TV series Meitantei Holmes.
POINTS OF INTEREST: Japanese-Italian co-production. This is the first record of Miyazaki's work with Italian animator Marco Pagott, after whom he named the lead of his 1992 movie Porco Rosso (aka Kurenai No Buta, or The Crimson Pig).
CATEGORIES: U

A cinema compilation from this charming TV series, in which Holmes, Watson, Mrs Hudson, the villainous Moriarty and the other characters are transformed into anthropomorphised animals (mostly dogs). Kondo's chara designs are charming and the scripts clever and entertaining. Deserves wider exposure. ★★★☆

KENYA BOY

(Eng trans for SHONEN KENYA)

JAPANESE CREDITS: © S. Yamakawa, Haruki Kadokawa, Toei Doga. 110 mins.
ORIGINS: Manga by Soji Yamakawa, pub Omoshiro Bunka, title Shonen Oja, trans 'The Boy King'.
CATEGORIES: A, U

Mr Murakami owns a textile house in Kenya in 1941. When he takes his son Wataru with him on a business trip out of town, they are attacked by a rampaging rhino and separate to escape the animal. Before he can rejoin his son, Mr Murakami is arrested and interned as an enemy alien (Britain and Japan are now at war). The boy finds a Masai tribe who take him in, and soon makes friends with a warrior and a beautiful young girl and goes native. Together they set out to find his father and have a host of adventures with lions, elephants, a lost valley of tyrannosaurs and other extinct creatures, and a slimy Nazi spy. The exotic animals and well depicted bush backgrounds make this an attractive-looking title. ★★☆?

KINNIKUMAN

JAPANESE CREDITS: © Toei Doga. 45 mins.
ORIGINS: Manga & TV series.
POINTS OF INTEREST: Shared the Toei Manga Matsuri (Manga Festival) bill with The Pumpkin Wine: Nita's Love Story.
CATEGORIES: C, U

Also:
KINNIKUMAN — TRASH EVERYTHING! SUPERLAWGIVER
(Eng trans for KINNIKUMAN — OABARE! SEIGICHOJIN)

CREDITS: As above except: 48 mins.
ORIGINS, CATEGORIES: As above.

This comic opera about pro wrestling features one of the masked men so popular in the grunt'n'groan ring as its clownish hero with a heart of gold and muscles of steel. But there's a vital difference — this masked wrestler comes from outer space and has a wide range of super-powers, among them the ability to fly by super-farting. The series parodies both TV wrestling shows and American-style spandex-costumed superheroes. As befits the sport, the action is pure slapstick throughout and the story an excuse for a series of increasingly improbable fights, a formula Akira Toriyama was to exploit successfully in his *Dragonball* series. ★★?

LENSMAN
(Eng title for SF SHINSEIKI LENSMAN, lit Lensman New Century SF)

JAPANESE CREDITS: Dir: Kazuyuki Hirokawa & Yoshiaki Kawajiri. Screenplay: Soki Yoshikawa. Chara des: Yoshiaki Kawajiri & Kazuo Tomizama. © E. E. 'Doc' Smith, Kodansha, MK Company. 108 mins.
WESTERN CREDITS: US video release 1991 on Streamline Pictures; UK video release

1992 on Manga Video, 107 mins, Eng dialogue Steve Kramer & Tom Wyner.
ORIGINS: The Lensman series of novels by E. E. 'Doc' Smith. Lensman is loosely based on the third novel, Galactic Patrol.
POINTS OF INTEREST: The use of the CRAY-1 supercomputers at New York Institute of Technology's Computer Graphics Lab and the Japan Computer Graphics Lab led to the best yet blend of computer graphics and animation. The film marks the début of a major directorial talent in Kawajiri, whose later works include Cyber City Oedo 808 and Ninja Scroll. The Lensman novels were a major influence on Star Wars and Kawajiri returns the compliment with numerous references to Lucas's films.
SPINOFFS: The film's success led to a TV series, which was also edited into a second theatrical feature. This has had US and UK satellite screenings.
CATEGORIES: SF, U

Young Kimball (Kim) Kinnison is leaving his family home for a wider education, but when a Galactic Patrol ship crashes on their land he receives a mysterious Lens from the dying pilot. The half-sentient Lens implanted into his hand becomes the focus for a series of upheavals in his

Lensman

life — the death of his father, a space battle and a meeting with an attractive Galactic Patrol nursing officer called Chris. Impelled by the power of the Lens and the new world it has opened up for him, he encounters creatures and situations he could never have envisaged back on the farm, and risks his life to save Chris — and the galaxy. ★★★

LIGHT-HEARTED TALES OF PRO BASEBALL PART II
(Eng trans for PROYAKYU O JUBAI TANOSHIKI MIRU HOHO PART II)

JAPANESE CREDITS: Prod: Magic Bus. © Filmlink. 95 mins.
ORIGINS: Emoto Takenori's baseball books; 1983 movie.
CATEGORIES: C, N

After the huge success of the 1983 movie, the producers cashed in. More of Emoto Takenori's humorous tales of the baseball world.

LOCKE THE SUPERMAN
(Eng title/trans for CHOJIN LOCKE, aka STAR WARRIORS and LOCKE THE SUPERPOWER)

JAPANESE CREDITS: Dir: Takeshi Hirota. Prod: Nippon Animation. © T. Sei, Shonen Gohosha, Nippon Animation. 100 mins.
WESTERN CREDITS: US video release 1989 on Just For Kids, 1994 on Best Film and Video, dub; UK video release 1991 on Bano Childrens label as 2 separate tapes, Star Warriors Vol 1 & 2, dub, each c50 mins.
ORIGINS: Yuki Hijiri's manga; Hirota's 1980 pilot film Cosmic Game (10 mins).
POINTS OF INTEREST: Appears to be the only anime release on this British-Asian label; dub with original chara names retained. The earlier US release used the title Locke The Superpower to avoid conflict with DC over the Superman trademark, but the currently listed release carries the 'Superman' title.
CATEGORIES: SF, U

Another film experimenting with the fusion of traditional cel animation and computer graphics, this is the story of a thousand-year-old farmer who is one of the galaxy's most powerful psychics. He just wants a simple, peaceful life, but is asked to use his powers to help the authorities thwart Lady Kahn, who is amassing an army of psychics to create an 'esper empire' and enslave the humans who at present hate and fear those with paranormal powers.

(Remind you of a certain mutant superhero or several?) Despite his powers, Locke is a pacifist at heart and this makes him vulnerable. He wins in the end, but his actions bring him back into the limelight and cost him the woman he loves. The style of the film is still very much of the seventies, with gravity-defying hairstyles and vast 'soul-mirror' eyes. The technical aspects leave much to be desired in the light of modern advances, but the story still has power and is worth seeking out. ★★★

MACROSS: DO YOU REMEMBER LOVE?

(Eng trans for CHOJIKU YOSAI MACROSS AI OBOETE IMASUKA, aka CLASH OF THE BIONOIDS, aka MACROSS THE MOVIE, aka SUPER DIMENSIONAL FORTRESS MACROSS, aka SUPER SPACE FORTRESS MACROSS)

JAPANESE CREDITS: Dir & mecha des: Shoji Kawamori. Chara des: Haruhiko Mikimoto. Prod: Tatsunoko. © Big West, Tatsunoko. 112 mins.
WESTERN CREDITS: Super Dimensional Fortress Macross (dub, 115 mins), US video release 1994 on Best Film and Video; Clash of the Bionoids (dub, 98 mins), Macross Do You Remember Love? (sub, 112 mins), UK video release 1995 on Kiseki Films.
ORIGINS: 1982 TV series.
POINTS OF INTEREST: The Super Space Fortress Macross version was originally dubbed as a language teaching aid for young Japanese. In the 'officially revised' Macross timeline released in 1995 to coincide with the new OAV Macross Plus and the TV series Macross 7, the film is listed as a docudrama made in the Macross universe as a fictionalised account of events from recent history. According to Trish Ledoux and Doug Ranney's book on US anime releases, and to their source, the US sleeve notes, the American release runs longer than the Japanese original! Since this bucks the established Western trend of taking footage out of anime, it has caused me much puzzlement, but in the absence of a copy of the US tape I can only conjecture as to whether this arises from an extended credit sequence to accomodate Western credits, unspecified extra footage or just a very approximate timing on the sleeve notes.
CATEGORIES: SF, R, U

A slightly altered take on the TV series, which sets the love triangle of young pilot Hikaru Ichijo, officer Misa Hayase and idol singer Lynn Minmei against a sprawling backdrop of invasion by giant alien warriors and mankind's desperate struggle for survival. The film has too much schmaltz for some, but the action sequences are well worth seeing, the magnificent Valkyrie mecha still among the most convincing ever designed and the idea that a song can save the world still curiously touching. The 'ark in space' concept is an old one, but the design of the SDF-1, combination weapon and flying city, is a detailed and powerful presentation of the old idea. Love, death and music combine in a space-opera cocktail. ★★★

THE PUMPKIN WINE: NITA'S LOVE STORY

(Eng trans for THE KABOCHA WINE: NITA NO AIJO MONOGATARI)

JAPANESE CREDITS: © M. Miura, TV Asahi, Toei Doga. 24 mins.
ORIGINS: Manga by Mitsuru Miura; 1982 TV series.
POINTS OF INTEREST: Shared the summer's Toei Manga Matsuri (Manga Festival) bill with Kinnikuman.
CATEGORIES: C, N

Based on the comic soap-opera about Shunsuke, who is repelled by women, yet not gay. His family enrol him in a co-educational high school in the hope that this will help his serious girl phobia and enable him to relate normally to the opposite sex. His phobia and the funny situations it gets him into are the centre of both the series and this film. ★★?

URUSEI YATSURA — BEAUTIFUL DREAMER

JAPANESE CREDITS: Dir & screenplay: Mamoru Oshii. Chara des: Kazuo Yamazaki. Anime dir: Kazuo Yamazaki & Yuji Moriyama. Art dir: Shichiro Kobayashi. Prod: Kitty Film. © Takahashi, Shogakukan, Toho Co. 98 mins.
WESTERN CREDITS: US video release 1993 on US Manga Corps, sub by AnimEigo, trans Shin Kurokawa, Mariko Nishiyama & Aki Tanaka.
ORIGINS: Manga by Rumiko Takahashi, pub Shogakukan, Eng trans pub Viz Communications; 1981 TV series; 1983 movie.
CATEGORIES: C, N

Ataru Moroboshi has a dream. The day before the Tomobiki High School prom it comes true — sort of. Of course, babes and mayhem are involved. But there's something strange — the dream keeps on repeating itself and everybody is involved in it.

Another masterly outing for the UY team as they bring the classic Japanese folk tale of Urashima into the present. Oshii uses the story as a basis for a comedy which plays with serious issues like time, space, reality and perception. ★★★

WARRIORS OF THE WIND
(Eng title for KAZE NO TANI NO NAUSICAA, lit Nausicäa of the Valley of the Wind)

JAPANESE CREDITS: Dir & writer: Hayao Miyazaki. Chara des: Kazuo Komatsubara. Music: Jo Hisaishi. Exec prod: Isao Takahata. Prod: Nibariki. © Nibariki, Tokuma Shoten, Hakuhodo, Toei. 118 mins. WESTERN CREDITS: US video release 1986 on New World Video, dub, prod Riley Jackson, 95 mins; UK video release late eighties on Vestron Video, dub, same version re-release 1994 on First Independent, 94 mins.
ORIGINS: Manga by Hayao Miyazaki, first appearing in Animage magazine, later pub in the USA by Viz Communications.
CATEGORIES: SF, U

The problem with writing about Hayao Miyazaki's work is the continual need to search for new superlatives. This is considered by many to be his finest film and even in the edited US and UK ver-

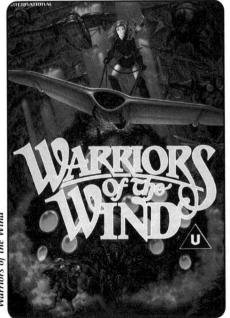

Warriors of the Wind

sions, shorn of its widescreen splendour and a good deal of the logic of its plot, its quality shines through. The animation and background painting are excellent, particularly evoking beauty and tenderness in their attention to the blighted and devastated natural order of a future earth. The writing is good, the characterisation wonderful and the music score compelling. Scenes of apocalyptic conflict and Messianic resurrection strike no discordant notes in this story of a heroic and innocent girl so in love with every living thing that she is prepared to sacrifice her own life to save her people and her world. The Valley of the Wind is a peaceful farming community invaded by outsiders who mean to wreak havoc on the world with a terrible living weapon. Princess Nausicäa must take responsibility for her people when their safe little haven is destroyed, learn to deal with the anger and hatred that prevent a peaceful resolution, not just in others, but in herself, and find a way to resolve the conflicts that threaten both her own people and the enemy. This is a wonderful film for children of all ages and one that every little girl should see, although both sexes will find Miyazaki's joyous depictions of flight and his creation of an alien yet totally coherent natural world irresistible. Adults will respect the absolute simplicity and honesty with which this great director handles his material. The best animated film of 1984 by a long way. And I don't just mean in Japan. ★★★★★

OAVS

CREAMY MAMI — FOREVER ONCE MORE
(Eng title for MAHO NO TENSHI CREAMY MAMI — EIEN NO ONCE MORE, lit Magic Angel Creamy Mami – Forever Once More)

JAPANESE CREDITS: Dir: Osamu Kobayashi. Writer: Kazunori Ito. Chara des: Akemi Takada. Prod: Studio Pierrot. © NTV, Bandai. 45 mins.
ORIGINS: Manga by Yuko Kitagawa & Kazunori Ito; 1982 TV series.
POINTS OF INTEREST: Creamy Mami is representative of a genre dating back to 1966 and the TV series Mahotsukai Sally (Little Witch Sally). Stories about cute little girls with magical powers have been popular with Japanese children ever since, as well as attracting older fans nostalgic for childhood or, as in the case of the recent hit Sailor Moon, for stories about cute little girls.
CATEGORIES: DD, U

The space kittens Pozi and Nega gave little Yu a magic baton and for a year she possessed the power to transform into grown-up idol singer Creamy Mami and use her magic for good. Sometimes her powers caused more problems than they solved, and though everything worked out well she finally returned the baton. Ever since, Mami has been absent from the music scene, but suddenly her return is announced in a blaze of publicity. Yu and her friends uncover a campaign by bad boy Shingo to deceive the singer's many fans. ★★☆?

DALLOS — REMEMBER BARTHOLOMEW

JAPANESE CREDITS: Dir: Mamoru Oshii. Writer: Hisaishi Toriumi. Prod: Studio Pierrot. © Studio Pierrot, Network, Bandai. 30 mins. ORIGINS: 1983 OAV. CATEGORIES: SF

The first story of the series was the second OAV released in Japan. The tale of young Shun Nomura's involvement with the guerrilla movement starts with the death of his brother and brings him into conflict with the Earth government and their commander of armed forces on the Moon, Alex Riger. ★★

Also:
DALLOS III — SEA OF MEMORIES PART 1
(Eng trans for DALLOS III BOKYU NO UMI NO TATSU)

CREDITS, ORIGINS, CATEGORIES: As above.

The first generation of Lunarians don't want to fight Earth, but their grandchildren want independence. Rebel leader Dog McCoy invites Shun to join forces with him, but Shun, influenced by his beloved grandfather, is undecided. Meanwhile, Riger faces opposition in the Earth/Lunar Government. An attack on the residential quarter finally decides Shun's course for him. ★★

Also:
DALLOS III — SEA OF MEMORIES PART 2

CREDITS, ORIGINS, CATEGORIES: As above.

The concluding episode shoots for pathos and grandeur, and doesn't entirely fail. The guerrilla leaders urge the colonists to meet in the ruins of Dallos and Riger takes personal command of the

field troops for the decisive battle. Shun survives to take his grandfather on a last journey across the Sea of Memories to the cemetery of all the colonists who yearned to return to Earth and now will never succeed. Resting his eyes on the world from which he has been exiled, the old man dies. Shun, who was born on Luna and never felt the same emotional ties to the home planet, realises that he and his generation must now begin to build a new life for themselves and their world. ★★☆

LITTLE STORIES FROM THE STREET CORNER
(Eng trans for MACHIKADO NO MERUHEN)

JAPANESE CREDITS: © Kitty Film, Five Ace. 52 mins. CATEGORIES: R, N

Hiroshi is a high school student who dreams of one day writing a children's book. But knowing that dreams need money to become a reality, he works hard and saves for the day when he can be a writer. A chance meeting with Hiroko on the subway leads to love and is vital in helping him finally realise his ambitions. ★★☆?

WORLD OF THE TALISMAN
(Eng title for BIRTH, aka PLANET BUSTERS)

JAPANESE CREDITS: Chara des: Koretaku Kanda. Mecha des: Makoto Kobayashi. Anime dir: Shinya Sadamitsu. Art dir: Geki Katsumata. Prod: Kaname. © Victor, Idol Co. 80 mins. WESTERN CREDITS: US video release 1987 on Harmony Gold USA/Idol Co, 1992 on Streamline Pictures as Planet Busters, dub, Eng version adapted by Greg Snegoff; UK release 1988 on Kids Cartoon Collection, dub. CATEGORIES: SF

Namu Shurugi and Rasa Yupiter are descended from a race wiped out by the people of the planet Acquaroid, who are engaged in a huge and devastating global war with a race of androids. They and their companions must struggle to survive and reach a goal that will finally explain the enigma of their mission. But the mission, and their very lives, are not what they seem. A paradoxical and densely layered story makes this very unsuitable for small children, but lots of action, neat bikes and frequent shots of Rasa's rear end may appeal to SF buffs who like some window-dressing around the meaning of life. ★★★

A superb year for anime in the cinema saw a number of important new films make their début, and as computer animation techniques grew ever more assured, experiments in integrating computers with the traditional cel animation in which Japan excels continued to be made. The OAV hit its stride, with almost fifty releases during the year. About a quarter were erotica, with the *Cream Lemon* series predominating. This series remains a fan favourite, covering mild soft porn and tackling such themes as lesbianism, bondage and fetishism in a light-hearted and generally inoffensive manner; it is only a very distant ancestor of such titles as *Twin Dolls. Cream Lemon* OAVs continued to be made throughout the decade and still have a certain charm, but as the youth market for video developed, fantasy and sf were the major themes.

MOVIES

CAPTAIN TSUBASA: THE GREAT EUROPEAN CHALLENGE
(Eng trans for CAPTAIN TSUBASA: EUROPE DAIKESSEN)

JAPANESE CREDITS: Dir: Hiroyoshi Mitsunobu. © Y. Takahashi, Shueisha, Tsuchida. 41 mins.
ORIGINS: Manga by Y. Takahashi; 1983 TV series.
POINTS OF INTEREST: The surname of the lead character translates as 'wing' — appropriate for a footballer!
CATEGORIES: N, U

Also:

CAPTAIN TSUBASA: DANGER! THE JAPANESE JUNIOR CHAMPIONSHIP
(Eng trans for CAPTAIN TSUBASA: AYAUSHI! ZENNIHON JR)

CREDITS, ORIGINS, CATEGORIES: As above except: 60 mins.

Soccer was around long before Gary Lineker hit Japan, and Ozora Tsubasa's exploits were read by teenage boys everywhere, making him Japan's nearest equivalent to Roy of the Rovers. He rises to become captain of the national junior squad and leads his team against the world's best, as well as facing all kinds of opposition at home. Triumph, disaster, unsporting behaviour and classic footballing skills reinforce the message in every film that both mavericks and team players have to aim at the same goal. The 'exotic' backgrounds for overseas tours were another attraction to a generation of young teenagers unlikely to have had much opportunity to travel outside Japan. ★★☆?

THE DAGGER OF KAMUI
(Eng title for KAMUI NO KEN, lit Sword of Kamui, US aka REVENGE OF THE NINJA WARRIOR, US aka THE BLADE OF KAMUI)

JAPANESE CREDITS: Dir: Taro Rin. Writer: Mamoru Mazaki. Chara des: Moriyoshi Murano. Music: Ryudo Ozaki & Eitetsu Hayashi. Prod: Project Team Argos, Madhouse. © Haruki Kadokawa, Project Team Argos, Madhouse. 132 mins.
WESTERN CREDITS: Early US video release as Revenge of the Ninja Warrior; US video release as The Blade of Kamui on Best Film and Video, dub; US video release 1993 on AnimEigo, sub, trans Shin Kurokawa & Vincent Winiarski.
ORIGINS: Novel series by Tetsu Yano.
POINTS OF INTEREST: Many charas are fictionalised versions of real people and the story is based on real events in Meiji era Japan. Tetsu Yano is Robert Heinlein's Japanese translator and is also the first Japanese author to be nominated for a Hugo, the World Science Fiction Convention's annual awards.
CATEGORIES: P, SH

The story opens with the orphaned Jiro falling into a trap, accused of murdering his foster mother and sister and killing his own father for the sinister Bishop Tenkai. He is trained as a ninja by the Bishop for a special purpose, but it is not until he

sets out alone, a fugitive once more, that he begins to uncover the mystery of his past. Jiro is only half Japanese. His mother was a Princess of the Ainu, the aboriginal people who still live on the north island now known as Hokkaido, and the dagger he carries is both a sacred object and the passport to a great treasure. Fictionalising Japanese history of the last century with conviction and skill, the story takes Jiro to his mother's village and his father's grave, across the sea to America, to the Wild West, along the coast of California and finally back to Japan, where he has a crucial part to play in shaping the modern nation. Death follows him everywhere at Tenkai's behest. His mother, the innocent girl and elderly dissident who befriend him, and many others fall to the Bishop's men. Nevertheless, Jiro survives and presses on towards the treasure his father was determined to keep out of Tenkai's hands. The film is full of unexpected delights — Jiro's meeting with the journalist Samuel Clemens, better known as Mark Twain; the stand-off between ninja skills and Colt 45s in a Western town; the hallucinatory sequence where three of Tenkai's most terrible living weapons exert their magical powers against the young man. These and many more sequences make *The Dagger of Kamui* one of the best examples of the historical-fantasy genre, with understated but firm anti-racist messages thrown in. The music is especially good, using traditional instruments and vocal chants to great effect. ★★★★☆

DORAEMON — NOBITA'S LITTLE STAR WARS
(Eng trans for DORAEMON — NOBITA NO LITTLE STAR WARS)

JAPANESE CREDITS: © Shin'ei Doga. 90 mins.
ORIGINS: Manga by Fujiko-Fujio, pub Shin'ei Doga; 1979 TV series; 1984 movie.
CATEGORIES: C, U

A comic tale in which the Doramon regulars re-enact George Lucas's famous saga. Nobita is a dozy, hopelessly inept kid, and Doraemon is a robot cat from the future, sent back by Nobita's descendants to make sure he doesn't grow up useless and leave them a pile of debt and disgrace. The series provides a whimsical but basically accurate picture of a Tokyo suburban childhood in the 1960s. ★★☆?

GIGI AND THE FOUNTAIN OF YOUTH
(Eng title for MAHO NO PRINCESS MINKY MOMO: LA RONDE IN MY DREAM, lit Magical Princess Minky Momo: La Ronde in My Dream, aka MAGICAL PRINCESS GIGI)

JAPANESE CREDITS: Dir: Hiroshi Watanabe. Script: Takeshi Shudo. Prod: Kunihiko Yuyama. Prod co: Ashi Pro. © Ashi, Network, Bandai. 80 mins.
WESTERN CREDITS: US video release 1987 on Harmony Gold, re-release 1994 as Magical Princess Gigi on Celebrity Home Entertainment, dub, story by Carl Macek, written by Greg Snegoff, c76 mins; UK video release 1994 on Kids Corner.
ORIGINS: 1982 TV series.
CATEGORIES: DD, U

Gigi/Minky Momo is Princess of a magical land of dreams, but has been sent to Earth by her parents and lives as a normal human girl with human parents, a home and pets, in fact a completely ordinary little girl's life — except that she can transform into a grown-up magical heroine to help solve problems. When her human parents go off on holiday their plane disappears, and Gigi and her animal friends set off to find them. They come to a mysterious tropical isle where a group of strange and sinister people are gathering. In a magical kingdom, floating above the island, there is a world where everyone is a child forever; a teenager called Peter controls a magic fountain of youth and has used its powers to create a world of childlike happiness. Her parents have been taken there to act as mother and father to the perpetual children, and seem happy in Peter's Never-NeverLand. But the forces of greed and violence from outside the magic world are gathering to destroy it. Lightweight, sweet and beautifully designed, with plenty of humorous touches, this is a real treat for animation fans of all ages. ★★★☆

KINNIKUMAN — COUNTERATTACK! THE SECRET SUPERMAN FROM SPACE
(Eng trans for KINNIKUMAN — GYAKUSHU! UCHUKAKURECHOJIN)

JAPANESE CREDITS: © Toei Doga. 39 mins.
ORIGINS: Manga & TV series; 1984 movies.
CATEGORIES: C, U

Also:
KINNIKUMAN — WHAT A GUY! THE SUPERLAWGIVER
(Eng trans for KINNIKUMAN — HARESUGATA! SEIGICHOJIN)

CREDITS, ORIGINS, CATEGORIES: As above except: 60 mins.

MY PERSONAL TOP TEN

A list like this is always changing because there are always new titles with their own special attraction. However, there are a few titles that have been in there ever since I first saw them, and I don't think anything will ever top them for me. Watch them yourself and see if you agree.

1 MY NEIGHBOUR TOTORO

My all-time favourite film. Whenever I watch it it makes me feel good, and everyone I've ever shown it to has enjoyed it. The story is breathtakingly simple and has all the honesty and immediacy of a child's drawing, subtly paced and enhanced by one of the greatest film-makers in the world. It's like revisiting the happiest summer of your childhood. Oh, and it's technically as near-perfect a piece of animation as you could wish for.

2 PORCO ROSSO

It came out in 1992 and it's still up there. I'm not a plane buff or a World War One freak, but I really respect the level of research and detail that has gone into this film. There's a story, a moral, real emotional engagement, and the characters are fabulous. The action sequences include aerial battles that have never been bettered in live-action film, and the comedy is superbly placed.

3 LAPUTA

Yes, another Miyazaki film, and for all the same reasons. Written with a true epic sweep and grandeur, it's a near-perfect film with something for everyone. The animation is superb, the characterisation excellent, and while it is entirely suitable for children it's not just a 'children's film'. As with my first two choices, the score alone is sufficient justification for its ranking.

4 NAUSICAA OF THE VALLEY OF THE WIND

Topping the *Animage* magazine poll as Best Anime Ever Made for a decade, this eco-drama with its enchanting young heroine and powerful fable of our world as it might become is a fan favourite in the West too. Despite savage editing and sometimes inadequate redubbing, its Western version, *Warriors of the Wind*, is an impressive work, but the original will take your breath away as Miyazaki demonstrates how to build a perfectly convincing world onscreen.

5 THE WINGS OF HONNEAMISE

Real science fiction, world-building worthy to stand beside Miyazaki's, and a great story. In my opinion this is one of the best SF films ever made. Its slow pace, length and extended thematic development make demands on the audience which few Western directors would risk, but it succeeds magnificently.

6 ARION

Yasuhiko at his not inconsiderable best reworks Greek myth with a grandeur and pathos which can't be ignored, and brings out powerful erotic and sado-masochistic undertones. Technically it was up with the best of its day and it still packs a punch.

7 CHAR'S COUNTERATTACK (part of the Gundam series)

A film of Arthurian scope and emotional intensity starring my favourite Aryan blond. Great battles, great mecha, great characters and a huge story which moves space opera into the realms of fable. It is sadly true that they don't make 'em like this any more.

8 LUPIN III: THE GOLD OF BABYLON

Funny, literate, clever, grown-up film with lots of action, comedy, adventure and romance, pastiching a wide range of influences with huge success. Any *Lupin III* outing is worth watching, but of the ones that fall within the scope of this book, *The Gold of Babylon* is my favourite. But beware the UK edition's subtitles, which are not always as the translator intended.

9 NIGHT ON THE GALACTIC RAILROAD

Gisaburo Sugii's hypnotic fable set in an imaginary realm pays homage to the novella on which it's based but also adds something of his own. The director of *Streetfighter II* turns in a visually stunning, intellectually demanding, slow-moving film which neither makes nor needs concessions to commercialism.

10 DIRTY PAIR: PROJECT EDEN

I just love the girls, and this is their best romp ever. Weird science, mad scientists, heroic thieves, a bathroom scene and mass destruction. Just enjoy it, it's great.

In both films the heroic masked wrestler from space faces terrible opposition, but things work out fine after much slammin' to the mat for all parties. ★★?

KITARO GEGEGE
(Eng title for GEGEGE NO KITARO)

JAPANESE CREDITS: © Mizuki Prod, Toei Doga. 39 mins.
ORIGINS: Manga by Shigeru Mizuki based on Japanese folk tales; 1968 & 1985 TV series.
POINTS OF INTEREST: There has also been a live-action version of the series, featuring Mizuki himself in a cameo role.
CATEGORIES: H, U

Kitaro is a perfectly normal little boy except that one eye is home to his father's spirit and can climb around from its preferred travelling perch in his hair, and his constant companions are ghosts. Luckily, he also has plenty of human friends his own age, all of whom seem to be plagued with relatives with a penchant for getting into supernatural trouble and needing Kitaro's help. The earlier series had Kitaro and his father battling with all manner of nasty and thoroughly wicked monsters; the 1985 series which inspired this film is re-designed, remodelled and more light-hearted. Kitaro still fights bad spirits — and bad people — with the help of his ghostly and human friends. His battery of weapons includes traditional wooden sandals that he can fire off his feet as missiles and hair that stiffens into sharp porcupine-like quills which shoot out of his head to spear evil-doers. Good fun, and an interesting window onto the superstitions and folk traditions that underlie the culture of modern Japan. ★★★

LUPIN III: THE GOLD OF BABYLON
(Eng title for LUPIN SANSEI — BABILON NO OGON DENSETSU, lit Lupin III — Legend of the Gold of Babylon, aka RUPAN III: LEGEND OF THE GOLD OF BABYLON)

JAPANESE CREDITS: Dir: Seijun Suzuki & Shigetsu Yoshida. Screenplay: Chiku Owaya. Chara des: Yoshio Urasawa & Jiku Omiya. Music: Yuji Ono. Prod: Tokyo Movie Shinsha. © Monkey Punch, Sotsu Agy, TMS. 100 mins.
WESTERN CREDITS: US video release 1995 on AnimEigo as Rupan III: Legend of the Gold of Babylon, sub, trans Shin Kurokawa & Michael House; UK video release 1995 on Western Connection, sub.

ORIGINS: The Arsène Lupin stories by Maurice Leblanc; manga by Monkey Punch; 1971 & 1977 TV series; 1978 movie.
POINTS OF INTEREST: Note the presence of cult sixties live-action director Seijun Suzuki, whose live oeuvre is currently available in the UK on ICA Video.
CATEGORIES: C, M

A witty, wacky, literate film full of invention and energy. The story opens in New York where Monkey Punch's loveable rogue and his gang are pursued by the Mafia, the police and the elderly lush Rosetta, who chants a proverb about the Babylon legend between protestations of passion for Lupin. The trail leads from Madison Square Gardens, scene of possibly the most hilarious bike chase ever filmed, to the Middle East, and back again to New York, pastiching Indiana Jones, Erich Von Daniken, Mafioso epics and Tom and Jerry along the way. The gold is actually buried under New York, in the form of an alien building with spaceflight capacity. So what will happen to New York when the aliens come back to claim it? Rosetta finally reveals herself in her true form and Lupin is left cursing that he missed out on an interstellar sex goddess, but Fujiko, ever practical, is more concerned with keeping as much of the gold as possible. A beautifully drawn finale shows a fine butter-yellow rain drifting down into the Hudson under a huge moon. Fantasy for grown-ups. ★★★★

NIGHT ON THE GALACTIC RAILROAD
(Eng trans for GINGA TETSUDO NO YORU, aka NIGHT ON THE MILKY WAY RAILROAD)

JAPANESE CREDITS: Dir: Gisaburo Sugii. Writer: Minoru Betsuyaku. © Matamura, Asahi, Herald Tack. 107 mins.
WESTERN CREDITS: US video release planned for summer 1996 on Central Park Media.

Lupin III: The Gold of Babylon

ORIGINS: Novella by Kenji Miyazawa, pub Kodansha, trans J. Bester.
POINTS OF INTEREST: Gisaburo Sugii, one of the least prolific but most inventive and daring of anime directors, has recently completed the anime movie version of computer game hit Street Fighter II, released in the USA by Sony and the UK by Manga Video.
CATEGORIES: DD

A gentle, magical yet dark-toned fantasy about life and death, this hypnotic film requires a good deal of attention, but its slow and carefully controlled pace allows the dazzling imagery to linger in the mind and build to a lasting effect. The story is deceptively simple, seeming almost aimless at first, and the use of cats as protagonists and the dream-like quality of the settings put a safe emotional distance between the viewer and the poignant ending. Young Giovanni, with difficult circumstances at home and an unhappy life at school, falls asleep in a field one night and wakes to see the Galactic Railroad touch the Earth. He boards the gleaming train and finds his classmate Campanella already aboard. As they steam through the night sky, meeting baffling fellow-travellers and visiting strange places, Giovanni finds that he possesses a return ticket. The amazement this causes, and Campanella's sudden departure, are explained when, waking once again in the field near his home, he finds that the villagers are dragging the canal for Campanella's body. Hearing a train whistle through the night, he races back up the hill to where the starry railroad once touched the ground, to look for his friend. The simplicity of this outline is decorated with wonderful touches. Giovanni's village is an Italianate fantasy powerfully reminiscent of the dream-village of Portmeirion in Wales, and the festival scenes there, the still, endless heat of summer afternoons at school and the awful embarrassment of shy children faced with the casual cruelty of their classmates, are all wonderfully evoked. But the best moments come on the journey itself; the arrival of the great engine, steaming to a halt in a field of star-like flowers; the view from the window onto a mystical landscape where cranes, the symbols of life, are born from the Sandman's sack; the halt in a huge, echoing station; the parting at journey's end. This is a great and very rewarding film. A bright older child would enjoy it immensely, but don't be deceived by the cute kitties — it's not for most under-fifteens.
★★★★☆

ODIN
(Eng title for ODIN — KOSHI HANSEN STARLIGHT, lit Odin — Photon Ship Starlight)

JAPANESE CREDITS: Dir: Takeshi Shirato, Toshio Masuda & Eiichi Yamamoto. Writer & prod: Yoshinobu Nishizaki. Screenplay: Kazuo Kasahara, Toshio Masuda & Eiichi Yamamoto. Chara des & art dir: Geki Katsumata. Anime dir: Eiichi Yamamoto & Kazuhito Udagawa. Art dir: Tadano Tsuji. Music: Hiroshi Miyagawa, Kantaro Haneda, Noboru Takasaki, Masamichi Amano & Fumitaka Anzai. © Westcape Corp. 139 mins.
WESTERN CREDITS: US video release 1992 on US Manga Corps, 93 mins, sub & dub; UK video release 1993 on Manga Video, 93 mins, dub, Eng adaptation George Roubicek.
CATEGORIES: SF

This beautifully designed film is probably the worst ever Western edit. The pedestrian story and cardboard characterisation may not be entirely due to the hacking out of over forty-five minutes in the Western release versions, but it must play a part, as must the dub and translation, which are wooden in the extreme. The story of a youthful crew and experienced captain setting out in a spacegoing sailing ship on a dangerous mission with the lure of a beautiful, mysterious girl is much better done in Nishizaki and Matsumoto's Space Battleship Yamato. Despite the more contemporary design and technical skill displayed in Odin, it doesn't hold a candle to its older stablemate. The ship itself is an interesting concept, gorgeously executed, but only the design work saves the Western version from the pits. ★

URUSEI YATSURA — REMEMBER MY LOVE

JAPANESE CREDITS: Dir: Kazuo Yamazaki. Screenplay: Tomoko Konparu. Chara des: Akemi Takada. Anime dir: Yuji Moriyama. Art dir: Shichiro Kobayashi & Torao Arai. Music: Mickey Yoshino. © R. Takahashi, Shogakukan, Kitty Film. 90 mins.
WESTERN CREDITS: US video release 1992 on AnimEigo; UK video release 1994 on Anime Projects, sub, trans Shin Kurokawa & Eriko Takai.
ORIGINS: Manga by Rumiko Takahashi, pub Shogakukan, Eng trans pub Viz Communications; 1981 TV series; 1983 & 1984 movies.
CATEGORIES: C, R

The closest to a pure SF story ever achieved by the Urusei Yatsura team, this tale of transdimensional travel, obsessive love and the line between childhood

and adulthood is both cleverer and deeper that its lunatic surface charm indicates. Neglected by his parents, the boy Lu is looking for someone to love and settles on Lum. Lu brings a magic carnival (shades of Ray Bradbury, and with the same razor edge of threat wrapped in the candyfloss) to Tomobiki Town and sets up a show in which he is the glamorous masked hero and Ataru is left stranded on the stage in the shape of a pink hippopotamus, carrying Lum off to his transdimensional galleon at the climax of the show. But Ataru and Lum are linked by a powerful force, and the same applies to all her classmates in Tomobiki High as well as her girlfriends Oyuki, Benten and Ran. Lu has stolen one of the most important people in their lives, and they set out to get her back. Beautifully designed and written, well worth add-ing to any collection. ★★★★

OAVS

ANGEL'S EGG
(Eng trans for TENSHI NO TAMAGO)

JAPANESE CREDITS: Dir: Mamoru Oshii.
Chara des: Yoshitaka Amano. Prod: Studio
Dean. © Tokuma Shoten. 80 mins.
POINTS OF INTEREST: Footage was cut into
the Australian live-action post-apocalypse
film In the Aftermath.
CATEGORIES: DD

A dreamlike, mystical tale which moves slowly but gracefully to a pointless ending. The birds are all but extinct and soon nothing will remain but distant memories of them. A young soldier sees a girl carrying a huge egg through the shadowy streets. The two decide to join forces to try to find a safe place for it, since the girl hopes that if brooded over the egg could hatch a live bird, or perhaps something even more wonderful. She keeps it at her side, but the soldier breaks it while she is asleep. When she wakes, he is overcome by guilt and grief and commits suicide. For all its beauty and delicate allegory, not many viewers will get into this film. Certainly no one could accuse it of rampant commercialism. ★★★

AREA 88 ACT I — THE BLUE SKIES OF BETRAYAL
(Eng trans for AREA 88 ACT I — URAGIRI NO AOZORA)

JAPANESE CREDITS: Dir: Eikoh Toriumi.
Screenplay: Akiyoshi Sakai. Chara des
& chief animator: Toshiyasu Okada.

Art dir: Mitsuji Nakamura. Music: Ichiro
Nitta. © K. Shintani, Shogakukan, Project
88. c50 mins.
WESTERN CREDITS: US video release 1994
on US Manga Corps, sub, trans Neil
Nadelman.
ORIGINS: Kaoru Shintani's manga series,
pub Shogakukan, Eng trans pub by Viz
Communications.
CATEGORIES: W

Also:
AREA 88 ACT II — THE REQUIREMENTS OF WOLVES
(Eng trans for AREA 88 ACT II — OKAMITACHI NO JOKEN)

CREDITS, ORIGINS, CATEGORIES: As above
except: 57 mins.

Shin Kazama is an ace pilot duped by his 'friend' Kanzaki into signing on for a three-year stretch in a mercenary force headed by Prince Saki Vashutarl of the Arab kingdom of Asran. The only way out — apart from death — is to raise enough money by his 'kills' to buy himself out, so that he can rejoin his beloved Ryoko back in Japan. Kanzaki wants her and her father's airline for himself and thinks Shin can't survive, but Shin's skills are equal to the challenge of combat. He is on the verge of earning enough to buy his way out when tragedy strikes at the end of Act I. In Act II, Ryoko, a determined young woman despite her lack of worldly wisdom, enlists the help of her father's secretary and searches for Shin, while he continues to fly into danger, and Kanzaki's plots continue. The contrasts of Shintani's art — realistic planes and aerial sequences juxtaposed with willowy, ethereal faces and figures — hark back to the work of Leiji Matsumoto, whose assistant he was. The atmosphere of tension and desperation in *Area 88* marks it out as a serious and thoughtful essay on the effects of combat on pilots, and a cracking adventure story — both of which aspects the cute charas might lead one to overlook. ★★★☆

ARMOURED TROOPER VOTOMS: THE LAST RED SHOULDER
(Eng trans for SOKOKIHEI VOTOMS THE LAST RED SHOULDER)

JAPANESE CREDITS: Dir & mecha des:
Ryosuke Takahashi. Chara des: Norio
Shioyama. Prod: Nippon Sunrise. © Sunrise,
Toshiba. 60 mins.
WESTERN CREDITS: All the Votoms OAVs
TV episodes are scheduled for US video

release from autumn 1996 on US Manga Corps, trans Neil Nadelman.
ORIGINS: Story by Ryosuke Takahashi; 1983 TV series.
CATEGORIES: SF

One of the most respected 'mech war' series, widely held to be the most gritty and realistic representation of this kind of warfare in anime. The OAV continues the story of Chirico Cuve from the TV series, as he flees the city of Udo seeking traces of his beloved Fiana. *En route* he meets three ex-comrades intent on killing the dictator Persen and learns that Fiana is Persen's prisoner. Naturally, he goes along for the ride... ★★★?

BAVI STOCK I — FATED TO BE A TARGET
(Eng title for BAVI STOCK I — HATESHINAKI TARGET, lit Bavi Stock I — Infinite Target)

JAPANESE CREDITS: Dir & chara des: Shigenori Kageyama. Script: Kenji Terada. Guest chara des: Mutsumi Inomata. Mecha & image des: Takahiro Toyomasu. Sub mecha des: Masanori Nishii. Anime dir: Masahiro Shida & Ryunosuke Otonashi. Art dir: Hageshi (Geki) Katsumata. Music: Yasuaki Honda. Gen prod: Hiromasa Shibazaki. Prod: Toshihiro Naga. Prod co: Studio Giants. © Kaname, Hiro Media. 45 mins.
ORIGINS: Novel by Kenji Terada, pub Kadokawa Shoten.
POINTS OF INTEREST: Fred Patten tells me that Mr Shibazaki informed him the name Bavi was chosen for the hero because it is a popular one in the West — 'like your Bavi Kennedy'.
CATEGORIES: SF

Agent Kate Lee Jackson of the GPP (space police) frees the mute girl Muna from a prison on the Bentika Empire, a huge floating satellite. She also frees Bavi Stock, a young boxer jailed after accidentally killing an opponent and in danger of being killed by the brutal prison regime. The prison doctor Sammy, who has been trying to ensure Bavi stays alive, joins them and they head for GPP HQ. But the bad guys from Bentika, Ruth Miller and her henchman Iceman, are ahead of them, and disintegrate the GPP headquarters (echoes of the end of planet Alderaan in *Star Wars*!). With nowhere else to go, they head for Sammy's homeworld, arriving on the eve of a big skysled race. Sammy and Bavi enter and end up facing off against Iceman, while Ruth Miller tries to sabotage the race control computers and Kate

and Muna have to stop her. Some beautiful design work — note Inomata's guest credit. ★★★?

CREAMY MAMI — LONG GOODBYE
(Eng title for MAHO NO TENSHI CREAMY MAMI — LONG GOODBYE, lit Magic Angel Creamy Mami — Long Goodbye)

JAPANESE CREDITS: Dir: Osamu Kobayashi. Chara des: Akemi Takada. Prod: Studio Pierrot. © NTV, Network, Bandai. 50 mins.
ORIGINS: Manga by Yuko Kitagawa & Kazunori Ito; 1982 TV series.
CATEGORIES: DD, U

A few years after the return of her magic baton, Yu starts to transform into her alter ego, idol singer Creamy Mami, by day, reverting to her own form at night. Of course, this can't be kept secret because she was such a popular singer and still has legions of fans. Shingo Tachibana persuades Creamy to make a science fiction film, also starring Megumi Ayase. As ever, Creamy uses her powers for good, and by the end of the film Megumi has at last succeeded in getting her beloved Shingo to the altar. Wonderfully fluffy romance. ★★★?

DALLOS SPECIAL
(aka BATTLE FOR MOON STATION DALLOS)

JAPANESE CREDITS: Dir: Mamoru Oshii. Writer: Hisaishi Toriumi. Prod: Studio Pierrot. © Studio Pierrot, Network, Bandai. 90 mins.
WESTERN CREDITS: US video release late eighties as Battle for Moon Station Dallos, label unknown. Current US release on Best Film & Video as Dallos, dub.
ORIGINS: 1983 & 1984 OAVs.
CATEGORIES: SF

An edited compilation of the 1983 and 1984 OAV series. ★★

DIRTY PAIR: AFFAIR ON NOLANDIA
(Eng title for DIRTY PAIR: NOLANDIA NO DENSETSU, lit Legend of Nolandia, aka DIRTY PAIR: AFFAIR OF NOLANDIA)

JAPANESE CREDITS: Dir: Masaharu Okuwaki. Screenplay: Kazunori Ito. Chara des: Tsukasa Dokite. Mecha des: Studio Nue. Music: Yoshihiro Kunimoto. © Takachiho,

Studio Nue, Nippon Sunrise, Bandai.
55 mins.
WESTERN CREDITS: US video release 1994
on Streamline Pictures, dub, Eng script
Ardwight Chamberlain.
ORIGINS: Novels by Haruka Takachiho;
appearance in 1983 movie Crushers; 1985
TV series.
POINTS OF INTEREST: The Pair are
generally considered to look more mature
in this OAV than in the TV series.
CATEGORIES: M, SF

Just before the TV series went off the air, this OAV let Dirty Pair fans take their dream girls home. World Welfare Work Agency Trouble Consultants Kei and Yuri are pulled back from leave to go to Nolandia, planet of strange phenomena, where a hugely powerful psychic force originates. In a series of terrifying and baffling visions, torn between dream and reality, the Pair meet the child Mizuni, product of genetic experimentation. They determine to find out who is carrying out these terrible experiments and stop them once and for all. Who can stand in the way of the most ruthless 'social workers' in the galaxy once they get mad? ★★★

DREAM DIMENSION HUNTER FANDORA
(Eng trans for YUME JIGEN HUNTER FANDORA)

JAPANESE CREDITS: © Dynamic Planning,
Hiro Media Associates Inc. 45 mins.
ORIGINS: Manga by Go Nagai.
CATEGORIES: SF, H

It's Dimensional Year 2002. Man can warp between dimensions, and where many can go, crime follows. The Dimensional Police Force has been set up to counter this new wave of crime, but with too many criminals to cope with they turn to bounty hunters for help. Enter Fandora and her partner Que. They go to the dimension of Lem in search of the criminal Red-Eye Geran and find an oppressed land. Can Fandora's magic Rupia Gem save her life and save Lem from the power of a dimensional criminal? ★★☆?

DREAM HUNTER REM: THREE DREAMS TO REVIVE DR DEATHGOD
(Eng trans for DREAM HUNTER REM: SANMU YOMIGAERU SHINIGAMIKAHASE)

JAPANESE CREDITS: © Project Team Eikyu,
King. 45 mins.
CATEGORIES: DD, H

Rem can't sleep — ever — but she can enter the world of dreams just the same, so she decides to use her unusual powers to make a living as a private investigator in the dreamworld. Lieutenant Sakaki doesn't think it's a good idea... ★★☆?

GOSHOGUN THE TIME ETRANGER
(Eng title for SENGOKU MAJIN GOSHOGUN ETRANGERE, lit God Warrior Goshogun Strange Lady)

JAPANESE CREDITS: Dir: Kunihiko Yuyama.
Story & screenplay: Takeshi Shudo. Chara
des & anime dir: Hideyuki Motohashi.
Music: Tachio Akano. Prod: Ashi. © Ashi,
Tokuma Shoten. 80 mins.
WESTERN CREDITS: US video release 1995
on US Manga Corps, sub, trans Neil
Nadelman; UK video release 1996 on Manga
Video, dub.
ORIGINS: 1981 TV series.
POINTS OF INTEREST: Sometimes called
'Time Stranger' through confusion with
another OAV of that name.
CATEGORIES: SF, H

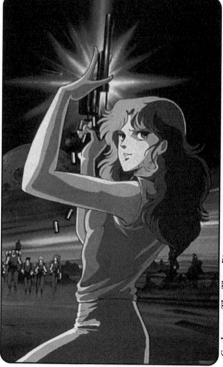

Goshogun The Time Etranger

In a desert city, the team that pilots giant mecha Goshogun receive letters predicting that one of them, Remi, will die. Forty years on, Remi is alive and heading for one of the team's reunions when she is suddenly injured in a car crash and rushed to hospital in a critical condition. At her bedside the others relive the past and remember the threatening letters, realising how she was saved from certain death long ago in that desert city, only to face the same danger now. Adrift in time and space, Remi herself is once again fighting for her life as she relives events from that time and even further in the past, in her own childhood. ★★

GREED

JAPANESE CREDITS: © Film Link, Pony Canyon, Vibo. 57 mins.
CATEGORIES: DD

From the brief description I can find, this is standard fantasy/action screenfodder. Wicked Vai is master of planet Greed until young Rid Kairu decides to get rid of him and so bring about world peace. This runs in the family — his father tried the same thing years ago without success. *En route* to challenge Vai, Rid acquires five companions, including the regulation underdressed babe, and their aid proves essential to his final victory. Sounds like every D & D game you ever played, hmmm? ★☆?

ICZER-ONE ACT I
(Eng title for TATAKAE! ICZER-ONE ACT I, lit Fight! Iczer-One Act I)

JAPANESE CREDITS: Dir, writer & chara des: Toshihiro Hirano. Mecha des: Hiroaki Motoigi & Shinji Aramaki. Anime dir: Narumi Kakinouchi, Masami Obari & Hiroaki Ogami. Art dir: Yasushi Nakamura & Kazuhiro Arai. Music: Michiaki Watanabe. Prod: AIC. © Kubo Shoten, AIC. c30 mins. WESTERN CREDITS: US video release 1992 on US Renditions on one tape with Act II, dub, trans Trish Ledoux & Toshifumi Yoshida, Eng screenplay Doug Stone. POINTS OF INTEREST: The Cthulhu are sometimes transliterated as the 'Cutowolf', which disguises the links with HP Lovecraft's formless horrors from beyond the dimensions. CATEGORIES: H, SF

The Cthulhu are drifting in space when they encounter an evil intelligence which transforms them. Later, on Earth, Nagisa Kano is just an ordi-

nary schoolgirl, but she holds the fate of Earth in her hands when the Cthulhu invade. Iczer-One, a powerful being cloned by the Cthulhu, needs her unique and hidden abilities to help fight them in the mighty Iczer Robo. At first Nagisa resists, increasingly bewildered and terrified by the horrific events and monstrous manifestations around her; but when her parents are destroyed she joins Iczer-One to unleash all her anger and grief against the Cthulhu mecha Delos Theta and its pilot Cobalt. This is a tense action thriller which is also a marvellous, dark-toned Gothic horror tale, with an atmosphere of foreboding which is rarely equalled. ★★★★

JUSTY
(Eng title for COSMO POLICE JUSTY)

JAPANESE CREDITS: Prod: Studio Pierrot. © Studio Pierrot, Justy Project, King Record. 44 mins. ORIGINS: Manga by Tsugo Okazaki, Eng trans from Viz Communications (some chara names changed). CATEGORIES: SF, A

Justy Kaizard is a Galactic Patrol 'Hunter' — his job is to track down rogue psychics and exterminate them before they can harm others. He and his partner Broba Len track down the criminal psychic Magnaman Vega, and Justy kills him in front of his six-year-old daughter. The distraught child swears she would kill Justy if she were bigger, and her own latent psychic powers, triggered by the tragedy, suddenly mature and transform her into a sixteen-year-old. But the shock of suddenly acquiring a sixteen-year-old body is too much for a six-year-old mind to cope with, and she is left with complete amnesia. Growing up at Galactic Patrol headquarters under the care of Justy's friend Jilna Star, she treats him as an adored big brother. But then a group of criminal psychics decide to dispose of Justy by awakening her memory and her hatred of the man who killed her father. ★★☆

KARUIZAWA SYNDROME

JAPANESE CREDITS: © Kitty Film, Nihon AVC, Five Ace, Pony Canyon. ORIGINS: Manga by Yoshihisa Tagami. CATEGORIES: R

The little I know about this soap-opera romance tells me it could hardly be more different from the bleak nihilism of Tagami's other works like *Horobi*, *Grey* and *Pepper*. It's set in a mountain resort in cen-

tral Japan and tells the story of young artist Sumiyo, her big sister Kaoru and Kaoru's secret love for photographer Kohei.

LEDA: FANTASTIC ADVENTURE OF YOKO
(Eng title for GENMUSENKI LEDA, lit Leda Dream War)

JAPANESE CREDITS: Dir: Mamoru Oshii. Chara des: Mutsumi Inomata. © Toho, Kaname Prod. 72 mins.
CATEGORIES: DD, R

Yoko is a shy teenager secretly in love with a schoolmate. She writes a melody to express her love and the tune proves to be the bridge between two worlds. Yoko is drawn into the world of Leda, where an ex-priest of the deity is gathering his powers to cross the divide and conquer Earth. Aided by warrior-priestess Yoni, talking dog Ringum and a huge robot-like something hammered together in the land of Oz, Yoko must draw on her courage and faith to become Leda's Warrior and pilot the Wings of Leda into the enemy's floating citadel. Here, her ability to distinguish true love from falsehood will be tested to the utmost. Original and striking use of visual imagery, a couple of good action sequences and well-maintained atmosphere make this OAV well worth watching. ★★★☆

LOVE POSITION — LEGEND OF HALLEY
(Eng trans for LOVE POSITION — HALLEY NO DENSETSU)

JAPANESE CREDITS: Dir & original story: Osamu Tezuka. Prod & © Tezuka Production. 93 mins.
CATEGORIES: SF, M

The story opens as a crippled man tells his son about his experiences in the Vietnam war. He met a young girl, Lamina, in a temple — a strange, beautiful creature, almost elfin in appearance. After she saved him from the Viet Cong he befriended her and took a fatherly interest in her, but her origins remained a mystery to him and she refused to reveal her past. He was invalided home, and now fifteen years later he's received a letter from Lamina saying she is coming to the USA and desperately needs his help. Since he is too ill to help, but feels he owes her a great debt, he asks his son Subaru to take his place. When Subaru meets Lamina he is surprised to find she still appears to be the teenager his father met fifteen years before. As they set

off across America, a meteorite crashes into the desert and an entity inside takes over a man who comes to investigate it, a loner and petty criminal. He pursues Subaru and Lamina, determined to kill her, and a series of increasingly dramatic attacks take place. The final outcome is mysterious, but not in any Earthly sense — Lamina is the spirit of Halley's Comet, the messenger of the planet/goddess Venus to Amaterasu, the Sun. The possessed man was the tool of Venus' enemy Mars. This SF-thriller has intelligent, adult writing from a genius. ★★★☆?

MEGAZONE 23
(aka ROBOTECH THE MOVIE)

JAPANESE CREDITS: Dir & author: Noboru Ishiguro. Script: Hiroyuki Hoshiyama. Chara des: Toshihiro Hirano & Haruhiko Mikimoto. Music: Shiro Sagisu. Prod: Toru Miura. Prod co: Artmic, Idol. © Artmic, Idol, Nihon AVC. 80 mins.
WESTERN CREDITS: Re-edited and partly re-written, with some extra footage specially shot in Japan, as Robotech the Movie, festival screening and one-week US theatrical release 1987 by Cannon. US video release 1990 on Streamline Pictures, dub, Eng version written by Greg Snegoff.
ORIGINS: Inspired by the novel Universe by Robert A. Heinlein. Original story by Noboru Ishiguro
POINTS OF INTEREST: First of 3 parts. Part 3 UK video release 1995 on Manga Video. The title can be rendered Mega Zone 23 or as above; the preliminary logo design showed a 'working title' of Omegazone 23.
CATEGORIES: SF

Tokyo, the present: Shogo Yahagi works in a burger bar and is just a normal bike-mad, girl-mad teenager until he finds an unusual motorbike called the Garland on a massive Government conspiracy. Suddenly his friends are getting killed and he and the Garland are the targets of a huge manhunt. How is the idol singer Eve Tokimatsuri involved? And what will happen to his girlfriend Yui and her two flatmates? In terrible danger, Shogo struggles to uncover the truth of Megazone 23, gradually realising that nothing in his entire life has ever been exactly as it seemed. ★★★

NORA

JAPANESE CREDITS: © Film Link, Pony Canyon. 56 mins.
CATEGORIES: SF

Set in the second half of the twenty-first century in a frontier colony on the outer rim of the galaxy, this is the story of how Nora, a beautiful teenage girl, decides to resolve the nuclear threat and end the current war. Two scientists, Dr Zakaiasen and Prof Dohati, agree to help her. Judging from the few stills I've seen, the artwork is competent but not wildly exciting.

OTAKU NO VIDEO
(Eng title for 1982 OTAKU NO VIDEO and 1985 ZOKU OTAKU NO VIDEO)

JAPANESE CREDITS: Dir: Takeshi Mori. Script: Toshio Okada. Graphic concepts: Kenichi Sonoda. Music: Kohei Tanaka. Prod: Studio Fantagia, Gainax. © Toshiba Picture Soft. 95 mins.
WESTERN CREDITS: US video release (both titles on one tape) 1993 on AnimEigo, trans Shin Kurokawa, Trish Ledoux & Toshifumi Yoshida; UK video release as for US, 1994 on Anime Projects.
ORIGINS: The history and experience of the renowned production team Gainax.
POINTS OF INTEREST: The title has different interpretations, the most popular being 'Fan's Video' or simply 'Your Video'!
CATEGORIES: N, C

The way of the otaku — the true fan — isn't easy. But if followed with dedication, it can lead to more than obscure copies of early eighties TV series and prime chara cels. It can lead to the fulfilment of your wildest dreams, and be a way of life in itself. This insane fake documentary, whose live-action segments have fooled at least one reviewer into taking them as fact, has a large element of reality stirred into its wryly comic mix. It is a history of the renowned anime production team Gainax, with the names and events changed a bit to protect the innocent; and it's a history of every otaku, the rip-offs, the disappointments, the social ostracism, the cameraderie and the sheer joy. The final triumphant scenes of the second segment, in which the pure spirit of otaku, undimmed by disappointment or experience, finally triumphs over the sordid cynicism of the world, will have you shedding a tear or two, and the 'mock doc' interviews will raise a smile (often one of recognition!) ★★★☆

ROUND VERNIAN VIFAM — THE 12 WHO DISAPPEARED
(Eng title for GINGA HYORYU VIFAM KEITA JUNININ, lit Vifam Castaway of the Galaxy, The 12 Who Disappeared)

JAPANESE CREDITS: Prod: Nippon Sunrise. © Sunrise, Warner, Pioneer. 50 mins.
ORIGINS: 183 TV Series.
CATEGORIES: SF

Also:
ROUND VERNIAN VIFAM KATE'S REFLECTIONS — CONCERNING THE STRATEGIES OF BETRAYAL
(Eng trans for GINGA HYORYU VIFAM KATE NO KIOKU — NAMIDA NO DAKKAI SAKUSEN)

JAPANESE CREDITS, CATEGORIES: As above except: 33 mins.

Science fiction stories of space war and how it affects a group of young friends caught up in it.

RUMIKO TAKAHASHI'S RUMIK WORLD — FIRE TRIPPER
(Eng trans for RUMIKO TAKAHASHI'S RUMIK WORLD — HONO TRIPPER)

JAPANESE CREDITS: Dir & anime dir: Osamu Vemura. Screenplay: Tomoko Konparu. Chara des: Katsumi Aoshima. Art dir: Torao Arai. Music: Koiichi Oku. Prod: Kitty Film. © R. Takahashi, Shogakukan, Kitty Film, Fuji TV. 48 mins.
WESTERN CREDITS: US video release 1992 on US Manga Corps, trans William Flanagan & Pamela Ferdie, Eng rewrite Jay Parks; UK video release 1995 on Manga Video.
ORIGINS: Manga by Rumiko Takahashi, pub Shogakukan, Eng trans pub Viz Communications.
CATEGORIES: H, P

A strange tale of time travel and reincarnation. Suzuko is involved in a gas explosion with a neighbour's child and finds herself in fifteenth century Japan. Saved by Shukumaru and taken to his village, she persists in searching for the child Shuhei. When the village is attacked, she and her rescuer are thrown back to the twentieth century and she finds he is both the man she loves and the child she has been seeking. Suzuko risks everything to return them both to his village and time. This is a far cry from the slapstick romance of *Urusei Yatsura* and *Ranma 1/2*, but still cleverly written and prettily drawn. The voice acting on the UK dub has come in for some fierce criticism in fandom, but it's worth a look. ★★★

SUPERPOWERED GIRL BARABAMBA
(Eng trans for CHONORYOKU SHOJO BARABAMBA)

JAPANESE CREDITS: © Dynamic Planning. c50 mins.
ORIGINS: Manga by Go Nagai.
CATEGORIES: DD, R

Fleeing from a hyperspace crime syndicate leader charmingly named D'Rool, space pirate Baraba and her robot Mia cross the dimensional barrier into our world and change form — Baraba becomes a beautiful human girl and Mia a cute fluffy animal. A young man named Hiro Bamba steps in to save Baraba from the unwanted attentions of some thugs, and three lesbian sisters offer the trio shelter. Meanwhile, D'Rool has also crossed the dimensional barrier and mutated into a hideous form. Baraba will have to deal with him, but she's starting to like her new shape and falling for Hiro. Can love conquer the criminal leader? And will Hiro and Baraba be able to stay in the same dimension? ★★★?

VAMPIRE HUNTER 'D'

JAPANESE CREDITS: Dir: Toyo'o Ashida. Screenplay: Yasushi Hirano. Chara des: Yoshitaka Amano. Anime dir: Hiromi Hirano. Art dir: Satoshi Matsudaira. Music: Noriyoshi Matsuura. Prod: Ashi Pro. © Ashi, Epic. 80 mins.
WESTERN CREDITS: US video release 1992 on Streamline Pictures; UK video release 1992 on Manga Video, both dub, Eng dialogue Tom Wyner.
ORIGINS: Hideyuki Kikuchi's original novels, pub Sonorama Bunko. The film is based on the first book, which came out in 1983.
CATEGORIES: H, DD

Earth, the far future: vampires and mutants rule the world and terrorise mankind. Young Doris is almost caught by the evil Count Lee, who wants her for his next bride, but is saved by a mysterious cloaked figure in a huge hat, who is known only as 'D'. The Count is still determined to have her, and most of the townsfolk think she should give herself up and save them a lot of trouble — except for the Mayor's son, who thinks she should save herself for him. Doris is having none of that — she's fallen for D and, guess what, D is part-vampire himself! He's none other than Dracula's son and has taken it upon himself to travel the world, ridding it of his father's kind. Despite strong opposition from Lee's snobbish daughter Ramika, her aide Reigin and various other

monsters, D wins through and saves Doris, then rides off into the sunset. Yes, this is a vampire Western. Anyone who's seen the artwork for Amano's glorious chara designs will regret the huge losses involved in simplifying them enough to translate to economically viable animation cels. A fan favourite which has, sadly, outlived its own legend. ★★

WHAT'S MICHAEL?

JAPANESE CREDITS: Prod: Kitty Film. © M. Kobayashi, Kitty Film, Kodansha. 60 mins.
ORIGINS: Manga by Makoto Kobayashi, pub Kodansha in Comic Morning, 1984, Eng trans pub USA.
CATEGORIES: N, C

Michael is a cat — with a difference. He lives with a cartoonist and his wife and does his best to keep his cool amid the trials of everyday life in suburbia, like fussing human girls, the local tough cat Nyazilla — just like the big grey lizard, a foe too fearsome to take risks with — and the females of his own species. As the manga developed it took off more and more into such fabulous flights of fantasy as cat corporations — complete with boring board meetings — cat nightclubs and more. ★★★?

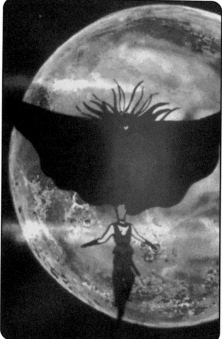

Vampire Hunter 'D'

This was another spectacular year for quality anime, with Hayao Miyazaki's *Laputa* and Yoshikazu Yasuhiko's reworking of Greek legend in *Arion* hitting the cinema circuit, along with apocalyptic fantasy *Fist of the North Star* and schoolgirl comedy *Project A-Ko*. OAVs topped fifty in number. A year with only two *Cream Lemon*s would be considered a retrograde step by some, but there were plenty of non-erotic gems to compensate. Of historical interest is the first anime incarnation of *The Guyver*, later to be remade as a twelve-part half-hour series and achieving huge success in the West for LA Hero and, later, Manga Video; also note two July movie releases, *Running Boy* and *Super Mario Brothers*, introducing video game charas — including the still-popular *Mario Bros.* — to the big screen for the first time.

MOVIES

ARION

JAPANESE CREDITS: Dir, writer & chara des: Yoshikazu Yasuhiko. Co-writer: Akiko Tanaka. Music: Jo Hisaishi. Prod: Nippon Sunrise. © Yasuhiko, Sunrise, Tokyo Movie Shinsha. 120 mins.
ORIGINS: Manga by Yoshikazu Yasuhiko, pub Tokuma Shoten, based on Greek myth and history.
CATEGORIES: P

This magnificent fable gives an Oriental twist to Greek mythology, creating a splendid adventure strongly reminiscent of Ray Harryhausen's Greek epics, with the same marvellous sense of scale backed up by deft character building. Arion's mother, Demeter, is a victim of the strife between Zeus and his brother Poseidon, and Arion himself is unaware of his true identity. Caught up in the power struggles of the lesser Gods, he finds himself the prisoner of the dangerously unstable Artemis and her capricious brother Apollo, and begins to fall in love with beautiful slave-girl Lesfeena. Is she really his sister? Was Poseidon really his father? And are the cruel, selfish Gods really entitled to rule the destiny of mankind? Epic battles, perverse cruelty, great heroism and unselfish love all have their place in this film, which is superior in every way to Yasuhiko's later *Venus Wars*. ★★★★

BAREFOOT GEN II
(Eng trans for HADASHI NO GEN II)

JAPANESE CREDITS: Dir: Masaki Mori. Writer: Keiji Nakazawa. Anime dir: Kazuo Tomizawa. Art dir: Kazuo Ojika. Prod: APPP. © Project Gen, APPP. 85 mins.
ORIGINS: Manga by Keiji Nakazawa; 1983 film.
CATEGORIES: T, P, V

Set three years after the Hiroshima bombing, this second film follows the further history of Gen. He now looks after his mother with the help of adopted 'little brother' Ryuta, whose own family died in the bombing, as well as keeping an eye on three orphans who live next door. The trials and terrors of life in postwar Japan are movingly yet unsentimentally depicted by the new team selected to tell the second chapter of Gen's story. Films about courage and hope are always welcome, and rarely do they carry the same conviction as this true story by a survivor, which neither points fingers nor assigns blame, but simply states what happened to thousands in the aftermath of the world's most destructive weapon. ★★★★☆

CAPTAIN TSUBASA: RUN TOWARDS TOMORROW
(Eng trans for CAPTAIN TSUBASA: ASU NI MUKATTE HASHIRE)

JAPANESE CREDITS: © Tsuchida. 41 mins.
ORIGINS: Manga by Y. Takahashi; 1983 TV series; 1985 movies.
CATEGORIES: N, U

Also:
CAPTAIN TSUBASA: GREAT WORLD CHALLENGE! JUNIOR WORLD CUP!
(Eng trans for CAPTAIN TSUBASA: SEKAIDAIKESSEN! JUNIOR WORLD CUP)

CREDITS, ORIGINS, CATEGORIES: As above.

More soccer action with the anime adventures of the Japan youth side. That's all I know!

DORAEMON — NOBITA'S IRONMAN PLATOON
(Eng trans for DORAEMON — NOBITA NO TETSUJIN HEIDAN)

JAPANESE CREDITS: Prod: Shin'ei Doga. © Fujiko-Fujio, Shogakukan, Shin'ei Doga. ORIGINS: Manga by Fujiko-Fujio, pub Shin'ei Doga; 1979 TV series; 1984 & 1985 movies. CATEGORIES: U, C

More comic cuts with the robot cat from the future and his nerdish little chum Nobita. A homicidal alien wants to take over the world. To fight him, Doraemon and Nobita pile into a giant mecha of their own for a light-hearted spoof on the genre which had ruled the TV airwaves for so long. ★★?

DRAGONBALL — LEGEND OF THE DIVINE DRAGON
(Eng trans for DRAGONBALL — JINRYU NO DENSETSU, aka DRAGONBALL — LEGEND OF SHIN LON)

JAPANESE CREDITS: Dir: Daisuke Nishio. Music: Shunsuke Kikuchi. Prod: Toei Animation. © Bird Studio, Shueisha, Toei. 50 mins. WESTERN CREDITS: US video release 1991 on Harmony Gold, dub. ORIGINS: Akira Toriyama's manga; 1986 TV series. CATEGORIES: DD, C, V

The first of the *Dragonball* movies, which have appeared regularly ever since (though the thirteenth movie, released in the summer of 1995, was to be the last), this reflects the events of the manga and TV series, although the movies vary in some details and have their own internal chronology. The early episodes, and this film, show their roots in the legend of the Monkey King, basis for the popular live-action series *Monkey* as well as many other anime and manga. Young Son Goku, gifted with huge strength and unusual powers, but very naïve, meets Bulma and joins her search for the mysterious Dragonballs. The control of these will release the Dragon God Shin Lon to grant the bearer a wish. They meet the lecherous Kamesennin, handsome but shy Yamcha, shape-shifting, panty-freak, pig Oolong, and Gyuma-O and his daughter, ChiChi, who will become Goku's wife several stories later. The *Dragonball* TV series is currently showing on US TV and the movies provide

a wonderful taster for the show's unique mix of visual energy and high-impact mayhem. Toriyama's genius as designer and humorist is displayed to good effect by the movie staff. ★★★

FIST OF THE NORTH STAR
(Eng title for HOKUTO NO KEN, lit Fist of the North Pole)

JAPANESE CREDITS: Dir: Toyo'o Ashida. Screenplay: Susumu Takahisa. Chara des: Masami Suda. Anime dir: Masami Suda & Katsumi Aoshima. Art dir: Shiro Tanaka. Music: Katsuhisa Hattori. Prod: Toei Doga. © Tetsuo Hara, Buronson, Toei Doga. 110 mins. WESTERN CREDITS: US video release 1992 on Streamline Pictures, 1995 on Orion Home Video/ Streamline Pictures; UK video release 1992 on Manga Video; both dub, Eng trans Tom Wyner. ORIGINS: Manga by Buronson & Tetsuo Hara, Eng trans pub Viz Communications; 1984 TV series. POINTS OF INTEREST: The first release on the Manga Video label in the UK. CATEGORIES: V, X

The future: a world reduced to a feudal wasteland, with rival gangs warring for supremacy and the weakest going to the wall. Out of the dust walks Kenshiro, a young giant with a rare skill in the most deadly of martial arts. He's lost his fiancée to his evil brother and is trying to find them both. On the way he runs into numerous situations, which only his unique skills, much blood-letting, tearing off of heads and causing bodies to explode can resolve. This infinitely less subtle version of *Mad Max* is often written off by film buffs, but still has something to offer. Once the conventions of its absurdly serious violence are accepted, we can see beyond them to the epic sweep of a spaghetti Eastern whose excesses ask us to consider where we're going in our pursuit of mindless action and instant gratification. ★★

GALL FORCE — ETERNAL STORY

JAPANESE CREDITS: Dir: Katsuhito Akiyama. Screenplay: Sukehiro Tomita. Chara des: Kenichi Sonoda. Art dir: Jun-Ichi Azama. Prod: Animate Film, Artmic, AIC. © MOVIC, Sony Video Software Intl Corp. 86 mins. WESTERN CREDITS: US video release 1992 on US Manga Corps, sub, trans Neil Nadelman. ORIGINS: Manga by Hideki Kakinuma, based on series of scratchbuild model

features in Model Graphix magazine.
SPINOFFS: American pseudomanga, pub
CPM Comics; OAV series.
CATEGORIES: SF

Elsa, Catty, Rabby, Pony, Patty and Rumy are the crew of the *Starleaf*, a spaceship in the Solnoid navy. Lufy, a fighter pilot, joins them when her ship crashes onto their flight deck. The Solnoids, a race of cloned females, are fighting the non-humanoid Paranoids. Unknown to any but the highest ranking officers, there is a secret plan to unite the two species by producing offspring with the best qualities of both. The crew becomes its unwitting focus. As they face danger, and one by one begin to die, they realise that Patty has become hostmother to the first of the new race after a Paranoid attack; the remaining crew members must try and secure the future of both races with Patty's strange offspring. Sonoda's mastery of cute chara designs is evident even in this early work, which has long been a fan favourite. ★★★

JUMP! GHOST QTARO — GHOST'S MASTER PLAN
(Eng trans for OBAKE NO QTARO — TOBIDASE! BAKEBAKE DAI SAKUSEN)

JAPANESE CREDITS: Prod: Shin'ei Doga. ©
Fujiko-Fujio, Shueisha, Shin'ei Doga.
13 mins.
ORIGINS: Manga by Fujiko-Fujio; 1965 TV
series.
POINTS OF INTEREST: An experimental 3D
film that tried to make the viewer feel part
of the action.
CATEGORIES: C, U

When you're just a little kid and get frightened easily, having a ghost as a friend and mentor isn't all bad. The relationship between Qtaro and his young charge Tadashi is not unlike that between the manga duo's other well-loved creations, Doraemon and Nobita (except that no one is as stupid and clumsy as Nobita ...) The very short length reflects the experimental nature of the project, not the popularity of the subject; the TV series ran for eighty-nine episodes over two years. ★★☆?

KINNIKUMAN — CRISIS IN NEW YORK
(Eng trans for KINNIKUMAN — NEW YORK KIKI IPPATSU)

JAPANESE CREDITS: Prod: Toei Doga.
© T. Yude, Shueisha, Toei Doga. 45 mins.

ORIGINS: Manga & TV series; 1984 & 1985
movies.
CATEGORIES: C, U

More slapstick adventures of the wrestling superstar and his friends and opponents, this time in New York, where our hero meets a baaaaad guy (boo! hiss!) in the form of The General. ★★?

KITARO GEGEGE: THE GREAT GHOST WAR
(Eng trans for GEGEGE NO KITARO YOKAI DAISENSO)

JAPANESE CREDITS: Prod: Toei Doga. ©
Shigeru Mizuki, Fuji TV, Toei Doga.
39 mins.
ORIGINS: Manga by Shigeru Mizuki based
on Japanese folk tales; 1968 & 85 TV series;
1985 movie.
POINTS OF INTEREST: There has also been
a live-action version of the series featuring
Mizuki himself in a cameo role.
CATERORIES: H, C, U

Also:
KITARO GEGEGE: DESTRUCTIVE MONSTERS ARRIVE IN JAPAN
(Eng trans for GEGEGE NO KITARO SAIKYO YOKAI GUNDAN NIHONJORIKU)

CREDITS, ORIGINS, CATEGORIES: As above
except: 49 mins.

Also:
KITARO GEGEGE: DESTRUCTION! THE BIG REVOLT OF MONSTERS FROM ANOTHER DIMENSION
(Eng trans for GEGEGE NO KITARO GEKITOTSU! IJIGEN YOKAI NO DAI HANRAN)

CREDITS, ORIGINS, CATEGORIES: As above
except: 50 mins.

More adventures of the boy Kitaro and his ghostly friends. In the first film, a mob of evil ghosts from the West are planning to invade Japan and the gang have to show them the error of their ways. In the second, the threat is monsters from China. In the third — well, just read the title. Formulaic they may be, but they're also very popular and harmless fun. ★★☆?

LAPUTA
(Eng title for TENKU NO SHIRO LAPUTA, lit Laputa, Castle of the Sky)

JAPANESE CREDITS: Dir & writer: Hayao Miyazaki. Music: Jo Hisaishi. Prod: Isao Takahata. Prod co: Studio Ghibli. © Nibariki, Tokuma Shoten. 195 mins.
WESTERN CREDITS: Shown on British independent television (some regions only) 1989 & 1992, dub.
POINTS OF INTEREST: Miyazaki visited Wales to sketch for the mining village setting. The chara of Ma Dola is reputed to share some characteristics with his own mother. The robot design is borrowed from a Lupin III TV episode directed by Miyazaki. Also note the reference to Gulliver's Travels.
CATEGORIES: DD, U

The story opens in the sky. Sheeta is a prisoner of the secret police, on an airship *en route* to an unknown destination. When pirates attack, she tries to escape and falls from the ship, but is saved from death by the power of the necklet she wears. Its stone, glowing with a blue light, buoys her up so that she floats rather than plummets to earth. On the ground, orphaned mineworker Pazu spots the blue light and catches her as she lands, taking her into his own home and into his heart. The two children forge an alliance; Pazu dreams of following his father's wishes to build a flying machine and find the legendary flying city of Laputa, while Sheeta wants to stay out of the clutches of her captors. Together they embark on an adventure of epic scope. Sheeta's pendant is a chip of 'levitation stone', the powerful mineral that kept Laputa and a hundred cities like it in the air and powered their technology and weapons systems. The secret service wants that power for its own ends, and its agent Muska, like Sheeta a descendant of the ancient royal line of Laputa, wants it to enable him to rule the world. Meanwhile, Ma Dola and her pirate family just want to turn a dishonest living, never bargaining for the way gentle Sheeta and plucky Pazu will wind supposedly hard pirate hearts round their little fingers. Miyazaki's world-building, already wonderful in *Warriors of the Wind*, reaches new heights; every detail of Pazu's turn-of-the-century mining village (ah, but which century?), of the Government's steamtech, of the pirates' flying barge, every aspect of the minutiae of everyday life is perfectly realised. This extends to the natural world, where plants, animals and the landscape are so wonderfully evoked that we accept them as real without even noticing. The flying island itself, literally the calm at the heart of the storm, an oasis of peace and beauty sustained by an unimaginable force, is perhaps a metaphor for the whole natural world, which we exploit with little knowledge and potentially devastating consequences. The film's power is sustained over more than three hours without flagging by means of masterly cinematography

and Miyazaki's perfect sense of pacing. Jo Hisaishi's remarkably beautiful score makes a major contribution to the compelling flow of the story, which reaches a climax with a heart-breaking demonstration of the young heroes' courage and simplicity, followed by a cathartic devastation sequence and light-hearted coda. I can see absolutely no reason why Miyazaki's work is not better known in the West, especially given the availability of high quality dubbed versions like the one shown on British television. Parents everywhere are crying out for films with gripping stories, strong moral themes and high production values. Well, here is another Miyazaki masterpiece which lends new credibility to the much maligned term 'family viewing'. That it still awaits a UK cinema release is nothing short of incredible. ★★★★★

LOVE CITY
(Eng trans & title for AI CITY)

JAPANESE CREDITS: Dir: Koichi Mashimo. Script: Hideki Sonoda. Art dir: Torao Arai. Music: Shiro Washizu. Prod: Ashi Pro. © Toho, MOVIC. 90 mins.
WESTERN CREDITS: US video release 1995 on TRS International, sub; UK video release 1995 on Western Connection, sub, script consultant Jonathan Clements.
ORIGINS: SF manga by Shuho Itabashi explaining the theory of DNA.
POINTS OF INTEREST: The 'ai' in the Japanese title is a multiple pun, referring to the name of one of the lead charas, Artificial Intelligence, and of course the Japanese word for love. 'Ai shite', the nearest Japanese pronunciation of the title, means 'make love'.
CATEGORIES: SF

Ai is a young girl with extraordinary psychic powers, on the run from her captors with Kei, a cyborg

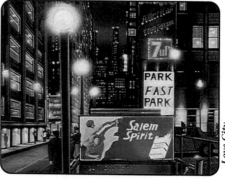

Love City

linked to a mysterious organisation of beings called Headmeters. Powerful Headmeter Leigh has his goons on their tail; he's after Ai's unique powers to use in his struggle against rival Headmeter Lyrochin. A cop on the trail of the criminal group experimenting on espers, a bunny girl with more to offer than just a neat tail, a solid SF story and some stunning visual effects compensate for the creaky animation and old-fashioned styling. ★★☆

PLEASE OPEN THE DOOR
(Eng trans for TOBIRA O AKETE)

JAPANESE CREDITS: Prod: Kitty Film. © Arai, Kitty Film. 83 mins.
ORIGINS: Manga by Motoko Arai.
CATEGORIES: N, SF

Miyako Neishi is a schoolgirl whose quiet exterior hides her paranormal powers. This 'opens the door' to a series of weird adventures into which her friend Kaoru Saki is helplessly drawn. ★★☆?

PROGOLFER SARU — CHALLENGE TO SUPER GOLF WORLD
(Eng trans for PROGOLFER SARU — SUPER GOLF WORLD E NO CHOSEN)

JAPANESE CREDITS: Prod: Shin'ei Doga. © Fujiko-Fujio, Shin'ei Doga. 45 mins.
ORIGINS: Manga by Fujiko-Fujio; 1982 TV special; 1985 TV series.
CATEGORIES: N, DD

Another Fujiko-Fujio hit, with a series that would run into 1988 and total 147 episodes. By way of a change from their well-known 'duo' format in which a small child finds a strange or exotic mentor/friend, the pair wanted to create a sports title which focused on a lone figure. Golf fitted the bill. A number of incidents in the Saru series are based on an extended run of fantasy tournaments in which the contestants use more and more special powers, akin to the highly developed, almost magical martial arts skills of films like *Enter the Dragon*, and this film is no exception. A mysterious 'Mr X' invites Saru to the world professional tournament, and Saru has the chance to face the greatest champions of his sport. Can he keep the absolute concentration needed to beat them? ★★?

PROJECT A-KO

JAPANESE CREDITS: Dir: Katsuhiko Nishijima. Screenplay: Yuji Moriyama, Katsuhiko Nishijima & Tomoko Kawasaki.
Original story: Katsuhiko Nishijima & Kazumi Shirasaka. Chara des & anime dir: Yuji Moriyama. Art dir: Shinji Kimma. Prod: APPP. © Fairy Dust, APPP, Final Nishijima. 80 mins.
WESTERN CREDITS: US video release 1993 on US Manga Corps, dub & sub, trans Matt Thorn; UK video release 1993 on Manga Video, dub, same version.
ORIGINS: Story by Katsuhiko Nishijima & Kasumi Shirasaka.
POINTS OF INTEREST: Music score written, produced (by Joey Carbone & Richie Zito) and performed by American musicians in Hollywood; all 3 major vocals performed in English.
SPINOFFS: Two OAV series followed. A Western pseudomanga version pub USA, CPM Comics, in 1995.
CATEGORIES: C

An alien spaceship crashes on Graviton City; people get used to it, and the business district is rebuilt on an island around the hulk. Years later, two new pupils arrive in class at the Graviton Institute for Girls. A-Ko Magami seems normal enough if you discount superstrength and superspeed, but her best friend C-Ko Kotobuki is sooooo cute that she awakens — or, as we learn later, re-awakens — an intense crush in brainy, gorgeous and filthy rich B-Ko Daitokuji, who determines to entice her away from A-Ko. The 'lesbian overtones' read into the script by those unfamiliar with the conventions of the girls' school story don't detract from the slambang slapstick of the battle between A-Ko and B-Ko for the affections of the bubble-brained C-Ko, nor from the numerous references to other icons of Western pop culture throughout the film. Just to start you off, the dipsomaniac, cross-dressing female Captain Napolipolita is a dig at both the heroic Captain Harlock and the doomed antihero Char Aznable of *Gundam*, whose voice actor Shuichi Ikeda plays the Captain; and A-Ko's skills are inherited from her parents, who appear briefly at the end of the film in their 'ordinary' alter egos as Clark Kent and Diana Prince. And what about Colonel Sanders' first starring movie role? Now see how many others you can find. It'll be no trial; this is a film you can watch again and again for a whole new definition of slapstick excess. ★★★☆

RUNNING BOY — STAR SOLDIER'S SECRET
(Eng trans for RUNNING BOY STAR SOLDIER NO HIMITSU)

JAPANESE CREDITS: Prod: Toho. © Hudson/ Film Link, Toho. 49 mins.
ORIGINS: Publicity campaign for Famicom video game from Hudson.
POINTS OF INTEREST: The first time a chara created for the purpose of selling video games was used in an anime film.
CATEGORIES: SF

Genta Shinoyama is a video game freak who suddenly finds himself dumped into a war against galactic pirates — for real, as a space pilot. Shades of *The Last Starfighter*, you might think and with some justification, but that's all I have to go on.

SUPER MARIO BROTHERS — PLAN TO FREE PRINCESS PEACH
(Eng trans for SUPER MARIO BROTHERS PEACH HIME KYUSHUTSU DAISAKUSEN)

JAPANESE CREDITS: © Nintendo. 60 mins.
ORIGINS: Video game of the same name.
CATEGORIES: DD

At the same time as *Running Boy* introduced its forthcoming video game in a cartoon, Nintendo brought out their first cartoon based on a video game. Mario, the little guy born to rescue the Princess in *Donkey Kong*, had done what all good tradesmen do and set up on his own with brother Luigi in *Mario Brothers*. The basic idea of the film is the same as in the game — they get rid of all kinds of nasty monsters who persistently get in the way and save the Princess. Not really much different from the later Bob Hoskins live-action version, but it's an historical curiosity nonetheless.★★?

THEY WERE 11
(Eng trans for JUNICHININ IRU)

JAPANESE CREDITS: Dir: Tetsu Dezaki & Tsuneo Tominaga. Screenplay: Toshiaki Imaizumi & Katsumi Koide. Chara des: Akio Sugino & Keizo Shimizu. Art dir: Junichi Azuma. Prod: Kitty Film. © M. Hagio, Shogakukan, Kitty Film. 91 mins.
WESTERN CREDITS: US video release 1992 on US Manga Corps, sub, trans Dan Kanemitsu & Tim Eldred.
ORIGINS: Manga by Moto Hagio, pub Shogakukan, currently available in English from Viz Communications.
CATEGORIES: SF

The story of the manga, somewhat condensed. An interplanetary team of ten military academy cadets set out on their end-of-course test — a voyage into space on an elderly ship. The idea is that they have to survive fifty-three days adrift; but there are not ten, but eleven of them. One of them doesn't belong on board, and a series of incidents and accidents grow more and more threatening. But who is the outsider and what is he or she trying to do? ★★☆?

TIME STRANGER
(Eng title for TOKI NO TABIBITO TIME STRANGER, lit The Time Travellers, Time Stranger)

JAPANESE CREDITS: Prod: Project Team Argos, Madhouse. © Mayumura, Kadokawa. 90 mins.
CATEGORIES: SF, R

Sometimes confused with *Goshogun The Time Étrangér*, this film proceeds along much the same lines as Takahashi's *Fire Tripper* without the cute infants and with the time disruption organised deliberately by a meddler trying to change history and a futuristic organisation trying to keep it stable. A busload of high school students is drawn further and further into time, to World War Two and then Japan's Middle Ages, where Tetsuko Hayasaka finds an impossible love with a man who has been dead for 500 years and a detective from the future tries to change history so as to alter his own world and ours. A disturbing and touching story. ★★★?

TOUCH: CHAMPION WITHOUT NUMBER
(Eng trans for TOUCH: SEBANGO NO NAI ACE)

JAPANESE CREDITS: Dir: Masamichi Fujiwara. Prod: Toho. © Adachi, Shogakukan, Toho, Asatsu. 93 mins.
ORGINS: Manga by Mitsuru Adachi; 1985 TV series.
CATEGORIES: N, R

Also:
TOUCH II: FAREWELL PRESENT
(Eng trans for TOUCH II: SAYONARA NO OKURIMONO)

CREDITS, ORIGINS, CATEGORIES:
As above except: 80 mins.

The TV series ran for a total of 101 episodes, and finished almost a year after these compilation

films appeared in the cinema and provided a chance for latecomers to the TV series to catch up on the story so far. Like Adachi's softball manga *Slow Step*, the anime version of which had a UK release on Western Connection, *Touch* is the story of a love triangle. Twin brothers Kasuya and Tatsuya Uesugi, who both play baseball (Japan's most popular Western sport), both love their childhood friend Minami. Kasuya is a baseball champion and seems to have it all, but he is tragically killed in an accident and his twin tries to take his place in the team, and in Minami's heart, while coming to terms with his own loss. The first film ends with Kasuya's death, the second opens a year later and follows the Meisei team to victory in the college baseball championships. ★★★

URUSEI YATSURA — LUM THE FOREVER

JAPANESE CREDITS: Dir: Kazuo Yamazaki. Screenplay: Kazuo Yamazaki & Toshiki Inoue. Chara des: Akemi Takada. Anime dir: Tsukasa Dokite. Art dir: Torao Arai. Music: Fumi Itakura. Prod: Kitty Film. © R. Takahashi, Shogakukan, Kitty Film. 94 mins.
WESTERN CREDITS: US video release 1993 on AnimEigo; UK video release 1994 on Anime Projects, sub, trans Shin Kurokawa & Vincent Winiarski.
ORIGINS: Manga by Rumiko Takahashi, pub Shogakukan, Eng trans pub Viz Communications; 1981 TV series; movies every year 1983-85.
CATEGORIES: C, R

Mendo decides to make a film so as to pass on his genius to posterity, and recruits Megane and the gang to help out. The story is an ancient legend of the Mendo family, passed down from genera-

tion to generation; the heroine, a magical Princess, is of course played by Lum. However, what no one realises is that all this activity — including the cutting down of an ancient cherry tree — has woken an ancient curse, and more than the success of the film is in danger. The trouble starts when Lum loses both her horns and her magical powers. Kitty's usual high production values meet Takahashi's usual romantic humour. ★★★☆

WINDARIA
(Eng title for WINDARIA LEGEND OF FABULOUS BATTLE, aka ONCE UPON A TIME)

JAPANESE CREDITS: Dir: Kunihiko Yuyama. Chara des & anime dir: Mutsumi Inomata. Mecha des: Syohei Ohara & Takahiro Sumimasu. Art dir: Tohru Katsumata. Music: Satoshi Kadukura. Prod: Kaname. © Victor. 101 mins.
WESTERN CREDITS: US video release 1987 on Harmony Gold. 1993 US video release on Best Film and Video, some edited footage restored, 96 mins; UK video release 1988 on MY-TV label, edited to 95 mins, as Once Upon a Time; all dubs, Eng dialogue Tom Wyner.
ORIGINS: Myths and folktales; some sources claim that the plays of Shakespeare were also influential.
POINTS OF INTEREST: Released to video in the same year and often described as an OAV.
CATEGORIES: DD, R

A beautiful story about love, greed, betrayal and death, this much underrated film deserves wider recognition. A young man living in a rural community is offered money and power if he will spy for a foreign country; he accepts, and leaves his devoted young wife to follow a dangerous path of debauchery and doublecross. Meanwhile two royal lovers, born on opposite sides of the conflict, are finally compelled by forces outside their control to join their countries' battles. In the end, they choose to die together rather than kill each other in battle. The young spy, whose greed helped to bring about the destruction, escapes with his life and returns home to find that, while love never dies, lovers do. The English dub and edit rob the story of some of its power in the interests of trying to adapt it for seven-year-olds, but it is a remarkable story nonetheless; the US edit is aimed at the original, older audience and should enable many new fans to enjoy one of anime's most remarkable works and wonderful designs by Mutsumi Inomata. ★★★★

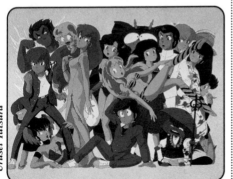

Urusei Yatsura

OAVS

AMON SAGA

JAPANESE CREDITS: *Chara des: Yoshitaka Amano. Des: Shingo Araki. Supervisors: Shingo Araki & Michi Himeno. Prod: Centre Studio, Toei Doga. © Ten Production, Tokuma Shoten, T & M. 75 mins.*
ORIGINS: *Manga by Yoshitaka Amano.*
CATEGORIES: DD

Amon's family was destroyed and their throne usurped by Valis, an evil mage. As the story opens he's wandering in search of revenge and runs into a black giant, Gaius, who befriends him. They decide to attack Valis' city, sited on the back of a giant turtle and therefore conveniently mobile, but others have the same idea, so they join forces. In the course of their infiltration of the city, Amon meets Princess Lycia, a hostage of Valis, and they fall in love. Captured by Valis and thrown into the dungeon to be devoured by his pet beast, Amon makes his escape while one of his companions rescues the Princess. Later that night their camp is attacked by werewolves and she is recaptured. Amon and his friends prepare for the final battle against the magician, a battle they must win to survive, free their peoples, reunite Lycia with her father and quench Amon's thirst for revenge. ★★?

AREA 88 ACT III — BURNING MIRAGE
(Eng trans for AREA 88 ACT III — MOERU SHINKIRO)

JAPANESE CREDITS: *Dir: Eikoh Toriumi. Screenplay: Akiyoshi Sakai. Original story: Kaoru Shintani. Chara des & chief animator: Toshiyasu Okada. Art dir: Mitsuji Nakamura. Music: Ichiro Nitta. Prod: King Record. © Shintani, Project K. 88 mins.*
WESTERN CREDITS: *US video release 1994 on US Manga Corps, sub, trans Neil Nadelman.*
ORIGINS: *Kaoru Shintani's manga series, Eng trans pub Viz Communications; 1985 OAV.*
CATEGORIES: W

In the final part of this moving drama of mercenary war, Shin Kazama finally returns to his beloved Ryoko, but finds that, while his heart is still torn, he can no longer fit in to a normal, peaceful life. Throwing away even the chance of seeing Ryoko once again, he returns once more to the skies above Area 88, where Saki is throwing everything into a last desperate battle. ★★★

ARMOURED TROOPER VOTOMS: BIG BATTLE
(Eng trans for SOHOKIHEI VOTOMS BIG BATTLE)

JAPANESE CREDITS: *Dir & mecha des: Ryosuke Takahashi. Prod: Nippon Sunrise. © Toshiba Soft.*
WESTERN CREDITS: *All the Votoms OAVs & TV series are scheduled for US video release on US Manga Corps from autumn 1996, trans Neil Nadelman.*
ORIGINS: *Story by Ryosuke Takahashi; 1983 TV series; 1985 OAV.*
CATEGORIES: SF

Bararant has taken Fiana hostage and is holding her in the experimental facility near Koba City. Chirico and his company have to fight their way past the defences to save her. ★★☆?

BAVI STOCK II — ICE MAN: LOVE'S HARD BLOWS
(Eng trans for BAVI STOCK II — ICE MAN AI NO KODO NO KANATAI)

JAPANESE CREDITS: *Dir & chara des: Shigenori Kageyama. Gen prod: Hiromasa Shibazaki. Prod co: Studio Unicorn. © Hiro Media. 45 mins*
ORIGINS: *Novel by Kenji Terada, pub Kadokawa Shoten; 1985 OAV.*
CATEGORIES: SF

Follow-up to the earlier Bavi Stock OAV.

BLUE COMET SPT LAYZNER ACT III
(Eng trans for AOKI RYUSEI SPT LAYZNER ACT III)

JAPANESE CREDITS: *Prod: Nippon Sunrise. © Sunrise, Toshiba Soft. 55 mins.*
ORIGINS: *1985 TV series.*
POINTS OF INTEREST: *SPT stands for Super Powered Tracer.*
CATEGORIES: SF

War between Earth and Grados has been averted, but dictator Kain hasn't given up, and his son Lu is determined to subjugate Earth. Eiji, born of human

and Grados blood, led the resistance during the TV series, and his sister Julia has joined a religious sect pressing for a resolution to the ongoing war. In the end, Julia solves the problem by calling on her mystical powers to warp Earth to a different part of the universe than Grados, well away from the threat of aggression — but not before Eiji and his giant mecha Layzner have had time to strut their stuff for their fans. ★★☆?

BOMBER BIKERS OF SHONAN
(Eng title for SHONAN BAKUSOZOKU — NOKOSARETA HASHIRYATACHI, lit Wild Explosive Motorbike Gang from Shonan — Superstitious Motorcyclists)

JAPANESE CREDITS: Dir: Nobutaka Nishizawa. Chara des: Satoshi Yoshida. Prod: Toei Video. © Yoshida, Shonen Gohosha, Toei. 55 mins.
WESTERN CREDITS: US video release 1994 on AnimEigo, sub.
ORIGINS: Manga by Satoshi Yoshida, pub Shonen Gohosha.
CATEGORIES: N, R

'Born to be wild in the land of the mild' was AnimEigo's copyline for this unexpectedly charming video. In Japan, where teenage rebellion is perming your hair and wearing a white tie with a black shirt, biker gangs aren't quite what we're used to in the West. The boys of Shobaku, as the gang is affectionately known, are a good-hearted bunch who just want to ride their bikes — after school and on weekends, of course — without any trouble. The leader of the pack, Yosuke Eguchi, is cool, brave, charismatic and the star of the school's embroidery club. His cohorts are similarly unusual and together they follow the teachings of former student Noboru Ishikawa, now graduated, but still the inspiration of the Shobaku members. A gang of less cool, less clever and far less popular bikers try to best Shobaku, and, failing, set their rivals up to be trashed by a hard mob from out of town. However, Eguchi's impassioned speech about what it really means to be a biker saves the day, and in the end everyone makes up and agrees to be true to their dreams. It sounds wet but it's charming, and the summery, sugaredalmond palette in which the whole work is executed adds to the enchanting impression of a gentler, funnier, nicer world than our own. ★★★☆

CALIFORNIA CRISIS — LOCAL ATTACK
(Eng trans for CALIFORNIA CRISIS — TSUIGEKI NOHIBANA)

JAPANESE CREDITS: Dir, scenario & storyboards: Mizuho Nishikubo. Chara des & key animation: Matsuri Okada. Prod: Studio Unicorn for Hiro Media. © Studio Unicorn, CBS Fox video. 45 mins.
CATEGORIES: DD, N

The present: on a business trip to Los Angeles, Noera stumbles into the rivalry between two gangs led by Convoy and Van. She flees with another girl, Masha; together they find a mysterious sphere and set off in search of the valley they 'see' therein. The poster art looks as if this has nice designs — the girls certainly look cute — but more than that I don't know.

CALL ME TONIGHT

JAPANESE CREDITS: Prod: AIC. © Bandai. 30 mins.
CATEGORIES: R, C

Schoolgirl Lumi Natsumi moonlights running a phone contact club. One night she gets a call which is weird even by Telecom standards — Ryo Sugiura says he turns into a horrible monster when certain things excite him... Lumi is a good-hearted girl and she decides to help him out by getting him used to being overexcited. No, this isn't *Cream Lemon*, it's a comedy, though mildly ecchi. Lumi takes him to an amusement park where, sure enough, after a few scary rides he does transform, but following a series of mishaps he finally manages, with Lumi's help, to change back to his own form. Problem solved, half an hour passed quite pleasantly. ★★☆?

COSMOS PINK SHOCK

JAPANESE CREDITS: Des: Toshihiro Hirano. Prod: AIC. © Japan Victor Co. 40 mins.
CATEGORIES: SF

SF adventure. Sixteen-year-old Mitsuko is a space pilot. Landing on an unfamiliar planet, she is arrested and sentenced to death. It's okay though, because she escapes with a few other prisoners. From what I've been able to find out about this, that's all that happens! ★☆?

DANCOUGAR: REQUIEM FOR VICTIMS
(Eng title for CHOJU KISHIN DANCOUGAR USHINAWARETA MONOTACHI E NO REQUIEM, lit Super Bestial Machine God

Dancougar Requiem for Victims)

JAPANESE CREDITS: Prod: Bandai. © Ashi.
90 mins.
ORIGINS: 1985 TV series.
CATEGORIES: SF

The Dancougar team are an élite unit of Earth's armed forces, formed to pilot four specialised weapons which can combine into the 'Super Bestial Machine God Dancougar' and fight off the menace of the alien Zolubados Empire. One of the Empire's greatest generals takes on Dancougar in hand-to-hand combat in another dimension. Even after they defeat him, the team still has to face the most powerful opponent of all — the Emperor Muge Zolubados himself. Will they make it? Of course, but not before impressive quantities of heavy metal have been slammed around the screen and the team — Shinobu, Sara, Ryu and Masato — have been tested to their limits. ★★☆

DARLING BETTY — DEMON STORY
(Eng trans for ITOSHI NO BETTY — MAMONOGATARI)

JAPANESE CREDITS: Prod: Big Ben for Toei
Co. © Toei Video. 53 mins.
ORIGINS: Manga by Kazuo Koike & Seisaku
Kano.
CATEGORIES: R, H

Betty is a witch and travels with Tanpei, demon-busting and dragon-destroying, to keep their homeland pleasant and stop their friends and Betty's parents being terrorised by demons and other nasties. Road movie meets early tentacle movie? ★★☆?

DELPOWER X — MIRACLE FORCE EXPLOSION
(Eng trans for DELPOWER X — BAKUHATSU MIRACLE GENKI)

JAPANESE CREDITS: Prod: Big Ben. ©
Nippon Columbia. 40 mins.
CATEGORIES: SF

Another giant robot adventure, this time with a girl in the pilot seat. Manami Hanemoto is the granddaughter of Delpower X's creator Dr Tatsuemon. The Germanoids, soldiers of the army of Getzeru, are out to destroy the robot and its young pilot as part of their mission of galactic conquest. I haven't seen any artwork from this so can't even hazard a guess as to its quality.

DREAM DIMENSION HUNTER FANDORA II: DEADLANDER CHAPTER
(Eng trans for YUME JIGEN HUNTER FANDORA II DEADLANDER HEN)

JAPANESE CREDITS: Prod: Kaname for Hiro
Media. © Dynamic Planning, Nippon
Columbia. 43 mins.
ORIGINS: Manga by Go Nagai; 1985 OAV.
CATEGORIES: SF, H

Also:
DREAM DIMENSION HUNTER FANDORA II: PHANTOS CHAPTER
(Eng trans for YUME JIGEN HUNTER FANDORA II PHANTOS HEN)

CREDITS, ORIGINS, CATEGORIES: As above
except: 45 mins.

During the destruction of the Deadlander Dimension by galactic criminal Yog Soggoth, young lovers Soto and Fontaine are separated. Later,

Bomber Bikers of Shonan

Fandora and Que meet a little boy called Soto, who is trying to get back to Deadlander. Back at Dimensional Police HQ Fandora sees the evidence that Yog used the magic blue Endran Gem to turn Deadlander into a den of thieves and villains, and sets off to investigate with Que and Soto. When the boy is wounded, she uses her red Rupia Gem to heal him and he turns into a young man again. In Part III, Fontaine is tricked by Yog into trying to get the Rupia Gem. The criminal is masquerading as 'the blue god', hiding inside an artificial sun, and claims that bringing the red and blue gems together will restore Deadlander to its former life. Soto takes the Rupia Gem to his lair, but luckily Que follows and stops it falling into the criminal's hands. Now Que and Soto are face to face with Yog Soggoth, but Fandora is alone, surrounded by all his henchmen, and he and they are ready for a fight! ★★☆?

DREAM HUNTER REM II: SPIRIT DREAM OF SEIBISHIN HIGH SCHOOL
(Eng trans for DREAM HUNTER REM II SEIBISHIN JOGAKUEN NO YOMU)

JAPANESE CREDITS: Prod: Project Team Eikyu. © Sai Enterprise, King Record. 60 mins.
ORIGINS: 1985 OAV.
CATEGORIES: DD

The pupils of Seibishin Girls' School are dying in mysterious circumstances and Rem is asked to investigate. She discovers from Yoko Takamiya that the deaths are being attributed to the ghost of her sister Kyoko, who died while being held prisoner by a group of boys in the clock tower. But is everything as it seems? ★★☆

GO GO TORAEMON

JAPANESE CREDITS: Prod: Studio Pierrot. © Warner, Pioneer. 30 mins.
CATEGORIES: T

Another sports video based on real people, this time the successful Hanshin Tigers baseball team. This light-hearted comedy features all the team and support crew and celebrates their victory in the national professional championships. ★★?

THE GUYVER: OUT OF CONTROL
(Eng title for KYOSHOKU SOKO GUYVER, lit Armoured Creature Guyver, aka BIO BOOSTER ARMOUR GUYVER)

JAPANESE CREDITS: Dir: Hiroshi Watanabe. Screenplay: Monta Iba. Chara des: Indori Goya. Anime dir: Hiromi Matsushita. Art dir: Torao Arai. Music: Shoji Nanba. Prod: Studio Live for Bandai. © Takaya, Tokuma Shoten, Network, Bandai. 55 mins.
WESTERN CREDITS: US video release 1993 on US Renditions, sub; UK video release of later 12-part OAV series in 1994 on Manga Video.
ORIGINS: Yoshiki Takaya's manga, pub Tokuma Shoten, Eng trans pub Viz Communications.
SPINOFFS: Apart from the OAV series, 2 live-action films, Mutronics and Guyver: Dark Hero, were also made in the USA.
CATEGORIES: V, H

This is a slightly different version of the story than the later twelve-part series, though the outline and inspiration are the same. Sho Fukamachi accidentally runs across a Guyver unit and is possessed by it while out walking with his girlfriend, who is understandably a bit shaken to see him turn into a spiky, muscular alien creature, a cross between a monster, an armoured knight and a superhero. The owners of the strange device, the Chronos Corporation, want it back and will stop at nothing to get it. They even send in Guyver 2, who in this version is a sleek and elegant woman before she transforms. An interesting variation on the series, and its relative brevity makes for more concentrated storytelling and less repetition. ★★☆

THE HUMANOID
(Eng title for THE HUMANOID — AI NO WAKUSEI LEZERIA, lit The Humanoid — Lezeria, Love's Sad Planet)

JAPANESE CREDITS: Dir: Shinichi Masaki. Screenplay: Koh-Ichi Minade & Kaname Productions. Chara & mecha des: Shohei Obara. Anime dir: Osamu Kamijoh. Art dir: Hagemu Katsumata. Prod: Kaname for Hiro Media. © Hiro Media, Kaname, Toshiba EMI. 45 mins.
WESTERN CREDITS: US video release 1993 on US Manga Corps, sub, trans Studio Nemo.
ORIGINS: 'Sexy Robot' illustrations by Hajime Sorayama.
CATEGORIES: SF

Manga have inspired many great anime, so why not illustrations? In this case, alas, Sorayama's astonishing technical facility is not even approximated and the rest of the charas, the plot and the pacing are distinctly lacklustre. A standard SF story

of a beautiful robot who is willing to sacrifice herself for her human friends has been the basis for some excellent writing and characterisation, as in Tezuka's *Space Firebird*, but not here. ★

ICZER-ONE ACT II
(Eng title for TATAKAE! ICZER-ONE ACT II ICZER SIGMA NO CHOSEN, lit Fight! Iczer-One Act II Iczer Sigma's Treachery)

JAPANESE CREDITS: Dir, writer & chara des: Toshihiro Hirano. Mecha des: Hiroaki Motoigi & Shinji Aramaki. Art dir: Yasushi Nakamura & Kazuhiro Arai. Music: Michiaki Watanabe. Prod & ©: AIC, Kubo Shoten. 29 mins.
WESTERN CREDITS: US video release 1992 on US Renditions, on single tape with Act 1, trans Trish Ledoux & Toshifumi Yoshida.
ORIGINS: 1985 OAV.
CATEGORIES: SF, H

Iczer-One and Nagisa fought as a team and successfully controlled Iczer Robo, killing Cobalt, the pilot sent against them by Big Gold. Now Big Gold throws in the mighty robot Iczer Sigma and evil clone Iczer-Two, with Cobalt's lover Sepia as their team-mate. Nagisa's anger at the death of her parents and the destruction of her world is now faced with Sepia's thirst for revenge for her dead partner and lover. Which will win? ★★★

LEGEND OF THE ROLLING WHEELS PART 1 TSUKUBA CHAPTER
(Eng trans for BARIBARI NO DENSETSU PART 1 TSUKUBAHEN)

JAPANESE CREDITS: Prod: Studio Pierrot. © Shigeno, Kodansha. 30 mins.
ORIGINS: Manga by Shigeno, pub Kodansha.
CATEGORIES: N

Also:
LEGEND OF THE ROLLING WHEELS PART 2 SUZUKA CHAPTER
(Eng trans for BARIBARI NO DENSETSU PART 2 SUZUKAHEN)

CREDITS, ORIGINS, CATEGORIES: As above.

Miyuki Ichinose sees something remarkable — a kid on a 50cc moped beat a 750cc bike — and being the daughter of a motorbike team chief, she does something about it and invites Gun onto the team. Gun finds it hard to fit in at first, and the rivalry between him and successful rider Hideyoshi makes things even harder. By the start of the second story, Gun has gained confidence; he and his friends decide to accept Hideyoshi's challenge to enter their team in the world championship. They succeed, but Hideyoshi's career is interrupted by a tragic accident. ★★?

MAGICAL EMI FLASHBACK
(Eng title for MAHO NO STAR MAGICAL EMI SEMISHIGURE, lit Star Witch Magical Emi Flashback)

JAPANESE CREDITS: Prod: Studio Pierrot. © Studio Pierrot, NTV, Bandai. 60 mins.
ORIGINS: 1985 TV series.
CATEGORIES: R, U

An OAV made up of flashbacks as Mai flicks through her photo album and recalls everything that has happened since she acquired a second life as Magical Emi, singing star and magic Princess. Cute art, sweet stories. ★★☆

M.D. GEIST: THE MOST DANGEROUS EVER
(Eng title for SOKIHEI M.D. GEIST, lit Demon Armour M.D. Geist)

JAPANESE CREDITS: Dir: Hayato Ikeda. Asst dir, original story & mecha des: Koichi Ohata. Screenplay: Riku Sanjo. Chara des: Tsuneo Ninomiya. Anime dir: Hiroshi Negishi. Art dir: Yoshinori Takao. Prod: Production Wave for Hiro Media. © Hiro Media, Wave, Nippon Columbia. 55 mins.
WESTERN CREDITS: US video release 1992 & 1994 on US Manga Corps, sub & dub.
ORIGINS: Chara and scenario created by Koichi Ohata.
SPINOFFS: American pseudomanga pub CPM Comics, art by Koichi Ohata & Tim Eldred. M.D. Geist 2 is now in production in Japan and is scheduled for US release in 1996.
CATEGORIES: SF, V

M.D. stands for 'most dangerous'. Geist is a biogenetically engineered superwarrior, last and most powerful of a breed created when his planet was tearing itself apart during the post-nuclear era. Now that some semblance of order is returning, Geist — having somehow survived the devastation — is called on again. The problem is, what is the world going to do with him afterwards? He may be an ideal man (or weapon) to have on your side in war time, but when the fighting stops he proves hard to

dispose of and he doesn't like being double-crossed. Heavy metal action for post-holocaust freaks. ★★

MEGAZONE 23 PART II: PLEASE KEEP IT SECRET
(Eng trans for MEGAZONE 23 PART II HIMITSU KUDASAI)

JAPANESE CREDITS: Dir: Toshihiro Hirano. Chara des: Yasuomi Umetsu. Eve designed by Haruhiko Mikimoto. Prod: AIC, Artland, Artmic. © Idol, Artmic, Victor. c60 mins. ORIGINS: Inspired by the novel Universe by Robert A. Heinlein. Original story by Noboru Ishiguro; 1985 OAV. POINTS OF INTEREST: The female wrestler Dump Matsumoto appears as herself. The chara designs by Umetsu bear absolutely no resemblance to the designs in the original Megazone 23. CATEGORIES: SF, X

Shogo is wanted for the murder of his girlfriend Yui's flatmate — a murder committed by the Government to cover its tracks. He is on the run, living in a squat with a community of young rebels and misfits, trying to stay out of the hands of the police and in touch with idol singer Eve Tokimatsuri, and to get back the Garland bike. Yui joins him and they rekindle their romance, but in the final battle with the police and their chief, B.D., she is badly injured. Shogo learns that Eve is a virtual reality computer entity and that the mighty computer Bahamood is a space capsule programmed to carry a group of survivors back to Earth when the dreadful contamination which devastated the planet centuries ago has dissipated. Megazone 23 isn't Tokyo at all; it's an artificial environment, one of many sent out from Earth, and everyone aboard has been living a lie. Whole generations have thought they were on Earth fighting to stop aliens invading, while they've really been in deep space, deceived by the authorities to prevent mass panic and despair. Shogo is angry at the deception but his main concern is for Yui. Eve is able to heal her, and together they and the other survivors of the fight with the police reach the revived Earth and determine to make a better world than their ancestors did. A stylish, well-paced SF story with lovely chara designs from Umetsu, though Mikimoto's Eve is the one that attracts most attention among fans. ★★★

OUTLANDERS

JAPANESE CREDITS: Dir: Katsuhisa Yamada. Chara des & anime dir: Hiroshi Hamazaki.

Art dir: Yusaku Saotome. Music: Megami Wakakusa. Prod: Tatsunoko. © Manabe, Hakusensha, Tatsunoko, Victor. 50 mins. WESTERN CREDITS: US video release 1993 on US Renditions, dub. ORIGINS: Johji Manabe's manga, pub Hakusensha, Eng trans pub Dark Horse. POINTS OF INTEREST: The voice acting début of Trish Ledoux, translator and editor of Animerica magazine, as Princess Kahm. CATEGORIES: SF, C, X

One of the hits of the year, this slapstick SF story opens with alien Princess Kahm slicing up unsuspecting Earthlings as part of her father's invasion plan. Things get confused when she falls into the arms of photographer Tetsuya Watakushi and decides to save him from the destruction visited on Japan and the rest of its population. Earth is a very small, insignificant planet in the plans of the vast Santovasku Empire, and if it wasn't for the strange attachment Kahm feels for this Earthling, it would have been wiped out without trace. Now, however, Tetsuya has a chance to save Earth and grab a piece of imperial cheesecake in an armoured bikini to boot. Despite the opposition of her father and friends and Tetsuya's own ineptitude, the feeling between the unlikely pair grows. In the end, he finds courage he never knew he possessed and she wins over the opposition to ensure she can wed her human. Light-hearted, sweet-tempered and lots of fun, with wonderful organic spaceship designs and convincing battle sequences. ★★★☆

PANZER WORLD GALIENT
(Eng title for KIKOKAI GALIENT TETSU NO MONSHO, lit Mechanical Corps Galient Steel Emblem)

JAPANESE CREDITS: Prod: Nippon Sunrise. © Sunrise, Toshiba Soft. 55 mins. ORIGINS: 1984 TV series. CATEGORIES: SF

As in the TV series, Madar is trying to unify the land of Asato using giant robots. Legend says that a champion, the Giant of Iron, will come to destroy all lesser armour. Madar's ambitious son Hai tries to kill him and his other children, Hai's own brother Jordy and little sister Chururu, wanting no question as to the succession. But the children are saved by a mysterious force, and Hai comes face to face with the Giant of Iron. A wonderfully designed set of mecha and excellent artwork contribute to this offshoot of a much under-rated series. ★★☆?

PELIKAN ROAD CLUB CULTURE

JAPANESE CREDITS: Dir, scenario & storyboards: Eiichi Yama. Chara des & key animation: Kazuhiko Udagawa. Prod: Studio World. © *Igarashi, Shonen Pictorial. 55 mins.*
ORIGINS: Original idea by Koichi Igarashi.
CATEGORIES: N

This was a good year for biker OAVs. Here the hero is Kenichi Watanabe, a high school student nuts about his MBX50. He and his friends set up a bike club called Culture, and this story chronicles their adventures on the journey towards adult life. ★★?

ROMANESQUE SAMY
(Eng title for CHOJIKU ROMANESQUE SAMY MISSING 99, lit Super Dimensional Romanesque Samy Missing 99)

JAPANESE CREDITS: Prod: Project Team Eikyu. © *TDK, KOA. 60 mins.*
CATEGORIES: SF

Once more it's a fight between good and evil. Ancient legends tell of a war between God and the Devil for control over the form of the universe. In the present, a new conflict arises for control of a new universe. The warriors of Good are Samy and her friends Tokyo, Silver and Dews, up against the might of the evil Noa. I don't have enough information on this to rate it, I'm afraid.

ROOTS SEARCH
(Eng title for ROOTS SEARCH — SHOKUSHIN BUTTAI X, lit Roots Search — Life Devourer X)

JAPANESE CREDITS: Dir: Hisashi Sugai. Screenplay: Mitsuru Shimada. Chara des & anime supervisor: Sanae Kobayashi. Art dir: Yoshinori Takao. Prod: Production Wave. © *Nippon Columbia. 45 mins.*
WESTERN CREDITS: US video release 1992 on US Manga Corps, trans Alara Rogers.
CATEGORIES: SF, X

On the Tolmekus Research Institute's satellite, a powerful psychic, Moira, probes a passing ship which has set off all the station's alarms, and 'sees' a terrible slaughter. An alien has invaded the ship and begun playing with the minds of the crew members, filling them one by one with painful memories and then killing them. Even when ejected into space, the alien continues to claim victims. Only Moira can communicate with it, and as she explores its mind she begins to learn that there may be far more behind the alien attack than anyone has imagined. ★★?

RUMIKO TAKAHASHI'S RUMIK WORLD — MARIS THE WONDERGIRL
(US aka RUMIKO TAKAHASHI'S RUMIK WORLD — MARIS THE CHOJO, US aka THE SUPERGAL)

JAPANESE CREDITS: Dir: Kazuyashi Katayama & Tomoko Konpaku. Screenplay: Tomoko Kaneharu & Hideo Takayashiki. Chara des: Rumiko Takahashi & Katsumi Aoshima. Art dir: Torao Arai. Music: Ichiro Nitta. Prod: Studio Pierrot. © *R. Takahashi, Shogakukan, Kitty Film, Fuji TV. 50 mins.*
WESTERN CREDITS: US video release 1992 on US Manga Corps as Rumiko Takahashi's Rumik World — Maris the Chojo, sub; UK video release 1994 on Manga Video as Rumik World — Maris the Wondergirl, dub.
ORIGINS: Manga by Rumiko Takahashi pub Shogakukan, Eng trans pub Viz Communications; 1985 OAV.
POINTS OF INTEREST: Chojo translates, of course, as 'supergirl', but it was thought it would confuse the public to have a video entitled 'The Supergirl' going round as well as the famous comic book character, hence the range of titles and US variant title spelling.
CATEGORIES: SF, C

Space Police Officer Maris comes from a superstrong race and keeps breaking things — her spaceship, buildings, cars — so she's always in debt. The chance to rescue a rich, handsome kidnap victim is too tempting to resist. She dreams that he'll sweep her off her feet and save her from a life of poverty. All that happens is that she encounters an old foe from her pro-wrestling days and ends up in the ring again. Her sidekick Murphy is in danger of losing his partner and in the end Maris misses out on the reward and the guy. Humour from Rumiko Takahashi is always worth looking at and there are some great sight gags — watch out for Darth Vader — but this is a long way off her best. ★★

THE SCARRED MAN
(Eng trans for KIZUOIBITO)

JAPANESE CREDITS: Dir: Toshio Takeuchi. Prod: Madhouse for Bandai. © *Koike,*

Ikegami, Shogakukan, Bandai. 40 mins.
ORIGINS: Manga by Ryoichi Ikegami &
Kazuo Koike, pub Shogakukan.
CATEGORIES: A

Another Ikegami manga into anime, this tells the
story of gold prospector Keisuke Ibarake and TV
journalist Yuko. They fall in love and Yuko decides
to follow Keisuke in his search for fortune. But can
their love survive the hardships and dangers of his
chosen way of life? ★★☆?

THREE LITTLE WITCHES
**(Eng title for ADESUGATA MAHO NO SANNIN
MUSUME)**

JAPANESE CREDITS: Prod: Studio Pierrot. ©
Studio Pierrot, Network. 30 mins.
ORIGINS: 1983 & 1985 'magical girls'
TV series.
CATEGORIES: U

A delightful little homage to three heroines of the
'magic Princess' genre. It's New Year and Yu, Mai
and Pelsha (also sometimes transliterated as Persia)
get together to celebrate and reminisce over the
magical adventures in their respective TV series.
Their three 'other selves', the alter egos Creamy
Mami, Magical Emi and Fairy Pelsha, join them for
a sparkling musical finale. ★★★?

TIMID VENUS
(Eng trans for OKUBYONA BINASU)

JAPANESE CREDITS: Chara des: Hiroyuki
Kitakubo. Des & supervision: Shingo Araki
& Michi Himeno. © Victor.
CATEGORIES: N

The story of a young singer's career.

TWINKLE HEART — DON'T LET'S REACH THE GALAXY
**(Eng trans for TWINKLE HEART GINGAKEI
MADE TODOKANAI)**

JAPANESE CREDITS: Prod: Project Team
Argos. © Project Team Argos, Krown Record.
45 mins.
CATEGORIES: SF

We start on a distant planet, where the treasure of
Love is being sought by order of Ogod. (The Japa-
nese prefix O, meaning King or ruler, indicates the
top dog in any particular group.) Cherry, Lemon

Urusei Yatsura

and Berry join the search and finally reach Earth,
instal their spaceship in a hamburger bar and decide
that this is a good way to look out for any inform-
ation regarding the treasure. With a synopsis like
this, it won't surprise you to learn that the art shows
charas like smiley versions of those saccharine
paintings of wistful kids with huge eyes and ragged
teddy-bears... I think this might seriously damage
the brain of anyone who goes near it. ★?

URBAN SQUARE KOHAKU'S CHASE
**(Eng trans for URBAN SQUARE KOHAKU NO
TSUIGEKI)**

JAPANESE CREDITS: Prod: Network. ©
Bandai.
CATEGORIES: M

A police drama makes a nice change from the diet
of SF, schmaltz and bikers offered by most of this
year's OAVs. If it sounds a bit like the sixties clas-
sic *Blow Up*, don't worry. Ryu Matsumoto is a
screenwriter who sees a murder, but finds his test-
imony rubbished by the police because the body
has vanished without trace before they reach the
scene. Ryu engages private eye Mochizuki to pro-
tect him and try to find out more. Then the beau-
tiful Yuki is taken hostage. The art looks nicely
realistic. ★★☆?

URUSEI YATSURA OVA 6: RYOKO'S SEPTEMBER TEA PARTY and MEMORIAL ALBUM

JAPANESE CREDITS: Prod: Kitty Film. ©
Takahashi, Shogakukan, Kitty Film, Fuji TV.
Each c45 mins.
WESTERN CREDITS: US video release 1993

on AnimEigo on one tape as Urusei Yatsura OVA 6.
ORIGINS: Manga by Rumiko Takahashi, pub Shogakukan, Eng trans pub Viz Communications; 1981 TV series; movies every year 1983-85.
CATEGORIES: C, R

Two special 'flashback' OAVs. The first combines scenes from the original TV series with fifteen minutes of new animation to reveal the pasts of each of Ryoko's guests; the second shows the Mendo family satellite narrating the family history, again using scenes from the original TV series and new anime. ★★★?

VIOLENCE JACK EPILOGUE VOL 1 HARLEM BOMBER
(Eng trans for VIOLENCE JACK BANGAIHEN VOL 1 HARLEM BOMBER)

JAPANESE CREDITS: Dir: Ichiro Itano. Script: Noboru Aikawa. Chara des & anime dir: Takuya Wada. Art dir: Mitsuharu Miyamae. Photography dir: Norihide Kubota. Sound & music dir: Yasunori Honda. Planning prod: Naotaka Yoshida (Soeishinsha) & Nobuo Masumizu (Japan Home Video). Prod: Kazufumi Nomura. © Dynamic Planning, Soeishinsha, Japan Home Video. 40 mins
WESTERN CREDITS: UK & US video release 1996 on Manga Video, dub, trans Studio Nemo & John Wolskel.
ORIGINS: Manga by Go Nagai, pub 1973.
CATEGORIES: V, X

Following a huge meteorite shower and earthquakes, man's civilisation is destroyed. Small groups of people struggle to survive, banditry abounds and superstition is rife. A giant force of nature, seemingly more animal than human, Jack can 'sense' evil and wades in to stop it with gusto. A huge body count and massive blood flow is part of any *Violence Jack* story and those of a sensitive disposition should avoid them; but Nagai is, as ever, making a point as well as making entertainment to shock. There are some human deeds so wicked that nature could never be as terrible, and it takes catastrophe to cleanse them from the face of the Earth. ★★

WANNA-BE'S

JAPANESE CREDITS: Dir: Katsuhito Akiyama. Screenplay: Toshimitsu Suzuki. Chara des & anime dir: Yoshiharu Shimizu.

Chara des: Kenichi Sonoda. Art dir: Masazumi Matsumiya. Prod: Artmic, Animate Film. © MOVIC, Sony Music Entertainment. 45 mins.
WESTERN CREDITS: US video release 1992 on US Manga Corps, trans Neil Nadelman.
POINTS OF INTEREST: Released on Christmas Day, the last OAV of 1986; Sonoda's first work as a chara des.
CATEGORIES: N

The *Gall Force* team was together on this story of professional wrestling. With all its fakery and flamboyance, the sport is very popular in Japan, and girl tag teams are especially successful. This is the story of Eri and Miki, the Wanna-Be's, and their fight to get to the top and defeat their main rivals, the Foxy Ladies. Aficionados might find it instructive to compare this with the live-action film *All the Marbles...* (aka *The California Dolls*). Sonoda is not at his best, but it's still not bad. ★★☆

WITCH GIRL DEMOSTEADY
(Eng title for MAJO DEMOSTEADY)

JAPANESE CREDITS: Prod: Herald Pony. © Tokyo Media Connection, Ajiado. 42 mins.
CATEGORIES: R, SF

Hisashi Seki lives alone in an old apartment building built in a dimensional warp. He's unaware of this until he wakes up to find a gorgeous nude girl, Mami, in his room. They fall in love on sight and decide to stay together in Hisashi's world; but then an accident shoots Hisashi into another dimension, one inhabited by everyone's ideal partners. To return to his own place, he has to find Mami in this strange dimension. I have nothing to go on here except this short story synopsis, so I can't really comment on the art!

Violence Jack

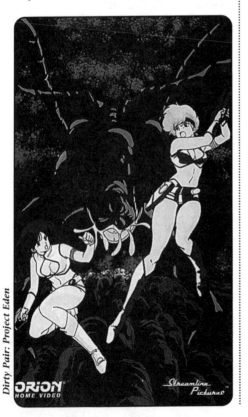

Dirty Pair: Project Eden

Those introduced to anime by the West's ever-growing stock of commercially available material will find themselves on increasingly familiar ground. Many of the titles released this year have now come out in the UK and USA, including the ground-breaking movie *Wings of Honneamise*, the *Lupin III* film *The Fuma Conspiracy* and a clutch of OAVs forming the infamous *Legend of the Overfiend*, aka *Urotsukidoji*. One of the most popular films of the year as far as English-speaking fans are concerned still awaits a UK release, although it is available in the USA — the *Dirty Pair* movie subtitled *Project Eden* by many fans. Rumours abound as to when the long-awaited British screen début of the Lovely Angels may occur; however, it should be remembered that, popular as they are in the West, they enjoyed no outstanding success on their TV début in Japan. The movie released this year was paired with a more popular subject — baseball comedy *Bats & Terry* — in an effort to ensure box-office success. No such problems assailed the other female team making its début this year, the Knight Sabers of *Bubblegum Crisis*, but by way of consolation to Kei and Yuri's fans, the hard-suited vigilantes have yet to make it to the big screen. On the erotic side, among other titles, three more *Cream Lemon* releases were accompanied by seven episodes of *New Cream Lemon*; some things are always in demand.

MOVIES

BATS & TERRY

JAPANESE CREDITS: Prod & © Nippon Sunrise. 80 mins.
POINTS OF INTEREST: Original theatrical release on a double bill with Dirty Pair: Project Eden.
CATEGORIES: N

A light-hearted sporty soap opera, this is the story of two mates, pitcher and catcher on a pro-baseball team, devoted to their game, bikes, girls and having a good time. When they meet a girl who is still mourning the death of her boyfriend in a bike accident, they try to help — though her beauty means their motives may not be entirely altruistic! — and thus innocently embroil her in a feud with a rival gang. Fights, kidnap, embarrassing situations (with partial nudity) and real danger ensue, but our heroes manage to sail through it all with good humour intact and nobody really hurt, and even help their new friend finally come to terms with the past and look to the future. A very enjoyable way to pass an evening with a big bowl of popcorn and a few beers, and gain some insight into what Japanese teens think cool guys ought to be like. ★★★☆

DIRTY PAIR: PROJECT EDEN
(aka DIRTY PAIR THE MOVIE)

JAPANESE CREDITS: Dir: Kouichi Mashita.

Script: Hiroyuki Hoshiyama. Chara des: Tsukasa Dokite. Mecha des: Kazutaka Miyatake. Art dir: Mitsuharu Miyama. Prod: Nippon Sunrise. © Takachiho, Studio Nue, Sunrise, NTV. 80 mins.
WESTERN CREDITS: US video release 1990 & 1994 on Streamline Pictures, dub, Eng screenplay Ardwight Chamberlain.
ORIGINS: Novels by Haruka Takachiho; appearance in 1983 movie Crushers; 1985 TV series & OAV. Why Kodansha don't bring the books out in the West I'll never know.
POINTS OF INTEREST: Look for a superbly idiosyncratic performance in the Japanese dub by Lupin III veteran Chikao Otsuka, the early voice of Goemon, as Professor Wattsman.
CATEGORIES: SF, C

The WWWA (3WA) is a sort of cross between a social work department, a mercenary army and a service bureau. Whatever problem you may have, 3WA operatives can sort it out for you — at a price. If the operatives assigned are Kei and Yuri, code-named the Lovely Angels but referred to in hushed tones as the Dirty Pair for their reputation of leaving no stone unturned, no wall undemolished, no vehicle unexploded when they finish a case, the price could be very high indeed. In this lunatic cocktail of Bond movies, telefantasy influences and romance (in every sense of the word), Kei and Yuri go to the mining planet Agama, where mysterious beasts are disrupting production and leading the planet's two superpowers ever closer to war. It's all the fault of ageing cyberfreak genius Professor Wattsman, who with the help of his faithful butler is trying to create a new race of mineral-based humanoid beings who are both powerful and beautiful. He's got the powerful bit right, but so far hasn't managed to make a silk purse out of a chunk of rock. Naturally enough, the Pair solve the case, and it won't exactly spoil the suspense if I tell you that the planet is completely wiped out at the end of the film. With a gratuitous bath scene, Wattsman's cyberantics, the heroic hunk Carson D. Carson (a thief with a sense of honour and romance and a taste for good wine) and plenty of large-scale destruction thrown in, the end may be predictable but the journey will be a pleasure. Lots of fun in the music too, and a credit sequence that would do Maurice Binder, the designer of many James Bond movies, proud. ★★★★

DORAEMON — NOBITA AND THE DRAGON KNIGHT
(Eng trans for DORAEMON — NOBITA TO RYU NO KISHI)

JAPANESE CREDITS: Prod: Shin'ei Doga. © Fujiko-Fujio, Shin'ei Doga.
ORIGINS: Manga by Fujiko-Fujio, pub Shin'ei Doga; 1979 TV series; movies every year 1984-86.
CATEGORIES: C, U

More comic adventures of the dozy boy and his robocat companion.

DRAGONBALL — THE SLEEPING PRINCESS IN DEMON GOD CASTLE
(Eng trans for DRAGONBALL — MAJINJO NO NEMURIHIME)

JAPANESE CREDITS: Dir: Daisuke Nishio. Prod: Toei Doga. © Bird Studio, Shueisha, Toei Doga.
ORIGINS: Manga by Akira Toriyama, pub Shueisha; 1986 TV series; 1986 movie.
CATEGORIES: C, V

A mad scientist, robots and — just as promised — a sleeping Princess are only an excuse for more Dragonball martial arts and mass destruction on an absurd scale. The movies form a linked but distinct continuity to the TV series and manga, enabling Toriyama's characters to shoot off down some strange and silly side alleys. ★★★?

GO, GHOST QTARO! THE ONE IN A HUNDRED PLAN
(Eng trans for OBAKE NO QTARO SUSUME! HYAKUBUN NO ICHIDAI SAKUSEN)

JAPANESE CREDITS: © Fujiko-Fujio, Shueisha, Shin'ei Doga. 40 mins.
ORIGINS: Manga by Fujiko-Fujio, pub Shueisha; 1965 & 1985 TV series; 1986 movie Jump! Ghost Qtaro.
CATEGORIES: C, U

Comic capers from the popular ghost and his human friend Tadashi.

LUPIN III: THE FUMA CONSPIRACY
(Eng trans for LUPIN III: FUMA ICHIZOKU NO INBO, aka RUPAN III: THE FUMA CONSPIRACY)

JAPANESE CREDITS: Dir: Masayuki Ozeki. Screenplay: Makoto Naito. Anime dir: Kazuhide Tomonaga. Art dir: Shichiro Kobayashi. Music: Kiyoshi Miyaura. Prod:

Tokyo Movie Shinsha. © Monkey Punch, Sotsu Agy, Toho Co Ltd, TMS. 75 mins. WESTERN CREDITS: US video release 1994 on AnimEigo as Rupan III — The Fuma Conspiracy, sub, trans Shin Kurokawa & Michael House; UK video release 1995 on Western Connection, sub. ORIGINS: The Arsène Lupin stories by Maurice Leblanc; manga by Monkey Punch; 1971 & 1977 TV series; 1978 & 1985 movies. CATEGORIES: M

I really love this film. It is amusing, intelligent, literate, sophisticated and very, very well made. The masterly direction of Masayuki Ozeki holds together and paces to perfection a wild cocktail of references from Indiana Jones to *The Name of the Rose* and Hong Kong swordsman flicks, while the well-loved cast of characters run through their familiar but always intriguing paces. Lupin is a thief, the descendant of European master-thief Arsène Lupin; but he's on his best behaviour for the wedding of his long-time associate, master swordsman Goemon Ishikawa, to the grand-daughter of one of his teachers, heiress to the Suminawas, another old samurai family. The rival Fuma clan kidnap the bride at the ceremony and offer to exchange her for the key to an ancient Suminawa clan treasure; Lupin, Jigen and Fujiko decide to help out, not just because Goemon is an old and valued friend, but also because an ancient clan treasure is a lure no self-respecting thief can resist. Inspector Zenigata, who has abandoned the world and entered a monastery believing Lupin was dead, regains his old *joie de vivre* when he learns that he can return to his life's work — the pursuit of the master thief who is his nemesis. The plot is well worked out, the music beautiful and the characterisations marvellous. Buy it, it's worth it. The US version's English subtitles are superior to those of the UK release. ★★★★

MIDSUMMER NIGHT'S DREAM
(Eng trans for MANATSU NO YO NO YUME)

JAPANESE CREDITS: © Tokyo Hall. 75 mins. CATEGORIES: P

Said to be a reworking of Shakespeare's classic play.

PROGOLFER SARU — KOGA SECRET ZONE: LAUGHING NINJA GOLFER
(Eng trans for PROGOLFER SARU — KOGA HIKYO KAGE NO NINPO GOLFER SANJO)
JAPANESE CREDITS: Prod: Shin'ei Doga. ©

Fujiko-Fujio, Shin'ei Doga. 75 mins. ORIGINS: Manga by Fujiko-Fujio; 1982 TV special; 1985 TV series; 1986 movie. CATEGORIES: N, DD

More fantasy golfing adventures for the lone sportsman.

SAINT SEIYA

JAPANESE CREDITS: Dir: Kozo Morishita & Masayuki Arehi. Chara des, des & supervision: Shingo Araki & Michi Himeno. Prod: Toei Doga. © M. Kurumada, Shueisha, Toei Doga. 45 mins. ORIGINS: Manga by Masami Kurumada, pub Shueisha; 1986 TV series, which ran until 1989. CATEGORIES: DD, A

The story of Seiya and his companions, youthful guardians of the Earthly incarnation of the Goddess Athena, and the machinations of those who sought to use her power for their own ends, or overthrow her and seize power themselves. This is thought by many to be the archetypal 'mystic warrior' series — a group of young men studying the martial arts, but calling on powers which are not of this world to serve good and fight evil. The protagonists are ordinary, imperfect teenagers, but each possesses some special quality which, provided he learns to work as part of the team, is essential to help them achieve all their objectives. Some such sagas use Japanese history or legend as a base, others raid mythology from other parts of the world for names and influences. In this film, the source is ancient Greece. The infant school teacher Eris sees a glowing object fall from the sky one night. It's a golden apple in which is trapped the spirit of the Goddess of Discord whose name she bears. Possessing her namesake's body, the Goddess Eris sets out to capture Saori, the incarnation of Athena. Seiya and the other Saints of Athena must foil her and safeguard their Goddess, despite the opposition of Eris' fearsome warriors, the Ghost Five. A fantasy with enough young men in short skirts to remake *Jason and the Argonauts*, plus lots of blood, heroics and suffering, this is a good way to decide whether you like *Saint Seiya* enough to try and see the whole series. ★★☆

THE TALE OF GENJI
(Eng trans for GENJI MONOGATARI)

JAPANESE CREDITS: Dir: Gisaburo Sugii. Screenplay: Tomomi Tsutsui. Chara des: Yasuhiro Nakura. Anime dir: Yasuo Maeda.

*Art dir: Mihoko Magori. Music: Harumi
Hosono. Prod: Group Tack. © W. Yamamoto,
Asahi, Nippon Herald, Group Tack. 110 mins.
WESTERN CREDITS: US video release 1995
on Central Park Media, sub, trans Studio
Phoenix.
ORIGINS: Ancient Japanese novel by the
court lady Murasaki Shikibu; manga by
Waki Yamamoto.
POINTS OF INTEREST: Produced to celebrate
the 100th anniversary of the Japanese
newspaper Asahi Shimbun and the 30th
anniversaries of Asahi National
Broadcasting and Nippon Films.
CATEGORIES: P*

The story of the elegant, accomplished and powerful Hikaru Genji, son of the Emperor of Japan, his tragic love for his father's young wife, and his many other loves, is one of the oldest classics of Japanese literature. It is also the source for many other artistic creations like music and Noh plays, and — because this is Japan — manga and anime. If it were written today in the West, this story would be a fat paperback by someone like Danielle Steele or Jackie Collins, and the Genji of Sugii's film would not be at all out of place. He is a thoroughly contemporary hero, angst-ridden and constantly seeking love. By placing the battle for sole possession of Genji's heart at the core of his film, and thus providing a hook for modern audiences, Sugii has been able to take risks with other aspects like the slow pacing and static shot composition. This director doesn't know how to compose a bad frame, and given the beauty of the subject, the result is a series of beautiful, evocative tableaux, whose designs are closely based on traditional art. The visuals are well complemented by an excellent soundtrack and music track and blended into one sleek and gorgeous vision of a man of rare energy and ability caged in a hothouse court, which reflects the hothouse of his own emotions. ★★★☆

TOUCH III: YOU PASS NEARBY
(Eng trans for TOUCH III: KIMI GA TORISUGITA ATO NI)

*JAPANESE CREDITS: Dir: Masamichi
Fujiwara. Prod: Group Tack for Toho. ©
Adachi, Shogakukan, Toho, NTV. 85 mins.
ORIGINS: Mitsuru Adachi's manga; 1985 TV
series; 1986 movies.
CATEGORIES: N*

The third film edited from this popular sports soap series, this sees Tatsuya still coming to terms with his own identity after the death of his twin. Minami has her own problems — should she return to man-

aging the baseball team? New coach Kashiwaba has problems too — he seems to be working out his difficulties with his older brother by driving the team mercilessly and perhaps wrecking their chances of success. Is he out for some strange form of revenge? The story ends as the successful Meisei team leave for Koshien stadium to contest the national schools' baseball championships. Stylishly and simply designed and animated. ★★★?

TREASURE ISLAND
(Eng trans for TAKARAJIMA)

*JAPANESE CREDITS: Prod & © Tokyo Movie
Shinsha. 90 mins.
WESTERN CREDITS: Rumoured to have had
a UK release on a children's video label in
the 1980s, but so far I have been unable to
track down a copy.
ORIGINS: Novel by Robert Louis Stevenson.
CATEGORIES: A, U*

A retelling of the classic novel.

TWILIGHT OF THE COCKROACHES
(Eng trans for GOKIBURI TACHI NO TASOGARE)

*JAPANESE CREDITS: Dir: Hiroaki Yoshida.
Anime des: Hiroshi Kurogane. Music:
Morgan Fischer. Prod: Kitty Film. © TYO
Inc. 105 mins.
WESTERN CREDITS: US video & theatrical
release 1992 on Streamline Pictures, dub,
Eng adaptation Carl Macek.
CATEGORIES: DD, N*

This is a fascinating experiment, not just in mixing live action with animation but in tackling a subject most people in Japan and the West find immensely distasteful — pest infestation — from the viewpoint of the pests. It has been said that Yoshida views the cockroaches as a metaphor for teenagers (parasites who simply want to eat at someone else's expense, make a mess and have an easy life) while the humans stand in for parents (those who end up insisting the parasites clean up or get out); parallels with the Japanese situation at the end of World War Two are also often pointed out. Whatever analogies you choose to read into this story of a small, helpless group facing annihilation at the hands of a much larger, more powerful one, this is an unexpectedly entertaining film. The cockroaches are Disneyesque and charming — if ever an all-live-action version were made, a number of outstanding

beauties would be needed to play the girl roaches and there are some great character parts to tempt Hollywood's finest. Our heroes live with a bachelor whose housekeeping can only be described as casual, and enjoy such peace and plenty that the stories of other roaches from less fortunate communities don't make the impact they should. Some do begin to question whether they should allow themselves to become so dependent on a powerful alien species. Then their human, Mr Saito, finds a girlfriend who's more particular than he is and the situation becomes tense. Eventually the pair declare war on the roaches, and the film skews at breakneck pace from the pure comic spectacle of mankind doing battle against the insects with all the chemical weaponry at its disposal to the heroic defensive actions of our heroes in the face of impossible odds. Roaches have their myths too, and for the few survivors a host of new names have passed into legend at the end of a battle that leaves the community all but destroyed. This film would be completely at home in a TV season of wild Oriental movies, but it's worth seeking out in its own right. Technically, too, it has some interesting moments. ★★★

WINGS OF HONNEAMISE
(Eng title for ONEAMISU NO TSUBASA ORITSU UCHU GUN, lit Wings of Honneamise Royal Space Force, aka STARQUEST)

Wings of Honneamise

JAPANESE CREDITS: Dir & writer: Hiroyuki Yamaga. Chara des: Yoshiyuki Sadamoto. Anime dir: Hideaki Anno, Yuji Moriyama, Fumio Iida & Yoshiyuki Sadamoto. Art dir: Hiromasa Ogura. Music: Ryuichi Sakamoto. Prod: Gainax. © Gainax, Bandai Visual. 120 mins.
WESTERN CREDITS: US & UK video release 1994 & 1995 by Manga Entertainment, sub & dub. An attempted rape scene is cut from the UK version.
POINTS OF INTEREST: The first film from Gainax, who also made the OAVs Otaku No Video, the TV series The Secret of Blue Water and, most recently, the TV series Evangelion. An earlier version of this film, freely translated and edited and entitled Starquest, was produced by Go East Film for a US première in 1987 and shown once only.
CATEGORIES: SF, X

Its eight-billion yen budget was the biggest ever for an anime film. The talented young team met while working on *Macross* in 1982 and by the summer of 1984 were discussing their own production. A ten-minute pilot was pitched to Bandai in 1985 and *Wings of Honneamise* was the result. Its length, relatively slow pace and attention to minute detail may seem to some the antithesis of *Akira*, which followed a year later and was the first film to break anime into the mass entertainment market in the UK and USA, but in my opinion it is the better film. Whereas Otomo's dazzling, assured box of tricks condenses and reconfigures the complex story of his manga in the interests of a slam-bang tour of the blind alleys of modern civilisation, Yamaga's script — an astonishing achievement for a writer of twenty-three — examines in detail the development of a young man's spiritual and political awareness against a background of everyday life on which the huge events of the story impinge only marginally. The story is complex, but its gradual development lets us take it in gently. A young man in a small, backward country threatened by big, rich neighbours — almost a Third World state, if this were our world — volunteers for his nation's half-hearted, much-mocked 'space programme' and realises his childhood dream of flight. In so doing, he loses his naïvety while somehow managing to keep much of his innocence, and starts to look for the meaning of his own soul. The world-building of the design and animation team is so precise and so perfect that it almost escapes our notice, yet creates a convincingly alien milieu for characters to whom we can easily relate. It thus echoes the whole thrust of the film — things are not always as they seem and you have to examine them closely to find out what's really valuable and

what is simply fake. If you don't start out on that journey of discovery, you will never be truly human. It is rare indeed that a film as beautifully crafted in every respect is still as memorable for its script and story as for the many, many breathtaking or intriguing moments which catch the eye onscreen. A fabulous achievement which has rarely been equalled on film. ★★★★★

OAVS

BATTLE ROYAL HIGH SCHOOL
(Eng title for SHINMAJINDEN BATTLE ROYAL HIGH SCHOOL, lit New Warlock Legend Battle Royal High School)

JAPANESE CREDITS: Dir: Ichiro Itano. Chara des: Nobuteru Yuki. Prod: Yoshiyuki Sadamoto. Prod co: DAST. © Tokuma Japan. 60 mins.
ORIGINS: Novel by Hideyuki Kikuchi, comic pub Monthly Shonen Captain.
POINTS OF INTEREST: Aside from the presence of heavyweights Yuki (Record of Lodoss War, Five Star Stories) and Sadamoto (Wings of Honneamise), fellow-Honneamise worker Hideaki Anno was also involved in the production in an advisory capacity.
CATEGORIES: H

A tale of demonic possession in an everyday Japanese high school, but this time revolving around martial arts rather than tentacle rape. Byodo, a magician from another dimension, controls the mind of karate kid Ricky Hyodo. His rival, Kain, takes over Ricky's classmate Yuki Toshihiro, planning to use Yuki to vanquish Ricky and thus Byodo. Yuki thinks all this ought to stop and so does Space Inspector Zankan. 'A story of blood-soaked violence' said the Japanese promotional material. ★★

BLACK MAGIC M-66

JAPANESE CREDITS: Dir, screenplay & original story: Masamune Shirow. Dir & chara des: Hiroyuki Kitakubo. Mecha dir: Toru Yoshida. Anime dir: Takayuki Sawaura. Music: Yoshihiro Katayama. Prod: Animate Film. © Shirow, Seishinsha, MOVIC, Bandai. 48 mins.
WESTERN CREDITS: US video release 1993 on US Renditions, sub & dub, trans Toshifumi Yoshida & Trish Ledoux; UK video release 1994 on Kiseki Films, sub & dub.
ORIGINS: Loosely based on the manga of the same name by Masamune Shirow.
CATEGORIES: SF

Shirow is one of the darlings of Western manga and anime fandom, and although M66 can only be described as an extremely free rendering of his manga — different story, different characters — it's very much in his spirit of intelligent scepticism towards government and science. In an ordinary modern city, hostilities with neighbouring states and terrorists are part of everyday life. When freelance reporter Sybell gets a lead on the scoop of a lifetime, she learns that things are not always as they seem, or even as they are finally reported. Two military robots have been 'lost' in a plane crash; one is destroyed with much loss of life, the other heads off in pursuit of the target set in its test programme — its creator's teenage granddaughter. Once Sybell finds out about this, things change from the simple pursuit of a scoop at all costs to a desperate race to save the girl, and the story takes off into one of the tensest, best paced and plotted action-adventure finales I've ever seen. The debt to *Alien* and Sigourney Weaver is obvious, as is that to *The Terminator* and Mary Shelley, but this is more than merely derivative. The innocent appearance of the M-66, a jointed doll simply doing what it was made for by its victim's own bloodline, reinforces the underlying message about our responsibility for what we make — and, as it turns out, for what is done in our name by those we appoint. ★★★★

BOMBER BIKERS OF SHONAN 2 1/5 LONELY NIGHT
(Eng title for SHONAN BAKUSOZOKU 2 1/5 LONELY NIGHT, lit Wild Explosive Motorbike Gang from Shonan 2 1/5 — Lonely Night)

JAPANESE CREDITS: Prod: Toei Doga. © Toei Video. 50 mins.
ORIGINS: Manga by Satoshi Yoshida, pub Shonen Gohosha; 1986 OAV.
CATEGORIES: N, R

Also:
BOMBER BIKERS OF SHONAN 3 THE TEN OUNCE LINK
(Eng title for SHONAN BAKUSOZOKU 3 JUONSU NO KIZUNA, lit Wild Explosive Motorbike Gang from Shonan 3 — The Ten Ounce Link)

JAPANESE CREDITS, ORIGINS, CATEGORIES: As above except: 52 mins.

More stories of the 'Shobaku' gang, Part II chronicling the trials and tribulations, doubts and indecisions and plain ham-handedness of Yoshimi's courtship of Nagisa. Charming, soft-hearted stuff. Part III is a wee bit harder, as boxer Kondo causes trouble for Shobaku. ★★★?

BUBBLEGUM CRISIS 1: TINSEL CITY

JAPANESE CREDITS: Dir: Katsuhito Akiyama. Screenplay: Kenichi Matsuzaki, Hideki Kakinuma, Shinji Aramaki & Katsuhito Akiyama. Chara des: Kenichi Sonoda. Music: Kaouji Makaino. Prod: AIC, Artmic. © Artmic, Youmex. 53 mins.
WESTERN CREDITS: US video release 1993 on AnimEigo; UK video release 1993 on Anime Projects, sub & dub, trans Michael House & Shin Kurokawa.
ORIGINS: Original idea by Toshimichi Suzuki.
POINTS OF INTEREST: Kenichi Sonoda's chara designs remain among anime fandom's biggest favourites. AIC are currently (early 1996) asking fan opinion and input via the Internet as to further Bubblegum Crisis adventures.
CATEGORIES: SF

Also:
BUBBLEGUM CRISIS 2: BORN TO KILL

CREDITS, ORIGINS, CATEGORIES: As above except: Screenplay: Katsuhito Akiyama. 30 mins.

Also:
BUBBLEGUM CRISIS 3: BLOW UP

CREDITS, ORIGINS, CATEGORIES: As above except: 30 mins.

MegaTokyo, 2032: the city has struggled to rebuild itself after a terrible earthquake and in the aftermath the GENOM Corporation has become a major force, owning most of MegaTokyo and with ambitions to go much, much further. Sylia Stingray is the daughter of a brilliant scientist who worked for GENOM before his unexplained death and who has left her a strange legacy along with vast wealth to carry out his final wishes. On the surface she's a quiet, refined businesswoman living with her younger brother, Mackie. Priss Asagiri is a wannabe rock star, singing with a band called the Replicants; Linna Yamazaki is a wannabe entertainer and gym instructor; and Nene Romanova is a school drop-out, teenage run-

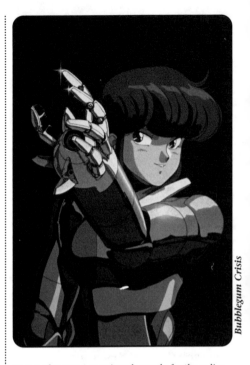

Bubblegum Crisis

away and computer genius who works for the police. Like Sylia, all of them have a secret life. They are the Knight Sabers, a team of vigilantes in way-beyond-the-state-of-the-art body armour, who appear from nowhere to fight the latest threat to MegaTokyo's security, the wave of crime by biomechanical creatures called Buma. With a cocktail of influences from anime's Holy Trinity of contemporary Western idols — *Blade Runner*, *The Terminator* and *Alien* — a driving pop/rock score, and a script which gives each protagonist a real and engaging personality with a blend of problems, ideals and dreams with which many cultures can identify, *Bubblegum Crisis* had a rapid ride to success. Almost a decade after its appearance it remains not simply a huge fan favourite but a genuinely enjoyable show. ★★★★

CIRCUIT ANGEL: DETERMINATION'S STARTING GRID
(Eng trans for CIRCUIT ANGEL KETSUI NO STARTING GRID)

JAPANESE CREDITS: Prod: Studio Unicorn. © TDK Core. 45 mins.
CATEGORIES: N, R

Determined to become a motorbike champion, Sho accidentally injures Mariko's boyfriend during a

race. This doesn't please either Mariko, who vows revenge, or the trainer, Nagase, who is very fond of her. With his help, she decides to avenge her love by taking his place on the starting grid and trains hard for victory.

CRYSTAL TRIANGLE
(Eng title for KINDAN NO INOKU SHIROKU CRYSTAL TRIANGLE, lit Forbidden Apocalypse Crystal Triangle)

JAPANESE CREDITS: Screenplay: Junki Takegami. Chara des: Toyo'o Ashida, Kazuko Tadano & Mandrill Club. Anime dir: Kazuko Tadano. Art dir: Masazumi Matsumia. Prod: Yasuhisa Kazama, Nagateru Kato & Yukio Nagasaki. Prod co: Animate. © MOVIC, Sony Video Soft. 86 mins.
WESTERN CREDITS: US video release 1992 on US Manga Corps label, sub, trans Neil Nadelman.
CATEGORIES: SF, X

Archaeologist Koichiro Kamishiro has been researching an ancient book of prophecy. However, as so often with research, at the start one has no idea of the strange places it could lead to. KGB, CIA, yakuza and Buddhist monks are all on it too, hoping that it will lead them to the fabled Mirror of God. What they find is an alien artefact which may be as old as the meteor that finished off the dinosaurs — a buried ship with one alien still aboard. ★★☆

DANGAIO
(Eng title for HAJATAISEI DANGAIO, lit Dangaio, Giant Star Warrior)

JAPANESE CREDITS: Dir & chara des: Toshihiro Hirano. Screenplay: Noboru Aikawa. Mecha des: Shoji Kawamori, Yasushi Ishizu & Masami Obari. Anime dir: Kenichi Onuki. Art dir: Kazuhiro Arai. Prod: AIC. © AIC, Bandai/Emotion. 45 mins.
WESTERN CREDITS: US video release in full on US Renditions, 1990 & 1993, sub, Eng trans Deborah Grant; edited to form the first 10 mins of Manga Video's UK release of Dangaio, 1995.
POINTS OF INTEREST: Made as a homage to the giant robot team shows of the seventies.
CATEGORIES: SF

Mia Alice, Pai Thunder, Lamda Nome and Roll Kuran are four teenagers with extraordinary psy-

chic powers, all abducted and brainwashed by Professor Tarsan and forced to train as warriors. The evil of the pirate Galimos must be fought, but even so the four rebel against Tarsan's high-handedness. However, they forge into a team in time to pilot the mighty robot Dangaio against the fearsome Blood-D1 piloted by Galimos' man, Gil Berg. Affectionately conceived but scarcely up to the weight of its mighty forebears, the edit available in the UK does this episode no justice. ★★

DEAD HEAT

JAPANESE CREDITS: Prod: Nippon Sunrise for CIC Victor. © Sunrise, Nihon AVC. 25 mins.
CATEGORIES: SF

Motocross in the twenty-first century, using motobikes which convert to full body armour in place of Formula 1 cars. The twist, apparently, is that this is very much a full contact sport.

DEVILMAN: THE BIRTH
(Eng trans for DEVILMAN TANJO HEN, aka DEVILMAN: GENESIS)

JAPANESE CREDITS: Dir & screenplay: Tsutomo Ida. Screenplay supervisor: Go Nagai. Chara des: Kazuo Komatsubara. Music: Kenji Kawai. Prod: O Production for King Record. © Dynamic Planning, Kodansha, Bandai Visual. 55 mins.
WESTERN CREDITS: UK video release 1994 on Manga Video, dub; US video release 1995 on US Renditions, sub, as Devilman: Genesis, and on Manga Video, dub.
ORIGINS: Manga by Go Nagai; 1972 TV series.
POINTS OF INTEREST: The UK dub uses a large amount of profane language.
CATEGORIES: H, X

Sixteen years on, Go Nagai's favourite character is reborn in what was planned as part one of a trilogy. Part two didn't appear until 1990 and part three is still awaited. Naturally, in sixteen years some changes in the look of the character were inevitable. Kazuo Komatsubara's chara designs move Devilman and his human alter ego, Akira Fudo, into new territory, updating the superhero-in-spandex look of Nagai's original into something raw, powerful and very sexy, which is totally in keeping with the spirit of the master's original creation. The story has also been updated and in some respects rather toned down — both in this and the

second chapter, the overtones of sexual attraction in the relationship between Akira and his friend Ryo, and Ryo's own hidden demonic ancestry, are missing. However, there's plenty left — Ryo's father has discovered a horrible secret and Ryo turns to his old friend for help. Akira is transformed from a mild-mannered teenager who likes bunny rabbits to a raging demon with a mission to protect mankind and an unashamed enjoyment of bloodshed. A powerful revision of an original concept from a man who enjoys doing horror, and does it very well. ★★★

DIGITAL DEVIL STORY — GODDESS REBORN
(Eng trans for DIGITAL DEVIL MONOGATARI MEGAMI TENSEI)

JAPANESE CREDITS: Dir & screenplay: Mizuho Nishikubo. Music: Usagi-gumi. Prod: Animate. © Tokuma Shoten, Animate. 45 mins. WESTERN CREDITS: UK video release 1996 on Kiseki Films, sub. ORIGINS: Based on a novel by Aya Nishitani, pub Tokuma Shoten. CATEGORIES: DD, H

Akemi, a computer geek who's much too bright for his own good and has no conscience, uses the school's extremely well-equipped computer centre to call up a 'digital devil', Loki. The demon is unleashed from the machine with the co-operation of one of his teachers, a strange young woman who fancies Loki like mad, but the whole school is also in on the experiment with the exception of one new girl, Yumiko, who finds it all confusing and terrifying. An orgy of blood and violence follows Loki's unleashing. The boy who started it all is horrified and barely escapes with the new girl, to discover that she is really the reincarnation of an ancient spirit of goodness. His only chance to save the world — and his own skin — is to get her to an ancient tomb. The digital demon, able to move through any computer system, starts to cause havoc (beginning in the local bank) with the help of the besotted teacher. Then the action takes off into another dimension as the runaways fight back. It's disjointed, poorly structured and not very good. ★

DIRTY PAIR: FROM LOVELY ANGELS WITH LOVE
(Eng trans for DIRTY PAIR LOVELY ANGELS YORI AI KOMETE)

JAPANESE CREDITS: Prod: Nippon Sunrise

for VAP Video. © Takachiho, Gakken, NHK. 50 mins. ORIGINS: Novels by Haruka Takachiho; appearance in 1983 movie Crushers; 1985 TV series & OAV; 1987 movie. CATEGORIES: SF

The 1985 TV series had such limited success that the last two episodes were not aired. This video brought them to the Japanese public for the first time. Like *Star Trek*, whose success and reputation grew from a relatively unsuccessful TV début, the Pair had begun to win friends and influence people, helped by the popularity of the much grittier, less comic version of their adventures showcased in *Affair on Nolandia*. These two episodes, while still in wacky mode, did well enough for the twenty-four screened episodes to get a video release from VAP on eight compilation tapes. The rest, as they say, is history. In the first of the two unscreened episodes, the pursuit of currency counterfeiters takes the Pair to a remote house, a strange family and a fight with a cyborg straight out of *The Terminator*; in episode two, a very important hostage is being held in 3WA's experimental arms laboratory, and Kei and Yuri have to effect a rescue on their own home turf. The difference, not just in mood and pace but in design and overall style, between these episodes and *Project Eden* and *Affair on Nolandia* is interesting. ★★★

Also:
DIRTY PAIR I
(Eng ep titles: Prison Revolt! We Hate Stubborn People and Count Us Out! Ultimate Hallowe'en Party)

JAPANESE CREDITS: Prod: Nippon Sunrise. © Takachiho, Studio Nue, Sunrise, VAP Video. Each 25 mins. ORIGINS, CATEGORIES: As above.

The success of the films and video release of the TV series was followed up by this OAV series — ten episodes on five tapes, of which this is the first. (I understand from Fred Patten that the main reason for this was that Italian network RAI were interested in buying the series for TV screening, but only if Sunrise could provide at least thirty-five episodes.) In episode one, a prison director is held hostage on planet Karos and the Pair have to get him out alive. Episode two has one of their best loved excursions as, on a Hallowe'en night when every crook in town thinks it's cute to work in fancy dress, a rogue robot with zero sense of responsibility goes on the run with Kei and Yuri in pursuit. That makes three of them, and the fireworks are spectacular. ★★★☆

DREAM HUNTER REM III: FANTASTIC LEGEND OF THE HEADLESS WARRIOR
(Eng trans for DREAM HUNTER REM III MUINKUBANASHI MUSHA DENSETSU)

JAPANESE CREDITS: Prod: Project Team Eikyu. © King Record. 60 mins.
ORIGINS: 1985 & 1986 OAVs.
CATEGORIES: DD, H

A headless ghost is haunting the village of Muimura: the ghost of Tomomori Taira, treacherously beheaded there many years ago. The villagers have tried all kinds of things to appease him, including making a doll in the likeness of his fiancée and placing it in the local temple. The ghost gets even more peeved when the doll is spirited away, and Rem has to fight him. ★★☆?

DREAMING GENTLEMAN TEMPESTUOUS ADVENTURE CHAPTER
(Eng trans for MUGEN SHINSHI BOKEN KATSUGEKI HEN)

JAPANESE CREDITS: Prod: Picture Kobo. © T. Moriyama, Studio Gallopp, Network. 49 mins.
ORIGINS: Manga by T. Moriyama.
POINTS OF INTEREST: Mugen (dreaming) is also the name of the hero.
CATEGORIES: DD, M

Young women are being kidnapped — five so far, the last being the beautiful ballerina Atsuko Fukuin. Mamiya Mugen is a young investigator who suspects that a criminal organisation is behind the spate of abductions and that the next victim will be pianist Sakurako Satomi. There's more behind the whole story than meets the eye, though — a fantastic machine which can bring the dead to life, but which needs the energy of young lives as fuel. Can Mugen save Sakurako? ★★☆?

ELF 17

JAPANESE CREDITS: Prod: Agent 21. © Toei. 30 mins.
ORIGINS: Manga by Atuzi Yamamoto.
CATEGORIES: DD? SF? C

I have very little information on this, though the manga is obviously comedic. Prince Masked Tyler decides to make a voyage across the Milky Way and holds a competition to choose two companions to act as his guards. He picks the girl Lu and the massive zealot K.K., both powerful fighters.

FLASHBACK 2012
(Eng title for CHOJIKU YOSAI MACROSS FLASHBACK 2012, lit Super Dimensional Fortress Macross Flashback 2012)

JAPANESE CREDITS: Dir & mecha des: Shoji Kawamori. Chara des: Haruhiko Mikimoto. Prod: Tatsunoko. © Big West, Bandai, Tatsunoko. 30 mins.
ORIGINS: 1982 Macross TV series; 1984 movie Macross: Do You Remember Love?
CATEGORIES: SF, R

Presented as a music video looking back over Lynn Minmay's singing career, and including eight minutes of previously unseen footage (some cut from the final edit of *Macross: Do You Remember Love?*, some newly shot for this video) showing events from the characters' lives after the end of the series. It also features Shoji Kawamori's magnificent designs for the huge space fortress *Megaroad*, successor to the SDF-1. Many of the Chinese singing star's best loved songs are here in a dazzling concert presentation, compiled from the new footage, TV series and movie, and voice actress and singer Mari Iijima is on strong form. Idol singing at its best. ★★★

GALL FORCE II: DESTRUCTION

JAPANESE CREDITS: Dir: Katsuhito Akiyama. Story & screenplay: Hideki Kakinuma. Chara des: Kenichi Sonoda. Music: Ichizo Seo. Prod: Artmic, AIC. © MOVIC, Sony Video Soft. 50 mins.
WESTERN CREDITS: US video release 1993 on US Manga Corps, sub, trans Neil Nadelman.
ORIGINS: Original story by Hideki Kakinuma; 1986 movie.
CATEGORIES: SF

The Fighting Gallant Girls, as Sonoda's team of cuties were christened, struck a chord in the anime fan world. The first team might have been destroyed but, as any SF movie fan will tell you, total destruction is no barrier to a sequel. Lufy is found floating in suspended animation (you see, she didn't die after all!) by the crew of the *Lorelei*, two of whom, Shildy and Spea, revive her. Most of the crew are androids and one is identical to Catty from the *Starleaf*; she tells Lufy that there are lots of her, based on the commander of the Elite Intelligence Agency, who is a prime mover in the Plan for Unification of the

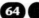

Species. Now the *Lorelei* is *en route* to see if the Plan is working. Meanwhile, the half-Paranoid, half-Solnoid child born to Patty and his mate, *Starleaf* survivor Rumy, are slowly starting to repopulate their planet with the new, unified species. But the war is still raging and a new threat may destroy the whole Unification Plan. A good SF story with attractive chara designs from Sonoda. ★★★

GOD BLESS DANCOUGAR
(Eng title for CHOJU KISHIN DANCOUGAR GOD BLESS DANCOUGAR, lit Super Bestial Machine God Dancougar God Bless Dancougar)

JAPANESE CREDITS: Dir: Kenichi Ohnuki. Prod: Ashi. © Ashi, Toho. 80 mins. WESTERN CREDITS: UK video release 1995 on Western Connection, sub. ORIGINS: 1985 TV series; 1986 OAV. CATEGORIES: SF

It's been a year since the 'end' of the conflict with the Zolubados Empire. There is still unrest, but Earth is slowly rebuilding and the members of the Beast Machine God Corps are all back on their old tracks. Shinobu is preparing for his next concert (presented as part of the story, a mini-pop video with incongruous songs), Sara is a model, Ryu is in the military as a trainer and Masato is back in cadet school. His girlfriend Laura, who was involved in the war along with the team, dreams of another terrible threat, and sure enough a giant robot appears in the centre of town. The four Dancougar pilots move to meet it, but when it self-destructs they are arrested and convicted for the deaths and damage caused in the incident. How can they clear their names and get out of jail in time to defend Earth from the threat they know is coming, in an atmosphere of ever-increasing tension and repression? ★★☆

GOOD MORNING ALTHEA

JAPANESE CREDITS: Prod: Animate. © Bandai, Animate. 50 mins. CATEGORIES: SF

During the war between Earth's army and the planet Stemma, the automated weapon known as Automaton was lost, but it's still able to function, even though the conflict is over. Three brave young people decide to find and destroy it.

GREY DIGITAL TARGET

JAPANESE CREDITS: Dir: Tetsu Dezaki.

Screenplay: Yasushi Hirano, Kazumi Koide & Tetsu Dezaki. Music: Goro Omi. Prod: Ashi. © Y. Tagami, Tokuma Shoten. 80 mins. WESTERN CREDITS: UK video release 1994 on Western Connection, sub, trans Jonathan Clements. ORIGINS: Yoshihisa Tagami's manga, pub Tokuma Shoten, trans pub US Viz Communications, 1988-9. CATEGORIES: SF

The manga is a bleak, ultimately nihilistic story of the effects of urban civilisation and political corruption, and the anime echoes its cold tones. Set in the twenty-sixth century, *Grey Digital Target* shows the human race still divided by classes, and only the upper class, Citizens, live in comfort. The lower orders scrape an existence in bleak ghettoes from which the only escape is to enrol in the armed forces and work your way up from the lowest class grunt — F — to class A, and Citizenship, by accumulating points for kills, turning war into a cross between social climbing and video game. At first the eponymous central character is content to live in the ghetto with his girl, but she wants more. She joins up, and her death leads him down the same path. Ironically, since he seems to care for nothing, including his own life, he scales the ranks rapidly, walking away from every dangerous engagement, often as sole survivor. Eventually he has survived long enough and seen enough death to meet people, make connections and begin to question the reason behind the endless war. This makes him even more dangerous than before. *Grey* is not just about man's inhumanity to man, but about our own responsibility; about blind, unquestioning acceptance of the status quo and reliance on something else — government, technology or God — to solve all our problems. It is bleak, cold and questioning, and, as befits such an intelligent storyline, its animation and design is minimal but very elegant. ★★★☆

HEAVY METAL L-GAIM III FULL METAL SOLDIER

JAPANESE CREDITS: Dir & writer: Yoshiyuki Tomino. Writer, chara des & mecha des: Mamoru Nagano. Prod: Nippon Sunrise. © Bandai, Sotsu Agency, Sunrise. 55 mins. ORIGINS: 1984 TV series. POINTS OF INTEREST: This series was the jumping-off point for Nagano's later manga and subsequent mecha movie The Five Star Stories, which is very similar in design concept. CATEGORIES: SF

Continues the story of the rebels of planet Pentagona from the series. The young hero Daba Mylord, pilot of the giant robot *L-Gaim*, and his companions, continue to fight against the evil ruler Oldona Poseidal. The mecha of *L-Gaim* are known as Heavy Metals, or HMs, hence the title. Another chance to see one of Japan's wildest talents at work in Nagano's unique designs. ★★?

HELL TARGET

JAPANESE CREDITS: Prod: Nakamura. © Victor. 50 mins.
CATEGORIES: SF, H

A spaceship is lost near planet Inferno II. Some years later, a second ship with a crew of nine gets there and encounters a monster that rapidly makes mincemeat of most of them. Then a message indicates a third ship is on the way. The sole survivor, Makuro Kitazato, must face the monster alone, knowing that unless he defeats it the next ship will be at its mercy.

ICZER-ONE ACT III
(Eng title for TATAKAE! ICZER-ONE ACT III KANKETSUHEN, lit Fight! Iczer-One Act III Final Chapter)

JAPANESE CREDITS: Dir, writer & chara des: Toshihiro Hirano. Mecha des: Hiroaki Motoigi & Shinji Aramaki. Anime dir: Narumi Kakinouchi, Masami Obari & Hiroaki Ogami. Art dir: Yasushi Nakamura & Kazuhiro Arai. Music: Michiaki Watanabe. Prod: AIC. © Kubo Shoten, AIC. c48 mins.
WESTERN CREDITS: US video release 1992 on US Renditions, dub, trans Trish Ledoux & Toshifumi Yoshida.
ORIGINS: 1985 & 1986 OAVs.
POINTS OF INTEREST: The Cthulhu are sometimes transliterated as the 'Cutowolf', which disguises the links with Lovecraft's formless horrors from beyond the dimensions.
CATEGORIES: H, SF

Iczer-Two takes over Nagisa's mind and carries her off to the alien ship. Iczer-One comes to get her back and faces terrific opposition from monsters and her clone sister, who taunts her that she will bring her own former partner to kill her. In an intensely touching scene, Nagisa breaks Iczer-Two's mind control and begs Iczer-One to kill her instead, so that she can go on to save the world from the terrible fate the demonic Big Gold has in store for it. But a remarkable

thing happens — Nagisa's courage and sacrifice make it possible for her to truly merge with Iczer-One, so that at last they are the fighting unit they were fated to be. Iczer-One wields the combined strength of her alien origins and Nagisa's human heart. When the Cthulhu are finally set free of Big Gold's evil influence and set off once more to seek a new home, Iczer-One must watch over them and protect them. Before leaving Earth she turns back time to the morning before all the trouble began, when Nagisa first glimpsed her sitting in a tree, so that the human girl will forget all that has passed between them, but will have her life back, untroubled by evil. Emotionally charged, some would say overwrought, but powerful drama is perfectly conveyed by the animation style and colour palette, which reflects the mood of each scene admirably. The evil aliens are also all memorably nasty, the messy tentacled ones in particular showing the Lovecraft influence. ★★★

Also:
ICZER-ONE SPECIAL
(Eng title for TATAKAE! ICZER-ONE TOKUBETSU HEN, lit Fight! Iczer-One Special Chapter)

CREDITS, ORIGINS, CATEGORIES: As above except: 100 mins. No English version.

An edited version of the whole story of all three OAVs, with additional footage at the beginning,

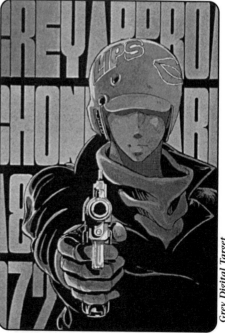

Grey Digital Target

plus a 'making of' special on recording the sound-track with footage of the voice actresses. ★★★

LADIUS
(Eng title for MAKYO GAIDEN LE DEUS, lit Demon Frontier Legend Le Deus)

JAPANESE CREDITS: Dir: Hiroshi Negishi. Music: Hiroyuki Namba. Prod: Ashi Pro. © Toho Video. 48 mins.
WESTERN CREDITS: UK video release 1995 on Western Connection as Ladius, sub, trans Jonathan Clements.
POINTS OF INTEREST: Hiroshi Negishi went on to direct eco-comedy OAV KO Century Beast Warriors; Hiroyuki Namba later produced the music for Armitage III.
CATEGORIES: DD

An elegantly designed and crisply painted anime that can't quite decide where it's going; is it a fantasy, a giant robot story, a team show first episode or an ecological homily? It looks gorgeous, but doesn't quite live up to its image. The team are handsome young devil Randall, a bit of a rebel but brave and honest; voluptuous twins Spika and Seneca; and their new recruit Yuta, who is not at all keen to join them at first. She's persuaded to

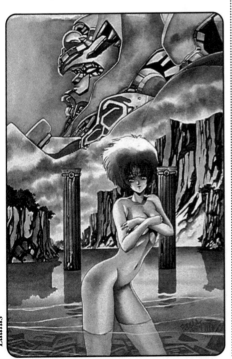

Ladius

change her mind after being abducted by the Demstar group, who, like Randall, are after a limit-less energy source to which Yuta holds the key. The fantasy comes in the D & D-type tavern and the scenario of a post-industrial, neo-feudal society looking for a new energy source. And the giant robot? Well, it sort of pops up out of the blue, but it's very nice looking and packs a good wallop. There's a tavern fight. There are swimming scenes. There's a robot. What do you mean, there's no particular story? A pretty ★★

LEGEND OF THE OVERFIEND I
(Partial Eng trans for CHOJIN DENSETSU UROTSUKIDOJI, lit Legend of the Overfiend — The Wandering Kid, US aka UROTSUKIDOJI PERFECT COLLECTION, Eng ep title BIRTH OF THE OVERFIEND, aka WANDERING KID)

JAPANESE CREDITS: Dir: Hideki Takayama. Screenplay: Noboru Aikawa & Goro Sanyo. Music: Masamichi Amano. Prod: JAVN, Angel. © T. Maeda, Westcape Corp. c45 mins.
WESTERN CREDITS: Legend of the Overfiend, edited movie version of OAVs 1-3, dub, UK video release 1993 on Manga Video; US video release 1993 on Anime 18, dub, screenplay: Noboru Aikawa & Michael Lawrence. Prod: Angel; Urotsukidoji Perfect Collection, Legend of the Overfiend OAVs I-V, unedited US video release 1994 on Anime 18, sub.
ORIGINS: Manga by Toshio Maeda.
CATEGORIES: H, V, X

This OAV series, in its movie form the *bête noire* of the early British anime market, gained an infamous reputation, mostly from reviewers and moral commentators who, even if they have troubled to do more than read the sensationalist press releases, have no understanding of its source manga, background or context. The UK releases from Manga Video were edited for theatrical release in Japan from the OAVs and somewhat toned down in the process, a process continued by British censors who have removed the most 'shocking' material. They also lost a good deal of their story continuity, and the patches and seams of the edit necessarily show to disadvantage. The US boxed set release gives the full, uncut five-OAV original version in subtitled format. The story is a standard apocalypse, made outstanding in Western eyes by the amount of gore and sexual violence contained therein. Every 3000 years a 'Chojin' arises to unite the three realms of existence — human, Makai or demon, and Jyujinkai or man-beast — into one. Amanojaku of the

Jyujinkai and his sister Megumi are seeking the Chojin. They are convinced it is the popular human high school sports ace Ozaki of Myojin High School. In the beginning, they seem to take their quest fairly lightly. Akemi, a beautiful student, is being watched and adored by Nagumo, the no-hoper who secretly fancies her. When one of the teachers transforms into a demon and attacks her, Amano leaps to the rescue, but she thinks she's been saved by Nagumo and romance blossoms. Ozaki does indeed transform into a demon, but Amano trashes him and so comes to think that the Chojin must be Nagumo. The episode ends in a violent climax with a hospital torn apart by a demon with multiple, infinitely extensible tentacles. There are a number of very violent rape scenes, nobody dies tidily and the overall impression is one of shuddering revulsion at a world run out of control. Teenage romance of the soppiest sort is overwhelmed by horror and every decent instinct finds itself powerless and irrelevant against the naked might which comes to crush it. The fact that that's probably a pretty fair summing up of events and circumstances in even a minor, local apocalypse — and if you don't believe me, ask the people of My Lai, or Sarajevo, or Rwanda, where there isn't even the excuse of demonic intervention — seems to have been cast aside in the babble of outrage; but *Legend of the Overfiend* is worthy of more serious consideration. The backgrounds are often spectacularly well painted, the animation isn't bad — before it was patched for theatrical release, that is — and the story (again pre-edit) has an epic sweep of grandeur. It's punctuated by scenes of romance which may seem absurd to Western eyes, but are perfectly natural in the culture for which it was made, and as such lend poignancy to the terrible situation in which the characters will shortly find themselves. Maeda wasn't even born when the Enola Gay dropped her cargo over Hiroshima, but his work does a good job of recording the mythic resonances of that fall and its effects on popular culture, and director Takayama keeps faith with him. If nothing else, this is the film that once and for all convinced the West that some cartoons should be kept away from kids. A flawed but magnificent ★★★

LILY-C.A.T.

JAPANESE CREDITS: Dir: Hisayuki Toriumi. Screenplay: Hiroyuki Hoshiyama. Chara des: Yasuomi Umetsu. Mecha des: Yusuhiro Moriki. Monster des: Yoshitaka Amano. Anime dir: Toshiyasu Okada. Music: Akira Inoue. Prod: Studio Pierrot. © Victor Music.

70 mins.
WESTERN CREDITS: US video release 1994 on Streamline Pictures, dub, Eng dialogue Greg Snegoff.
CATEGORIES: SF, H

The spaceship *Saldes* is heading for planet L.A.O.3, carrying seven passengers. Not all of them are on the right side of the law; not all of them are being totally open about their backgrounds and motives; but all of them, and the six crew members, are in deadly danger. Death is stalking the ship, and no one can work out what's killing the thirteen travellers one by one, or why — or who will be the next to die! What does Lily, the pet cat of passenger Nancy, have to do with the ship's computer? Another take on the *Alien* scenario so beloved of anime scriptwriters. ★★☆

MADOX-01
(Eng title for METAL SKIN PANIC MADOX-01)

JAPANESE CREDITS: Dir & story: Noboyuki Aramaki. Chara des: Hideki Tamura. Mecha des: Noboyuki Aramaki & Kimitoshi Yumane. Prod: AIC. © Fujisankei. 50 mins.
WESTERN CREDITS: US video release 1990 on AnimEigo, sub, the first release on the label, & 1994, dub; UK video release 1995 on Manga Video, dub.
CATEGORIES: SF, A

Koji has a date with his girlfriend Shiori. Koji doesn't want to be late, because if he is, she'll be really, really mad. But when the military are testing out a new mobile armour, there are those for and against its use. Egos get involved, and Koji just gets caught in the middle and finds himself in possession of the latest state-of-the-art armour and the target of a massive operation to find it again. So what can he do? He has just one priority: to stay alive so as not to be late for his date. This is a light-hearted action adventure that sends up the whole mobile armour genre from a range of everyday contemporary viewpoints. ★★★

MAGICAL GIRLS CLUB FOURSOME: ALIEN X FROM SPACE A
(Eng trans for MAJOKKO CLUB YONINGUMI A KUKAN KARA NO ALIEN X)

JAPANESE CREDITS: Prod: Studio Pierrot. © Studio Pierrot, Bandai. 45 mins.
ORIGINS: 4 different 'magical girl' TV series.
CATEGORIES: C, U

An alien race attacks Earth. Who you gonna call? The Magical Girl Club, four of whose distinguished members — Yu, Mai, Pelsha and Yumi, aka Magical Emi, Creamy Mami, Fairy Pelsha and Pastel Yumi — step out of their various TV series and join forces to recover their magic and defeat the aliens using Japan's deadliest weapon, the Power of Cute. It's very hard to think of a Western parallel that would properly sum up the comic sweetness of this collection of sugared-almond sentiment, short skirts and small fluffy animals — Barbie, Sindy and My Little Pony joining forces to wipe out the Borg from *Star Trek: The Next Generation* wouldn't even come close. We have nothing like this in the West. More's the pity, say some. ★★★?

MAGIC FAIRY PELSHA
(Eng trans for MAHO NO YOSEI PELSHA)

JAPANESE CREDITS: Dir: Takeshi Anno. Prod: Pierrot Project. © T. Aonuma, Shueisha, Studio Pierrot, NTV. 45 mins.
ORIGINS: Manga by Takako Aonuma, pub Shueisha; 1984 TV series.
POINTS OF INTEREST: Some sources prefer to transliterate the kana for 'Pelsha' as 'Persia', which is just as valid a reading.
CATEGORIES: U

A compilation of music clips with the original soundtrack from the TV series, plus some new animation, edited into a musical summary of Pelsha's adventures. ★★☆?

MAPS: THE VOYAGE OF THE LEGENDARY ALIENS
(Eng trans for MAPS SAMAYOERU DENSETSU NO SEIJINTACHI)

JAPANESE CREDITS: Dir: Keiji Hayakawa. Script: Kenji Terada. Chara des & key animator: Masaki Tsuji. Art dir: Shichiro Kobayashi. Music: Kohei Tanaka. Prod: Masao Miyashita. Prod: Gakken. © Y. Hasegawa, Studio Gallopp, Nippon Columbia. 53 mins.
ORIGINS: Manga by Yuichi Hasegawa, pub Gakken in Comic Nora.
SPINOFFS: New Maps OAV series released in 1994.
CATEGORIES: SF, R

High school student Gen and his girlfriend Oshimi are kidnapped by the space pirate Lipmila. 20,000 years ago, other aliens hid an ancient and priceless map on Earth. Gen knows how to find it — or so they tell him. Some of the most gloriously impractical starship designs ever conceived — imagine a ship several thousand metres long and looking like the Spirit of Ecstasy mascot soaring free from the bonnet of a gigantic Rolls Royce — fly through this off-the-wall SF treasure hunt. ★★★

NEO-TOKYO
(Eng title for MANI MANI MEIKYU MONOGATARI, lit Mani Mani Labyrinth Tales)

JAPANESE CREDITS: Dir: Yoshiaki Kawajiri, Katsuhiro Otomo & Taro Rin. Music: Micky Yoshino. Prod: Project Team Argos, Kadokawa Shoten. © Haruki Kadokawa Films Inc. 50 mins.
WESTERN CREDITS: US theatrical & video release 1992/3 on Streamline Pictures, dub, Eng dialogue Ardwight Chamberlain.
CATEGORIES: H, SF

Another anthology, and just as worthy of notice as *Robot Carnival*, though much darker in overall mood. *Neo-Tokyo* brackets short films by two of the West's favourite Japanese directors, Kawajiri of Madhouse and Otomo, inside a chiller by the revered Taro Rin. In Rin's story, 'Labyrinth', little Sachiko ignores her mother's warnings about staring for too long into mirrors and not playing with strangers, with predictable but terrifying results. She and her cat fall through a mirror and are led into a surreal world by a sinister clown. The director also designed the characters for this segment and shows a masterly hand at sustaining suspense and shading imagery to appear first innocent, then threatening. There is a carnival atmosphere, but it's another Ray Bradbury carnival, one where you don't want to linger 'til it gets dark. Otomo's piece, 'Order to Stop Construction', is about automation run mad, as a salaryman goes to inspect a remote installation and discovers that, for machines as well as men, bureaucracy can be both its own reward and its own tomb. Kawajiri's 'Running Man' is a tense, dynamic mood piece which goes nowhere in swift and stylish fashion, the story of a racing car driver who has been champion of the twenty-first century's big game, the Death Race, for over a decade and now finds he literally can't quit. ★★★★

PHOENIX — YAMATO CHAPTER
(Eng trans for HI NO TORI — YAMATO HEN; Yamato is an early name for Japan)

JAPANESE CREDITS: Prod: Madhouse for CIC Victor. © Tezuka Pro, Madhouse. 48 mins.

ORIGINS: Osamu Tezuka's manga in the Hi Ni Tori (Phoenix) series.
CATEGORIES: DD, P

Also:

PHOENIX — SPACE CHAPTER
(Eng trans for HI NO TORI — UCHU HEN)

CREDITS, ORIGINS, CATEGORIES: As above.

The legendary Phoenix, known across many civilisations and centuries as a symbol of the power of the life force, has never been captured. However, the beauty of Oguna's flute playing draws the bird to him, and she gives him a drop of her own blood which grants an eternally blessed life. Set in the ancient state of Yamato, the earliest name for Japan, this continues the story of karma and reincarnation which was the 'life's work' of the great Osamu Tezuka. In the second story, the power of the Phoenix extends from the past into the future as man explores space. ★★★

PROJECT A-KO II: PLOT OF THE DAITOKUJI COMPANY
(Eng trans for PROJECT A-KO II DAITOKUJIZAIBATSU NO INBO, aka PROJECT A-KO II: PLOT OF THE DAITOKUJI FINANCIAL GROUP)

JAPANESE CREDITS: Dir, original idea, chara des & anime dir: Yuji Moriyama. Screenplay: Takao Koyama. Art dir: Junichi Azuma. Music dir: Yasunori Honda. Prod: Kazufumi Nomura. Prod co: APPP for

OSAMU TEZUKA

'The Manga God' to millions of fans, an incredibly prolific writer and artist who produced over 150,000 pages of manga in his lifetime, as well as making films, OAVs and TV series, setting up and running two studios, lecturing, advertising products and qualifying as a physician. Hugely influential and admired in East and West, his *Jungle Emperor* is thought by many to have heavily influenced the Disney hit *The Lion King*.
RECOMMENDED WORKS: Frederik L. Schodt included some translation from the *Phoenix* cycle in his book *Manga! Manga!*, and *Adolf* is available in a beautifully translated and presented edition from Cadence Books. Look out for the 1980 movie *Space Firebird* on Western Connection. *Broken Down Film*, a joyous short that plays with the whole idea of film, sometimes crops up on UK television.

Soieishinsha. © Soeishinsha, Final Nishijima, Pony Canyon. 70 mins.
WESTERN CREDITS: US video release 1993 on US Manga Corps as Plot of the Daitokuji Financial Group, sub & dub; UK video release 1995 on Manga Video, dub.
ORIGINS: Story by Katsuhiko Nishijima, Kazumi Shiraishi & Yuji Moriyama; 1986 movie.
CATEGORIES: C, SF

The second *A-Ko* adventure keeps up the lunatic excess of the first. B-Ko hasn't given up on her pursuit of the incredibly cute C-Ko, and when the bubblebrained blonde and her best friend A-Ko are invited onto the alien spaceship (which B-Ko's father is plotting to acquire) she sees a chance to further her plans. But daddy isn't the only one who wants the alien technology; spies from every country in the world are also around. With the battle for the ship and C-Ko about to commence, don't expect to see much of the fixtures, fittings and surrounding area by the time the end credits roll. But do look out for the usual roll call of guest appearances by charas from other anime and manga, and even a few Western sources. ★★★

RELIC ARMOUR LEGACIUM

JAPANESE CREDITS: Dir: Hiroyuki Kitazume. Prod: Atrie Giga. © Bandai. 50 mins.
CATEGORIES: SF

The inhabitants of planet Libatia are held under mind-control by the evil Dats. Professor Grace steals a mighty robot, Legacium, from them. His daughter Arusha takes it into hiding, and with the help of her friends Dorothy and Bric and of one Zeno Mosesti, fights the Dats.

ROBOT CARNIVAL

Nine-part anthology film, individual segment titles below.
JAPANESE CREDITS: Dir: 'Opening' & 'Closing' by Atsuko Fukushima & Katsuhiro Otomo; 'Starlight Angel' by Hiroyuki Kitazume; 'Cloud' by Lamdo Mao; 'Deprive' by Hidetoshi Omori; 'Franken's Gears' by Koji Morimoto; 'Presence' by Yasuomi Umetsu; 'A Tale of Two Robots' by Hiroyuki Kitakubo; 'Nightmare' by Takashi Nakamura. Music: Jo Hisaishi, Isaku Fujita & Masahisa Takeshi. Prod: APPP for Victor. © APPP Co Ltd, Victor. 100 mins.

WESTERN CREDITS: US theatrical & video release 1991 on Streamline Pictures, dub, Eng dialogue by Tom Wyner.
POINTS OF INTEREST: The US release slightly alters the running order of the segments.
CATEGORIES: SF, DD

An anthology in which each director was asked to create a short piece interpreting the theme of robots, this is a dazzling film which encapsulates an impressive range of talents and styles ranging from high comedy to New Age simplicity. Otomo's and Fukushima's contribution brackets the film, serving as opening and closing sequences with a wry look at just what the (literal) bells and whistles of high technology generally do for poor, backward people in Third World countries. Mao's 'Clouds' is New Age anime, a series of beautiful, curiously hypnotic images combined with soothing music and buried narrative. Every segment has something special to offer; my personal favourite, Yasuomi Umetsu's 'Presence', is another Frankenstein/technofailure fable, but reworks the theme in unashamedly romantic manner into a fifteen-minute, three-hankie weepie with gorgeous design and music that sticks in your heart and refuses to go away. Don't wait for a UK release — if you have a video set-up with NTSC capacity I urge you to get a copy of this from the USA or Japan by any possible means. ★★★★☆

RUMIKO TAKAHASHI'S RUMIK WORLD — THE LAUGHING TARGET
(Eng trans for RUMIKO TAKAHASHI'S RUMIK WORLD — WARAU HYOTEKI)

JAPANESE CREDITS: Dir: Tohru Matsuzono. Screenplay: Tomoko Kaneharu & Hideo Takayashiki. Chara des: Hidekazu Obara. Art dir: Torao Arai. Music: Kawachi Kuni. Prod: Studio Pierrot. © R. Takahashi, Shogakukan, Kitty Film. 50 mins.
WESTERN CREDITS: US video release 1993 on US Manga Corps, sub, trans William Flanagan & Pamela Ferdie, Eng rewrite Jay Parks; UK video release 1994 on Manga Video, dub.
ORIGINS: Manga by Rumiko Takahashi, pub Shogakukan, Eng trans pub Viz Communications; 1985 & 1986 OAVs.
CATEGORIES: H, N

Takahashi's Rumik World is the series label for short stories quite outside her usual long-running series, which may or may not turn into the foundation stones for new series; a place to try out ideas, in other words. The Laughing Target is a complete contrast to last year's offering Maris the Wondergirl; dark, threatening and set entirely in the real world of contemporary Japan — a world in which arranged marriages are still perfectly normal and many ancient customs are still active in society, so how can the possibility of demonic intervention be entirely discounted? Azusa comes from the kind of good old family which still arranges marriages in childhood, and her chosen mate is her cousin Yuzuru. But while she is being brought up quietly in the old family mansion in the country, she has some very strange experiences, culminating in the death of her mother, the head of the clan. Meanwhile, Yuzuru is growing up in the suburbs, going to a normal school and, naturally enough for a good-looking, likeable boy, going out with a girl — a girl he really loves. When Azusa turns up on the doorstep to claim him as her fiancé and live with his family until they are old enough to be married, the situation is very difficult, more so because Azusa has grown into a spectacular beauty and has never even considered the possibility that Yuzuru's affections might be engaged elsewhere. A series of terrifying events leads to tragedy and a resolution straight out of Japanese folklore. ★★☆

THE SAMURAI

JAPANESE CREDITS: Prod: Suno Kubo. © Suno Kubo, CBS Sony. 45 mins.
CATEGORIES: N, X?

Modern-day swordsman story in which Takashi has to defend the sword his father won in battle from Kagemaru Akari when the Akari twins come to reclaim it and avenge their father's death.

THE SCARRED MAN ACT II GOLDEN AVENGER
(Eng trans for KIZUOIBITO ACT II OGON NO FUKUSHUSHA)

JAPANESE CREDITS: Prod: Madhouse. © Koike, Ikegami, Shogakukan, Bandai. 45 mins.
ORIGINS: Manga by Ryoichi Ikegami & Kazuo Koike, pub Shogakukan; 1986 OAV.
CATEGORIES: N, A

Also:
THE SCARRED MAN ACT III BLOND DEVIL
(Eng trans for KIZUOIBITO ACT III HAKUKATSUKI)

CREDITS, ORIGINS, CATEGORIES: As above except: 30 mins.

Prospector Keisuke Ibaraki, aka 'blond demon Baraki', is in the jungle with his beloved Yuko when he saves a tribal elder from an attack by a puma. The grateful old chief tells him where to find treasure, but of course the actual acquisition is fraught with danger. Yuko dies and Baraki gets away with both the treasure and a new girl, Peggy. It's out of the frying pan and into the fire for Peggy in Act III when she is taken hostage by porn merchants and forced to take part in erotic scenes.

SPACE FANTASIA R2001
(Eng title for SPACE FANTASIA NISENNICHIYA MONOGATARI, lit Space Fantasia Story of the 2001 Nights)

JAPANESE CREDITS: Dir: Yoshida Shigetsugu. Prod: Tokyo Movie Shinsha, Victor Music. © Y. Hoshino, S. Takanashi, TMS. 58 mins.
ORIGINS: Manga by Yukinobu Hoshino, Eng trans pub US Viz Communications; possibly also a reference to the US comic Space Family Robinson, which became a TV series known as Lost in Space.
CATEGORIES: SF

In 2085, man sets out to ensure the survival of the human race by sending out a sleeper ship carrying Robinson family embryos into space, heading for planet Ozma. On the way a community grows up and after 375 years the ship reaches Ozma, and life settles down into a peaceful rhythm. Then a second ship arrives, captained by yet another Robinson, who wants the help of the Ozma population in spreading the human race even further into space. ★★☆?

TAIMAN BLUES NAOTO SHIMIZU CHAPTER
(Eng trans for TAIMAN BLUES SHIMIZU NAOTO HEN)

JAPANESE CREDITS: Prod: Keibunsha. © Premier International. 30 mins.
CATEGORIES: N

Rivalry between two motorcycle gangs, MND and Laku, and a personal vendetta between MND's Naoto and Laku's Yokota.

TAKE THE X TRAIN
(Eng title for X DENSHA DE IKO, lit Let's Go on the X Train)

JAPANESE CREDITS: Dir: Taro Rin. Prod:

Argos. © Konami Kogyo. 50 mins.
POINTS OF INTEREST: Based on the SF story by Koichi Yamano. The title is a parody of the popular American song 'Take the A Train'.
CATEGORIES: H

Public relations man Toru sees a phantom train while waiting on an underground platform. Ghosts are about to take on the human world and the army is, of course, helpless. Toru is the only one who can fight them. A beautifully spooky little piece from a master director. ★★★?

TO-Y

JAPANESE CREDITS: Dir: Atsushi Kanjo. Chara des: Naoyuki Onda. Music dir: Masayuki Matsura. Prod: Studio Gallopp. © Kanjo, Shogakukan, CBS Sony, Studio Gallopp. 60 mins.
ORIGINS: Manga by Atsushi Kanjo, pub Shonen Sunday Comics Wide.
POINTS OF INTEREST: Music director Matsura is a member of top eighties pop band PSY-S.
CATEGORIES: N

To-Y, leader of the band Gasp, has a deep rivalry with another musician, Yoji. He comes under pressure from an ambitious lady manager who wants him to dump the band and work for her. She tries to play him and Yoji off against each other and threatens to stop Gasp playing a big concert which is vital to their career. However, To-Y decides that sticking to the kind of music he wants to play with the people he chooses is more important than anything. In the end, he and Gasp manage to play anyway, setting up their own gig near the concert in the park and drawing a big audience. This is an enjoyable pop soap designed after the manga's charming, contemporary style, which would go down well in any teenage girls' magazine, Western or Eastern. ★★★

THE TRIUMPHANT PITCHER
(Eng trans for SHORU TOSHI)

JAPANESE CREDITS: Prod: Toei Doga. © Toei Video. 72 mins.
CATEGORIES: N

Katsumi, a member of the top student baseball team, is offered a place in the professional world by pro team leader Hoshi, and starts a great career. The following year, Hoshi becomes team president and leads them to glory in the national finals.

TWD EXPRESS ROLLING TAKEOFF

JAPANESE CREDITS: Prod: Gakken. ©
Shokichu Home Video. 55 mins.
ORIGINS: Manga by Yuki Hijiri.
CATEGORIES: SF

A crew of space cargo workers rescue a beautiful
android and land themselves in trouble thereby.

TWILIGHT Q LABYRINTHINE FILE 538
(Eng trans for TWILIGHT Q MEIKYU BUKKEN FILE 538)

JAPANESE CREDITS: Prod: Studio Dean. ©
Network, Bandai. 30 mins.
CATEGORIES: M, SF

A hardbitten detective is on the trail of whatever it
was that suddenly made every aircraft over Tokyo
vanish without trace. His investigations lead to a
strange couple, but there's not a single shred of evi-
dence to back up his suspicions.

URUSEI YATSURA OVA 1: INABA THE DREAM-MAKER
(Eng title for URUSEI YATSURA 87: YUME NO SHIKAJIN INABA-KUN HATSUJOH — LUM NO MIRAI WA DOH NARUCCHA, lit Urusei Yatsura 87: Arrival of Inaba the Dream-maker — What Future for Lum?)

JAPANESE CREDITS: Prod: Kitty Film. ©
Takahashi, Shogakukan, Kitty Film. 57 mins.
WESTERN CREDITS: US Video release 1994
on AnimEigo.
ORIGINS: Manga by Rumiko Takahashi, pub
Shogakukan, Eng trans pub Viz
Communications; 1981 TV series; movies
every year 1983-86.
CATEGORIES: C, R

Shinobu is on her way home from shopping when
she meets a strange guy in a bunny suit. After a
spirited exchange (he tries it on with her, she
demonstrates she is not a woman to be trifled with
by hitting him hard) she sees he has dropped a key.
Of course, a key needs a door, so Lum decides to
build one to fit it. When she, Shinobu and Ataru go
through the door they walk into their own future
— or futures, because there are a huge range of pos-
sibilities. But poor Inaba is in big trouble with his
colleagues at the Destiny Management Bureau —
how is he going to sort out the tangle he's caused?
★★★

VIOLENT ENCOUNTER WITH THE STEEL DEMONS
(Eng trans for DAIMAJU GEKITO HAGANE NO ONI, aka DEVIL ROBOT)

JAPANESE CREDITS: Dir: Tashihiro Hirano.
Script: Noboru Aikawa. Music: Masahiro
Kawasaki. Dir & mecha des: Koichi Ohata.
Chara des: Naoyuki Honda. Prod: AIC. ©
Tokuma Shoten. 60 mins.
CATEGORIES: SF

A UFO is brought down on a remote island after an
experimental laser at the research base there causes
an explosion. Scientists Haruka and Takuya risk
their lives to get a sample of its contents, and open
a door to another dimension in the process. A
being from this dimension possesses Haruka and
transforms him into a giant biomechanical warrior,
Doki. Takuya has to save his friend and the world.

WICKED CITY
(Eng trans for YOJU TOSHI, aka MONSTER CITY, aka SUPERNATURAL BEAST CITY)

JAPANESE CREDITS: Dir & chara des:
Yoshiaki Kawajiri. Screenplay: Kisei Cho.
Art dir: Yuji Kaeda. Music: Osamu Shoji.
Prod: Madhouse. © Japan Home Video.
c90 mins.
WESTERN CREDITS: US video release 1992
on Streamline Pictures, dub, ADR dialogue
by Greg Snegoff. US theatrical release 1993
by Streamline Pictures; UK video release
1994 on Manga Video, dub.
ORIGINS: Novel by Hideyuki Kikuchi.
POINTS OF INTEREST: A live-action version
of the story was made in Hong Kong and
released on video in the UK in 1995 on
East2West Films.
CATEGORIES: H, X

One of Japan's foremost horror directors makes an
interesting example of City Gothic horror. As in
Legend of the Overfiend and *Devilman*, the story pos-
tulates another world of demons which has existed
alongside ours for thousands of years. A truce has
kept men and demons apart for centuries, but now
it is up for re-negotiation and some demons are get-
ting into the human world to feed, while others
want to come in and take it over altogether, seeing
humans as easy prey. The Dark Guard exists to
police the uneasy truce and has both human and
demon agents. One of these, Taki, is assigned to
defend the intermediary negotiating the truce, Dr
Giuseppe Mayart, along with a beautiful demon
colleague. But all is not as it seems, since the two

are not simply fighting horrendous monsters from the demon side, but are also unwittingly part of a secret plot by their own masters. Spectacularly nasty demons, including a spider-woman who should put male viewers off picking up girls in bars for quite a while, and a climactic battle in, on and around a church, provide plenty of action. There's some relatively explicit sex and gallons of blood. The US dub is superior to the UK one both in terms of translation — despite a few awkward passages — and of well-cast and convincing voice actors. ★★★

WIND AND TREES SONG
(Eng title for KAZE TO KI NO UTA SEINARU KA NA, lit Song of the Wind and Trees)

JAPANESE CREDITS: Storyboards: Yoshikazu Yasuhiko. Prod: Konami Kogyo, Herald. © K. Takemiya, Shogakukan, Herald Enterprise. 60 mins.
ORIGINS: The first 3 volumes of Keiko Takemiya's manga, pub Shogakukan.
CATEGORIES: R, P

The end of the nineteenth century: a European boys' school starts its new academic year and Serge finds himself sharing a room with Gilbert Cocteau, a ravishing little blond vamp. Serge suspects Gilbert of gay tendencies (yes, he's a bit slow on the uptake) and is at first concerned, but the basic sweetness of Gilbert's nature and his not inconsiderable physical charms gradually win him over, and the pair soon move from acquaintance to friendship and then become lovers. But the relationship is under stress almost from the start. Serge has a very inconvenient conscience, which keeps telling him that their relationship is immoral, and the naturally flirtatious Gilbert has no shortage of pressing offers from other boys, staff and visitors. It's difficult for the West to take in this kind of subject matter in animation. We only 'do' gay love stories in nineteenth century dress as consciously arty films and generally avoid the subject of teenage homosexuality. Takemiya, without our cultural baggage, produces a tender, stars-in-the-eyes romantic melodrama. Would that some intelligent company, sensitive to the need of young gays for the same kind of love fantasies their straight counterparts can get in comics and videos everywhere, bring in good translations of both the anime and the manga. ★★★

YOTODEN
(Eng title for SENGOKU KITAN YOTODEN AGOKU NO SHO, lit Tales of the War of the Legendary Mysterious Sword, Escape Chapter)

JAPANESE CREDITS: Dir: Sato Yamazaki.

Writer: Noboru Aikawa. Chara des: Kenichi Onuki. Monster des: Junichi Watanabe. Music: Hidetoshi Honda. Prod: Minami Machi Bugyosho. © CIC Picture Video. 43 mins.
ORIGINS: Novel by Jo Nakiumi.
POINTS OF INTEREST: One of many anime to feature the mediaeval warlord Oda Nobunaga as a villain in league with dark forces.
CATEGORIES: H, P, X

Also:
YOTODEN II
(Eng title for SENGOKU KITAN YOTODEN II KIKOKU NO SHO, lit Tales of the War of the Legendary Mysterious Sword, Homecoming Chapter)

JAPANESE CREDITS, ORIGINS, CATEGORIES: As above except: 40 mins.

In 1582 AD, Japan is in the middle of a civil war. Oppressive lords and bandits alike terrorise the peasantry, and demons arise once again, possessing warlord Oda Nobunaga through his mysterious adviser Ranmaru, who is really a centuries-old evil entity. The only way to control the demons is through three magical objects: a dagger, a sword and a pike. Ayame of the ninja Kasumi clan has the dagger. On her brother's death she changes her name to the masculine Ayanosuke, because now she must represent the clan in the fight against evil. Sakon of the Hyuga clan has the sword, and Ryoma of the Hakagure clan the pike. They come together to fight the demon threat and, as they travel though Japan, learn that Ranmaru has been hatching a plot to bring demons into the world for a long time. The story is based around real events of the Civil War era, and accurate historical detail mixed with pure invention lends a powerful sense of period but doesn't slow down the many battles with humans and demons. ★★★

Urusei Yatsura

There are still, no doubt, those Western film critics who think that the Japanese animation industry was born on 16 July 1988 when *Akira* opened. While this was a date of huge importance in the anime calendar for Japan as well as the West, it wasn't the only red-letter day in a year of superb films and OAVs. March saw the resolution of nearly a decade of conflict between *Gundam* protagonists Char Aznable and Amuro Ray, while in April Miyazaki's fantasy of childhood summers, *My Neighbour Totoro*, opened on a double bill with Takahata's harrowing *Tombstone for Fireflies*. But perhaps the most telling milestone in year five of the OAV format's existence is that while almost thirty movies were released this year, an increase of over a third on 1983's total, OAV releases rose from one to over 100 (and only ten percent were erotica!) While not all of the titles were worthy of special note, a year which saw the first episodes of *Patlabor*, *Legend of Galactic Heroes*, *GunBuster* and *Vampire Princess Miyu* can hardly be held to have been unremarkable. Another straw in the wind of change and growth was Nippon Sunrise's name change; this year the company became simply Sunrise, and the stated aim of the change was to mark its intention to be active in the world entertainment market and not simply in Japan. And in the USA, Carl Macek, whose work on *Robotech* for Harmony Gold gave a huge boost to America's awareness of Japanese animation, got together with Jerry Beck to set up Streamline Pictures, first as a theatrical distributor and then as a home video label.

MOVIES

AKIRA

Akira

JAPANESE CREDITS: Dir, scriptwriter & chara des: Katsuhiro Otomo. Scenario: Izo Hashimoto. Art dir: Toshiharu Mizutani. Chief animator: Takashi Nakamura. Music: Geinoh Yamashiro Group. © Akira Committee (Kodansha Ltd, Mainichi Broadcasting System Inc, Bandai, Hakuhodo Inc, Toho Co Ltd, Laserdisc Corp, Sumitomo Corp, Tokyo Movie Shinsha Co Ltd). 124 mins.
WESTERN CREDITS: US theatrical release 1989, video release 1990, both on Streamline Pictures; UK theatrical release 1990 by ICA Films, video release 1991 on Island World Communications, now Manga Video. Special doublepack release included widescreen sub version and a 'making of' documentary. Dir: Sheldon Renan. Eng adaptation: Michael Haller. Both sub & dub. Also screened on BBC TV in January 1994 in a specially-produced sub version, of higher quality than the video sub.
ORIGINS: Based on Otomo's manga Akira, pub Young magazine, Kodansha; graphic novel US pub Epic; UK pub Mandarin.
CATEGORIES: SF

KATSUHIRO OTOMO

The man who made *Akira* also created other films and manga which are even more interesting. Fascinated by the darker corners of contemporary urban life, and showing the face of Japan which not many outsiders notice, he is a marvellous draughtsman whose work is full of power and detail.

RECOMMENDED WORKS: *Domu*, a chilling manga tale, is available in translation in the UK from Equinox Books and the USA from Dark Horse Comics. The anime *Roujin Z*, the unlikeliest follow-up to *Akira* imaginable, is pure delight and is available on Manga Video.

On 16 July 1988, Tokyo was destroyed by what was believed to be a new type of bomb, triggering World War Three. (It was, in fact, a psychic blast from Akira himself.) Thirty-one years later, in 2019, Neo-Tokyo has arisen from the ashes under Japan's new political system; but the glittering city is built on foundations of poverty, ignorance and despair. Akira is a shadowy, mysterious figure, almost as mythical as King Arthur, but the film is not 'about' him or any one individual; if anything, it's about how life shapes us and what happens to those who kick back. Kaneda and his slum gang run into forces too great for them to comprehend; the runt of the litter, Tetsuo, uses a lifetime's anger as fuel to fire those forces in himself; and the puppet masters of Neo-Tokyo's political destiny find that the blunt instruments of chicanery and repression only work until people have nothing left to lose. The climactic resolution sees another armageddon hit Tokyo, repeating the truth the world learned in 1988 (or 1945): a phoenix can only rise from a nest of flame. *Akira's* force as a film comes not merely from its epic scope — the manga is far bigger and more daring — nor from its technical brilliance, but from the mosaic construction which allows the audience to glimpse the myriad facets of the city and embraces as essential components of its reality the slums and no-go areas as well as the spiritual and scientific heights and depths which urban civilisation embraces. There have been films as good, but few as dazzling, and few that have attempted so much and succeeded so far. It deserves its benchmark five-star status. ★★★★★

BIKKURIMAN

JAPANESE CREDITS: Prod & © Toei Doga. 25 mins.
ORIGINS: Comedy manga; 1981 TV series.
CATEGORIES: C, U

Also:
BIKKURIMAN: SECRET TREASURE OF THE ABANDONED ZONE
(Eng trans for BIKKURIMAN MUEN ZONE NO HIHO)

CREDITS, ORIGINS, CATEGORIES: As above.

The TV series was described as 'a funny story of odd gods', and had Super Devil, King of the World of Devils fighting Super Zeus, King of the Angelic World. Saint Fenix and human boy Prince Yamato set out together to find seven followers and lead them on a quest to establish a new, unified peaceful land called 'Jikai'. I don't know anything about these two features but I suppose them to follow the supernatural slapstick line of the TV episodes.

CHAR'S COUNTERATTACK
(Eng title for KIDO SENSHI NU GUNDAM GYAKUSHU NO CHAR, lit Mobile Suit Nu Gundam Char's Counterattack)

JAPANESE CREDITS: Dir & writer: Yoshiyuki Tomino. Chara des: Hiroyuki Kitazume. Mecha des: Yoshinori Sayama. Mobile suit des: Yutaka Izubuchi. Prod: Sunrise. © Sunrise, Sotsu Agy, Bandai. 120 mins.
ORIGINS: Novels by Yoshiyuki Tomino, some trans into Eng by Frederik L. Schodt, pub Del Rey; 1979 & subsequent TV series.
SPINOFFS: TV & OAV series based on the Gundam premise are still being made; the latest, Gundam 08 Platoon, is starting to appear as I write in early 1996. The SD Gundam series also spun off from the original. Merchandise is widespread.
CATEGORIES: SF

From the beginning of the *Gundam* saga almost a decade earlier an important focus of the storyline had been the intense personal rivalry between gifted NewType mobile suit pilot Amuro Ray and his military and political opponent Char Aznable. By the end of the first series, there was blood between them — the blood of the girl they both loved, who had dashed between them as Amuro struck at Char and died to save them both. During the second they were allies for a time. In the intervening years, political and military forces acting on them and their world have brought both to a point where the final confrontation is inevitable. Char, heir to a murdered hero and an old political tradition, has come into his inheritance as leader of the Neo-Jion movement, determined to end Earth's exploitation of the space colonies and lead his

people to freedom. Amuro, in many ways disillusioned and embittered by Earth's inept and corrupt government, is nevertheless sworn to defend her. The scene is set for a conflict as pitiless as any classical tragedy, and *Char's Counterattack* is almost Arthurian in its scope as it leads us to its inevitable resolution. *Gundam* was the first robot saga to present a credible view of a world in which these giant machines and humans could interact on a practical level. The robots and mobile suits were simply tools; some people had more skill in using them than others, or a special gift for the work, but anyone could be trained to operate them to a minimal level of competence. Being expensive, they were the tools of military and political machines and used to work their will. The men and women operating them were random groupings of people, thrown together and torn apart with the casual frequency common in military life, with sudden death a constant threat. This is a huge contrast to the mystically selected and uniquely gifted teenager operators of earlier giant robot series, and the major threat of conflict is also from a different source. There are no aliens in *Gundam*; all the evil, pain and suffering in its universe is caused by humans, sometimes the very people viewers have come to love and admire. The epic complexity of Tomino's story captured fans' imaginations, and its convincing neo-realism changed the course of the giant robot genre. ★★★★

CYNICAL HYSTERY HOUR 1 TRIP COASTER

JAPANESE CREDITS: Prod: Group Tack. 30 mins.

I haven't a clue what it's about or who it's by, but what a title! If any reader tracks it down I would very much appreciate some information. There may be some connection with the 1990 short film *Cynical Hystery Hour* shown at the Cardiff Film Festival in 1992 — see 1990 entry.

DORAEMON — NOBITA'S PARALLEL 'JOURNEY TO THE WEST'
(Eng trans for DORAEMON — NOBITA NO PARALLEL SAIYUKI)

JAPANESE CREDITS: Prod: Shin'ei Doga. © Fujiko-Fujio, Shogakukan. 90 mins. ORIGINS: Manga by Fujiko-Fujio, pub Shin'ei Doga; 1979 TV series; movies every year 1984-87. CATEGORIES: C, U

A comic rehash of the ancient legend of the Journey to the West, the basis of the Monkey King myth.

DRAGONBALL — THE MARVELLOUS MAGICAL MYSTERY
(Eng trans for DRAGONBALL MAKAFUSHIGI DAIBOKEN)

JAPANESE CREDITS: Dir: Daisuke Nishio. Prod: Toei Animation. © Bird Studio, Shueisha, Fuji TV, Toei Doga. 46 mins. ORIGINS: Akira Toriyama's manga, pub Shueisha; 1986 TV series; 1986 & 1987 movies. CATEGORIES: SH, U, C

Third in the movie series, this film shows Tao Pai Pai, the Crane Hermit and Ten Shin Han arriving in Penguin Village, setting for Toriyama's other long-running series *Dr Slump*, and meeting many of its crazy inhabitants. ★★★?

ESPER MAMI — DANCING DOLL OF THE STARRY SKY
(Eng trans for ESPER MAMI HOSHIZORA NO DANCING DOLL)

JAPANESE CREDITS: © Fujiko-Fujio, Shin'ei Doga. 46 mins. ORIGINS: Manga by Fujiko-Fujio. CATEGORIES: SF, DD

I have no further information on this title.

GRAVE OF THE FIREFLIES
(Eng title/trans for HOTARU NO HAKA, aka TOMBSTONE FOR FIREFLIES)

JAPANESE CREDITS: Dir & writer: Isao Takahata. Chara des: Yoshifumi Kondo. Art dir: Nizo Yamamoto. Music: Michio Mamiya. Prod: Toho. © A. Nosaka, Shinchosa. 90 mins. WESTERN CREDITS: US video release 1993 on Central Park Media, sub, trans Neil Nadelman. ORIGINS: Semi-autobiographical novel by Ayuki Nosaka. POINTS OF INTEREST: Originally screened on a double bill with My Neighbour Totoro. CATEGORIES: W, N

One of those rare films that transcends racial, national and cultural boundaries and speaks for children everywhere. Teenage Seita and his little

sister Setsuko lose their mother when their small town is devastated during the firebombing of Japan in World War Two. Their father is away in the Navy. They go to live with a relative but she is not sympathetic to the trauma the youngsters have been through, and eventually they decide to live alone in a cave by the river. At first the charm of 'playing house' sustains them, but as time goes by their meagre stores of food are exhausted. Then the family's carefully hoarded savings begin to run out, and Seita is reduced to stealing to try and feed his little sister while keeping some money back for emergencies. Finally she dies of malnutrition, and the boy makes his way to the city, where he too starves to death. This is, in fact, made clear in the opening moments of the film, but one spends the next hour and a quarter foolishly hoping that something can be done to change history. In the closing moments, two unresentful little ghosts look down on the lights of the big city, the brave new Japan of peace and plenty which has risen on their bones. The characterisation is particularly fine; Takahata wrote the script himself, and the sharp, grasping aunt, preoccupied cousins, and hard-pressed officials like the local policeman and doctor, who are painfully aware that they can do little or nothing to help the children, are all well depicted. The backgrounds and animation are so skilfully handled that it is very quickly possible to forget you are watching an animation at all. However, it can't be denied that a story of this kind has a particular resonance for Westerners when presented as a 'cartoon'. We know that animation is for children; animation is Disney and Tiny Toons, light, pretty, funny and safe. It reflects our wish to create a world in which children are not blown apart, shot, shrapnelled, or starved. To see such a story presented in such a form brings home to us even more strongly the pity and shame of a world which is still allowing children to suffer as Seita and Setsuko and hundreds of thousands like them suffered. No one should ever make the mistake of labelling this film by its origins. Its message is, sadly, universal. ★★★★★

LEGEND OF GALACTIC HEROES: ACROSS THE SEA OF STARS
(Eng trans for GINGA EIYU DENSETSU WAGAYUKU WA HOSHI NO UMI)

JAPANESE CREDITS: Dir: Noboru Ishiguro. Screenplay: Takeshi Shoji. Prod: Madhouse. © Y. Tanaka, Tokuma Shoten, Kitty Film. 59 mins.
ORIGINS: Novel series by Yoshiki Tanaka.
CATEGORIES: SF

Reinhart Von Musel, who later changes his name to Von Lohengrimm, is an able young commander who has attracted the envy and even loathing of many of his older colleagues because of his genius, his youth and his arrogant attitude. On the opposing side, Yang Wen-Li is similarly gifted though a good deal more laid back, and also has his problems — he doesn't want to be in the military at all, and the commanders on his own side can be just as difficult. Set a year before the huge OAV series due for release later in 1988, this curtain-raiser has all the style and quality of its successor, though the depth of plot and characterisation possible in thirteen hours of video obviously has less scope here. ★★★

MAISON IKKOKU LAST MOVIE

JAPANESE CREDITS: Dir: Takashi Anno. Writer: Kazunori Ito. Chara des: Akemi Takada. Prod: Kitty Film. © R. Takahashi, Shogakukan, Kitty Film. 70 mins.
ORIGINS: Manga by Rumiko Takahashi, pub Shogakukan; 1986 TV series.
CATEGORIES: R, N

The longed for climax of this much loved series is finally reached when Kyoko and Godai marry, and this film allows *Maison Ikkoku*'s legion of fans to wallow in sheer, unashamed romance as they share this great event, from Kyoko and Godai's visit to the tomb of her first husband Soichiro in a symbolic search for his approval, to the final scenes which show what will happen, not just to the happy couple, but to each of the inhabitants of anime's most famous boarding house, all of whom find a niche in life which contents them. ★★★?

MY NEIGHBOUR TOTORO
(Eng title/trans for TONARI NO TOTORO)

JAPANESE CREDITS: Dir, screenplay & original story: Hayao Miyazaki. Anime dir: Yoshiharu Sato. Music: Jo Hisaishi. Prod: Studio Ghibli. © Nibariki, Tokuma Shoten. 75 mins.
WESTERN CREDITS: US theatrical release 1993 by Troma/150th Street Films; US video release 1994 on Fox Video, both dub.
POINTS OF INTEREST: The English dub was done in 1989 by Streamline Pictures for Tokuma Shoten to enable the movie to be shown inflight on JAL. The film has inspired a Japanese environmental group to buy and preserve forest land, and the first 'Totoro Forest' has now been created in Saitama Prefecture, where the film is set. Miyazaki's

mother was hospitalised (for TB) for a lengthy period in his childhood, like the mother of the two young heroines.
SPINOFFS: There is a vast amount of Totoro merchandise; a 'Totoro shop' in Tokyo provides a focus for collectors.
CATEGORIES: U, DD, N

Declaration of bias: I think this film is perfect. It is also my favourite movie, of any kind, in any genre, ever. You may therefore wish to take what I say about it with a pinch of salt. Nevertheless, every superlative heaped on it is deserved. Like its precursors *Warriors of the Wind* and *Laputa*, it redeems that much maligned term 'family film' from its accumulated undesirable associations. It is magnificently crafted, beautifully shot and directed, and among its many delights is another of Jo Hisaishi's glorious scores, drawing on sources as diverse as Japanese folk music, playground songs and Western orchestral traditions. Miyazaki's aim in making the film was to give to young urban Japanese an image of the country childhood they never had. As Japan industrialised and recovered from the Second World War, Tokyo, Osaka and other major centres began to expand, and more and more leafy villages and small towns were swallowed up in the urban sprawl. Anime and manga orginated in the sixties reflect this today — the Tokyo suburb in which Nobita and Doraemon live has vanished from the real world long since, and is as mythical to most Tokyo children of the nineties as the setting of any SF story or fairytale. The forests and fields of *My Neighbour Totoro* have been squeezed further and further into the margins and are likewise under threat; but this is still in the future on the brilliant summer morning in the late fifties or early sixties when Satsuki, her little sister Mei and their father Professor Kusakabe arrive at the old house in the country which is to be their new home. They're moving to be closer to their mother, a long-term patient in a sanatorium. Father works at home and takes the bus to town when he has to lecture at the university, Satsuki goes to the local school, and Mei — Mei gets lost in the undergrowth and finds a magic kingdom. Woodland spirits too evanescent to be captured by adult eyes are everywhere, and both children accept and trust absolutely in their presence and their benign power. When Mei, confused and impatient at the ways of the adult world, which can seem vague and threatening to the very young, takes off alone in search of her mother, it is to those powerful spirits that Satsuki finally turns for help. Very few works of art are truly simple, but a few have the courage to appear so. In this case, that semblance of simplicity is essential to achieve the film's aims.

Only by leading us back to the simplicity of childhood can Miyazaki open the door to Totoro's world. His two previous films were hammered out of myth and adventure, packed with events, shaped by huge forces to which the protagonists had no choice but to react. In *My Neighbour Totoro*, the deliberate reduction of scale from the epic to the everyday makes one of the major points of the film — that importance and impact are relative to viewpoint, that the tiniest trivia have huge impact on those earliest years and how they shape us. There are many, many things to treasure in this film; it is a joyous celebration of the possibilities, as well as the realities, of childhood, and it gives us all somewhere good to go back to. It is a perfect memory of a perfect summer. ★★★★★

SAINT SEIYA: LEGEND OF HOT BLOODED BOYS
(Eng trans for SAINT SEIYA SHINKU NO SHONEN DENSETSU)

JAPANESE CREDITS: Chara des, des & supervision: Shingo Araki & Michi Himeno. Prod: Toei Doga. © M. Kurumada, Shueisha, NTV, Toei Doga. 75 mins.
WESTERN CREDITS: The Saint Seiya TV series & a number of the movies have appeared on TV & video in France under the title Les Chevaliers du Zodiaque (Zodiac Knights); It is also popular in Italy.
ORIGINS: Manga by Masami Kurumada; 1986 TV series, which ran until 1989; 1987 movie.
SPINOFFS: Action figure range produced for France and Italy; huge merchandise range in Japan.
CATEGORIES: DD

Abel de Pheobus, a reincarnation of the god Apollo and therefore, unsurprisingly, very attractive, persuades Saori to join him in his temple. The Bronze Saints are not happy about this but Saori's instructions to keep out of it, plus the forceful intervention of Apollo's Phoebus Saints, make it impossible for them to prevent her going. Abel is, of course, up to no good. He intends to use Saori/Athena's power for his own ends, and when she finally realises this and tries to resist he puts her in a trance-like state — but not before she has used her psychic powers to warn her Saints and bring them rushing to the rescue. It's gold-armour time again as Seiya, Hyoga and Shiryu face Apollo's heavy-duty fighters Aphrodite, Camus, Saga, Shura and Deathmask. The good win in the end, of course, but only after much bloodshed and suffering. ★★☆

Also:
SAINT SEIYA: THE GODS' FIERCE BATTLE
(Eng trans for SAINT SEIYA KAMIGAMI NO ATSUKI TATAKAI)

CREDITS, ORIGINS, CATEGORIES: As above except: 46 mins.

Cygnus Saint Hyoga intervenes to save a man under attack by mysterious warriors, but is attacked himself. Saori and the Bronze Saints go to Asgard, home of the Norse Gods, to try and find a trace of him. Dolvar, High Priest of Odin, tells them that he has no knowledge of Hyoga, but asks them to stay awhile. He has secret plans to kidnap Saori and rule the world, but the young God Frey and his sister Freya oppose these evil schemes and try to help the Bronze Saints. During the battle Frey sacrifices himself to save Saori, and Hyoga, who has been brainwashed, is found fighting on the other side but recovers his memory just in time. Seiya faces off against Dolvar in the final conflict, and the gold armour of Sagittarius tips the scales in favour of the Saints of Athena. The pretty boys in short skirts win again. ★★☆

SUNNY BOARDINGHOUSE: KASUMI, YOU'RE IN A DREAM
(Eng trans for HYATARI RYOKO KASUMI YUME NO NAKA NI KIMI GA ITA)

JAPANESE CREDITS: Dir: Hiroko Tokita. Chara des: Minoru Maeda. Prod: Masato Fujiwara. Prod co: Group Tack. © M. Adachi, Shogakukan, Toho, Asatsu. 70 mins. ORIGINS: Manga by Mitsuru Adachi, pub Shogakukan; 1987 TV series. CATEGORIES: N, R

Adachi's speciality, sports soap operas with sympathetic female characters, has stood him in good stead throughout a long and distinguished career, though his work is hardly known in the UK and USA. His style is distinctive and unchanging; artwork and cels for Hyatari Ryoko are instantly recognisable as 'Adachi anime' to those who have seen *Slow Step, Touch* or any of his other work. The series and movie centre on young Kasumi, who lives in a student hostel run by her aunt. She makes friends there, and one of them, a boy called Yusaku, complicates her relationship with her fiancé Kazuhiko, who is studying in America. In the film, her marriage is rapidly approaching and she has to decide whether to continue towards the future she has planned for so long with Kazuhiko, or to go in a completely different direction with

Yusaku. All Adachi's stories bear his hallmarks of humour and everyday incident and provide interesting clues to Japan's life and attitudes. ★★☆

TAKE THE LEAD! MEN'S SCHOOL
(Eng trans for SAKIKAGE! OTOKO JUKU)

JAPANESE CREDITS: © Toei Doga. 75 mins. CATEGORIES: V, N

'Juku' implies more than just any old school; it's a private school, usually a 'cram school' outside the State system, often single-sex, not dissimilar to a British public school. Contrary to the rather sissy image of public schools in the UK, the boys of the Otoko Juku look like something out of *Fist of the North Star*, big and very, very tough; so it will come as no surprise to learn that it is a super-élite fighting school. Ken Totaro is in an ordinary boys' high school but wants to pursue the martial arts, so he drops out and enrols at Otoko Juku. ★★★?

ULTRA B: DICTATOR B.B. FROM THE BLACK HOLE
(Eng trans for ULTRA B BLACK HOLE KARA NO DOKUSAISHA B.B.)

JAPANESE CREDITS: © Shin'ei Doga. 20 mins. CATEGORIES: C, SF

This is all the information I have on this title.

URUSEI YATSURA MOVIE 5 — THE FINAL CHAPTER
(Eng title for URUSEI YATSURA LAST MOVIE — BOY MEETS GIRL)

JAPANESE CREDITS: Dir: Tetsu Dezaki. Screenplay: Tomoko Konparu. Chara des: Setsuko Shibbunoichi. Anime dir: Yukari Kobayashi. Art dir: Torao Arai. Music: Toshiyuki Omori. Prod: Magic Bus. © R. Takahashi, Shogakukan, Kitty Film. 85 mins. WESTERN CREDITS: US video release 1994 on AnimEigo, trans Shin Kurokawa & Mariko Nishiyama; UK release 1995 on Anime Projects, both sub. ORIGINS: Manga by Rumiko Takahashi, pub Shogakukan, Eng trans pub Viz Communications; 1981 TV series; movies every year 1983-86; 1987 OAV. POINTS OF INTEREST: Based on the story of the final Urusei Yatsura manga volume. CATEGORIES: C, R, SF

Lum's grandfather has a confession to make; years ago a man from the mushroom planet saved his life, and in gratitude he promised to let his grandson marry Lum when the pair were old enough. Now Hijo's rather hunky grandson Lupa has turned up seeking his bride, but Lum flatly refuses to co-operate. He is a man of action; he pops on a ring which disables her powers and makes her lose those cute little horns, then carries her off, right under Ataru's nose. Obviously this state of affairs can't be allowed to continue, and Ataru is so outraged he actually joins Mendo and Lum's girlfriends in a rescue mission. Meanwhile Lupa's girlfriend Carla doesn't like the way things are going either. The chaos culminates in yet another game of tag to decide the fate of Earth. (Weapons of mass destruction might actually be kinder...) Of course it wasn't the last movie — members of the vocal Kitty Fan Club persuaded the company to put out two further specials this year alone — but don't let that spoil it for you. ★★★

(OAVS)

AIM FOR THE ACE! II STAGE ONE
(Eng trans for ACE O NERAE! II STAGE I)

JAPANESE CREDITS: Dir: Osamu Dezaki. Prod: Tokyo Movie Shinsha, © S. Yamamoto, Tokyo Movie Shinsha. 75 mins. WESTERN CREDITS: TV series screened in Italy as Jenny La Tennista. ORIGINS: Manga by Sumika Yamamoto; 1973 TV series; 1979 film. CATEGORIES: N

Also:
AIM FOR THE ACE! II STAGE TWO

CREDITS, ORIGINS, CATEGORIES: As above except: 50 mins

Also:
AIM FOR THE ACE! II STAGE THREE

CREDITS, ORIGINS, CATEGORIES: As above except: 25 mins

Also:
AIM FOR THE ACE! II STAGE FOUR

CREDITS, ORIGINS, CATEGORIES: As above except: 50 mins

Also:
AIM FOR THE ACE! II STAGE FIVE

CREDITS, ORIGINS, CATEGORIES: As above except: 50 mins

Following on chronologically from the 1979 film, the OAV series chronicles the further adventures of tennis hopeful Hiromi. While representing Japan in a major tournament in the USA, she hears that her beloved coach, Jin, has died of leukaemia. Despite the efforts of her friend Todo and Jin's old friend Katsura, an ex-tennis player and now a Buddhist monk, she takes a long time to recover from this blow; when she finally begins to take an interest in life again, she and her team-mate Reika have to decide whether or not to turn professional. Another visit to the USA to improve their technique follows, but when the girls return to Japan there are some surprises in store. In the end Hiromi succeeds in winning a major professional tournament and a brilliant future stretches before her; she also finds love again with Todo.

APPLESEED

JAPANESE CREDITS: Dir & screenplay: Kazuyoshi Katayama. Chara des & anime dir: Yumiko Horasawa. Mecha des: Kiyomi Tanaka. Art dir: Hiroaki Ogura. Music: Norimasa Yamanaka. Prod: Gainax. © M. Shirow, Soeishinsha, AIC, Bandai. 70 mins. WESTERN CREDITS: UK & US release 1994 on Manga Video, dub; US video release 1994 on US Renditions, sub, trans John Wolskel. ORIGINS: Manga by Masamune Shirow, pub Soeishinsha, Eng trans pub Dark Horse. CATEGORIES: SF

The compression of part of Shirow's complex and intriguing manga into a seventy-minute video feature was bound to leave out many of the subtleties; *Appleseed* is a straight adventure story, while the manga has much more to offer. A young policeman, whose wife has committed suicide because she was unable to live any longer in the 'Utopian' society of Olympus, cracks under the strain and begins to work secretly with a terrorist group out to destroy the rule of genetically altered or cloned people in the city. Deunan Knute and her partner Briareos Hecatonchires, outsiders now working in the Olympus police force, are investigating the terrorist activity and gradually realise their colleague's involvement. ★★☆

ARMOURED TROOPER VOTOMS: ROOTS OF TREACHERY
(Eng title for SOKOKIHEI VOTOMS RED SHOULDER DOCUMENT YABO NO RUTSU, lit

Armoured Trooper Votoms Red Shoulder
Document: Roots of Treachery)

*JAPANESE CREDITS: Dir: Ryosuke
Takahashi. Chara des: Norio Shioyama.
Mecha des: Kunio Okawara. Prod: Sunrise.
© Takahashi, Sunrise, Toshiba Eizo Soft.
56 mins.
WESTERN CREDITS: US video release of all
OAVs & TV series planned for autumn 1996
on US Manga Corps.
ORIGINS: Story by Ryosuke Takahashi; 1983
TV series; 1985 & 1986 OAVs.
CATEGORIES: SF, W*

This story is set before the TV series and shows
Chirico's origins as a genetic experiment, how he
became a Perfect Soldier, how he was recruited for
the Red Shoulder group and how his long enmity
with Perzen started. Gripping mechwar tale. ★★★?

ARMOUR HUNTER MELLOWLINK VOLS 1 & 2
(Eng title for SOKOKIHEI VOTOMS KIKO
RYOHEI MELLOWLINK, lit Armoured Trooper
Votoms Armoured Warrior Mellowlink)

*JAPANESE CREDITS: Dir: Takeyuki Kanda.
Chara des: Moriyasu Taniguchi. Mecha des:
Kunio Okawara. Prod: Sunrise. © VAP,
Toshiba, Sunrise. Each 50 mins.
ORIGINS: Devised by Ryosuke Takahashi as
a spinoff of Armoured Trooper Votoms.
CATEGORIES: SF, A*

The desert: a boy, maybe seventeen or eighteen,
alone with a big gun, an even bigger bike and a thirst
for revenge. He is the youngest member and only
survivor of a platoon cut down owing to official chi-
canery, and framed for desertion and the deaths of
his colleagues. He intends to avenge them and each
OAV shows one act of vengeance on one of the
betrayers. Another of those series which is crying out
for a Western release, this brilliantly paced action-
adventure story is well worth a look. ★★★☆

AURA BATTLER DUNBINE
(Eng trans for SEISENSHI DUNBINE)

*JAPANESE CREDITS: Prod & © Sunrise.
80 mins.
ORIGINS: 1983 TV series by Yoshiyuki
Tomino, creator of Gundam.
POINTS OF INTEREST: Each OAV tape also
features a compilation of TV episodes. The
Aura Battlers themselves were afterthoughts*
for Tomino; he had wanted to do a pure
fantasy series and when the sponsor toy
company demanded 'giant robots' he put in
the most organic ones he could devise, which
had an immediate influence on anime
mecha design.
CATEGORIES: DD

Having already revolutionised the giant robot genre
with *Gundam*, Tomino took it in another direction
altogether with the Aura Battlers: half-sentient, half-
organic, powered by 'aura power' (think 'The Force')
and looking like a cross between late mediaeval
knights and huge insects, these were like no other
robots in anime. The design team rose to the chal-
lenge, and the impact of the robot/fantasy combin-
ation introduced a new element to mecha design.
The OAV takes place 700 years after the TV series; the
old cast of characters is gone, and the magical land of
Byston Well has forgotten the Aura Battlers. The land
of Balan Palan is ruled by a Princess and its people are
rumoured to possess a great treasure. The evil Raban
seeks it. The giant mecha Serbine is found by heroic
young warrior Sho who uses its power to fight the
evil that threatens the Princess and people. ★★☆

Also:
AURA BATTLER DUNBINE II
(Eng trans for SEISENSHI DUNBINE II)

*CREDITS, ORIGINS, CATEGORIES: As above
except: 75 mins.*

Sho and his companions flee into the desert, where
a knight of the Roshun clan saves them from an
attack by venomous insects. Their rescuer asks
them to join the fight against the evil Raban but
they refuse. Then Lemuru is taken hostage. ★★☆

Also:
AURA BATTLER DUNBINE III
(Eng trans for SEISENSHI DUNBINE III)

*CREDITS, ORIGINS, CATEGORIES: As above
except: 75 mins.*

Lemuru has been kidnapped by Raban, and Sho
sneaks into the castle to rescue her. Meanwhile
Raban's second-in-command Shoto presses for the
use of nuclear missiles in the battle. Sho and
Lemuru must flee to Terra to try and save their own
land. ★★☆

BOMBER BIKERS OF SHONAN 4 HURRICANE RIDERS
(Eng title for SHONAN BAKUSOZOKU 4
HURRICANE RIDERS, lit Wild Explosive

BIKERS IN ANIME

Akira is generally considered the ultimate anime biker movie, but there are many others; bikers are a favourite motif for rebellious youth. Here are my top five.

1 PRISS ASAGIRI: BUBBLEGUM CRISIS

Not just a biker but lead singer with a rock band too, Priss is the classic misunderstood rebel; orphaned, her boyfriend killed by evil corporation GENOM, she is rootless and looking for a purpose when Sylia Stingray asks her to join the Knight Sabers.

2 FUJIKO MINE: LUPIN III — THE FUMA CONSPIRACY

Lupin III's lady gives Priss more than a run for her money when she zips up her red leathers and guns her scarlet Kawasaki into top gear in this action-packed caper movie. Fujiko has never been misunderstood in her life; she knows exactly what she wants and she usually gets it. Her one and only soft spot is for Lupin and she keeps that well under control.

3 SHOGO YAHAGI: MEGAZONE 23 PART II — PLEASE KEEP IT SECRET

In *Megazone 23*, he's just a bike-mad kid with no particular axe to grind. By *Part II*, he's become a classic biker hero and leader of the pack. He doesn't shrink from action — some of the fight scenes in this movie are pretty graphic — but he's really just looking for a better world for everyone. Oh, and he looks a lot cooler in *Part II* as well.

4 YOSUKE EGUCHI: BOMBER BIKERS OF SHONAN

Embroidering Eguchi, the pride of Shobaku, might seem an odd choice. But he certainly looks the part — look at that perfect quiff! And although he's really a peaceable kind of guy, he'll fight if forced to; but it's his intelligence and charisma that keep him at the head of his gang.

5 KEIICHI MORISATO: OH MY GODDESS!

OK, he's pretty wet. Even after living with a beautiful girl for weeks, he's still dithering over whether or not he ought to hold her hand. He really does love bikes, though, and with a trio of goddesses rooting for him, chances are he'll win any race he enters.

Motorbike Gang from Shonan 4 — Hurricane Riders)

JAPANESE CREDITS: Prod: Toei Doga. © S. Yoshida, Shonen Gohosha, Toei Video. 50 mins.
ORIGINS: Manga by Satoshi Yoshida, pub Shonen Gohosha; 1986 & 1987 OAVs.
CATEGORIES: N, R

Eriko's boyfriend Seiji, a surf freak, loses an important competition and goes crazy. Plunged into depression, he's desperately seeking a rematch. Eriko goes to her friend Eguchi, head of the Shobaku biker gang, for help. Will the ultracool Eguchi be able to help Seiji find his sense of proportion? ★★★?

BRIDE OF DEIMOS
(Eng title for DEIMOS NO HANAYOME RAN NO KUBIKYOKU, lit Bride of Deimos: The Orchid Suite)

JAPANESE CREDITS: Dir: Taro Rin. Des: Yuhio Ashibe. Anime dir: Hiroshi Hamazaki. Prod: Madhouse. © E. Ikeda, Akita Shoton, Toei Video. 30 mins.
ORIGINS: Manga by Etsuko Ikeda, pub Akita Shoten.
CATEGORIES: H

This elegant horror tale gives ample evidence of the grounds for the high regard in which veteran director Taro Rin is held. The atmosphere of the manga, with its slowly developing hothouse tensions and erotic undertones, is subtly caught without detriment to the pacing of the anime story, and the film will strike chords with fans of the often surprisingly elegant and well-crafted British horror movies of the sixties and early seventies, such as *Eye of the Devil*. A young journalist is familiar — in the other worldly sense — with the demon Deimos, who leads her into strange adventures. In this one, a crippled orchid-grower and her fey younger brother have a great deal to hide, not just in their methods of cultivation but in their family history. A *tour de force* of refined suspense. ★★★★

BUBBLEGUM CRISIS 4: REVENGE ROAD

JAPANESE CREDITS: Dir: Hiroki Hayashi. Screenplay: Emu Arii. Chara des: Kenichi Sonoda. Music: Kaouji Makaino. Prod: AIC, Artmic. © Artmic, Youmex. 40 mins.
WESTERN CREDITS: US video release 1992 sub, 1994 dub, on AnimEigo; UK video

Bubblegum Crisis 4: Revenge Road

Toshimichi Suzuki. Chara des: Kenichi Sonoda. Music: Kaouji Makaino. Prod: AIC, Artmic. © Artmic, Youmex. 45 mins.
WESTERN CREDITS: US video release 1992 sub, 1995 dub, on AnimEigo; UK video release 1994 sub, 1995 dub, on Anime Projects, trans Michael House & Shin Kurokawa.
ORIGINS: Original story by Toshimichi Suzuki; 1987 OAV.
POINTS OF INTEREST: AIC are currently (early 1996) asking fan opinion and input via the Internet as to further Bubblegum Crisis adventures.
CATEGORIES: SF, H

Five girls are trying to escape a space station; only two succeed in getting to earth, damaging a shuttle and causing the loss of a one-man battlepod. A vampire is on the prowl in MegaTokyo, draining all the blood from the bodies of its victims. Priss befriends a young newcomer, Sylvie. The Knight Sabers are asked to help in recovering the lost battlepod and gradually learn that the space island was being used illegally to develop weapons for GENOM — and two such weapons, girl Bumas of a type that cannot repair damaged tissue without fresh human blood, have escaped. Sylvie is one of these 3-3-S 'Sexaroid' Bumas, and she is taking blood for her friend Anri, injured in the escape. She tries to steal the information needed to correct Anri's defect, and comes into conflict with the Knight Sabers. How can Priss hunt down her new friend? ★★★

CHALK COLOURED PEOPLE
(Eng trans for CHALK IRO NO PEOPLE)

JAPANESE CREDITS: Prod: Watase Seizo. © NEC Avenue. 54 mins.
CATEGORIES: A

Said to be an adventure story.

CRYING FREEMAN 1: PORTRAIT OF A KILLER

JAPANESE CREDITS: Dir: Daisuke Nishio. Screenplay: Higashi Shimizu. Anime dir: Koichi Arai. Art dir: Masahiro Sato & M. Nakamura. Music: Hiroaki Yoshino. Prod: Toei Doga. © Toei Doga, Toei Video. 50 mins.
WESTERN CREDITS: US video release 1993 on Streamline Pictures, their first mass-market video release, dub, Eng dialogue Greg Snegoff; UK video release 1994 on Manga Video.

release 1994 on Anime Projects, sub & dub, trans Michael House & Shin Kurokawa.
ORIGINS: Original story by Toshimichi Suzuki; 1987 OAV.
POINTS OF INTEREST: AIC are currently (early 1996) asking fan opinion and input via the Internet as to further Bubblegum Crisis adventures.
CATEGORIES: SF

When Priss is checked over in hospital after a minor tumble, she sees a young girl in a wheelchair who is terrified by the sound of motorbikes in the street. A vigilante in a superpowered car is hunting down motorcyclists, and the police are on his tail. Suspicion falls on J.J. Gibson, the injured girl's boyfriend. She was traumatised by a vicious attack by a gang of bikers and he's out for revenge. This time it's not Bumas who are the Knight Sabers' target, but Gibson has made some modifications to his car, the Griffon, that make it difficult even for the Knight Sabers to stop him. Can the bike Mackie's been building save the day? ★★★

BUBBLEGUM CRISIS 5: MOONLIGHT RAMBLER

JAPANESE CREDITS: Dir, storyboards & mecha des: Masami Obari. Screenplay:

ORIGINS: *Manga by Kazuo Koike & Ryoichi Ikegami. Eng trans pub Viz Communications 1993.*
CATEGORIES: X, M

Yo Hinomura is an internationally acclaimed potter until he gets inadvertently mixed up with the 108 Dragons crime syndicate and turned into a lethal killing machine known as Crying Freeman. One of his kills is witnessed by the lonely Emu Hino, but when he comes to eliminate her, she asks him to sleep with her first — she doesn't want to die a virgin. Meanwhile the Yakuza are co-operating with the police to track down Freeman because he killed one of their bosses. There's a huge bloodbath, but in the end Yo and Emu, realising they love each other, decide to leave their old lives behind and commit themselves to the 108 Dragons, which they will one day lead together. Of the two different English dubs the UK one is absolutely dire, with some deeply offensive fake-Chinese accents. The animation is fairly limited but the story is not without excitement. On the whole, though, a disappointing rendition of a fine manga. ★☆

CURSE OF THE UNDEAD — YOMA
(Eng title for GAI YOMA KAKUSEI, lit Evil Demon Purification)

JAPANESE CREDITS: *Dir: Takashi Anno. Script: Noboru Aikawa. Chara des: Matsuri Okuda. Prod: Toei Doga. © Kusunoki, Shueisha, Toho, MPS. c40 mins.*
WESTERN CREDITS: *US video release 1994 on AD Vision, on single 85 mins tape with part 2, sub, trans Masako Arakawa & Chris Hutts.*
ORIGINS: *Manga by Kei Kusunoki, pub Shueisha, based on Japanese history of the 15th-16th century.*
CATEGORIES: SH, P, H

The Japanese civil war is a time of disruption. When the great warlord Shingen Takeda dies, one of his ninja, Maro, tries to escape from the clan, and Maro's best friend Hikage is sent to hunt him down. After much danger he glimpses Maro in a strange village where the people seem to have no memories of their earlier lives; while staying there to try and see Maro again, he falls in love with Aya. But the village is really just a fattening ground for men and women who have lost their will to live and are being held in a state of happy forgetfulness as sacrificial food for a demon god, and Maro seems to have been drawn into its coils. When Hikage breaks the spell, Aya, remembering her past sadness, kills herself. ★★★

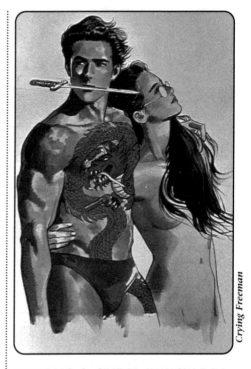

Crying Freeman

DANGAIO 2: SPIRAL KNUCKLE IN TEARS
(Eng title for HAJATAISEI DANGAIO II NAMIDA NO SPIRAL KNUCKLE, lit Giant Star Warrior Dangaio II Spiral Knuckle Tragedy)

JAPANESE CREDITS: *Dir & chara des: Toshihiro Hirano. Screenplay: Noboru Aikawa. Mecha des: Shoji Kawamori & Masami Obari. Anime dir: Kenichi Onuki. Art dir: Kazuhiro Arai. Storyboards: Koichi Ohata. Prod: AIC. © AIC, Bandai. c40 mins.*
WESTERN CREDITS: *US video release 1992 on US Renditions, sub, trans Trish Ledoux & Toshifumi Yoshida; UK video release 1994 on Manga Video, dub, edited onto one tape with Dangaio 1 & 3.*
ORIGINS: *1987 OAV.*
POINTS OF INTEREST: *US release also includes a 10-minute prologue recounting 'the story so far'. This was the only portion of the first episode to make it into the Manga Video UK release.*
CATEGORIES: SF, X

A testing time for Lamda as she and her companions face three of Galimos' most powerful servants, one of whom revives hidden memories. Lamda was a Princess on her home planet, and one of the three

sent to kill her was once one of her ladies. Now under Galimos' control, she is out to kill her former charge. Can Dangaio overcome her powerful mecha, and can Lamda really kill an old friend? Dubbed for the UK with the addition of excessive bad language, and badly edited, this standard giant robot offering is seriously wounded. ★☆

DIRTY PAIR II
(Eng ep titles: Challenge to the Gods! We're Not Afraid of Your Divine Wrath, and They're Only Kids? Wargamers Must Die)

JAPANESE CREDITS: Prod: Sunrise for VAP Video. © Takachiho, Studio Nue, Sunrise, NTV. Each 25 mins.
ORIGINS: Novels by Haruka Takachiho; appearance in 1983 movie Crushers; 1985 TV series & OAV; 1987 movie & OAV.
CATEGORIES: SF, A

The success of the VAP Video re-release of the TV series episodes, and the sale of the show to Italian TV requiring additional episodes, led to ten new OAVS, released two to a tape from December 1987 through this year. The first episode on this tape shows the Pair dealing with a rogue computer system and religious fanatics on planet Hazaru. In the second, they have to sort out a group of children who take over an experimental centre on planet Amega to demand, among other things, more anime on TV. ★★★

Also:
DIRTY PAIR III
(Eng ep titles: And Then No One Played, and What!? A Surprise Seaside Wedding Panic)

CREDITS, ORIGINS, CATEGORIES: As above.

Two more OAV episodes. The first involves Kei and Yuri helping out a colleague who is a gambling addict (see the Angels in evening dress!) and the second brings Yuri to the altar as the Pair try to uncover a counterfeit banknote racket. A fan fantasy favourite, it not only has Yuri in a wedding gown but Kei dressed as a waitress and a nun! ★★★☆

Also:
DIRTY PAIR IV
(Eng ep titles: Rigged Revenge of the Muscle Lady, and This Girl Is My Elder! Sleeping Beauty)

CREDITS, ORIGINS, CATEGORIES: As above.

The Pair's old friend Sandra has got mixed up in a racket involving wrestlers and anabolic steroids.

They eventually stamp out the drug ring, but at a high price. In the second episode we meet Tia, the only survivor of a tragedy aboard the good ship *Swan*; her father's ex-assistant is determined to have control of his boss's research at any cost. ★★★

Also:
DIRTY PAIR V
(Eng ep titles: Slaughter Squad! Red-Eyed Hell Signal, and Evil Speaks For Itself! Space Truckers)

CREDITS, ORIGINS, CATEGORIES: As above.

A terrorist group is causing disruption to peace negotiations; Kei and Yuri are brought in, and naturally enough the slaughter, destruction and chaos escalate. In the second story, the Pair get involved with an investigation into strange incidents involving interplanetary transport companies, and go undercover disguised as space truckers. ★★★

DOCTOR CHICHIBUYAMA

JAPANESE CREDITS: Prod: Pony Canyon. © Fuji, Pony Canyon, Ashi. 30 mins.
CATEGORIES: C

No information about this other than that it is a comedy.

DOMINION TANK POLICE ACT I
(Eng title for DOMINION HANZAI GUNDAN, lit Dominion Crime Corps)

JAPANESE CREDITS: Dir, screenplay & storyboards: Koichi Mashimo. Chara des & anime dir: Hiroki Takagi. Art dir: Mitsuharu Miyamae. Prod: Agent 21. © Shirow, Hakusensha, Agent 21, Toshiba Video Soft. 40 mins.
WESTERN CREDITS: US video release 1991 on US Manga Corps, one Act per tape, sub, trans Trish Ledoux & Toshifumi Yoshida; also US release of UK dub on US Manga Corps, 1993, 2 Acts per tape; UK video release 1993 on Manga Video, dub, 2 Acts per tape.
ORIGINS: Masamune Shirow's manga, Eng trans pub by Dark Horse Comics.
POINTS OF INTEREST: The UK release has a redubbed and remixed music track, replacing the original Japanese songs with specially written English ones.
CATEGORIES: SF, C

Shirow wrote *Dominion* as a bit of a giggle, a diver-

sion from his 'serious' works such as *Appleseed*. The title is a joke — the 'crime corps' refers to the Tank Police, as much a problem for the good folk of futuristic metropolis Newport City as the pollution which makes the air all but unbreathable and the criminals they pursue with such lunatic determination. Leona Ozaki is a new recruit to the corps, determined to do well. With the help of her driver Al, who loves her devotedly, and her handbuilt mini-tank Bonaparte, on which she lavishes all her affection, she and the rest of the Tank Police are on the track of the notorious Buaku Gang, genetically engineered misfits whose crime spree has another, greater purpose. Buaku's principal sidekicks are Annapuna and Unipuma, sexy cat-girl twins whose main purpose in life seems to be to cause mayhem. It's an open question whether Newport City can afford justice as meted out by the Tank Police, whose capacity for demolition and affinity for disaster is almost as great as that of the Dirty Pair. ★★★

Also:
DOMINION TANK POLICE ACT II
(Eng title for DOMINION ACT II HANZAI SENSO, lit Dominion Act II Crime War)

CREDITS, ORIGINS, CATEGORIES: As above except: US release trans Neil Nadelman.

The Tank Police are on the trail of the Buaku Gang after their raid on the hospital. The only thing stolen appears to have been samples of urine from perfectly healthy patients. What is Buaku after? Leona and Captain Brenten of the Tank Police don't much care to ponder the issue; they just want to capture him. The massed ranks of the Tank Police set out in hot pursuit, but a cargo of giant self-inflating dildos dumped in the road might just hamper their progress a bit. ★★★

DRAGON CENTURY DIVINE CHAPTER AD 1990
(Eng trans for RYUSEIKI SHINSHO AD 1990)

JAPANESE CREDITS: Dir & chara des: Hiroyuki Kitazume. Prod: AIC. © Kubo Shoten. 30 mins.
CATEGORIES: DD

Riko hates the ugliness of urban life and sometimes wishes her city could be destroyed. When dragons start to appear in the world, it seems as if her wish might come true. Naturally the Government does what people normally do in the face of something they don't understand — it has the dragons killed. Only one baby, rescued and named Carmine by Riko, survives. They are tracked down by Shoryu, a

soldier whose colleagues were killed during a dragon-hunt and who wants revenge; but before he can finish off the young dragon, monsters appear — demons, feeding on the evil thoughts of corrupted human hearts. Carmine tells Riko that soon she will have her wish and the world she hated will be destroyed, because the dragons were sent to the human world to fight these demons and he is the only one left alive. She realises that she doesn't want the world destroyed, but only the ugliness created by mankind, and she and Carmine go to fight the Demon King with Shoryu's help. As Riko dies in the attempt to wipe the world clean of ugliness, the sky cracks open and hordes of dragons fly through to defeat the demon hordes. ★★★?

Also:
DRAGON CENTURY DEMON CHAPTER RC 297 RURISHA
(Eng trans for RYUSEIKI MASHO RC 297 RURISHA)

CREDITS, CATEGORIES: As above.

Three hundred years after the demon invasion was defeated, Earth has still not recovered from the attack and is in a post-apocalyptic state. The dragon Carmine is still there, keeping his promise to Riko to guard her world. A young girl called Rurisha finds him and names him Vermilion, taking him to fight in the Ryuto (Dragon fighting) tournament, a sport at which her father was a master before he was killed. She is determined to find and beat the black dragon that killed him. Relations between humans and dragons are not all they might be, but demons are still around, and are gathering their forces to attack the remnants of human civilisation. Just as they did 300 years ago, the dragons must once again fly to the defence of mankind. ★★★?

DRAGON'S HEAVEN

JAPANESE CREDITS: Des: Makoto Kobayashi. Prod: AIC. © AIC, Toshiba EMI. 45 mins.
ORIGINS: Manga by Makoto Kobayashi.
POINTS OF INTEREST: The mecha designs are some of the most unusual ever presented — a classic example of form in flight from function and a contrast to the 'real robot' shows such as Dougram. Kobayashi cites Jean 'Moebius' Giraud as one of his major influences.
CATEGORIES: SF

In 3195 began a great war which destroyed most of civilisation, a war between human armies using

mechanical warriors which rapidly became more powerful than the humans they were made to serve. The robot Shaian lay dormant for a thousand years after the death of his human operator, but is accidentally revived by the girl Ikaru, travelling and scratching a living since the death of her father when their town was destroyed by the all-conquering Brazilian Imperial Army. Shaian asks for her help in finding an old enemy, El Medain, robot commander of the Brazilian forces; he tells her that he needs a human operator to function at full capacity, and that with her help he can defeat El Medain. After some hard fighting the pair are victorious, and head off together into the wastelands as a new team. ★★★

FANTASY KINGDOM WAR PART 1, THE GOLDEN DRAGON
(Eng trans for SHINSHU RINIHEN KAN NO ICHI OGON NO RYU)

JAPANESE CREDITS: Prod: Magic Bus. © Japan Communication. 30 mins.
CATEGORIES: DD

I have no other information.

FASHION LALA: THE STORY OF THE HARBOUR LIGHT
(Eng trans for HARBOUR LIGHT MONOGATARI FASHION LALA YORI)

JAPANESE CREDITS: Prod: Studio Pierrot. © Pierrot Project. 50 mins.
CATEGORIES: N, DD, U

Trading on the popularity of the 'magic girls' theme, the story opens with a ballet contest, and Miho is trying to finish a beautiful costume for her little sister Shuri. The contest is delayed by the sponsor's son, who seems to want to stop it going ahead, and during the delay the girls' aunt ruins Shuri's costume. Miho is in despair, but during the night she is visited by a good fairy who transforms her into Lala, a top designer. The ending is apparently a bit of a cop-out — it's all been a dream! ★★☆?

GALL FORCE III: STARDUST WAR

JAPANESE CREDITS: Dir: Katsuhito Akiyama. Screenplay & original story: Hideki Kakinuma. Chara des: Kenichi Sonoda. Mecha des: Rei Yumeno. Music: Ichizo Sei. Prod: Artmic, AIC. © MOVIC, CBS Sony. 60 mins.
WESTERN CREDITS: US video release 1994

on US Manga Corps, sub, trans Neil Nadelman.
ORIGINS: Original story by Hideki Kakinuma; 1986 movie; 1987 OAV.
CATEGORIES: SF

The new race on Terra is now free to develop in peace thanks to the efforts and sacrifices seen in the previous movie and OAV. But the Solnoid and Paranoid remnants are doomed, determined to annihilate each other. A new team is set up — the android Catty joins Shildy, Lufy, Spea and Ami to try to avert the final conflict in the hope that the last members of both races can still have a future together. The Gall Force mixture of heroic young women and impossible odds works again. ★★★

GOD MARS: LEGEND OF SEVENTEEN
(Eng title for ROKUSHIN GATTAI GOD MARS JUNANANSAI NO DENSETSU, lit Six Gods in One Body God Mars: Seventeen-Year-Old's Legend)

JAPANESE CREDITS: Dir: Tetsuo Imazama. Prod: Tokyo Movie Shinsha. © Hikaru Prod, TMS, Toho Video. 56 mins.
ORIGINS: Manga by Mitsuteru Yokoyama; 1981 TV series.
CATEGORIES: SF

Marg is one of twin boys whose parents have been killed by the emperor of Gishin. Rescued from danger by a rebel group, he lives in their village and falls in love with the beautiful Lulu, but the Government forces find them and massacre almost everyone. Brainwashed into serving his former enemy, Marg becomes a ferocious fighter on the Emperor's side. Meanwhile his twin has grown up on another planet, Earth, and is pilot of the giant robot God Mars, part of a team sworn to fight evil such as that of the empire. The two brothers are fated to meet again in mortal combat. Is there such a thing as a blood-tie that nothing can break? It's interesting to look at this OAV, made in the same year as Patlabor, yet faithful to its much older roots and with intense emotional content. ★★

GO FOR IT! KICKERS — OUR LEGEND
(Eng trans for GANBARE KICKERS BOKURA NO DENSETSU)

JAPANESE CREDITS: Dir: Akira Sajino. Des: Takeshi Ozaka. Prod: Studio Pierrot. © SPO.

90 mins.
ORIGINS: Manga by Yuji Nunokawa;
TV series.
CATEGROIES: N

Another story about a young footballer who wants
to become a champion. The OAV is a musical jour-
ney through the highlights of the TV series.

GUNBUSTER
**(Eng title for TOP O NERAE! GUNBUSTER,
lit Aim for the Top! GunBuster)**

*JAPANESE CREDITS: Dir: Hideaki Anno.
Chara des: Haruhiko Mikimoto. Mecha des:
Koichi Ohata & Kazuki Miyatake. Art dir:
Masumi Higuchi. Music: Kohei Tanaka.
Prod: Gainax. © Gainax, Bandai, Victor.
55 mins.
WESTERN CREDITS: US video release 1992
on US Renditions, one of the company's first
2 releases, trans Deborah Grant & Yuki
Nakashima; UK video release 1994 on Kiseki
Films; both sub.
POINTS OF INTEREST: One of veteran voice
actor Norio Wakamoto's great roles as
Coach Ota.
CATEGORIES: SF*

The first of a six-part series, telling the story of
orphan Noriko Takaya, who dreams of following
her father into space but is such a klutz at school
that she can't even master the RX-7 training robot.
Encouraged by Coach Ota, who sees her potential,
by her friend Kimiko who keeps reading her horo-
scope, and by senior class heroine Kasumi Amano,
whom she admires, Noriko perseveres and is even-
tually selected for the top secret GunBuster project.
Beautifully animated and full of engaging and
rather well-developed schoolgirls, *GunBuster* has
more to offer than the bouncing boobs that have
made it famous among 'ecchi' (perverted) fans.
One of its great charms is the spurious but very
convincing little 'science lessons' taken by the
characters in SD mode after each episode. ★★☆

HADES PROJECT ZEORYMER
(Eng trans for MEIOU KIKAKU ZEORYMER)

*JAPANESE CREDITS: Dir: Toshihiro Hirano.
Script: Noboru Aikawa. Chara des:
Michitaka Kikuchi. Music: Eiji Kawamura.
Prod: AIC. © AIC, Artmic, Chimi. 30 mins.
WESTERN CREDITS: US video release 1993
on US Manga Corps, on one tape with part
2, sub, trans Neil Nadelman.*

*ORIGINS: Original story by Morio Chimi.
CATEGORIES: SF*

Fifteen years ago scientist Masaki Kihara rebelled against
the Haudragon criminal organisation, destroyed seven
of the Hakkeshu, the huge mecha he had created for
them, and hid the eighth, the most powerful of all,
Zeorymer. Now the seven mecha are rebuilt and the
Hades Project can go forward as planned. Masato Akita
discovers that his entire life has been a lie. His 'parents'
were paid by the Government to raise him, and now the
Government intends that he should do what he was,
apparently, born for — pilot Zeorymer, but against the
Haudragon. In this he is to be helped by Miku, a girl
who works for the Government body which has guard-
ed Zeorymer ever since Masaki Kihara hid it. Masato
and Miku are successful in their first encounter, killing
the lover of Yuratei, the Haudragon leader, and destroy-
ing his Hakkeshu. The rest of Haudragon is now bent on
revenge. Striking designs and a complex plot based
around the I Ching complement a character-driven
drama. ★★★

HIGH SCHOOL AGENT

*JAPANESE CREDITS: Screenplay: Izo
Hashimoto. Prod: Agent 21. © Toei Video.
30 mins.
CATEGORIES: A*

Kosuke Kanemori is an ordinary high school boy
who gets entangled with a group calling them-
selves the UN. His first mission is to go to Spain
and steal a treasure from the Madera Palace. What
is the importance of the Egg of Basku? ★★?

Also:
HIGH SCHOOL AGENT II

CREDITS, CATEGORIES: As above.

Kosuke has to steal a gold bar from the submarine
U-Boot. It used to belong to Hitler and it holds the
key to leadership of a new right-wing movement.
When it is taken from him by the ambitious Mina,
Kosuke infiltrates the movement's headquarters to
get it back. ★★?

HIGH SCHOOL CONVENIENCE STORE SERIES ANTIQUE HEART
**(Eng trans for GAKUEN BENRIYA SERIES
ANTIQUE HEART)**

*JAPANESE CREDITS: Prod: Animated Film.
© Toshiba EMI. 40 mins.
CATEGORIES: H*

A horror story with a twist. Three lads turn up on-site to demolish an old school building. The ghost of the beautiful Saki tries to persuade them not to go ahead by telling them her tragic story, but their orders are to press on regardless. ★★?

HURRICANE LIVE 2032

JAPANESE CREDITS: Prod: Artmic. © Artmic, Youmex. 25 mins.
WESTERN CREDITS: US video release 1992 on AnimEigo; UK release 1994 on Anime Projects, trans Michael House & Natsumi Ueki.
ORIGINS: Bubblegum Crisis OAV series.
CATEGORIES: SF

By popular demand, the Knight Sabers in concert present some of their most famous numbers. The video is shot, edited and promoted as a 'live' concert video, with the characters, Priss, Linna, Nene and Sylia, as the band — an unusual approach to Western thinking, but normal in anime where characters assume a popularity quite separate from that of the real actors who play them. ★★★

JAPANESE GHOST STORIES
(Eng trans for NIHON NO OBAKE BANASHI)

JAPANESE CREDITS: Prod: O Production. © Toshiba EMI. 30 mins.
ORIGINS: Folktales.
CATEGORIES: H

Also:
JAPANESE GHOST STORIES II
(Eng trans for NIHON NO OBAKE BANASHI II)

CREDITS, ORIGINS, CATEGORIES: As above.

The traditional ghost stories and folktales of Japan play a big part in its popular culture. As current hit TV series like *Yu Yu Hakusho* and *Ghost Sweeper Mikami* demonstrate, Japanese kids find nothing too weird about the idea of dealing with ghosts on an everyday basis. The OAV series presents several ghost stories, with spectres ranging from a vengeance-hungry spirit to a girl who died young but returns to the world to be by her fiancé's side. ★★?

KIMAGURE ORANGE ROAD: I WANT TO RETURN TO THAT DAY

(Eng trans/title for KIMAGURE ORANGE ROAD ANO HI NI KAERITAI, aka ORANGE ROAD THE MOVIE)

JAPANESE CREDITS: Dir: Osamu Kobayashi. Chara des: Akemi Takada. Prod: Studio Pierrot. © I. Matsumoto, Shueisha, Toho, Studio Pierrot. 70 mins.
WESTERN CREDITS: US video release 1995 on AnimEigo, sub, trans Richard Uyeyama & Shin Kurokawa.
ORIGINS: Izumi Matsumoto's manga, pub Shueisha; 1987 TV series.
POINTS OF INTEREST: Kimagure, usually rendered 'Capricious' in this context, actually means 'caprices' (in the sense of follies or escapades) — so the closest rendition of the title is probably 'Orange Road Follies'!
CATEGORIES: DD, R

The series, a big fan favourite in the USA, covers the trials and tribulations of Kyosuke, who is not only one of a psychic family and plagued with two unscrupulous younger sisters, but also the centre of a love triangle. His classmate Hikaru loves him, he fancies their mutual friend Madoka like crazy, Madoka loves him but doesn't want to hurt Hikaru. Madoka also has family problems of her own. The 'movie' shows Kyosuke reflecting on the events which resolved the triangle as he and Madoka prepare to go to university. ★★★?

LEGENDARY MAH JONG ADVENTURE: THE WEEPING DRAGON
(Eng trans for MAH JONG SHODEN NAKI NO RYU)

JAPANESE CREDITS: Prod: Gainax, Magic Bus. © Bandai. 45 mins.
ORIGINS: Manga.
CATEGORIES: N, M

Mah jong champion Ryu (nicknamed Nakino) is usually very lucky, but his luck turns. Yakuza boss Ishikawa decides he wants Ryu to represent his family, and makes him an offer he'd be foolish to refuse.

LEGEND OF GALACTIC HEROES VOLS 1 & 2
(Eng trans for GINGA EIYU DENSETSU I & II)

JAPANESE CREDITS: Dir: Noboru Ishiguro. Script: Takeshi Shoji. Prod: Artland. © Y. Tanaka, Tokuma Shoten, Kitty Enterprise. Each 30 mins.
ORIGINS: Novel series by Yoshiki Tanaka; 1988 movie.
CATEGORIES: SF, W

The first two episodes of a massive series still in the making. Two young commanders on opposing sides, Yang Wen-Li and Reinhart Von Lohengrimm, formerly known as Von Musel, are engaged in a vast space battle between the Free Planets Alliance and the Empire. Both are brilliant commanders, and their fates are linked. For the moment Reinhart's luck is running higher and his skills prevail. Yang loses a good friend in the battle and has to bring the news home to his fiancée, while his opponent brings his adored older sister Annerose, the Emperor's mistress, a glorious victory as a birthday gift. In these first two episodes with their huge, slow-moving space battles and detailed character building we can see the mapping out of relationships both personal and political which are still evolving in the fourth series at present. ★★★

LEGEND OF THE OVERFIEND II — CURSE OF THE OVERFIEND
(Partial Eng trans for CHOJIN DENSETSU UROTSUKIDOJI II, lit Legend of the Overfiend: The Wandering Kid II, aka WANDERING KID, US aka UROTSUKIDOJI PERFECT COLLECTION)

JAPANESE CREDITS: Dir: Hideaki Takayama. Writer: Goro Sanjo & Noboru Aikawa. Music: Masamichi Amano. Prod: AIC. © T. Maeda, Westcape Corp, JAVN. 54 mins.
WESTERN CREDITS: Edited with the first OAV into the movie version, Legend of the Overfiend, UK video release 1993 on Manga
Video; US video release 1993 on Anime 18. US video release as part of Urotsukidoji Perfect Collection 5-OAV set in unedited format 1993 on Anime 18.
ORIGINS: Manga by Toshio Maeda; 1987 OAV.
CATEGORIES: X, V, H

Nagumo and Akemi are together as though nothing had happened, and very happy. Niki, a timid nerd who also loves Akemi, is unhappy at home and bullied at school. He meets two demons who offer him huge powers for a high price. After Akemi and Nagumo have been indulging in some heavy petting, he kidnaps her and licks her face, swallowing some of Nagumo's sperm and thereby absorbing some of the powers of the Chojin. When he and Nagumo face off, he is transformed into a terrifying creature. Meanwhile Amanojaku is still fighting to understand what the Chojin's coming will mean to the worlds of men, demons and his own people. It's easier to follow the story and the underlying ideas in the unedited OAV format, but *Legend of the Overfiend* will (simply by the nature of its content) offend many and horrify some. ★★

LEINA STOL I: LEGEND OF THE WOLFBLADE
(Eng trans for KENRO DENSETSU I LEINA STOL)

JAPANESE CREDITS: Prod: Ashi. © Ashi, Toshiba EMI. 30 mins.
ORIGINS: The 2 Machine Robo TV series,

Legend of the Overfiend

1986 & 1987.
POINTS OF INTEREST: *The series were based around Bandai's Transformer-like Machine Robo toy line, marketed in the West as Robo Machines and Gobots, from which the awful US cartoon series was spawned. The Japanese were luckier.*
CATEGORIES: DD

Also:
LEINA STOL II: LEGEND OF THE WOLFBLADE
(Eng trans for LEINA KENRO DENSETSU II)

CREDITS, ORIGINS, CATEGORIES: As above.

In a Japanese high school, pupils are mysteriously disappearing. Leina Stol, a Kronos warrior and sister of Rom Stol, *Machine Robo*'s hero, decides to disguise herself as a pupil to investigate. Doffing her fantasy bikini armour, she dons a Japanese school uniform and soon makes friends. When one of her new friends, Yuko Sano, vanishes without trace during a trip to town, Leina goes into action to find the perpetrators. ★★?

MADONNA FIRE TEACHER
(Eng trans for MADONNA HONO NO TEACHER)

JAPANESE CREDITS: Prod: Studio Uno. © Toei Video. 50 mins.
CATEGORIES: N

Mako Domon has been looking for a job for quite some time when she is at last offered a place as a teacher in a school for disturbed youngsters. It's almost too much for her, but when she is on the point of resigning the Head asks her to take over as coach of the football team, and through the team she finally makes contact with the juvenile delinquents in her care. She starts to see them as people and help them effectively. This is apparently another of those sports soaps the industry is so fond of, but I haven't seen any pictures or artwork.

MATASABURO OF THE WINDS
(Eng trans for KAZE NO MATASABURO)

JAPANESE CREDITS: Dir: Taro Rin. Prod: Project Team Argos. © Konami. 30 mins.
ORIGINS: Story by Kenji Miyazawa.
CATEGORIES: DD

In this classic tale by a famous Japanese writer, the mysterious Saburo Takada is transferred to a small country school in a beautiful mountainous region.

One of his classmates decides that he is really Matasaburo, the Wind Imp, son of the Wind God — though teacher insists his father is a mining engineer come to work in the area. Considering the excellent geneaology of this production I'm surprised to have found only sketchy references and no pictures in the sources available to me, and therefore can't give it a rating.

MONSTER CITY
(Eng title for MAGAI TOSHI SHINJUKU, lit Demon City Shinjuku, aka HELL CITY SHINJUKU, US aka DEMON CITY SHINJUKU)

JAPANESE CREDITS: Dir & chara des: Yoshiaki Kawajiri. Screenplay: Kaori Okamura. Backgrounds: Masao Maruyama. Anime dir: Naoyuki Onda. Art dir: Yuji Ikeda. Music: Osamu Shoji. Prod: Madhouse. © Kikuchi, Asahi Sonorama, Japan Home Video. 82 mins.
WESTERN CREDITS: US video release 1993 on US Manga Corps as Demon City Shinjuku, trans Neil Nadelman; UK video release 1994 on Manga Video.
ORIGINS: Novel by Hideyuki Kikuchi.
CATEGORIES: H, V

Madhouse's reputation for action-horror was furthered by this chilling City-Gothic piece which pits young hero Kyoya, heir to the powers of his father the great mage Genichiro, and Kyoko, daughter of a politician who has been taken hostage by the powers of darkness, against Revi Ral, the wielder of those powers, who has turned Tokyo's renowned Shinjuku district into a reasonable facsimile of Hell. Influences from Dante to Cocteau, Japanese folklore to nightmare build an environment rich with unnerving resonances as the pair, helped by unexpected allies, negotiate the labyrinth of terrors to finally defeat the monster, revealing the pure outline and ambiguous ending of a fairytale under the masterfully executed modern trappings. ★★★★

ONE POUND GOSPEL
(Eng title/trans for ICHI POUND NO GOSPEL)

JAPANESE CREDITS: Dir: Makura Saki. Screenplay: Hideo Takayashiki & Tomoko Konparu. Chara des: Katsumi Aoshima. Anime dir: Shojuro Yamauchi. Prod: Studio Gallopp. © R. Takahashi, Shogakukan. 55 mins.
WESTERN CREDITS: US video release 1995 on Viz Video, exec script editor Trish Ledoux, sub by Studio Nemo.

ORIGINS: Manga by Rumiko Takahashi, pub Shogakukan, Eng trans pub 1995 by Viz Communications.
CATEGORIES: N

Sister Angela is a novice nun and Kosuke Hatakana is a young boxer. He adores food and has real problems keeping to his fighting weight, which means that he has never fulfilled his true potential and drives his coach to despair. Her concern for the young man and his future goes beyond the detached compassion expected of a nun. Determined not to make him ashamed of him or betray her confidence in his ability, Kosuke seems finally set to prove himself — his big chance is coming. A light-hearted look at a very unusual relationship from the woman known as the 'manga Princess', better known in the West for fantasy. ★★★

PATLABOR
(Eng title for KIDO KEISATSU PATLABOR, lit Mobile Police Patlabor)

JAPANESE CREDITS: Dir: Mamoru Oshii. Script: Kazunori Ito. Chara des: Akemi Takada. Mecha des: Yutaka Izubuchi. Anime dir: Kazuya Kise. Art dir: Hiromasa Ogura. Photography dir: Shigeo Sugimura. Sound des dir: Shigeharu Shiba. Music: Kenji Kawai. Prod: Studio Dean. © Headgear, Tokuma Shoten, Bandai. 30 mins.
WESTERN CREDITS: The 2 movies based on the Patlabor concept were released theatrically on video by Manga Entertainment in the UK & USA in 1995. The TV series & OAVs are scheduled for video release in the USA on US Manga Corps starting in autumn 1996.
ORIGINS: Story & manga by Masami Yuuki, pub Shogakukan.
CATEGORIES: SF, N

Tokyo, 1998. Ozone depletion has led to rising sea levels worldwide, and low-lying cities, Tokyo especially, are planning to stave off impending disaster. The Babylon Project, a massive land reclamation venture in Tokyo Bay, has led to increased use of huge powered suits called labors, and this in turn has led to the use of labors by criminals. A new police force is formed to combat labor crime, and the force is itself equipped with patrol labors — 'patlabors'. In this first episode of the series which has become a multimedia phenomenon, rookie Noa Izumi has arrived on base for the first time when crooks make off with the new Ingram

labor. Throwing caution and dignity to the winds, she gives chase and saves the day. Lighter in tone and with more comedy elements than the later *Patlabor* movies, the OAV series is one of the most enjoyable ever created and gets off to a winning start with this car (and foot and moped and labor) chase story. ★★★★

Also:
PATLABOR II LONG SHOT
(Eng title for KIDO KEISATSU PATLABOR VOL II LONG SHOT, lit Mobile Police Patlabor Vol II Long Shot)

CREDITS, ORIGINS, CATEGORIES: As above.

Clancy Kanuka, a commander in the New York police and a third generation Japanese-American, takes personal responsibility for the safety of the Mayor of New York during his civic visit to Tokyo. Meanwhile the Special Vehicle Division is trying to foil a group of terrorists who have planted a bomb to kill the distinguished visitor. Gripping stuff. ★★★☆

Also:
PATLABOR III THE 450 MILLION YEAR TRICK
(Eng title for KIDO KEISATSU PATLABOR VOL III YONOKUGOSENMANNEN NO WANA, lit Mobile Police Patlabor Vol III The 450 Million Year Trick)

CREDITS, ORIGINS, CATEGORIES: As above.

Weird goings-on in Tokyo Bay, disturbed by the Babylon Project — people and cars are simply vanishing, pulled mysteriously into the sea. The Special Vehicle Division have a mad — very mad — scientist to deal with, and he's dumped something big and nasty into the water. A touch of the off-the-wall fantasy of *The Avengers* in this adventure. ★★★☆

Also:
PATLABOR IV THE TRAGEDY OF L
(Eng title for KIDO KEISATSU PATLABOR VOL IV L NO HIGEKI, lit Mobile Police Patlabor Vol IV The Tragedy of L)

CREDITS, ORIGINS, CATEGORIES: As above.

The team are at a training centre when they start to see strange things; the bath water runs blood-red, the ghost of a young girl appears at a window, and what seems to be the spectre of a robot pops out of nowhere. Asuma decides to investigate, and everyone on the team learns that things are not

always what they seem. A 'trick ending' story. ★★★

Also:
PATLABOR V & VI SECTION 2'S LONGEST DAY, ACT 1 & 2
(Eng title for KIDO KEISATSU PATLABOR VOL V NIKA NO ICHIBAN NAGAI HI ACT 1 & 2, lit Mobile Police Patlabor Vol V Section 2's Longest Day Act 1&2)

CREDITS, ORIGINS, CATEGORIES: As above.

Two-part story in which the members of SVD Section Two go off-base for some R & R at home, while in Tokyo a terrorist group prepares to threaten the Government of Japan with a stolen American nuclear missile. Called back to work, Goto and his team have to find and defeat the group which calls itself Kekigun before Japan suffers yet another nuclear disaster. ★★★☆

PEACOCK KING: FEAST FOR RETURNING DEMONS
(Eng trans for KUJAKU-O KIKANSAI)

JAPANESE CREDITS: Dir: Katsuhito Akiyama. Screenplay: Noboru Aikawa. Chara des: Masayuki. Prod: AIC. © AIC, Pony Canyon. 55 mins.
ORIGINS: Japanese & Chinese legend.
POINTS OF INTEREST: A 1988 live-action version featuring martial arts star Yuen Biao was made as a Japanese-Hong Kong co-production.
CATEGORIES: H, SH

The sinister Tatsuma is up to no good. A statue of the god Ashura is stolen from the temple at Nara and young avatar Kujaku's sensei Ajari, and his fellow-avatar and friend Ashura, suspect that Tatsuma means to use it to resurrect a demon. They're right. Tatsuma has fearsome psychic powers which he has never been taught to control or use properly, and is seeking to test them out, while evil black magic master Onimaru is out to take advantage of the situation. The most dangerous of demons were imprisoned in the statues at Nara, and if even one of them is released the results could be disastrous for mankind. Executed very much in the contemporary, 'Madhouse-type' style of anime folktale updates, this OAV has plenty of demonic rumblings as the young avatar of an ancient god fights off terrifying opponents; but measured against the real Madhouse McCoy its pacing lacks something, though the art and detail are good. ★★★

PROJECT A-KO III: CINDERELLA RHAPSODY

JAPANESE CREDITS: Dir, chara des & anime dir: Yuji Moriyama. Screenplay: Tomoko Kawasaki. Original idea: Katsuhiko Nishijima, Yuji Moriyama & Kazumi Shiraishi. Art dir: Satoshi Matsudaira. Music dir: Yasunori Honda. Prod: Studio Fantasia. © Final Nishijima, Soeishinsha, Pony Canyon. 50 mins.
WESTERN CREDITS: US video release 1994 on US Manga Corps, sub & dub, trans Pamela Ferdie & William Flanagan, Eng rewrite Jay Parks, lyrics rewrite David Mayhew; UK video release 1995 on Manga Video, dub.
ORIGINS: Story by Katsuhiko Nishijima, Kazumi Shiraishi & Yuji Moriyama; 1986 movie; 1987 OAV.
CATEGORIES: C, SF

Love is in the air when A-Ko meets Kei, and decides she has to get a special dress to impress him at the big dance. She gets a part-time job in a fast food restaurant to save for the dress of her dreams. Of course, what A-Ko wants, B-Ko has to have, and she determines to rob her rival of both the outfit and the man. But they're both wasting their time because Kei has seen C-Ko and lost his heart to her incredible cuteness. The bubblebrain, however, hates him because he's taking A-Ko's attention away from her. The whole thing boils over into a huge fight at the best disco party in town, sited on that crashed alien battlecruiser and hosted by none other than Captain Napolipolita and Agent D. The opening and closing credit sequences with artwork by Yasuomi Umetsu, animated in a soft and beautiful 'realistic' style, and sadly missing from the UK release, are worthy of special note, as are the numerous 'guest appearances' paying affectionate tribute to anime and kaiju eiga icons. That insane A-Ko magic works once again. ★★★☆

SALAMANDER BASIC SAGA: MEDITATING PAOLA
(Eng trans for SALAMANDER BASIC SAGA MEISO NO PAOLA)

JAPANESE CREDITS: Dir: Hisayuki Toriumi. Chara des: Haruhiko Mikimoto. Mecha des: Tatsuharu Moriki. Prod: Studio Pierrot. © Studio Pierrot, Konami Video. 50 mins.
WESTERN CREDITS: UK video release 1995 on Western Connection, sub.
ORIGINS: The computer game Gradius;

original story by Kazusane Hisashima.
CATEGORIES: DD, A, U

The evil Bacterian, galaxy-devouring parasites, are heading for planet Gradius, and ace pilot Stephanie's father is missing. A beautiful girl is found floating in an abandoned spaceship; back on the planet she tells them her name is Paola and warns of an approaching Bacterian invasion. As Stephanie becomes convinced she can hear her father speaking to her, the others wonder how far to trust Paola. Is she an agent of destruction in disguise? This looks just beautiful, but overall it's pretty dire and unless you're a really dedicated *Gradius* or Mikimoto fan you won't want to watch it to the end. ★

Also:
SALAMANDER INTERMEDIATE SAGA
(NOTE: This is the only part of the series with no sub-title)

CREDITS, ORIGINS, CATEGORIES: As above.

The Bacterian are nasty galactic parasites with a very aggressive bent. When they invade his planet, the tall, blond and gorgeous Lord British calls on three heroic warriors from planet Gradius to help him. Eddie, Stephanie and Dan and their ultra-powerful spacecraft are just the team to deal

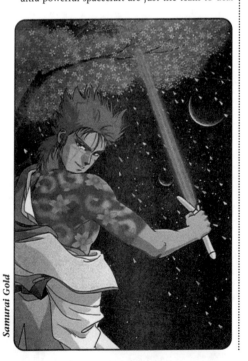

Samurai Gold

with the problem, providing they can sort out their own problems first. When this video was released in the UK, an ecstatic fan wrote to me that 'if you had a points bar at the top of the screen it would be exactly like playing the game' and he's right. This might appeal to game freaks, and the Mikimoto designs are beautiful; but the story is most kindly described as weak — I was bored out of my skull. ★

SAMURAI GOLD
(Eng title for TOYAMAZAKURA UCHUCHO YATSU NO NA WA GOLD, lit Cosmic Commander of the Toyama Cherry Trees: The Guy's Name is Gold)

JAPANESE CREDITS: Dir: Atsutoshi Umezawa. Screenplay: Akiyoshi Sakai. Music: Kentaro Haneda. Prod: Toei Doga. © Toei Doga, Tokuma Shoten. 60 mins. WESTERN CREDITS: 1994 UK video release on Western Connection, sub, trans Jonathan Clements. ORIGINS: Japanese historical/legendary tales of Toyama no Kinsan; novel by Tatsuro Jinde & Kyosuke Yuki, pub Tokuma Shoten. POINTS OF INTEREST: Shares many of its production staff with Grey Digital Target. CATEGORIES: SF, A

In the 21st century, Earth and its colonies are controlled by five administrators using EDO, a vast computer system. There are those who consider that being completely controlled may not be a politically desirable way of life. Gold is a well-to-do young layabout who hangs around his favourite bar gambling or drinking his time away, but when his father (who just happens to be one of the Administrators) is attacked after the assassination of Duke Plenmatz, he rushes to track down the would-be killer, and in the process uncovers a conspiracy of terrifying dimensions. But what makes a story is not the bald facts of the synopsis, but the manner in which they are presented and the attitude behind them. Like a beautifully wrapped Christmas package which turns out to be handkerchiefs again, this lovely-looking production will disappoint anyone looking for meaning and substance. It is essentially light entertainment trying for depth, but not very hard. The homosexual/crossdressing sequences may offend. ★☆

THE SCARRED MAN ACT IV MISTY CONNECTION
(Eng trans for KIZUOIBITO ACT IV MISTY CONNECTION)

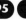

JAPANESE CREDITS: Prod: Madhouse. ©
Koike, Ikegami, Shogakukan, Bandai.
30 mins.
ORIGINS: Manga by Ryoichi Ikegami &
Kazuo Koike, pub Shogakukan; 1986 & 1987
OAVs.
CATEGORIES: A

The GPX, the bad guys from part III, kidnap Misty to try and get Keisuke; but he rescues her and goes after them.

Also:

THE SCARRED MAN ACT V LAST CHAPTER FINAL TOUCH DOWN
(Eng trans for KIZUOIBITO ACT V KANKETSUHEN FINAL TOUCH DOWN)

CREDITS, ORIGINS, CATEGORIES: As above
except: Prod: Magic Bus.

Keisuke's final showdown with the forces of evil.

SCOOPERS

JAPANESE CREDITS: Prod: ACC. © ACC, CIC
Victor. 58 mins.
ORIGINS: Created by Monkey Punch, author/
artist of Lupin III.
CATEGORIES: A, SF

It's 2016 on another planet. Young journalist (hence the title) Yoko and her cyborg sidekick and cameraman Vito are following up a hot story when Yoko is kidnapped. Vito manages to save her by destroying the programming of the central computer in the building where she's being held. That's all I know.

SD GUNDAM
(Eng title for KIDO SENSHI SUPER DEFORMED GUNDAM, lit Mobile Warrior Super Deformed Gundam)

JAPANESE CREDITS: Dir: Osamu Kanda.
Chara des: Gen Sato. Prod: Sunrise. ©
Sunrise, Bandai. 30 mins.
ORIGINS: Gundam TV & OAV series & movies;
the Roboroboco series of parodies of Tomino's
series by Gen Sato.
POINTS OF INTEREST: The original series
voice actors provide the parody voices too.
CATEGORIES: SF, C, U

Well, the films and TV series and OAVs had been a huge success, so in June Bandai brought out another weapon from the mighty *Gundam* mer-

chandising armoury — Super Deformity. SD charas have heads almost as big as their bodies, little shrunken arms and legs, and Seriously Defective attitudes. The SD OAVs introduced both charas and mecha in SD mode in parodies of and total departures from their full-scale anime relationships and adventures. Each of the early SD OAVS contains three stories, one based on the first *Gundam* series. Weird fun. ★★★

SHIBUYA HONKY TONK

JAPANESE CREDITS: Prod: Knack. ©
Tokuma Japan. 35 mins.
CATEGORIES: M, A

Fourteen-year-old Naoya Abe comes from a good family, but he wants a life of organised crime. He manages to talk his way into the clan that controls Shibuya, the Todogumi, but it's a lot tougher and less glamorous than he thought it would be. His girl, Yoko, is threatened and he kills a rival clan member and decides to get out and head for London.

Also:

SHIBUYA HONKY TONK II-IV

CREDITS, CATEGORIES: As above.

In part 2, Naoya gets a job in London as an assistant photographer working for Aoki. He's soon in trouble again. He gets involved in the theft of military secrets and when his criminal past comes to light he's sent back to Japan. I have no information about the two following parts of his story.

STARSHIP TROOPERS I-III
(Eng trans for UCHU NO SENSHI I-III)

JAPANESE CREDITS: Dir: Tetsuro Amino.
Chara des: Hiroyuki Kitakubo. Monster des:
Yutaka Izubuchi. Mecha des: Studio Nue.
Prod: Sunrise. © Bandai. Each 50 mins.
ORIGINS: Loosely based on Robert Heinlein's
novel Starship Troopers.
CATEGORIES: SF, A

Carmencita wants to become a starship pilot. Johnny is hopelessly in love with her, so despite his parents' disapproval he joins up too. Once in the forces he finds things a lot tougher than he expected, and he's soon heading into a war zone. I have very little information about this, except that it's said to be one of the earliest retro-styled anime; I'm told that the artwork doesn't altogether justify the retro label, though

considering that it's based on a novel already almost 40 years old, that's not inappropriate.

THE STORY OF WATT POE
(Eng title for WATT POE TO BOKURA NO OHANASHI, lit The Story of Us and Watt Poe)

JAPANESE CREDITS: Chara des: Mutsumi Inomata. Prod: Diva. © Konami. 55 mins. CATEGORIES: P, A

Fisherfolk in a small Japanese village find their living ruined when the rare local cetacean Watt Poe, the guardian god, disappears. After twenty years of misery and misfortune little Jamu can hear strange, beautiful music — music no one else can hear — wafting from the mountains. With three friends and his dog he sets out to look for the source of the music, and keeps going even when attacks by one-eyed monsters and giant lizards put his friends to flight. Unexpectedly, he discovers what happened to Watt Poe. He finds the creature has been kidnapped by a strange flying tribe and carried off to a mountain lake, where a lovely young girl is trying to keep it calm and content with music. She agrees to help him return Watt Poe to the sea, where he belongs; but they will face terrible danger to do so. The title creature was designed as a cross between an orca, a narwhal and a baleen whale. The art and design look charming. ★★☆?

TAIMAN BLUES NAOTO SHIMIZU CHAPTER 2
(Eng trans for TAIMAN BLUES SHIMIZU NAOTO HEN 2)

JAPANESE CREDITS: Dir: Tetsu Dezaki. Prod: Magic Bus. © Tokuma Shoten. 30 mins. ORIGINS: 1987 OAV. CATEGORIES: M, A

Naoto's battles with a rival biker gang land him in prison. That's all the information I have.

TEN LITTLE GALL FORCE

JAPANESE CREDITS: Dir: Masaki Tatsuya. Chara des: Kenichi Sonoda. Prod: AIC, Artmic, Animate Film. © MOVIC, CBS Sony. 30 mins. WESTERN CREDITS: US video release 1993 on AnimEigo; UK video release 1994 on Anime Projects (on double bill with Scramble Wars, entitled Super Deformed

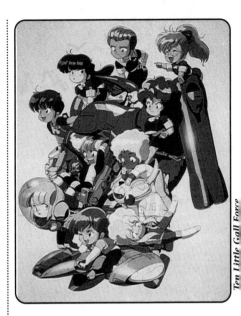

Ten Little Gall Force

Double Feature, both sub). ORIGINS: Gall Force OAV series; SD parodies. POINTS OF INTEREST: The crew in the anime are all parody versions of the real-life series crew. CATEGORIES: C, U

Maybe it was something in the air. SD fever hit town, and while the *SD Gundam* OAV was in the making, the Artmic crew were at work on this parody of the *Gall Force* charas. The Fighting Gallant Girls, squashed down to tiny, doll-like versions of their svelte selves, come together to make a video; but what with their vanity, bickering, practical jokes and — worst of all — Catty's total inability to sing, it ends in hilarious chaos. ★★★

TOKYO VICE

JAPANESE CREDITS: Dir: Sato Yamazaki. Anime dir: Kenichi Onuki. Prod: Minami Machi Bugyosho. © Minami Machi Bugyosho, Polydor. 60 mins. POINTS OF INTEREST: Title parodies the then-popular American crimebusting show Miami Vice. CATEGORIES: A

Three students at Tokyo University, Keiko, Akira and Junpei, are working with the police as undercover agents. An agent who has been missing for five years shows up out of the blue and hands the gang a com-

puter disk before collapsing and dying. It seems there are illegal goings-on at the local engineering factory, but orders come down from Very High Up not to investigate any further. Naturally, this piques the good guys' curiosity, and an 'accident' involving Junpei followed by the kidnapping of his younger sister gets them thoroughly involved. Slick, attractively contemporary animation, plenty of fast action and explosions, and heroics from Akira and Junpei keep things moving along nicely. ★★☆

ULTIMATE TEACHER
(Eng title for KYOFUN NO BYONINGEN SAISHU KYOSHI, lit The Dreadful Sick Man: The Ultimate Master)

JAPANESE CREDITS: Dir: Toyo'o Ashida. Screenplay: Monta Ibu. Chara des: Atsuji Yamamoto & Mandrill Club. Art dir: Setsuko Ishizu. Music: Miyuki Otani. Prod: Studio Live. © MOVIC, Sony Music Entertainment. 60 mins.
WESTERN CREDITS: US video release 1993 on US Manga Corps, sub, trans C. Sue Shambaugh; UK video release 1994 on Manga Video, dub.
ORIGINS: Manga by Atsuji Yamamoto.
CATEGORIES: SF, C

Ganpachi Chabane is the result of a genetic experiment, a cross between a man and a cockroach. Escaping from the lab where he was created, he gets a job as a teacher in Emperor High School. His idea of education chimes in pretty well with that of the pupils — both parties view it as a battleground where only the strong survive. Leader of one of the foremost student gangs is Hinako Shiratori, and besides being a mean martial artist she's also a bit of a panty fetishist; unless she's wearing her lucky blue bloomers with their cute white cat decoration, she has no confidence in her fighting ability. An interesting translation aside: in the US version these are 'lucky gym shorts' while the UK translation calls them 'velvet pussy panties'. This pretty well indicates the tone of the story; it's crude, overt and not very clever, just the kind of thing pre-pubescent boys go for. ☆

URUSEI YATSURA OVA 5: NAGISA'S FIANCE
(Eng trans for URUSEI YATSURA NAGISA NO FIANCES)

JAPANESE CREDITS: Prod: Kitty Film. © Takahashi, Shogakukan, Kitty Film. 30 mins.
WESTERN CREDITS: US video release 1993,
on tape with 1989 OAV The Electric Household Guard, from AnimEigo, sub, trans Thomas Amiya, Mariko Nishiyama & Hitoshi Doi.
ORIGINS: Manga by Rumiko Takahashi, pub Shogakukan, Eng trans pub Viz Communications; 1981 TV series; movies every year 1983-86 & 1988; 1986 & 1987 OAVs.
CATEGORIES; C, R, SF

The unfortunate Ryunosuke is compelled to pretend she's a boy to fulfil her family's wishes. Her father has a gift for wishing trouble on his children. He has become friendly with the head of a family of ghosts and the two have agreed a match between their children — a very suitable match, considering that the pretty young ghost Nagisa is a boy pretending to be a girl. But if Nagisa can just succeed in kissing 'her' fiancé, she can get into paradise at last. The arrival of Lum, Ataru, Mendo and Shinobu at the family's inn may not help matters for either party. ★★★?

Also:
URUSEI YATSURA OVA 2: RAGING SHERBET
(Eng trans for URUSEI YATSURA IKARI NO SHARBET)

CREDITS, ORIGINS, CATEGORIES: As above except: Prod: Herald. US video release 1993 on one tape with 1989 OAV I Howl at the Moon.

Lum's friend Ran is always dreaming up new money-making schemes and while on a visit to Oyuki's palace on Neptune she sees a golden opportunity. Neptune's famous sherbet birds have cone-shaped beaks which are actually cones of ice-cold sherbet, constantly self-renewing and delicious. Ran persuades Oyuki to let her take one of the birds to Earth on the pretext of 'looking after' it, and sets up a sherbet stand in the park. The creature doesn't take too kindly to being exploited, and its escape triggers a wonderful slapstick chase sequence through the skies above Tomobiki Town. The sight of Benten on her skybike, heavy weaponry at the ready, being dive-bombed with ice-cream cones by a furiously squawking sherbet bird, is enough to bring tears to the most blasé of eyes. Subplot and moral are present but irrelevant in this glorious comic romp. *Urusei Yatsura* at its very best. ★★★☆

VAMPIRE PRINCESS MIYU 1 CAPITAL OF MYSTERY
(Eng title for KYUKETSUKI MIYU DIAICHIWA AYAKASHI NO MIYAKO,

lit Vampire Miyu 1, Ghost City, US aka
VAMPIRE PRINCESS MIYU 1 UNEARTHLY
KYOTO)

*JAPANESE CREDITS: Dir: Toshihiro Hirano.
Screenplay: Noboru Aikawa. Chara des,
anime dir & storyboards: Narumi
Kakinouchi. Monster des & prod des:
Yasuhiro Moriki. Anime dir: Masahiro
Nishii. Art dir: Yoji Nakaza & Yoichi Nango.
Music: Kenji Kawai. Prod: AIC. ©
Soeishinsha, Pony Canyon. 30 mins.
WESTERN CREDITS: US video release 1992
on AnimEigo, sub, trans Masaki Takai, Shin
Kurokawa & Richard Uyeyama, on one tape
with Part 2; UK video release 1995 on
Manga Video, dub, on one tape with Part 2.
ORIGINS: Manga by Narumi Kakinouchi.
POINTS OF INTEREST: Narumi Kakinouchi
is the pen name of Narumi Hirano. The
usual reading for the kanji of the title is
Kyuuketsuhime Miyu, lit Bloodsucking
Princess Miyu. However, Kakinouchi has
chosen to use a variant reading,*

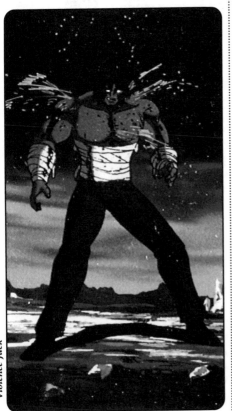

Violence Jack

*Kyuuketsuki Miyu, lit Vampire Miyu. So
both English translations of the title are
correct!
CATEGORIES: H*

Himiko Se is a medium who is called in to try and
free little Aiko from her cursed sleep. When she
glimpses a strange young girl and her black-
cloaked companion, she can't rid herself of the
idea that the girl is evil and dangerous. Her battle
against Miyu and her attempts to wake Aiko lead
her down dangerous pathways and into vampire
territory, and she learns that things are not
always as they seem. A chilling and beautifully
constructed half-hour of high quality horror.
★★★☆

Also:
VAMPIRE PRINCESS MIYU 2 PUPPET FESTIVAL
**(Eng title for KYUKETSUKI MIYU DAI NIWA SO
NO UTAGE, lit Vampire Princess Miyu 2 Dance
of the Marionettes, US aka VAMPIRE PRINCESS
MIYU 2 A BANQUET OF MARIONETTES)**

CREDITS, ORIGINS, CATEGORIES: As above.

Himiko goes to a high school where students are
mysteriously disappearing, at the request of the
father of a missing girl. Miyu is there too, and
soon finds Kei Yusuke, a dreamy young man who
is in love with the mysterious Lanka, another
vampire. She has promised him eternal love and
happiness, and despite Miyu's best efforts she
keeps her promise, transforming Kei into a mari-
onette to join her already large collection. But to
Himiko's and Miyu's bafflement, the boy yields
willingly, unable to find anything in his life as
meaningful as this strange un-death. Intelligent,
elegant horror. ★★★☆

VIOLENCE JACK EVIL TOWN
**(Eng trans for VIOLENCE JACK JIGOKU GAI,
aka VIOLENCE JACK HELL TOWN)**

*JAPANESE CREDITS: Dir: Ichiro Itano.
Script: Noboru Aikawa. chara des & anime
dir: Takuya Wada. Art dir: Mitsuharu
Miyamae. Photography dir: Norihide
Kubota. Sound & music dir: Yasunori
Honda. Planning prod: Naotaka Yoshida
(Soeishinsha) & Nobuo Masumizu (Japan
Home Video). Prod: Kazufumi Nomura. ©
Dynamic Planning, Soeishinsha, Japan
Home Video. 60 mins.
WESTERN CREDITS: UK & US video release
1996 on Manga Video, dub, trans Studio*

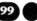

Nemo & John Wolskel.
ORIGINS: Manga by Go Nagai, pub 1973;
1986 OAV.
CATEGORIES: X, V, H

An underground shopping mall in Shinjuku has become a true hell, with cannibalism rife. The gigantic Jack, an almost elemental force with huge strength, is asked by Aira, leader of a group of women living in Zone C, to help her impose some kind of law and order after she and her women are brutally gang-raped by men from Zone A. But the worst threat is in Zone B where an insane monster is leading his gang in an orgy of cannibalism, child-killing and perversion. Over-the-top violence and gross destruction are the order of the day in this gorefest. It is one of the nastiest anime videos ever made and you really should not watch it if you are at all sensitive. However, like all Nagai stories it does have a moral and a point, if you can keep your attention on the story long enough to spot it. ★☆

WHAT'S MICHAEL? II

JAPANESE CREDITS: Prod: Kitty Film. © Kobayashi, Kitty Enterprises. 45 mins.
ORIGINS: Manga by Makoto Kobayashi, pub Kodansha in Comic Morning 1984, Eng trans pub USA; 1985 OAV; 1988 TV series.
POINTS OF INTEREST: Though Patlabor is acclaimed as being the first OAV-to-TV transfer, What's Michael shares the glory — the 1985 OAV eventually made it as a TV series this year. True, it wasn't as big as Patlabor, but it's fun.
CATEGORIES: C

More adventures of Kobayashi's wryly comical cat, the Garfield of Japan. ★★?

XANADU: LEGEND OF DRAGONSLAYER
(Eng trans for XANADU DRAGONSLAYER DENSETSU)

JAPANESE CREDITS: Prod: Toei Doga. © Kadokawa Shoten. 50 mins.
CATEGORIES: DD

Queen Rieru of Xanadu was widowed by the evil Reichswar, who killed her husband to gain possession of a magic crystal and intends to rule the whole of Xanadu. Into the fight between black and white magic steps a brave young warrior, and when the Queen is kidnapped he takes the magic blade Dragonslayer to go to her rescue. You may notice a certain similarity between the design and that of Aura Battler Dunbine. ★★?

YOTODEN III
(Eng title for SENGOKU KITAN YOTODEN III ENJO NO SHO, lit Story of the Legendary War of the Mysterious Sword III Chapter of Burning Emotion)

JAPANESE CREDITS: Dir: Sato Yamazaki. Writer: Noboru Aikawa. Chara des: Kenichi Onuki. Monster des: Junichi Watanabe. Music: Hidetoshi Honda. Prod: Minami Machi Bugyosho. © CIC Victor. 45 mins.
ORIGINS: Novel by Jo Nakiumi; 1987 OAV.
CATEGORIES: H, SH, P

Ayanosuke and Ryoma discover that they have assassinated impostors, not Oda Nobunaga and Ranmaru. Meanwhile Sakon waits in a cave for enlightenment. The battle to defeat Nobunaga and his army of demons has reached a critical stage, and the three magic blades unite in a titanic battle at Azuchi Castle to stop the evil Ranmaru forming the link between Hell and Earth which will start the reign of the Demon God. But victory is won at a terrible price; Ryoma and Sakon both die, leaving Ayanosuke alone again. Four hundred years later, their story is all but forgotten, and Azuchi Mountain keeps its dark secrets hidden. ★★★

ZILLION — BURNING NIGHT
(Eng title for AKAI KODAN ZILLION UTAHIME YAKYOKU — BURNING NIGHT, lit Red Laser Zillion Night Songstress — Burning Night)

JAPANESE CREDITS: Script: Tsunehisa Itoh. Anime dir: Yoshio Mizumura. Prod & ©: Tatsunoko. 45 mins.
WESTERN CREDITS: US video release 1991 on Streamline Pictures, dub, ADR script & direction: Tom Wyner.
ORIGINS: 1987 TV series; this series originated from a toy, a futuristic-style pistol with a photoelectric cell, which the characters of the show subsequently carried.
CATEGORIES: SF, A

This is a spinoff story from the original TV series, with musical numbers. In the peaceful times that follow the end of the Noza Wars, former fighters JJ, Champ, Dave and Apple have formed a rock band on planet Maris. They get embroiled in trouble with the criminal Odama gang when Apple is kidnapped. With lots of songs and more action footage, this enjoyed much success with fans. ★★☆

A nother Miyazaki movie, *Kiki's Delivery Service*, dominated the year in the theatres. There was also the only anime version of Nagano's famous manga saga, *The Five Star Stories*, and a whole clutch of series-inspired theatrical releases, including the second anime movie to make a huge impact in the English-speaking world, the theatrical edit of *Legend of the Overfiend*. Meanwhile, in the OAV listings more and more titles familiar to us in the West make their appearance as the cyberpunk boom gets into its stride. But the golden oldies are holding their own against the tide of cyberbabble — look for Shintani's delicious *Cleopatra D.C.* and solid work from masters like Yoshikazu Yasuhiko. Meanwhile in America, long-standing anime fans Robert J. Woodhead and Roe R. Adams set up AnimEigo, a new company devoted to the acquisition and release of high quality subtitled anime translations for the US home video market. Their first release, *Madox-01*, came in 1990.

MOVIES

CITY HUNTER: A MAGNUM OF LOVE'S DESTINY

JAPANESE CREDITS: Prod: Sunrise. © T. Hojo, Shueisha, Sunrise. 89 mins. ORIGINS: Manga by Tsukasa Hojo, pub Shueisha; 4 TV series between 1987 & 1991. CATEGORIES: N, A

'Sweeper' (private eye cum hitman) Ryo Saeba and his partner Kaori Makimura have been out of work for almost two months when a young pianist, Nina Shutenberg, comes to them for help in finding her father. She's visiting Japan on a concert tour from her homeland of West Galiera, with her grandfather, who is now her manager. Her father left just before she was born and her mother died five years ago. On her deathbed, she told Nina her father was in Japan. There's not much to go on — just a locket and one initial, J — but Ryo soon finds there's more to the case than meets the eye. The neighbouring country of East Galiera has an interest in Nina's father too, and her grandfather Klaus has unfinished business with the man who abandoned his daughter just before their child was born. It takes a considerable amount of danger, intrigue, skill with various handguns and explosives, and Ryo's trademark lechery before the situation can be resolved and what was lost is found. The story could easily be made as a major live-action movie, but you'd be pushed to find a live leading man with Saeba's charm. ★★★☆

DRAGONBALL Z

JAPANESE CREDITS: Dir: Daisuke Nishio. Prod: Toei Animation. © Bird Studio, Shueisha, Fuji TV, Toei Doga. 48 mins. ORIGINS: Manga by Akira Toriyama, pub Shueisha; 1986 TV series; movies every year 1986-88. CATEGORIES: SH, U, C

First of the movies to bear the Z logo, this introduces us to Son Gohan and Garlic Junior, a villain who would pop up in the TV series after Freezer's defeat, largely to give the manga time to get ahead of the TV storyline. More martial arts and hard battles with a comic twist. ★★★?

THE FIVE STAR STORIES

JAPANESE CREDITS: Dir: Kazuo Yamazaki. Screenplay: Akinori Endo. Chara des: Mamoru Nagano & Nobuteru Yuuki. © Nagano, Toys Press. c60 mins. ORIGINS: Mamoru Nagano's ongoing manga series, commenced 1986 in NewType magazine. CATEGORIES: SF, DD

GLOSSARY: Because Nagano has created so many words unique to the *Five Star Stories* universe, here's a short glossary to help you through the synopsis.
ETRIML: low grade subhuman construct used to run cheaper robots or in the absence of a Fatima.
FATIMA: artificially enhanced human, usually but not always female, used to run the weapons and other systems of a Mortar Headd (see below).

HEADLINER: Mortar Headd pilot.
IMPRESSION: The ceremony at which a Fatima chooses, or 'recognises', her life partner or 'Master', whose Mortar Headd he/she will pilot.
MEIGHT: Genetic engineer who can create Fatimas.
MEISTER: Mortar Headd designer and builder/ engineer.
MORTAR HEADD: giant robot.

2988, the Joker Cluster (the 'five stars' of the title). Dr Chrome Ballanche, the greatest meight of all time, has just completed his two most perfect creations, the Fatimas Lachesis and Clotho. Atropos, the other Fatima of the trio, has vanished. The two Fatimas are due to go to the castle of local overlord Uber to be Impressed — a ceremony in which they select their partners from among the assembled ranks of Headliners. It's an important occasion as Fatimas, particularly of this quality, are rare. Many pilots have to make do with etrimls, a much less effective creation, and all new Headliners hope to Impress a Fatima. To the same ceremony go Ladios Sopp, effeminate-looking but immensely influential meister and Voards Viewlard, wandering mercenary. But in fact nothing is quite as it seems. Uber's intentions are evil, Sopp and Viewlard are both masquerading, and so is the Emperor Amaterasu Des Grandes Adines, who turns up to witness the ceremony with a party of his most feared knights. In a dramatic and at times impenetrable story, much condensed from one segment of the sprawling saga, both Fatimas will find their fates, everyone will in the end reveal their true intent, and some of the most breathtaking mecha ever designed will slug it out before the climax at Lachesis' wedding to the Emperor in front of the mighty Knight of Gold Mortar Headd. This baroque extravaganza of world-building is the only anime version to emerge so far from the vast Joker Cluster universe created by Nagano — a former fashion illustrator and designer turned rock musician — and has seduced many a viewer into seeking out the whole mass of his manga works. ★★★

HEAVEN VERSION: UNIVERSAL PRINCE
(Eng trans for TANJO HEN UTSUNOMIKO)

JAPANESE CREDITS: Writer: Keisuke Fujiwara. Chara des: Mutsumi Inomata. Anime dir: Kazuya Kise. Prod: Toei Animation. © Kadokawa Novel, Bandai. 55 mins.
ORIGINS: Based on the novel by Keisuke Fujiwara, pub Kadokawa Books, illustrated Mutsumi Inomata.
CATEGORIES: P, DD

Movie curtain-raiser for the OAV series. The young Prince Utsunomiko, born into eighth century Japan, seeks to stand up for the common people against the oppression of the aristocrats. But will he be outcast because he is different from the rest of his people — a magical being with a single horn on his head? ★★☆?

KIKI'S DELIVERY SERVICE
(Eng title for MAJO NO TAKKYUBIN, lit Witch's Special Delivery)

JAPANESE CREDITS: Dir & writer: Hayao Miyazaki. Chara des: Katsuya Kondo. Anime dir: Katsuya Kondo, Shinji Otsuka & Yoshifumi Kondo. Musical dir: Isao Takahata. Music: Jo Hisaishi. Prod: Studio Ghibli, Tokuma Shoten, Yamato Transport Co Ltd, NTV. © E. Kadono, Nibariki, Tokuma Shoten. 105 mins.
ORIGINS: Novel by Eiko Kadono, pub Fukuinkan Shoten.
POINTS OF INTEREST: The term 'takkyubin' (special or express delivery) had been trademarked by Yamato Transport and Isao Takahata had to do some strenuous negotiation to get permission for its use in the title of the movie. So successfully did he handle this that the delivery company put money into the production. Look for various earlier Miyazaki characters making guest appearances in the crowd scenes — Lupin III, Lord Yupa, Ma Dola and Professor Kusakabe all make an appearance!
CATEGORIES: DD, U

Another year, another Miyazaki masterpiece, another heroine. When the director was asked in an interview why he made girls the main protagonists of his films, he replied 'Why not?' But Kiki is no Nausicäa; she's a contemporary heroine, living in one of Miyazaki's dreams of Europe as it never was but should have been. If it isn't quite our world and lags a score or so of years behind the film's release date, it's still recognisably contiguous. Kiki is a normal teenager who wants to follow in her mother's footsteps and make a career in the family business, as a witch. This means that, in her thirteenth year, she has to leave home and support herself for a year in a strange town using only her magical talents. A party of family and friends show up to see her off, and after a hair-raising journey (on her broom, with her black cat Jiji, naturally) she finds a seaside city and decides to make this her new home. Flying is her only talent, so, with the encouragement of a friendly local bakery owner, she sets up a flying delivery service, using the bak-

Legend of the Overfiend

ery as her base. She has all the normal teenage problems — she hates the 'uniform' black dress she has to wear as a trainee witch, and longs for pretty things; she worries about meeting new people; and of course there's the agonising embarrassment of liking a boy and wondering if he likes her. She also has to confront the possibility that life may not work out just as she wants it to; her talents may fail her, she may not be a big success, and maybe she'll just have to get by on hard work, good nature and kindness. Her faith in herself wavers, and it takes the help of good friends to restore it; but she comes to realise that, whatever special talents or abilities people may have, it's their human qualities that make them special in themselves. This is a film whose conflicts are almost all internal and whose surface is gentle, simple and quiet, cloaking both the issues it confronts and the involving, entertaining way they are presented. A quiet film, yes, but not a dull one. Kiki hesitates on the border between childhood and the adult world, uncertain that she wants to go forward, knowing that she must, unsure if she can cope with this different way of life. Not many films allow a child — and in particular a girl — to deal with the problems of selfhood, self-reliance, personal adequacy, creativity and love, and not many such struggles take place in so beautifully executed a setting. Miyazaki creates

somewhere we'd all like to visit, and his beautiful streets and sunlit sea-vistas are a holiday in themselves. Technically stunning, decorated with another ravishing Jo Hisaishi score, this is an endearing piece of enchantment. ★★★★★

LEGEND OF THE OVERFIEND
(Partial Eng trans for CHOJIN DENSETSU UROTSUKIDOJI, lit Legend of the Overfiend — The Wandering Kid)

JAPANESE CREDITS: Dir: Hideki Takayama. Screenplay: Noboru Aikawa & Goro Sanjo. Art dir: B.B. Cat. Music: Masamichi Amano & Jeffrey Jackson. Prod: Angel. © T. Maeda, JAVN. 108 mins.
WESTERN CREDITS: UK video release 1992 on Manga Video; US video release 1993 on Anime 18, script Michael Lawrence, both dub.
ORIGINS: Toshio Maeda's manga; 1987 & 1988 OAVs.
POINTS OF INTEREST: Also shown this year at a film festival in Paris and at Fantafestival, the Rome festival of fantasy films.
CATEGORIES: X, V, H

The edited theatrical version, made up from the first two OAV episodes and later released in the UK and USA, possesses a certain grandeur and epic sweep despite its poor editing. One of the most renowned films in the West — even people who've never seen it can tell you how shocking it is — thanks to a brilliant marketing campaign by UK label Manga Video. It has a story, and even a moral dimension. ★★★

SAINT SEIYA: WARRIORS OF ARMAGEDDON
(Eng trans for SAINT SEIYA ARMAGEDDON NO SENSHI)

JAPANESE CREDITS: Dir: Kozo Morishita. Chara des: Shingo Araki. Prod: Toei Animation. © M. Kurumada, Shueisha, MOVIC, Toei. 45 mins.
WESTERN CREDITS: The TV series is shown in France, Belgium, Luxembourg, Italy & Spain, supported by an action figure range and other toys.
ORIGINS: Manga by Masami Kurumada; 1986 TV series, which ran until 1989; 1987 & 1988 movies.
CATEGORIES: DD

The powers of the evil protagonists of the three previous movies were not lost when their owners were defeated. Instead, they have gone to fuel a new evil. Aeons ago, a 'holy trinity' of St Michael, the Buddha and Athena thrust Lucifer down into Hell to prevent his evil from spreading over the Earth. Now, with the powers of Eris, Poseidon and Abel/Apollo, he returns with his Fallen Angels and takes command of Athena's Sanctuary. Saori, Athena's modern incarnation, must face him, and her Saints support her in their most terrible battle to date. They win, of course. ★★☆?

VENUS WARS

JAPANESE CREDITS: Dir, writer, screenplay & chara des: Yoshikazu Yasuhiko. Chara des: Hiroshi Yokoyama. Art dir: Shichiro Kobayashi. Music: Jo Hisaishi. Prod: Kugatsu-sha. © Kugatsusha, Gakken, Shogakukan, Bandai. 104 mins.
WESTERN CREDITS: US video release 1992 on US Manga Corps, sub & dub, trans Toren Smith; UK video release 1993 on Manga Video, dub, same version.
ORIGINS: Yoshikazu Yasuhiko's manga, Eng trans pub Dark Horse.
POINTS OF INTEREST: Note the use of live-action and photographic backgrounds and cel animation.
CATEGORIES: SF, W

Susan Sommers, a young reporter, goes to Venus to report on the war between two of the planet's nations, Ishtar and Aphrodia. Meanwhile a team of young Aphrodian bikers, the Killer Commandos, compete on the monocycle track in a dangerous race game where two teams each try literally to knock the other out of the action. As the game goes on, Ishtar invades, and the Commandos pick up Sue, filming the action, as they struggle back from the track to their junkyard squat. From being a disaffected and aimless gang, the Commandos begin to take notice of the war and get involved. As Ishtar takes more and more ground, they are eventually drawn into the Aphrodian rebel forces. Sue arranges to interview the Ishtar commander, Donner, but she has more on her mind than just an interview — she has lost her journalistic objectivity in the face of her friends' suffering, and aims to assassinate the invading leader. By the end of the film, Sue and the other survivors find out that war is not quite as simple as it appears and that their own preconceptions and responses are not always reliable. Based on one of Yasuhiko's most popular manga, this is a faithful rendition of his style and story. However, it lacks the edge of passion and the perverse undercurrents that made his earlier film *Arion* so memorable. ★★☆

Venus Wars

SAMURAI DRAMAS

A well-loved category of live-action films is well represented in anime, where horror and ghost-story elements are often added to give an extra shiver to the action. These are some of the best titles to watch for.

1 THE DAGGER OF KAMUI

Beautifully written, with a complex plot which takes the hero from Japan across Russia to the USA, *The Dagger of Kamui* is convincingly rooted in pseudo-history, but with enough folklore and horror elements to provide plenty of chills. Its characters are well worked out and it has an excellent music score using traditional instruments and chants to dramatic effect.

2 CURSE OF THE UNDEAD — YOMA

A chilling tale of demonic possession based on real Japanese history, *Yoma* has wonderful fight sequences and some truly scary moments. The popular theme of the ninja forced to hunt down his treacherous and/or possessed friend/sibling is subtly played here.

3 NINJA SCROLL

Superbly executed by the Madhouse team under the direction of Yoshiaki Kawajiri, this is set in the last century and makes excellent use of period detail, as well as having some spectacular fight set pieces.

4 DEMON SLAYING SWORD OF SHURANOSUKE

Set in the sixteenth century and full of excellent period detail, *Demon Slaying* takes elements of fairy tale — a beautiful Princess carried off by the forces of evil magic, an invincible lone warrior, a treacherous woman and an evil master-magician — and weaves them into an exciting, action-packed story full of tension and drama.

5 SAMURAI TROOPERS

The story of five teenagers who become warriors of the light to fight against evil forces trying to take over the world has recently been dubbed and re-edited for US TV by Graz Entertainment as *Ronin Warriors*. High school magical stories have long been popular with Japanese kids, and *Samurai Troopers* attracted a huge following among teenage girls. Plenty of battle action and strong moral pointers.

VOYAGE TO FANTASIA

JAPANESE CREDITS : Dir: Masami Hata. Prod: Sanrio Film. © Sanrio. WESTERN CREDITS: US video release in early nineties, label unknown. ORIGINS: Inspired by Disney's Fantasia. CATEGORIES: DD, U?

Michael, the son of a composer and a violinist, loves flowers (and even talks to them) but is lukewarm about his music classes. One night he meets the little fairy Florence, and is taken by her on an adventure to save the Land of Flowers and the Valley of Music from an evil force.

YOTODEN
(Eng title for SENGOKU KITAN YOTODEN, lit Story of the Legendary War of the Mysterious Sword)

JAPANESE CREDITS: Dir: Sato Yamazaki. Writer: Noboru Aikawa. Chara des: Kenichi Onuki. Monster des: Junichi Watanabe. Music: Hidetoshi Honda. Prod: Minami Machi Bugyosho. © CIC Picture Video. 87 mins. ORIGINS: Novel by Jo Nakiumi; 1987 & 1988 OAVs. CATEGORIES: P, SH, H

An edited-for-cinema version of the three OAVs already released.

OAVS

AIM FOR THE ACE! FINAL STAGE VOLS 1-3
(Eng trans for ACE O NERAE! FINAL STAGE VOLS 1-3)

JAPANESE CREDITS: Dir: Osamu Dezaki. Prod: Tokyo Movie Shinsha. © S. Yamamoto, Bandai, Tokyo Movie Shinsha. Each 50 mins. ORIGINS: Manga by Sumika Yamamoto; 1973 TV series; 1979 film; 1988 OAV. CATEGORIES: N, R

Following on from the 1988 OAV series, this final OAV series chronicles Hiromi's adventures in the world of professional tennis.

ANGEL COP 1 SPECIAL SECURITY FORCE
(Eng title for ANGEL COP 1 TOKUSHU KOAN,

lit Angel Cop 1 Special Public Safety)

JAPANESE CREDITS: Dir: Ichiro Itano.
Screenplay: Noboru Aikawa. Chara des:
Nobuteru Yuuki. Anime dir: Yasuomi
Umetsu. Prod: DAST, Studio 88. ©
Soeishinsha, Japan Home Video. 30 mins.
WESTERN CREDITS: US & UK video release
1995 on Manga Video, dub.
ORIGINS: Story by Ichiro Itano, based on
manga by Taku Kitazaki.
CATEGORIES: SF, X

Also:
ANGEL COP 2 THE DISFIGURED CITY
(Eng title for ANGEL COP 2 HENBOU TOSHI, lit Angel Cop 2 Changed City)

CREDITS, ORIGINS, CATEGORIES: As above
except: Anime dir: Satoru Nakamura.

In the 1990s Japan's economic and political status
is such that it is a prime target for international ter-
rorism, and the Government has created a special
police unit to deal with the threat. Each member
has a codename and a licence to kill. Angel is one
of them. In the first episode a terrorist leader is
brought to Japan for trial but freed in a fast-paced,
blood-soaked scenario. Part two sees Angel and her
colleagues on the trail of the terrorists — but mem-
bers of the group keep turning up as corpses, killed
off by another unknown organisation. The know-
ledge that the terrorists are using psychics to eaves-
drop on the police adds to the tension. A violent
contemporary cop story with fantasy elements
added to *Die Hard*-type action. ★★☆

ARIEL
(Eng title for ARIEL VISUAL 1 SCEBAI SAIDAI NO KIKI ZENPEN, lit Ariel Visual 1, Scebai, The Biggest Crisis, Part 1)

JAPANESE CREDITS: Prod: Animate Film. ©
Pony Canyon. 30 mins.
POINTS OF INTEREST: ARIEL is an acronym
for All Round Intercept and Escort Lady. It
is also the name of the inventor's dead wife.
CATEGORIES: SF

Also:
ARIEL VISUAL 2 SCEBAI SAIDAI NO KIKI KOU HEN
(lit Ariel Visual 2, Scebai, The Biggest Crisis, Part 2)

CREDITS, CATEGORIES: As above.

Grandpa Kishida (mad scientist, first class) has built
a giant mecha, ARIEL, and persuades his two grand-
daughters and their friend to pilot it against the
attacking aliens led by Hausaa. Kasumi has a great
time but her big sister Aya and friend Miya both say
an emphatic 'never again'. But Grandpa is persistent
and when a second wave of aliens arrive to attack
Earth the girls have little choice. There's an alien
love triangle involved here. Hausaa's aide Shimon
loves him; the second wave attack leader, their
mutual friend Magnus, loves her; and Hausaa is only
interested in wiping out these pesky Earthlings and
their Scebai Base, and in finding Breastsaver Haagen,
a powerful fighter whom he believes is on Earth. The
reluctant team members go into action again to try
and save the base from Hausaa and Magnus. What's
Haagen going to do? You probably won't care
because this is a very boring take on the giant robot
genre. It's nicely designed, but the characters and
story aren't gripping enough to be action-adventure;
many feel it's a parody and find it hilarious. The
English-language trailers will reduce any English-
speaking audience to helpless hysteria. ★

ARMOUR HUNTER MELLOWLINK, VOLS 3-6
(Eng title for SOKOKIHEI VOTOMS KIKO RYOHEI MELLOWLINK VOLS 3-6, lit Armoured Trooper Votoms Armoured Warrior Mellowlink Vols 3-6)

JAPANESE CREDITS: Dir: Takeyuki Kanda.
Chara des: Moriyasu Taniguchi. Mecha des:
Kunio Ogawara. Prod: Sunrise. © VAP
Video, Toshiba, Sunrise. Each 50 mins.
ORIGINS: Devised by Ryosuke Takahashi as
a spinoff of Armoured Trooper Votoms; 1988
OAV.
CATEGORIES: SF, X

Further adventures of the young survivor out to
avenge his platoon; the innocence with which he
started out is rapidly being eroded as his journey
takes him deeper into the corrupt heart of the mili-
tary and political high command. Among his adven-
tures is one of the most thrilling arena games ever, a
sure-fire hit as a console scenario, man against
mobile suit, on foot with only what weaponry he can
carry. The boy wins, but it's edge-of-the-seat, gut-
wrenching action until he finally gets his man.
There's also a sickening prison torture scene, fol-
lowed by an escape sequence as convincing at the
time as it's silly on cold reflection, in volume six. This
is non-stop, slam-bang action close to its best. It
doesn't just suspend disbelief, it stuns it. I'm astound-
ed the series hasn't been released by a Western com-
pany yet; it's a personal favourite of mine. ★★★☆

ASSEMBLE INSERT

JAPANESE CREDITS: Dir: Ayumi Chibuki.
Script: Mitsuru Toyota. Chara des: Masami
Yuuki. Mecha des: Yutaka Izubuchi. Des dir:
Toyomi Sugiyama. Prod: Studio Core. ©
Yuuki, Tohokushinsha. 30 mins.
ORIGINS: Masami Yuuki's 'aniparo'
(animation parody manga, a glorious send-
up of some of anime's staple themes).
CATEGORIES: SF, C

The near future: Tokyo faces a crisis as a mysterious crime syndicate, Demon Seed, makes a mockery of the police, using armed powersuits. No one has any ideas until the rather tipsy Chief Hattori suggests that they hold a public audition to find a superheroine to fight the Demon Seed organisation. It's a measure of the city's desperation and the plot's silliness that this idea is taken seriously, and fourteen-year-old Maron Minamikaze is chosen because of her great physical strength. This deliciously absurd anime is an earlier work by the creator of *Patlabor*, and despite the differences in style shares many of the same qualities of pacing, inventive plotting and sly humour. ★★★

BAOH
(Eng title for BAOH RAIHOUSA, lit Baoh the Visitor)

JAPANESE CREDITS: Dir: Hiroyuki
Yokoyama. Screenplay: Kenji Terada. Chara
des: Michi Sanaba. Prod: Studio Pierrot. ©
Araki, Shueisha, Toei. 50 mins.
WESTERN CREDITS: US video release
1995 on AnimEigo, sub & dub, exec prod
Robert J. Woodhead, trans Shin Kurokawa
& Michael House.
ORIGINS: Manga by Hirohiko Araki, pub
Shueisha, Eng trans pub Viz
Communications.
POINTS OF INTEREST: AnimEigo's first
simultaneous release in both sub and dub
format.
CATEGORIES: SF, X

The DORESS organisation, a criminal syndicate, has created a genetically-engineered parasite which turns any host into a living survival machine, capable of adapting its body to deal with any threat and possessing immense power. Young psychic Sumire and Ikuro, the first human host for the parasite Baoh, escape together from the DORESS mobile research lab on a train. Ikuro has no idea how or why he came to be there, but as the pursuit hots up and he is first injured, then killed, the parasite manifests itself and his injuries heal rapidly and

completely. DORESS operatives recapture Sumire and the scene is set for devastation as Ikuro, in Baoh mode, goes to the rescue, determined to wipe out the evil syndicate forever. Unnecessarily extravagant quantities of gore are on display, overloading an otherwise unremarkable story. ★

BEAT SHOT

JAPANESE CREDITS: Prod: Gainax, AIC. ©
Bandai. 30 mins.

I know nothing more about this title.

BE-BOY: KIDNAPP'N IDOL

JAPANESE CREDITS: Prod: AIC. © Toshiba
EMI, AIC. 30 mins.

I know nothing more about this title.

BLUE SONNET VOL 1
(Eng title for AKAI KIBA BLUE SONNET SHIREI-01 TSUISEKISHA, lit Red Fang Blue Sonnet Order-01 Chaser)

JAPANESE CREDITS: Dir: Takeyuki Kanda.
Chara des: Shouichi Nakayama. Art dir:
Naoshi Yokose. Music dir: Susumu
Aketagawa. Prod: Mushi. © Shibata,
Hakusensha, Mushi Pro, Walker Japan.
30 mins.
WESTERN CREDITS: US video release 1994 on
US Manga Corps, all 3 episodes on single
tape, trans William Flanagan & Pamela
Parks, Eng rewrite Jay Parks.
ORIGINS: Masahiro Shibata's 1982 manga,
pub Hakusensha.
CATEGORIES: SF

Also:
BLUE SONNET STRATAGEM
(Eng title for AKAI KIBA BLUE SONNET SHIREI - 02 STRATAGEM, lit Red Fang Blue Sonnet Order-02 Stratagem)

Also:
BLUE SONNET CHALLENGER
(Eng title for AKAI KIBA BLUE SONNET SHIREI - 03 CHALLENGER, lit Red Fang Blue Sonnet Order-03 Challenger)

CREDITS, ORIGINS, CATEGORIES: As above.
Rescued from the slums of the inner city and rebuilt as a combat cyborg, esper Sonnet is totally

instantaneously — to fight the aliens. Some of the Borgmen become teachers at a school as a cover, and several of their pupils get involved in the action. This OAV takes place almost a year after the series ends; the Borgmen have been powered down now that the Yoma are no longer considered a threat, but illegal combat cyborgs are being built in secret by a mysterious force, and the team has to reform to fight them. Without the power broadcasts which used to transmit enhancements to their strength and power for their weapons, will their Borgman armour be enough to do the job? ★★☆?

BUBBLEGUM CRISIS 6: RED EYES

JAPANESE CREDITS: Dir, mecha des & storyboards: Masami Obari. Screenplay & original story: Toshimichi Suzuki. Chara des: Kenichi Sonoda. Music: Kaouji Maikano. Prod: Artmic, AIC. © Artmic, Youmex. 45 mins. WESTERN CREDITS: US video release sub 1992, dub 1995 on AnimEigo, trans Michael House & Shin Kurokawa; UK video release sub 1994, dub 1995 on Anime Projects. ORIGINS: Created by Toshimichi Suzuki; 1987 & 1988 OAVs. POINTS OF INTEREST: AIC are currently (early 1996) asking fan opinion and input via the Internet as to further Bubblegum Crisis adventures. CATEGORIES: SF

The babes are back, on the wrong side of the law. In reality it's Largo's Bumas who are impersonating the Knight Sabers so as to discredit them. Priss, devastated over the death of Sylvie in episode five, has decided to leave the Knight Sabers, so the girls are minus one as they face their evil alter egos and are defeated. Priss confronts Largo and Sylvie's friend, Anri, who believes her responsible for Sylvie's death. In a climactic final battle the Knight Sabers finally come together again and win through against their most dangerous adversary to date — for Largo is himself a Buma, plotting to control both GENOM and the world. ★★★★

CAPTAIN TSUBASA: FLAP, WING! CHALLENGE TO THE WORLD
(Eng trans for CAPTAIN TSUBASA TSUBASA YO HABATAKE! SEKAI ENO CHOSEN)

JAPANESE CREDITS: Prod: Animate Film. © Group SNE. 30 mins. ORIGINS: Manga by Y. Takahashi; 1983 TV series; 1985 & 1986 movies. CATEGORIES: N

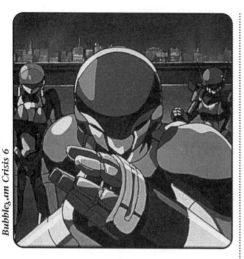

Bubblegum Crisis 6

devoted to her creator, the evil Dr Mericus. He fears that other psychics could pose a threat to his plans for conquest, and sends Sonnet to Japan to investigate a mysterious esper known only as 'Red Fang'. The search uncovers more than Sonnet expected; secrets from her own past are as deadly as esper weapons. ★★★

BOMBER BIKERS OF SHONAN 5
(Eng title for SHONAN BAKUSOZOKU 5, lit Wild Explosive Motorbike Gang from Shonan 5)

JAPANESE CREDITS: Prod: Toei Animation. © Toei Video. 50 mins. ORIGINS: Manga by Satoshi Yoshida, pub Shonen Gohosha; OAVs every year 1986-88. CATEGORIES: N, A

I know nothing more about this title.

BORGMAN: LAST BATTLE
(Eng title for CHOSENSHI BORGMAN: LAST BATTLE, lit Supersonic Soldier Borgman: Last Battle)

JAPANESE CREDITS: Prod: Ashi Pro. © NTV, Toho Video. 60 mins. ORIGINS: 1988 TV series. CATEGORIES: SF

The Yoma, an alien race skilled in mind control and genetic manipulation, have possessed a number of humans in their efforts to invade Earth. An international force uses advanced technology to create Borgmen — humans who can have cyborg armour and weapons transmitted onto their bodies almost

Also:
NEW CAPTAIN TSUBASA: CONCENTRATE! RIVALS OF THE WORLD
(Eng trans for SHIN CAPTAIN TSUBASA SHUKETSU! SEKEI NO RIVAL TACHI)

NEW CAPTAIN TSUBASA: CONFRONT! KNOCK DOWN HERNANDES
(Eng trans for SHIN CAPTAIN TSUBASA TAIKETSU! HERNANDES O TAOSE)

NEW CAPTAIN TSUBASA: DEAD HEAT! GENIUS DIAS VS JAPAN
(Eng trans for SHIN CAPTAIN TSUBASA BYAKUNETSU! TENSAI DIAS VS ZEN-NIHON)

NEW CAPTAIN TSUBASA: DEFEAT! START AGAIN FROM ZERO!
(Eng trans for SHIN CAPTAIN TSUBASA HAIBOKU ZERO KARA NO SAISHUPPATSU)

NEW CAPTAIN TSUBASA: REVIVE, GOLDEN PAIR
(Eng trans for SHIN CAPTAIN TSUBASA FUKKATSU GOLDEN COMBI)

NEW CAPTAIN TSUBASA: SHOOT! J-BOY SOCCER
(Eng trans for SHIN CAPTAIN TSUBASA HASSHIN! J-BOY SOCCER)

CREDITS, ORIGINS, CATEGORIES: As above.

More footballing adventures with the Japanese youth soccer squad and their heroic young captain.

CIPHER THE VIDEO

JAPANESE CREDITS: Prod: Magic Bus. © Victor Music. 40 mins.
ORIGINS: Manga.
POINTS OF INTEREST: The original Japanese release is said to have been dubbed in English with Japanese subtitles.
CATEGORIES: N, R

Based on a popular girls' manga, this charming romantic tale of identical twins, brother and sister, who share an identity at college to save on fees, and the complications this brings, is set in New York City. The city is rendered with such accuracy and affection that residents, and even occasional visitors to the Big Apple like me, have no trouble picking out locations and landmarks. ★★★?

CLEOPATRA D.C.: APOLLO'S THUNDER
(Eng trans for CLEOPATRA D.C. APOLLON NO KAMINARI)

JAPANESE CREDITS: Prod: Agent 21. © Shintani, Toei Video. 30 mins.
ORIGINS: Manga by Kaoru Shintani, who also produced the bleak mercenary tale Area 88.
CATEGORIES: M, A

Also:
CLEOPATRA D.C.: CRYSTAL PHARAOH

CREDITS, ORIGINS, CATEGORIES: As above.

Cleo is sexy, sharp and very clever. She is also Chief Executive Officer of CORN Corp, the most powerful company in the world — which makes her the 'moving capital of the world', hence the DC of the title. Even she gets a little bit fazed, however, when a pilot shows up in her bedroom complete with his plane. The light aircraft has been shot down and crashed into her building; the pilot, semi-conscious (not how Cleo normally likes her men) is calling out for 'Mary Ann'. Cleo and her partner, Surei, tie this to Mary Ann Harper, missing daughter of the Oil Minister. The pilot is in love with her. Top suspect in the kidnap is Junior, an oilman at odds with the Minister — whom they've just been hired to protect. Now the plot starts twisting. Junior sets one of his men, Apollo, on to Cleo, but she easily evades him and makes him look a complete idiot. He gets fired, gets mad, threatens to destroy Junior's empire and forces the oilman to turn to the only person he knows who can stop Apollo. Cleo's price is $100 million. A lightweight adventure story with plenty of gloss, excitement and explosions. ★★★?

CRUSHER JOE: THE ICE HELL TRAP
(Eng trans for CRUSHER JOE HYOKETSU KANGOKU NO WANA)

JAPANESE CREDITS: Dir, writer & chara des: Yoshikazu Yasuhiko. Co-writer: Haruka Takachiho. Prod: Sunrise. © Takachiho, VAP Video, Sunrise. 50 mins.
ORIGINS: Novel series by Haruka Takachiho; see also 1983 movie Crushers.
CATEGORIES: SF, A, U

Planet Auro, a despotic state ruled by Ghellstan, sends its dissidents to the gulag moon of Debri. Unfortunately the moon's orbit is affected by a

laser beam malfunction and starts to decay. Ghellstan calls the Crushers to solve the problem, and Crusher Dan, head of the mercenary organisation, puts Joe and his team onto it. They've just started a vacation so they aren't too happy to be recalled, and when they reach the planet the job doesn't seem to be entirely as specified. In fact, it's just a plot to discredit the Crushers and make a fast buck by claiming on the damage insurance when they fail in their task (helped out by the moon-destroying bomb that Ghellstan and his sidekick Hume have buried in Debri). Joe doesn't like to fail, though. He and the team manage to save the dissidents and give the bad guys their come-uppance. Clean, crisp design and animation, and plenty of action including some very nice aerial battle-sequences, make up a fun space opera. ★★★

Also:
CRUSHER JOE: LAST WEAPON ASH
(Eng trans for CRUSHER JOE SAISHU-HEIKI ASH)

CREDITS, ORIGINS, CATEGORIES: As above except: 52 mins.

The Crushers are engaged secretly by the president of Bardole to find out who is behind a conspiracy to seize Ash, the ultimate weapon which can wipe out all life on a planet. They go to planet Davidoff, where a pretty efficient weapon already exists — clockas, self-replicating weapons that kill any animal life they come across. They proved to be uncontrollable and were dumped on the planet years ago. Colonel Malod, a member of the conspiracy, is already there, and so is Lieutenant Tanya, who holds the secret of Ash and is also dedicated to uncovering the conspiracy. By disabling the weapon's safeguards she forces Maldo to name the leader of the conspiracy, but then another conspirator, fatally wounded, activates the weapon. With just twenty minutes to go, can Crusher Joe and co save Tanya and her vital information before everything on Davidoff, them included, turns to ash? ★★★

CRYING FREEMAN 2 SHADES OF DEATH PART 1
(Eng title for CRYING FREEMAN 2 FUSEI KAKUREI, lit Crying Freeman 2 Frightened by Rustling Leaves)

JAPANESE CREDITS: Dir: Nobutaka Nishizawa. Script: Tatsunosuke Ohno. Anime dir: Koichi Arai. Art dir: Masahiro Sato & Mitsu Nakamura. Music: Hiroaki Yoshino. Prod: I.S., Toei Doga. © Toei Video.

50 mins.
WESTERN CREDITS: US video release 1993 on Streamline Pictures, dub, Eng dialogue Gregory Snegoff; UK video release 1993 on Manga Video, dub.
ORIGINS: Manga by Kazuo Koike & Ryoichi Ikegami, pub Shogakukan, Eng trans pub Viz Communications 1993; 1988 OAV.
CATEGORIES: M, X

The second episode introduces us to the gross but very powerful Bayasan, more a figure of fun here than in the manga where she is a major influence, and marks Yo's consolidation of his hold on the 108 Dragons — and the start of the series' decline. Sadly, the standard of animation deteriorates starting here, with more and more reliance on static shots and reduction of cel numbers. ★☆

CURSE OF THE UNDEAD — YOMA PART 2
(Eng title for GAI YOMA KAKUSEI, MARO NO YOKIBA, lit Evil Demon Purification, Maro's Evil Fang)

JAPANESE CREDITS: Dir: Takashi Anno. Script: Noboru Aikawa. Chara des: Matsuri Okuda. Prod: Animate Film, JC Staff. © Kusunoki, Shueisha, Toho, MPS. c40 mins.
WESTERN CREDITS: US video release 1994 on AD Vision, on single 85 minute tape with part 1, sub, trans Masako Arakawa & Chris Hutts.
ORIGINS: Manga by Kei Kusunoki, pub Shueisha, based on Japanese history of the 15th-16th century; 1988 OAV.
CATEGORIES: SH, P, H

Hikage meets another Aya, a ninja girl with the same name as his dead love, and learns that when the Demon King of the Sea joins with the Demon

RYOICHI IKEGAMI

Creator of a wide range of works, he has collaborated with several different partners and some of his manga have been translated. Recently honoured at the 1995 San Diego Comic Convention.
RECOMMENDED WORKS: *Sanctuary*, a riveting tale of political corruption and crime in modern Japan, and *Crying Freeman*, a Chinese Mafia tale, are both available in translation in the West from Viz Communications. The anime version of *Crying Freeman* is available in the US from Streamline Pictures and Orion and in the UK from Manga Video.

King of the Land, all the yoma (devils) in the world will be reborn. Returning to the village where he killed the giant spider, he finds it haunted by the ghosts of former residents, including Maro's betrothed Kotone, whom Maro accidentally killed. She tells Hikage she is afraid for her beloved because he is trapped by the Demon King and will make it possible for the two Demon Kings to unite. In the final confrontation Maro asks Hikage to join him as a lord of the kingdom of Hell, but after a bloody battle Hikage kills his friend and prevents the union of the Demon Kings. Rejoining Aya to leave the evil place, he sees that she now looks very much like the first Aya, who killed herself in part one. On the road they see a dead woman with a living baby, and when Aya takes the child in her arms Hikage sees with a shudder that the baby boy looks just like Maro. Is evil reborn eternally? ★★★

DANCOUGAR FINAL
(Eng title for CHOJU KISHIN DANCOUGAR BYAKUNETSU NO SHUSHO ACT 1, MAJINTENSHO, lit Super Bestial Machine God Dancougar, Final Chapter of Heat, Act 1, Evil's Reincarnation)

JAPANESE CREDITS: Prod: Ashi. © Toho, Bandai. 30 mins.
ORIGINS: 1985 TV series; 1986 & 1987 OAVs.
CATEGORIES: SF

More giant robot adventure as the team gear up to face their intergalactic enemies once more. The first part of a four-OAV series. ★★☆?

DANGAIO 3: GIL BURG'S REVENGE
(Eng title for HAJATAISEI DANGAIO DAI-ICHIWA KANKETSUHEN FUKUSHUKI GIL BARG, lit Giant Star Warrior Dangaio Three, End of First Part, Revenge Demon Gil Burg, aka THE DEMONIC VENGEANCE OF GIL BURG)

JAPANESE CREDITS: Dir & chara des: Toshihiro Hirano. Screenplay & storyboards: Toshihiro Hirano & Koichi Ohata. Mecha des: Shoji Kawamori & Masami Obari. Anime dir: Kenichi Onuki. Art dir: Kazuhiko Arai. Prod: AIC. © AIC, Artmic, Emotion. 40 mins.
WESTERN CREDITS: US video release 1992 on US Renditions, sub, trans Toshifumi Yoshida & Trish Leroux; UK video release 1994 on Manga video in edited version with parts 1 & 2, dub.
ORIGINS: 1987 & 1988 OAVs.
CATEGORIES: SF

The climax of the story has Roll's past coming back to haunt him as Gil Burg, the tool of pirate King Gallimos, comes to take his revenge on the team that humiliated him. The four young psychics finally understand the purpose for which they were brought together. Not the world's greatest giant robot show by a long chalk, but it deserved a better edit and translation than it got in the UK. ★☆

DEMON BEAST PHALANX 1-3
(Eng trans for MAJUSENSEN)

JAPANESE CREDITS: Prod: Magic Bus. © Dynamic Planning, Tokuma Shoten. Each 45 mins.
ORIGINS: Ken Ishikawa's novel, pub Tokuma Shoten.
CATEGORIES: H

A story of science run mad with pride, the Frankenstein myth replayed. Thirteen scientists are seeking a way to tap the powers of both mankind and the beasts by creating a fearful new life form from a human and animal hybrid. They think this will give them the powers of the gods, and to achieve such power they are willing to sacrifice their own families. Some years later, the son of one of the scientists becomes involved with three Christian superbeings and decides to try and help them redress the terrible harm done by his father and his colleagues. Animation which is neither fluid nor very detailed is nevertheless powerful and the story packs an emotional punch. ★★★

DOG SOLDIER — SHADOWS OF THE PAST

JAPANESE CREDITS: Dir: Hiroyuki Ebata. Screenplay: Sho Aikawa. Chara des: Masateru Kudo. Art dir: Takuji Jizomoto. Prod: Animate Film, JC Staff. © Saruwatari, Shueisha, MOVIC, Sony. 45 mins.
WESTERN CREDITS: US release 1992 on US Manga Corps, trans Neil Nadelman.
ORIGINS: Manga by Tetsuya Saruwatari, pub Shueisha.
CATEGORIES: M, W

The name of the game is a cure for AIDS — or is it? Veteran Japanese-American soldier John Kyosuke Hiba is called out of retirement to help a childhood friend, Cathy, who is embroiled in a deadly plot to steal a biological secret which could be a deadly weapon in the wrong hands. He and his former comrade find themselves in the most dangerous battle of their lives. ★★☆?

DOMINION TANK POLICE ACTS III & IV

(Eng title for DOMINION ACT III & IV HANZAI SENSO, lit Dominion Crime Corps Acts III & IV)

JAPANESE CREDITS: Dir: Takaaki Ishiyama. Screenplay: Dai Kohno. Chara des & anime dir: Hiroki Takagi. Art dir: Osamu Honda. Prod: Agent 21. © Shirow, Hakusensha, Agent 21, Toshiba VideoSoft. Each 40 mins. WESTERN CREDITS: US video release 1991 on US Manga Corps, trans Neil Nadelman; UK video release 1993 on Manga Video, music track redubbed by Brown Eyes. ORIGINS: Masamune Shirow's manga, pub Hakusensha, Eng trans pub Dark Horse Comics. CATEGORIES: SF, C

Shirow's 'light relief' eco comedy continues to amaze and amuse, with the Puma Twins ever more ditzy and deadly and Leona moving closer to an understanding of Buaku's position. Buaku is out to steal a famous picture, which appears to be a portrait of himself. It holds the clues to his origins and it is the only thing in a vault stuffed with valuables that he wants. The Pumas have other ideas, however; they quite fancy the furs, gems and money too, and don't understand why their boss has gone all philosophical on them. And what is the role of the strange winged girl known as Greenpeace? Like the twins, Leona isn't paid to think, just to get Buaku; but when she finds herself locked with him in a struggle to survive, she begins to understand his motives, if not share his views. The plot, of necessity compressed from the manga and with many omissions, doesn't exactly make sense, but it's fun. ★★★

EARTHIAN

JAPANESE CREDITS: Dir & chara des: Kenichi Onuki. Prod: J.C. Staff. © Toshiba EMI. 45 mins. ORIGINS: Manga by Yun Kouga, aka Yun Takakawa. CATEGORIES: SF

I have no further information on this title.

EVIL DRAGON WAR CENTURY 2

(Eng trans for MARYU SENKI 2)

JAPANESE CREDITS: Chara des: Naoyuki Honda. Prod: AIC. © Bandai. 30 mins.

I have no further information on this title.

EXPLORER WOMAN RAY VOLS 1 & 2

JAPANESE CREDITS: Dir: Hiroki Hayashi. Screenplay: Masayori Sekijima. Chara des: Hiroyuki Ochi. Art dir: Junichi Higashi. Prod: Animate, AIC. © Okazaki, AIC, Animate, Toshiba Picture Soft. Each 30 mins. WESTERN CREDITS: US video release 1993 on US Manga Corps, sub, trans William Flanagan & Pamela Ferdie, Eng rewrite Jay Parks. ORIGINS: Manga by Takeshi Okazaki, pub Comic Nora. CATEGORIES: A, DD

Ray Kizuki is an archaeologist and black-belt martial artist, a sort of contemporary female Indiana Jones. Her father left her a mysterious mirror and she thinks it might be the key to a recently uncovered temple in the middle of nowhere, so she sets off to find out. A couple of feisty teenage girls and a smooth-talking villain called Rig Veda complicate the quest considerably. ★★☆?

GALL FORCE: EARTH CHAPTER 1

(Eng trans for GALL FORCE CHIKYUSHO 1)

JAPANESE CREDITS: Dir: Katsuhito Akiyama. Screenplay: Yuichi Tomioka. Chara des: Kenichi Sonoda. Music: Kaoru Mizutani. Prod: AIC, Artmic. © Artmic. 45 mins. WESTERN CREDITS: US video release 1994 on US Manga Corps, sub, trans William Flanagan & Pamela Parks, Eng rewrite Jay Parks. ORIGINS: Original story by Hideki Kakinuma; 1986 movie; 1987 & 1988 OAVs. See also Rhea Gall Force, 1989. CATEGORIES: SF

The human race is descended from the Solnoid and Paranoid forces, thanks to the sacrifices made by the crew of the *Starleaf* in the first *Gall Force* story. Now, in 2085, Earth is a ruined wasteland thanks to Man's final war. Most of mankind has fled to Mars and only a handful of warriors were left behind. Cyberoid war machines called the MME are doing their utmost to eliminate this remnant, led by computer entity Gorn. But a secret sect claims to have the key to revive the shattered planet. Can Sandy Newman and her comrades survive to use it? ★★★?

GOKU: MIDNIGHT EYE VOLS 1 & 2

JAPANESE CREDITS: Dir: Yoshiaki Kawajiri. Screenplay & original story: Buichi Terasawa. Chara des: Hiroshi Hamazaki. Art dir: Mitsuo Kozeki. Music dir: Yukihide Takekawa & Kazz Toyama. Prod: Toei, Madhouse. © Terasawa, Toei, Scholar. Each 45 mins.
WESTERN CREDITS: UK video release 1995/6 on Manga Video, dub.
ORIGINS: Manga by Buichi Terasawa, pub Scholar, Eng trans pub Viz Communications.
CATEGORIES: SF, A

Terasawa's easygoing, amoral lead chara follows the lead of his precursor Cobra in slipping easily into the Bond-style Western adventure mould. He's a private detective whose eye has a special implant enabling him to access and read computer data direct. The first episode tells how he loses the eye and gains the implant, in a story of illegal weapons sales packed with android creations such as a peacock woman, complete with tail, and a motorbike girl. In the second episode, when a beautiful young woman asks him to find her missing brother, he discovers he has taken on a case with more complications than meet even his eye. The standard gumshoe mould is enhanced with high-tech flourishes, a dark, brooding colour palette and clever lighting, but at bottom it's still a good old-fashioned detective tale. ★★☆

GUNBUSTER VOLS 2-6

(Eng title for TOP O NERAE! GUNBUSTER VOLS 2-6, lit Aim for the Top! Gunbuster vols 2-6)

JAPANESE CREDITS: Dir & art dir: Hideaki Anno. Chara des: Haruhiko Mikimoto. Mecha des: Kazuki Miyatake & Koichi Ohata. Anime dir: Yuji Moriyama, Toshiyuki Kubo'oka & Yoshiyuki Sadamoto. Art dir: Masami Higushi. Prod: Gainax. © Bandai, Victor Music, Gainax. Each 30 mins.
WESTERN CREDITS: US video release 1991 on US Renditions, sub, trans Toshifumi Yoshida & Trish Ledoux; UK video release 1994 on Kiseki Films, sub.
ORIGINS: 1988 OAV.
POINTS OF INTEREST: Manga translator Toren Smith, head of Studio Proteus, makes a 'guest appearance', lending his name to the space cadet who is heroine Noriko's first love. The last episode is shot in black and white.
CATEGORIES: SF, R

Noriko and Kasumi go to the Space Academy where they meet other cadets, especially the buxom Russian Jung Freud, and rivalries and studies both cause problems for the girls. Noriko still has a long way to go in gaining self-confidence but she finds first love with fellow cadet, Smith Toren, only to have him torn from her. Kasumi, meanwhile, loves Coach Ota, and he her, but he is dying and their time together may be cut short. The team gradually learns more and more about the enemy they face, and it emerges that the 'alien attack' may be the galaxy's defence mechanism against a dangerous viral organism called mankind. The cold equations of science become more and more apparent as the series progresses. Each time Noriko goes into space and travels faster than light, time stands still for her, but it moves on Earth at the same pace as ever, and gradually her best friend grows up, bears a daughter, and ages, while Noriko is still stuck in the perpetual cute teen mode so beloved of anime designers and fans. The final battle comes and no one is sure of anything except that by the time Noriko and Kasumi know the outcome, time on Earth will have moved on so far that, assuming they return at all, there may be no one left to remember them. The tension builds brilliantly through each episode to a moving finale. ★★★★

GUNDAM 0080: A WAR IN THE POCKET VOLS 1-6

(Eng title for KIDO SENSHI GUNDAM 0080 POCKET NO NAKA NO SENSOU, lit Mobile Suit Gundam 0080 A War in the Pocket. Ep titles: 1 How Many Miles to the Battlefield?; 2 Reflections in a Child's Brown Eyes; 3 At the Other End of the Rainbow; 4 Over the River and Through the Woods; 5 Say It Ain't So, Bernie!; 6 War in the Pocket)

JAPANESE CREDITS: Dir: Fumihiko Takayama. Script: Hiroyuki Yamaga. Chara des: Haruhiko Mikimoto. Des & mecha des: Yutaka Izubuchi & Mika Akitaka. Prod: Sunrise. © Bandai, Sunrise. Each 30 mins.
ORIGINS: Novels by Yoshiyuki Tomino; 1979 onwards TV series; 1988 movie Char's Counterattack.
CATEGORIES: SF, N

This moving series shows the *Gundam* conflict from another angle — that of the little people who make up the bulk of participants and victims in any war. Instead of the personal dramas and heroic actions of Char Aznable, Amuro Ray, Bright Noah and the other high-level NewTypes and officers, we see an ordinary little boy coming to understand the pain and betrayal of war on a deeply personal level.

Al begins by wanting to collect war mementoes like any other kid, meets a soldier on the opposite side and is innocently drawn into a deception. He sees two people he has come to love face each other in mobile suits for a battle from which only one of them will walk away. The web of deception and emotion is so tightly drawn that he cannot escape without hurt, and must carry the whole weight of the knowledge of what has happened alone. The small scale and delicate pacing of this OAV series make it one of the most beloved of *Gundam* stories and a masterpiece of science fiction. Its craftsmanship matches its serious intent, with fine chara and mecha design and careful, imaginative cinematography. ★★★★

THE GUYVER DATA 1-5
(Eng title for KYOSHOKU SOKO GUYVER, lit Armoured Creature Guyver, aka BIO BOOSTER ARMOUR GUYVER)

JAPANESE CREDITS: Dir: Koichi Ishiguro. Screenplay: Atsushi Sanjo. Chara des: Hidetoshi Omori. Anime dir: Sumio Watanabe & Atsuo Tobe. Art dir: Junichi Higashi. Music dir: Jun Watanabe. Prod: Takaya Pro, Animate Film. © Takaya Pro, KSS, Bandai, MOVIC, Tokuma Shoten. Each 30 mins.
WESTERN CREDITS: US video release 1992 on US Renditions, 2 eps on a tape (ep titles 'Genesis of the Guyver', 'The Battle of Two Guyvers', 'Mysterious Shadow Guyver III', 'Attack of the Hyperzoanoid Team Five' & 'The Death of the Guyver') dub, Eng screenplay & voice direction Raymond Garcia; UK video release 1994/5 on Manga Video, dub.
ORIGINS: Manga by Yoshiki Takaya, pub Tokuma Shoten, Eng trans pub Viz Communications; 1986 OAV.
SPINOFFS: Apart from the OAV series, 2 live-action films, Mutronics and Guyver: Dark Hero, were also made in the USA.
POINTS OF INTEREST: Garage kit range created by Max Factory is featured in the Zoanoid Data Files at the end of each tape.
CATEGORIES: SF, V

Schoolboy Sho Fukumachi accidentally activates a Guyver Unit, an alien symbiont which transforms the wearer into a super powered biomechanical warrior. The Chronos Corporation is out to retrieve the unit using its own gruesome bio-engineered monsters. Sho's best friend, the girl he loves and his father are all in terrible danger as Sho does his best to come to terms with his 'other self' — which he can't even activate without outside stress or stimu-

lus — and fight the evil Dr Balcus and Chronos. The video series eventually ran to twelve episodes and has proved to be one of the most successful UK releases ever, especially popular with younger male fans. It's not spectacularly well animated and is undemanding in plot and characterisation terms,

The Guyver

but there are regular monster rumbles and huge amounts of gore as limbs get torn off and body parts fly in all directions. Like *Power Rangers*, it's a case of kids kick ass. ★☆

HADES PROJECT ZEORYMER II: DOUBT
(Eng trans for MEIOU KIKAKU ZEORYMER II GIWAKU)

JAPANESE CREDITS: Dir: Toshihiro Hirano. Script: Noboru Aikawa. Chara des: Michitaka Kikuchi. Music: Eiji Kawamura. Prod: AIC. © Chimi, Artmic, AIC. 30 mins. WESTERN CREDITS: US video release 1993 on US Manga Corps, on one tape with part I, trans Neil Nadelman. ORIGINS: Original story by Morio Chimi; 1988 OAV. CATEGORIES: SF

Also:
HADES PROJECT ZEORYMER III: AWAKENING
(Eng trans for MEIOU KIKAKU ZEORYMER III KAKUSEI)

JAPANESE CREDITS, ORIGINS, CATEGORIES: As above. WESTERN CREDITS: US video release 1993 on US Manga Corps, on one tape with Part IV, sub, trans Neil Nadelman.

Masato continues to cut a swathe through the Haudragon battle lines as he learns more about himself and doesn't like what he finds. Wondering who he really is, he leaves the base and is captured by Haudragon. Yuratei plans a bloody revenge for Taira, whom he killed, and tells him she was to have been Zeorymer's pilot; but when Masaki stole the mecha, he input the brain pattern of what was to become Masato into its memory, and now no one else can pilot it. Having deprived her of both her mecha and her lover, Masato looks set for a nasty end, but Miku arrives to save him. Back in Zeorymer's cockpit he finds that the shocks of the last few days have awakened his dark side, and he mercilessly wipes out the twin girl pilots of the next two Haudragon mecha. In episode three, his cruelty and arrogance become so pronounced that Miku runs away from the base; now it's her turn to be captured and tortured. Masato has calmed down and become his usual self, but when he sets off to save her he finds that Zeorymer can only access one-third of its usual power without her aboard. Miku, in fact, is a sophisticated android who is closely linked to

the mecha's operating systems. The next warrior sent out by Haudragon is full of hatred for Masaki and all his works, including the Hakkeshu and Masato, and is determined to wipe all traces of Masaki's creations from the face of the earth. As Zeorymer destroys him, both he and Masato realise that Masato is not just genetically engineered by Masaki — he is a clone of the scientist, implanted with his personality. Masato is just as much a thing created to fulfil Masaki's wishes as the Hakkeshu are; but is he anything more? Good plotting and character development and superb, spiky mecha design make this series well worth watching. ★★★

HI SPEED JECY VOL 1 PROLOGUE, EXPLOSION
(Eng trans for HI SPEED JECY VOL 1 PROLOGUE KIBAKU)

JAPANESE CREDITS: Dir: Shigenori Kageyama. Chara des: Haruhiko Mikimoto & Akinobo Takahashi. Prod: Studio Pierrot. © VAP Video. 30 mins. ORIGINS: Novel by Eiichiro Saito, illustrated Haruhiko Mikimoto. CATEGORIES: SF

Also:
HI SPEED JECY VOL 2 MOBIUS MEMORY
(Eng trans for HI SPEED JECY VOL 2 MOBIUS KIOKU)

HI SPEED JECY VOL 3 FIGHT PURSUIT
(Eng trans for HI SPEED JECY VOL 3 FIGHT TSUIGEKI)

HI SPEED JECY VOL 4 ZONE EVIL SKY
(Eng trans for HI SPEED JECY VOL 4 ZONE MAKU)

HI SPEED JECY VOL 5 HIJACK

HI SPEED JECY VOL 6 STAMPEDE BIG MASS

CREDITS, ORIGINS, CATEGORIES: As above except: Each volume contains 2 30 min eps.

Jecy gets his nickname from his skill as a phenomenally fast runner. He is a pacifist who detests all forms of violence, but nonetheless he's on a quest for revenge — to find the killers of his parents. He saw an emblem on the killers' ship

and is searching all through the galaxy for it, travelling in the 'living ship' *Paolon*, which can manifest itself in the persona of a distinguished-looking elderly gentleman. I.T. and ship's management expert Tiana is travelling with him, posing as his 'sister' (though she would prefer a very different kind of relationship) and the third traveller is Folk Green, priest of the Heartland sect. Heartlanders believe that the only way sinners can come to Heaven is by dying in the most painful manner possible, and Folk does his best, as part of his priestly duties, to make sure that all sinners have a good chance of admission to the heavenly realms. Jecy doesn't approve of this and the sometimes strained relationships between travelling companions with different aims form a lively backdrop to his quest. Crisp, attractive and engaging. ★★★

HYPERSPACE GEO GARAGA

JAPANESE CREDITS: Chara des: Moriyashi Taniguchi. © ASMIC. 2 eps, each 50 mins.
WESTERN CREDITS: US video release 1996 on US Manga Corps.
ORIGINS: Novel by Satomi Mikiyura.
CATEGORIES: SF

It is the twenty-eighth century. Man has expanded throughout the galaxy via an interstellar jump gate known as God's Ring. The cargo ship *Xebec* enters the gate on a routine run, but something goes wrong and ship and crew crash-land on an Earth-type planet where all the people, including the beautiful Queen, are espers. What has brought them here?

KIMAGURE ORANGE ROAD OVA VOL 2: WHITE LOVERS
(Eng title for KIMAGURE ORANGE ROAD: SHIROI KOIBITOTACHI, lit Orange Road Follies: White Lovers)

JAPANESE CREDITS: Dir: Koichiro Nakamura. Writer: Kenji Terada. Chara des: Akemi Takada. Art dir: Satoshi Miura. Prod: Studio Pierrot, Toho. © I. Matsumoto, Toei Video. 25 mins.
WESTERN CREDITS: US video release 1993 on AnimEigo on one tape (Vol 2) with Hawaiian Suspense, sub, dir Michael House, trans Shin Kurokawa, Andy Kim, Masaki Takai & Richard Uyeyama.
ORIGINS: Manga by Izumi Matsumoto, pub Shueisha; 1987 TV series; 1988 OAV.
CATEGORIES: DD, R

Also:
KIMAGURE ORANGE ROAD OVA VOL 2: HAWAIIAN SUSPENSE

JAPANESE CREDITS: Dir: Takeshi Mori & Naoyuki Yoshinaga. Script: Isao Shizuya & Kenji Terada.
WESTERN CREDITS, ORIGINS, CATEGORIES: As above except: Trans uncredited.

Also:
KIMAGURE ORANGE ROAD OVA VOL 1: I WAS A CAT, I WAS A FISH
(Eng t0rans for KIMAGURE ORANGE ROAD WAGAHAI WA NEKODEATTARI OSAKANADEATTARI)

JAPANESE CREDITS: Dir: Naoyuki Yoshinaga, Takeshi Mori & Koichiro Nakamura. Script: Kenji Terada & Isao Shizuya.
ORIGINS, CATEGORIES: As above except: Trans uncredited.
POINTS OF INTEREST: The title parodies Natsume Soseki's famous novel I Am a Cat.

Three self-contained stories of the romantic misadventures of Kyosuke, Madoka, Hikaru and their friends, all charming. *White Lovers* has the gang getting caught up in an old ghost legend while visiting family in the winter; Kyosuke and Madoka help two tormented souls find peace. *Hawaiian Suspense* also has a holiday setting, but in the third OAV Kyosuke is at home, but not feeling at all like himself. ★★★

KOJIRO VOLS 1-6
(Eng title for FUMA NO KOJIRO, lit Wind Demon Kojiro or Kojiro of the Fuma Clan)

JAPANESE CREDITS: Dir: Hidehito Ueda. Chara des, des & supervision: Shingo Araki & Michi Himeno. Prod: Animate. © Group SNE. Each 30 mins.
ORIGINS: Manga by Masami Kurumada, pub Shonen Jump 1982-3.
CATEGORIES: DD, N

The *Fuma No Kojiro* manga appeared before *Saint Seiya* and was the inspiration for it. It's the story of five boys who are the incarnations of elemental spirits, with magical weapons and martial arts skills. The hero, Kojiro, receives a letter from Himeko, the young owner of Hakuo High School, who is having problems with gang intimidation at the school. He decides to help her because she's very

cute, but gang violence is the least of the school's problems. A rival clan is planning a takeover and Kojiro must face Nibu, one of their champions. Meanwhile another adversary, Oscar Musashi, arrives, and in a distant hospital a little girl wakes, crying that a storm is brewing. The inter-clan school struggle is just a cover for attempts by the powers of evil to gain control of all ten magical swords which determine the balance of power in the universe, and Kojiro has to prevent their victory. The retro styling of this series and its firm roots in the 'mystic warriors' genre mean that it won't be to everyone's taste. ★★

LEGEND OF GALACTIC HEROES VOLS 3-26
(Eng trans for GINGA EIYU DENSETSU)

JAPANESE CREDITS: Dir: Noboru Ishiguro. Screenplay: Takeshi Shudo. Prod: Kitty Film Mitaka Studios. © Y. Tanaka, Tokuma Shoten, Kitty Enterprise. Each 30 mins. ORIGINS: 10-novel series by Yoshiki Tanaka; 1988 movie & OAV. CATEGORIES: SF

This massive OAV series covers approximately one quarter of the ground marked out in the novels; three further twenty-six-episode series are planned and at the time of writing it's expected that the saga should be completed in 1996. It's a slow-developing and very 'talky' story, exploring the ideas and motivations of a large cast and a number of different power groups in a future in which mankind can span the stars, but can't resolve its age-old political problems of corruption, greed and incompetence. The minor noble, Reinhart Von Musel, later known as Von Lohengrimm, rises from an obscure and impoverished childhood to rule the empire, determined not to repeat the mistakes of those who went before. But he is powerless, despite his immense talents, against the currents of history and human nature. In the rival Free Planets Alliance, would-be historian Yang Wen-Li is sucked into a military career and leadership of the armies opposing Reinhart, where he faces almost identical problems. Linked by fate, the two men and their friends, enemies and lovers play out their public roles against a background of private triumphs, losses and sorrows. This first series covers Reinhart's climb to the threshold of absolute power; in the last episode, his childhood dream is almost within his grasp but he has paid with the life of his dearest friend and changed forever his relationship with his adored older sister. Nothing here for the action-adventure freaks, though the space battles are highly realistic; lovely designs, animation which is always adequate and sometimes excellent, and writ-

ing and character develop-ment of a high order will compensate the rest of us. A personal favourite. ★★★☆

LEGEND OF THE OVERFIEND III — FINAL INFERNO
(Partial Eng trans for CHOJIN DENSETSU UROTSUKIDOJI III, lit Legend of the Overfiend: The Wandering Kid III, aka WANDERING KID, US aka UROTSUKIDOJI PERFECT COLLECTION)

JAPANESE CREDITS: Dir: Hideaki Takayama. Writer: Goro Sanjo & Noboru Aikawa. Music: Masamichi Amano. Prod: AIC. © T. Maeda, Westcape Corp, JAVN. 54 mins. WESTERN CREDITS: Edited with the first OAV into the movie version, Legend of the Overfiend I; UK video release 1993 on Manga Video; US video release as part of 5-OAV set in unedited format 1993 on Anime 18, sub. ORIGINS: Manga by Toshio Maeda; 1987 & 1988 OAVs. CATEGORIES: X, V, H

Nagumo and Akemi are drawn even further into the horror of the Overfiend. ★★

LOCKE THE SUPERMAN: LORD LEON 1-3
(Eng trans for CHOJIN LOCKE LORD LEON 1, KIKAIJIKAKE NO TEO MOTSUOKOTO, lit Locke the Superman Lord Leon, Man with a Mechanical Hand; CHOJIN LOCKE LORD LEON 2 ESPER CONFRONTATION; CHOJIN LOCKE LORD LEON 3, AOIME NO FLORA, lit Locke the Superman Lord Leon 3, Flora's Blue Eyes)

JAPANESE CREDITS: Dir & writer: Takeshi Hirota. Prod: Japan Animation. © Bandai. Each 30 mins. ORIGINS: Yuki Hijiri's manga; Hirota's 1980 pilot film Cosmic Game (10 mins); 1984 movie. CATEGORIES: SF

Cyborg pirate Lord Leon kills the grandson of a wealthy industrialist, Great Jogu, whose starship building project is running into financial problems. Galactic Security ask Locke to get involved in dealing with the threat Leon poses, and he reluctantly agrees, not wanting to sacrifice his peaceful private life again, but impelled by duty. When they finally meet, Leon realises that Locke is the new man in his sister Flora's life, the one she's been hoping her wandering brother will stick around long enough to meet. It

transpires that eighteen years ago, on planet Antropi, Jogu destroyed their whole family and left Leon crippled and Flora blinded. The children were saved by family friend Dr Matai, who used his genius as a cybersurgeon to heal their injuries. Leon vowed revenge on Jugo, who went on to acquire even greater wealth and power. After a titanic battle between Locke and Leon, a nervous Jugo has Flora kidnapped by members of his Psychic Corps, but Locke rescues her. Meanwhile Leon sails into a trap... The animation is old-fashioned by mid-nineties standards but the story is complex and coherent and would give much modern esper science fiction a run for its money. ★★★?

MAH JONG FLYING LEGEND: GROAN'S DRAGON
(Eng trans for MAH JONG HISHODEN UMEKI NO RYU)

JAPANESE CREDITS: Prod: Magic Bus. © Bandai. 30 mins.

I have no further information on this title, but it seems reasonable to guess it will have something to do with mah jong...

MEGAZONE 23 PART III: EVE'S RETURN
(Eng trans for MEGAZONE 23 PART III EVE NO MEZAME)

JAPANESE CREDITS: Dir: Hiroyuki Kitazume, Shinji Araboku & Kenichi Yatagai. Chara des: Hiroyuki Kitazume. Mecha des: Morifumi Naka. Eve des by: Haruhiko Mikimoto. Prod: Artmic, AIC. © Victor Music. 50 mins.
WESTERN CREDITS: UK video release 1995 on Manga Video, dub.
ORIGINS: Inspired by the novel Universe by Robert A. Heinlein; original story by Noboru Ishiguro; 1985 & 1986 OAVs.
POINTS OF INTEREST: Radical style changes between each part.
CATEGORIES: SF

Also:
MEGAZONE 23 PART III: DAY OF LIBERATION
(Eng trans for MEGAZONE 23 PART III KAIKO NO KI)

CREDITS, ORIGINS, CATEGORIES: As above.

In *Megazone 23* Part I we saw young Shogo gain

political and social awareness as he learned that his whole world was a lie, and his people lived not on Earth but in colony ships. In Part II, a more stylish and radical Shogo fought for and won the chance to make a new world, free of the mistakes and prejudices of both the original planet and its shipbound simulacrum. At the beginning of Part III it's obvious that he failed. Eden, Earth's last city, is descended from one of the Megazones and is populated by the same kind of controlling politicians, lying power figures, disaffected punks and ignorant kids as Megazone 23 itself. Eiji Tanaka is one of a clique of yuppie layabouts addicted to a computer game known as *Hard On* (proof that cultural references just don't translate). His unique game and hacker talents get him recruited into an élite unit which hunts down 'terrorist' netjackers; but, of course, the top dogs in Eden are really the bad guys and the terrorists are the good guys, and Eiji uses his insider position to save the world from the control of Eden City's management and the controlling computer network, System. The gloss and glitz of high production values in design and battle-sequence terms is let down by some truly limited animation, but more so by the decline in thoughtful story and characterisation from Part I. ★★

MIROKU — REVIVAL OF KING AJARA
(Eng title for KYOMU SENSHI MIROKU AJARA — OH NO FUKKATSU, lit Nihilistic Military History Miroku, Revival of King Ajara)

JAPANESE CREDITS: Dir: Hideyuki Motohashi & Yukio Takeuchi. Prod: Animate Film. © Ishikawa, Dynamic Planning, Tokuma Japan. 30 mins.
ORIGINS: Novel by Ken Ishikawa, pub Tokuma Shoten.
CATEGORIES: DD

Ninja fantasy in which the silent warriors are also psychics, possessed of many paranormal powers. It seems that many aeons ago a huge spaceship crashed on Earth and was buried under the Japanese archipelago. When the ninjas disappeared from history, they actually vanished into the bowels of the Earth beneath Japan, where they encountered the crew of the spaceship and battled with them. Shogun Ieyasu Tokugawa is just one of the famous figures of the civil war period who shows up in this rewritten history.

PATLABOR VII SPECIAL VEHICLE SECTION, GO NORTH!
(Eng title for KIDO KEISATSU PATLABOR: TOKUSHATAI, KITA E!)

JAPANESE CREDITS: Dir: Mamoru Oshii. Writer: Kazunori Ito. Chara des: Akemi Takada. Mecha des: Yutaka Izubuchi. Anime dir: Kazuya Kise. Art dir: Hiromasa Ogura. Photography dir: Shigeo Sugimura. Sound des dir: Shigeharu Shiba. Music: Kenji Kawai. Prod: Studio Dean. © Headgear, Shogakukan, Tohokushinsha. 30 mins. WESTERN CREDITS: TV series & OAVs are scheduled for release in US on Manga Corps starting in Autumn 1996. ORIGINS: Story & manga by Masami Yuuki, pub Shogakukan; 1988 OAV; 1989-90 TV series. CATEGORIES: SF, N

Last of the first OAV series, begun last year, the story opens with a truck speeding North. It's been stolen twice — by the terrorist group Earth Defence Force, and from them! The cargo is a stolen Type 7 Brocken belonging to Schaft Enterprises, whose eagerness to get it back suggests that the company may have been up to no good — maybe smuggling it out under the guise of sending it to an International Labor Show, then selling it to rather shady clients? Schaft operatives tangle with Noa and the truck thief, who join forces to defeat them. It turns out that the thief stole the truck from the original thieves with no idea of what anyone was up to — he just needed a vehicle to get to a distant hospital for the birth of his baby. Goto and Nagumo agree to forget he ever existed and blame everything on the EDF, as he embraces his wife and new son in hospital. Goto makes yet another doomed romantic overture to his elegant colleague Nagumo. ★★★★

PEACOCK KING 2: CASTLE OF ILLUSIONS
(Eng trans for KUJAKU-O 2 GENEI-JO)

JAPANESE CREDITS: Dir: Katsuhito Akiyama. Screenplay: Noboru Aikawa. Chara des: Masayuki. Prod: Studio 88, DAST. © Shueisha, Soieshinsha, Pony Canyon. 60 mins. ORIGINS: Japanese & Chinese legend; 1988 OAV. POINTS OF INTEREST: A 1988 live-action version featuring martial arts star Yuen Biao was made as a Japanese-Hong Kong co-production. CATEGORIES: DD, H

A team digging up relics of the mediaeval warlord Oda Nobunaga are killed when they discover two mysterious scrolls. Only the sorcerer Onimaru and young graduate student Hatsuko escape. A blind sorceress predicts the resurrection of Nobunaga. If the two halves of the scrolls are joined, Azuchi Castle will rise again for its master, and the world will become Hell. Kujaku and Ashura join forces with Hatsuko, Onimaru and the Taoist exorcist Huong to defeat this evil; but Nobunaga's thirst for revenge on those who betrayed him has been brewing for four hundred years, and he takes Ashura and Hatsuko hostage to ensure his plans will not be hampered. ★★☆

PROJECT A-KO FINAL
(Eng title/trans for PROJECT A-KO KANKETSUHEN)

JAPANESE CREDITS: Dir, chara des & anime dir: Yuji Moriyama. Screenplay: Tomoko Kawasaki. Art dir: Junichi Azuma. Music dir: Yasunori Honda. Prod: Studio Fantasia. © Final Nishijima, Soeishinsha, Pony Canyon. 60 mins. WESTERN CREDITS: US video release 1994 on US Manga Corps, sub & dub, trans Pamela Ferdie & William Flanagan; UK video release 1995 on Manga Video, dub, same trans. ORIGINS: Original story by Katsuhiko Nishijima, Yuji Moriyama & Kazumi Shiraishi; 1986 movie; 1987 & 1988 OAVs. CATEGORIES: SF, C

Despite her lack of success in *Cinderella Rhapsody*, A-Ko still loves Kei; Kei, however, still loves C-Ko. But B-Ko's father is acting as go-between in Kei's marriage negotiations with Miss Ayumi, the girls' teacher, who has on a weird pendant and is acting very strangely. And remember C-Ko's origins as lost Princess of an alien race? Well, Mother is about to arrive to bring her little girl home. This is a mishmash of parody and slapstick laced with unforgettable moments — the finding of an ancient idol which looks just like our favourite bubblebrain; B-Ko's dramatic entrance, clad in black, to disrupt Ayumi-sensei's wedding; the arrival of a huge alien ship (which may look strangely familar to fans of SF movies) and guest appearances galore. It ends, though, with the status quo restored and A-Ko and C-Ko still the best of friends; lacking the emotional tension of *Cinderella Rhapsody*, it's still fun. ★★★

RHEA GALL FORCE

JAPANESE CREDITS: Dir: Katsuhito Akiyama. Screenplay: Hideki Kakinuma. Chara des: Kenichi Sonoda. Music: Etsuko Yamakawa. Prod: Artmic, AIC. © MOVIC, CBS Sony. 60 mins. WESTERN CREDITS: US Video release 1994 on US Manga Corps, sub, trans Neil

Nadelman.
POINTS OF INTEREST: The prequel to Gall
Force Earth Chapter; may have been inspired
by Fred Saberhagen's SF novel Berserker.
ORIGINS: Original story by Hideki
Kakinuma; 1986 movie; 1987 & 1988 OAVs.
CATEGORIES: SF

The events of the original *Gall Force* sparked the
creation of human civilisation. Now all that is in
the distant past. The wreck of a Paranoid spaceship
was found on Earth's moon and using its technol-
ogy mankind created MMEs — Man Made Exist-
ences. These intelligent machines turned on their
creators and initiated a nuclear war that reduced
mankind to the status of hunted scavengers. Even
now, humans haven't learned to put aside their dif-
ferences and unite against a common enemy and
the only hope is to evacuate the survivors to a Mars
base to regroup and plan the liberation of the
home world. A small group led by Sandy and her
best friend Melodi resolve to fight for the freedom
of Earth from the MMEs. ★★★?

RIDING BEAN

JAPANESE CREDITS: Dir: Yasuo Hasegawa.
Writer, supervisor & chara des: Kenichi

Sonoda. Mecha des: Kenichi Sonoda, Kinji
Yoshimoto, Satoshi Urushibara, L. Lime &
Yoshihisa Fujita. Tech dir: Yasunori Ide.
Anime dir: Masahiro Tanaka, Osamu
Kamijo, Ohira Hiroya & Jun Okuda. Art dir:
Hiroaki Sato. Planning: Toshimichi Suzuki.
Prod: Artmic, AIC. © Sonoda, Toshiba EMI.
45 mins.
WESTERN CREDITS: US video release, sub,
1993 on AnimEigo, dub 1994 on AnimEigo;
UK video release, sub, 1993 on Anime
Projects, dub 1994 on Anime Projects, trans
Michael House & Shin Kurokawa.
POINTS OF INTEREST: AnimEigo's first ever
dub release.
CATEGORIES: M, N

Bean Bandit is also known as the Roadbuster; he's
a driver/courier, one of the best in the business,
and makes his living on the outside edge of the
law. Yet he avoids any really nasty stuff — he's
one of the good guys, a true Western-style anti-
hero with a heart, showing the movie influences
of his creator (Dirty Harry, the Blues Brothers et
al) very clearly. He and his partner, Rally
Vincent, get unwittingly involved with a psy-
chotic kidnapper who sets them up to take the rap
for her crimes, but they fight their way out in a
hail of bullets and a screech of brakes. *En route*

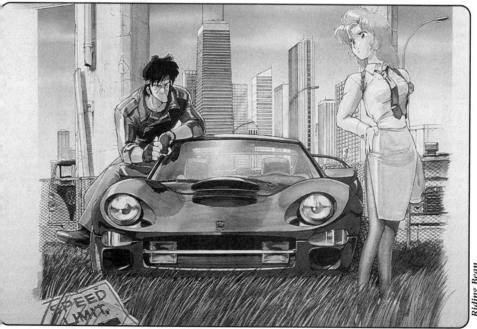

Riding Bean

Sonoda-san tips his hat at some Japanese influences too, notably *Lupin III* — watch for the Tom and Jerry relationship of cop and criminal. Some of the best car chases in anime, through the lovingly rendered streets of Chicago, are balanced with a harrowing touch of child abuse in a sado-masochistic relationship, seeming almost out of place in what is otherwise a light-hearted take on its genre. Beautifully executed, though it must be noted that the voice acting and sound mix of the English dub are far inferior to that of the Japanese original. ★★★☆

RIKI-OH
(Eng title for POWER KING)

JAPANESE CREDITS: Prod: Magic Bus. © Bandai. 45 mins.

I have no further information.

SACRED BEAST MACHINE CYGUARD
(Eng trans for SEIJUKI CYGUARD, aka CYBERNETICS GUARDIAN)

JAPANESE CREDITS: Dir & mecha des: Koichi Ohata. Writer: Mutsumi Sanjo. Chara des: Atsushi Yamagata. Music: Norimasa Yamanaka. Prod: AIC. © AIC, Soshin Picture. 45 mins.
ORIGINS: Created by Koichi Ohata.
WESTERN CREDITS: US video release 1996 on US Manga Corps, sub, trans Neil Nadelman.
POINTS OF INTEREST: Inspired by Jackie Chan's Armor of God & by old horror movies.
CATEGORIES: SF

In the expanding futuristic city of Cyberwood, the slum area known as Cancer has become the HQ of the terrorist cult Dold. The cult has plans to awaken the evil god Saldo with a human sacrifice, and use his powers to take over the city. The chosen sacrifice is one John Stalker, a scientist working for the SGC Research Institute on a project to turn human 'life energy' into useable physical energy. His team leader, Laia Rosetta, is a beautiful and energetic woman and isn't likely to let one of her staff be used for a human sacrifice without a fight. And far from being sacrificed to Saldo, John is fated to transform into the monster god and use the powers unleashed in him in ways Dold had never bargained for. Look out for numerous shots paying homage to the director's many influences in Western film, from Willis O'Brien's *King Kong* to the anime staple, *The Terminator*. ★★★

SALAMANDER ADVANCED SAGA: THE AMBITION OF GOFAR
(Eng trans for SALAMANDER ADVANCED SAGA GOFAR NO YABO)

JAPANESE CREDITS: Dir: Hisayuki Toriumi. Writer: Kazuhito Hisajima. Chara des: Haruhiko Mikimoto. Prod: Studio Pierrot. © Konami. 60 mins.
WESTERN CREDITS: UK video release 1995 on Western Connection.
ORIGINS: Based on the computer game Gradius; original story by Kazusane Hisashima; 1988 OAVs.
CATEGORIES: SF

The Prince of the British visits Gradius to sign a peace treaty, and also to visit Stephanie, whom he secretly loves. Then the evil Bacterians kidnap her and carry her off to their HQ on the artificial sun of Salamander. They plan to rip out her brain and sew it into the skull of a creature named Gofar, who will then pulverise Gradius. The Prince, aided by his ex-enemy Darn, rushes to the rescue, but with a surface heat beyond a million degrees Kelvin on Salamander, and a firebird blocking the way, can they save Stephanie before they're burned to a crisp? The final *Salamander* OAV is as gorgeous and as pointless as its precursors. ★☆

SAMURAI TROOPERS EXTRA STORY — ARMOURED FIGHTERS RETURN!
(Eng title for YOROIDEN SAMURAI TROOPER EXTRA STORY GAIDEN YOROISENSHI FUTATABI!, lit Legendary Armour Samurai Troopers Extra Story Armoured Fighter Return!)

JAPANESE CREDITS: Prod: Sunrise. © Sunrise, Group SNE. 30 mins.
ORIGINS: 1989 TV series.
SPINOFFS: In its day a huge favourite with female fans, Samurai Troopers spun off a large quantity of fan fiction and manga, some of it extremely sexually explicit and violent, mostly produced by and for women.
POINTS OF INTEREST: The TV series has been adapted and screened in the USA under the title Ronin Warriors.
CATEGORIES: SF, DD, X

Also:
SAMURAI TROOPERS EXTRA STORY — SAVE A FRIEND, SAMURAI HEART!
(Eng trans for YOROIDEN SAMURAI TROOPER EXTRA STORY TOMO O SUKUE, SAMURAI HEART)

MASAMI KURUMADA

Creator of mystic warrior boy gangs in shows like *Kojiro* and *Saint Seiya*, which in turn influenced such TV shows as *Samurai Troopers*, now screened on US TV as *Ronin Warriors*, his manga are heavily influenced by both Japanese and foreign mythology. The central theme of these stories, a group of friends whose principal loyalty is to each other and the good cause they serve, and whose various talents have to be welded into a harmonious whole for success, can seem simplistic and sentimental but have proved hugely popular in Europe, where *Saint Seiya* is widely shown and heavily merchandised as *Knights of the Zodiac*, as well as Japan.
RECOMMENDED WORKS: Again, no translated manga available in the West, but *Kojiro* and *Saint Seiya* are available in France and Italy on TV and video.

Also:
SAMURAI TROOPERS EXTRA STORY — THE ARMOUR HAS STARTED TO ACT!
(Eng trans for YOROIDEN SAMURAI TROOPER EXTRA STORY GAIDEN HASHIRIHAJIMETA YOROI)

Also:
SAMURAI TROOPERS EMPIRE LEGEND
(Eng trans for YOROIDEN SAMURAI TROOPER TEI DENSETSU TAIYO NO MUKARA)

CREDITS, ORIGINS, CATEGORIES: As above.

The first three titles form one three-part story, outlined here; the fourth is an independent, self-contained narrative about which I have no information. *Samurai Troopers* is cast in the same mould as *Saint Seiya* — a group of brave teenage boys unite to save the world — and still enjoys widespread support among female fans in Japan, the USA and Europe, although it was intended as a 'boys' show'. The five Troopers — Ryo, Seiji, Shin, Toma and Fan — are pitched into a trans-Pacific adventure with their friends Nasti and little Jun. A group of New York toughs attack a stranger in 'weird armour' and are trashed so badly it ends up on the international news bulletins. Ryo sees the broadcast as he arrives at a hotel in Shinjuku for his birthday party, and the Troopers decide to go to New York and see if their old foe demon lord Arago is involved. By the time they arrive, the cameraman who took the news pictures in the bulletin has been killed and his sister is out for revenge. Seiji has been kidnapped and is being held in an underground dungeon in Los Angeles by an evil spirit, Shikaisen, who wants control of both his

Armour and his mental powers. Using torture to try and break Seiji while a computer analyses both him and his Armour, Shikaisen and his scientist sidekick are also planning to use what they learn to take over all five Armours eventually. They're prepared to go to any lengths — kidnapping Nasti and Jun so as to lure the other Troopers into a trap, and killing the people of L.A. to draw power from their deaths. Is Arago about to manifest himself, and how can the four remaining Troopers, without Seiji's help, defeat the power of evil? Not in the *Legend of the Overfiend* league for violence, but torture scenes and homoerotic undercurrents mean this might be too strong for Western under-twelves. ★★☆

SD GUNDAM MK II
(Eng title for KIDO SENSHI SD GUNDAM MK-II, lit Mobile Suit SD Gundam MK-II)

JAPANESE CREDITS: Dir: Osamu Kanda. Chara des: Gen Sato. Prod: Sunrise. © Bandai, Sunrise. 30 mins.
ORIGINS: Gundam TV, OAV series & movies; the Roboroboco series of parodies of Tomino's series by Gen Sato; 1988 SD Gundam OAV.
CATEGORIES: C, U

Also:
SD GUNDAM 3 — APPEAR! MUSHA GUNDAM
(Eng trans for KIDO SENSHI GUNDAM SD 3 MUSHA GUNDAM SANJO!)

Also:
SD GUNDAM 4 — SD HIGH SCHOOL PANIC!
(Eng trans for KIDO SENSHI GUNDAM SD 4 SD GAKUEN PANIC!)

CREDITS, ORIGINS, CATEGORIES: As above.

Adventures of the mini-mobile suits in a universe of wacky events bearing only superficial resemblance to the series full-size *Gundam* world at which it pokes fun. High slapstick and very enjoyable. Musha Gundam are especially interesting in that they were created for the SD universe, being 'samurai warrior' versions of the *Gundam* robots with their own historical settings and battle-dramas; they were so popular that kits of full size versions later made their way back into the vast *Gundam* kit range. ★★★?

SHUTENDOJI
(Eng title for SHUTENDOJI RYOKI NO SHO, lit Heaven Kid — Evil's Chapter)

JAPANESE CREDITS: Dir: Jun Nishimura.
Art dir: Hideyuki Motohashi. Prod: Studio
Signal. © Dynamic Planning, Japan
Columbia. 50 mins.
WESTERN CREDITS: UK & US video release
1996 on AD Vision.
ORIGINS: Manga by Go Nagai, serialised in
Shonen magazine 1977.
CATEGORIES: DD, H

Back in the seventh century the ogre Shutendoji
was defeated in Kyoto by Yoshimitsu Minamoto.
Fast forward to the present and high school student
Dojiro Shuten, the offspring of human and ogre
blood, who possesses great but as yet unawakened
mystical powers. He could lead mankind to
Paradise — or to Hell — but can he use his ogre heri-
tage to battle the great evil now threatening the
human world? Nagai's unique mix of contemp-
orary horror, gore and myth. ★★☆

SPACE FAMILY CARLBINSON
(Eng trans for UCHU KAZOKU CARLBINSON)

JAPANESE CREDITS: Prod: Doga Kobo. ©
Tokuma Shoten. 45 mins.
ORIGINS: Manga by Yoshito Asari, pub
Shonen Captain Comics.
POINTS OF INTEREST: Note another play on
the 'castaway' theme of Robinson Crusoe

Shutendoji

and American comic Space Family
Robinson, which was made for TV as Lost
in Space.
CATEGORIES: SF, C

A travelling show group of alien performers are hap-
pily whiling away some journey time with a card
game when a vessel comes out of warp space and
nearly crashes into their ship. They track the space
hog to planet Anika and find it has crashed. The
sole survivor is a human baby girl, Corona. They
decide to look after her, at least until someone
comes to claim her. In order to equip themselves to
play the parts of a 'normal' human family and its
friends, they take information from the crashed
ship's data banks and embark on one of the longest
runs of their career. But playing any role for too
long leads to problems when you start to identify
with it; by the time a human ship comes for
Corona, five years later, they really *are* her family
and friends. ★★★?

STARCAT FULL HOUSE: CHIKURA WILL ASCEND
(Eng trans for HOSHINEKO FULL HOUSE: CHIKURA SHOTEN)

JAPANESE CREDITS: Dir: Noboru Ishiguro.
Prod: Artland. © Walkers Company. 30 mins.
CATEGORIES: SF,C

Slapstick space comedy in the cockpit of an inter-
planetary delivery service ship. One of six thirty
minute episodes, spoken of very highly by fans of
this great director. ★★★?

TAIMAN BLUES LADY'S CHAPTER 1 & 2

JAPANESE CREDITS: Dir: Tetsu Dezaki.
Prod: Magic Bus. © Tokuma Japan. 30 mins.
ORIGINS: 1987 & 1988 OAVs.
POINTS OF INTEREST: The Japanese
promotional material mentions the 'realism
of the story' and the influence of comics.
CATEGORIES: A

Fifteen-year-old high school girl Mayumi moves to
Osaka (described as a 'rough town') when her par-
ents split up and remarry. Her new friend Noriko is
a big help to her in settling in to this strange new
life, and the two become so close that Noriko even
moves into her flat. Mayumi helps her friend out in
her job at a petrol station, and they get to know
one of the regular customers, Big Bear, and his
biker gang. Through knowing this tribe of boy rac-

ers, Mayumi and Noriko get more and more interested in the biker lifestyle and eventually get into their own gang of girl racers. ★★☆?

Also:
TAIMAN BLUES NAOTO SHIMIZU CHAPTER 3
(Eng trans for TAIMAN BLUES SHIMIZU NAOTO HEN 3)

CREDITS, ORIGINS: As above.
CATEGORIES: M

Naoto finally gets out of prison. But can he stay out of trouble?

URUSEI YATSURA OVA 2: I HOWL AT THE MOON

JAPANESE CREDITS: Prod: Kitty Films. © Takahashi, Shogakukan, Kitty Film, Fuji TV. 26 mins.
WESTERN CREDITS: US video release 1993 on AnimEigo, on one tape with Raging Sherbet (1988), sub, trans Thomas Amiya, Mariko Nishiyama & Hitoshi Doi.
ORIGINS: Manga by Rumiko Takahashi, pub Shogakukan, Eng trans pub Viz Communications; 1981 TV series; movies every year 1983-86 & 1988; OAVs every year 1986-1988.
CATEGORIES: SF, R, C

Ataru gobbles down some of Lum's home-made delicacies and turns into a werewolf. How can she get her darling back? A funny, really enjoyable romantic jaunt — not quite on the level of *Raging Sherbet*, its US release partner, but still good fun. ★★★

Also:
URUSEI YATSURA OVA 3: CATCH THE HEART and GOAT CHEESE

CREDITS, ORIGINS, CATEGORIES: As above except: trans Hiroshi Haga, Takayuki Karahashi, Eriko Takai & Vincent Winiarski. 2 Japanese OAVs released in the USA on one tape in 1993.

A naughty little sprite gives Ran a heart-shaped candy bar. Anyone who eats it gets a magic heart over their head — anyone who catches the heart, captures the heart of the owner! In the second OAV Mendo incurs an ancient family curse — can Miss Sakura and his teacher help him ward it off? Takahashi is a mistress of stories that go nowhere delightfully; both here and in *Ranma 1/2*, we know

the protagonists and their assigned roles well, but still enjoy seeing just how the situation will run this time around. ★★★?

Also:
URUSEI YATSURA OVA 5: THE ELECTRIC HOUSEHOLD GUARD

CREDITS, ORIGINS, CATEGORIES: As above except: released on one tape with Nagisa's Fiancé (1988) in 1993.

Mendo loves getting expensive new toys. His new personal Ninja is his pride and joy — but what will happen when his manipulative sister Ryoko gets her hands on the new bodyguard? ★★★?

VAMPIRE PRINCESS MIYU 3 & 4
(Eng trans for KYUKETSUKI MIYU FRAGILE ARMOUR and FROZEN TIME, US aka VAMPIRE PRINCESS MIYU VOL 2)

JAPANESE CREDITS: Dir: Toshihiro Hirano. Screenplay: Noboru Aikawa. Chara des, anime dir & storyboards: Narumi Kakinouchi. Art dir: Yoichi Nango. Music: Kenji Kawai. Prod: AIC. © Soieshinsha, Pony Canyon. Each 30 mins.
WESTERN CREDITS: US video release 1992 on AnimEigo, sub, both on one tape as Vampire Princess Miyu Vol 2, sub, trans Masaki Takai, Shin Kurokawa & Mariko Nishiyama; UK video release 1995/6 on Manga Video, dub.
ORIGINS: Manga by Narumi Kakinouchi; 1988 OAV.
CATEGORIES: H

Miyu's servant Lava is in trouble and Miyu turns to Himiko for help. We meet Miyu's parents and learn how and why she became a vampire. Himiko begins to understand that the distinction between good and evil is not always clear cut. ★★★☆

WATARU
(Eng title for MASHIN EIYUDEN WATARU MAJINZAN HEN KAETTEKITA KYUSEISHU, lit Divine Tale of Heroism Wataru, Evil God Mountain Part 1, The Saviour Has Returned)

JAPANESE CREDITS: Dir: Toyo Ashida. Prod: Sunrise. © Sunrise, R, NAS, NTV. 30 mins.
CATEGORIES: C, U

A comedy series aimed squarely at the kiddies' market with a strong fantasy influence, SD mecha, slapstick fights and lots of gags. ★★☆?

This was a fabulous year for cyberpunk, with the first *Patlabor* movie shifting the mood of the first OAV series down into a darker gear, and the second *Patlabor*, AD Police and *Cyber City Oedo 808* OAV series setting the benchmark for the cyberpunk OAV. A grittier element entered fantasy, too, with the OAV series *Record of Lodoss War* making its début. Soppy fantasy, though, held its own against the dark chrome tide, with cute girls and fluffy animals still going strong. A new *Dirty Pair* OAV combined the two elements, with the galaxy's deadliest cuties in an action-packed storyline. In the comedy field, SD fans had six new *SD Gundam* titles to enjoy. Despite the presence of more and more titles familiar to Western readers, the impression is still of a huge iceberg, the bulk of which is as yet unseen. In the USA, new label AnimEigo's first release was *Madox-01*; the year also saw the founding of Central Park Media by John O'Donnell. This New York based company was to expand and develop into one of the foremost distributors of anime, as well as releasing material on three of its own labels. On the other side of the USA, the US Renditions label was founded as the home video arm of Books Nippan. And on the other side of the Atlantic, the UK's first-ever dedicated anime programme at a convention took place at Easter, while *Akira* had its first official UK screening in May.

MOVIES

CYNICAL HYSTERY HOUR: THROUGH THE NIGHT

JAPANESE CREDITS: Dir: Kiriki Kubo. Prod: Group Tack. 30 mins.
WESTERN CREDITS: Screened at Cardiff Animation Festival in 1992 as part of their anime programme.
ORIGINS: Possibly connected with the film of similar title made in 1988.
CATEGORIES: N?

A young girl is sent to bed at nine every evening, and longs to find out what life after dark is really like. When her parents have to leave her at home while they make an overnight trip, she stays up all night in search of the delights of nightlife, with surprising results. ★★☆?

DRAGONBALL Z — THE STRONGEST ON THIS WORLD

JAPANESE CREDITS: Dir: Daisuke Nishio. Prod: Toei Animation. © Bird Studio, Shueisha, Fuji TV, Toei Doga. 48 mins.
ORIGINS: Manga by Akira Toriyama, pub Shueisha; 1986 TV series; movies every year 1986-89.
CATEGORIES: DD, C, V

Also:
DRAGONBALL Z — SUPER DECISIVE BATTLE FOR THE WHOLE WORLD

CREDITS, ORIGINS, CATEGORIES: As above.

In the first film, Goku's powers as the strongest fighter on Earth are challenged by a mad scientist and his robots. In the second, we are introduced to the concept of the Saiyajin, the super-strong people of Goku's homeworld, as Goku's evil clone arrives on Earth to plant a tree which will eventually destroy the planet. ★★★?

THE LOST TREASURES OF THE ANCIENT QUEEN

JAPANESE CREDITS: Prod: Tokyo Movie Shinsha. © Red, Hudson, Kadokawa Media Office, TMS. 110 mins.
ORIGINS: Computer game.
CATEGORIES: DD

In a fantasy kingdom, a sinister religious sect seizes power. The Princess possesses the key to the vast treasures and mystic powers of an ancient Queen of the realm, and the sect wants them. She is rescued in the nick of time by a mischievous thief, and they go on the run from her pursuers, gathering a motley band of adventurers who will help them fight the evil sect and free the kingdom. ★★☆?

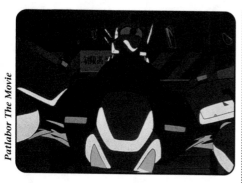

PATLABOR THE MOVIE
(Eng title for KIDO KEISATSU PATLABOR 1999 TOKYO WAR, lit Mobile Police Patlabor 1999 Tokyo War)

JAPANESE CREDITS: Dir: Mamoru Oshii. Des dir: Koji Sawai. Script: Kazunori Ito. Chara des: Akemi Takada. Mecha des: Yutaka Izubuchi. Anime dir: Kazuya Kise. Art dir: Hiromasa Ogura. Photography dir: Shigeo Sugimura. Sound des dir: Shigeharu Shiba. Music: Kenji Kawai. Exec prod: Bandai, Tohokushinsha. Prod: Studio Deen. © Headgear, Emotion, TFC. 120 mins. WESTERN CREDITS: UK & US video & theatrical release 1995 on Manga Video, sub & dub. Later released as twin pack with Patlabor 2. ORIGINS: Manga by Masami Yuuki; TV series; 1988 & 1989 OAVs. POINTS OF INTEREST: The numerous Biblical references in the film. CATEGORIES: SF, N

The mood is much darker than the OAV series; to reflect this, the colour palette is much colder and less bright and the music carries more ominous low notes. The other striking feature is that the characters are neither explained nor introduced. The presumption is that the audience already knows these people and their various relationships and functions; we plunge straight into the action, with no need for niceties. The brilliant but insane computer and engineering genius, E. Hoba, commits suicide in Tokyo Bay, site of the Babylon Project, leaving behind a string of clues to the time bomb he has designed into the operating system of hundreds of Shinohara Labors. The Special Vehicle Section must solve his riddle to prevent a massive malfunction with possibly appalling consequences. A superbly crafted contemporary SF film looking at the possibilities for disaster inherent in our reliance on technology and those who make it. ★★★★

PLEASE WINK FOR ME GRANDMA
(Eng trans for PACCHINSHITE OBAACHAN)

JAPANESE CREDITS: Dir: Shinichi Tsuji. Writer: Susumu Mukahira. Prod: Masaki Ito. Prod co: Group Tack. ORIGINS: The book Living in the Light by Hiro Seki, based on the diaries kept by friends of the heroine. CATEGORIES: N

A real-life story centred on Yasue Kitajino, who at the age of eighty suffered a stroke which left her almost completely disabled. Yasue had another four years of life, and lived them more fully than anyone thought possible thanks to the intervention of her daughter, Hiro, and a group of friends which eventually expanded to fifty-four in number. Many did not know Yasue at the time of her stroke but were drawn in by other friends, and they all gave their time and love to this old lady, whose indomitable spirit seems to have inspired everyone she met. They would read to her, make music with her, paint pictures with her, not simply allowing her to watch, but constantly demanding her participation and communicating with her in whatever ways her disabilities would allow. Animated in simple, realistic style, this is an inspirational story about the real value and joy of life. ★★★?

OAVS

AD POLICE FILE 1: THE PHANTOM WOMAN
(aka UK AD POLICE FILE 1: VOOMER MADNESS)

JAPANESE CREDITS: Dir: Takamasa Ikegami. Screenplay: Noboru Aikawa. Story & chara des concepts: Tony Takezaki. Original story & planning: Toshimichi Suzuki. Chara des & anime dir: Fuji Oda. Prod: Artmic, AIC. © Bandai. 40 mins. WESTERN CREDITS: US video release 1993, sub, 1995, dub, on AnimEigo, trans Shin Kurokawa & Eriko Takai; UK video release 1995 on Manga Video, dub. ORIGINS: Stories by Toshimichi Suzuki; manga by Tony Takezaki, Eng trans pub Dark Horse Comics (US), Manga Publishing (UK). Spinoff from the Bubblegum Crisis series. CATEGORIES: SF, X

Also:
AD POLICE FILE 2: THE RIPPER
(UK aka AD POLICE FILE 2: THE PARADISE LOOP)

JAPANESE CREDITS: As above except:
Dir: Akira Nishimori. Chara des: Toru
Nakasugi. Anime dir: Hiroyuki Kitazume
& Masami Ota.
WESTERN CREDITS, ORIGINS, CATEGORIES:
As above.

Also:
AD POLICE FILE 3: THE MAN WHO BITES HIS TONGUE
(UK aka AD POLICE FILE 3: I WANT MEDICINE)

JAPANESE CREDITS: As above except:
Screenplay: Tony Takezaki. Chara des: Toru
Nakasugi. Anime dir: Hiroyuki Kitazume &
Masami Obari.
WESTERN CREDITS, ORIGINS, CATEGORIES:
As above.

A dark and brooding cyberpunk series presents the *Bubblegum Crisis* universe without the Knight Sabers. It's often described as a 'prequel' to *Crisis*; Leon McNichol is a relatively raw officer in the AD Police and the series focuses on his colleagues in the force and their day-to-day anti-Buma operations. Each file tells a self-contained story about how the abuse of technology can dehumanise and exploit both biological and artificial intelligences. In File one, McNicol and his partner Geena are on a case involving Bumas running amok, and track back to a criminal reactivating Bumas which have been 'scrapped' by police action. One of the recycled creatures is haunted by a recurring memory of the cop who scrapped her — Leon — and is out to get him. Is it right to make beings so close to human that they *feel* human if you're going to treat them as disposable dolls, not people? File two shows detective Ailis investigating a series of vicious murders of call-girls and uncovering a potential link between the fashion for cybernetic 'augmentation' and the

killer's twisted psyche. Can one add so many upgrades and high-fashion implants that one ceases to be human? File three has a cop, Billy Fanword, turned into a cyborg after sustaining terrible injuries from a runaway Buma. How does a person remember he's human when the only way to feel any physical sensation is to bite his tongue? Bleak but interesting. ★★★

AIM FOR THE ACE! FINAL STAGE VOLS 4-6
(Eng trans for ACE O NERAE! FINAL STAGE VOL 4-6)

JAPANESE CREDITS: Dir: Osamu Dezaki.
Prod: Tokyo Movie Shinsha. © S. Yamamoto,
Bandai, TMS. Each 50 mins.
ORIGINS: Manga by Sumika Yamamoto;
1973 TV series; 1979 movie; 1988 & 1989
OAV series.
CATEGORIES: N

The conclusion of the story of tennis ace Hiromi, with our heroine finding happiness again. ★★☆?

A-KO THE VS: BATTLE 1, GREY SIDE
(aka PROJECT A-KO V)

JAPANESE CREDITS: Dir: Katsuhiko
Nishijima. Screenplay: Katsuhiko Nishijima
& Tomoko Kawasaki. Chara des & anime
dir: Hideyuki Motohashi. Art dir: Mitsuharu
Miyamae. Music dir: Yasunori Honda. Prod:
Studio Fantasia. © Final Nishijima,
Nextart. 55 mins.
WESTERN CREDITS: US video release 1994
on US Manga Corps, sub & dub; UK video
release 1995 on Manga Video, dub.
ORIGINS: Story by Katsuhiko Nishijima,
Yuji Moriyama & Kasumi Shirasaka; 1986
movie, Project A-KO, & subsequent OAVs
every year 1987-9.
POINTS OF INTEREST: 'Alternate universe'
story with the original charas in new
relationships and settings.
CATEGORIES: SF, C

Also:
A-KO THE VS: BATTLE 2, BLUE SIDE
(aka PROJECT A-KO V)

CREDITS, ORIGINS, CATEGORIES: As above
except: Screenplay: Yuji Kawahara. Chara
des & anime dir: Katsuhiko Nishijima.

AD Police File 2

CATEGORIES: SF, V

Baffled by her comrades' actions, Angel pursues Raiden from the terrorists' devastated warehouse. Meanwhile a terrorist reveals under questioning that his group was set up to destroy Japan economically, and that others will follow; but an anti-terrorist vigilante called the Hunter is on their tail. A senior officer orders the Special Police eliminated and sends a J-SWAT team to do the job. The secrets of political chicanery begin to come out, and Angel learns that Raiden is a cyborg. The episode ends with lots of explosions; it's a well crafted and ultimately hollow bloodbath. ★★

ARIES

JAPANESE CREDITS: Prod: Studio Zain. © Akita Novel. 45 mins.

No other information available.

ASSEMBLE INSERT 2

JAPANESE CREDITS: Dir: Ami Tomobuki. Script: Mitsuru Shimada. Chara des: Masami Yuuki. Mecha des: Yutaka Izubuchi. Prod: Studio Core. © Tohokushinsha. 30 mins. ORIGINS: Masami Yuuki's; 1989 OAV. CATEGORIES: SF, C

The insanity continues. Chief Engineer Hattori and co promote Maron as a top idol singer in an effort to make her destruction of city property more acceptable to the public, and to pull in some cash from her concerts and records to pay for repairs and more crime fighting. But the bad guys at Demon Seed are determined to see her defeated. Who will win the final confrontation? ★★★

A revision of the original *Project A-Ko* scenario has A-Ko and B-Ko as partners — one the brawn and one the brain of a monster hunting operation. C-Ko, the ten-year-old adopted daughter of a shipping magnate, is as yet unknown to either of them, but she drops in (quite literally) when kidnappers whisk her away from her birthday party and manage to lose her *en route* to their hideout. A-Ko and B-Ko both think she's incredibly cute, but there's more to the bubblebrain than that. Once again she's an alien, this time the channel to great mystical powers, and the kidnappers were hired to deliver her to a man who wants to control these powers for his own ends. And he's a dish. And B-Ko dies and falls madly in love with him, in that order. Yet more slapstick and parodic mayhem for your enjoyment. ★★★

ANGEL COP 3 THE DEATH WARRANT
(Eng title for ANGEL COP 3 MASSATSU SHIREI, lit Angel Cop 3 Erase Command)

JAPANESE CREDITS: Dir: Ichiro Itano. Script: Noboru Aikawa. Chara des: Nobuteru Yuuki. Anime dir: Satoru Nakamura. Prod: DAST, Studio 88. © Itano, Soieshinsha, Japan Home Video. 30 mins. WESTERN CREDITS: US & UK video release 1995 on Manga Video, dub. ORIGINS: Story by Ichiro Itano; 1989 OAV.

BEAST BATTLE FRONT VOLS 1-3
(Eng trans for JYUSENKI VOLS 1-3)

JAPANESE CREDITS: Prod: Animate Film. © Tokuma Japan. Each 45 mins.

No other information available.

BE-BOP HIGH SCHOOL 1 & 2

JAPANESE CREDITS: Prod: Toei Animation. © Toei Video. 30 mins & 50 mins. ORIGINS: Manga by Kazuhiro Kiuchi. CATEGORIES: N

Angel Cop 3

Stories about macho modern Japanese schoolboys, very hard edged.

BLUE SONNET VOL 2
(Eng title for AKAI KIBA BLUE SONNET, lit Red Fang Blue Sonnet, vols 4 & 5)

JAPANESE CREDITS: Dir: Takeyuki Kanda. Original story: Masahiro Shibata. Chara des: Shouichi Nakayama. Art dir: Naoshi Yokose. Music dir: Susumu Aketagawa. Prod: Mushi Pro. © Shibata, Hakusensha, Mushi Pro, Walkers Company. Each 30 mins.
WESTERN CREDITS: US video release 1994 on US Manga Corps on single tape, sub, trans William Flanagan & Pamela Parks, Eng rewrite Jay Parks.
ORIGINS: Masahiro Shibata's 1982 manga, pub Hakusensha; 1989 OAV.
CATEGORIES: SF

As Sonnet questions her own existence, Ran decides that she must stop the evil Doctor. But is she too late to prevent him completing his cloning project and creating an army of psychic warriors? And if she succeeds, what will become of Sonnet, his creation? ★★☆

BOMBER BIKERS OF SHONAN 6
(Eng title for SHONAN BAKUSOZOKU 6, lit Wild Explosive Motorbike Gang from Shonan 6)

JAPANESE CREDITS: Prod: Toei Animation. © Toei Video. 50 mins.
ORIGINS: Manga by Satoshi Yoshida, pub Shonen Gohosha; OAVs every year 1986-89.
CATEGORIES: N, A

More teen adventures with the sweetest-natured and most honourable biker gang in the East.

BORGMAN: LOVER'S RAIN
(Eng title for CHOSENSHI BORGMAN LOVER'S RAIN, lit Supersonic Soldier Borgman: Lover's Rain)

JAPANESE CREDITS: Prod: Ashi Pro. © Toho Video. 33 mins.
ORIGINS: 1988 TV series; 1989 OAV.
CATEGORIES: SF

This second *Borgman* OAV is widely considered by fans to have a stronger story and far better continuity with the TV series than the first. At the end of the TV series, former Borgman team leader Memory Green had been killed in the last battle with the invading Yoma after killing her younger brother, a Yoma slave. The other main team members, Ryo, Chuck and Anice, are still close to each other, but the Yoma threat is considered over. Ryo is still tortured by memories and haunted by the idea that maybe Memory let herself be killed to atone for the death of her brother. His negative emotion attracts a surviving Yoma, which attacks him and Anice. The battle action is considered to be the best animated and choreographed in the *Borgman* saga. ★★★?

BUBBLEGUM CRISIS 7: DOUBLE VISION

JAPANESE CREDITS: Dir: Fumihiko Takayama. Chara des: Kenichi Sonoda & Satoshi Urushibara. Mecha des: K. Sonoda, Shinji Aramaki & Hideki Kakinuma. Art dir: Katsuhiro Arai. Music: Kaouji Makaino. Planning & original story: Toshimichi Suzuki. Prod: Artmic. © Artmic, Youmex. 45 mins.
WESTERN CREDITS: US video release, sub, 1992, dub, 1994 on AnimeEigo, trans Shin Kurokawa & Michael House; UK video release 1994 on Anime Projects.
ORIGINS: Created by Toshimichi Suzuki; OAVs every year 1987-89
POINTS OF INTEREST: AIC are currently (early 1996) asking for fan opinion and input via the Internet as to further Bubblegum Crisis adventures.
CATEGORIES: SF

Singing sensation Vision — real name Reika — has lost her parents to the Gulf Bradley Co and sister to GENOM, and wants revenge. She uses the opportunity of a concert in MegaTokyo around the same time as GENOM and GB are co-operating on a new Buma project to get it. There's a plot afoot to get GENOM top man Quincy too. Intrigue, action and a closing concert by Vision make up a good value OAV. ★★★

CAROL

JAPANESE CREDITS: Writer & prod: Naoto Kine. Chara des: Yun Kouga. Prod co: Animate Film, Magic Bus. © Kine, Youga, TM Needs, MOVIC, Sony Music Entertainment (Japan) Ltd. 60 mins.
ORIGINS: Story by Naoto Kine.
SPINOFFS: A 2nd Carol OAV is planned for 1996 release in Japan.
CATEGORIES: DD, U

1991. Carol is the teenage daughter of a famous cellist living in London, and strange things have been happening round her. First her favourite rock band, Screen, started to lose popularity. Then her father finds he can no longer make music. Next Big Ben loses its chimes, and finally when Carol tries to listen to her Screen CD, no sound comes out of the speakers. Someone is stealing all sound; meanwhile Carol hears a strange voice in her head, begging for her help, and as she realises what is happening she is surrounded by a strange light. A door between two worlds opens and she finds herself in Lapas Lupas. Her first reaction on meeting the elf Tico and realising that she isn't in her own world any more is perfectly natural — she faints. From Tico she learns that a musician, Clark, has been trying to contact her for help against the evil Gigantica, who feeds on sound and has gradually been stealing all the sound both from Lapas Lupas and her own world. At first Carol only wants to go home, but after meeting a swordsman called Flash and a talking rabbit, Domos, she and Flash are captured by Gigantica's goblins. In Gigantica's stronghold they meet Clark, discuss tactics and escape to enlist the help of the Spirit of the Lake. Its magic and some brave fighting from Flash and Tico destroy Gigantica, and Lapas Lupas is restored to its former beauty. Parting from her new friends with some regret, Carol is returned to her own world, where the beauty of sound is once again restored. A sweet, innocent fable quite suitable for the younger viewer. ★★☆

CITY HUNTER: BAY CITY WARS

JAPANESE CREDITS: Dir: Kenji Kodama. Chara des: Sachiko Kimimura. Art dir: Yasue Kitahara. Prod: Sunrise. © CIC Victor. 45 mins.
ORIGINS: Manga by Tsukasa Hojo, pub Shueisha; 4 TV series between 1987 & 1991; 1989 movie.
POINTS OF INTEREST: Hojo also created the earlier Cat's Eye manga and TV series.
CATEGORIES: M

A reception is being held for the grand opening of the new Tokyo Metropolitan Hotel, built on an artificial island of the Bay City project and connected to the mainland by the Bay Bridge. Ryo and Umibozu, his old friend and cohort, get involved with some heavy artillery of a kind that shouldn't be around a civilian area, and the reception guests — including Ryo's partner Kaori and Umibozu's wife Miki — are taken hostage by forces working for Central American dictator General Geliya, whom the Pentagon have just helped depose. His daughter Luna plans to help him wreak revenge by programming the Pentagon's computer to aim all its missiles into the USA. There are lots of carefully and powerfully choreographed fight sequences, lots of big explosions with buildings, bombs and high-tech hardware going kaboom, and plenty of action for supercool Ryo and his big pal Umibozu, as well as for the females, who prove more than capable of handling their share of the excitement. ★★★

Also:
CITY HUNTER: MILLION DOLLAR PLOT

CREDITS, ORIGINS, CATEGORIES: As above except: Art dir: Sachiko Kimamura. 47 mins.

In Los Angeles, a beautiful blonde is given her next target — Ryo Saeba. In Tokyo, she introduces herself to Ryo and Kaori as Emily O'Hara, looking for a job and a place to lie low until some mob problems she has die down. She offers to pay them a million dollars to keep her safe, with ten thousand down; it's way over the odds for a bodyguard job, and rumours are out that someone is due in from LA to kill Ryo. But Emily is in fact a CIA agent sent to follow Ryo so as to get a shot at the real hitman, Douglas — who also happens to be the guy who killed her older brother. Cross, doublecross and plain old English bedroom farce humour are mixed with a light hand in this cocktail of action thriller and sex comedy. Ryo does end up with the million dollars — but how much will be left once all the damage has been paid for? ★★★

CRYING FREEMAN 3 SHADES OF DEATH PART 2

JAPANESE CREDITS: Dir: Johei Matsuura. Screenplay: Higashi Shimizu. Music: Hiroaki Yoshino. Prod: Toei Animation. © Toei Video. 50 mins.
WESTERN CREDITS: US video release 1993 on Streamline Pictures, dub, Eng dialogue

Gregory Snegoff; UK video release 1994 on Manga Video, dub.
ORIGINS: Manga by Kazuo Koike & Ryuichi Ikegami, pub Shogakukan, Eng trans pub Viz Communications 1993; 1988 & 1989 OAVs.
CATEGORIES: M, X

One of the most compelling episodes of the manga — Emu's bonding with the cursed Muramasa blade — forms the second part of this episode and is worth seeing, though not nearly so powerful here as in the manga. The other part concerns Yo's and Bayasan's encounter with the African Tusk group, and Yo's much closer encounter with their lady boss for some mutual and not entirely bloody physical assault. Note: the UK and US dubs are different. The UK dub is dire. ★☆

CYBER CITY OEDO 808 FILE-1 VIRTUAL DEATH
(Eng title for CYBER CITY OEDO 808 DATA-1 INISHIE NO KIOKU, lit Cyber City Oedo 808 File-1 Ancient Record, aka ANCIENT MEMORY. US title omits subtitle)

JAPANESE CREDITS: Dir & chara des: Yoshiaki Kawajiri. Screenplay: Akinori Endo. Chara des & anime dir: Hiroshi Hamazaki. Mecha des: Takashi Watanabe. Art dir: Katsushi Aoki. Music: Kazz Toyama. Music dir: Yasunori Honda. Prod:

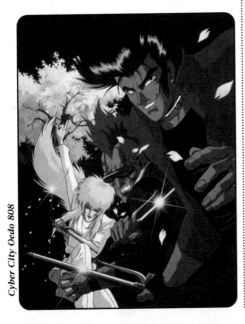

Cyber City Oedo 808

Madhouse. © Japan Home Video. 48 mins.
WESTERN CREDITS: UK video release 1994/5 on Manga Video, dub, script adaptation George Roubicek; US video release 1995 on US Manga Corps, sub & dub, Eng rewrite Jay Parks.
ORIGINS: Original idea by Juzo Mutsuki.
POINTS OF INTEREST: The UK release has a new soundtrack by Rory McFarlane. The Cyber City Oedo Original Soundtrack CD available in the UK on Demon Records contains this original UK soundtrack, not the original Japanese music.
SPINOFFS: An American pseudomanga retelling the series has been produced by Studio Go! for CPM Comics.
CATEGORIES: SF, M, X

One of Kawajiri's finest works and a compelling homily on the addictive potential of computer hacking. It's 2808. Sengoku, Benten and Goggle are three criminals, each of them with enough time stacked up to cover several lifetimes for crimes from murder to traffic violations. The chief of the Cyber Police offers them a choice — of sorts. Work for him, equipped with full metal collar. Every assignment successfully completed within the time limit knocks a few years off the sentence. The first assignment not completed within the time limit will simply mean that the collar blows the wearer's head off. As a productivity incentive it takes some beating, but after three and a half years Sengoku has only managed to reduce his sentence from 375 to 312 years. The next case, though, is something special. A hacker is getting into the Kurokawa Tower systems. The most likely suspect is a computer whiz named Amachi, a colleague of the same Kurokawa for whom the Tower is named — but he disappeared fourteen years ago. Goggle and Benten are called in to help, but it's Sengoku who finally fights his way to the basement and finds the secret network that Amachi's cybernetic implants have established to control the computer from his dead brain and wreak his revenge at long last on the man who killed him so as to steal all the credit for the work they did together on the tower's central computer. Exciting stuff. ★★★★

Also:
CYBER CITY OEDO 808 FILE-2 PSYCHIC TROOPER
(Eng title for CYBER CITY OEDO 808 DATA-2 OTORI NO KIKO, lit Cyber City Oedo 808 File-2 System of Recall. US title omits subtitle)

CREDITS, ORIGINS, CATEGORIES: As above except: Chara des: Yoshiaki Kawajiri & Michio Mihara. 52 mins.

Sengoku is the action hero of the criminal cop trio, but beefy Goggle is the computer and cybernetics wizard. However, in this episode he has to take on an action role as he goes up against the city's newest weapon prototype — a cyborg soldier à la Robocop — and faces his own feelings for the beautiful girl who used to be his partner and has now betrayed him. Meanwhile the Chief is involved in political manoeuvrings to outwit the Cyber Police's enemies in the regular force and Government. All the action you could reasonably expect in a good old fashioned cyber-thriller. ★★★☆

DANCOUGAR: LAST CHAPTER OF HEAT ACT 2-4
(Eng title for CHOJU KISHIN DANCOUGAR BYAKUNETSU NO SHUSHO ACTS 2-4, lit Super Bestial Machine God Dancougar Last Chapter of Heat Acts 2-4)

JAPANESE CREDITS: Prod: Ashi Pro. ©
Bandai. Each 30 mins.
ORIGINS: 1985 TV series; 1986, 1987 & 1989
OAVs.
CATEGORIES: SF

More chapters of the Machine God Corps' final adventures.

DELICIOUS DAD
(Eng title for TOKKYU NO CHEF WA OISHINBO PAPA, lit The Best Chef is My Delicious Dad, aka COOKING PAPA)

JAPANESE CREDITS: Prod: Raiden Film. ©
Japan Columbia. 45 mins.
CATEGORIES: N, C

No relation to the 1988 TV series *Oishinbo*, which chronicled the romantic adventures of a young restaurateur, this is a charming domestic comedy centring around a father who can solve a lot of problems through his gourmet cooking — eventually! ★★★?

DEMON BEAST INVASION 1-6

JAPANESE CREDITS: Dir: Jun Fukuda.
Script: Joji Maki. Chara des: Mari Muzuta.
Art dir: Naoto Yokose. Music dir: Teruo
Takahama. © Maeda, Daiei Co. Each 45
mins.
WESTERN CREDITS: US video release 1995/6
on Anime 18, sub.

ORIGINS: Manga by Toshio Maeda, creator
of Legend of the Overfiend.
CATEGORIES: X, V

A hundred million years ago, Demon Beasts were driven from Earth by a huge ecological disaster. Now they're trying to come back. Unable to survive in the Earth's atmosphere, they have to take over human bodies and decide to seek out human women to mate with so as to breed Demon Beasts adapted to Earth's environment, to prepare the planet for their return in force. But the Interplanetary Mutual Observation Agency means to stop them, and agents Kasu and Muneto are on the trail of the first Demon Beast on Earth. However, Muneto's old friends Tsutomu and Kayu get unwittingly involved; Tsutomu is possessed, he rapes Kayu and Kasu is killed, then Muneto kills Tsutomu. That's as far as I got. In part two, the mating of Tsutomu and Kayu produces a child which aims to kill Muneto, as the murderer of its father, and sets about turning Mother's friends into a mindless slave army as a first step to preparing the world for the invasion of the Demon Beast brood, waiting in Space. On the strength of part one and my reviewer's report on part two, I'll give this a grudging ☆

DEVILMAN II THE DEMON BIRD
(Eng title for DEVILMAN YOCHO SHIRENU, lit Devilman Winged Nemesis Shirenu, aka SIREN THE DEMON BIRD)

JAPANESE CREDITS: Dir & screenplay:
Tsutomi Iida. Original work, supervisor &
screenplay: Go Nagai. Chara des: Kazuo
Komatsubara. Anime dir: Shoji Ando.
Music: Kenji Kawai. Prod: Oh Production. ©
Dynamic Planning, Kodansha, Bandai.
60 mins.
WESTERN CREDITS: UK video release 1994
on Manga Video, dub, script adaptation
John Wolsky; US video release 1995 on US
Renditions, sub, as Siren the Demon Bird.
ORIGINS: Manga by Go Nagai; 1972 TV
series; 1987 OAV.
POINTS OF INTEREST: The female demon's
name can be romanised as Shirenu, Sirene
and Silene with equal veracity.
CATEGORIES: D, X, V

Akira Fudo is living a 'normal' life with his uncle, aunt and cousins, but all the while he has another life as Devilman, the powerful human/demon hybrid created in a bloody battle with demons which has left his friend Ryo in hospital. Ryo doesn't seem to be suffering too much, with the constant

CATS

They're cute, they're cuddly and they're always smarter than we are. These are my five favourite felines from the anime world.

1 MICHAEL — WHAT'S MICHAEL?

This cat is seriously cool. His dancing is so hip, sometimes you'd think he was Michael Jackson — indeed, there are a few frames of him dressed as Michael just to help you get the idea. He survives suburban Tokyo and his nerdish human with style.

2 APOLLO — GALACTIC PIRATES

What is it with cats and black entertainment idols? Apollo thinks he's Eddie Murphy, except that Eddie could never talk that fast. He's a hit with all the cutest girls too, which annoys his human partner Latell no end.

3 NUKU-NUKU — CATGIRL NUKU-NUKU

You can take the brain out of the cat, but you can't take the cat out of the brain... Nuku-Nuku is genetically engineered to be the perfect combination of schoolgirl and kitten, two of the most irresistible and most infuriating life-forms in the universe.

4 MUGHI — DIRTY PAIR

In his TV and video incarnation he's a fat cat rather than the sleek panther-like creature of the novels, and he's big — Lupin III has driven cars that are smaller than Mughi. Cuddly, seriously cute and probably brighter than both Kei and Yuri, he can even fly their spaceship, the *Lovely Angel*.

5 TORA — USHIO & TORA

Not really a cat, but since his human companion gives him the Japanese word for tiger as a name he qualifies. An elemental spirit imprisoned in a temple by an ancestor of the boy who eventually releases him, he's wild, fierce and deadly. As disinterested as most felines in anything but his own comfort and food, he is nevertheless capable of loyalty and unselfishness, much to his own annoyance.

attentions of pretty nurses to make life more pleasant, but the demons don't intend to let matters go so lightly. They send turtle demon Jinmen to taunt Akira with the death of his mother, and attack what remains of his family through demons under the command of Silene, the sexiest creature ever to sink her vicious nine-inch talons into an enemy. The battle between her and Devilman forms most of the latter half of the OAV, and a magnificent one it is, with wonderful flight sequences and arresting images framing the gory hand-to-hand fighting with pure visual poetry. In the end it's only Ryo's intervention that saves the day, and Akira's second major victory against the demons is won at considerable cost. The UK version boasts not a great translation and a truly awful dub, but this is a powerful OAV. ★★★☆

DIRTY PAIR: FLIGHT 005 CONSPIRACY
(Eng trans for DIRTY PAIR SAKURYAKU No. 005 BIN)

JAPANESE CREDITS: Dir: Toshifumi Takizawa. Script: Fuyushi Itsutake. Chara des: Tsukasa Dokite. Mecha des: Kazutaka Miyatake & Yasushi Ishizu. Art dir: Ariaki Okada. Music: Tohru Okada. Prod: Sunrise. © Takachiho, Nue, Sunrise. 60 mins. WESTERN CREDITS: US video release 1994 on Streamline Pictures, dub, Eng screenplay Ardwright Chamberlain. ORIGINS: Novels by Haruka Takachiho; appearance in 1983 movie Crushers; 1985 TV series & OAV; 1987 movie; 1987 & 1988 OAVs. CATEGORIES: SF, A

A plane explodes in flight after a hijack attempt, but not a single insurance claim is made, despite over 300 deaths. A scientist and his family disappear. It's time to send for 3WA's top Trouble Consultants, the Dirty Pair. For some reason the computer has erased the passenger lists but it's known that the last two passengers, who boarded late and in a hurry, gave false names and the address of a deserted research laboratory. The Pair survive attempts on their lives (which is more than can be said for anyone else in the vicinity) and track the attackers back to planet Dolz. The missing scientist and his family are rescued and the mystery explained. What do you mean, what about the cost? What did you expect? Well, this is a departure from the Pair's usually sillier antics, a real thriller with drama and action. But whether action or comedy is the cause, mass destruction is the effect. ★★★☆

EARTHIAN II

JAPANESE CREDITS: Dir & chara des: Kenichi Onuki. Prod: J.C. Staff. © Toshiba EMI. 45 mins.
ORIGINS: Manga by Yun Kouga, aka Yun Takakawa; 1989 OAV.
CATEGORIES: DD, R

Cliff, a rock singer, is really a fallen angel living on Earth. (Please note that this is not intended to portray any actual rock idol, living or dead!) He has fallen in love with a human, Blair. This is, of course, strictly forbidden, and when the heavenly survey team find out there'll be trouble. That's all I know about this one, but it sounds intriguing, probably for all the wrong reasons. ★★?

EIJI

JAPANESE CREDITS: Prod: Animate Film. © Shueisha, Pony Canyon. 45 mins.

I have no further information about this title.

EVERY DAY IS SUNDAY VOLS 1 & 2
(Eng trans for MAINICHI GA NICHIYOBU VOLS 1 & 2)

JAPANESE CREDITS: Prod: Animate Film. © Tokuma Japan. Each 30 mins.
ORIGINS: Based on manga by Kosuke Fujishima, author of Oh My Goddess! & You're Under Arrest!
CATEGORIES: N, R

A police drama/romance. Yumi Takeshita is saved from a road accident but her rescuer is injured. A year later she meets him again — by this time she's a rookie policewoman with the twin aims of working for justice and finding a boyfriend. His name is Toru Ichidaiji and he's a magician. He would have gone to Hollywood by now, but the accident he had a year ago held him back. And now he's met her again, he may as well stay in Japan to form half of an unusual crime fighting team. ★★☆?

EVIL LAND VOLS 1 & 2
(Eng title for TENGAI MAKYO JIRAI YA OBORO-HEN, lit Evil Land Mineshaft Watch Chapter)

JAPANESE CREDITS: Prod: Tokyo Movie Shinsha. © Takara, Kadokawa. Each 50 mins.

I have no further information.

FEMALE SOLDIERS EFE & JEILA: GOUDE'S COAT OF ARMS
(Eng trans for ONNA SENSHI EFE & JEILA GOUDE NO MONSHO)

JAPANESE CREDITS: Dir: Kazusane Kikuchi. Script: Isao Seiya. Chara des: Tsukasa Dokite. Key animation: Masamitsu Kudo. Art dir: Kazunori Sagawa. Prod: J.C. Staff. © Tairiku Novel. 45 mins.
CATEGORIES: DD, A

I have little information about this except that it's a *Dirty Pair* clone in a sword-and-sorcery universe; Efe, the cute green-haired one, and Jeila, the redhead with the big broadsword, are very nicely drawn and full of character.

GALACTIC PIRATES 1-6
(Eng title for TEKI WA KAIZOKU NEKOTACHI NO KYOEN, lit The Enemy is the Pirate: Party of Cats)

JAPANESE CREDITS: Dir: Masahisa Yamada. Chara des & art dir: Takayuki Goto. Mecha des: Takashi Watanabe. Prod: Masatoshi Tahara. Prod co: Kitty Film Mitaka Studio. © Kitty Video. Each 30 mins.
WESTERN CREDITS: UK video release 1994 on Western Connection, dub, trans D. R. Shoop.
ORIGINS: SF novel by Chohei Kanbayashi.
POINTS OF INTEREST: Despite the very American idiom and accents, this was dubbed on the instructions of Kitty Film especially for the English market. The soundtrack is performed by Air Pavilion, a band composed of members and former members of Whitesnake, Iron Maiden, Motorhead, Tommy Shaw and other metal deities.
CATEGORIES: SF, C

A fast, furious, funny, fabulous cats-on-acid-drops romp with a jive-talkin' feline hero who sounds like Eddie Murphy on fast forward and some wild concepts wrapped around the story of piracy, kitties and two cops who just can't seem to keep their noses clean. Apollo and his human partner, Latell, are involved in a race to see who will resign — or get fired — from the force first, but they eventually manage to solve a case involving piracy, cross, doublecross, the game of baseball as a religio-militaristic training ritual, and everybody around them turning into cats. There are so many ideas packed into the story, and they are shot at you at such a speed, that the convo-

I have no further information.

lutions of *Legend of the Overfiend* look quite straight-forward by comparison. Their snooty supercomputer-ship is a great character in its own right and the cat-shaped flying machine is something you have to see. If you survive the first episode you'll love this. ★★★

GALL FORCE: EARTH CHAPTER PARTS 2 & 3
(Eng trans for GALL FORCE CHIKYUSHO 2 & 3)

JAPANESE CREDITS: Dir: Katsuhito Akiyama. Screenplay & original story: Hideki Kakinuma. Chara des: Kenichi Sonoda. Music: Kaoru Mizutani. Prod: Artmic, AIC, Dirts. © Artmic. Part 2 50 mins, Part 3 c60 mins.
WESTERN CREDITS: US video release 1994 on US Manga Corps, sub, trans William Flanagan & Pamela Parks, Eng rewrite Jay Parks.
ORIGINS: Original story by Hideki Kakinuma; 1986 movie; OAVs every year 1987-89.
CATEGORIES: SF, W

The war for Earth rages on with the mighty plasma cannon Hekatonkeira aimed at the MME base. Mars Defence Force commits major assault forces in a bid to destroy the MME once and for all. In the midst of the battle Catty tries to establish contact with the MME supra-intellect, GORN. When it refuses to lis-ten to her, she must manoeuvre Sandy and her group into a battle in which she and GORN can meet again, hoping that GORN will read Sandy's mind and realise the value of the human emotions its kind lack. But the computer entity has its own reasons for wanting to meet Sandy — her father, Dr Newman, who died in the apocalypse, held one last key element the machines need for their plan to eliminate the last of mankind, and Sandy may have it. Once again, the two races must come together if either is to survive, but will their plots and aggression foil all attempts to find peace? Meanwhile, on Mars General McKenzie plans a massive return to Earth. ★★☆?

GRANDZORT: THE LAST MAGICAL WAR
(Eng title for MADOU GRANDZORT SAIGO NO MAGICAL TAISEN, lit Evil King Grandzort the Last Magical War)

JAPANESE CREDITS: Prod: Sunrise. © Takara. 2 parts, each 30 mins.
CATEGORIES: U, C, SF

A comedy in which an SD giant robot team save Earth from the falling moon.

GUNDAM ILLUSTRATED BOOK
(Eng title for KIDO SENSHI GUNDAM MOBILE SUITS DAIZUKAM, lit Mobile Suits Special Illustrated Book)

JAPANESE CREDITS: Prod: Sunrise. © Bandai, Sunrise. 30 mins.
ORIGINS: Novels by Yoshiyuki Tomino; 1979 onwards TV series; 1988 movie Char's Counterattack; 1989 OAV.
CATEGORIES: SF

I have no further information.

THE GUYVER DATA 6
(Eng title for KYOSHOKU SOKO GUYVER, lit Armoured Creature Guyver, aka BIO BOOSTER ARMOUR GUYVER)

JAPANESE CREDITS: Dir: Koichi Ishiguro. Screenplay: Atsushi Sanjo. Chara des: Hidetoshi Omori. Anime dir: Sumio Watanabe & Atsuo Tobe. Art dir: Junichi Higashi. Music dir: Jun Watanabe. Prod: Takaya Pro, Animate Film. © Takaya Pro, KSS, Bandai, MOVIC, Tokuma Shoten. Each 30 mins.
WESTERN CREDITS: UK video release 1994/5 on Manga Video, dub, ep title 'Terminal Battle: The Fall of Chronos Japan'; US video release 1994 on US Renditions, dub, on one tape with part 5 as Guyver Vol 3, ep title 'Terminal Battle! The Fall of Chronos', Eng screenplay & voice direction Quint Lancaster & Robert Napton.
ORIGINS: Manga by Yoshiki Takaya, pub Tokuma Shoten, Eng trans pub Viz Communications; 1986 & 1989 OAVs.
SPINOFFS: Apart from the OAV series, 2 live-action films, Mutronics and Guyver: Dark Hero, were also made in the USA.
CATEGORIES: SF, X

The deadly bio-engineered Cronos warrior Enzyme is set to do battle with the Guyver. Can Sho survive this? It was a cliffhanger ending in Japan, since *Guyver Act II* had not then been announced, although of course manga readers already knew the story doesn't end here. ★☆

HADES PROJECT ZEORYMER IV
(Eng title for MEIOU KIKAKU ZEORYMER)

JAPANESE CREDITS: Dir: Toshihiro Hirano. Script: Noboru Aikawa. Chara des: Michitaka Kikuchi. Music: Eiji Kawamura.

Prod: AIC. © Chimi, Artmic, AIC. 30 mins. WESTERN CREDITS: US video release 1994 on US Manga Corps, on one tape with part III, sub, trans Neil Nadelman. ORIGINS: Original story by Morio Chimi; 1988 & 1989 OAVs. CATEGORIES: SF

Wholly confused about his own identity and feeling himself submerged by his 'father', the mysterious scientist who cloned him and donated some very nasty personality traits in the process, Masato feels he has no choice but to continue to battle the warriors of the Haudragon. But at least he now knows he has a faithful friend in Miku, who is more than just a machine to help him. The final showdown brings the world to the knife-edge of nuclear destruction. Tense and thrilling. ★★★

THE HAKKENDEN VOLS 1-4
(lit The Eight Dog Soldiers Legend)

JAPANESE CREDITS: Prod: AIC. © Soushin Picture, Artmic. Each 30 mins. ORIGINS: 98 volume Edo period novel by Bakin Kyokutei. CATEGORIES: SH, H

Another mediaeval ninja tale with quantities of the supernatural thrown in. It tells the story of a Lord so desperate for victory that he promised to give his daughter to anyone who would bring him the head of his enemy. When his faithful hound brought back the head, the Princess was determined to uphold her father's honour and was carried off into the mountains by the dog. Her lover, furious at this unnatural union, killed her in attempting to kill the hound. From her body flew eight glowing orbs, each representing one of the eight Confucian virtues and one of the eight sons she would have borne to the hound. These orbs came to rest in eight warriors, thus making them the sons of the Princess and hound, and brothers in spirit. All were formidable fighters against evil in their own ways, but they became outcasts from society and were drawn together by fate to rebuild the fortunes of their spiritual mother's family. Stylish art and animation. ★★☆

HEAVEN VERSION: UNIVERSAL PRINCE VOLS 1-3
(Eng trans for TANJO HEN UTSUNOMIKO)

JAPANESE CREDITS: Writer: Keisuke Fujiwara. Chara des: Mutsumi Inomata. Prod: Toei Animation. © Kadokawa Novel, Bandai. Each 30 mins.

ORIGINS: Novel by Keisuke Fujiwara, pub Kadokawa Books, illustrated Mutsumi Inomata; 1989 movie. CATEGORIES: P, DD

Set in eighth century Japan, this is the story of Prince Utsunomiko, born with psychic powers and marked with a horn on his head. The common people are oppressed by tyrannical aristocrats who are ignoring Japan's Shinto gods and their traditional ways in favour of Indra, patron god of the fashionable new foreign religion, Buddhism. Utsunomiko makes the hazardous journey to Heaven to fight Indra for the rights of the people and their native gods. Pretty artwork and delicate backgrounds. ★★☆?

HI SPEED JECY VOLS 7 & 8

JAPANESE CREDITS: Dir: Shigenori Kageyama. Chara des: Haruhiko Mikimoto & Akinobu Takahashi. Prod: Studio Pierrot. © VAP Video. Each 30 mins. ORIGINS: Novel by Eiichiro Saito, illustrated Haruhiko Mikimoto; 1989 OAV. CATEGORIES: SF

Jecy's quest for his parents' killers continues. The relationship between him and his masquerading 'sister' grows more complicated and his enemies trade on this. ★★★

ICZER-3 VOLS 1 & 2
(Eng title for BOKEN! ICZER-3, lit Adventure! Iczer-3)

JAPANESE CREDITS: Dir, original story & chara des: Toshihiro Hirano. Script: Emu Arii & Toshihiro Hirano. Music: Takashi Kudo. Prod: AIC. © Artmic, AIC, Kubo Shoten. Each 60 mins. ORIGINS: OAVs every year 1985-87. POINTS OF INTEREST: The voice of Iczer-3 is women's wrestling superstar, Cutey Suzuki. CATEGORIES: DD

Iczer-1 went into deep space at the end of *Iczer-1 Act III*, seeking a home for the Cthulhu. Now they return to Earth led by a new version of the old evil, Neos Gold, and a new Nagisa, descendant of the original Nagisa Kano, finds a new partner in the baby-cute shape of Iczer-3, Iczer-1 and Iczer-2's 'little sister' clone. More action, fights, messy organic monsters and massive sibling rivalry. The malevolent redhead Iczer-2 shows up again, as does good-as-gold Iczer-1. It all works out in the end, but this is a poor imitation of the original, substituting the

saccharine of high-energy, industrial-strength cuteness for horror and suspense. ★☆

KARULA MAU PARTS 1 & 2
(Eng title for HENGEN TAIMA YAKU KARULA MAU SENDAI SHOSAISHI ENKA, lit Illusion Evil Night Train Dancing Karula)

JAPANESE CREDITS: Dir & screenplay: Takaaki Ishiyama. Anime dir: Chuichi Iguchi. Art dir: Mitsuharu Miyamae. Music: Makoto Mitsui. © Toshiba EMI. Each 30 mins. ORIGINS: Manga by Takakazu Nagakubo, pub Monthly Hallowe'en magazine. CATEGORIES: DD, H

In Japanese Buddhism a karula is a powerful warrior of justice. Twins Maiko and Shoko Ogi are not just ordinary teenage girls — they are the thirty-eighth generation of mystic warriors in the holy Karula Shinyo line, and so they each have vast supernatural powers which they can call on at will. They can also switch minds and combine their powers for greater strength against evil. Raised and trained by their grandmother, herself a psychic warrior of awesome powers, they fight the ancient evil spirits which still lurk under the modern face of Japan. ★★★?

KIMAGURE ORANGE ROAD OAV VOL 1: HURRICANE AKANE! AKANE THE SHAPECHANGING GIRL
(Eng title for KIMAGURE ORANGE ROAD HURRICANE HENSHIN SHOJO AKANE, lit Orange Road Follies: Hurricane! Changing Girl Akane)

JAPANESE CREDITS: Dir: Naoyuki Yoshinaga, Takeshi Mori & Koichiro Nakamura. Screenplay: Kenji Terada & Isao Shizuya. Chara des: Akemi Takada. Anime dir: Tomomitsu Mochizuki. Art dir: Satoshi Miura. Music: Sagisu. Prod: Studio Pierrot. © Toho, Studio Pierrot. 25 mins. WESTERN CREDITS: US video release 1994 on AnimEigo, on single tape with I Was a Cat, I Was a Fish; sub, trans Michael House. ORIGINS: Manga by Izumi Matsumoto, pub Shueisha; 1987 TV series; 1988 & 1989 OAVS. CATEGORIES: DD, R, C

Also:
KIMAGURE ORANGE ROAD OAV VOL 3: LOVE STAGE, HEART ON FIRE PART 1 YOUTH IDOL
(Eng trans for KIMAGURE ORANGE ROAD KOI NO STAGE HEART ON FIRE ZENPEN

HAMWA IDOL, aka KIMAGURE ORANGE ROAD OAV VOL 3: LOVE STAGE, HEART ON FIRE PART 1 SPRING IS FOR IDOLS)

Also:
KIMAGURE ORANGE ROAD OAV VOL 3: LOVE STAGE, HEART ON FIRE PART 2 A STAR IS BORN
(Eng trans for KIMAGURE ORANGE ROAD KOI NO STAGE HEART ON FIRE HOSHI TANJO HEN, aka KIMAGURE ORANGE ROAD OAV VOL 3: LOVE STAGE, HEART ON FIRE PART 2 BIRTH OF A STAR)

JAPANESE CREDITS, ORIGINS, CATEGORIES: As above. WESTERN CREDITS: US video release 1995 on AnimEigo on one tape; part 1 entitled Spring is for Idols, Part 2 entitled Birth of a Star. Each 25 mins.

Three new adventures of the familiar and much-loved *Orange Road* team. In the first OAV, Akane goes shape-shifting and causes chaos. In the second and third, a two-part story, Kyosuke changes personalities with singing star Mitsuru Hayuta. Oddly enough, though, he finds he doesn't enjoy being the idol of thousands of teenage girls quite as much as you might expect. ★★★?

KOJIRO OF THE FUMA CLAN: HOLY SWORD WAR VOLS 1-6
(Eng trans for FUMA NO KOJIRO SEIKEN SENSOU HEN)

JAPANESE CREDITS: Dir: Hidehito Ueda. Chara des, des & supervision: Shingo Araki & Michi Himeno. Prod: Animate Film. © SME. Each 30 mins. ORIGINS: Manga by Masami Kurumada, pub Shonen Jump 1982-3; 1989 OAV. CATEGORIES: DD, SH

More adventures of the young ninja Kojiro and the other elemental ninja warriors he encounters. Retro characters and styling gives this martial arts drama a curiously dated feel. ★★☆

LEGEND OF THE OVERFIEND IV — LEGEND OF THE DEMON WOMB
(Partial Eng trans for CHOJIN DENSETSU UROTSUKIDOJI IV, lit Legend of the Overfiend: The Wandering Kid IV, aka WANDERING KID, US aka UROTSUKIDOJI PERFECT COLLECTION)

JAPANESE CREDITS: Dir: Hideaki

Takayama. Writer: Goro Sanjo & Noboru
Aikawa. Music: Masamichi Amano. Prod:
AIC. © T. Maeda, Westcape Corp. 54 mins.
WESTERN CREDITS: Edited with the 5th OAV
into the movie version, Legend of the Demon
Womb, UK video release 1993 on Manga
Video; US video release 1993 on Anime 18,
both dub. US video release also as part of
Urotsukidoji Perfect Collection 5-OAV set in
unedited format, 1993 on Anime 18, sub.
ORIGINS: Manga by Toshio Maeda; OAVs
every year 1987-89.
CATEGORIES: X, V, H

In 1944, Nazi scientist Dr. Myunihausen (aka Munchausen) conducted a monstrous Satanic rite using his Death Rape Machine to try to rupture the boundary separating the worlds and conjure up the Overfiend. Years later, in modern Tokyo, his neglected son is still in search of the secrets of the Overfiend. Akemi and Nagumo are ignorant of these machinations but Amanojaku and Megumi, with the help of their faithful accomplice Kuroko, are determined to thwart him. ★★

LICCA PARTS 1 & 2
(Eng title for LICCA FUSHIGINA YUNIA MONOGATARI, lit Licca Amazing Yunia Story)

JAPANESE CREDITS: Prod: Ashi Ado. ©
Takara, Victor Music Product. Each 30 mins.
CATEGORIES: DD, U

Licca is playing the piano when she notices one of the keys doesn't work. Opening it up to see why, she is transported to the world of Yunia with her stuffed bird toy, Dodo, and Ine the cat. Trying to find a way back to her own world, she meets many strange things — the craftsman who makes dreams, the Square Pole Forest where they all meet their own doubles, and more. A dragon tells her to seek the Amaranth Flower at the Tower of Beginning; but Ine has become spoiled by all the fuss he gets in this world, and wants to stay. Licca and Dodo are almost trapped in the Maze of Anger by their bad-tempered arguments, but eventually they find their way to Sky Garden and the Rainbow Bridge that can take them home — because all endings connect to their beginnings. A charming fable. ★★☆

LIGHTNING TRAP LEINA AND LAIKA

JAPANESE CREDITS: Script: Hideki Sonoda.
Planning: Hiroshi Kato. Prod: Ashi Pro. ©
Toshiba EMI. 30 mins.

ORIGINS: Machine Robo TV series in 1986 &
1987; Leina Stol OAVs in 1988.
CATEGORIES: DD

Leina Stol, sister of Rom Stol, is back again in another fantasy adventure. The Kronos warrior is on a plane when it is hijacked; also aboard is cyborg Interpol officer Laika, and the deadly duo team up to save the day. ★★?

MAD BULL 34 PART 1 SCANDAL

JAPANESE CREDITS: Dir: Tetsu Dezaki.
Screenplay: Toshiaki Imaizumi. Art dir:
Nobutaka Ike. Music dir: Katsunori Shimizu.
Prod: Magic Bus, Shueisha, Pony Canyon. ©
Shueisha, Pony Canyon. c49 mins.
WESTERN CREDITS: UK video release 1996
on Manga Video, dub.
ORIGINS: Manga by Kazuo Koike &
Noriyoshi Inoue, pub Shueisha.
CATEGORIES: M

The mean streets of New York, the present day. A young Japanese-American cop is paired with a veteran known as Sleepy, or 'Mad Bull' because of his cavalier attitude to the rules. (The '34' refers to his precinct number.) The rookie starts off by doing it all by the book, then gradually succumbs to the style of his partner. The pair spend a good deal of the episode undercover in drag, and their New York is populated by street punks and pretty, grateful white-trash hookers. Someone actually thanked me for not asking them to review this, saying 'there are only so many synonyms for tedious'. ☆

MOMOKO VOLS 1 & 2

JAPANESE CREDITS: Prod: Mook, Central
AV. © Apolon. Each 45 mins.

I have no further information.

NEW CAPTAIN TSUBASA VOLS 7-13
(Eng trans for SHIN CAPTAIN TSUBASA)

JAPANESE CREDITS: Prod: Animate Film. ©
Group SNE. Each 30 mins.
ORIGINS: Manga by Y. Takahashi; 1983 TV
series; 1985 & 1986 movies; 1989 OAV.
CATEGORIES: N

The ever-popular Japanese answer to Roy of the

Rovers keeps hitting the back of the net with his new OAV series. ★★?

NEW DREAM HUNTER REM: THE KNIGHTS AROUND HER BED

JAPANESE CREDITS: Prod: St. Zaine. © Meldukk. 45 mins.
ORIGINS: OAVs; see also Dream Hunter Rem, every year 1985-87.
CATEGORIES: DD

Another version of the Snow White story. Rem befriends a little girl, Mina, who has been injured in an accident. She can't walk, but she can enter other people's dreams, which is how she and Rem met. A wicked witch, jealous that her mirror calls Rem the most beautiful girl in the world, lures her to eat an apple in a dream, and in the real world, she is possessed by it and falls into a trance. As her friends gather round to try and revive her, the witch gloats over Rem's dream self in the dream-world, telling her that the apple in the real world will explode, killing her and her friends. In the end, it is Mina's courage that saves the day. Cute is the word for this OAV . ★★☆?

NEXT DOOR'S PLACE
(Eng trans for TONARI NO TOKORO)

JAPANESE CREDITS: Prod: Pasteoinc. © Bandai. 40 mins.

I don't know anything about this but it is worth citing to avoid confusion with Miyazaki's 1988 movie *Tonari No Totoro.*

NINETEEN19

JAPANESE CREDITS: Dir: Naoyuki Honda. Music: Toshiku Kadometsu. Prod: Madhouse. © Victor Music. 42 mins.
CATEGORIES: N, R

This elegant story is a complete change of tack for the renowned studio known in the West as the 'house of horror', and its style and pace exude an atmosphere of quiet refinement. It's geared to the mood of young, rich, middle class Tokyo dwellers of the early nineties, a simple love story of two university students. Popular footballer Kazushi meets the girl of his dreams one day. He's seen her (and fallen for her) in an advertisement, but she's really a medical student, and love blossoms against the background of student life. ★★☆?

OFFICE LADIES REMODELLING LECTURE
(Eng trans for OL KAIZO KOZA)

JAPANESE CREDITS: Prod: Tokyo Movie Shinsha. © Japan Herald Movie. 91 mins.
ORIGINS: Manga.
CATEGORIES: N, C

A light-hearted look at 'how to get on in the office' aimed at twentysomething metropolitan girls. ★★★?

PATLABOR S-1 & S-2
(Eng title for KIDO KEISATSU PATLABOR, lit Mobile Police Patlabor)

JAPANESE CREDITS: Dir: Mamoru Oshii. Script: Kazunori Ito. Chara des: Akemi Takada. Mecha des: Yutaka Izubuchi. Prod: Sunrise. © Headgear, Shogakukan, Bandai. Each 30 mins.
WESTERN CREDITS: The TV series & OAVs are scheduled for video release in the US on US Manga Corps starting in autumn 1996.
ORIGINS: Story & manga by Masami Yuuki, pub Shogakukan; 1988 & 1989 OAVs; 1989-90 TV series; 1990 movie.
POINTS OF INTEREST: As well as these 'standard edition' OAVs, there is also a 'Perfect Edition', where each of these episodes is accompanied on one tape by three episodes from the TV series.
CATEGORIES: SF, M

The first episodes of this new OAV series bring the familiar characters back in new adventures. The darker mood of the movie has changed the direction of the original, happy-go-lucky OAVs slightly, but there's still plenty of comedy around. ★★★☆

RANMA 1/2 DEAD HEAT MUSIC MATCH VOLS 1 & 2
(Eng title for RANMA 1/2 NETTO UTAGASSEN, lit Ranma 1/2 Dead Heat Song War)

JAPANESE CREDITS: Prod: Kitty Film. © Takahashi, Kitty, Five Ace. Each 25 mins.
ORIGINS: Rumiko Takahashi's manga, pub Shogakukan, Eng trans pub Viz Communications; 1990 TV series.
CATEGORIES: DD, R, C

The popular stars of the Tendo dojo and friends tune up their vocal chords for two musical adventures of great charm and silliness. ★★★☆

RECORD OF LODOSS WAR VOLS 1-6
(Eng trans for LODOSS DO SENKI, US aka RECORD OF LODOSS WAR VOLS 1-3)

JAPANESE CREDITS: Dir: 1-3 Shigeto Makino, Akinori Nagao & Katsuhisa Yamada. Script: Mami Watanabe. Chara des: Yutaka Izubuchi & Nobuteru Yuki. Art dir: Hidetoshi Kaneko. Prologue animation: Taro Rin. Music: Mitsuo Hagita. Prod: Madhouse. © Mizuno, Group SNE, Kadokawa, Marubeni, TBS. Each 30 mins. WESTERN CREDITS: US video release 1995 on US Manga Corps, sub, trans Neil Nadelman; eps 1-3 'Prologue to the Legend', 'Blazing Departure' & 'The Black Knight' on Vol 1, eps 4 & 5 'The Grey Witch' & 'The Desert Kingdom' on Vol 2, eps 6 & 7 'The Sword of the Dark Emperor' & 'The War of Heroes' (Jap release 1991) on Vol 3. ORIGINS: Roleplaying game scenario & novels by Ryo Mizuno; original story by Hitoshi Yasuda & Ryo Mizuno. CATEGORIES: DD, R

Dungeons and Dragons was not widely known in Japan when Mizuno's gaming group first introduced his *Record of Lodoss War* scenario to a wider public via a gaming magazine. It soon caught on; the concept of heroic fantasy, already popular through Western myth and legend, rapidly became one of the most powerful motifs in anime, thanks to the strength of Mizuno's concept and the dazzling array of talent dedicated to bringing it to the public. The tale of the cursed island of Lodoss, its struggles for peace, and young Pern's journey towards adulthood and his destiny as a warrior of the forces of Light, catches the imagination like all good myths. Pern and his companions — unbelievably cute elf, Deedlit, friendly and wise young cleric, Eto, reserved but selfless mage, Slayn, tough, gruff, dwarf, Gim, on his romantic quest for his friend's lost daughter, and the cheeky thief, Woodchuck — embody all the characteristics of the perfect dungeon party, and their journey is a typical treasure seekers' adventure writ large. But if that was all it was, *Lodoss War* would not have remained so enduringly popular. There are so many characters popping in and out of the story, so many other stories half-told or only hinted at, so much of the land of Lodoss to explore outside the paths our heroes tread, that the imagination is caught and lured off towards them. The Japanese have read Mizuno's eight novels and so have a better idea of the map of Lodoss than we do; the OAV series forms a seductive introduction. On the debit side, the animation is fairly limited and the story told in a fashion that may seem random at first — but it has its reasons, and its charm is immense. ★★★★

RIKI-OH 2
(Eng title for POWER KING)

JAPANESE CREDITS: Prod: Magic Bus. © Bandai. 45 mins. ORIGINS: 1989 OAV.

As with the first *Riki-oh* OAV, I have no further information on this one.

SAINT MICHAEL'S SCHOOL STORY 1
(Eng trans for SAINT MICHAEL GAKUEN HYORYU-KI JYO-JAN)

JAPANESE CREDITS: Dir: Hiroshi Fukutomi. Script: Satoru Motohira. Chara des: Michitaka Kikuchi. Key animator: Tetsuro Aoki. Prod: Visual SD. Prod co: Production Eureka. © Bandai. 40 mins. CATEGORIES: N

St Michael's looks like an ordinary girls' high school, but it contains horrors and dark forces unknown to outsiders. School horror and ghost stories are an enduringly popular anime staple. ★★?

SD GUNDAM EXTRA STORY I
(Eng trans for KIDO SENSHI SD GUNDAM GAIDEN 1)

JAPANESE CREDITS: Music: Kenji Kawai. Prod: Sunrise. © Bandai, Sunrise. 40 mins. ORIGINS: Gundam TV, OAV series & movies; the Roboroboco series of parodies of Tomino's series by Gen Sato; 1988 & 1989 SD Gundam OAVs. CATEGORIES: C, U

Also:
SD GUNDAM MK III
(Eng trans for KIDO SENSHI SD GUNDAM MK III, lit Mobile Soldier Gundam MK III)

JAPANESE CREDITS: Music: Kenji Kawai. Prod: Sunrise. © Sunrise, Bandai. 35 mins.

SD GUNDAM MK IV
(Eng trans for KIDO SENSHI SD GUNDAM MK IV, lit Mobile Soldier Gundam MK IV)

ANIME TO AVOID

There are lots of anime that don't really excite me, but only a few titles listed in this book which I would honestly try to dissuade people from seeing. Of course, one person's yawn being another's best experience ever, your favourite may be among them — this is a purely personal, subjective list. Read and be warned!

1 THE PROFESSIONAL: GOLGO 13 (UK release)

A truly awful dub and a not very good film. The fact that when the Japanese try to make films for us, they make such a total hash of it, ought to warn them off getting too many Western writers and producers to work in anime just because they *are* Western. Misread cultural cues have led to the production of a film with all the worst characteristics of Western cinema in the seventies and none of the merits. A great team and computer effects which were state-of-the-art in their day can't save it.

2 ODIN (UK release)

It may well be the fault of the edit. How many films could have nearly forty minutes ripped out and survive? Beautiful design and production values decorate a complete yawn, with no coherent character development, motivation or plot development left. Don't waste your time on this.

3 VAMPIRE HUNTER 'D'

I really, really dislike this movie. Maybe it's Doris's Pollyanna impression, or maybe it's the fact that Yoshitaka Amano's chara design artwork is so stunningly atmospheric, but none of that atmosphere has made its way into the animated versions.

4 VIOLENCE JACK

I'm a big Nagai fan and I actually quite like the *Violence Jack* OAVs. But the title is accurate and fair, and I've had strong men and *Urotsukidoji* fans leave the room looking green in the face when I've shown particular sequences during lectures; so I really don't think nice people would enjoy them at all, and I recommend you avoid them. The UK versions, however, will have been edited for BBFC certification.

5 THE GIGOLO

No, it's not here because it's offensive and sexist, it's just dead boring and very predictable. Despite a 'tragic' ending to its story of mob violence and Thatcherite free-enterprise sexual commerce, the real tragedy is that this OAV is so bland and undistinguished in every way that even its casual sex and violence are sanitised, made inoffensive by their inadequacy. How can you be shocked, let alone incited to imitation, by something that leaves you so bored you'd just as soon watch paint dry? Some of the other titles on this list have a saving grace, a specific merit which is worth looking out for — like *Odin*'s lovely artwork or *Violence Jack*'s warped yet sincere morality — but not this one. Life is too short for this kind of thing.

SD GUNDAM MK V
(Eng trans for KIDO SENSHI SD GUNDAM MK V, lit Mobile Soldier Gundam MK V)

SD GUNDAM EXTRA STORY II

SD GUNDAM EXTRA STORY III

CREDITS, ORIGINS, CATEGORIES: As above.

More SD mayhem from the warped comic end of the *Gundam* universe. ★★★★?

SHUTENDOJI 2
(Eng trans for SHUTENDOJI KOMA NO SHO, lit Shutendoji Fallen Devil Chapter)

JAPANESE CREDITS: Dir: Hideyuki Motobashi. Prod: Toei Animation. © Dynamic Production, Japan Columbia. 48 mins.
ORIGINS: Manga by Go Nagai, serialised in Shonen magazine 1977; 1989 OAV.
CATEGORIES: H, V

More legendary horror from Go Nagai's original as Jiro — Dojiro Shuten, an ordinary Japanese high school student — follows his destiny as the carrier of ogre and human blood, the one who will either save or destroy the human race. In this episode, having killed the monk Jawanbo who was possessed by evil powers, he takes off into the unknown to fight the forces of evil, taking with him his girl-friend Miyuki and his faithful aide. ★★☆

SOL BIANCA

JAPANESE CREDITS: Dir: Katsuhito

Akiyama. Story: Mayori Sekijima. Chara des & anime dir: Naoyuki Okida. Mecha des: Atsushi Takeuchi. Art dir: Shigemi Ikeda. Voice dir: Hiroki Hayashi. Music: Tohru Hirano. Prod: AIC. © NEC Avenue. 60 mins.
WESTERN CREDITS: US video release 1993 on AD Vision, sub, trans Ichiro Araki & Dwayne Jones; UK video release 1995 on Kiseki Films, sub, trans Jonathan Clements.
ORIGINS: Concept by Tohru Miura.
SPINOFFS: AD Vision's Graphic Visions comic line has produced a Sol Bianca comic.
POINTS OF INTEREST: AIC are currently (early 1996) asking for fan opinion via the Internet on whether they should make another 3 Sol Bianca OAVs.
CATEGORIES: SF, M

Not just another all-girl team, the crew of the good ship *Sol Bianca* are pirates. When they find a stowaway among their latest batch of stolen cargo they are not inclined to help him out, but for a little boy he certainly has a developed understanding of female pirate psychology — he tells them of a great treasure on planet Torres. The evil general Battros has seized his mother and he wants her back; the treasure is the fabled Gnosis, rumoured to contain vast amounts of information — some say it comes direct from the hand of God. The five girls find it less simple than they had hoped to get onto and off Torres without trouble; but, in the end, the treasure they get, while not quite what they had expected, is worth all the risk. The characters are nicely differentiated, with a real range of personality, and well designed and drawn in contemporary mode. Their ship, the *Sol Bianca*, is a wonderfully elegant craft with hidden depths not fully explored in this first OAV. Interesting. ★★★

TRANSFORMER Z

JAPANESE CREDITS: Prod: Toei Animation. © Japan Columbia. 25 mins.

It sounds as if it should be science fiction of some sort.

ULTRAMAN GRAFFITI

JAPANESE CREDITS: Prod: Tsubaraya Pro. © Bandai. 50 mins.
ORIGINS: Live-action series by Tsubaraya Pro, about a superhero from another galaxy

who saves Earth from a series of ever stranger and sometimes siller monsters.
CATEGORIES: C, U

Adventures of the SD Ultrafamily, where our hero is a salaryman and contends with trials and tribulations like crowded trains, unreasonable bosses and the troubles of office life. Great fun for anyone, and a must for SD fans. ★★★

VIOLENCE JACK HELL'S WIND

JAPANESE CREDITS: Dir: Ichiro Itano. Script: Noboru Aikawa. Chara des & anime dir: Takuya Wada. Art dir: Mitsuharu Miyamae. Photography dir: Norihide Kubota. Sound & music dir: Yasunori Honda. Planning prod: Naotaka Yoshida (Soeishinsha) & Nobuo Masumizu (Japan Home Video). Prod: Kazufumi Nomura. © Dynamic Planning, Soeishinsha, Japan Home Video. 60 mins.
WESTERN CREDITS: UK & US video release 1996 on Manga Video, dub, trans Studio Nemo & John Wolskel.
ORIGINS: Manga by Go Nagai, pub 1973; 1986 & 1988 OAVs.
CATEGORIES: V, X, H

The Hell's Wind biker gang are terrorising what's left of post-apocalypse Tokyo, murdering a boy and raping his girlfriend on their way to the defenceless earthquake zone at Orp-Town where they establish themselves. Several years later their dominion is challenged by a gang of Amazons led by June, their former rape victim. As June pursues the gang, Violence Jack appears to intervene in the conflict. This is just as gross, excessive and gut-churning as the last *Violence Jack* OAV. You've been warned. ★☆

WATARU 2
(Eng title for MASHIN EIYUDEN WATARU YOMIGAERE! DENSETSU NO KOUTEIRYU, lit Divine Tale of Heroism Wataru, Rise! Legendary Dragon Emperor)

JAPANESE CREDITS: Dir: Toyo Ashida. Prod: Sunrise © Sunrise, R, NAS, NTV. 30 mins.
ORIGINS: 1989 OAV.
CATEGORIES: C, U

A comedy series aimed squarely at the kiddies' market with a strong fantasy influence, SD mecha, slapstick fights and lots of gags. ★★☆?

The surprise of the year was Otomo's *Akira* follow-up; nobody had expected a movie about the care of the elderly in modern Japan. The creator of *Akira* expressed a desire to get away from the sterility of giant robots and cute girls and the other trappings of science fiction, and move into new areas, where the genius of anime could blossom freely; *Roujin Z* has a giant robot bed and a cute nurse, but is still a funny and original take on the man-machine interface. Others, however, were content to be less adventurous; *Gundam F91* stayed with the more conventional form of the giant robot, and there was plenty of babe-packed fantasy around too, in the dark shape of *Silent Möbius*, Kia Asamiya's 'cyber psychic movie' among others. There was also, though, the inspired silliness of *CB Chara*, Go Nagai's excursion into Super Deformity, while in the movie theatres Isao Takahata's essay in nostalgia, *Only Yesterday*, provided a lyrical escape into the recent past. On the OAV front, too, the classic cyberbabe series *Bubblegum Crisis* came to an abrupt end, not because of fan weariness, lack of funds or talent, but thanks to a corporate falling-out between production houses. The year also saw the UK's first major exposure to anime on video when Island World Communications released *Akira*, while America's anime companies continued to gain ground in the developing marketplace.

MOVIES

CAPTAIN TSUBASA: THE GREATEST RIVAL! HOLLAND'S YOUTH
(Eng trans for CAPTAIN TSUBASA SAIKYO NO TEKI! HOLLAND YOUTH)

JAPANESE CREDITS: Dir, screenplay &
anime dir: Junyasu Furukawa. Chara des &
general anime dir: Yomohiro Okahaku. Art
dir: Hichiro Kobayashi. Sound dir:
Katsunori Shimizu. Prod: Yomiuri
Kokoku-Sha, J. C. Staff. © Takahashi, YKS,
Pony Canyon. 48 mins.
ORIGINS: Manga by Yoichi Takahashi; 1983
TV series; 1985 & 1986 movies; 1989 & 1990
OAVs.
POINTS OF INTEREST: This sank without
trace on its theatrical release, but enjoyed a
new lease of life when it was released as an
OAV in 1995.
CATEGORIES: N

More adventures of the most experienced captain in national youth soccer: he's been leading Japan's squad for thirteen years now! This time they take the field against the mighty Dutch youth side. ★★☆?

DORABIAN NIGHTS

JAPANESE CREDITS: Prod: Shin'ei Doga. ©
Fujiko-Fujio, Shogakukan, Shin'ei Doga.
c85 mins.
ORIGINS: Manga by Fujiko-Fujio, pub
Shin'ei Doga; 1979 TV series; movies every
year 1984-88.
CATEGORIES: C, U

The year's *Doraemon* movie has the characters re-enacting scenes from the Arabian Nights. As usual, Nobita is a klutz and Doraemon's promise to keep him out of trouble, while well meant, is more honoured in the breach than the observance. ★★?

DRAGONBALL Z — SUPER SAIYAJIN SON GOKU

JAPANESE CREDITS: Dir: Mitsuo Hashimoto.
Chara des: Minoru Maeda. © Bird Studio,
Shueisha, Fuji TV, Toei Doga. c48 mins.
ORIGINS: Akira Toriyama's manga, pub
Shueisha; 1986 TV series; movies every year
1986-90.
CATEGORIES: C, U, V

Also:
DRAGONBALL Z — BATTLE OF THE STRONGEST VS THE STRONGEST

CREDITS, ORIGINS, CATAGORIES: As above.

The first *DBZ* film of 1991 goes deeper into the Saiyajin plotline with Son Goku becoming a

Super Saiyajin, a one-in-a-million warrior whose powers are even more extraordinary than they were before. The second has Cooler, the older, meaner brother of Freezer, one of the villains from the TV series, arriving on Earth to look for Goku, after some revenge. Only an eye and a cheek will survive the battle, but Cooler will be back... ★★★?

FLY PEEK!
(Eng title for TOBE! KUJIRA NO PEEK, lit Fly! Peek the Whale, aka PEEK THE BABY WHALE)

JAPANESE CREDITS: Dir: Koji Morimoto. Script: Keiko Nobumoto & Koji Morimoto. Chara des: Satoru Ustunomiya. Art dir: Yuji Ikehata. Prod: Keiji Kusano. © Kujira Production Committee. 80 mins. WESTERN CREDITS: UK video release 1995 on Kiseki Films, sub. ORIGINS: Original story by Hideto Hara. CATEGORIES: N, U

Two young brothers find a baby white whale trapped by rock in a shallow inlet on the Spanish coast. It was thrown there by a huge storm, and now the waters are calm its mother is calling for it from the deep waters beyond. The boys mean to keep the little whale a secret until they can work out how to return it to the sea, but Kei, tormented by older children, lets the secret out. When the baby is taken away by the unscrupulous owner of a sea circus as a result of this stupid action, Kei feels he has to put matters right; so he travels to the town to set Peek free, and succeeds against all odds. Beautiful settings and charmingly retro-styled character designs combine in a high-quality film for children and nature lovers of all ages. ★★★

GUNDAM F91
(Eng title for KIDO SENSHI GUNDAM F91, lit Mobile Suit Gundam F91)

JAPANESE CREDITS: Dir & script: Yoshiyuki Tomino. Chara des: Yoshikazu Yasuhiko. Mecha des: Kunio Okawara. Prod: Sunrise. © Sunrise, Bandai. c90 mins. ORIGINS: Novels by Yoshiyuki Tomino; 1979 onwards TV series; 1988 movie Char's Counterattack; 1989 & 1990 OAVs. CATEGORIES: SF, W

UC0123, three years after Char Aznable and Amuro Ray sacrificed themselves in *Char's Counterattack*. Seabrook Arno and his friend, Cecily

Fairchild, are caught up in the war when their home, Frontier IV Colony, is invaded. It seems that Cecily is not in fact the daughter of Theo Fairchild; her mother Nadia took her from her true home over a decade ago to keep her from the influence of her family, the Ronah, leaders of the political movement Crossbone Vanguard, who mean to create a thousand year empire in space. Cecily learns that she was born Berah Ronah, and at first, dazzled by her new family's wealth and power, she adopts the role and fights on the side of the Vanguard. Meanwhile Seabrook, fighting for the Federation, has problems of his own — his mother Monica, a mobile suit designer, has never had time for him and his young sister, putting work first. In the end, though, it is his mother who helps him find Cecily when the fighting is over and it seems impossible that they can be reunited. Widely considered by *Gundam* fans to be a disappointing addition to the *Gundam* mythos, despite the creative big guns at the helm. ★★

THE HEROIC LEGEND OF ARISLAN
(Eng title for ARSLAN SENKI, lit Arslan Battles)

JAPANESE CREDITS: Dir: Mamoru Hamatsu. Script: Tomoya Miyashita & Kaori Takada. Chara des: Sachiko Kamimura. Anime dir: Kazuya Kise. Art dir: Yuji Ikeda. Music: Norihiro Tsuri. Prod: Animate Film. © Tanaka, MOVIC, Kadokawa Shoten, Sony Music Entertainment. 60 mins. WESTERN CREDITS: UK video release 1993 on Manga Video, dub; US video release 1993 on US Manga Corps, sub & dub, trans Pamela Ferdie & William Flanagan, Eng subtitle rewrite Jay Parks. ORIGINS: Novel by Yoshiki Tanaka; film created by Haruki Kadokawa, Hiroshi Inagaki & Yutaka Takahashi. POINTS OF INTEREST: An extra 'i' was inserted into the UK title by Manga Video to avoid UK specific jokes. However, the Japanese felt this was unnecessary and the 1995 release of part 3 omits the 'i'. CATEGORIES: DD

The first of two films set in the land of Parse, based on historic Persia, and telling the story of the heroic Prince Arslan, whose father is defeated and imprisoned by a mysterious silver-masked usurper and who goes into hiding with the soldier Daryoon to try and rally resistance and win back his father's lands. Gloriously pretty, made to a high standard, and with some very inventive techniques making high art out of limited animation; paced rather slowly, but the prettiness makes up for a lot. ★★★

LEGEND OF THE OVERFIEND II — LEGEND OF THE DEMON WOMB
(Eng title for CHOJIN DENSETSU UROTSUKIDOJI II)

JAPANESE CREDITS: Dir: Hideki Takayama. Writer: Noboru Aikawa. Music: Masamichi Amano. Prod: AIC. © T. Maeda, Westcape Corp. 88 mins.
WESTERN CREDITS: US video release 1993 on Anime 18; UK video release 1993 on Manga Video; both dub.
ORIGINS: Manga by Toshio Maeda; OAVs every year 1987-91; this film is edited version of 1990 & 1991 OAVs.
CATEGORIES: X, V, H

Nazi Germany, 1944: Dr Myunihausen (aka Munchausen) is conducting a terrifying experiment cum sacrificial rite for the Fuhrer, using his Death Rape Machine to break the boundaries between the human world and the other two realms. Almost fifty years later in modern Tokyo, his son is looking for a monster strong enough to match the Overfiend; he seeks to fulfil the old legend which says that he who defeats the Overfiend will rule the three worlds in his place. Can Amanojaku and Meg-

Legend of the Overfiend II

umi stop him? Even in its edited format this is a nasty piece of work, but there is a point to it, if you can stay with it long enough. ★★

LITTLE NEMO

JAPANESE CREDITS: Dir: William T. Hurtz & Masami Hata. Screen concept: Ray Bradbury. Screenplay: Chris Columbus & Richard Outten. Story: Jean (Moebius) Girard & Yutaka Fujioka. Concept des: Jean Girard. Des development: Brian Froud, Paul Julian & Kazuhide Tomonaga. Anime dir: Kazuhide Tomonaga & Nobuo Tomizawa. Storyboards: Masami Hata, Kazuhide Tomonaga, Nobuo Tomizawa & Yasuo Otsuka. Art dir: Nizo Yamamoto. Photography dir: Hajime Hasegawa. Prod: Yukata Fujioka. Prod co: Tokyo Movie Shinsha. 120 mins.
ORIGINS: Winsor McCay's picture strip Little Nemo in Slumberland.
POINTS OF INTEREST: A true Japanese-Western co-production of a major movie several years ahead of Ghost in the Shell! Among the animators were Disney alumni Frank Thomas and Ollie Johnson. Note the involvement of Western comics giant Moebius and Brian (Dark Crystal) Froud in the design. Songs were by the renowned Sherman brothers, who penned such Western hits as 'Chitty Chitty Bang Bang', with music by the London Symphony Orchestra and the title song sung by Grammy award winner Melissa Manchester.
CATEGORIES: DD, U

This is beautiful. The production art and animation quality show off TMS's years of movie-making skills at their finest and the film is a perfect example of how to bring modern skills to a classic story without destroying its heart. In the last century, a little boy named Nemo dreams he's travelling to Slumberland to train as Royal Playmate to the King's lonely little daughter. Sadly, at the urging of his naughty clown friend Flip, he opens the one door in the Palace he's been told he must never open and learns it's the door that connects the World of Dreams to the World of Nightmares. The evil King of that world kidnaps the good King of Slumberland, so Nemo has to take responsibility for his misdeeds and put right the wrong he did by journeying into the terrifying World of Nightmares to rescue the King. There is a happy ending, of course, but not until after a thoroughly satisfying perilous journey. The twin fantasylands of the nineteenth century and dreamland are beautifully evoked. Highly rec-

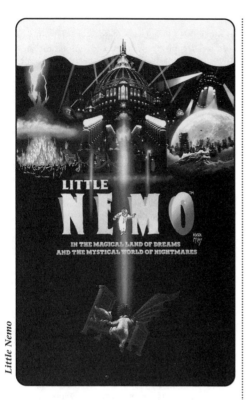

Little Nemo

ommended for children of any age, and anyone who keeps the child in their heart alive. ★★★★

MAGICAL TALRUTO-KUN THE MOVIE

JAPANESE CREDITS: © Egawa, Shueisha.
ORIGINS: Manga by Tatusya Egawa, pub Shueisha in Shonen Jump; 1990 TV series.
CATEGORIES: U, C

Adventures of a young boy and his cheeky young warlock friend Talruto-kun. Fifth-grader Honmaru Edojo summons a warlock to Earth from the world of magic in the hope that magic can help him become less of a nerd and impress Iyona Kawaii, the cutest girl in his class. Unfortunately Talruto-kun is only a trainee and his magic lasts ten minutes at most. Even while the spell operates it doesn't always work as intended — poor Honmaru has to create a secret identity for all the times his willing but wacky little friend transforms him into a girl. Distinguished by a baby-blue wizard's getup with a huge floppy pointed cap, and an equally huge and floppy pink tongue, Talruto-kun is an endearingly cute character. ★★☆?

ONLY YESTERDAY
(Eng title for OMOIDE POROPORO, lit Tearful Thoughts)

JAPANESE CREDITS: Dir & script: Isao Takahata. Chara des: Yoshifumi Kondo. Prod: Hayao Miyazaki, Studio Ghibli. © Nibariki, Tokuma Shoten. 120 mins.
ORIGINS: Manga by Hotaru Okamoto & Yuko Tone.
CATEGORIES: N, R

The action skips back and forth between 1966 and 1984 as office lady Taeko, in the country on a working sabbatical, recalls scenes from her youth in the Japan of the sixties — childhood achievements and embarrassments, dreams, hopes, and people from the past. She reflects on these things as she tries to decide whether to return to the city and go on with her career, or marry and settle in the country. The beauty of the animation is of course almost to be taken for granted, this being a Studio Ghibli production; the high quality of the script and gentle, nostalgic charm give it an uncommon value. ★★★★

RANMA 1/2: THE MOVIE — BIG TROUBLE IN NEKONRON, CHINA
(Eng title for RANMA 1/2 CHUGOKU NEKONRON DAIKESSEN OKITE YABURI NOGEKITO, lit Rama 1/2: Nekonron, China, Big War Lawbreakers' Rage)

JAPANESE CREDITS: Dir & screenplay: Shuji Iuchi. Chara des: Atsuko Nakajima. Prod: Kitty Film. © Takahashi, Shogakukan, Kitty, Fuji TV. 74 mins.
WESTERN CREDITS: US video release 1994 on Viz Video, dub, trans Toshifumi Yoshida, written by Trish Ledoux.
ORIGINS: Rumiko Takahashi's manga, pub Shogakukan, Eng trans pub Viz Communications; TV series; 1990 OAV.
CATEGORIES: R, DD, C

The first *Ranma 1/2* movie has all the ingredients that made the manga and TV series a hit — gender and shape shifting, romance, martial arts and mass confusion. A girl on a giant elephant shows up to settle an old score with panty thief Happosai. He left an old scroll promising eternal happiness to the holder with her great-grandmother and she wants to know why it doesn't work. Akane picks up the scroll just as the magical Prince Kirin shows up to fulfil the old prophecy and carry her off to the magical, mystical land of China. Ranmaniacs will adore it, of course, but

TALKING ANIMALS

Anthropomorphics are a popular theme in Japanese as much as thay are in Western cartoons, but anime often gives them a slightly different slant. They can still be used to provide comic relief, but can also be an integral part of the story. Here are a few examples.

1 NIGHT ON THE GALACTIC RAILROAD

Kenji Miyazawa's novella *Night Train to the Stars* is a beautiful fantasy about the meaning of life and death. Director Gisaburo Sugii decided to animate it using anthropomorphised cats in place of the human characters. Apart from adding great charm to the designs, it gives the viewer a distancing device from a story whose emotional intensity is often close to unbearable.

2 RUMIKO TAKAHASHI'S RUMIK WORLD — MARIS THE WONDERGIRL

In Rumiko Takahashi's girl wrestling spacecop adventure, the partner of the unfortunate Maris is a fox-creature called Murphy, with multiple tails and a deeply untrustworthy and exploitative nature. Despite this, he can be relied on to haul Maris out of trouble when the chips are down, though he usually leaves her to pick up the bill.

3 GALACTIC PIRATES

Who could resist the wisecracking, jive-talking cat cop Apollo? Always a couple of steps ahead of his human partner Latell, Apollo is anarchic, excitable and bone idle — the classic gifted-yet-erratic maverick so beloved of Western cop shows, a cross between Eddie Murphy in *Beverley Hills Cop* and Mel Gibson in *Lethal Weapon*.

4 USHIO & TORA

Not just Tora, but also the weasel spirits in the ninth and tenth OAVs, are classic anthropomorphic spirits from Japanese folklore.

5 RANMA 1/2

Literally half the cast of Takahashi's high school martial arts romance are not just anthropomorphised, but literally change into animals when doused with water. From Ranma Saotome's father Genma (the name means illusion) who becomes a giant panda, to others whose fate it is to become a pig or a goose, these ablutionally-challenged individuals cause much hilarity.

those with a more detached interest will probably admire the pretty settings and animation and then ask themselves what all the fuss is about. ★★☆?

ROUJIN Z
(lit Old Man Z)

JAPANESE CREDITS: Dir: Hiroyuki Kitakubo. Story & screenplay: Katsuhiro Otomo. Chara des: Hisashi Eguchi. Art dir: Hiroshi Sasaki. Prod: APPP. 120 mins.
WESTERN CREDITS: UK theatrical and video release 1994 on Manga Video, dub, script adaptation George Roubicek.
POINTS OF INTEREST: The title may be a pun on Ro(bo)jin, ie Robo-man.
CATEGORIES: N, SF, R

A pretty young student nurse is a volunteer carer for a housebound elderly man; when he is selected to test the latest concept in care for the aged, a computerised bed that supplies every need, she is sceptical and concerned for him. As it turns out, she is right — the authorities are using the excuse of needing a highly sophisticated computer to anticipate his every need as a cover for a far more sinister use in weapons development. But thanks to the courage (one might even say foolhardiness) of the girl, an ornery set of hackers unwilling to go quietly to the great scrapyard in the sky without a fight, and the spirit of his dead wife, Old Man Z not only gets to take part in one of the best giant robot fights ever filmed, but he even fulfils his wish to go to the seaside again. A funny, clever, humane and touching film which should be seen by everyone. ★★★★

THE SENSUALIST

JAPANESE CREDITS: Dir & art dir: Yukio Abe. Screenplay: Eichi Yamamoto. Music: Keiji Ishikawa. Prod: Groupier Production. 50 mins.
WESTERN CREDITS: UK video release 1993 on Western Connection.
ORIGINS: Novel by Saikaku Ihara.
CATEGORIES: P, X

The Sensualist chronicles a few of the amorous adventures from the life of merchant Yonosuke, hero of Ihara's novel *The Life of an Amorous Man*. This seventeenth century classic is presented in the most exquisite, jewel-like animation, each cel steeped in the languid, hothouse atmosphere of the geisha quarters and glowing with superb

RUMIKO TAKAHASHI

Creator of *Ranma 1/2* and *Urusei Yatsura*, she was influential in bringing high school romance together with SF and comedy, though her own favourite works are social comment pieces like *Maison Ikkoku* and *One Pound Gospel*.
RECOMMENDED WORKS: Translated and widely distributed by Viz Communications Inc, Takahashi's manga are readily available in graphic novel format. The anime versions of *Urusei Yatsura* are available in the US from AnimEigo and the UK from Anime Projects; *Ranma 1/2* and *One Pound Gospel* are available in the US from Viz Video.

artistry. Its pace is as slow and precisely calculated as a courtesan's every move and its erotic aspects are similarly artistically conveyed, with sex shown by omission and suggestion rather than the explicit crudery of many contemporary films. It is a highly original and very beautiful piece of work and should be seen by all animation fans and by everyone who thinks anime is only about giant robots and tentacled horrors. ★★★★

SILENT MOBIUS THE MOTION PICTURE

JAPANESE CREDITS: Dir: Michitaka Kikuchi. Chara concepts & des: Kia Asamiya & Michitaka Kikuchi. Mecha & monster des: Yasuhiro Moriki. Art dir: Norihiro Arai. Music: Kaoru Wada. Prod: Studio Tron. © Asamiya, Studio Tron, Kadokawa, Pioneer LDC. 50 mins. WESTERN CREDITS: US video release 1992 on Streamline Pictures, dub, Eng dialogue Tom Wyner. ORIGINS: Manga by Kia Asamiya, pub Comp Comics, Eng trans pub Viz Communications. CATEGORIES: H, X

It is 2028. Tokyo is a city of enormities and excesses, overcrowded for years and dangerously polluted. But not all its dangers are of this world. Tokyo is a gateway for demonic entities known as Lucifer Hawks. The AMPD — Attacked Mystification Police Department — exists to keep them at bay. When Katsumi Liquer arrives in Tokyo from her job in Hawaii to visit her mother in hospital, she has no idea that her visit will change her life. She doesn't know that she is the child of the archmage Gigelf Liquer; that her adored mother is a sorceress of no mean power; and that the creatures of darkness are after her, both for the latent power she possesses, and for revenge on her father's blood. *Silent Möbius* is a beautiful thing to look at, rain-drenched and steeped in the spirit of *Blade Runner*, dark and brooding under a glittering carapace. Wonderful action and magic sequences and an intriguing cast of characters promise more than they have time to deliver. ★★★

OAVS

ARIEL: GREAT FALL
(Eng title for ARIEL HATSUDO HEN: GREAT FALL, lit Ariel Movement Chapter: Great Fall)

JAPANESE CREDITS: Prod: Animate Film. © Pony Canyon. 45 mins. ORIGINS: 1989 OAV. See also Deluxe Ariel: Contact below. CATEGORIES: SF

The last part of the adventure sees monsters pounding their way through the Crystal Barrier around Scebai Base. The girls face ferocious opposition from Magnus and are convinced that the base, and Grandpa, have been destroyed. However Breastsaver Haagen shows up and seriously damages Magnus so that the girls can polish him off; but then Hausaa arrives to help his friend. The girls and their mecha triumph thanks to the help of Breastsaver Haagen, and Grandpa is OK after all. ★☆

BE-BOP HIGH SCHOOL BOOTLEG 1

JAPANESE CREDITS: Dir: Yukio Kaisawa. Prod: Toei Animation. © Toei Video. 40 mins. ORIGINS: The successful high school manga; parody version of the Be-Bop High School OAVs. CATEGORIES: C, N

Also:
BE-BOP HIGH SCHOOL BOOTLEG 2

Also:
BE-BOP HIGH SCHOOL BOOTLEG 3 TEENAGE SEX FESTIVAL
(Eng trans for BEBOP HIGHSCHOOL BOOTLEG 3 JYUDAI NO SEITEN)

CREDITS, ORIGINS, CATEGORIES: As above except: 50 mins.

Parody charas of the *Be-Bop High School* gang in a series of skits and musical numbers.

BOMBER BIKERS OF SHONAN 7 SPORTING GUTS MAD SPECIAL
(Eng title for SHONAN BAKUSOZOKU 7 SUPON KON MAD SPECIAL, lit Wild Explosive Motorbike Gang from Shonan 7 — Sporting Guts Mad Special)

JAPANESE CREDITS: Prod: Toei Animation. © Toei Video. 60 mins.
ORIGINS: Manga by Satoshi Yoshida, pub Shonen Gohosha; OAVs every year 1986-90
CATEGORIES: N, A

More adventures of the biker gang who are really nice at heart.

BUBBLEGUM CRASH 1-3
(Ep titles: 1 Illegal Army; 2 Geo Climbers; 3 Meltdown)

JAPANESE CREDITS: Dir: 1 & 3 Hiroshi Ishiodori; 2 Hiroyuki Kukushima. Script: 1 Hiroshi Ishiodori, 2 & 3 Emu Arii. Chara des: Kenichi Sonoda. Prod des: Shinji Aramaki. Anime dir: 2 Noboru Sugimitsu; 3 Yasuyuki Noda. Art dir: 2 & 3 Yumiko Ogata. Planning & original story: Toshimichi Suzuki. Music: 1 & 3 Takehito Nakazawa, 2 Michihiko Ota. Prod: Artmic, Artland. © Polydor. Each 45 mins. WESTERN CREDITS: US video release 1994 on AnimEigo, dub & sub, trans Shin Kurokawa & Michael House.
ORIGINS: Created by Toshimichi Suzuki; see also Bubblegum Crisis, OAVs every year 1987-90.
CATEGORIES: SF

Bubblegum Crisis was originally planned as thirteen episodes, but contractual disputes led to the dissolution of the original team after part eight. The name had to change, and so, to many fans' horror, did the voice of Priss, but it was decided to press on with three more episodes. The hardsuits have been slightly redesigned and the charas show further development in these stories; we see them interacting in different situations and learn how the Buma struggle has affected them. The final episode shows Sylia locked in conflict with an old adversary, and drops hints about the legacy of her father's work on Buma technology to his own children. Powerful stuff. ★★★

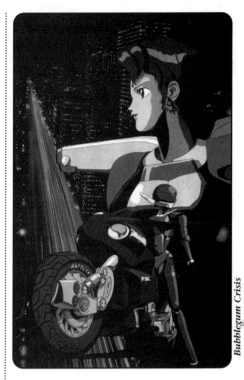

Bubblegum Crisis

BUBBLEGUM CRISIS 8: SCOOP CHASE

JAPANESE CREDITS: Dir: Hiroaki Goda. Screenplay: Hidetoshi Yoshida. Original story & planning: Toshimichi Suzuki. Chara des: Kenichi Sonoda. Music: Kaouji Makaino. Prod: Artmic. © Toshiba EMI. 45 mins. WESTERN CREDITS: US video release 1993 sub, 1994 dub, on AnimEigo, trans Shin Kurumada & Michael House; UK video release 1994 sub, 1995 dub, on Anime Projects.
ORIGINS: Created by Toshimichi Suzuki; OAVs every year 1987-90.
POINTS OF INTEREST: AIC are currently (early 1996) asking fan opinion and input via the Internet as to further Bubblegum Crisis adventures.
CATEGORIES: SF

Although the alphabetical arrangement of this book means that the entry for *Bubblegum Crash* precedes this, *Crisis 8* did in fact appear well before *Crash 1*. Lisa, the AD Police chief's niece, is a journalist out to get an exclusive on the Knight Sabers. She manages to take a shot when Nene's hardsuit faceplate is damaged in combat and her identity exposed. The team has more important things to

worry about, though — GENOM executive Meriam has plans to destroy the ADP and use its resources to smash the Knight Sabers and take over GENOM itself. With the ADP HQ under siege, the Sabers attempt to free it. Eventually Lisa realises there are more important things at stake than a scoop story, and returns the photo and negative to Nene. ★★★

BURN UP!

JAPANESE CREDITS: Dir: Yasunori Ide. Writer: Jun Kanzaki. Chara des: Kenjin Miyazaki. Art dir: Kenji Kamiyama. Music: Kenji Kawai. Prod: AIC. © NCS, Media Ring, AIC. 50 mins.
WESTERN CREDITS: US video release 1994 on AD Vision, sub, trans Ichiro Araki & Dwayne Jones.
ORIGINS: Original story & manga by Yasunori Ide & Jun Kanzaki.
POINTS OF INTEREST: US release includes bonus art portfolio on the tape. US pseudomanga version from AD Vision.
CATEGORIES: M, X

When a female police recruit is kidnapped by a white slave gang, her two partners don't like it a bit. They wade into the gang with all the firepower and heavy armour they can muster, and that's quite a bit. Not suitable for anyone under eighteen or anyone of a nervous disposition, but doesn't take itself too seriously. ★★☆

CAPRICORN

JAPANESE CREDITS: Prod: Aubeck. © King Record. 45 mins.
ORIGINS: Manga by Johji Manabe.

I have no further infomation about this title.

CAT ILLUSION SONG: FANTASIA
(Eng trans for NEOKNEKO GENSOKYOKU: FANTAGIA)

JAPANESE CREDITS: Prod: Animate Film, AIC. © Shueisha. 30 mins.

I have no further information about this title.

CB CHARA GO NAGAI WORLD
(Eng title for whole series. Component parts are: vol 1 ORE WA AKUMADA DEVILMAN, I'm a

Devil, Devilman; vol 2 I'M STRONG — MAZINGER Z; vol 3 KANKETSUHEN — VIOLENCE JACK, Final Chapter — Violence Jack)

JAPANESE CREDITS: Prod: Triangle Staff. © Dynamic Planning, Bandai. Each 45 mins.
ORIGINS: Go Nagai's manga & anime characters.
CATEGORIES: C

These three form a fascinating study of the strands of Nagai's world in a comic form. In Vol 1, the familiar *Devilman* charas find themselves in another dimension in which everyone is in CB (chibi, or 'child body') form. There's lots of fun as they eat bits of the terrible demon Jinmen and Shirenu does her Lum impression, but Ryu is determined to find out why this has happened to them and what it means. In Vol 2, the characters and mecha from Nagai's early manga and giant robot TV series *Mazinger Z* join in, and the good and bad guys from both sides join forces to find a way out and even begin to make friends. But Ryu is still suspicious of the whole situation and causes a lot of disruption. In the final volume, two popular manga charas, the demon Psychogenie and the Great Demon Lord Satan, are animated for the first time, and it is hinted that Violence Jack is an extension of the Devilman character. Great fun if you're not a student of Nagai's work, essential viewing if you are. ★★★

CLEOPATRA D.C.: PANDORA'S BOX
(Eng trans for CLEOPATRA D.C. PANDORA NO HAKO)

JAPANESE CREDITS: Prod: J.C. Staff. © Toei Video. 50 mins.
ORIGINS: Manga by Kaoru Shintani, who also produced the bleak mercenary tale Area 88; 1989 OAV.
CATEGORIES: A

More adventures of Shintani's sexy Corporate Woman.

CRYING FREEMAN 4 ABDUCTION IN CHINATOWN
(US aka CRYING FREEMAN 5)

JAPANESE CREDITS: Dir: Takaaki Yamashita. Screenplay: Ryunosuke Ohno. Music: Hiroaki Yoshino. Prod: Toei. © Koike, Ikegami, Shogakukan, Toei Video. 50 mins.
WESTERN CREDITS: US video release 1993 on Streamline Pictures as Crying Freeman 5, Eng dialogue Gregory Snegoff; UK video

release 1994 on Manga Video.
ORIGINS: Manga by Kazuo Koike & Ryoichi
Ikegami, pub Shogakukan, Eng trans pub
Viz Communications 1993; OAVs every year
1988-90.
CATEGORIES: X, V

I find the Streamline Pictures dub preferable to the Manga Video one, but in either case this is a profoundly offensive and negative excuse for an adventure story. The female villain is a psychopathic bitch whose quest for sexual fulfilment is doomed by the animation — she has all the anatomical definition of a Barbie doll, rendering the frequent nude shots a bit pointless. Once again hostages are taken in a bid to lure Freeman into a trap and challenge the 108 Dragons' dominance, once again the 'good' females (ie Freeman's women) turn up to help him beat the 'bad' (ie sexually depraved and *really* nasty) one, once again I wonder why anyone wastes their time on such a lame, transparent plot and feeble characterisation. ☆

CYBER CITY OEDO 808 FILE-3 BLOODLUST
(Eng trans for CYBER CITY OEDO 808 DATA-3 KURENAI NO BAITAI, lit Cyber City 808 File-3 Crimson Medium, US aka CYBER CITY OEDO 808 FILE-3)

JAPANESE CREDITS: Dir & chara des:
Yoshiaki Kawajiri. Screenplay: Akinori
Endo. Chara des: Hiroshi Hamazaki &
Masami Kosone. Des: Takeshi Watanabe.
Anime dir: Hiroshi Hamazaki. Music: Kazz
Toyama. Music dir: Yasunori Honda.
Planning: Masao Maruyama. Prod:
Madhouse. © Madhouse, Japan Home Video.
49 mins.
WESTERN CREDITS: UK video release 1995
on Manga Video, dub, new soundtrack by
Rory McFarlane; US video release 1995 on
US Manga Corps, dub & sub, Eng rewrite Jay
Parks. US title omits subtitle.
ORIGINS: Original idea by Juzo Mutsuki;
1990 OAV.
SPINOFFS: An American pseudomanga
retelling the series has been produced by
Studio Go! for CPM Comics.
CATEGORIES: H, V, R

My favourite episode of this OAV series and one of my favourite pieces of City Gothic anywhere in anime, the story focuses on the androgynous martial artist Benten. This beautiful vampire romance revolves around an evil old creature who can only keep living by drinking the lives of younger creatures; he uses an innocent cyborg vampire, Remi, for this purpose. Benten takes him on, and the titanic struggle between combat masters high above the planet is only matched for impact by the poignant sight of Remi's coffin floating into space at the end, filled with drifting petals from a scarlet rose. Terrific. ★★★★

DELUXE ARIEL: CONTACT
(Eng trans for DELUXE ARIEL: SESSHOKU)

JAPANESE CREDITS: Prod: Animate Film. ©
Pony Canyon. 45 mins.
ORIGINS: 1989 OAV. See also Ariel: Great
Fall, above.
CATEGORIES: SF

More adventures of the *Ariel* team. I haven't seen this version.

DEMON-SLAYING SWORD OF SHURANOSUKE
(Eng trans for SHURANOSUKE ZANMAKEN)

JAPANESE CREDITS: Dir: Osamu Dezaki.
Screenplay: Jo Toriumi. Chara des & key
animation: Akio Sugino. Art dir: Yukio Abe.
Prod: Naoko Takahashi, Takeshi Tamiya,
Tetsu Dezaki. © Toriumi, Suromisu, Toei.
50 mins.
ORIGINS: Novel by Jo Toriumi, pub
Kadokawa.
POINTS OF INTEREST: Chara designer
Sugino worked on boxing TV series and
movie Tomorrow's Joe, while Yukio Abe is
better known to fans in the West as director
of the beautiful 'art-house anime' The
Sensualist.
CATEGORIES: P, X

The year is 1636, a generation after Tokugawa Ieyasu unified Japan and established his new capital at Edo. When a gigantic, ghostly white tiger starts to plague his town, bold samurai Shuranosuke goes into action with his legendary blade Onimaru. There's a beautiful Princess to be rescued, an equally beautiful female ninja, and evil magic to fight against. The mixture of history and magic is well balanced, giving an action-adventure film with spooky moments as well as beautiful designs and artwork to delight the eye. ★★★

DETONATOR ORGUN 1 & 2
(Eng trans for DETONATOR ORGUN 1 TANJO HEN, lit Birth Chapter, and DETONATOR ORGUN 2 TSUISO HEN, lit Choice Chapter)

JAPANESE CREDITS: Dir: Masami Obari.
Script & original story: Hideki Kakinuma.
Chara des: Michitaka Kikuchi. Prod des:
Hideki Kakinuma, Kimitoshi Yamane &
Junichi Akutsu. Music: Susumu Hirasawa.
Prod: AIC. © Darts, Artmic. Part 1 60 mins,
part 2 50 mins.
WESTERN CREDITS: US video release 1994
on US Manga Corps, sub, trans Neil
Nadelman.
CATEGORIES: SF

Tomoru's dreams are being influenced by forces
outside himself — maybe even outside this Earth.
He used to be a normal guy with a normal life and
no worries beyond what to do after university; now
he's working with Michi, a very attractive member
of the Earth Defence Force, and an unbelievably
powerful supercomputer to unravel the mystery of
an alien armour found on the Moon! It's going to
change his whole life as he learns that a renegade
alien soldier, Orgun, is being hunted by his people,
the Evoluder, and only Tomoru can help him resist
the coming invasion of planet Earth. Kumi, a psy-
chic, starts to make contact with the Evoluder
leader, while Michi finds the key to the riddle of
the Evoluder in her dreams. ★★☆?

DEVIL HUNTER YOKO
(Eng trans for MAMONO HUNTER YOKO)

JAPANESE CREDITS: Dir: Katsuhisa Yamada.
Script: Yoshihiro Tomita. Chara des: Takeshi
Miyau. Anime dir: Tetsuro Aoki. Art dir:
Takeshi Waki. Music: Hiroya Watanabe.
Prod: Madhouse. © NCS, Toho Video. 46 mins.
WESTERN CREDITS: US video release 1993
on AD Vision, sub, Eng trans Ichiro Araki &
Dwayne Jones; UK video release 1995 on
Western Connection, sub, trans Jonathan
Clements.
CATEGORIES: H, A

Yoko Mano is just a normal schoolgirl who lives
with her divorced mother and grandmother and
has a crush on a handsome classmate. But she's also
the 109th generation of a family of demon hunters,
and now that she's sixteen her powers have awak-
ened and she can inherit the family tradition, prov-
iding she stays pure in heart and in body — not
entirely what she had in mind! She has to cope with
a school principal who's really a demon, a possessed
wannabe boyfriend out to destroy her demon-hunt-
ing potential in the usual way, and the school beau-
ty who — yes, you guessed it — turns into a demon
and kidnaps the boy she loves. Rampaging teenage
hormones and demons alike, lots of comic

moments and lots of action, mostly revolving
around girls' clothes getting slashed with huge
demonic blades, can't prevent a lingering impres-
sion that at its heart this story is curiously innocent
and sweet. Not so much Legend of the Overfiend,
more Buffy the Vampire Slayer meets Bambi. ★★★

DOOMED MEGALOPOLIS — THE DEMON CITY
(Eng title for TEITO MONOGATARI MITO HEN,
lit Imperial City Story: Evil City, aka THE
HAUNTING OF TOKYO)

JAPANESE CREDITS: Series dir: Taro Rin.
Dir: Kazuhiko Katayama. Script: Akinori
Endo. Chara des: Masayuki. Anime dir:
Koichi Hashimoto. Art dir: Hideyoshi
Kaneko. Music: Kazz Toyama. Prod:
Madhouse. © Toei Video, Oz Co. 60 mins.
WESTERN CREDITS: US video release 1993
on Streamline Pictures, dub, Eng dialogue
Ardwight Chamberlain; UK video release
1994 on Manga Video, dub, trans Studio
Nemo, script adaptation George Roubicek.
POINTS OF INTEREST: There is also a
live-action version available in the UK on
Manga Video and the USA on Fox Lorber.
All 4 episodes have been shown on UK late-
night TV.
ORIGINS: Novel by Hiroshi Aramata, The
Tale of the Capital, pub Kadokawa.
CATEGORIES: H, X, P

A malevolent force broods over Tokyo. An inno-
cent girl, Yukari, senses it but cannot stop it. Her
brother seems torn between love and hate towards
her, and the young man who loves her is con-
cerned. An evil sorcerer who should be long dead
wants to use the city for his own ends, and to that
end he will make a demon child to work his will on
the future. In just a short time, the greatest earth-
quake Tokyo has ever known will begin. A beauti-
fully designed and chilling horror tale. ★★★

DRAGON FIST

JAPANESE CREDITS: Dir: Shigeyasu
Yamauchi. Chara des: Shingo Araki & Michi
Himeno. Anime dir: Shingo Araki.
Storyboards: Michitaka Kikuchi. Music:
Kenji Kawai. Prod: Agent 21. © Toshiba
EMI. 40 mins.
ORIGINS: Manga by Shu Katayama.
CATEGORIES: SF?

I have no further information on this title.

DRAGON KNIGHT

**JAPANESE CREDITS: Dir: Jun Fukada.
Original concept: Yoshinori Nakamura.
Prod: elf, Just. © Polystar. 30 mins.
WESTERN CREDITS: US video release 1994
on AD Vision, sub, trans Ichiro Araki &
Dwayne Jones.
ORIGINS: Original idea by Dr Pochi;
original computer RPG of same name by
Masato Hiruta (elf)
CATEGORIES: DD, X**

Take a sword, a dozen beautiful girls in those skimpy little outfits so beloved of D & D fantasy book cover artists, and an instant camera, and our brave knight is ready to rock and roll. Yes, this is one knight for whom the age of chivalry is definitely dead and the age of lechery has begun. A sex comedy with just about every fantasy element thrown in. ★★☆?

EASE VOLS 4-7

**(Eng title for EASE 4 TABBY NO SHO, Tabby
Chapter; 5 MESA NO SHO, Mesa Chapter; 6
JEMMA NO SHO, Jemma Chapter; 7 FACT NO
SHO, Fact Chapter)**

**JAPANESE CREDITS: Prod: Urban Product,
O Production. © King Record. Vol 4 40 mins,
vols 5-7 each 30 mins.**

I have no further information for this title.

EVERY DAY IS SUNDAY VOLS 3 & 4
(Eng trans for MAINICHI GA NICHIYOBI)

**JAPANESE CREDITS: Prod: Animate Film. ©
Tokuma Japan. Each 30 mins.
ORIGINS: Manga by Kosuke Fujishima; 1990
OAV.
CATEGORIES: R, N**

Further adventures of the lady cop and her handsome magician sidekick in modern Tokyo. ★★☆?

GALL FORCE EARTH CHAPTER: VISUAL COLLECTION
**(Eng trans for GALL FORCE CHIKYUSHO
VISUAL COLLECTION)**

**JAPANESE CREDITS: Prod: Artmic, AIC. ©
Polydor. 30 mins.
ORIGINS: Original story by Hideki**

**Kakinuma; 1986 movie; OAVs every year
1987-90.
CATEGORIES: SF**

A collection of clips and music videos for Gall Force fans.

GALL FORCE: NEW ERA 1
(Eng trans for GALL FORCE SHINSEIKIHEN)

**JAPANESE CREDITS: Original story &
screenplay: Hideyuki Kakinuma. Chara des:
Kenichi Sonoda. Prod des: Hideki Kakinuma
& Kimitoshi Yamane. Anime dir: Hideaki
Ohba & Yoshitaka Huzimoto. Music:
Takehito Nakazawa. Prod: AIC, Kyuma. ©
Artmic. 50 mins.
WESTERN CREDITS: US video release 1995 on
US Manga Corps, sub, trans Pamela Parks.
ORIGINS: As above.
CATEGORIES: SF, A**

The year 2291. There has been peace for some time now after the terrific war between the humans and the Yuman. But the leader of the Yuman is not convinced it's over, and plans to strike first before he is tricked into defeat by human treachery. Meanwhile the android Catty is still planning for peace. She selects six normal girls for a great adventure — another new world. Will they survive both a hostile environment and a dangerous enemy? More conflict, emotional tension and drama for the fighting gallant girls; still well made, but beginning to drag a little more with each new reprise. ★★☆?

GUNDAM 0083: STARDUST MEMORY PARTS 1-6
**(Eng title for KIDO SENSHI GUNDAM 0083
STARDUST MEMORY, lit Mobile Soldier Gundam
0083 Stardust Memory. Ep titles: 1 Stolen
Gundam; 2 Endless Pursuit; 3 Albion Takes Off;
4 Battle in the Kalahari Desert; 5 Gundam, To
the Sea of Stars!; 6 The Warrior of Von Braun)**

**JAPANESE CREDITS: Dir: Mitsuko Kase &
Takashi Imanishi. Chara des: Toshihiro
Kawamoto. Mecha des: M. Akitaka, Yasushi
Sekitsu, Toru Toya & Hajime Katoki. Prod:
Sunrise. © Bandai, Sunrise. Part 1 55 mins,
parts 2-6 each 30 mins.
ORIGINS: Novels by Yoshiyuki Tomino; 1979
onwards TV series; 1988 movie Char's
Counterattack; 1991 movie; 1989 & 1990 OAVs.
POINTS OF INTEREST: Most of the crew are
relative unknowns. A photonovel-style comic
using colour frame blow-ups is available in**

English from Viz Communications. Heavily promoted during the theatrical run of Gundam F91.
CATEGORIES: SF

In many ways this is a replay of the earliest *Gundam* saga. There's a Char Aznable clone, the charismatic Anavel Gato, recognised as second only to the legendary Char in fighting skill; a brash young ensign, Kou Uraki, who wants to pilot a mobile suit; and a beautiful girl, mecha designer Nina Purpleton. They and their friends and colleagues are caught up in a web of intrigue and war worthy of *Gundam* at its finest. An attractive and involving series — not quite the equal of its mighty progenitor, but certainly a worthy successor. ★★★

GUY: AWAKENING OF THE DEVIL

JAPANESE CREDITS: Dir: Yorihisa Uchida. Chara des: Yasuhiko Makino. Mecha des: Yukio Tomimatsu. Music: Nobuhiko Kashihara. Prod: Friends. © Media Station. 40 mins.
WESTERN CREDITS: US video release 1993 on AD Vision, sub, trans Ichiro Araki & Dwayne Jones; UK video release 1994 on Animania, dub.
CATEGORIES: SF, X, V

Guy and Raina are mercenaries out to earn a semi-honest penny any way they can. Information picked up during a salvage operation puts them onto a revolutionary youth drug being developed on the prison planet Geo. The fastest way to get there is to become an inmate. As Geo's guards and warden would make *Ilsa, She-Wolf of the SS*, look like a children's TV presenter, this is not without its dangers. Much of the sadism and sexual violence was toned down for UK release — the infamous gun rape sequence has completely vanished — but it's still gory, nasty stuff, guaranteed to appeal to anyone who liked *Legend of the Overfiend*. And yet the crisp, bright colours and characters, obviously designed to be fashionable and slick, signal that sad men in anoraks are not the intended audience. This is schlock-horror for cool dudes. Unfortunately it isn't especially well plotted or original, and those who like some story to hang their shocks on may be disappointed. ★☆

THE GUYVER DATA 7 & 8
(Eng title for KYOSHOKU SOKO GUYVER ACT II, part 1 and 2, lit Armoured Creature Guyver, aka BIO BOOSTER ARMOUR GUYVER. Ep titles: UK: Data 7 The Battle Begins; Data 8

The Lost Unit. US: 7 Prelude to the Chase; 8 The Lost Unit's Challenge)

JAPANESE CREDITS: Dir: Masahiro Otani & Naoto Hashimoto. Screenplay: Riku Sanjo. Chara des: Hidetoshi Omori. Art dir: Masuo Nakayama. Prod: Takaya Pro, Animate Film. © Takaya Pro, Tokuma Shoten, G.P. c60 mins. WESTERN CREDITS: US video release 1993 on US Renditions, dub, Eng screeplay & voice direction Raymond Garcia, as The Guyver Vol 4; UK video release 1994 on Manga Video, on 2 tapes, dub, each 27 mins. ORIGINS: Manga by Yoshiki Takaya, pub Tokuma Shoten, Eng trans pub Viz Communications; 1986, 1989 & 1990 OAVs. SPINOFFS: Apart from the OAV series, 2 live-action films, Mutronics and Guyver: Dark Hero, were also made in the USA. POINTS OF INTEREST: Although made as 2 distinct epsodes, this seems to have been released on one tape in Japan. CATEGORIES: SF

The second half of the animated *Guyver* saga sees Sho, presumed dead, come to the rescue of the others just in time. But Sho, who has been regenerated by the Guyver unit after his near-dissolution by Enzyme, isn't sure who or what he is any more. The pressure of events has made him nervous and it's near-impossible for him to summon the Guyver armour with any degree of certainty or confidence. How will he keep his friends safe from the continuing attacks of the Cronos organisation? ★☆

THE HAKKENDEN VOLS 5 & 6
(lit The Eight Dog Soldiers Legend)

JAPANESE CREDITS: Prod: AIC. © Soushin Picture. Each 30 mins. ORIGINS: 98 volume Edo period novel by Bakin Kyokutei; 1990 OAV. CATEGORIES: SH, H

More adventures of the eight spiritual 'brothers' using their supernatural powers to fight demons and restore their clan's fortunes in old Japan. ★★☆?

HEAVEN VERSION: UNIVERSAL PRINCE VOLS 4-11
(Eng trans for TANJO HEN UTSUNOMIKO)

JAPANESE CREDITS: Prod: Toei Animation. © Kadokawa Novel, Bandai, TV Tokyo. Each 30 mins. ORIGINS: Novel by Keisuke Fujiwara, pub

Kadokawa Books, illustrated Mutsumi Inomata; 1989 movie; 1990 OAV.
CATEGORIES: P, DD

Further adventures of the horned Prince as he seeks justice for the people and their old gods in eighth century Japan.

HERE IS GREENWOOD: LOVE YOUR LIFE
(Eng trans for KOKO WA GREENWOOD, NANJI NO NICHIJO O AISEYO)

JAPANESE CREDITS: Dir & screenplay: Tomomichi Mochizuki. Chara des & anime dir: Masaku Goto. Photography dir: Masahide Okino. Music: Shigeru Nagada. Prod: Pierrot Project. © Victor Music Production. 30 mins.
WESTERN CREDITS: Due for US video release 1996 on Software Sculptors.
ORIGINS: Manga by Yukie Nasu, pub Hakusensha in Hana To Yume (Flowers and Dreams) girls' weekly magazine.
CATEGORIES: N, DD

A relaxed and humorous slice-of-life story about a student dorm with some unusual inhabitants, and even one or two supernatural visitors. Because Kazuya's brother has just married Sumire, the woman he secretly loves, Kazuya has left the family home and moved into his school dormitory, generally known as Greenwood. To his dismay, his roommate is a girl pretending to be a boy, and many of the other inhabitants seem to have unusual personalities or problems. Can he cope with living in such a strange place? In fact, Greenwood turns out to be the supportive environment he needs. His adventures and the resolution of his love for Sumire and anger towards his brother form the basis of this ongoing soap opera with a difference. ★★★?

INFERIOUS PLANET WAR HISTORY: CONDITION GREEN, 1
(Eng trans for INFERIOUS WAKUSEI SENSHI GAIDEN CONDITION GREEN, aka CONDITION GREEN: PLATOON #801)

JAPANESE CREDITS: Dir: Shigeyasu Yamauchi. Chara des: Shingo Araki, Michi Himeno & Eisaku Inoue. Prod: Hero Communications. © KSS Inc. c50 mins.
CATEGORIES: SF, W

The galaxy of Inferious is in the grip of war. An evil emperor, Vince, has started on a programme of planetary conquest using high technology and overwhelmingly powerful armies. When he turns his attention to Emerald Earth, though, he runs into a solid line of defence. There are five of them. Their names are Keith, George, Edward, Yang and Sho. They are officially Platoon #801, but the people call them 'Condition Green'. And they're going to stop Vince. ★★?

IZUMO PARTS 1 & 2

JAPANESE CREDITS: Chief dir: Eiichi Yamamoto. Original story: Yoshihiko Tsuzuki. Voice dir & storyboards: Shin Mizutani. Prod: Kove. © Tsuzuki, Gakken, Pioneer LDC, Herald. Each 45 mins.
ORIGINS: Manga by Yoshihiko Tsuzuki, pub Gakken in Comic Nora.
CATEGORY: DD

Set in a fantastic world loosely based on Japan's semi-legendary early history, the hero Izumo has to go on a quest to the distant land of Yamatai. The arduous journey would only take an hour by train today, but this was a time when only the southernmost parts of the Japanese mainland were occupied, and even then not by 'Japanese' in the modern sense but by several opposed warring states, the Japanese equivalent of our own mythical King Arthur's Albion. Izumo's press release promises 'action and romance'.

JUDGE
(Eng title for ANKOKU NO JUDGE, lit Darkness' Judge)

JAPANESE CREDITS: Dir: Hiroshi Negishi. Screenplay: Katsuhiku Chiba. Chara des & anime dir: Shin Matsuo. Art dir: Tatsunori Oyama. Music: Toshiro Imaizumi. Prod: Animate Film. © Hosono, Futabasha. 45 mins.
WESTERN CREDITS: UK video release 1994 on Manga Video; US video release 1994 on US Manga Corps, sub, trans William Flanagan & Pamela Parks, Eng rewrite Jay Parks.
ORIGINS: Based on story by Fujihiko Hosono, pub Futabasha, an updated version of an ancient Japanese legend.
CATEGORIES: H

When evil is done in this world, sometimes the victims have no one to speak for them; in particular, the dead have no voice and must rely on the living for justice, which is often denied them. But wrongdoers can be called to account in a higher court —

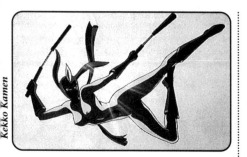

Kekko Kamen

ORIGINS: Manga by Go Nagai.
POINTS OF INTEREST: The title is a pun on renowned sixties live-action TV show Gekko Kamen or Moonlight Mask. In the same year Go Nagai also directed and wrote a live-action version of Kekko Kamen, 60 mins long, starring Chris Aoki, Playmate Japan 1990.
CATEGORIES: X, C

the Court of Darkness — which decides their final fate more justly and more certainly than any human court. The hereditary Judge of Darkness, Hoichiro Oma, has a day job as a mild-mannered salaryman, but by night he descends to his Court and metes out justice to those who have evaded detection in the human world. But even in this court, shyster lawyers can turn the tide of justice with legal tricks, and an appeal to the Highest of High Courts may be needed to ensure that justice is done. An interesting idea, with some intriguing design devices, is rendered less powerful by slowness of pacing and uneven execution. ★★

She's masked. She's a brilliant martial artist. She keeps her identity secret by making sure that the last thing anyone is ever likely to look at is her face. In sadistic Sparta College, the only hope for students tortured by the evil and perverted staff is Kekko Kamen, the Warrior of Love and Justice. Go Nagai's comic parody manga comes to life as Kekko Kamen takes on and beats first Topoko Gessha (or Gestapo Girl), the S & M queen of Sparta College, then Taro Schwarzenegger, gym teacher and superstud, in this comic romp which cocks a crude and irreverent snook at just about every form of sexual sensibility. It's a hoot, and about as harmful as a *Carry On* film or smutty seaside postcard. You'll be too busy laughing to look for the parodies. ★★★☆

KARULA MAU PART 3
(Eng title for HENGEN TAIMA YAKU KARULA MAU SENDAI SHOSAISHI ENKA, lit Illusion Evil Night Train Dancing Karula)

JAPANESE CREDITS: Dir & screenplay: Takaaki Ishiyama. Anime dir: Chuichi Iguchi. Art dir: Mitsuharu Miyamae. Music: Makoto Mitsui. Prod: Picture Kobo. © Toshiba Picture Soft. 30 mins.
ORIGINS: Manga by Takakazu Nagakubo, pub Monthly Hallowe'en magazine; 1990 OAV.
CATEGORIES : DD, H

Conclusion of the story of twin priestesses fighting evil.★★★?

KEKKO KAMEN
(Exact Eng trans very complex: KAMEN means 'masked' and KEKKO is a phrase which can infer 'I got lucky today!')

JAPANESE CREDITS: Based on characters by Go Nagai. Prod: Studio Signal. © Dynamic Planning, Japan Columbia. 55 mins.
WESTERN CREDITS: UK video release 1995 on East2West, dub, trans Jonathan Clements; US video release 1995 on AD Vision, sub, trans Masako Arakawa & Chris Hutts.

KIMAGURE ORANGE ROAD: UNEXPECTED SITUATION
(Eng trans for KIMAGURE ORANGE ROAD OMOIGAKENAI SITUATION, US aka KIMAGURE ORANGE ROAD VOL 4: UNEXPECTED SITUATION)

JAPANESE CREDITS: Dir: Naoyuki Yoshinaga, Takeshi Mori & Koichiro Nakamura. Screenplay: Kenji Terada & Isao Shizuya. Chara des: Akemi Takada. Art dir: Satoshi Miura. Music: Sagisu. Prod: Studio Pierrot. © Toho, Studio Pierrot. 25 mins.
WESTERN CREDITS: US video release 1995 as Kimagure Orange Road Vol 4 on one tape with Message in Rouge, below.
ORIGINS: Manga by Izumi Matsumoto, pub Shueisha; 1987 TV series; OAVs every year 1988-90.
CATEGORIES: DD, R, C

Also:
KIMAGURE ORANGE ROAD: LIPSTICK MESSAGE
(Eng trans for KIMAGURE ORANGE ROAD ROUGE NO DENGON, US aka KIMAGURE ORANGE ROAD VOL 4: MESSAGE IN ROUGE)

CREDITS, ORIGINS, CATEGORIES: As above.

In the first story Akane's schoolfriends don't believe she is interested in boys at all, and to escape their teasing when they come home with her, she asks

Kyosuke to pretend to be her boyfriend — with predictably awful results. In the second OAV Madoka's father, a famous musician, is in town to play a Mendelssohn concerto; but Madoka has got the idea that he's seeing another woman behind her mother's back. Devastated, and unable to wait and meet him as if nothing had happened, she leaves a message for him scrawled on the mirror in lipstick and goes to Kyosuke for help and a shoulder to cry on. Comedy, romance and fantasy combined make these spinoffs of the hit series very appealing. ★★★?

LEGEND OF GALACTIC HEROES VOLS 27-46
(Eng trans for GINGA EIYA DENSETSU)

JAPANESE CREDITS: Dir: Noboru Ishiguro. Prod: Kitty Film Mitaka Studios. © Tanaka, Kitty Enterprise. Each 30 mins.
ORIGINS: Yoshiki Tanaka's novel series; 1988 movie; 1988 & 1989 OAVs.
CATEGORIES: SF, W

The huge story begun in the first twenty-six-part OAV series continues to unfold in Tanaka's first 'legend' of the year. More background is filled in on the early life of the major characters as Reinhart Von Lohengrimm (formerly Von Musel) continues his relentless climb towards imperial power, now bereft of his one close friend, Siegfried Kircheis, and largely cut off from his adored elder sister, Annerose. Each episode brings him closer to his ultimate goal, while his adversary, Yang Wen-Li, also pursues his own dreams as the war drags on. Superb talking-heads drama with masses of atmosphere. ★★★★

LEGEND OF THE FOUR KINGS PARTS 1-3
(Eng title for SORYUDEN, lit Dragon Kings Legend; US aka SOHRYUDEN LEGEND OF THE DRAGON KINGS. Ep titles: UK 1 The Dragon Prophecy; 2 Ancient Truths; 3 The Awakening. US 1 The Four Brothers Under Fire; 2 The Legend of Dragon Springs; 3 Black Dragon King Revealed)

JAPANESE CREDITS: Dir: Shigeru Ueda & Yoshihiro Yamaguchi. Chara des: Shunji Murata. Art dir: Shichiro Kobayashi & Jiro Kono. Prod: Kitty Film Mitaka Studio. © Tanaka, Kitty, Fuji, Kodansha. Each c45 mins. WESTERN CREDITS: US video release 1995 on US Manga Corps, sub, Eng rewrite Jay Parks; UK video release 1995 on Manga Video, dub. ORIGINS: Novel by Yoshiki Tanaka. CATEGORIES: DD, A

The four Ryudo brothers are not ordinary boys. For one thing, they live alone, under the guardianship of the eldest brother, with occasional household help from a bouncy teenage cousin. For another, one of the most important criminals in Japan wants them — and will go to any lengths to get them. They all possess extraordinary powers, of which the youngest is not yet aware; they are avatars of the ancient dragon gods of China. An interesting premise from one of the best pulp SF and fantasy writers in Japan, sadly executed with little verve or pace, although with considerable gloss. ★★

LEGEND OF THE OVERFIEND V — BATTLE AT THE SHINJUKU SKYSCRAPERS
(Partial Eng trans for CHOJIN DENSETSU UROTSUKIDOJI V, lit Legend of the Overfiend: The Wandering Kid V, aka WANDERING KID, US aka UROTSUKIDOJI PERFECT COLLECTION)

JAPANESE CREDITS: Dir: Hideaki Takayama. Writer: Goro Sanjo & Noboru Aikawa. Music: Masamichi Amano. Prod: AIC. © T. Maeda, Westcape Corp, JAVN. c50 mins. WESTERN CREDITS: Edited with the 4th OAV into the movie version, Legend of the Demon Womb. UK video release 1993 on Manga Video; US video release 1993 on Anime 18, both dub. US video release also as part of Urotsukidoji Perfect Collection 5-OAV set in unedited format 1993 on Anime 18, sub. ORIGINS: Manga by Toshio Maeda; OAVs every year 1987-90. CATEGORIES: X, V, H

Amanojaku and Megumi are fighting to stop Myunihausen Jnr killing the Overfiend and assuming total dominion of the three worlds. The whole series is unlikely ever to pass the British censorship process, considering that the two films, already edited for cinema release, sustained further cuts. This is probably just as well since it would seem that many of us are assumed to be incapable of seeing such horrors without wishing to emulate them in real life. Whatever happened to the cathartic effects of fantasy? ★★

LOCKE THE SUPERMAN: NEW WORLD BATTLE TEAM 1 & 2
(Eng trans for CHOJIN LOCKE SHIN SEKAI SENTAI 1 & 2)

JAPANESE CREDITS: Prod: SIDO © Bandai. Each 50 mins.

ORIGINS: *Yuki Hijiri's manga; Hirota's 1980 pilot film Cosmic Game (10 mins); 1984 movie; 1989 OAV.*
CATEGORIES: SF

Further adventures of the reclusive farmer with amazing psychic powers. Locke finds he is one of a group of psychics stripped of their memories, but not their super-powers. The only way they can retrieve their memories, and know their former selves, is to find the creature known as the Tsar. ★★☆?

LUNA VARGA VOLS 1-4
(Eng title for MAJUSENSHI LUNA VARGA, lit Demon Beast Soldier Luna Varga)

JAPANESE CREDITS: Dir: Shigenori Koyama. Script: Aki Tomato & Yumiko Tsukamoto. Chara des: Yuji Moriyama. Art dir: Geki Katsumata. Film dir: Kazuhiro Konishi. Music: Kenji Kawai. Prod: AIC, Studio Hakk. © Kadokawa, Nextart. Each 30 mins.
CATEGORIES: DD, A

Dungeons and dragons with a twist — how many stories combine the dragon and the Princess into one battle-ready form? *Luna Varga* is set in a peaceful world in which humans and monsters live together and the city-states enjoy prosperity until one, the Dunbas Empire, starts on a mission of conquest. The three Princesses of Rimbell are determined to defend their city's freedom and middle sister Luna, a skilled fighter known as the Tomboy Princess, will do so in a very strange way. In a secret chamber in the castle she is engulfed by a ray of light, recovering to find herself half-embedded in the head of a giant tyrannosaur-like beast which communicates with her telepathically, calling her its 'brain'. To save her land, she has been granted control over the legendary 'dragon' Varga, and even when not in dragon form she now has a dragon's tail. She manages to fight off the attackers threatening the city, but her sister Vena has been kidnapped by the Dunbas forces and Luna sets out on a quest to rescue her, meeting some strange, shady and downright disreputable types along the way! Nicely drawn with much humour. ★★★

MADARA 1 & 2
(Eng title for MIRROR WAR MADARA 1, TAIZO and 2, KINGO HEN)

JAPANESE CREDITS: Original concept: Eiji Otsuka. Chara des: Sho Tajima. Monster des: Hidetomo Aga. Prod: Madara Project, Animate Film. © Bandai, MOVIC, Kadokawa.
ORIGINS: *Eiji Otsuka's concepts; Sho Tajima's manga, pub Kadokawa.*
CATEGORIES: H, DD

Madara is the son of the Evil Emperor and a good Princess. It was prophesied that he would threaten his father's power, so at his birth his father sacrificed him and his body was scattered to the eight Chakras. His spirit, however, remained whole and powerful. Now he has to bring all his parts back together, and fight his father, not just for revenge but to end the reign of evil. Of course, having inherited his mother's tendencies to goodness, he also has to stop anyone else getting hurt in the process. ★★☆?

MAD BULL 34 PART 2 THE MANHATTAN CONNECTION

JAPANESE CREDITS: Dir: Tetsu Dezaki. Screenplay: Toshiaki Imaizumi. Art dir: Nobutaka Ike. Photography dir: Hideo Okazuki. Music dir: Katsunori Shimizu. Prod: Magic Bus. © Koike, Inoue, Shueisha, Pony Canyon. 50 mins
WESTERN CREDITS: UK video release slated for 1996 on Manga Video, dub, script adaptation John Wolskel.
ORIGINS: *Manga by Kazuo Koike & Noriyoshi Inoue, pub Shueisha; 1990 OAV.*
CATEGORIES: M, X

An attractive new female detective is assigned to the thirty-fourth Precinct; she's an old friend of Sleepy 'Mad Bull' Estes. Another old acquaintance is back too, a drug dealer who's out to settle the score with the cop who put him in a wheelchair. Mad Bull's partner Diazaburo finds himself in deep — can Mad Bull save him? I haven't seen this yet and will avoid the temptation to rate it on the strength of the last *Mad Bull* release.

MAISON IKKOKU EXTRA STORY: IKKOKU ISLAND GIRLS HUNTING EVENT
(Eng trans for MAISON IKKOKU BANGAI HEN: IKKOKU-THO NANPA SHIMATSU KI)

JAPANESE CREDITS: Dir: Takashi Amano. Writer: Kazunori Ito. Chara des: Akemi Takada. Prod: Kitty Film. © Five Ace, Takahashi, Shogakukan, Kitty. 30 mins.

ORIGINS: Manga by Rumiko Takahashi, pub Shogakukan; 1986 TV series; 1988 movie.
CATEGORIES: N, R

Another OAV based on the popular manga and TV series. I don't know enough about this particular one to rate it.

MONKEY PUNCH WORLD: HARRIS
(Eng trans for MONKEY PUNCH NO SEKAI: HARRIS)

JAPANESE CREDITS: Prod: Takahashi Studio. © Monkey Punch, Toho Video. 60 mins.
ORIGINS: Based on Monkey Punch's manga.

I have no further information on this title.

MOSAICA 1-4
(Eng title for EIYU YOROIDEN MOSAICA, lit Legendary Armoured Hero Mosaica; part 1 FUYA NO SHO, Sealed Valley Chapter; part 2 MAJO NO SHO, Evil Castle Chapter; part 3 ROURAN NO SHO, Ancient Egg Chapter; part 4 ONI NO SHO, Demon Chapter)

JAPANESE CREDITS: Dir: Ryosuke Takahashi. Writer, chara des & art dir: Kazuo Shioyama. Prod: Studio Dean. © Walkers Co. Each 30 mins.
CATEGORIES: DD, A

The kingdom of Mosaica is on the verge of being overrun by King Sazara when the great warrior Wu Dante is executed for questioning the King of Mosaica's judgement. His son Wu Talma decides to save Mosaica for his father's sake. Ancient giant robots lie dormant in a hidden valley; on the advice of the hermit Ritish, Talma decides to gather together a force to oppose the enemy first, then use mystic arts to try to awaken the robot warriors. Meanwhile Princess Menoza has been taken prisoner, and Talma joins the group that has set out to rescue her as the first stage in his plan to bring about the downfall of the invaders. But will he also avenge the unjust death of his father? ★★☆?

NG KNIGHT LAMUNE & 40 EX HEART BEAT TRIANGLE BIG LOVE PROJECT VOLS 1-3
(Eng trans for NG KISHI LAMUNE & 40 EX BIKUBIKU TRIANGLE AINO ARASHI DAISAKUSEN; vol 1 AI FUTATABI, Returned Love; vol 2 AI NAGASARETE, Involved in Love; vol 3 AI WA KATSU, Love Must Win)

JAPANESE CREDITS: Prod: Ashi Pro. © King Record. Each 30 mins.
ORIGINS: 1990 TV series.
CATEGORIES: C, U

The mighty warrior Lamuness the Brave — well, actually, Lamune, aged ten — fell into the kingdom of A'lala while playing that ace computer game *King Sccasher*. Now he and Princesses Milk and Cocoa invite you to join them and Tama-Q the robot for another terrific adventure. It'll be funny, cute and very, very silly. ★★★?

PATLABOR S-3-S-12
(Eng title for KIDO KEISATSU PATLABOR, lit Mobile Police Patlabor; S-3 GAKUSHU NO SCHAFT, Schaft's Revenge; S-4 SHICHORITSU 90%, Audience Rating 90%; S-5 SHIJO SAIDAI NO KESSEN, The Biggest War; S-6 KUROI SANRENBOSHI, Black Range Stars; S-7 GAME OVER; S-8 NI NO NANUKA KAN, Fire Days; S-9 VS, Versus; S-10 SONONA WA AMUNEGIA, The Name is Amnesia; S-11 AMENOHI KITA GOMA, Goma Appeared in the Rain; S-12 FUTARI NO KARUIZAWA, Our Karuizawa)

JAPANESE CREDITS: Dir: Mamoru Oshii. Writer: Kazunori Ito. Chara des: Akemi Takada. Mecha des: Yutaka Izubuchi. Prod: Sunrise. © Headgear, Tohokushinsha, Bandai. Each 30 mins.
WESTERN CREDITS: All the Patlabor OAVs & TV eps are slated for release on US Manga Corps, starting in autumn 1996.
ORIGINS: Story & manga by Masami Yuuki, pub Shogakukan; OAVs every year 1988-90; 1989-90 TV series; 1990 movie.
POINTS OF INTEREST: As well as these 'standard edition' OAVs, there is also a 'Perfect Edition', where each of these episodes is accompanied on one tape by three episodes from the TV series.
CATEGORIES: SF, M

More episodes of the second OAV series, with the further adventures of the Patlabor squad on the streets of Tokyo. ★★★★

PEACOCK KING 3
(Eng trans for KUJAKU-O 3)

JAPANESE CREDITS: Dir: Katsuhito Akiyama. Prod: Aic. © Shueisha, Nextart. 50 mins.
ORIGINS: Japanese & Chinese legend; 1988 & 1989 OAVs.

POINTS OF INTEREST: *A 1988 live-action version featuring martial arts star Yuen Biao was made as a Japanese-Hong Kong co-production.*
CATEGORIES: H, A

More demonic exploits from young avatar Kujaku and his friend Ashura.

RECORD OF LODOSS WAR VOLS 7-13
(Eng trans for LODOSS DO SENKI, US aka RECORD OF LODOSS WAR VOLS 3-6)

JAPANESE CREDITS: *Dir: 7, 9-11 Taiji Ryu; 8 Hiroshi Kawasaki; 12 & 13 Akinori Nagaoka. Script: 7 & 13 Mami Watanabe; 8-11 Mami Watanabe & Kenichi Kanemaki. Chara des: Yutaka Izubuchi & Nobuteru Yuuki. Art dir: Hidetoshi Kaneko. Music: Mitsuo Hagita. Prologue animation: Taro Rin. Prod: Madhouse. © Mizuno, Kadokawa, Marubeni, TBS. Each 30 mins.*
WESTERN CREDITS: *US video release 1995 on US Manga Corps; ep 7 'The War of Heroes' on one tape with ep 6 as Vol 3; eps 8 & 9, 'Requiem for Warriors' & 'The Sceptre of Domination' as Vol 4; eps 10 & 11 'The Demon Dragon of Fire Dragon Mountain' & 'The Wizard's Ambition' as Vol 5; eps 12 & 13 'Final Battle! Marmo the Dark Island' & 'Lodoss: The Burning Continent' as Vol 6. Sub, all trans Neil Nadelman*
ORIGINS: *RPG scenario & novels by Ryu Mizuno; original story by Hitoshi Yasuda & Ryu Mizuno; 1990 OAV.*
CATEGORIES: DD, A

The magnificent legend comes to a close, but not before fire, war, self-sacrifice, love beyond death, dragon fights and lots of sword swinging have kept you on the edge of your seat. The Dark Emperor of Marmo, Beld, and good King Fahn fight to the death; Ashram and Kashue inherit leadership of the forces of darkness and light. Meanwhile Gim the Dwarf finds his friend's lost daughter, and the grey witch Karla takes a new body — that of Woodchuck the Thief, while evil sorceror Vagnard sends Dark Elf Pirotessa to kidnap Deedlit for his own dark purposes. Both leaders race to try and win the Sceptre of Dominion from the ancient dragon Shooting Star's hoard, but when the dragon attacks, Pirotessa sacrifices herself for love of Ashram and dies in his arms. Deedlit is to be used in a ritual to channel the power of evil goddess Kardis into the world through the sacrifice of her soul, and Pern must face dark sorcery from Vagnard and cold steel from Ashram to save her. A fabulous series that

ends even stronger than it started, and in which the limited animation is compensated for by the power of the writing, music and design. ★★★★

RIKA-CHAN AND HER AMAZING MAGIC RING
(Eng trans for RIKA-CHAN FUSHIGI NA MAHO NO RING)

JAPANESE CREDITS: *Prod: Asahi Ado. © Takara. 30 mins.*
CATEGORIES: DD??

I have no information about this title.

RUMIKO TAKAHASHI'S RUMIK WORLD — MERMAID'S FOREST
(Eng trans for RUMIKO TAKAHASHI'S RUMIK WORLD — NINGYO NO MORI)

JAPANESE CREDITS: *Dir: Takuya Mizutani. Screenplay: Masaichiro Okubo. Chara des: Sayuri Ichiishi. Art dir: Katsuyoshi Kanemura. Music: Kenji Kawai. Prod: O.B. Planning. © Takahashi, Shogakukan, Victor Music Production. c60 mins.*
WESTERN CREDITS: *US video release 1992 on US Manga Corps, sub; UK video release 1994 on Manga Video, dub.*
ORIGINS: *Rumiko Takahashi's manga, pub Shogakukan, Eng trans pub Viz Communications; OAVs every year 1985-87.*
CATEGORIES: H, DD

A *Rumik World* story which has spun off another series of manga and OAVs in its own right, this is the tale of Yuta, a mediaeval sailor who ate mermaid's flesh and became not simply immortal but fixed forever in his youth. He has been searching ever since for a way to fill in his endless days, and maybe also to rid himself of forever. He has joined forces with Mana, a young girl in the same position. On their travels they encounter a strange family — twins, one young and beautiful but hiding a dark secret, one old, shrivelled and driven by guilt. The dreadful events of the past fifty years in the isolated house on the clifftop finally come to light as both Yuta and Mana face danger. Chilling and well-crafted, the script is a study in selfishness. ★★★

SAMURAI TROOPERS MESSAGE 1-5
(Eng title for YOROIDEN SAMURAI TROOPER MESSAGE, lit Legendary Armour Samurai Troopers Message; 1 WAKATTIETA

KETSUMATSU, Well Known Result; 2 SHIRASARETA MIRAI, Expected Future; 3 title unknown; 4 SAMAYOERO KOKORO, Wandering Heart; 5 OTOZUREATA SHINJITSU, New Truth)

JAPANESE CREDITS: Prod: Sunrise. © SME. Each 30 mins.
ORIGINS: 1989 TV series; 1989 OAVs.
SPINOFFS: In its day a huge favourite with female fans, Samurai Troopers spun off a large quantity of fan fiction and manga, some of it extremely sexually explicit and violent, mostly produced by and for women.
CATEGORIES: DD, A

More adventures of the armoured boy heroes fighting the evil forces of magic which threaten the modern world.

SD GUNDAM 8 & 9
(Eng title for KIDO SENSHI SD GUNDAM, lit Mobile Soldier SD Gundam)

JAPANESE CREDITS: Prod: Sunrise. © Bandai. Each 30 mins.
ORIGINS: Gundam TV, OAV series & movies; the Roboroboco series of parodies of Tomino's series by Gen Sato. SD Gundam OAVs every year 1988-90.
CATEGORIES: C, U

Also:
SD GUNDAM EXTRA STORY IV KNIGHT OF LIGHT
(Eng trans for KIDO SENSHI SD GUNDAM GAIDEN IV HIKARI NO KISHI, aka SD GUNDAM 10 — SD GUNDAM GAIDEN IV HIKARI NO KISHI)

JAPANESE CREDITS: Prod: Sunrise. © Bandai, Sunrise. 40 mins.
CATEGORIES, ORIGINS: As above.
POINTS OF INTEREST: An edited 30 minute version of this tape was also released as SD Gundam 10 — SD Gundam Gaiden IV Hikari No Kishi.

More manic adventures of the squashed suits.

SHURATO 1-4
(Eng title for TENKU SENKI SHURATO SOUSE ENO ANTO, lit Heaven Space War Shurato: Fight to the Genesis; vol 1 GENMA, Illusion; vol 2 KAISO, Recollection; vol 3 SEIYA SOGU, Meeting with the Saint; vol 4 TANMADO, Moving Devil)

JAPANESE CREDITS: Dir: Takao Koyama & Masanori Nishii. Chara des: Matsuri Okuda. Armour des: Ammonite. Prod supervisor: Ippei Kuri. Prod: Tatsunoko Co, Sotsu Picture. © King Record. Each 30 mins.
ORIGINS: Hindu & Buddhist myths; concept by Go Mihara; TV series.
CATEGORIES: DD, A

Shurato and his friend Gai are facing each other in the finals of the Tokyo Junior Karate Championships when they are whisked into another world. But suddenly Gai is in armour and in deadly earnest; Shurato realises his old friend wants to kill him. The goddess Vishnu, ruler of the Sky World, is being assailed by the forces of Shiva the Destroyer, and her own captain Indra will use her forces and powers against her. Shurato must learn to use magical armour and amulets, spells and mantra, and all the while try to avoid killing or being killed by his oldest friend. To complicate matters, Indra frames him and two other warriors for turning Vishnu to stone, and appoints Gai as the leader of the force sent to track the fugitives down. A gripping, characterful and exotic fantasy. ★★★

SHUTENDOJI 3 & 4
(Eng title for SHUTENDOJI 3 TEKKI NO SHO, lit Heaven Kid 3 Iron Demon Chapter, and SHUTENDOJI 4 KANKETSUHEN KIGOKU NO SHO, lit Final Part Demon Hell Chapter)

JAPANESE CREDITS: Dir: Jun Kawagoe. Script: Masashi Togawa. Chara des: Satoshi Hirayama. Prod: Dynamic Production, Studio Signal. © Dynamic Production, Japan Columbia. Each c48 mins.
ORIGINS: Manga by Go Nagai, serialised in Shonen magazine 1977; 1989 & 1990 OAVs.
CATEGORIES: H, X

Part two of *Shutendoji* had a conclusion of sorts, with ogre foundling Jiro returning to his paranormal roots to fight evil, taking his girl Miyuki along and leaving his adoptive parents sad and alone. Part three splits him from his devil-fighting team and throws him through a dimensional gate into the year 2100 AD, where the deepspace cruiser *Alfard* is fighting an enemy Q-ship. Their war-cyborg Iron Kaiser is on the enemy ship on a suicide mission; Jiro arrives just in time to save him. The captain, a Cutey Honey lookalike called Persis Mahmoud, and her crew set about trying to return Jiro to his own dimension; but it turns out that Iron Kaiser is actually the son of a human monk, Jawanbo, killed by Jiro in part two, who became a cyborg to avenge his father. The scene

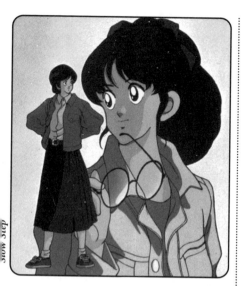

Slow Step

on Western Connection, trans Jonathan
Clements, on 3 tapes.
ORIGINS: Mitsuru Adachi's manga.
POINTS OF INTEREST: Note Adachi's
presence as music director!
CATEGORIES: N, R

Minatsu is a softball ace at her high school and a
very popular girl. She fancies one boy; another
fancies her. How to go out with both? And what
to do about the softball coach at school, who fan-
cies Minatsu but is going out with another girl,
one of her most difficult and aggressive class-
mates? Everyday life in a Japanese suburb is
depicted here, with all the things the Japanese
think of as normal enough for a soap opera, and
this gives us a wonderful insight into their world.
The animation is charming, the backgrounds are
great, the romance and humour would be wel-
come additions to most live-action soaps, and the
plot keeps us guessing who Minatsu will choose
right up until the last frame of the closing credits.
★★★

SOL BIANCA 2

JAPANESE CREDITS: Dir: Hiroki Hayashi.
Chara des: Naoyuki Onda. Mecha des &
prod des: Atsushi Takeuchi. Anime dir:
Naokyuki Onda. Planning: Tohru Miura.
Music: Kosei Kenjo. Prod: AIC © NCS, NEC
Avenue, AIC. 60 mins.
WESTERN CREDITS: US video release 1993
on AD Vision, sub, trans Ichiro Araki &
Dwayne Jones; UK video release 1996 on
Kiseki Films, sub, trans Jonathan Clements.
ORIGINS: Concept by Tohru Miura; 1990
OAV.
SPINOFFS: AD Vision's Graphic Visions
comic line has produced a Sol Bianca comic.
POINTS OF INTEREST: AIC are currently
(early 1996) asking for fan opinion via the
Internet on whether they should make
another 3 Sol Bianca OAVs.
CATEGORIES: SF, A

The second OAV takes us further into the mys-
tery of the semi-sentient Sol Bianca and its links
with its pilot, June. When she rescues the others
on a heist that goes wrong, the ship is fired on
and virus missiles begin to burrow within its
structure. As the damage to the ship affects June
she becomes gravely ill. The others have to fly
back into danger to get her to a doctor — and
then learn that there's little he can do because
June isn't human. Superior pulp science fiction.
★★★

is set for a shipboard battle that draws heavily on
the first two *Alien* films, but Jiro is the winner
and is eventually reunited with his friends in his
own time and space. Part four shows Jiro and his
team battling their way through Hell, while his
adoptive mother goes insane with grief over the
loss of her son. Her husband saves her by destroy-
ing the pictures drawn from ancient screenpaint-
ings depicting Hell with which she has decorated
her room in the asylum. After many battles Jiro
finally puts a stop to ogre invasion for the fore-
seeable future and returns home to the human
world for good, to settle down with his parents
and Miyuki. ★★★?

SILENT BOSS: YAKUZA SIDE STORY
(Eng trans for SHIZUKANARA DON: YAKUZA
SIDE STORY)

JAPANESE CREDITS: Prod: Tokyo Movie
Shinsha. © Toho Video. 45 mins.
CATEGORIES: M

I have no more information on this title.

SLOW STEP 1-5

JAPANESE CREDITS: Dir: Kunihiko Yuyama.
Script: Toshimichi Saeki & Kenji Terada. Art
dir: Mitsuki Nakamura. Music dir: Mitsuru
Adachi. Prod: Pastel. © M. Adachi, Toho
Video. Each c45 mins.
WESTERN CREDITS: UK video release 1995

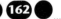

SUKEBAN DEKA 1-3
(lit Bad High School Girl Cop; part 1 TANJO HEN, The Origin; part 2 GYAKUSHU HEN, Revenge; part 3 FUKUSHU HEN, Review)

JAPANESE CREDITS: Exec dir & prod: Takeshi Hirota. Chara des: Nobuteru Yuki. Music dir: Takashi Takao. Prod: Tateo Hiraya. Prod co: SIDO. © JVD, JH Project. Part 1 50 mins, parts 2 & 3 each 40 mins. WESTERN CREDITS: US & UK video release in late summer 1996 on A.D. Vision. ORIGINS: Original creator Shinji Wada; live-action TV show & films of the same title. CATEGORIES : M, X

When Saki left high school she didn't head for college but put on a prison uniform instead. Now the Feds need someone with very special skills to infiltrate a crime syndicate masquerading under the cover of an exclusive high school, so they turn to Saki. Armed with a secret weapon that looks like an innocent yoyo, Saki is back on the streets again as a lovely, lethal schoolgirl. ★★★?

3 x 3 EYES I & II
(Eng title for SAZAN EYES; I TENSEI NO CHO, lit Reincarnation Chapter; II YAKUMO NO CHO, lit Yakumo's Chapter, US aka 3X3 EYES PERFECT COLLECTION)

JAPANESE CREDITS: Dir: Daisuke Nishio. Script: Akinori Endo. Chara des & anime dir: Koichi Arai. Art dir: Junichi Taniguchi. Music: Kaoru Wada. Prod: Tabac, Toei Animation. © Y. Takada, Kodansha, Plex, Star Child. Each 30 mins. WESTERN CREDITS: US video release 1993 on Streamline Pictures, on 4 single tapes, dub, and as a one-tape, 110 minute compilation video entitled 3 x 3 Eyes Perfect Collection; UK video release 1994 on Manga Video, both parts on one tape, dub. ORIGINS: Original story by Yuzo Takada; manga by Yuzo Takada, pub Kodansha in Young Weekly, Eng trans pub Innovation & Dark Horse Comics. CATEGORIES: H

Yakumo is a fairly ordinary teenage boy. OK, since his dad disappeared while working abroad, he's been living with a group of transvestites and working in a TV bar after school, but he's fine. Then a cute Tibetan girl called Pai turns up, and suddenly he's got Pai as a zombie. Pai is host-body to the last of a race of immortals, the Sanjiyan Unkara; only by finding the statue of Ningen (humanity)

can she become human, and she really, really wants to become human. So it looks as if Yakumo will have to take off in search of the statue with her, and his life has changed forever. This very prettily drawn series is, of necessity, more cramped than the manga in storytelling terms, but it achieves its horror and suspense effects very skilfully. ★★★☆

U-JIN BRAND

JAPANESE CREDITS: Dir: Osamu Okada. Writer: U-Jin. Chief animator: Yumi Nakayama. Music: Nobuo Ito. Prod: Animate Film. © U-jin, SEIYO, Animate Film. 45 mins. WESTERN CREDITS: US video release 1993 on US Manga Corps, Eng rewrite Jay Parks. ORIGINS: Manga by U-Jin; created by Hideo Takano. CATEGORIES: X, C

Comedy romance with a wildly erotic angle in this anthology of three stories. The first deals with the problems of a songwriter who has to get to know a teen idol singer very well before he can write for her. The other two involve seducer extraordinaire Toyama No Benbo, first helping out a girl whose fiancé has been stolen by a rival, then resolving the problems of a young man being pushed into marriage with the boss's daughter, even though he really loves another girl.

URUSEI YATSURA OVA 4: DATE WITH A SPIRIT and GIRLY-EYES MEASLES

JAPANESE CREDITS: Prod: Kitty Film. © Takahashi, Shogakukan, Kitty, Fuji TV. Each 25 mins. WESTERN CREDITS: US video release 1995 on AnimEigo, 2 separate OAVs on one tape, sub, trans Vincent Winiarski, © Sue Shambaugh, Marvin Nakajima & Miho Mishida. ORIGINS: Rumiko Takahashi's manga, pub Shogakukan, Eng trans pub Viz Communications; 1981 TV series; movies every year 1983-86 & 1988; 1986, 1988 & 1989 OAVs. CATEGORIES: SF, R, C

A beautiful ghost has attached herself to Sakura's fiancé Tsubame. But dead or alive, no girl is safe from lecherous Ataru Moroboshi. The second story has Ten giving Ataru an alien illness, Girl Measles,

whose main side effect is to make the eyes all big and twinkly, just like a young girl in a manga. When Ataru spreads the virus all over town as he chases girls, Lum isn't pleased. ★★★?

VIRAGO IN DUNGEON 1-3
(Eng title for OZANARI DUNGEON KAZE NO THO, lit Perfunctory Dungeon Tower of Wind; part 1 YOROSHIKU PRELUDE, Introduction Prelude; part 2 MADAMADA CAPRICCIO, Still Capriccio; part 3 OMATASE KODA, Sorry to be Late Coda)

JAPANESE CREDITS: Prod: Tokyo Movie Shinsha. © TMS, Toshiba EMI. Each 30 mins.
CATEGORIES: DD

Mocha, Blue Mountain, and Kilimanjaro are hired by King Gazelle to steal the famous Dragon Head relic from the Shrine of Fire. The trio are startled when the relic introduces itself to them as Morrow and asks them to take it, not to Gazelle's Tower of Fire, but to the Tower of Wind. Morrow is an organic program which can transform the Tower of Wind into a weapon of destruction called the Space Dragon. Gazelle is just a frontman for the real enemy. Who is he, this mysterious being who is out to control Space Dragon and destroy all mankind? ★★☆?

WIZARDRY

JAPANESE CREDITS: Dir: Takashi Shinohara. Script: Masaru Terajima. Chara des: Satoshi Hirayama. Anime dir: Yasushi Nagaoka. Art dir: Mitsuharu Miyamae. Prod: Shochiku Fuji Ltd, TMS. © Shochiku Fuji Ltd. 50 mins.
ORIGINS: Based on well-known computer game.
POINTS OF INTEREST: One of the game's designers was Robert Woodhead, better known in anime circles as founder and head of American anime label, AnimEigo; the other was Roe R. Adams III.
CATEGORIES: DD

The wizard Werdna is a nasty guy. He's stolen a very powerful amulet from crazy King Trebor, and constructed a ten-level dungeon right under the King's own castle, where he and the amulet are hiding. The King offers assistance and a reward to anyone who can recover the amulet. Shin Garland takes the challenge and joins a band of adventurers to descend into the wizard's lair. ★★?

ZENON
(Eng title for ESPER ZENON)

JAPANESE CREDITS: Dir, chara des & key animation: Yuji Moriyama. Orginal idea: Yuichi Hasegawa & Yuji Moriyama. Prod: Studio Fantasia. © Nippon Victor, Studio Fantasia. 60 mins.
ORIGINS: Manga pub Anime V magazine.
CATEGORIES: DD?

Our hero Tadashi is a high school student and computer game addict. He gets drawn into a very strange game in which he plays the superheroic character Zenon — only this time, the game is for real!

ZIGGY THE MOVIE: LET'S GO! R & R BAND
(Eng trans for ZIGGY THE MOVIE: SOREYUKE! R & R BAND)

JAPANESE CREDITS: Prod: Studio Dean. © Tokuma Japan. 70 mins.

I have no further information about this title.

Sukeban Deka

JAPANESE CREDITS: Dir: Hideo Nishimaki. © Fujiko-Fujio, Shin'ei Doga. 50 mins. **ORIGINS: Manga by Fujiko-Fujio, pub Shin'ei Doga; 1979 TV series; movies every year 1984-88 & 1991.** **CATEGORIES: C, U**

Another revamp of Japanese myth as Nobita and his robot cat Doraemon go on another adventure.

DRAGONBALL Z — COLLISION! BILLION POWERED WARRIORS

JAPANESE CREDITS: Dir: Daisuke Nishio. Prod: Toei Animation. © Bird Studio, Shueisha, Toei Doga. 47 mins. ORIGINS: Manga by Akira Toriyama, pub Shueisha; 1986 TV series; movies every year 1986-91. **CATEGORIES: C, X**

Cooler was beaten but not destroyed. He fuses with a computer chip and a spacecraft and comes back as 'Metal Cooler'. Piccolo's people are being enslaved by his robot and Goku and Vegata must defeat the self-regenerating metal monster that he has become. ★★★?

Also:
DRAGONBALL Z — EXTREME BATTLE! THREE SUPER SAIYAJIN

CREDITS, ORIGINS, CATEGORIES: As above except: c45 mins.

Goku's wife ChiChi is going shopping. Krilyn and Kamesennin are taking young Trunks out on the town. With most of our heroes occupied, three killer cyborgs from the criminal Red Ribbon organisation show up on the scene. The action moves to the Arctic for some incredible fight scenes. ★★★?

EIGHT MAN AFTER: FOR ALL THE LONELY NIGHTS

JAPANESE CREDITS: Dir: Sumiyasu Furuhawa. Script: Yasushi Hirano. Chara des: Kenichi Onuki. Prod & © ACT Co Ltd, Kuwata, Hirai. **ORIGINS: 8 Man manga by Jiro Kuwata & Kazumasa Hirai; 1963 TV series.** **CATEGORIES SF, H**

The original Eight Man was the original Robocop, a murdered detective whose mind was implanted in a cyborg body. This is a 'side story' exploring the

Viewers in the UK, and to a lesser extent the USA, are so used to a diet of anime releases on video consisting mainly of OAVs with the odd movie thrown in that they tend to think this is the natural state of the art. Not so. In the 1992 edition of the annual reader poll conducted by *Animage* magazine to find the most popular anime of the year, the top twenty included only two films and three OAVs, all the other slots being taken up by anime TV series. Another startling fact from the 1992 reader poll was that, for the first time, the latest Miyazaki movie did not automatically get the number one slot. *Porco Rosso* was perhaps a little more overtly political and thereby less accessible to the young than his earlier offerings, but the fact that it ranked third behind new number one TV hit *Sailor Moon* does not accurately reflect the relative quality of the two titles, whatever it may say about popularity or the preferences of the magazine's readership. However, Miyazaki's *Warriors of the Wind* was — as in every year from its release in 1984 until toppled in 1995 — voted the best anime production of all time. (Ironically, it was toppled by another TV hit, ghost series *Yu Yu Hakusho*, which once again is not up to its quality in any aspect, though a charming series.) In America, Matt Greenfield founded a new anime company, AD Vision; in Britain Island World Communications, encouraged by the success of *Akira*, announced the setting up of a new label, Manga Video, with *Fist of the North Star* its first release.

MOVIES

DORAEMON — I'M KITARO!
(Eng trans for DORAEMON — BOKU WA KITARO!)

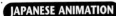

father-and-son-style rivalry between Hachiro, the second Eight Man, and Professor Tani, who 'created' his cyborg form. There's also a complication in the shape of an evil cyborg, Ken. ★★?

ELEGY FOR BEES
(Eng trans for HIKA NO KOZE NO AMEN)

JAPANESE CREDITS: Dir & writer: Leiji Matsumoto.
CATEGORIES: DD

A short (ten mins?) film telling the story of how a hive of humanoid bees respond to a threat to their community. The leading bees are portraits of famous film and TV stars. Made for showing at a theme park and never released elsewhere.

GREAT CONQUEST: ROMANCE OF THREE KINGDOMS

JAPANESE CREDITS: Dir: Masahara Okuwaki. Screenplay: Kazuo Kasahara. Story: Takamasa Yoshinari & Shoji Yazawa. Chara des & anime dir: Koichi Tsunoda. Prod des: Takamura Mukuo. Art dir: Takamura Mukuo & Tadao Kubota. Photography dir: Toshiharu Takei & Yoichi Takashima. Music: Seiji Yokayama. Prod: Enoki Films, Shinano Kikaku. © Shinano Kikaku. 90 mins.
WESTERN CREDITS: US theatrical & video release 1994 on Streamline Pictures, dub, Eng dialogue Tom Wyner.
ORIGINS: Chinese history & mythology; book by Chen Shou; manga by Mitsuteru Yokoyama; 1991 TV series.
POINTS OF INTEREST: Narrated by Japanese-American actor Noriyuki 'Pat' Morita.
CATEGORIES: P, A

A historical epic which opens in 169 AD in a divided China, as the dynasty of the Han Emperors crumbles and bandits, plagues, famines, and floods devastate the land. The warrior heroes Liu Pei, Kuan Yu and Chang Feng unite the people to defeat the bandits and struggle for peace and justice. Their battles, defeats and victories, and the many people, good and bad, drawn into the struggle, laid the foundations of the Chinese nation. The artefacts and costumes are as historically accurate as possible. Carefully researched background details and battle action combine to bring a remote period of history to life. ★★★

GUNDAM 0083: STARDUST MEMORY: ZION'S FADING LIGHT
(Eng title for KIDO SENSHI GUNDAM 0083 STARDUST MEMORY: ZION'S FADING LIGHT, lit Mobile Soldier Gundam 0083: Stardust Memory: Zion's Fading Light)

JAPANESE CREDITS: Dir: Mitsuko Kase & Takashi Imanishi. Chara des: Toshiro Kawamoto. Mecha des: Yasushi Sekitsu, Toru Toya, Hajime Katoki & Mika Akitaka. Prod: Sunrise. © Sunrise, Bandai. 110 mins.
ORIGINS: Novels by Yoshiyuki Tomino; 1979 onwards TV series; 1988 movie Char's Counterattack; 1991 movie; OAVs every year 1989-91.
CATEGORIES: SF

A theatrical version of the 1991 OAV series. Ten minutes of footage edited out of the OAVs pre-release was spliced back in to tie the different parts together, but the overall story is the same, though many characters and battle scenes have been deleted. The 'happy ending' with Kou and Nina reunited is cut; instead the story ends with his trial and sentencing and the erasure of all records of the Gundam test units. ★★★

THE HEROIC LEGEND OF ARISLAN II
(Eng title for ARSLAN SENKI II, lit Arslan Battles II)

JAPANESE CREDITS: Dir: Mamoru Hamatsu. Screenplay: Megumi Sugihara. Chara des: Sachiko Kamimura. Anime dir: Kazuya Kise. Art dir: Kazuhiro Kinoshita. Chief animator: Masuo Nakada. Music: Yasuo Urakami. Prod: Animate Film. © Tanaka, MOVIC, Kadokawa Shoten. 60 mins.
WESTERN CREDITS: US video release 1993 on US Manga Corps, sub, trans William Flanagan & Pamela Ferdie, Eng rewrite Jay Parks; UK video release 1994 on Manga Video, dub.
ORIGINS: Novel by Yoshiki Tanaka; created by Haruki Kadokawa, Hiroshi Inagaki & Yutaka Takahashi; 1991 movie.
POINTS OF INTEREST: Theatrical release on a triple bill with Silent Möbius 2 and The Weathering Continent.
CATEGORIES: DD, P

As the evil Silver Mask continues to oppress the land of Parse, Prince Arslan and his small band of comrades gather together the threads of resistance and begin to form outside alliances. But is the usurper really more sinned against than sinning? Is

his claim that Arslan's father killed his family and cast him out of the realm true? Is he, in fact, the rightful Prince and Arslan's beloved father the usurper? The same gorgeous design as in the first film, and the same innovative use of at times very limited animation, making not just a virtue but an art from cost-cutting measures. The story develops slowly and the lack of a formal conclusion within this feature may bother Western audiences not accustomed to multi-part movies on short-feature bills. ★★☆

MAGICAL PRINCESS MINKY MOMO: EMBRACING DREAMS AND HOPES
(Eng trans for MAHO NO PRINCESS MINKY MOMO, lit Magical Princess Minky Momo. All available information gives the subtitle in English)

JAPANESE CREDITS: Prod: Ashi Pro. © Ashi, Network, Bandai. c50 mins.
ORIGINS: 1982 TV series; 1985 movie Gigi and the Fountain of Youth.
CATEGORIES: DD, U

The first Minky Momo came to Earth from the 'dreamland' of Fenalinasa to help humans regain their lost dreams and hopes. When she died as the result of a car accident, a new Momo was sent from another dreamland, Marinnasa, located on the ocean floor, to help revive mankind's capacity to dream. Like the first Momo, she lives as an ordinary human child. Her new human 'parents' are an archaeologist who is looking for the ruins of Fenalinasa, now destroyed by man's inability to dream, and his wife, a mystery writer whose biggest failing is that she gets so caught up in the mysteries she writes that she always forgets to reveal the culprit. As before, Momo can turn into a young woman and use her magic to help others. ★★☆?

PORCO ROSSO
(Western title most commonly used in Japan, UK & USA for film also known as KURENAI NO BUTA, lit The Crimson Pig)

JAPANESE CREDITS: Dir & writer: Hayao Miyazaki. Music: Jo Hisaishi. Prod: Studio Ghibli. © Nibariki, TNNG. 120 mins.
WESTERN CREDITS: Released on video in Spain on Anime label by Oro Films SA.
ORIGINS: Miyazaki's manga Zassho No To Hikontei Jidan, trans 'The Age of Hydroplanes', appearing in Model Graphix magazine from 1989.

POINTS OF INTEREST: Highest grossing film in Japan in 1992. The hero's real name, Marco Pagott, is a homage to Italian animator Marco Pagott, an old colleague. Miyazaki drew on his own family background for this film — his uncle was a partner in a firm making aircraft between the 2 World Wars. The film was dubbed for inflight showing on JAL by Carl Macek and in this form was considered for UK video and theatrical release by at least 2 companies. CATEGORIES: P, DD

After his quiet, charming fable of domestic magic, *Kiki's Delivery Service*, Miyazaki wanted to make a film for the overworked, harried salarymen who form the backbone of Japan's cultural life, to say that even if they weren't living up to the ideals and dreams of their youth, they could still try to be true to their innermost selves. So he made them a fable of an air ace who is turned by circumstance into a pig, but who still keeps faith as best he can with his friends and the purity of his youthful dreams. *Porco Rosso* is set in the Adriatic of the 1920s, a time when Fascism was on the rise, the Balkans were in turmoil, and the buccaneers of the air, sky-pirates and mercenaries alike, wove tales of adventure and romance in their tiny planes high amid the clouds. It's a film which sets Miyazaki free to indulge his passion for old planes to the full — the flying machines in the film are perfect in every detail and the aerial sequences are breathtaking. The classic Miyazaki heroine, the innocent and impulsive Fio, is balanced by another female lead just as appealing and powerful. Harking back to the relationship in *Cagliostro Castle*, his first feature, between the innocent Clarisse and the worldly Fujiko, he brings together aircraft brat Fio and Gina, a beautiful, thrice-widowed chanteuse whose heart has been broken once too often by the men who didn't come back. Gina owns a bar and hotel where the fliers of the Adriatic congregate; Marco Pagott, the man now known as Porco Rosso, is a childhood friend and the only other survivor of a happy group of young people in a photograph she keeps on the wall. Fio is the granddaughter of the factory owner who builds and repairs Marco's planes for him; after he is shot down in a dogfight with ambitious American flier Donald Curtis, Fio, though only seventeen, designs some modifications to make his beloved bird faster and more effective than ever before. Through a weird twist of fate Fio ends up volunteering herself as the prize in an air battle between Marco and Curtis; but there's more at stake than just some light romance and pilot prestige. The Italian government is already cracking down on mavericks like Marco and Curtis, who refuse to give allegiance to a political system they

don't believe in, and the secret police are on Marco's tail. A series of plot strands are beautifully orchestrated into a compelling whole, and as is usual with Miyazaki, although there's action aplenty and the plot and dialogue are intelligent and absorbing, there is nothing in the film to upset or offend, proving once again that you can make films for grownups without making 'adult films'. The backgrounds are fabulous, the animation first class — look particularly at the way water is handled, since it has rarely, if ever, been done better. Another wonderful Jo Hisaishi orchestral score completes the picture. A richly deserved ★★★★★

RANMA 1/2: THE MOVIE 2 — NIHAO MY CONCUBINE
(Eng title for RANMA NIBBUN NO ICHI KESSEN TOGEN KYO! HAYANOME O TORIMODOSE!, lit Ranma 1/2: Attack of the Enchanted World! Retake Your Brides!)

JAPANESE CREDITS: Dir: Kou Suzuki. Screenplay: Ryota Yamaguchi. Chara des & art dir: Atsuki Nakajima. Prod: Kitty Film. © Takahashi, Shogakukan, Kitty. c60 mins. WESTERN CREDITS: US video release 1994 on Viz Video, dub, trans Toshifumi Yoshida, written by Trish Ledoux. ORIGINS: Rumiko Takahashi's manga, pub Shogakukan, Eng trans pub Viz Communications; 1990 TV series; 1990 OAV; 1991 movie. POINTS OF INTEREST: The 2nd Ranma theatrical release, produced by the OAV team, on a double bill with Yawara! for its début. CATEGORIES: DD, R

Ranma and Co are shipwrecked on a small island in the South Seas. It's not uninhabited, though; young illusionist Toma is there to abduct all the girls in the party and make them compete in a series of tests so he can choose one to be his bride. In order to save the others, Ranma-chan has to enter for such gruelling tests as survival flower-arranging and obstacle-course cookery. More complete insanity from the *Ranma* team, produced to the usual high Kitty standards of animation and filming. ★★★

RUN, MELOS!
(Eng trans for HASHIRE MELOS!)

JAPANESE CREDITS: Dir & writer: Masaaki Osumi. Chara des: Hiroyuki Okiura. Backgrounds: Hiroshi Ono. Music: Kasumasa Oda. Prod: Visual 80. © TV

Asahi, Visual 80. 107 mins. ORIGINS: Osamu Dazai's 1940 novella based on Greek legend. POINTS OF INTEREST: The novella is a classic of Japanese literature and Toei Animation had already made an 87-minute TV special based on the story in 1981. Composer Oda had enjoyed a successful career as a pop idol prior to this, his first anime music score. CATEGORIES: P

Ono was responsible for the beautifully-painted backgrounds in *Kiki's Delivery Service* and he produces work of the same quality here. The classical countryside is stunningly portrayed and the animation overall is of a very high standard. The story is set in classical Greece, where a simple farmer, Melos, is travelling to a family wedding when he gets involved in a dispute with a local ruler. Melos is in trouble with the King, and has to answer for it, but his sister's wedding is imminent. He asks for a few days' grace to see her safely married and the King agrees, but only when a friend volunteers to act as surety for Melos. If he doesn't return on time, an innocent man will be executed. Despite many misadventures along the way, Melos keeps his word and shows himself worthy of his friend's confidence, and the King relents and decides to free them both. The story hinges on the ability to trust, the necessity of keeping one's word and the nature of friendship itself. (Sadly, the writer was later to die alone and by his own hand, making the happy resolution of this story bitterly ironic.) It sounds banal, but it isn't, and it looks wonderful. Well worth seeing for those background paintings alone, but with much more to offer. ★★★☆

SHOCHAN SORABA OTOBU

JAPANESE CREDITS: Prod: Jupiter Film.

That's all I know!

SILENT MOBIUS 2 THE MOTION PICTURE

JAPANESE CREDITS: Dir & chara des: Michitaka Kikuchi. Mecha des: Yasuhiko Mori. SFX art: Takashi Okazaki & Tatsuya Soma. Prod: Studio Tron. © Asamiya, Studio Tron, Haruki Kadokawa, Pioneer LDC. 40 mins. ORIGINS: Kia Asamiya's manga, pub Comp Comics, Eng trans from Viz Communications; 1991 movie.

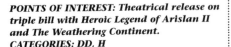

POINTS OF INTEREST: *Theatrical release on triple bill with Heroic Legend of Arislan II and The Weathering Continent.*
CATEGORIES: DD, H

This essentially covers the same ground as the first movie, giving us further insights into Katsumi Liquer's recruitment as a member of Tokyo Police's anti-demon squad the AMPD. Snippets of information about the other squad members, Katsumi herself, her parents, their relationship and the nature of the Lucifer Hawks are revealed as Katsumi at first rages against her mother's death, then gradually accepts her own destiny. The story is very slight and moves our understanding of the characters on very little, mostly reinforcing or reflecting impressions from the first movie and introducing only one major new character; but, although it does very little, it does it beautifully, with the same brooding elegance as the first movie. It's not so much a triumph of style over substance as a substitution of style *for* substance, creating a mood for its own sake. ★★☆

THE WEATHERING CONTINENT
(Eng title for KAZE NO TAIRIKU, lit Continent of the Wind)

JAPANESE CREDITS: *Chara des: Nobuteru Yuuki, based on illustrations by Mutsumi Inomata. Music: Michiru Oshima. © S. Takekawa, Kadokawa Shoten. c60 mins.*
ORIGINS: *Novel by Sei Takekawa, illustrated by Mutsumi Inomata, pub Kadokawa Shoten.*
POINTS OF INTEREST: *Set in Atlantis. Triple bill release with Heroic Legend of Arislan II and Silent Möbius 2.*
CATEGORIES: DD

The audiences coming out of this triple bill must have found the streets of everyday Tokyo almost unbearably drab, immersed as they had been for three hours in three very different but equally beautiful visual universes. This is at the end of the cycle; *Heroic Legend of Arislan* showed an early feudal civilisation in a lush young world, *Silent Möbius* a highly developed urban civilisation set in a contemporary Gothic cityscape of grandeur and horror, but *The Weathering Continent* is set at the end of its continent's history, in a once-powerful, now-dead civilisation whose collapse is so final that it is crumbling to dust even as we watch. It is almost completely deserted, with the survivors of a series of natural disasters constantly under threat from scavengers and bandits, and almost no water. The winds that scour the land carry no rain clouds, and

most of its springs have long dried up. Across this landscape of desolation walk three travellers — Tieh, a young mystic; Boice, a mercenary; and the lady Lakshi Arun Ard. Through a series of strange events they find themselves in a City of the Dead, facing the anger of departed souls as a group of pirates seek to plunder their comfortable afterlife. Tieh and Lakshi must confront their own demons, and all three have to fight to return from the City of the Dead to the light of the dying world. A slow-paced mystical tale of great beauty; the inspiration of Inomata's original artwork fuels Yuuki's excellent chara designs. ★★★

YAWARA!

POINTS OF INTEREST: *Originally released on a double bill with Ranma 1/2: The Movie 2 — Nihao My Concubine.*
CATEGORIES: N

Adventures of a Fashionable Judo Girl (as the series was subtitled) in her struggle to live like a normal human being while her grandfather only sees her as a potential champion athlete.

OAVS

AKAI HAYATE VOLS 1 & 2
(Eng title for AKAI HAYATE 1-4, lit Red Gale 1-4; 1 HAYATE TANJO, Birth of Hayate; 2 NIKKO NO TENGU, Long-nosed Goblin of Nikko; 3 NANSO NO HOKAI, Collapse of the South; 4 KESSEN, Decisive Battle)

JAPANESE CREDITS: *Dir: Osamu Tsuruyama. Original story & screenplay: Osamu Yamazaki. Art dir: Shoji Sato. Music: Takashi Kudo. Prod: Minami-machi Bugyosho, Nextart. © Soeishinsha, Plan, Minami-machi Bugyosho, O. Yamazaki. Each 30 mins.*
WESTERN CREDITS: *US video release 1995 on Central Park Media on 2 tapes, 2 parts per tape, sub, trans William Flanagan & Yuko Sato, Eng rewrite Jay Parks.*
ORIGINS: *Manga by Osamu Yamazaki.*
CATEGORIES: SH, DD

The real rulers of modern Japan are the Shinogara ninja clan, whose base is in a hidden valley at the foot of Mount Fuji. The leader's son, Hayate (the name means 'gale') has rebelled and killed his father. Pursued by ninja of the clan, eventually he has to stand and fight, and is killed. But it doesn't

MITSUTÉRU YOKOYAMA

A boys' manga artist whose action-packed science fantasy stories are enduringly popular with today's Japanese youth, he was also fascinated by myth and legend, Western as well as Japanese. The first ever anime TV series to feature a giant robot, *Iron Man No. 28*, known in the US as *Gigantor*, was based on his manga of the same name. *Giant Robo* was also inspired by one of his manga, which took its own inspiration from the ancient legends of the Water Margin; and like *The Water Margin*, *Giant Robo* too had a live-action TV version, screened in Japan in 1968 and even shown on US TV.
RECOMMENDED WORKS: No translated manga are available in the West, but look for the anime version of his manga *Babel II*, available in the US from Streamline Pictures and Orion and in the UK from East2West, and for *Giant Robo* from Manga Video.

end there. He transfers his soul into the body of his sister Shiori. They hide out in Tokyo under the alias Yukiki, still pursued by assassins bent on vengeance — and on covering up the true cause of Hayate's actions. Shiori can call up her brother's spirit to become a mighty warrior clad in mystic shadow armour — but every time she does so, she loses a fraction of her own soul. Meanwhile Hayate's comrade Ikkaku Idate is trying to find out what's behind the clan's strategy. With the clan's three top warriors in rebellion, a major power struggle has broken out, and in the final showdown at clan headquarters, using the tools of technology against ancient mystic arts, the answers to many questions will finally emerge. But will Hayate be able to leave Shiori's body before her own soul is completely consumed and she is lost forever? ★★☆?

APPLELAND STORY
(Eng trans for APPLELAND MONOGATARI)

JAPANESE CREDITS: Prod: J.C. Staff. © Tokuma Novel. 90 mins.
ORIGINS: Yoshiki Tanaka's novel, pub Tokuma, serialised in Animage magazine.
CATEGORIES: P, A

The advertising for this looks very pretty, all soft pastels and cute, wide-eyed charas, giving it a childlike air. However this is deceptive. It's 1905, and the military buildup that will eventually culminate in Europe's Great War of 1914-18 is just getting underway. Appleland is right in the centre of Europe and would be quite a prize for any country intent on military expansion. Virgil Sibelius, an

orphan pickpocket, befriends Frida, who holds the seal which will decide Appleland's destiny. Many others want it — they become the targets of a military pursuit, and the proud and beautiful Aryana, whose only confidant is her panther Attila, is also on their trail. Can they even trust their old friend, Renbach? ★★☆?

BABEL II 1-4
(Eng trans for BABEL NISEI; Jap ep titles: vols 1 & 2 SAJIN NO TAIKETSU, Battle in the Sand; vol 3, HIKARU TO KAGE NO AIDA E, Battle Between Light and Shadow; vol 4 AOKI SENKO NO KANATA E, Beyond the Blue Light. Ep titles (Western): 1 The Awakening; 2 First Blood; 3 Crossroads; 4 Conflict)

JAPANESE CREDITS: Dir: Yoshihisa Matsumoto. Writer: Bin Namiki. Chara des: Shingo Araki. Music: David Tolley. Prod: T Up, J.C. Staff. © Yokoyama, Hikara Pro, Sohbi Planning, T Up. Each 30 mins.
WESTERN CREDITS: US video release 1994 on Streamline Pictures, dub, Eng dialogue Steve Kramer; UK video release 1995, on East2West dub.
ORIGINS: 1960s manga by Mitsuteru Yokoyama; 1973 TV series.
CATEGORIES: SF, A

Akai Hayate

In the days of ancient Babylon an alien base was constructed on Earth. Koichi is descended from the builder of that base, though he thinks he's just another schoolboy. He's troubled by a recurring dream of a desert tower and a mysterious voice calling him Babel II. An encounter with girl psychic Juju awakens his own latent powers and embroils him in a struggle with the sinister Yomi, Master of the Psychist cult, who seeks to use the powers of other psychics for his own ends. The ancient servants of Babel, the dragon Ropros, shapeshifter Roden and giant robot Poseidon, come to his aid, and he is caught up in a battle to save the world from Yomi's domination. The retro-styling, in keeping with both anime trends of its day and the original manga, is interesting, and the story has a number of intriguing concepts, but ultimately the pace is a little too slow and the manga a little too condensed, especially in parts three and four where several named characters turn up and vanish with no explanation whatever other than their function as cannon-fodder. ★★

BAKABON: 19000 MILES LOOKING FOR OSUMATSU'S CURRY
(Eng trans for BAKABON: OSUMATSU NO CURRY O SAGASHITE SANZAN-RI)

JAPANESE CREDITS: Prod: Studio Pierrot. © Pony Canyon. 50 mins.
ORIGINS: The long-running gag manga Bakabon.
CATEGORIES: C

I have absolutely no idea what this OAV is about and have not managed to find anyone who has seen it. I include it for two reasons — the title was irresistible, and if proof of the scope of anime beyond straight SF-cyberfare is needed, titles like this provide it. If you have a copy available for viewing, please let me know!

BASTARD!! 1-3
(Eng title for BASTARD!! ANKOKU NO HAKAI JIN, lit Bastard!! Darkness Destroying God; vol 1 BAKUFU NO MAJUTSUSHI, Fire and Explosion Magician; vol 2 KAEAN MAJIN IFREET, Evil Fire-god Ifreet; vol 3 NINJA MASTER GALA)

JAPANESE CREDITS: Dir: Katsuhito Akiyama. Writer: Hiroshi Yamaguchi. Chara des: Hiroyuki Kitazume. Monster des: Masanori Nishii. Anime dir: Moriyasu Taniguchi & Takahiro Kimura. Music: Kohei Tanaka. Prod: AIC, Anime R. © K.

Hagiwara, Shueisha, Pioneer. Each 30 mins.
ORIGINS: Manga by Kazushi Hagiwara, pub Shueisha.
POINTS OF INTEREST: The Bastard!! of the title is the term used for a kind of mediaeval European sword. Note the huge number of heavy metal references and excruciating puns in the manga, some of which carry over — the city of Metal Licania, the resurrected demon Anthrasox, the characters Guns'n'Ro and Bon Jovina, etc, etc, etc.
CATEGORIES: DD, X

Once upon a time there was a very powerful magician named Dark Schneider. He wasn't just very powerful, he was also a hunk — tall and muscular with white-blond hair right down his back and a somewhat lecherous disposition. Unfortunately he had a very, very bad temper, so a wizard locked him away in the body of an innocent baby, Rushe Lenlen, to protect the town from him. But now, years later, the town is under attack by evil forces and only Dark Schneider is strong enough to defeat them. Time to get the cute heroine to kiss little Rushe, transforming him into a tall, blond, powerful and very bad-tempered magical hunk. What happens next? A hugely successful fantasy OAV series with titanic battles, armoured warriors of both sexes, excessive use of dangerous magic and masses of fun, that's what. ★★★☆

BE-BOP HIGH SCHOOL BOOTLEG 4

JAPANESE CREDITS: Dir: Yukio Kaisawa. Prod: Toei Animation. © Toei Video. 50 mins.
ORIGINS: The successful high school manga; parody version of the Be-Bop High School OAV's; 1991 OAV.
CATEGORIES: C

Fourteen skits on such themes as period theatre, sumo and the circus, performed by the *Be-Bop* parody gang.

BLACK LION
(Eng title for GIKU SENGOKUSHI KURO NO SHISHI JINNAI HEN, lit Original History from the Time of the Civil War: Black Lion: Inside the Camp)

JAPANESE CREDITS: Dir: Takashi Watanabe. Script: Ritsuko Hayasaka & Yoshimitsu Takaki. Chara des & key animator: Hideyuki Motohashi. Mecha des: Koichi Ohata. Prod: Dynamic Planning, Minamachi-Hokjo, Tokyo Kids. © Dynamic

Planning, Japan Columbia. 45 mins.
ORIGINS: *Manga by Go Nagai.*
CATEGORIES: *P, SH, H*

Another horror-action tale with its roots firmly in Japanese myth and history from the pen of Go Nagai. The story opens in 1581 during Japan's civil war; but this is an alternative history, and Oda Nobunaga and the other great names of Japanese history are fighting their war with modern weaponry and methods. Lots of ninja battles in this story of blood, guts and suffering, mixed in with tanks and missiles. ★★☆?

BOMBER BIKERS OF SHONAN 8 LEGEND OF THE RED STAR
(Eng title for SHONAN BAKUSOZOKU 8 AKAI HOSHI NO DENSETSU, lit Wild Explosive Motorbike Gang from Shonan 8 — Legend of the Red Star)

JAPANESE CREDITS: *Prod: Toei Animation. © Toei Video. 45 mins.*
ORIGINS: *Manga by Satoshi Yoshida, pub Shonen Gohosha; OAVs every year 1986-91.*
CATEGORIES: *N, A*

No other information about this segment of the popular video series about a nice-natured biker gang.

CATGIRL NUKU-NUKU 1 & 2
(Eng title for BANNO BUNKA NEKO MUSUME CHOTTO DAKE NUKU-NUKU, PHASE-OI and -OII, lit All-Purpose Cultural Cat Daughter Nuku-Nuku, Phase-01 and -02)

JAPANESE CREDITS: *Supervising dir: Yuji Moriyama. Dir: Hidetoshi Shigematsu & Yutaka Takahashi. Chara des: Yuzo Takada. Art dir: Kazuhiro Arai. Music: Hitoshi Matsuda, Beat Club & Vink. Prod: Animate Film. © MOVIC, SME, Y. Takada, Futabasha. Each 30 mins.*
WESTERN CREDITS: *UK video release 1994 on Crusader Video, dub, parts 1-3 on one tape; US video release 1995 on AD Vision, sub, trans Masako Arakawa & Chris Hutts.*
ORIGINS: *Manga by Yuzo Takada, pub Futabasha.*
POINTS OF INTEREST: *The UK release was the first anime video to introduce the softer, cuter side of non-children's anime to the British mass market, and to use British regional accents in the dub. The music track is unchanged but the songs have been replaced with new ones by British band*

Marina Speaks. Nuku-Nuku means 'Snuggly Wuggly'.
CATEGORIES: *C, DD*

Despite the extreme youth of hero Ryan (Ryunosuke in the Japanese version), *CatGirl Nuku-Nuku* is aimed at teenage boys, and every element of the story — computer wizardry, heavy weaponry, domineering harpy bitches, and cute, compliant, curvy anthropomorph — is geared to their tastes. Nuku-Nuku is an android with a cat's brain and feline tastes — fish, basking in the sun and so on. She's created both as a sop to the conscience of Ryan's dad, who was partly responsible for killing her kitten self in a car chase, and to look after Ryan while he's busy. The characterisation goes a bit deeper than this might imply, with Nuku-Nuku eventually gaining the ability and experience to assess people and situations for herself and realising that relationships must be viewed from a number of angles before any judgements can be made. Considering that the story revolves around the acrimonious divorce and custody battles of a pair of egocentric parents, one of whom runs a heavy weaponry factory and one who is a mad scientist, it may seem odd to describe it as a well-paced, entertaining romp; but judge for yourself. The animation is crisp and fresh and uses a colour palette of zingy, souped-up pastels and brights to good effect. ★★★☆

CHAMELEON

JAPANESE CREDITS: *Prod: Reona, Egg. © Pack In Video. 50 mins.*

No other information available.

CRYING FREEMAN 5 A TASTE OF REVENGE
(US aka CRYING FREEMAN 4)

JAPANESE CREDITS: *Dir: Shigeyasu Yamauchi. Screenplay: Higashi Shimizu. Music: Hiroaki Yoshino. Prod: Toei Animation. © Koike, Ikegami, Shogakukan, Toei Video. 50 mins.*
WESTERN CREDITS: *US video release 1993 on Streamline Pictures as Crying Freeman 4, Eng dialogue by Gregory Snegoff; UK video release 1994 on Manga Video, UK title The Hostages. Both dub.*
ORIGINS: *Manga by Kazuo Koike & Ryuichi Ikegami, pub Shogakukan, Eng trans pub Viz Communications 1993; OAVs every year 1988-91.*
CATEGORIES: *X, V*

The plan is to replace Freeman with a double so exact it will fool even his wife, and so to use the 108 Dragons' influence to spread the cult of the Great Bear God throughout the world. Bad guy Naitai doesn't seem to have realised it would have c st him less and been more interesting to buy an evangelical TV station. ☆

CYBER FORMULA GPX 1 & 2
(Eng title for SHINSEIKI GPX CYBER FORMULA II, lit New Century GPX Cyber Formula II, Round 1 and Round 2)

JAPANESE CREDITS: Prod: Tamiyoshi Tomito. Prod co: Sunrise. © VAP. Each 30 mins. ORIGINS: 1990 TV series. POINTS OF INTEREST: Top ranked OAV (10th place) in 1996 Animage reader poll. CATEGORIES: A

Motor racing is a tough world, but it's one many kids dream of entering. This successful series takes a fourteen-year-old boy who is determined to be a champion and follows his progress towards his dream. To succeed, he has to compete on equal terms with adults, and also to persuade a team to take him on and keep him on; despite problems and personality conflicts, everything has to be subordinated to the success of the team if his own ambition is to be achieved. Hayate and Team Asurado Sugo face travel all over Japan, then round the world, in pursuit of the points they need to win the World Grand Prix. It's not just a man's world either — girls and women can be team chiefs and even mechanics — but romance takes second place to winning. Crisply designed and animated, the cute chara style has deceived some Westerners into thinking it's purely for small children; but with its mix of character development and gripping race-track action it makes for fun viewing. ★★★?

DESPERATE LOVE 1989
(Eng trans for ZETSUAI 1989)

JAPANESE CREDITS: Dir: Takuji Endo. Script: Tatsuhiko Urahata. Anime dir: Tetsuro Aoki. Art dir: Shinichi Uehara. Storyboards: Yoshiaki Kawajiri. Prod: Madhouse. © M. Ozaki, Shueisha. ORIGINS: Manga by Minami Ozaki, pub Shueisha in Margaret magazine. POINTS OF INTEREST: While Kawajiri is perceived in the West as a cyberpunk horror director, his range of interests and abilities is much wider, as his contributions to titles like this show.

CATEGORIES: R

The yaoi genre is distinguished by its stories of romantic and passionate love and hopeless emotional intensity in which women feature only as onlookers or voyeurs. (The name is a contraction of the Japanese phrase 'yame-nashi, ochi-nashi, imi-nashi' meaning 'without climax, without conclusion, without content'.) It is hugely popular with Japanese women from their teens onwards, mirroring perhaps the popularity in Western media fan fiction for 'slash' stories — in this context, stories which place two male characters in homoerotic situations. In this particular yaoi story, young entertainer Izumi appears on the surface to have it all, but he has a dark history which will bring him into contact with rock singer Koji Nanjo and Koji's friend Katsumi Shibuya. ★★☆?

DETONATOR ORGUN 3: DECISIVE BATTLE
(Eng trans for DETONATOR ORGUN 3 KESSEN HEN)

JAPANESE CREDITS: Dir: Masami Obari. Script & original story: Hideki Kakinuma. Chara des: Michitaka Kikuchi. Prod des: Hideki Kakinuma, Kimitoshi Yamane & Junichi Akutsu. Music: Susumu Hirasawa. Prod: AIC. © Darts, Artmic. 55 mins. WESTERN CREDITS: US video release 1994 on US Manga Corps, trans Neil Nadelman. ORIGINS: 1991 OAV. CATEGORIES: SF

The final part of the OAV series. The Evoluder are heading for Earth in their battle-planet and things don't look good until Tomoru finally unlocks the mystery of Orgun's advanced weapons systems. Now Earth might stand a fighting chance — but Kumi is still hoping that her psychic link with the Evoluder leader may enable her to prevent any fighting. The final showdown is a dramatic clash of forces and ideas. ★★☆?

DEVIL HUNTER YOKO 2
(Eng trans for MAMONO HUNTER YOKO 2)

JAPANESE CREDITS: Dir: Hisashi Abe. Script: Hisaya Takabayashi. Chara des: Takeshi Miyao. Anime dir: Tetsuru Aoki. Art dir: Takeshi Waki. Prod: Madhouse. © Toho Video, Madhouse. 30 mins. WESTERN CREDITS: US video release 1994 on AD Vision, on one tape with part 3, sub, trans Ichiro Araki; UK video release 1995 on

 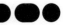

Western Connection, sub, trans Jonathan Clements.
ORIGINS: 1991 OAV.
CATEGORIES: H, A

Yoko is coming to terms with her heritage as a devil hunter when another complication arises — her best friend Chikako decides that it would be a really good idea for her to manage Yoko's work so as to ensure that the large amounts of money which are undoubtedly to be made in the devil-hunting business can be looked after properly. And as if this wasn't enough, a cute young girl, Azusa, turns up on the doorstep and demands that Yoko accept her as a trainee devil hunter. It turns out that Yoko will need all the help she can get, because a local construction company has disturbed a woodland shrine and unleashed two furious samurai spirits bent on revenge for their disturbed sleep. Heads are torn off, gore flows and there are numerous calls on the company pension fund. Can Yoko save the day, even with her new apprentice's help? ★★★

D-1 DEVASTATOR: CONTACT
(Eng trans for D-1 DEVASTATOR SESSHOKU HEN)

JAPANESE CREDITS: Dir: Tetsuo Isami. Script: Masashi Togawa. Mecha des: Seiji Daicho. Art dir: Mitsuhara Miyamae. Key animator: Naoki Ohira. Prod: Dynamic Pro. © Takara. 50 mins.
SPINOFFS: Drama CDs, manga in Asky Comic and several computer game tie-ins.

I have no other information on this title.

DOOMED MEGALOPOLIS 2-4
(Eng title for TEITO MONOGATARI, lit Imperial City Story. Ep titles (UK): 2 Disaster; 3 The Rise of the Dragon; 4 The Battle for Tokyo. Ep titles (US/Japanese): 2 Doomed Megalopolis 2 The Fall of Tokyo, Eng title for TEITO MONOGATARI RYUDOHEN, lit Imperial City Story: Dragon's Way; 3 Doomed Megalopolis 3 The Gods of Tokyo, Eng title for TEITO MONOGATARI: BOSATSUO HEN, lit Imperial City Story: Murderer King; 4 Doomed Megalopolis 4 The Battle for Tokyo, Eng title for TEITO MONGATARI: KESSEN HEN, lit Imperial City Story: Battle Story)

JAPANESE CREDITS: Series dir: Taro Rin. Dir: 2, Kazuyoshi Katayama & Koichi Chigira; 3 & 4 Kazushige Kume. Writer: Akinori Endo. Chara des: Masayuki Goto.

Anime dir: Koichi Hashimoto. Art dir: Hideyoshi Kaneko. Music: Kazz Toyama. Prod: Madhouse. © Toei Video. Each 60 mins.
WESTERN CREDITS: US video release 1993 on Streamline Pictures, Eng dialogue Ardwight Chamberlain; UK video release 1994 on Manga Video, both dub.
ORIGINS: Novel by Hiroshi Aramata, The Tale of the Capital, pub Kadokawa; 1991 OAV.
CATEGORIES: X, V

The evil sorcerer Kato triggered the great Kanto earthquake and gave a child to the innocent Yukari. Yukiko is now fourteen and ready to become a focus for his power. More tremors shake Tokyo and the tunnelling of a new railway system disturbs ancient forces more magical than geological. But a new element enters the equation — Yukari's tormented, withdrawn brother marries Keiko, a beautiful mystic who is determined to fight Kato. Their magical battles work up to a thrilling climax, though the ending, with Kato saved by coming to understand the purity of love, is a bit of a cop-out. We also learn the truth about Yukari's murky relationship with her brother. A series with considerable style and more content than it's usually given credit for. ★★★

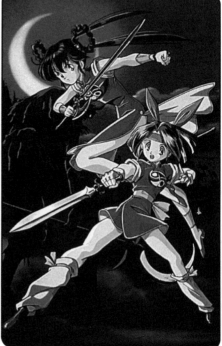

Devil Hunter Yoko 2

DRAGONSLAYER HERO LEGEND 1 & 2
(Eng trans for DRAGONSLAYER EIYU DENSETSU VOLS 1 & 2)

JAPANESE CREDITS: Prod: Dragon Slayer Project. © Amuse Video. Each 30 mins.
CATEGORIES: DD

I have no further information about this title.

ELLICIA DEMON OF ILLUSION PARTS 1 & 2
(Eng trans for GENMA ELLICIA PARTS 1 & 2)

JAPANESE CREDITS: Dir: Tsugoyasu Furukawa. Chara des & anime dir: Yasuomi Umetsu. Mecha des: Yasuharu Morimoto. Art dir: Hiroaki Sato. Music: Tatsumi Yano. Prod: J.C. Staff. © CIC Victor. Each 45 mins.
POINTS OF INTEREST: Glorious chara design work from Umetsu, whose other works include the 'Presence' segment of Robot Carnival and Megazone 23 Part II.
CATEGORIES: DD, A

Ellicia is a tale of seaborne adventure and the technology of a bygone age. The industrial city of Megalonia is becoming more and more ambitious and greedy. When the Prince of Eiji Island is held prisoner there, a crew of pirates from the island go to his rescue. This is their adventure, and it looks gorgeous. ★★☆?

GALL FORCE: NEW ERA 2
(Eng trans for GALL FORCE SHINSEIKIHEN)

JAPANESE CREDITS: Screenplay & original story: Hideki Kakinuma. Chara des: Kenichi Sonoda. Prod des: Hideki Kakinuma & Kimitoshi Yamane. Anime dir: Hideaki Ohba & Yoshitaka Huzimoto. Music: Takehito Nakazawa. Prod: AIC, Kyuma. ©

Genesis Surviver Gaiarth

Artmic. 50 mins.
WESTERN CREDITS: US video release 1995 on US Manga Corps, trans Pamela Parks.
ORIGINS: Original story by Hideki Kakinuma; 1986 movie; OAVs every year 1987-91.
CATEGORIES: SF, A

Mankind has been destroyed by the evil computer intelligence GORN. Only six young women remain, saved by the android Catty. Created by an ancient alien race, only Catty foresaw the cycles of war and destruction that have devastated mankind from the time of its earliest ancestors, which she has always striven to prevent. Thanks to her, a single escape pod leaves Earth for deep space. But GORN is on their track, using the body of a human girl, Nova, as his tool. The last remnant of humanity may yet be wiped out, leaving the galaxy to the machines. ★★★?

GENESIS SURVIVER GAIARTH STAGE 1 & 2
(Eng title for SOSE KISHI GAIARTH, lit Genesis Knight Gaiarth)

JAPANESE CREDITS: Dir: Shinji Aramaki & Hiroyuki Kitazume. Script: Shinji Aramaki & Emu Arii. Story outline: Shinji Aramaki. Chara des: Hiroyuki Kitazume. Mecha dir: 1 Hiroyuki Ochi; 2 Norie Kuwabare. Anime dir: 1 Jun Okuda & Seiji Tanda; 2 Makoto Bessho. Prod: AIC, Artmic. © Toshiba EMI. Each 45 mins.
WESTERN CREDITS: US video release 1993 on AnimEigo, trans Shin Kurokawa & Michael House; UK video release 1994 on Anime Projects, both sub.
CATEGORIES: SF

A hundred years of war have destroyed much of human civilisation. Ital de Labard is an orphan raised by elderly war-roid Randis, with the intention that they will one day fight the ruling Republican forces together. When those forces kill Randis, Ital sets out to avenge him. He meets up with junk-hunter Sahari, a very cute young lady, and goes with her to the city of Van Gohl; in the bowels of a republican land-base he meets another war-roid, Zaxxon, who joins him on his journey. Good design and animation help keep this upbeat SF adventure crackling along. ★★★

GIANT ROBO 1: BLACK ATTACHE CASE
(Eng trans for GIANT ROBO 1 KUROI ATTACHE CASE)

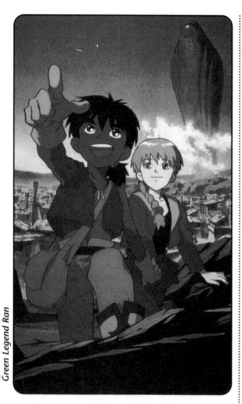

Green Legend Ran

create mayhem to excellent effect. Well written, extremely well designed, and very enjoyable. ★★★☆

GRANDZORT 2 VOLS 1 & 2
(Eng title for MADOU GRANDZORT BOKEN HEN! VOLS 1 & 2, lit Evil King Grandzort Adventure Chapter Vols 1 & 2)

JAPANESE CREDITS: Prod: Sunrise. © Takara. Each 30 mins.
ORIGINS: 1990 OAV.
CATEGORIES: C, U

More adventures of the Super Deformed giant robot team.

GREEN LEGEND RAN 1-3

JAPANESE CREDITS: Dir: 1 Satoshi Saga; 2 Kengo Inagaki; 3 Junichi Watanabe. Script: Yu Yamamoto. Chara des & anime dir: Yoshimitsu Ohashi. Art dir: Ken Arai. Photography dir: Yasunori Honda. Music: Yoichiro Yoshikawa. Prod: M D P. © Pioneer LDC. Each 45 mins.
WESTERN CREDITS: US, sub & dub, & UK, dub, video release 1995 on Pioneer.
CATEGORIES: SF, U

JAPANESE CREDITS: Dir & Screenplay: Yasuhiro Imagawa. Image concept des: Makoto Kobayashi. Anime dir: Kazuyoshi Katayama. Art dir: Hiromasa Ogura & Masanori Kikuchi. Music: Masamichi Amano. Prod: Mu Film. © Hikari Pro, Amuse Video, Plex, Atlantis. 50 mins.
WESTERN CREDITS: US video release 1995 on one tape with ep 2; UK video release 1996 both on Manga Video, both dub.
ORIGINS: Manga by Mitsuteru Yokoyama; 1968 live-action TV series.
POINTS OF INTEREST: 1968 series dubbed for US TV screening as Johnny Sokko and His Flying Robot.
CATEGORIES: SF, A

One of the most widely acclaimed OAV series of the nineties, this retro-styled, forties-feel anime is a fast-paced, funny adventure story which deserves its acclaim. Orphan Daisuke pilots Giant Robo for the Experts of Justice, an organisation of fighters for good, who are ranged against the evil intent of criminal group Big Fire. Gorgeous heroine Ginrei, mad scientist Franken Von Folger, the dastardly Alberto of Big Fire and the rest of the cast

Part one of the three-part series opens with the world under alien attack. Suddenly, six huge alien artefacts — the Holy Mothers — descend. The areas around them are green and fertile; everywhere else is desert. The religious cult of Rodo rapidly gains power and influence, controlling access to the Holy Green fertile areas and to the scarce water supply outside them. The resistance group Hazzard fights the Rodoists. Orphan Ran, whose mother was murdered when he was a child and who never knew his father, is caught up in the Resistance and meets a quiet, mysterious, silver-haired girl, Aira. His determination to find his mother's killer, guided only by his childhood memory of a huge scar on the man's chest, is joined by a new resolve to keep Aira from harm. When she is carried off to the Holy Mother's citadel he seeks her out, and together they manage to prevent the entire world being covered in a tidal wave of Holy Green, which would lead to the total destruction of humanity. An ecological adventure tale with an engaging enough story and characters to hold the attention of quite young children, it also has something to offer older fans, not least in the blocky, deliberately simplified chara designs which work perfectly against the beautifully painted backgrounds. ★★★

GUNDAM 0083: STARDUST MEMORY PARTS 7-13

(Eng title for KIDO SENSHI GUNDAM 0083 STARDUST MEMORY, lit Mobile Soldier Gundam 0083 Stardust Memory. Ep titles: 7 Shining Blue Fire; 8 Sector of Conspiracy; 9 The Nightmare of Solomon; 10 Battle Zone; 11 La Vie En Rose; 12 Assault: The Critical Intercept Point; 13 The Storm That Runs Through)

JAPANESE CREDITS: Dir: Takashi Imanishi. Prod: Sunrise. © Sunrise, Bandai. Each 30 mins.
ORIGINS: Novels by Yoshiyuki Tomino; 1979 onwards TV series; 1988 movie Char's Counterattack; 1991 movie; OAVs every year 1989-91.
CATEGORIES: SF, W

The conclusion to the story of Kou Uraki, Anavel Gato and Nina Purpleton, caught up like the rest of their society in a war which often dictates their choices for them. The surviving forces of Zion under Admiral Aiguille Delaz plan to drop a space colony cylinder on Earth; while undoubtedly a good way to make a political point, it is not everybody's ideal debating method, and UNT forces under Colonel Bosq Ohm oppose it. But they're not alone — Delaz's fleet splits and a rebel faction sets out to fulfil its own agenda. Driven Zion mobile suit ace Anavel Gato defeats the faction and dies a hero's death, but the population of Earth is so shaken by events that a hardline government comes to power and a military dictatorship develops. Our hero, Gundam test pilot ace Kou Uraki, is sentenced to a year in prison for his part in trying to defend Earth's freedom, but in the end he and Nina Purpleton are happily reunited. ★★★

GUY: SECOND TARGET

(Eng title for GUY SECOND TARGET OGON NO MEGAMI, lit Guy Second Target: The Golden Goddess)

JAPANESE CREDITS: Dir & chara des: Yorihisa Uchida. Mecha des: Eichi Akiyama & Eiko Murata. Monster des: Masami Obari. Music: Kishio Yamanaka. Prod: Friends. © Media Station. 40 mins.
WESTERN CREDITS: UK video release 1994 on Animania, dub, on one tape with 1991's Guy: Awakening of the Devil; US video release 1994 on AD Vision, sub & dub, trans Ichiro Araki & Dwayne Jones.
ORIGINS: 1991 OAV.
CATEGORIES: SF, X

Having done their bit for prison reform in the first OAV, Guy and Raina set out to investigate a new religious cult. It seems that the Golden Goddess promises peace and plenty, but she is really a vicious fraud perpetrated by two calculating aliens. Guy gets to transform into a muscled monster again, but can he defend himself from an attack from the most unexpected quarter — Raina herself? Less bite than the first OAV, but also less sexual violence. Giant robot fans will enjoy spotting the homages to various mecha shows, and there's even a visual reference to the opening scene of the *Dirty Pair* movie. ★★

GUYVER DATA 9 & 10

(Eng title for KYOSHOKU SOKO GUYVER ACT II, lit Armoured Creature Guyver, aka BIO BOOSTER ARMOUR GUYVER)

JAPANESE CREDITS: Dir: Masahiro Otani & Naoto Hashimoto. Screenplay: Riku Sanjo. Story: Makoto Watanabe. Chara des: Hidetoshi Omori. Art dir: Masuo Yakamada. Prod: Hero Communications. © Takaya, Tokuma Shoten, G.P. 55 mins.
WESTERN CREDITS: US video release 1993 on US Renditions, on one tape as Guyver Vol 5, ep titles 'Shocking Transformation: The Tragedy of Enzyme' and 'Can We Escape? Haunted Takeshiro Village', Eng screenplay & voice direction Raymond Garcia; UK video release 1995 in 26 minute eps on Manga Video.
ORIGINS: Manga by Yoshiki Takaya, pub Tokuma Shoten, Eng trans pub Viz Communications; OAVs in 1986 & every year 1989-91.
SPINOFFS: Apart from the OAV series, 2 live-action films, Mutronics and Guyver: Dark Hero, were also made in the USA.
CATEGORIES: SF

Sho and his friends have met a mysterious journalist who seems to know a great deal about the Cronos organisation. On the run together, they face more monsters as Cronos and its dastardly minions pursue them. Sho learns his father is alive and tries to rescue him, but Cronos has transformed him into a Zoanoid and tragedy is inevitable. The stress and horror affect Sho's ability to transform and as the party goes through a small village they are ambushed. One of the most popular anime releases in the UK, the series continues to offer precisely what kids want — lots of rumbles and yucky monsters — but there's not much here for anyone interested in story development, character development or anything even slightly unpredictable. ★★

HEAVEN VERSION: UNIVERSAL PRINCE VOLS 12-16
(Eng trans for TANJO HEN UTSUNOMIKO)

JAPANESE CREDITS: Dir: Tetsuo Imazawa.
Chara drafts: Mutsumi Inomata. Prod: Toei
Animation. © Kadokawa Novel, Bandai,
Tokyo TV. Each 30 mins.
ORIGINS: Novel by Keisuke Fujiwara, pub
Kadokawa Books, illustrated Mutsumi
Inomata; 1989 movie; 1990 & 1991 OAVs.
POINTS OF INTEREST: 4 episode
compilations also released.
CATEGORIES: P, DD

Many of his friends have risked their lives to support his fight for justice for the people of Japan against cruel feudal overlords. Now, granted all their powers as well as his own, Utsunomiko becomes Fudo Myo-Oh, a powerful Buddhist guardian god, and breaks through the Wall of Light to final victory. ★★☆?

HERE IS GREENWOOD 2-4
(Eng trans for KOKO WA GREENWOOD; 2
NAGISA KYOSO KYOKU, Nagisa's Going Crazy;
3 GAKUENSAI SHUTTEN SAKU 'KOKO WA MAO
NO MORI', Artwork for the School Festival
'Here's a Devil's Forest'; 4 KORYU TO GHOST:
MIDORIBAYASHI RYO NO MABOROSHI, Light
and Ghost: Illusion in the Midoribayashi
Dormitory)

JAPANESE CREDITS: Dir & script:
Tomomichi Mochizuki. Chara des: Masako
Goto. Prod: Project Pierrot. © Victor Music
Co. Each 30 mins.
ORIGINS: Manga by Yukie Nasu, pub
Hakusensha in Hana To Yume (Flowers &
Dreams) girls' weekly magazine; 1991 OAV.
CATEGORIES: DD, N

Back to the friendliest, and strangest, high school dorm in Japan. The lovelorn Kazuya has more troubles at home — his adored Sumire is married to his brother, whom he suspects is not merely selfish and inconsiderate to his new bride but bisexual too. Since he's also the school doctor, it's hard for Kazuya to distance himself from the situation. Meanwhile his dorm-mates are struggling with various problems of their own. Nagisa, Shinobu's sister, is a psychopathic yakuza moll who's constantly out to get her brother. Shun, Kazuya's girl-masquerading-as-boy room-mate, has a 'sister', Reina, who's really a boy masquerading as a girl... The dorm gets together to make a movie for a school contest, with unexpected results, and

the ghost of a teenage girl comes to Greenwood in search of a boyfriend. The warmth and off-the-wall charm of this series is unmistakable and irresistible. ★★★?

HOMOSEXUAL WHITE PAPER: MAN'S DECISION
(Eng trans for OKAMAHAKUSHO: OTOKO NO KESSHIN)

JAPANESE CREDITS: Dir & chara des: Teruo
Kigurashi. Prod & © Knack. 45 mins.
ORIGINS: Manga by Hideo Yamaki.
CATEGORIES: N

Yukichi is gay, but troubled by uncertainties about his own feelings. His close friend Dan falls in love with Miki at first sight, and Yukichi decides to test out his inner fears and feelings by approaching her. A sensitive, tragi-comic approach to the subject makes this an unusual 'cartoon' by Western standards. ★★?

HUMANE SOCIETY
(Eng title for SEIKIMATSU II: HUMANE SOCIETY:
JINRUI AI NO MICHITA SHAKAI, lit End of the
Century II: Humane Society: A Society Full of
Love)

JAPANESE CREDITS: Prod: Animate Film. ©
SME. 47 mins.
POINTS OF INTEREST: The title is a pun on
the name of the starring group, Seikima-II,
pronounced Seikima-Tsu (which when written
in kanji can also be read 'Second Feast of
Holy Demons' or 'End of the Century'), and
also on one of their song titles. Demon
Kogure, the lead singer, is one of Godzilla's
biggest fans, winner of the 1984 national
Godzilla Scream Competition, and an extra
in the movie Godzilla vs Biollante.
CATEGORIES: SF

Featuring the music of Seikima-II, a Japanese version of KISS in their more outrageous make-up days, and their lead singer Demon Kogure, this is the story of rock stars out to save the planet from ecological and social disaster. ★★?

INFERIOUS PLANET WAR HISTORY: CONDITION GREEN PARTS 2 & 3
(Eng trans for INFERIOUS WAKUSEI SENSHI
GAIDEN CONDITION GREEN, aka CONDITION
GREEN: PLATOON #801)

SPACESHIPS

In the distant future, when human technology advances to new heights, is there any reason why we should cling to ancient forms and designs? One very good one is that they can be incredibly romantic, as well as setting up all kinds of associations and resonances within your audience.

That's probably what Leiji Matsumoto had in mind when he created Space Pirate Captain Harlock. Originally designed for the last thirteen episodes of the first *Space Battleship Yamato* series — episodes that were never made when the series' ratings failed to rise above seven percent — Harlock is a heroic warrior who struggles to set his people free, but finally, disgusted at their sheep-like acceptance of oppression, cuts his ties with Earth and sets sail for the stars as a free agent, a space pirate, under the sign of the Jolly Roger. And you can't fly the Jolly Roger off a shiny metal tube or a kit-bit engineering rig. You have to fly it off a seventeenth century galleon, a proper pirate ship, which is exactly what the rear end of Harlock's starship, the *Arcadia*, is. She even steers with a huge ship's wheel. Yes, it's absurd, as is the fact that his friend Queen Emeraldas has a ship which is part-galleon, part-airship. Don't lecture me about the behaviour of gasses in a vacuum. Scientifically it may be all wrong, but emotionally it's absolutely right.

It's so right, in fact, that when Matsumoto's producer, Yoshinobu Nishizaki, wanted to create a hit on his own, it too was set on a starship with sails. The title is *Odin* and the scientific rationale for the sails was a little more plausible; apparently the sails on the photon ship *Starlight* collect solar and photon energy, or something of the sort. It doesn't matter; the graceful lines of the nineteenth century schooner-in-space are their own justification.

Between them, Nishizaki and Matsumoto had already created the mother of all starships, the quixotic *Space Battleship Yamato*. Her history is rooted in the real world — the *Yamato*, pride of Japan's World War Two fleet, was sunk in the Pacific. As it turned out, she was sunk to save her for a greater destiny. When the Gamilons attacked Earth and all seemed lost, the rotting hulk of the *Yamato* was transformed by the dedication and conviction of one man into a gleaming space battleship to carry a young crew across the galaxy in search of salvation for the dying Earth.

Makes all those tin boxes with antennae stuck on top look pretty pedestrian really!

JAPANESE CREDITS: Dir: Shigeyasu Yamauchi. Chara des: Shingo Araki, Michie Himeno & Eisaku Inoue. Prod: Hero Communications. © KSS Inc. Each c50 mins.
ORIGINS: 1991 OAV.
POINTS OF INTEREST: Edited into 6 25-minute segments for Western sale under the title Condition Green: Platoon #801, by KSS.
CATEGORIES: SF

Evil emperor Vince of planet Gyazaria has already gained control of the planets Kal and Granad and is now planning to invade his next target, Emerald Earth. However the planet has its own line of defence — 'Condition Green'. And when Vince tangles with these boys, he's going to need all the help his planet-crushing army and superior technology can give him. ★★☆?

IRRESPONSIBLE CAPTAIN TYLER 1
(Eng title for MUSEKININ KANCHO TYLER 1 NUKEGAKE HEN, lit Irresponsible Captain Tyler 1, Forestall Others)

JAPANESE CREDITS: Dir: Koichi Mashita. Music: Kenji Kawai. Prod & © Tyler Project. 30 mins.
ORIGINS: 9-volume comedy novel series The Galaxy's Most Irresponsible Man by Taira Yoshioka; 1960s movie series Irresponsible Man; 26 episode TV & OAV series.
POINTS OF INTEREST: The homage to the sixties movie series in the title and lead chara Justy Ueki Tyler's name: he was Hitoshi Ueki, and the kanji for Hitoshi can be read as Taira. The first series was made specifically for both TV showing and direct-to-video release.
CATEGORIES: SF, C

Justy Ueiki Tyler is quite possibly the most laid-back, not to say disinterested, individual in the entire United Planets Space Force. He thinks that military life will be cushy and glamorous despite the impending war with the Rarlgon Empire. So how come he gets to be a lieutenant commander and captain of the good ship *Soyokaze* ('Gentle Breeze', or if you're being less polite, 'Slight Wind'!) at the age of twenty? And how come he manages to avoid demotion despite being totally irresponsible? Pure luck and a great crew play their part, of course, but his own charm comes in very useful. Tyler himself and his OAV series both poke fun at traditional military men, at people who see war as a career option, at gung-ho sloganising and rank-pulling wherever it arises. Tyler is a genuinely nice, if goofy, guy. Women are

always either getting mad at him or falling for him, and whatever weird situations he gets into, somehow they always turn out to his advantage. Stunningly designed and animated, pure comedy magic. ★★★☆?

JINGI: THE UPPER REACH OF THE SUMIDA RIVER PROJECT
(Eng trans for JINGI SUMIDAGAWA CHOJO SAKUSEN)

JAPANESE CREDITS: Prod: J.C. Staff. © Nichiei Agency. 50 mins.

I have nothing more on this title.

JOKER: MARGINAL CITY

JAPANESE CREDITS: Prod: Studio Zyn. © Michihara, Cycron. 45 mins.
ORIGINS: Manga by Katsumi Michihara.
CATEGORIES: SF

The Jokers are genetically engineered beings who can, among their other remarkable attributes, switch gender at will. A young man escapes from a secret research facility and goes on the run; he too is the product of genetic experimentation. A reporter befriends the fugitive, but has to call on the help of the Joker — in both gender forms — to keep the boy safe from his pursuers. Stylish, well paced science fiction, playing with the notions of gender and genetic tinkering. ★★★

KABUTO
(Eng title for UTENGU KABUTO: OGON NO MENO KEMONO, lit Raven Tengu Kabuto: Golden-Eyed Beast)

JAPANESE CREDITS: Dir, writer, chara des & lyrics: Buichi Terasawa. Anime dir: Hisashi Harai. Art dir: Takeshi Waki. Prod: Hero Communications, Nakamura Pro. © Terasawa, NEP, KSS. c45 mins.
WESTERN CREDITS: US video release 1994 on US Renditions, sub; UK video release 1995 on Manga Video, dub.
CATEGORIES: SH, DD

Warrior mage Kabuto visits his old training ground at Sado, and finds the castle and district under the rule of the sorceress Tamamushi and her Gadget Master, Jinnai, who commands a range of deadly automata. The rightful ruler, his childhood friend Princess Ran, is held prisoner in the castle, and Kabuto battles Tamamushi's Black Spider guards and Jinnai's ingenious gadgets to free his boyhood sweetheart. The simple 'girl is trapped — boy saves girl — boy gets girl' story holds no surprises, but it's decorated with some nice fantasy-tech touches and the gadgets are off-the-wall enough to be interesting in their own right. ★★☆

KAMA SUTRA
(Eng title for TOKKYO NO SEX ADVENTURE KAMA SUTRA, lit Ultimate Sex Adventure Kama Sutra)

JAPANESE CREDITS: Dir: Masayuki Ozeki. Script: Seiji Matsuoka. Chara des: Shinsuke Taresawa. Art dir & photography dir: Chihata Miyazaki. Music: Ken Yamjima. Prod: Animate. © Toho Video. 43 mins.
WESTERN CREDITS: UK release 1994 on Western Connection, sub.
ORIGINS: Ancient Hindi text; manga by Go Nagai.
CATEGORIES: X, C

A mythic Hindu seaside postcard of an OAV, *Carry On Up the Khyber* with psychic powers and archaeological set dressing thrown in for good measure. The story centres on a nineteen-year-old male virgin, a Hindu Princess reawakened after centuries in a block of ice, and a magic cup which can give eternal life and endless pleasure if the right fluids are drunk from it. As lurid and basic as a stick of rock, and completely harmless. ★★

KEKKO KAMEN 2
(Exact Eng trans very complex: KAMEN means 'masked' and KEKKO is a phrase which can infer 'I got lucky today!')

JAPANESE CREDITS: Based on characters by Go Nagai. Prod: Dynamic Planning, V Media. © Dynamic Planning, Japan Columbia. 50 mins.
WESTERN CREDITS: US video release 1995 on AD Vision, sub, trans Masako Arkawa & Chris Hutts; UK video release 1995 on East2West, dub, trans Jonathan Clements.
ORIGINS: Manga by Go Nagai; 1991 OAV.
POINTS OF INTEREST: The title is a pun on renowned sixties live-action TV show Gekko Kamen or Moonlight Mask. In 1991 Go Nagai also directed and wrote a live-action version of Kekko Kamen, 60 mins long, starring Chris Aoki, Playmate Japan 1990.
CATEGORIES: X, C

The Warrior of Love and Justice is back again, facing a truly fearsome foe — an android student who is out to win the innocent Mayumi's trust and then torture her all over again. A thrilling fight on the school roofs in the rain makes a fitting climax. In part two, a sleazy samurai with a pony-tail (and a great Sean Connery accent on the UK dub) is using his sword to denude the students and is then taking polaroids of them. Can Kekko Kamen triumph again? This is an extremely silly premise, but having accepted the idiocy of it the sexual angle is purely comic and quite harmless. ★★★

KO CENTURY BEAST WARRIORS 1-3
(Eng title for KO SEIKI BEAST SANJYUSHI, lit Ko Century Beast 3 Beast/Musketeers)

JAPANESE CREDITS: Dir: Hiroshi Negishi. Script: Satoru Akahori. Costume des: Kosuke Fujishima. Prod: Animate Film. © SME, KSS. Each c30 mins.
WESTERN CREDITS: UK video release 1994 on Anime UK Collection, all 3 parts on one tape, trans Jonathan Clements.
POINTS OF INTEREST: Note the elaborate pun in the title; jushi is an old Japanese word for a gunner (a musketeer, in fact!), jyu is the word for beast, and san is three. The title has been translated by Trish Ledoux with some justice as KO Century 3 Beastketeers; but for those of us who remember Dogtanian and similar tacky animal funnies, that has unfortunate overtones. Also note the costume design credit for the creator of Oh My Goddess!
CATEGORIES: C, U, SF

The world is split in two — quite literally. Humans have ruined their half with industrialisation, computerisation, mechanisation and pollution. Now they want to take over the Beasts' share. Sound like any world you know? Well, it doesn't look like one. This bright, zappy and beautifully animated excursion into the land of sheer insanity is a comic take on eco-disaster, and while it is perfectly suitable for small children providing you note a couple of uses of the word 'bastard' in the UK dub, it also appeals to many adults. Teens save the world again, but this time they're teen beasts — tigerboy Wan Dabada, mermaid Meima, funky chicken Badd Mint and turtle Mekka join forces with Doctor Password and his granddaughter Yuni to oppose the ambition of the evil Tourmaster, his villainous servants V-daan and V-zhon, and their tiny sidekick Akumako, a dollop of concentrated malevolence about the size of the average parrot, but

Kekko Kamen

much curvier. Both teams go in search of an ancient power source called Gaia, and in order to fight their way to Gaia they call on the ancestral Totems of the Beast Tribes, which look suspiciously like mecha of various shapes and sizes. The trail leads down many a blind alley with all manner of twists and turns, the pace kept up by an excellent music score and marvellous direction from Negishi. The ending doesn't resolve matters and a second OAV series followed. One of the 'new wave' of zany, upbeat fantasy OAVs started by *NG Knight Lamune & 40*, and one of the best. A strong Korean presence in the animation-studio department has contributed to the spikier, brighter overall look — and also doubtless to cost control. ★★★☆

KOJIRO FINAL CHAPTER: THE FUMA REVOLT
(Eng trans for FUMA NO KOJIRO KANKETSUHEN: FUMA HANRAN)

JAPANESE CREDITS: Dir: Hidehito Ueda. Chara des: Shingo Araki. Prod: J.C. Staff. © SME. 60 mins.
ORIGINS: Manga by Masami Kurumada, pub Shonen Jump 1982-3; 1989 & 1990 OAVs.

CATEGORIES: SH, DD
The last chapter of the story of the teenage elemental warrior Kojiro and his friends and foes.

LA BLUE GIRL 1 & 2

JAPANESE CREDITS: Dir: 1 Raizo Kitakawa; 2 Ran Fujimoto. Script: Megumi Ichiyanagi. Chara des: 1 Kinji Yoshimoto; 2 Rin Shin. Art dir: 1 Bibimba Miyake; 2 Taro Taki. Music dir: Teruo Takahama. © Maeda, Daiei Co Ltd. Each 45 mins.
WESTERN CREDITS: US video release 1995 on Anime 18; UK video release planned for 1996 on Manga Video, but prevented by the BBFC's refusal of a certificate.
ORIGINS: Orginal story by Toshio Maeda.
CATEGORIES: X, V

Miko Mido and her sister Miyu are descended from an ancient ninja clan which has kept peace with the Shikima, a demonic force, under a 600 year old treaty. Now Miko has suddenly been charged with running the family business and the clan's most precious relic, the signet case that sealed the demonic bargain, has been stolen by rival Suzuka clan members. Can Miko get it back, save Miyu from the tentacled denizens of the underworld, and keep the Shikima from overrunning Earth? Yes, but of course *en route* there's much tentacle rape, orifice abuse and shredding of underwear. You've seen it all before; in Britain, you won't see it again, thanks to the BBFC. ★☆?

LAPIS LAZULI PRINCESS 1 & 2
(Eng trans for RURI-IRO NO PRINCESS; 1 DEAI, Meeting; 2 MEZAMI, Awakening)

JAPANESE CREDITS: Prod: Studio Pierrot. © Japan Columbia. Each 30 mins.

I have no other information on this title.

LEGEND OF GALACTIC HEROES VOLS 47-54
(Eng trans for GINGA EIYU DENSETSU)

JAPANESE CREDITS: Dir: Noboru Ishiguro. Prod: Masatoshi Tahara. Prod co: Kitty Film Mitaka Studios. © Kitty Enterprise. Each 30 mins.
ORIGINS: Yoshiki Tanaka's novel series, pub Tokuma Shobo; 1988 movie; 1988, 1989 & 1991 OAVs.
CATEGORIES: SF, W

Also:
LEGEND OF GALACTIC HEROES: GOLDEN WINGS
(Eng trans for GINGA EIYU DENSETSU OGON NO TSUBASA)

CREDITS, ORIGINS, CATEGORIES: As above except: Prod: Magic Bus. © Tokuma Japan Communications.

The final episodes of the second series cover the decisive battle, and once again demonstrate creator Tanaka's understanding of how slowly things can develop in political conflict and how swiftly the tide can turn. Yang Wen-Li, youngest Admiral of the Fleet in the Free Planets' history, sees only one way to get his forces out of the mess they are in; he tries to drag Reinhart himself into battle, and defeats the fleets of three of the Empire's top commanders. He is unfortunately completely unaware that he is moving into the trap set by his equally brilliant opponent. Yang and Frederica finally get engaged just before the battle starts, and as the Free Planets' fleet plunges deeper into trouble, Yang finally understands his enemy's strategy and risks a desperate attack. It almost works; he comes close to Reinhart's headquarters; but, inexplicably, an order for unconditional cease-fire comes from the Free Planets' capital, Heinessen. It's a plot, and it works. The Free Planets become a territory of the Empire and Reinhart ascends the throne as first Emperor of the Reinhart Dynasty. This huge, densely plotted space opera is well crafted throughout and well worth watching. ★★★★

LEGEND OF THE FOUR KINGS PARTS 4-8
(Eng title for SORYUDEN, lit Dragon Kings Legend. Ep titles: US 4 Tokyo Bay Rhapsody, no information on other titles. UK 4 The Masked Enemy; 5 Programmed to Kill; 6 Dragon Alliance; 7 Kill the Dragon; 8 The Iron Dragon)

JAPANESE CREDITS: Series planner & script: Akinori Endo. Dir: Shigeru Ueda & Norio Kashima. Chara des: Shunji Murata. Art dir: Shichiro Kobayashi & Jiro Kono. Prod: Kitty Film Mitaka Studio. © Tanaka, Kodansha, Fuji TV, Kitty Film. Each c50 mins.
WESTERN CREDITS: UK video release 1995 on Manga Video, dub; US video release 1995 on US Manga Corps, sub, trans William Flanagan & Yuko Sato, Eng rewrite Jay Parks.
ORIGINS: Novel by Yoshiki Tanaka, 1991 OAV.
POINTS OF INTEREST: Televised on UK late-night TV.
CATEGORIES: DD, A

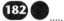
NOVELS

Manga aren't the only source for anime producers looking for a good story. A number of books by well-known Japanese and Western writers, in every genre from SF to school stories, have been animated. Here are just a few of them.

1 The LENSMAN novels by E.E. 'Doc' Smith

Animated as *Lensman*, the adaptation, based largely on the third novel *Galactic Patrol*, is considered to be one of the best by many of Smith's Western fans. The character of vanBuskirk is rendered quite faithfully, and although some details have changed — for instance, the Kinnison family didn't have a farm or cute R2D2 clone on the staff — the spirit of the books is preserved.

2 FEAST OF CATS by Chohei Kanbayashi

This acclaimed novella, which won the Japanese Seiun (Nebula) Award, the equivalent of the West's highest SF honour, the Hugo Award, became the OAV series *Galactic Pirates*. The wildly off-the-wall comedy which surrounds the SF and fantasy elements of the story is played up strongly, but the author's inventiveness is the most important factor. The idea of baseball as a half-forgotten religious ritual used for military training is a wonderful twist.

3 LEGEND OF GALACTIC HEROES by Yoshiki Tanaka

Tanaka is one of the most prolific writers of popular SF in Japan, with a number of his novels, such as *Heroic Legend of Arslan* and *Seven Cities Legend* (as *Tale of Seven Cities*) used as the basis for animation. *Legend of Galactic Heroes* is a ten-novel space opera covering the political, military and personal tragedies of a wide sweep of planets and their people, and to date there are seventy-eight OAV episodes and two movies covering about three-quarters of the story, packed with charismatic characters and realistic space-battle action.

4 WITCH'S DELIVERY SERVICE by Eiko Kadano

The story of a young girl approaching puberty and venturing out into the world with nothing but her own skills to rely on was animated by Hayao Miyazaki as *Witch's Special Delivery* and is known in the West as *Kiki's Delivery Service*. Set in a dreamworld of Europe as it never was, but should have been, it gives the director's love of flight free rein and creates a remarkable young female protagonist.

5 The ARSENE LUPIN stories by Maurice LeBlanc

Written at the turn of the century and centring on the French gentleman-thief Arsène Lupin, these might seem an unlikely source for anime. Not only have they provided the basis for the *Lupin III* manga by Monkey Punch, but two stories of the first Arsène Lupin, *The Mystery of 813* and *Lupin Versus Holmes*, have also been animated. Hayao Miyazaki used elements of two LeBlanc Lupin stories, *The Girl With Green Eyes* and *The Countess of Cagliostro*, in his first feature film *Lupin III — Cagliostro Castle* (1979).

Having saved their cousin and uncle from a kidnap attempt by the evil Kamakura no Gozen, and awoken the first of their dragon avatars, the brothers come up against his former employee, mad scientist Dr Tamozawa, who likes to vivisect people and feels he could get at the secrets of the brothers' powers that way. His cybernetic hunting dogs aren't quite as potent as the lure of tickets for a big league game to the two younger boys. The family's next adversary is the mysterious and elegant Lady L, who will stop at nothing to achieve world domination and sets out to seduce Tsuzuku to get control of his powers. Unfortunately her proposition has the opposite effect — it drives him, despite his own misgivings, to transform into his Red Dragon mode and attack Tokyo. Tamozawa still hasn't given up, and when he kidnaps Owaru again he finds he has bitten off more than he can chew when the remaining brothers steal a top-of-the-range tank to save their brothers and the city. The adventures of the four avatars of ancient dragon gods get more and more far-fetched, and the animation is not particularly striking, especially for a studio with Kitty's richly deserved reputation and with a string of top-quality productions under its belt. Mass market adventure fodder. ★★

LOVE'S WEDGE
(Eng trans for AI NO KUSABI)

JAPANESE CREDITS: Prod: AIC. © Michihara, Magazine Magazine. c60 mins. ORIGINS: Manga by Katsumi Michihara, pub Magazine Magazine. CATEGORIES: R, X

Ms Michihara is a popular exponent of the manga genre known as shonen ai or yaoi, centring on homosexual or homoerotic love. *Love's*

Wedge is a fantasy set in a class-driven world in which the rulers can purchase just about anything and the lower echelons have little or no protection against a corrupt political and legal establishment. The young hero sees his friends killed or imprisoned through the betrayal of one of their number, while he becomes the lust-object of a beautiful, charismatic and amoral nobleman. Despite his helplessness in the situation, his lover is unable to come to terms with his 'promiscuity' and violently rejects him. The elegant simplicity of the animation captures the mood of the manga, and despite the more compressed storyline it still retains a considerable emotional impact. ★★★☆

MACROSS II: LOVERS AGAIN VOLS 1-6

(Eng title for CHOJIKU YOSAI MACROSS II: LOVERS AGAIN, lit Super Dimensional Fortress Macross II: Lovers Again; Vol 1 Contact; Vol 2 Ishtar; Vol 3 Festival; Vol 4 Malduke Disorder; Vol 5 Station Break; Vol 6 Sing Along, aka MACROSS II THE MOVIE)

JAPANESE CREDITS: Dir: Kenichi Yagatai. Chara des: Haruhiko Mikimoto. Mecha des: Koichi Ohata, Junichi Akatsu & Jun Okuda. Art dir: Hidenori Nakahata. Music dir: Yasunori Honda. Prod: AIC, Oniro. © Big West, Macross II Project. Each 30 mins.
WESTERN CREDITS: US video release 1993 on US Renditions as 3 vols, 2 eps per tape, & as a compilation entitled Macross II The Movie, on Manga Video, dub, Eng screenplay Raymond Garcia; UK video release 1994 on Kiseki Films, dub.
ORIGINS: 1982 TV series; 1984 movie; 1987 OAV Flashback 2012.
POINTS OF INTEREST: Note that all the episode titles are English words, rendered in katakana, and thus intended to be perceived by the Japanese target audience as foreign. Look for a 'guest appearance' by Animerica magazine editor, Trish Ledoux, as idol singer Wendy Ryder on the English language dub. The 'official' Macross timeline released to coincide with the 1995 OAV series Macross Plus and TV series Macross 7, Lovers Again is defined as an alternate universe story, not part of the main Macross sequence.
CATEGORIES: SF

One of the most eagerly-awaited returns in anime history, the successor to the fabulously successful TV series, movie and *Robotech* progenitor could hardly have lived up to the amount of hype it got in any circumstances. Mikimoto's chara designs are lush and gorgeous, but the script doesn't live up to his work. It's hard to see why — the ingredients are the same as before. There's the young maverick — this time it's reporter Hibiki Kanzaki — the ice-cool, efficient, military Princess, the fighter aces, the big brother/father figure, the beautiful idol singer and the alien menace, just as before. Maybe the mix was wrong, or maybe, in the more cynical nineties, nobody was willing to believe any more that a song could save the universe. Whatever, this one lacks the absolute conviction of the original, despite its glistening surface. Kanzaki, given to talking first and thinking later, seeks to make his name with a foray into space, and finds himself bringing home one of the attacking alien Marduks' principal weapons — the priestess Ishtar, whose singing urges on the enemy troops. Of course he should turn her over to the authorities, but being a young maverick he takes her home, takes her shopping, gets her a trendy haircut and then takes her sightseeing. When her commander, Lord Feff, comes to take her back, she refuses to leave, and later the old SDF1, now a military monument, awakens strange memories in her. Meanwhile the military authorities are up to their usual tricks, deceiving the population in the interests of keeping up morale and putting on a good show, and air aces Sylvie and Nexx have to carry their share of the PR load as well as fighting the Marduk. (Well, how else were they going to work an idol singer concert cum flying display into the storyline?) Everything works out in the end, and a song saves the world once more. The beauty of the design and the sheer style deserve more, but given the overwhelming feeling of something lacking I can only make this a ★★

MAD BULL 34 PART 3 CITY OF VICE

(Jap ep title: CHARGING JACKIE)

JAPANESE CREDITS: Dir: Tetsu Dezaki. Screenplay: Kazumi Koide. Art dir: Nobutaka Ike. Photography dir: Hideo Okazaki. Music dir: Katsunori Shimizu. Prod: Shueisha, Pony Canyon, Magic Bus. © Shueisha, Pony Canyon. c50 mins.
WESTERN CREDITS: UK video release 1996 on Manga Video, dub, script adapatation John Wolskel.
ORIGINS: Manga by Kazuo Koike & Noriyoshi Inoue, pub Shueisha; 1990 & 1991 OAVs.
CATEGORIES: M, X

Also:

MAD BULL 34 PART 4 COP KILLER
(Jap ep title: GOODBYE SLEEPY)

CREDITS, ORIGINS, CATEGORIES: As above except: c46 mins.

More precinct action. In part three, Sleepy and the gang are protecting a TV reporter targeted by suspected rapist/murderer Edwards. But he may be too clever for them... Part four has a tragic conclusion to the career of one of the most loved and valued members of the Precinct 34 team.

NEW DREAM HUNTER REM: SLAUGHTER IN THE FANTASY MAZE

JAPANESE CREDITS: Prod: Studio Zyn. © Cycron. 50 mins.
ORIGINS: 1990 OAV. See also Dream Hunter Rem, OAVs every year 1985-87.

I have no further information on this title.

ORUORANE THE CAT PLAYER

JAPANESE CREDITS: Dir: Mizuho Nishikubo. Writer: Baku Yamemahura. © Polydor. CATEGORIES: DD

A musician, out of work and mooching round the town just before Christmas, befriends a cat who is very fond of good wine. The cat is Iruneido, one of a trio of cats owned by Oruorane, a mysterious old man who can 'play' cats as if they were musical instruments. Fascinated by this novel form of music, our hero aspires to learn cat playing. Don't expect a Pythonesque mouse-organ comic slant from this fantasy tale. ★★★?

PATLABOR S-13-S-16
(Eng title for KIDOKEISATSU PATLABOR, lit Mobile Police Patlabor; S-13 DON JUAN FUTATABI, Don Juan Returns; S-14 YUKI NO RONDO, Snow Rondo; S-15 HOSHIKARA KITA ONNA, Woman From a Star; S-16 DAINI SHOTAI IJYONASHI, Second Platoon, Nothing Wrong)

JAPANESE CREDITS: Dir: Mamoru Oshii. Script: Katsunori Ito. Chara des: Akemi Takada. Mecha des: Yukata Izubuchi. Prod: Sunrise. © Bandai, Tohokushinsha. Each 30 mins.

WESTERN CREDITS: All the Patlabor OAVs & TV eps are slated for release on US Manga Corps, starting in autumn 1996.
ORIGINS: Story & manga by Masami Yuuki, pub Shogakukan; OAVs every year 1988-91; 1989-90 TV series; 1990 movie.
POINTS OF INTEREST: As well as these 'standard edition' OAVs, there is also a 'perfect edition', where each of these episodes is accompanied on one tape by 3 episodes from the TV series.
CATEGORIES: SF, M

The plotline of Schaft Enterprises' dark intentions continues to develop amid the everyday adventures of the regular cast. It really is impossible to do these engaging and coherent stories justice in a few words, so I'll just tell you to see for yourself and award them a ★★★☆

PRINCESS ARMY 1 & 2, WEDDING COMBAT

JAPANESE CREDITS: Prod: Group Tack. © SME. Each 30 mins.

I have no more information.

RAIJIN-OH 1 & 2
(Eng title for ZETTAI MUTEKI RAIJIN-OH, lit Invincible King Raijin; 1 HATSUKOI DAISAKUSEN, First Big Love Project; 2 YOSHOJO KARAKURI YUMENIKKI, Sunrise Castle's Traps Dream Diary)

JAPANESE CREDITS: Prod: Kenji Uchida. Prod co: Sunrise. © Toshiba EMI. Each 30 mins.
ORIGINS: 1991 TV series.
CATEGORIES: SF, U

Raijin-Oh is the story of a class of eighteen fifth-grade elementary school kids (aged about eleven) who have to form a team to fight invading aliens when a giant robot crashes through the roof of their classroom. The pilot, Eldran, is badly hurt, so he passes on his powers to the kids and asks them to fight in his place as the Earth Defense Group, using the robot, Raijin-Oh, and its three component mecha. Although only three of the class can be pilots, they all have a part to play and have to learn to work together unselfishly; rather than using most as background charas, the show features each one strongly. The villains, Balzeb and Taidar, use their shape-shifting underlings, the Akudama, or Evil Orbs, to make part-cyborg monsters

based on the problems and troubles of modern life, like pollution, noise, litter and crime. Lots of fun and charm. ★★★?

RG VEDA 1 & 2
(Eng title for SEIDEN RIG VEDA, lit Saint Legend Rig Veda)

JAPANESE CREDITS: Dir: 1 Hiroyuki Ebata; 2 Takamasa Ikegami. Original writer: CLAMP. Script: Nanase Okawa. Chara des: 1 Mokono Apapa; 2 Tetsuro Aoki, Kiichi Takaoka & Futoshi Fujikawa. Anime dir: Tetsuro Aoki. Art dir: 1 Yoji Nakazaka; 2 Masuo Nakayama. Music: Nick Wood. Prod: Animate Film. © CLAMP, Shinshokan, Sony Music Entertainment, MOVIC. Each c45 mins. WESTERN CREDITS: US video release 1993 on US Manga Corps; UK video release 1993 on Manga Video. ORIGINS: Hindu myth; manga by CLAMP. CATEGOIRES: P, DD

The story is based on the ancient Indian scripture Rig Veda. 300 years before it starts, Ashura-Oh, head of the Ashura Clan, was betrayed by his wife Shashi to one of his treacherous commanders, Taishaku, who exterminated all opposing forces, killed his lord, declared himself Heavenly Emperor Taishaku-Ten and married Shashi. She gave birth to twins — Ashura, daughter of Ashura-Oh, and Ten-Tai, son of Taishaku-Ten. Rejected by her mother, who sought to kill her, Ashura was eventually rescued and adopted by Yasha, one of Taishaku-Ten's war leaders. For this action Yasha was declared a traitor and his entire clan sentenced to death, because a prophecy declares that Ashura and five companions, the 'Six Stars of Heaven' will end Taishaku-Ten's power. *Rig Veda* the manga tells the story of how the six companions come together and defeat Taishaku-Ten; this animated segment ends with the finding of the sixth star. Like all CLAMP stories, this is beautifully designed and allows plenty of time for character development and interaction; its Japanese audience, able to find out what happens after the anime ends from the much longer manga, are quite untroubled by the lack of conclusion. Although it bothers some Western audiences, you should just enjoy it for its own sake. ★★☆

RIKA-CHAN'S SUNDAY
(Eng trans for RIKA-CHAN NO NICHIYOBI)

JAPANESE CREDITS: Prod: Asai Ado. © Takara. 25 mins.

I have no further information about this title.

SCRAMBLE WARS: KEEP ON RUNNING! GENOM TROPHY RALLY

JAPANESE CREDITS: Prod: Artmic. © Toshiba EMI. 40 mins. WESTERN CREDITS: US video release 1993 on AnimEigo; UK video release 1995 on Anime Projects, in both cases as part of a 'double bill' on one tape with Ten Little Gall Force entitled Super Deformed Double Feature. ORIGINS: The series Bubblegum Crisis, AD Police, Riding Bean, Genesis Surviver Gaiarth & Gall Force; the SD phenomenon. CATEGORIES: C, U

SD madness didn't end with *Gundam* or go away, as this tape's enduring popularity proves. The squashed-down, compact versions of charas from five popular OAV series all compete in the big race for the Genom Trophy, across the desert to the town of Bangor. (Purely by coincidence, Bangor in Wales is where Anime Projects set up their new headquarters in 1995!) Their various craft reflect their relationships and characters — Ital and Sahari are on their mecha 'bird', Sylia and Mackie Stingray team up in the Silky Doll van, Priss is alone on her bike, Leon Nichol and Daley Wong have Leon's car, and there's a solitary Buma entrant as well as an AD Police team. The worst of everyone's character comes out in their sheer determination to win the trophy at any cost, including the use of tactical nuclear weaponry and systems of mass destruction, as well as sneakiness

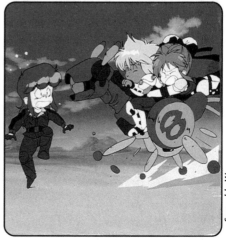

Scramble Wars

and cheating. Featured are jokey references to all kinds of anime staples, as well as Japanese custom and such everyday household items as Tempara Grease Hardener, a product to solidify waste so it can be disposed of neatly. Absolute mayhem in the spirit of *Wacky Races*. ★★★★

SHOTARO ISHINOMORI'S HISTORY ADVENTURE 1 & 2
(Eng trans for ISHINOMORI SHOTARO NO REKISHI ADVENTURE; 1 SEKIGAHARA NO GASSEN, KAWANAKAJIMA NO TATAKAI, Battle of Sekigahara, Fight at Kawanaka Island; 2 GENPEI GASSEN, NAGASHINO NO TATAKAI, Genpei Wars, Fight at Nagashino)

JAPANESE CREDITS: Prod: A.Z. Ltd. © Japan Victor, Media Design Lab. Each 50 mins. ORIGINS: Ishinomori's manga history of Japan. CATEGORIES: P, W

This is the anime version of part of Ishinomori's comic-book history of Japan, a project awarded to the master manga artist in recognition of his spectacularly successful career spanning almost forty years as a creative powerhouse, and his huge influence on a multitude of young artists and writers. Among his many creations are the live-action *Kamen Rider* series now being screened in the West as *Masked Rider*, and the sentai or team shows which are the basis for the *Mighty Morphin' Power Rangers*. ★★☆?

SHURATO 5 & 6
(Eng title for TENKU SENKI SHURATO SOUSE ENO ANTO, lit Heaven Space War Shurato Dark Fight to Genesis, aka HEAVENLY SPHERE SHURATO)

JAPANESE CREDITS: Dir: Yoshihisa Matsumoto. Chara des: Matsuri Okada. Prod: Tatsunoko Pro, Sotsu Picture. © King Record. Each c26 mins. ORIGINS: Hindu & Buddhist myths; concept by Go Mihara; TV series; 1991 OAV. CATEGORIES: DD, P

Shurato and his companions are still struggling to free Vishnu from the evil clutches of her treacherous general Indra. Our hero has been in the enemy camp, and now that he has seen their activities close up their plots have begun to make sense at last; but the conclusion is still in doubt until the last moments of this mythic-war series. ★★☆?

SMALL STORY FOR A SLEEPLESS NIGHT 1-3
(Eng trans for NEMURENU YORU NO CHIISAI NO OHANASHI; 1 NEKO-KUN NO OTOMODACHI HEN, Cat's Best Friend; 2 NEKO-KUN NO BOKEN, Cat's Adventure; 3 NEKO-KUN NO XMAS, Cat's Christmas)

JAPANESE CREDITS: Prod: Group Tack. © Victor Music Production. Each 33 mins.

No further information, but from these charming titles it sounds as if it might be some kind of fantasy.

SPIRIT OF WONDER, MISS CHINA'S RING
(Eng title for THE SPIRIT OF WONDER, CHINA-SAN NO YUTSU, lit Miss China's Melancholy)

JAPANESE CREDITS: Dir: Mitsuru Hongo. Screenplay: Michiru Shimada. Chara des & anime dir: Yoshiaki Yamagida. Art dir: Hiromasu Kogura. Photography dir: Akio Saito. Music: Kohei Tanaka. Prod: Asai Ado. © Tsuruta, Kodansha, Toshiba EMI. 55 mins. WESTERN CREDITS: US video release 1996 on AnimEigo, sub, trans Shin Kurokawa. ORIGINS: Manga by Kenji Tsuruta, pub Kodansha in Comic Afternoon, Eng trans pub Dark Horse Comics. CATEGORIES: P, R

Turn of the century England: Miss China manages a restaurant/bar and takes in boarders for the rooms above. Right now her residents are scientist Prof Breckenridge and his assistant Jim, whom Miss China secretly loves. But she thinks Jim is smitten with the local florist, Lilly, and that her love is hopeless. Then he gives her a moonstone ring... Ravishing artwork and colour and a story featuring mad scientists, weird science, adventure and romance combine to make this one of the prettiest OAVs of the year and an eagerly-awaited Western release among fans who have seen the manga, the stunning pre-production art, and clips from the original Japanese version. ★★★☆

STARDUST

JAPANESE CREDITS: Prod: Yoyogi Animation School, DAST. © Victor Music Production. 30 mins.

No more information, but this would seem to be a

'student film' from the acclaimed academy of anime excellence at Yoyogi.

TENCHI MUYO! RYO OH KI 1-4

(Japanese title used in English release. Variously trans as 'No Need For Tenchi', 'Good-For-Nothing Tenchi', or 'Heaven and Earth Prince', all followed by 'Ryo Oh Ki', which in this case is a proper name. Vol 1 RYOKO HUKKATSU, Ryoko Resurrected; 2 AEKA GA DETA, Here Comes Aeka; 3 KONNICHIWA RYO-OH-KI-CHAN, Hello Ryo Oh Ki Darling; 4 MIHOSHI FURU SATO NO BISEI FURI, Mihoshi Falls to the Land of Stars)

JAPANESE CREDITS: Dir: Hiroki Hayashi. Screenplay: Naoko Hasegawa, Masaki Kajishima & Hiroki Hayashi. Chara des & anime dir: Masaki Kajishima. Art dir: Takeshi Waki. Sound dir: Yasunori Honda. Music: Seiko Nagaoka. Prod: AIC. © AIC, Pioneer LDC. Each 30 mins.
WESTERN CREDITS: US, sub & dub, and UK, dub, video release 1994 on Pioneer. Eps 1-4 dialogue polish Jack Fletcher; trans 2 Eriko Mori, 3 Miyoko Miura, 4 Naomi K. Martin.
POINTS OF INTEREST: Pioneer are the first Japanese company to release on their own label under their own direct control in the West instead of licensing its titles to local companies for distribution. It remains to be seen whether other Japanese companies will follow this lead. The mighty Bandai, for instance, controls a huge anime catalogue and merchandising operation, and has a UK subsidiary, but has so far been content to license properties to UK companies rather than controlling its own UK market. Bolting on some anime expertise to the UK toy-vending subsidiary could transform the European anime scene, especially given Bandai's depth of catalogue in market segments so far not addressed or poorly addressed by British companies.
SPINOFFS: Manga, a popular radio drama series scripted by Naoko Hasegawa, a second OAV series, TV series, CDs & merchandise galore.
CATEGORIES: DD, R, C

Pioneer's first Western own-label release, and a huge hit in Japan and round the world, Tenchi has not quite everything, but most of it — as long as you're not a guts'n'gore cyberfreak who likes ripped limbs. Not that the story lacks action, adventure and fight scenes — far from it — but the emphasis is inherently comic and romantic. Tenchi is a temple kid, born to inherit the family shrine which was built to contain a terrible monster which his ancestor once defeated. Of course, Tenchi releases it — thereby giving the OAV 'new wave' another plot spin which proved very influential — and what at first looks like a hideously withered mummy turns out to be a gorgeous creature called Ryoko. She has a very bad attitude problem, however; she hasn't enjoyed the last few centuries shut up in the shrine and she's out to get the descendants of the guy who put her there. She's also a galactic criminal being pursued by the Jurai Princesses, Aeka and cute little sister Sasami, who are out for revenge for their lost step-brother, whom Aeka was to have married. When they crash their spaceship into a pool near Tenchi's home, the girls have to stay. Tenchi's father, who's been wondering when his son would start to show a proper interest in girls, is delighted (though the structural damage doesn't please him), but what about Grandfather? When Officer Mihoshi of the Galactic Police, a serious contender for the title of fluffiest brain in the galaxy, turns up too, things begin to get even more complicated. And Ryoko's spaceship hasn't grown up yet... You'll believe a cute fluffy bunny can transform into a gigantic starship. Really. You will. And you'll enjoy it too. ★★★★

Tenchi Muyo! Ryo Oh Ki

3 x 3 EYES III & IV
(Eng trans for SAZAN EYES; 3 SAISHO NO SHO, Saisho Chapter; 4 MEISO NO SHO, Gone Missing Chapter, US aka 3x3 EYES PERFECT COLLECTION)

JAPANESE CREDITS: Dir: Daisuke Nishio. Script: Akinori Endo. Chara des & anime dir: Koichi Arai. Art dir: Junichi Tanaguchi. Music: Kaoru Wada. Prod: Toei Animation, Tabac. © Kodansha, Takada Plex, Star Child. Each 30 mins.
WESTERN CREDITS: UK video release 1994 on Manga Video, both parts on one tape; US video release 1994 on Streamline Pictures, both parts on one tape. Also released as a 110 minute compilation, 3 x 3 Eyes Perfect Collection, in the USA by Streamline. All dub.
ORIGINS: Original story by Yuzo Takada; manga by Yuzo Takada, pub Kodansha in Young Weekly, Eng trans pub Innovation & Dark Horse Comics; 1991 OAV.
CATEGORIES: H, A

The race for the Ningen is hotting up, and there's another Immortal involved. In Hong Kong, Pai finally decides that she can't endanger her friends any longer. After a happy evening at a party with Yakumo, she leaves in secret to fight a great battle. At the end of part four, Yakumo has no idea where she is and sets out in search of her. Again, this 'ending' has infuriated English-speaking fans who don't have access to the complete manga to tell them the rest of the story; fortunately, further *3 x 3 Eyes* episodes were released in the summer of 1995 in Japan to help put them out of their misery. Despite the lack of conclusive ending, these two parts are just as beautifully executed as the first two. ★★★☆

TOKYO BABYLON

JAPANESE CREDITS: Dir: Koichi Chiaki. Original story: CLAMP. Screenplay: Tatsuhiko Urahata. Chara des & anime dir: Kumiko Takahashi. Art dir: Yuji Ikeda. Music: Toshiyuki Honda. Prod: Animate Film. © CLAMP, Shinshokan, MOVIC, SME. 50 mins.
WESTERN CREDITS: UK video release 1994 on Manga Video, dub, Eng rewrite George Roubicek; US video release 1994 on US Manga Corps, same version.
ORIGINS: Manga by CLAMP.
CATEGORIES: H, M

This stylish video assimilates elements of CLAMP's 'shojo' (romantic and feminine) art style and slow-er story pacing into a format acceptable to most horror fans. Young medium, Subaru Sumeragi, heir to an ancient line of mystics, is called on to help a company with trouble on a major project. People keep dying in site accidents, and most of them have been accompanied by the same staff member, who escapes unscathed every time. Then the director who hired Subaru also dies, and the sister of one of the victims unleashes forces she can't even spell correctly, let alone understand, in an effort to avenge her brother. Much of the complexity of the manga story is missing — there is no hint of the fascinating ages-old rivalry between psychic blood-lines, and a central relationship of the manga has been changed completely — but the video is never-theless a good introductory outline of CLAMP's style, both in art and story form. ★★★

USHIO & TORA 1-4
(Eng trans for USHIO TO TORA: 1 USHIO TORA TO DEAU NO, Ushio Meets Tora; 2 ISHIKUI MUKADE HENGE, Stone Eater Changing Centipede; 3 FUSHI KAMA, Whirling Scythe; 4 TENRIN SHISSHO, Spinning Wildly)

JAPANESE CREDITS: Dir: Kunihiko Yuyama. Script: Kenji Terada. Art dir: Kachiyoshi Kanamura. Prod: Pastel, Toho. © Fujita, Shogakukan, Toho Video, Toshiba EMI, OB Planning. Each c27 mins.
WESTERN CREDITS: UK video release 1995 on Western Connection, sub, trans Jonathan Clements.
ORIGINS: Manga by Kazuhiro Fujita, pub Shogakukan.
CATEGORIES: H, A

Almost a mirror-image of the hugely successful *Tenchi Muyo!*, *Ushio & Tora* brings a totally different viewpoint to the story of the temple kid who releases a monster. It's harsher, sharper, angrier and more acid than *Tenchi*, and this is reflected in its art style, colour palette and credit sequences which change as the story evolves. Ushio is much more aggressive than Tenchi; the girls in his life are not alien superbabes but his classmates, ordinary girls his own age. Even his relationship to the monster Tora is different; although, like Tenchi and Ryoko, they start out trying to kill and avoid being killed, they evolve an uneasy truce that turns into a kind of friendship. Tora is Japanese for Tiger, and Ushio gives him the name because a tiger is what he resembles; he has other, longer, more powerful names from his past in mediaeval Japan. Together they meet various traditional monsters, ghosts and ghouls, still lurking just below the glossy, modern surface of Japanese culture. Ushio finds that having

mystic powers and a magical spirit as an ally is very inconvenient in everyday life and puts those you love in real danger; and that close relationships, even if they are intensely combative, can also provide support when you need it most. Spiky and brilliant. ★★★★

VIDEO GIRL AI 1-6
(Eng title for DENEI SHOJO AI; 1 NAGUSAMETE AGERU, I'll Comfort You; 2 PRESENT; 3 YOTA GA KURETA FUKU O KITE HAJIMETE DATE SHITA HI, Memorial Day — The Day I Had a Date With Yota Wearing Clothes That He Gave Me; 4 KOKUHAKU, Confession; 5 AI GA KIERU!, Love Will Leave Us!; 6 AI, AI, AI, Sorrow, Love, Ai — each of the kanji in the title has a different meaning, even though the transliteration is the same; the last one is that used for Ai's personal name)

JAPANESE CREDITS: Dir: Mizuho Nishikubo. Chara des & chief animator: Takayuki Goto. Prod: I.G. Tatsunoko. © Shueisha, Katsura. Each 30 mins.
ORIGINS: Manga by Masakazu Katsura, pub Shonen Jump, 1990.
POINTS OF INTEREST: You can actually rent a 'video date' in Japan — a cassette showing a gorgeous girl who will say nice things to you, flirt with you and in some cases take off some clothing. It is most unlikely, however, that she will emerge from your VCR and change your life, like the video date in this OAV series.
CATEGORIES: R, DD

Yota Moteuchi's life will strike chords with many young male fans, which is one reason for the manga's huge popularity. (The other is the huge number of stunningly well drawn Japanese schoolgirls in the manga, and to a lesser extent in the anime.) He is short, not that good-looking, and lacks confidence; and his best mate is the school heart-throb, tall, gorgeous, and a member of a band. He is in love with his pretty classmate Moemi, who is in love with said best friend, Takashi. Even worse, she considers Yota a really nice guy and her closest friend, so she confides all her hopes and dreams for this love to him. In despair, Yota stumbles on a video store where the kindly old manager rents him a 'video date'. Carrying realism further than ever before, the beautiful and sympathetic Ai Amano emerges from the VCR and tells Yota she has come to console him. But something has gone wrong with Ai; instead of being a mere programmed plaything, she has become a person, with feelings and fears —

feelings of love for Yota, and fears that she will be 'recalled' to the library or that her tape will run out, ending her strange existence. She does her best to fulfil her programmed function and help Yota build his confidence enough to win Moemi's love, but her own feelings are becoming hard to ignore, even though they shouldn't exist. A sweet, romantic wish-fulfilment fantasy for boys, with an added human dimension of real charm, prettily executed. ★★★☆

WOLF GUY 1: PHOENIX PROJECT
(Eng trans for WOLF GUY 1 FUSHICHO SAKUSEN)

JAPANESE CREDITS: Dir: Naoyuki Yoshinaga. Script: Toshikazu Fujii. Chara des: Osamu Tsuruyama. Music: Kenji Kawai. Prod: J.C. Staff. © Bandai Visual. c27 mins.
ORIGINS: Based on a novel by Kazumasa Hirai.
CATEGORIES: H, X

A young man is infected by a terrible poison. The only antidote turns him into a lycanthrope — a werewolf. That's all I know about this title (apart from the fact that there's some nudity and bloodshed) but the art looks well executed.

YOSHIFUMI EGUCHI'S JUGORO SHOW

JAPANESE CREDITS: Dir: Masakatsu Iijima & Osamu Nabeshima. Prod & © Nextart. 35 mins.
ORIGINS: Comic tales created by Yoshifumi Eguchi.
CATEGORIES: C, N

Three very short stories, one a two-parter. 'The Low-Class Family' gives insight into two aspects of Japanese life often ignored in the West, a class system as defined as Britain's and the process of arranging a marriage, still widely practised. A young girl meets a young man with a view to seeing if bo.n would like to get to know each other better; if both parties are agreeable and their personal and family backgrounds are mutually satisfactory, matters proceed to a match. But what happens when the girl is the daughter of the lowest-class family in Japan, and the boy iᶜ the son of a family which is not only rich and ancient but ultra-refined to boot? Also includes 'Pointless Rebellion' and 'Monster Kingdom'. Broad comedy with a basis in home truths. ★★☆?

O ver 150 OAVs were released this year, marking the huge success of the format at the start of its second decade. Erotica still held its ground, with releases such as *Intense Feeling! I Wanna Put It In a Hole*, but they remained a minority segment of the market, though an important and profitable one. The continuing success of *Tenchi Muyo!* and *Giant Robo* confirmed two major trends — the relentless march of the cute, pretty, colourful OAV, and the 'retro' look, with old-style chara design exerting a new influence, and classics being remade for a new young audience as well as exploiting the nostalgia factor with older, now-solvent fans. The year's *Animage* magazine fan poll confirmed this, showing cute OAV *Oh My Goddess!* in third place, but TV remained of prime importance; this was the only OAV in the top ten, and the top rated film, *Patlabor 2*, came eleventh, with TV series occupying sixteen of the top twenty voting slots. TV releases on video were also showing strongly in the market, with old favourites like *Dragonball Z* and *Doraemon* soldiering on as popular as ever — there was even a massive *Dragonball Z* virtual reality game, packing fans into the Tokyo Dome throughout July and August. Of the movies devoted to TV favourites, two of the most popular, *Crayon Shin-Chan* and *Chibi Maruko-Chan: My Favourite Song*, bought into the cute/nostalgia wave with tales of elementary school children. These naïvely-drawn series about the very young have a considerable following among older fans, but I only mention these movies here as important indicators of another aspect of the trend for nostalgia. In the UK anime continued to gain popularity with the foundation of Anime Projects, a British offshoot of the US label AnimEigo, and Kiseki Films. In the USA, Viz Communications, the American offshoot of Japanese publishing giant Shogakukan, already known as a manga translation publisher, set up its own video label, Viz Video.

(MOVIES)

BIG WARS
(Eng trans for DAISENKI)

JAPANESE CREDITS: Dir: Toshifumi Takizawa. Chara des: Satomi Mikiyura. Mecha des: Hiroshi Yokoyama. Prod: Magic Bus. © Tokuma. c90 mins.
WESTERN CREDITS: US video release 1996 on US Manga Corps, sub.
ORIGINS: Novel by Yoshio Aramaki.
CATEGORIES: SF

'The Gods' — aliens who originally subjugated the primitive peoples of Earth and left them the foundations of technology — return in the year 2360 AD to see how their underlings are getting on. But this time, Man doesn't want to knuckle under meekly and decides to fight back. Weaponry has advanced quite a way, but the aliens have a mind control plague which can infect anyone. Even Captain Akuh of the battleship *Aoba* is getting worried — his girlfriend is showing the first signs of the plague. (One of them is nymphomania, apparently.) The mecha in this are really heavy and for once the war isn't just in space — there are orbital fighters and huge desert tanks. If the nymphomania angle doesn't get too silly this has all the signs of a promising action-adventure. ★★★?

THE BIOGRAPHY OF GUSCOE BUDORI

JAPANESE CREDITS: Dir & script: Yutaro Nakamura. Anime dir: Shinichi Suzuki. Art dir: Kazuhiro Arai. Music: Yoshihara Sugamo. Prod: BGB Movie Production Committee.
ORIGINS: Story by Kenji Miyazawa.
CATEGORIES: N

Budori and his little sister have grown up in the forests where their father was a lumberjack. When their parents disappear in a great famine and his little sister is kidnapped, Budori has to make his own way in the world. He scratches a living as best he can, doing any work available, but finally goes to the city looking for better opportunities. He gets a job at the agency responsible for monitoring volcanic activity, and eventually becomes one of the greatest experts in natural energy forces. ★★?

COO OF THE FAR SEAS
(Eng trans for TOI UMI KATAHIRA COO)

JAPANESE CREDITS: Dir: Tetsuo Imazawa. Script: Kikachi Okamoto. Chara des: Masahiko Okura. Backgrounds: Nizo Yamamoto. Music: Nick Wood. Prod: Toei Animation. © Kageyama, Toei Doga. 116 mins. ORIGINS: Novel by Tamio Kageyama. CATEGORIES: DD, N

The feel-good movie of the year, *Coo* tells the story of a small boy, a scientist's child, living with his father on an island in the Pacific, who befriends a baby pleiosaur — a cute little long-necked aquatic reptile which, while not a dinosaur, was certainly contemporary with them and shouldn't be alive in the modern ocean. Evil men find its mother's corpse and are on its trail, and the boy enlists the help of a beautiful lady journalist to keep his friend safe until he can be set free in the deep oceans once more. There is a great deal of danger — the villains will stop at nothing — but in the end Coo is safe and free. Ravishing island and sea backgrounds, winning character designs and a story sure to charm the hardest of hearts add up to a winner, an E.T. from our own planet with no need of mysterious powers to make magic. ★★★★

DRAGONBALL Z — GALAXY FLEX! WONDERFULLY BAD SPOT

CREDITS: Dir: Daisuke Nishio. Prod: Toei Animation. © Bird Studio, Shueisha, Toei Doga. c48 mins. ORIGINS: Manga by Akira Toriyama, pub Shueisha; TV series; movies every year 1986-92. CATEGORIES: V, C

A super-rich family runs a special martial arts tournament with Mr Satan 'saviour of the world from the terrible monster Cell' as Guest of Honour. However since we know that it was really Gohan who saved the world we can enjoy Mr Satan's worries that he'll get found out. And unfortunately for the four winners of the first round, they then face the Galaxy Warriors, led by Bo Jack and his sinister sidekick Sangria. Maybe this time Mr Satan will really have to save the world. ★★★?

Also:

DRAGONBALL Z — IGNITE! BURNING FIGHT — GREATER FIGHT — SUPER CONFLICT FIGHT

CREDITS, ORIGINS, CATEGORIES: As above.

More Saiyajin background as survivors of the destruction of Goku's homeworld arrive and ask Vegeta to come with them as King of the new Saiyajin homeworld. Vegeta's vanity makes him sure to agree but Trunks is suspicious, so he, Oolong, Krilyn, Gohan and Kamesennin go along for the ride. On New Vegeta, they meet the Super Saiyajin Broli, whose mind has become like broccoli due to a childhood trauma which left him with a great hatred of Goku. Scenes of domestic life also feature as Goku and ChiChi check out schools for Gohan. ★★★?

GET A GRIP, TSUYOSHI!

ORIGINS: Manga by Kiyoshi Nagantasu. **POINTS OF INTEREST: Appeared on the same bill as Make Up Lovely Soldiers, the Sailor Moon R movie.** *CATEGORIES: N*

The manga on which the film is based is about a high school student, Tsuyoshi, who is henpecked and harassed by a string of female relatives, but still always manages to save the day in their domestic dramas.

I CAN HEAR THE OCEAN
(Eng trans for UMI GA KIKOERU)

JAPANESE CREDITS: Dir: Tomomichi Mochizuki. Chara des: Yoshifumi Kondo. Prod: Studio Ghibli. © Nibariki, Tokuma Shoten. 72 mins. ORIGINS: Novel by Saeko Himuro. CATEGORIES: R, N

Another Ghibli masterpiece, even without the directorial hand of Miyazaki or Takahata. This delicate story of unexpressed feelings between high school students, and the misunderstandings that can arise when two people are too reserved to communicate, is beautifully told and has a suitably hopeful ending. ★★★

LEGEND OF GALACTIC HEROES II
(Eng trans for GINGA EIYU DENSETSU II)

JAPANESE CREDITS: Dir: Keizo Shimizu. Chara des & anime dir: Hiroharu Ikeda. Mecha concepts: Naoyuki Kato. Prod: Kitty Film. © Kitty Enterprise, Tanaka, Tokuma Shoten. 90 mins. ORIGINS: Yoshiki Tanaka's novel series, pub Tokuma Shobo; 1988 movie; 1988, 1989, 1991 & 1992 OAVs. CATEGORIES: SF, W

In the animated storyline there is a 'lost year' between the very first theatrical release and the beginning of the first (1988) OAV series. This film fills in the events of that year and tells us more about the early careers of Reinhart Von Lohengrimm and Yang Wen-Li. ★★★

NINJA SCROLL
(Eng title for JUBEI NINPOCHO, lit Jubei the Wind Ninja)

JAPANESE CREDITS: Dir, story & screenplay: Yoshiaki Kawajiri. Chara des & anime dir: Yutaka Minowa. Art dir & backgrounds: Hiromasa Ogura. Sound dir: Yasunori Honda. Music: Kaoru Wada. Prod: Madhouse. © Kawajiri, Madhouse, JVC, Toho, MOVIC. 90 mins.
WESTERN CREDITS: UK video release 1995 on Manga Video, dub, trans Raymond Garcia.
CATEGORIES: SH, X, P

A powerful, dramatic story set in the last century, with young ninja master Jubei battling political chicanery, the power of evil, black magic and elegant, ice-hearted villains. There's also the complication of his feelings for a girl whose kiss is, quite

Ninja Scroll

literally, poison. This is a magnificent piece of craftsmanship in terms of design and animation, and the pacing is perfect. ★★★☆

PATLABOR 2
(Eng title for KIDO KEISATSU PATLABOR 2 THE MOVIE, lit Mobile Police Patlabor 2 The Movie)

JAPANESE CREDITS: Dir: Mamoru Oshii. Script: Kazunori Ito. Chara des: Akemi Takada & Masami Yuuki. Mecha des: Yutaka Izubuchi, Shoji Kawamori & Hajime Katoki. Backgrounds: Hiromasa Ogura. Music: Kenji Kawai. Prod: IG Tatsunoko. © Headgear, Emotion, TFC, ING, Shogakukan. 90 mins.
WESTERN CREDITS: UK video release 1995 on Manga Video; US video release 1995 on Manga Entertainment.
ORIGINS: Story & manga by Masami Yuuki, pub Shogakukan; OAVs every year 1988-92; 1989-90 TV series; 1990 movie.
POINTS OF INTEREST: The addition of Macross mecha genius Kawamori and Gundam's Katoki to the talents of Yutaka Izubuchi produced one of the most awesome mecha teams in anime. It is greatly to the director's credit and that of a stellar team that, far from being permitted to dominate the story, their work melds perfectly into the completely credible whole.
CATEGORIES: SF, M

1999: a Japanese squad on loan to the UN is all but wiped out in anti-terrorist action. The commander, Yukihito Tsuge, vows vengeance on the weak Japanese government. Three years later, now retired, he finds the means to wreak his revenge through a corrupt government official. But he has reckoned without two things — the sharp brain of Mobile Police Captain Kiichi 'The Razor' Goto, and the courage and determination of his former pupil Shinobu Nagumo, also of the Mobile Police. Time has moved on for the former Special Vehicle Section 2 teammates; Noa Izumi and Asuma Shinohara now work on labor systems development for Shinohara's father's firm. Trigger-happy Isao Ota is a police instructor, Shige has taken the place of his widowed and retired boss as 'mecha god' of Section 2 and Shinshi has a child; but they come together again to help defeat one of the most serious threats to Tokyo's security in modern times. Like its precursor, *Patlabor 2* has a darker, cooler edge than the original OAV series, and another masterly script from Kazunori Ito provides the framework for a thriller as tense and exciting as anything Hollywood can offer. ★★★☆

RAMAYANA

JAPANESE CREDITS: Dir: Ram Mohan. Prod: Yugo Sako. Prod co & © Nippon Ramayana Film Co Ltd. 90 mins.
ORIGINS: The Hindu religious cycle attributed to the robber-poet Valmiki, c300 BC.
POINTS OF INTEREST: The first Indian-Japanese animated co-production required licences from Hindu religious authorities before work on the animation could proceed in India.
CATEGORIES: P, DD

The God-King Rama and his wife Sita go into exile after a political intrigue and embark on a quest to prove Rama's right to his throne. In the process they meet many helpers, including the Monkey God Hanuman, but Sita is kidnapped by the Demon King Ravana and held captive on his island home. Rama and their friends must rescue her and destroy Ravana. Shapeshifting vampires, flying fortresses and epic battles provide plenty of action and interest in a fascinating meeting of Asian cultures. ★★★

SAILOR MOON 3: PRELUDE OF ROMANCE

JAPANESE CREDITS: Prod: Toho. © Takeuchi, Toho, Kodansha. 100 mins.
ORIGINS: Manga by Naoko Takeuchi, pub RunRun magazine by Kodansha; 1992 TV series of same name, continuation of 2 earlier series, Bishoji Senshi Sailor Moon & Bishojo Senshi Sailor Moon R.
CATEGORIES: U, R

Also :
SAILOR MOON R: MAKE UP LOVELY SOLDIERS

CREDITS, ORIGINS, CATEGORIES: As above except: 60 mins.

I know nothing about these two movies except their titles and the fact that the first is an episode compilation from the second *Sailor Moon* TV series, and the second formed a double bill with *Get a Grip, Tsuyoshi*. Bandai's biggest money-spinner has run on US TV in edited form, so Western girls can enjoy the story of scatty fourteen-year-old Usagi and her friends, the magic powers they inherit as avatars of mystic girl warriors, and the fight to save the world from evil through the power of love and romance.

THE SECRET OF BLUE WATER: NADIA THE MOVIE

(Eng title for FUSHIGI NO UMI NO NADIA THE MOVIE FUZZY NO HIMITSU, lit Nadia of the Mysterious Seas: The Movie, the Secret of Fuzzy)

JAPANESE CREDITS: Dir: Hideaki Anno. Script: Hideaki Anno & Toshio Okada. Prod: Gainax. © NHK. c90 mins.
ORIGINS: 1991 TV series inspired by the novels of Jules Verne.
CATEGORIES: DD, A

Set some years after the events at the end of the series, in which orphaned Atlantean Princess Nadia and young inventor Jean saved the world from the evil power of Neo-Atlantis' mad dictator, the movie takes the characters' stories further into the first years of the twentieth century. Who is the mysterious girl whom Jean saves, and how will she affect his stormy relationship with Nadia? The series was beautifully designed with high production values, and the film keeps the same high standards. ★★★?

THE WIND OF AMNESIA

(Eng title for KAZE NO NAMAE WA AMUNEJIA, lit The Wind's Name is Amnesia, aka A WIND OF AMNESIA)

JAPANESE CREDITS: Dir: Kazuo Yamazaki. Script: Kazuo Yamazaki & Yoshiaki Kawajiri. Chara des & anime dir: Satoru Nakamura. Mecha des: Morifumi Naka. Art dir: Mutsuo Koseki. Supervisor: Taro Rin. Music: Kazz Toyama. 90 mins.
WESTERN CREDITS: UK video release 1994 on Manga Video, dub; US video release 1994 on US Manga Corps, sub, trans Neil Nadelman as A Wind of Amnesia.
ORIGINS: Story by Hideyuki Kikuchi.
CATEGORIES: SF

Mankind's memory is wiped clean overnight when a strange wind blows; civilisation reverts to barbarism as every aspect of human achievement — writing, art, science, culture — is forgotten. One small boy looking for food and shelter wanders into a laboratory where a dying child teaches him what he has lost, and sends him out on a quest to contact other humans and revive the world's memory if he can. He meets a mysterious girl on his travels — is she human or alien? What does she want? In the end, he learns she is alien and her aim is to ensure he will fulfil his mission — to help mankind relearn what they have lost and avoid the errors into which they were falling. A gentle, reflec-

tive road movie seems a contradiction in terms, but this is it. The presence of such a distinguished action/horror team on the credits might lead one to expect something faster-paced, but although there are action sequences the overall mood is almost dreamily slow. ★★★

YU YU HAKUSHO THE MOVIE

JAPANESE CREDITS: Dir: Noriyuki Abe. Script: Yoshiyuki Ohahsi, Sukehiro Tomita & Katsuyuki Sumisawa. Chara des: Minoru Yamasawa. Backgrounds: Yuji Ikeda. Music: Yusuke Honma. Prod: Studio Pierrot. © Y. Togashi, Shueisha, Fuji TV. 30 mins. ORIGINS: Manga by Yoshihiro Togashi, pub Shueisha; 1992 TV series. CATEGORIES: H, A

The TV series tells the story of a contemporary high school student killed before his time and brought back into the world to act as a psychic investigator. This short movie brought the popular characters to the cinema for a summer showing, though many fans consider it inferior to the longer 1994 movie. ★★☆?

OAVS

ADVENTURE DUO 1-3
(Eng title for YOJUSENSEN, lit Demon Beast War Battle Line, aka ADVENTURE KID)

JAPANESE CREDITS: Dir: Yoshitaka Fujimoto. Screenplay: Atsushi Yamatoya. Music: Masamichi Amano. Prod: Gainax. © Maeda, Westcape. Each c40 mins. WESTERN CREDITS: UK video release 1994 on Kiseki Films, sub; US video release 1994 on Anime 18, trans Neil Nadelman. A UK dub script was written & translated by Jonathan Clements but never released, since the planned dub did not go ahead; the UK release uses Neil Nadelman's subtitles. ORIGINS: Manga by Toshio Maeda. POINTS OF INTEREST: The UK title was adopted at the request of the British Board of Film Certification, who felt that the original title Adventure Kid might mislead parents into thinking it was a cartoon suitable for children and ignore the 18 certificate issued by the Board. CATEGORIES: H, X, V

A strange three-part OAV series which turns into a

demonic sex sitcom in the last episode. It starts out conventionally enough for Maeda; a computer left over from World War II carries four teenage chums into the past where they run into a platoon of blood-crazed zombie rapists. Then it starts to send itself up, and before too long we find ourselves in Hell, where the demon women know exactly what they want and how to get it, while the son of the King of Hades is a nice cuddly green monster who just wants to live inside girls' panties. The third episode is a crazed cocktail of romantic misunderstanding, sex-mad demons of both genders, a jealous school chum and a music teacher in S & M gear — a sort of *Terry and June* (or *I Love Lucy*) on white powder, deeply strange but not without a certain charm. It's hard to tell if the BBFC edits have destroyed or enhanced it; in a plot without much logic anyway, does it matter if most is hacked away? I am inclined to think not; a deceptive ★★☆

A-GIRL

JAPANESE CREDITS: Dir: Takuji Endo. Script: Asami Endo. Chara des & anime dir: Kazukuro Saeta. Prod: Madhouse for Margaret Video Series. © Kuramochi, Shueisha. c40 mins. ORIGINS: Manga by Fusako Kuramochi, pub Margaret magazine by Shueisha. CATEGORIES: N, R

First in a series of romance videos based on stories from the popular manga anthology. Take four people — sisters Mariko and May, Mariko's short-tempered boyfriend, and womanising male model Ichiro. Mix them together in contemporary Japan for a look at the roles people are forced into in relationships, and how only love and honesty can help them break free. I am sorry not to have seen any artwork for the series, and look forward to tracking down the tapes sometime in the future.

AMBASSADOR MAGMA 1-13
(Eng trans for MANGA TAISHI, released in Japan as 2 & 3 ep tapes; R-1 FUKKATSU HEN, Revival; R-2 SHIRYAKU HEN, Ambition; R-3 GEKITO HEN, Dead Heat; R-4 YABO HEN, Ambition; R-5 DENKI HEN, Strange Story; R-6 KANKETSUHEN, Final, aka AMBASSADOR MAGMA VOLS 1-6)

JAPANESE CREDITS: Dir: Hidehito Ueda. Script: Katsuhiko Koide. Chara des & anime dir: Kazuhiko Udagawa. Music: Toshiyuki Watanabe. Prod: Tezuka Pro, Picture Kobo. © Tezuka, Bandai Visual. 13

eps, each c25 mins, R-1 to 5 50 mins each, R-6 75 mins.
WESTERN CREDITS: US video release 1994 on US Renditions, trans Nobuhiro Hayashi, Eng screenplay Bill Kestin; UK video release 1994 on Kiseki Films, same version.
Western ep titles: Vol 1: 1 My Name is Goa; 2 The Gold Giant; 3 Silent Invasion. Vol 2: 4 The Two Mamorus; 5 The Government Strategy. Vol 3: 6 The Questionable Warrior; 7 Gigantic Task. Vol 4: 8 Hunter Whistle; 9 The Resurrection of Udo. Vol 5: 10 Mother and Her Love; 11 Race of the Earth. Vol 6: 12 Death of Magma; 13 The Planet of Love.
ORIGINS: Manga by Osamu Tezuka.
POINTS OF INTEREST: Note the shots of Tezuka's original manga art in the credit sequences.
CATEGORIES: SF

Teenager Mamoru is caught up in a titanic battle between good and evil as the demon lord Goa threatens to enslave the Earth with his shapeshifting minions. Mamoru finds a golden whistle which can call the golden giant Magma, defender of good, to fight Goa. Retro styling married to contemporary animation techniques and Tezuka's usual fascinating range of concepts and characters make for a solid mix of fantasy, adventure and humanistic principles. There is some atmospheric and threatening action, and several episodes are not for those afraid of dogs already, but subject to parental checking most twelve-year-olds would probably be comfortable watching this. ★★☆

A-PLUS FOR THE FASHION BOY

JAPANESE CREDITS: Dir: Takuji Endo. Script: Asami Endo. Chara des & anime dir: Kazukuro Saeta. Prod: Madhouse for Margaret Video Series. © Shueisha, Nonko. c40 mins.
ORIGINS: Manga by Atsumi Nonko, pub Margaret magazine by Shueisha.
CATEGORIES: N, R

Another in the series of videos based on popular stories from this bestselling magazine for women and girls. The 'fashion boy' is twenty-three-year-old Hodaka Kunishige, a successful boutique owner. He falls in love with a fourteen-year-old schoolgirl, and the problems of overcoming the age gap form the story of this comedy romance.

APPLELAND STORY 2
(Eng trans for APPLELAND MONOGATARI)

JAPANESE CREDITS: Prod: J.C. Staff. © Tokuma Novel. 40 mins.
ORIGINS: Yoshiki; Tanaka's novel, pub Tokuma, serialised in Animage; 1992 OAV.
CATEGORIES: P, A, DD

Further adventures of Virgil Sibelius and friends in the little Central European country which holds the key to power in the early years of this century. ★★☆?

BASARA
(Eng title for TAMURA YUMI ORIGINAL IMAGE VIDEO BASARA, lit Yumi Tamura's Original Image Video Basara)

JAPANESE CREDITS: © Pony Canyon. 30 mins.

All I've seen of this is some very attractive artwork which looks romantic and fantasy-based. Tamura is a manga artist so presumably it's based on one of her works.

BASTARD!! 4-6
(Eng title for BASTARD!! ANKOKU NO HAKKAI JIN lit Bastard!! Darkness Destroying God; 4 FUSHI-O DIE AMON, Immortal King Die Amon; 5 DENTEI ASHES NEI, Thunder Emperor Ashes Nei; 6 FUKKATSU NO DARK SCHNEIDER, Revival of Dark Schneider)

JAPANESE CREDITS: Dir: Katsuhito Akiyama. Writer: Hiroshi Yamaguchi. Chara des: Hiroyuki Kitazume. Monster des: Masanori Nishii. Anime dir: Moriyasu Taniguchi & Takahiro Kimura. Music: Kohei Tanaka. Prod: AIC. © Shueisha, Pioneer LDC. Each 30 mins.
ORIGINS: Manga by Kazushi Hagiwara, pub Shueisha; 1992 OAV.
POINTS OF INTEREST: The Bastard!! of the title is the term used for a kind of mediaeval European sword. Note the huge number of heavy metal references and excruciating puns in the manga, some of which carry over — the city of Metal Licania, the resurrected demon Anthrasox, the characters Guns'n'Ro and Bon Jovina, etc, etc, etc.
CATEGORIES: DD, X

More adventures of the wizard Dark Schneider and his reluctant allies in their fantasy world of swords, sorcery, idiotic grimaces and high romance. Please, somebody, bring this to Britain soon! ★★★☆

SCHOOLS

There are a number of educational establishments in anime that you just don't want to be enrolled in. These are the names to watch for. If your parents try to send you there, run away!

1 SPARTA COLLEGE — KEKKO KAMEN

Run by Principal Satan Tochiz as a cross between a concentration camp and a perverts' club, this is one school where the things you'll learn will most certainly *not* get you into the better universities!

2 TOMOBIKI HIGH — URUSEI YATSURA

If you're a boy, you'll fall hopelessly in love with Lum. If you're a girl, you'll be hopelessly jealous of Lum. Either way, your education will be constantly disrupted by alien taxi drivers, gigantic birds, bike-mad goddesses, flying ice-cream cones and other weird manifestations.

3 OTOKO JUKU - TAKE THE LEAD! MEN'S SCHOOL

Unless you're huge, well hard and a martial arts expert, the teachers will think you're a wimp. In fact, even the milk monitors will think you're a wimp. And girls, however tough, are not welcome — Otoko means 'man' in Japanese and this is definitely a men-only establishment.

4 EMPEROR HIGH SCHOOL — ULTIMATE TEACHER

The teacher, Ganpachi Chabane, is a cockroach. Really. The leader of the top gang has a fetish for blue bloomers with kittens on. The place is regularly trashed. What do you mean it sounds great?

5 THE EIGHTH DISTRICT YOUTH VOCATIONAL TRAINING SCHOOL — AKIRA

Great if you're into bikes, drugs and serious rumbles as a way of life. Not so hot if you're female (you'll end up pregnant or on the game or both) or hoping to become a chartered accountant.

BATTLE ANGEL ALITA 1 & 2
(Eng title for GUNNMU, lit Gun Dream; 1 Rusty Angel; 2 Tears Sign, aka BATTLE ANGEL)

JAPANESE CREDITS: Dir: Hiroshi Fukutomi. Script: Akinori Endo. Chara des: Nobuteru Yuki. Supervisor: Taro Rin. Prod: Animate Film. © Kishiro, Shueisha, MOVIC, KSS. Each c35 mins.
WESTERN CREDITS: US video release 1993 on AD Vision, trans Ichiro Araki & Dwayne Jones, on single tape as Battle Angel; UK video release 1994 on Manga Video.
ORIGINS: Manga by Yukito Kishiro, pub Shueisha, Eng trans pub Viz Communications.
POINTS OF INTEREST: UK dub follows the name changes made for the US manga trans. Alita is originally Gally in the Japanese, and in the US subtitled version.
CATEGORIES: SF, X

Alita is just a piece of junk when she is found in the Scrapyard by cyberphysician Ido and salvaged. Life in the Scrapyard, among the dregs of humanity, is hard, and the only way out is to make enough credits to buy your way onto the floating city of Zalem. Alita quickly becomes a feared Hunter-Warrior, a member of the Scrapyard's self-employed mercenary police force cum bounty hunter group, despite Ido's opposition. She befriends the young Hugo, whose dream of escape to Zalem is so powerful that he will do anything to bring it closer, with tragic consequences. A bleak cyberfuture softened only by love springing up in an unlikely place is revealed in limited animation, but with such beautiful design and background work that this is easily overlooked. ★★☆

BE-BOP HIGH SCHOOL 5

JAPANESE CREDITS: Prod: Toei Animation. © Toei Video. 50 mins.
ORIGINS: Manga by Kazuhiro Kiuchi; 1990 OAV.
CATEGORIES: N

More hard high school adventure.

Also:
BE-BOP HIGH SCHOOL BOOTLEG THE FINAL
(Eng title for BE-BOP HIGH SCHOOL BOOTLEG KANKETSUHEN)

JAPANESE CREDITS: Prod: Toei Animation. © Toei Video. 42 mins.

ORIGINS: Parody version of the Be-Bop High School Oavs; 1991 & 1992 Oavs.
CATEGORIES: C

Parody charas from the BBHS team in more skits and songs.

BLACK JACK CLINICAL RECORD I-III
(Eng trans for BLACK JACK CARTE I-III. Ep titles: 1 RYUKIO KIMAILA NO OTOKO, Kimaila Man — Floating Ice; 2 SORETSU YOGI, The Day of the Funeral; 3 MARIATACHI NO KUNSHO, Medals for Maria's Friends)

JAPANESE CREDITS: Dir: Mitsuru Dezaki. Chara des & chief animator: Akio Sugino. Supervisor: Akira Nagai. Prod & © Tezuka Pro. Each 45 mins.
ORIGINS: Manga by Osamu Tezuka.
POINTS OF INTEREST: Father and son voice actor team Chikao and Akio Otsuka appear together as Crossword and Black Jack.
CATEGORIES: SF, DD

One of Tezuka-sensei's most enduringly popular manga, about a maverick doctor operating outside the system and by his own rules, forms the basis for this OAV series. Familiar manga charas like businessman Crossword and Jack's childlike assistant Pinoki, whose body he constructed, like Frankenstein, when she was 'absorbed' by her twin sister in an early manga story, appear in contemporary style. In part one, Jack is offered $3 million to cure his old adversary Crossword of the rare Kimaila disease. But has he actually got it? In part two, Jack visits Sapporo in winter and treats a beautiful young girl, one of a happy group of friends, after an accident. That summer he returns and meets her again. She asks him to try and save her one remaining friend, who is now in a coma. The other two have died mysteriously... In part three, a *coup d'etat* occurs in a South American republic, orchestrated by a powerful Western nation. The former leader is forced to flee and Jack finds himself operating to save his life in a forest by moonlight. Marvellous medical drama with fantasy and horror elements. ★★★?

BOMBER BIKERS OF SHONAN 9 GOOD LUCK FOR ME AND YOU
(Eng title for SHONAN BAKUSOZOKU 9 ORE TO OMAE NO GOOD LUCK, lit Wild Explosive Motorbike Gang from Shonan 9 — Good Luck for Me and You)

JAPANESE CREDITS: Prod: Toei Animation.

© Toei Video. 50 mins.
ORIGINS: Manga by Satoshi Yoshida, pub Shonen Gohosha; Oavs every year 1986-92
CATEGORIES: N, R

Another adventure of the sweet-natured Shokabu gang.

BORGMAN 2 PARTS 1 & 2
(Eng title for CHOSENSHI BORGMAN 2, lit Supersonic Soldier Borgaman 2; 1 Endless City; 2 Downtown Blues)

JAPANESE CREDITS: Dir & writer: Yasushi Murayama. Chara des: Michitaka Kikuchi. Mecha des: Takehiro Yamada. Prod: Ashi Pro. © Toho. Each 30 mins.
ORIGINS: 1988 TV series; 1989 & 1990 OAVs.
CATEGORIES: SF, A

In 2058, the Yoma return under the humanoid Master, and there is a need for a whole new Borgman team. One of the original Borgman heroes, Chuck Sweager, now a doctor and cybernetic engineer, takes Memory Geen's place as mentor of the new team, with cleancut artillery man Curt as its new leader. Ken, a policeman fatally injured by Yoma, is transformed into a Borgman. His sister Eliza has psychic powers that interest the Master and is kidnapped in episode one, to reappear in episode two as a Yoma warrior. Her friend Sara is already a member of the Borgman team, and romance will blossom between her and Ken, but how can she fight her now transformed friend? A sleek, sharp update of an old favourite. ★★☆?

CASSHAN: ROBOT HUNTER 1-3
(Eng title for SHINZO NINGEN CASSHAN SHINWA KARA NO KIKAN, lit Armoured Body Fighter Casshan: Return from the Myth. Eng ep titles: 1 Return From the Myth; 2 Journey to the Past; 3 Blitz on the Bridge)

JAPANESE CREDITS: Dir: Hiroyuki Fukushima. Script: H. Fukushima & Noboru Aikawa. Chara des & anime dir: Yasuomi Umetsu. Prod: Artmic, Tokyo Kids. © Tatsunoko Pro. Each 30 mins.
WESTERN CREDITS: US video release 1995 on Streamline Pictures, on 3 tapes, dub, Eng dialogue Ardwight Chamberlain.
ORIGINS: 1973 TV series.
POINTS OF INTEREST: Released to commemorate Tatsunoko's 30th anniversary year.
CATEGORIES: SF, A

Remake of a much loved series in which, to combat the robots who have taken over the Earth and enslaved humans, a scientist transforms himself into the cyborg Casshan with the help of the beautiful Luna, his girlfriend and daughter of a famous scholar, and his robot dog, which can transform itself into a vehicle or weapon. The original chara designs were by the revered Yoshitaka Amano of *Vampire Hunter 'D'*, *Gatchaman* and *Final Fantasy* fame; Yasuomi Umetsu makes his own distinctive contribution in updating the designs while respecting the original work. Apart from a torn garment and glimpse of breast, this is suitable for most SF-mad twelve-year-olds, but the story has stood the test of time and nowadays offers an interesting twist; at a time when cyber-implants are viewed as progressive and even fashionable, the 'tragedy' of a man compelled to make himself less than human to save his people is not so readily understood. ★★☆

CATGIRL NUKU-NUKU PHASE OIII
(Eng title for BANNO BUNKA NEKO MUSUME, lit All-Purpose Cultural Cat Daughter)

JAPANESE CREDITS: Dir: Hidetoshi Shigematsu & Yutaka Takahashi. Chara des: Yuzo Takada. Art dir: Kazuhiro Arai. Music: Hiroshi Masuda, Beat Club & Vink. Prod: Animate Film. © King Record. 30 mins.
WESTERN CREDITS: UK video release 1994 on Crusader Video, dub, on one tape with the first 2 parts; US video release 1995 on AD Vision, sub, trans Masako Arakawa & Chris Hutts.
ORIGINS: Manga by Yuzo Takada, pub Futabasha; 1992 OAV.
CATEGORIES: SF, C

Nuku-Nuku has begun to see that 'father' isn't right all the time and that the family has to work out its own way of staying together, rather than be forced to pretend to fill roles the individuals can't handle. The finale of this magnificently cathartic episode shows the Prof and his spouse slugging it out with heavy weaponry and enjoying every second of it; for them, destruction of property is an expression of undying love. Just as wacky and just as funny as the first two parts, and beautifully crafted too. ★★★☆

CHAMELEON 2
(Eng title for CHAMELEON 2 JIGOKU NO KYODAI, lit Chameleon 2 Brothers in Hell)

JAPANESE CREDITS: Prod: Reona, Egg,

Domu. © Pack In Video. 53 mins.
ORIGINS: 1992 OAV.

I have no further information on this title.

CRIMSON WOLF
(Eng trans for HONG LANG, the Chinese reading of the title)

JAPANESE CREDITS: Dir: Shoichi Masuo. Script: Shoichi Masuo, Yasuhito Kikuchi & Isamu Imatake. Prod: APPP. © Toshiba EMI. 60 mins.
WESTERN CREDITS: US video release 1994 on Streamline Pictures, dub, Eng dialogue Ardwright Chamberlain.
CATEGORIES: SH, DD

Three untested ninja warriors bearing the Hong Lang birthmark are all that stands between the world and destruction. An archaeological expedition uncovers the tomb of Genghis Khan and reveals an ancient prophecy which says that the three with the Crimson Wolf mark must be found and destroyed. Then the members of the expedition begin to die... At the gates of the Forbidden City, three warriors come together to save themselves and the world. ★★☆?

CYBER FORMULA GPX 3-6
(Eng title for SHINSEIKI GPX CYBER FORMULA II, lit New Century GPX Cyber Formula II; Round 3 SHIN ASRADA NO TANJO, Birth of a New Asrada; Round 4 ZENKAI!, Open It Up; Round 5 KESSEN NO ASA, Morning of the Battle; Round 6)

JAPANESE CREDITS: Prod: Tamiyoshi Tomito. Prod co: Sunrise. © VAP Video. Each 30 mins.
ORIGINS: 1990 TV series; 1992 OAV.
CATEGORIES: N, A

Continuation of the 1992 motor racing OAV series — Hayate and his team-mates and their rivals battle for the right to enter the World Grand Prix. ★★☆?

DEMON STAR DESCENT — GHOST CENTURY WATER MARGIN
(Eng trans for YOSEIKI SUIKODEN — MASEI KORIN)

JAPANESE CREDITS: Writer: Taira Yoshioka. Prod: J.C. Staff. 46 mins.
ORIGINS: Based on the ancient Chinese

legend of The Water Margin, subject of a live-action Japanese TV series which made its way on to UK TV in the early eighties.
CATEGORIES: SH, A

A Buddhist rosary is scattered to the four winds; where the beads fall, those born as they hit the ground become the reincarnations of the 108 heroes of the legend. Nobuteru Sugo is one of them. In present-day Shinjuku he takes on the crime bosses who try to seize land illegally from the rightful owners. ★★☆?

DESERT ROSE

JAPANESE CREDITS: Dir: Yasumao Aoki. Script: Kaoru Shintani. Chara des & art dir: Minoru Yanasawa. Prod: J.C. Staff. © Hakusensha, Shintani. 50 mins.
ORIGINS: Manga by Kaoru Shintani, pub Young Animal magazine by Hakusensha.
CATEGORIES: M, A

The title character is a beautiful female agent code-named Marie Rose. After her husband and child are killed in a terrorist bombing, she is left with nothing but a rose-shaped scar and a thirst to avenge them. She joins the tactical assault squad C.A.T. ★★☆?

DEVIL HUNTER YOKO 3
(Eng trans for MAMONO HUNTER YOKO 3)

JAPANESE CREDITS: Dir: Hisashi Abe. Screenplay: Katsuhisa Yamada. Chara des: Takeshi Miyao. Prod: Madhouse. © Madhouse, Toho Video. 30 mins.
WESTERN CREDITS: US video release 1994 on AD Vision on single tape with part 2, trans Ichiro Araki; UK video release 1995 on Western Connection on single tape with part 2, trans Jonathan Clements; both sub.
ORIGINS: 1991 & 1992 OAVs.
CATEGORIES: DD, A

Also:
DEVIL HUNTER YOKO 4 — EVER THE MUSIC COLLECTION
(Eng trans for MAMONO HUNTER YOKO 4 — EVER THE MUSIC COLLECTION)

JAPANESE CREDITS, ORIGINS, CATEGORIES: As above except: 25 mins.
WESTERN CREDITS: US video release 1994 on AD Vision, on single tape and also on one tape with Devil Hunter Yoko 5. c30 mins.

Yoko 4 is a music video with clips from the first three OAVs. Part three is the 'shojo' episode of the series, full of romance and yearning but with no shortage of monster-busting action. Yoko is doing her best to train Azusa, with mixed results. Chikako is still 'managing' her demon-hunting activities. But no one is prepared for romance to come from another dimension. When a handsome imprisoned Prince calls on Yoko for help and tells her they have been in love in another world, she's only too happy to believe him and go rushing to the rescue. Chikako and Azusa are worried enough to try some magic themselves and follow her, though they're pretty inept about it. But in the end Yoko finds she has freed 'her' Prince for another, and has to go back to her own world to look for real love. Lots more of that cheongsam-slashing action so beloved of pubescent boys of all ages. ★★★☆

D-1 DEVASTATOR 2
(Eng title for D-1 DEVASTATOR 2 GEKITO HEN, lit D-1 Devastator 2 Dead Heat)

JAPANESE CREDITS: Dir: Tetsuo Isami. Script: Masashi Togawa. Mecha des: Seiji Daicho. Art dir: Mitsuhara Miyamae. Key animator: Naoki Ohira. Prod: Dynamic Planning. © Takara, Dynamic Planning. 50 mins.
SPINOFFS: Drama CDs, manga in Asky Comic & several computer game tie-ins.

I have no further information on this title.

DOWNLOAD: DEVIL'S CIRCUIT

JAPANESE CREDITS: Dir: Taro Rin. Chara des: Yoshinori Kaneda. Music: Hiroshi Katsuyama. Prod: Madhouse. © Toei Video. 47 mins.
ORIGINS: Manga by Wataru Nakajima; PC Engine game.
CATEGORIES: H

Shido is a priest and a genius in two fields — computer hacking and lechery. For the sake of the mysterious beauty Namiho, he takes on evil corporate president Echigoya in a battle of wits and skill. That's not enough to enable me to give this a rating, but Taro Rin's name attached to it indicates it's worth a look.

DRAGON HALF 1 & 2
(Eng title for DRAGON HALF; vol 1 MINK NO TABIDACHI, Mink's Departure; vol 2 KYOSATSU BUDOKAI, Violent Tournament)

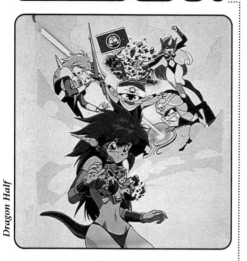

Dragon Half

JAPANESE CREDITS: Dir & script: Shinya Sadamitsu. Chara des: Masahiro Koyama. Art dir: Takahiro Kishida & Masahiro Koyama. Visual art dir: Yusuke Takada. Planning: Toshio Azami. Prod: Production I.G. © Mita, Kadokawa, Victor Entertainment. Each c30 mins. WESTERN CREDITS: US video release 1995 on AD Vision on single tape, sub. UK video release 1996 on AD Vision UK, same version. ORIGINS: Manga by Ryusuke Mita, pub Kadokawa in Dragon magazine. SPINOFFS: The characters have made their way into computer games & other merchandise. CATEGORIES: DD, C

Mink is the product of a strange union between a warrior and a dragon. She's definitely the cutest thing that ever flirted a pair of wings. She's also in big trouble, because the guy she's set her heart on is a dragonslayer by profession. The human half of her will be just fine, but what about the dragon half? Comical, slightly saucy fantasy action. ★★★

EIGHT MAN AFTER VOL 1: CITY IN FEAR
(Eng title for EIGHT MAN AFTER VOLS 1 and 2; US titles: Vol 1: City in Fear; Vol 2: End Run, US aka EIGHT MAN AFTER PERFECT COLLECTION)

JAPANESE CREDITS: Dir: Sumiyasu Furuhawa. Screenplay: Yasushi Hirano. Music: Michael Kennedy. Prod: Sanctuary, JC Staff. © Kuwata, Hirai, Act Co. Each 30 mins. WESTERN CREDITS: US video release 1994 on Streamline Pictures, dub, also released as a compilation of all 4 vols, Eight Man After Perfect Collection, 116 mins; UK video release 1995 on East2West, same version. **ORIGINS: 8 Man manga by Jiro Kuwata & Kazumasa Hirai; 1963 TV series; 1992 movie. CATEGORIES: SF, M**

Eight Man vanished some time ago, presumed killed. Now a new threat to the peace of the city has arisen — supercharged drugs and cyber-implants which turn people into crazed psycho-weapons. Professor Tani has to find a new Eight Man to meet the challenge; when private eye Hazuma is seriously injured on the track of a drug consignment, he gives the young man a new body and new powers. Hazuma hadn't banked on inheriting the original Eight Man's unfinished business in the romantic line, but the Professor's secretary has other ideas. An updated classic plot with cyber-trappings and gore, underlaid by the original solid story and character development. ★★☆

FILENA ETERNAL
(Eng trans for FILENA EIEN)

JAPANESE CREDITS: Chara des: Akemi Takada. ORIGINS: Story serialised in Animage magazine, illustrated by Akemi Takada. CATEGORIES: DD, A

A tyrannical society offers gladiatorial games to keep the masses happy. It's the only way for a commoner to make any kind of decent living, and a lucky few are made Citizens if they survive long enough. Filena poses as a man and enters the arena to make money to support her mother; but as time goes on she begins to wonder whether she should aspire to citizenship in such a corrupt society. Is it better to be a revolutionary and live in poverty and danger than to support evil for the sake of a comfortable life?

GAKUSAVER 1
(Eng title for RYUSEIKI GAKUSAVER, lit Shooting Star Machine Gakusaver; part 1 SHINGAKKI, KAGAI JIGYO, New School Term: Extracurricular Activity)

JAPANESE CREDITS: Dir: Shinya Sadamitsu. Chara des & art dir: Atsuo Tobe. Prod: Production I.G. © King Record, 60 mins. CATEGORIES: C, U

The school kid/robot team has remained enduring-

ly popular ever since the first giant robot series, *Gigantor*, aka *IronMan 28*, was screened. This is yet another example. Ten years ago a giant meteor crash-landed on Earth, and hidden inside were eight machine units of alien origin. Tokichi Hashiba, a teacher at International Academia High School, decides that Earth needs an alien defence force, proclaims himself director and tells his students that their end of year grades depend on co-operation. The students each have a different set of talents, attitudes and skills, and so each unit operates in a distinctive way according to the personality of its pilot; but when all eight units meld into the giant robot Gakusaver, the student who has the strongest drive and initiative at the time is the one who determines the fighting style. Ever seen a robot sumo wrestler? You will... ★★☆?

GENESIS SURVIVER GAIARTH STAGE 3
(Eng title for SOSE KISHI GAIARTH STAGE 3, lit Genesis Knight Gaiarth Stage 3)

JAPANESE CREDITS: Dir, story outline & script: Shinji Aramaki. Dir: Hideaki Oba. Script: Emu Arii. Chara des: Hiroyuki Kitazume. Anime dir: Keiichi Sato, Makoto Bessho, Eisaku Inoue & Tokoro Tomokazu. Prod: Artmic. © Toshiba EMI. 45 mins. WESTERN CREDITS: US video release 1994 on AnimEigo; UK video release 1994 on Anime Projects. ORIGINS: 1992 OAV. CATEGORIES: SF

Further adventures of Ital and Sahari continue the 1992 OAV series in a future world of warring robot factions. Will Ital get his revenge? A mysterious elf called Sakuya awakens from slumber to be captured by the General, who plans to use her powers to dominate the world or destroy it in the attempt. Ital, Sahari, Fayk and Zaxxon set out to stop him. ★★★

GENOCYBER 1-5

JAPANESE CREDITS: Dir: Koichi Ohata. Script: Noboru Aikawa & Emu Arii. Original story: Artmic. Chara des: Atsushi Yamagata. Prod des: Kimitoshi Yamane, Shinji Aramaki, Koichi Ohata, Yoshio Harada & Hitoshi Hukuchi. Anime dir: Kenji Kamiyama. Music: Michinori Matsuoka. Music: Hiroaki Kagoshima & Takehito Nakazawa. Prod: Artmic. Part 1 45 mins, parts 2-5 25 mins each. WESTERN CREDITS: US video release 1994

on US Manga Corps, 5 eps on 3 tapes, sub, trans Neil Nadelman; UK video release 1995 on Manga Video, first 3 parts only, dub. Ep titles US: 1 Birth of Genocyber; 2 & 3 Vajranoid Showdown; 4 & 5 Legend of Ark de Grand. UK: Stage 1 A New Life Form; Stage 2 Vajranoid Attack; Stage 3 Global War. The Legend of Ark de Grand episodes were never released in the UK. ORIGINS: Original story by Artmic; manga by Tony Takezaki. POINTS OF INTEREST: The extensive overlap with the AD Police origination and production team. CATEGORIES: X, V

A plot which can seem formless and at times makes the *Legend of the Overfiend* theatrical edit look coherent; over-the-top visuals with gallons of gunge and gore everywhere; more viscera on display than you'll find in most butchers' shops. This is the story of twin sisters Elaine and Diane, and their abiding love-hate relationship. Naturally, said relationship involves destruction on a massive scale to express its emotional complexity. One has been turned into a cyborg by their scientist father; the other has the mind of a wild animal and massive psychic powers. Daddy and the company he works for, the Kyuryu Group, would like to combine them into one to make a powerful new kind of weapon, the Genocyber, which would tip the balance of world power in their favour. He and most of his colleagues don't survive the success of the scheme, and nor does the city of Hong Kong. That's part one. In parts two and three, the Kyuryu Group, still not having learned its lesson, is testing a new weapon system, the Vajranoid, which can detect the Genocyber's power. This power is now contained in the body of wild-girl Elaine, who has been wandering since she escaped the destruction of Hong Kong and ends up on an American battleship in the test zone. She and the Vajranoid face off against each other with predictably bloody results. Parts four and five see Genocyber vanish at the end of a hundred years of war with the Kyuryu Group; three hundred years later, as mankind struggles back to a semblance of civilisation, a cult has grown up round the legend of Genocyber and two young lovers become embroiled in the final climactic battle. ★☆

GIANT ROBO 2 & 3
(Eng title for GIANT ROBO CHIKYU GA SEISHI SURU HI, lit Giant Robo the Day the Earth Stood Still; 2 BASHUTALE NO ZANGEKI, Tragedy of Bashutale; 3 HATSUREI! DENGI NET WIRE SAKUSEN SHANGHAI NI OTSU,

Command! Electromagnetic Wire Project Defeats in Shanghai)

JAPANESE CREDITS: Dir & Screenplay: Yasuhiro Imagawa. Des: Makoto Kobayashi. Anime dir: Kazuyoshi Katayama. Art dir: Yusuke Takeda. SFX dir: Hideaki Anno. Music: Masamichi Amano. Prod: Mu Film. © Amuse Video. Each 40 mins.
WESTERN CREDITS: US video release 1995; UK video release 1996 both on Manga Entertainment. Western ep titles: 2 The Tragedy of Bashtarle; 3 Magnetic Web Strategy.
ORIGINS: Manga by Mitsuteru Yokoyama; 1968 live-action TV series; 1992 OAV.
POINTS OF INTEREST: Note the spectacular orchestral performance by the Poland National Warsaw Philharmonic Orchestra on the soundtrack.
CATEGORIES: SF, A, C

Further adventures of orphan Daisuke and his huge retro-mech as they help the Experts of Justice battle the dastardly plans of Big Fire for world domination. Dr Shizuma and his prototype Shizuma Drive fall into the hands of Ivan, who explains the power of the Drive and its terrible effects on Bashutarle, as Alberto tries and fails to destroy Giant Robo's power source. Then an energy-sucking orb threatens the last functioning power source on Earth, the Shangahi oil refinery. Defying orders, Daisuke and Tetsugyu take Giant Robo there to help out the other Experts of Justice who are trying to solve the problem; but it seems the orb may be too strong even for Giant Robo. Funny, involving and exciting, an OAV series of superb quality. ★★★☆

THE GIGOLO
(Eng title for DOCHINPIRA, lit Vulgar Punk)

JAPANESE CREDITS: Dir & storyboards: Hironobu Sito. Screenplay: Amano. Art dir: Shigemune Kikoyama. Photography dir: Kenji Kawasaki. Sound: Hiroyuki Matsuoka. Prod: Studio Kikan. © Tetsumi Doko, Seiyo, Jackpot. 45 mins.
WESTERN CREDITS: UK video release 1994 on Kiseki Films, Eng screenplay Ryoichi Murata.
ORIGINS: Story by Makio Hara & Tetsumi Doko.
CATEGORIES: X, V

Jin, a twenty-two-year-old man living in modern Tokyo, decides that he can make a very good living using his looks and sexual prowess, and sets out to build a clientele among the bored rich women who haunt the bars and shopping arcades of the city, looking for ways to fill their time. He also finds himself offering a freebie to one of his former schoolmates, who would like to build a more permanent relationship with him; but before things can develop between them he stumbles into a gangland intrigue and finds himself falling for a beautiful but deadly lady assassin. The whole thing ends in tragedy but he shrugs it off and goes back to his homegirl. The artwork and animation are adequate but forgettable, which sums up the entire package. ☆

THE GIRL FROM PHANTASIA

JAPANESE CREDITS: Dir: Jun Kamiya. Originial story: Akane Nagano. Chara des & art dir: Kazuya Kise. Music: Toshiyuki Watanabe. © King Record. c40 mins.
WESTERN CREDITS: US release 1994 on AD Vision, sub, trans Ichiro Araki, includes bonus art portfolio.
CATEGORIES: X, DD

Akihiro is a student living in a typical student pad — too spartan to entice his girlfriend Michiko to stay over. When he sees a bargain rug he leaps at the chance to buy it and invite her to test out the pile. But sometimes bargains are more than you bargain for, and when Akihiro gets the rug home he finds it's a gateway to another dimension — and out pops a cute, curvy, and very female sprite whose presence he'll have trouble explaining to Michiko! And that's not all — the magic girl is followed by other, equally magic, but much less attractive creatures like the psychotic exiled magician Roll. How can Akihiro get them back into their own dimension before he gets into big trouble with his girl? Softporn fantasy. ★★☆?

GREAT ADVENTURE OF COLUMBUS
(Eng trans for COLUMBUS NO DAIBOKEN)

JAPANESE CREDITS: Prod: Telscreen. © SPO. 70 mins.
CATEGORIES: P?

I have no more information about this title.

THE HAKKENDEN NEW CHAPTER VOLS 1-6
(Eng title for HAKKENDEN SHIN SHO VOLS 1-6

lit The Eight Dogs Legend New Chapter Vols 1-6)

JAPANESE CREDITS: General dir: Takashi Anno. Screenplay: Noboru Aikawa. Chara des: Hiroyuki Ochi. Dir: 1 Takeshi Anno; 2 & 5 Yukio Okamoto; 3 & 6 Takeshi Aoki; 4 Takashi Nakamura. Art dir: 1 Yoichi Nango; 2 Takeshi Waki; 3 & 4 Tatsuya Kushida; 5 Tokuhiro Hiragi; 6 Kenji Kamiyama. Prod: AIC. © AIC, Pioneer. Each 30 mins. WESTERN CREDITS: US video release 1995 on Pioneer, 2 volumes to a tape, sub & dub. Ep titles: Vol 1: 1 The Kaleidoscope; 2 Dark Music of the Gods. Vol 2: 3 The Futility Dance; 4 Horyu Tower. Vol 3: 5 Demon's Melody; 6 The Cicada Spirit Cry. ORIGINS: 98 volume Edo period novel by Bakin Kyokutei; 1990 & 1991 OAVs. CATEGORIES: SH, H

A new series continues the story of the eight spiritually linked 'brothers' with a Princess for a mother and a dog for a father, who are reunited to fight evil and restore the honour of their mother's clan. Distinctive, magical visuals and some real chills. The story opens in 1457 when Princess Fuse is forced to marry her dog Yatsufusa because of a rash promise made by her father to give her to anyone who brought him the head of his enemy. Volume two introduces the first of the eight, orphaned Shino, whose father left him a priceless Murasame sword. Volume three sees the warrior Sosuke ordered to kill Shino but instead pledging brotherhood to him, and the maiden Hamaji is saved from a marriage she detests and reunited with her long-lost brother Dosetsu. Volume four sees two of our heroes in trouble when Sosuke is accused of murdering his parents and Shino's sword turns out to be a fake. Genpachi, the fourth dog warrior, helps Shino escape from captivity, but Sosuke faces crucifixion. Dramatic scenes of life in mediaeval Japan mixed with legend and religion make this a fascinating series. ★★★

HERE IS GREENWOOD 5, PARTS 1 & 2
(Eng title for KOKO WA GREENWOOD V: KIMI O SUKI DE YOKKATA PARTS 1 & 2, lit I'm Glad I Love You, Parts 1 & 2)

JAPANESE CREDITS: Dir & script: Tomomichi Mochizuki. Chara des: Masako Goto. Prod: Studio Pierrot. © Victor Entertainment. Each 30 mins. ORIGINS: Manga by Yukie Nasu, pub Hana To Yume (Flowers & Dreams) girls' weekly

magazine, Hakusensha; 1991 & 1992 OAVs. POINTS OF INTEREST: Kazuyuki Sekiguchi, of top Japanese rock band the Southern All Stars is credited as sound producer on the series. CATEGORIES: N, DD

Greenwood has been described as 'a more plausible version of *Urusei Yatsura*' — without the SF element, though with some fantasy, and with more grounding in real life, but with the same off-beat charm and the same sharp eye for real relationships between teenagers. As Kazuya struggles to come to terms with his feelings, prejudices and problems and with growing up, his friends and dorm-mates are going through the same process. Being in Greenwood makes life much easier and provides mutual support and sympathy. A charming series. ★★★?

THE HEROIC LEGEND OF ARSLAN 3 & 4
(Eng trans for ARSLAN SENKI 3 & 4, lit Arslan Battles 3 & 4, US aka HEROIC LEGEND OF ARISLAN 3 & 4)

JAPANESE CREDITS: Dir: Mamoru Hamatsu. Writer: Tomoya Miyashita & Kaori Takada. Chara des: Sachiko Kamimura. Music: Norihiro Tsuri. © Tanaka, Kadokawa, MOVIC, SME. Each 30 mins. WESTERN CREDITS: US release 1995 on US Manga Corps, sub, Eng rewrite Jay Parks; UK video release 1995/6 on Manga Video on two separate tapes, dub. ORIGINS: Novel by Yoshiki Tanaka; created by Haruki Kadokawa, Hiroshi Inagaki & Yutaka Takahashi; 1991 & 1992 movies. POINTS OF INTEREST: The UK release reverts to the original Japanese transliteration of the Prince's name, while the US release opts for preserving unity over the series by calling him Arslan. CATEGORIES: DD, A

The Lusitanian army is in command of the rich land of Parse and its Prince, Arslan, is on the run with five devoted followers, raising an army to oppose the invaders. The mysterious Silvermask, who raised such doubts in Arslan's mind, is out to track down a fanatic priest, Jon Bodan — not simply to eliminate him, as his allies think, but to use him to contact the dark powers of sorcery which will turn the key to his deepest desires. Can Narsus' magical powers repel the invaders and give their forces an advantage? Can Arslan survive and triumph? Despite the move from theatrical format

and the associated higher quality, these OAV episodes are still beautiful to look at and stuffed with pretty young men. ★★☆

HUMMINGBIRDS
(Eng title for IDOL BOETAI HUMMINGBIRD, lit Idol Defence Band Hummingbird)

JAPANESE CREDITS: Dir: Yasushi Murayama. Anime dir: Kenichiro Katsuro. Art dir: Torao Arai. Prod: Ashi Pro. © Toho Video. 50 mins. WESTERN CREDITS: UK video release 1995 on Western Connection, sub, trans Jonathan Clements. ORIGINS: Story by Taira Yoshioka, who originated Irresponsible Captain Tyler. POINTS OF INTEREST: Launched the careers of the five voice actresses in the leading roles and started a boom in providing stories stuffed with 'cute' roles for young actresses which continues to this day. CATEGORIES: R, A

Imagine, if you will, *Thunderbirds* starring the Nolan Sisters, or *Top Gun* with Kylie Minogue, pre-credibility transplant, in the leading rôle. The Hummingbirds are a group of idol singing sisters, and in these days of defence cuts and privatisation of services, Japan's air defences have been contracted out to idol singers, who compete for the contracts under the direction of their managers. Five cute girls ranging from pre-teenage to almost-adult fly their planes, wear silly costumes for promos, and sing at concerts in matching sunshine-coloured dresses while defeating their rivals' dastardly plots and fending off danger to their country. It's completely daft, but it's pretty, and the flying sequences are very well animated; and it was popular enough in Japan for more OAVs and concert tours by the voice actresses to enjoy success in the summer of 1994 and 1995 too. ★★

Hummingbirds

JOJO'S BIZARRE ADVENTURE 1 & 2
(Eng Trans for JOJO NO KIMIYONA BOKEN)

JAPANESE CREDITS: Dir: Hiroyuki Kitakubo. © Araki, Shueisha. Each c30 mins. ORIGINS: Based on vols 13-28 of the manga by Hirohiko Araki, pub Shueisha 1987. CATEGORIES: DD, X

One of the freakiest and most distinctive martial arts/horror manga of the nineties comes to the screen. The adventures of the Joestar clan started in Jack the Ripper's England, but the anime focuses on the third generation heir to the Joestar name and his titanic struggles with Nazis and psychic masters just before the Second World War. Heavily based on the Tarot and mystical texts, and stuffed with obscure references, this is a love-it-or-hate-it series, guaranteed to provoke a strong reaction. ★★★?

KAMEN RIDER SD

JAPANESE CREDITS: Prod: Toei Animation. © Ishinomori, Bandai Visual. 30 mins. ORIGINS: Manga by Shotaro Ishinomori; live-action TV series. CATEGORIES: C, U

The *Kamen (Masked) Rider* series was the point of origin of many live-action and anime concepts and is the first step in a line of development that led eventually to *The Mighty Morphin' Power Rangers*. In this SD version, too, the darker and more serious side of the original concept is overwhelmed by typical SD silliness. The various Kamen Riders get together, fall in love, do embarrassing things and generally have fun. ★★★

KISHIN CORPS 1-5
(Eng title for KISHIN HEIDAN, lit Machine God Army; 1 & 2 SHUTSUGEKI! RAIJIN KIDO SHIREI, Go Forth! Wake Up the Thunder God! parts 1 & 2; 3 BOSO RESSHA SAKUSEN, Violent Train Project; 4 & 5 KISHI TAI KOSENSHI, Machine God Vs Armoured Knights, parts 1 & 2)

JAPANESE CREDITS: Dir: Takaaki Ishiyama. Chara des & anime dir: Masayuki Goto. Mecha des: Takeshi Yamazaki & Koji Watanabe. Art dir: Mitsuki Nakamura. Music: Kaoru Wada. Prod: Ginga Teikoku. © Yamada, Chuokoronsha, Pioneer LDC. Each part 30 mins, except 1, c60 mins. WESTERN CREDITS: US & UK video release 1995 on Pioneer, dub. Ep titles: Vol 1: 1

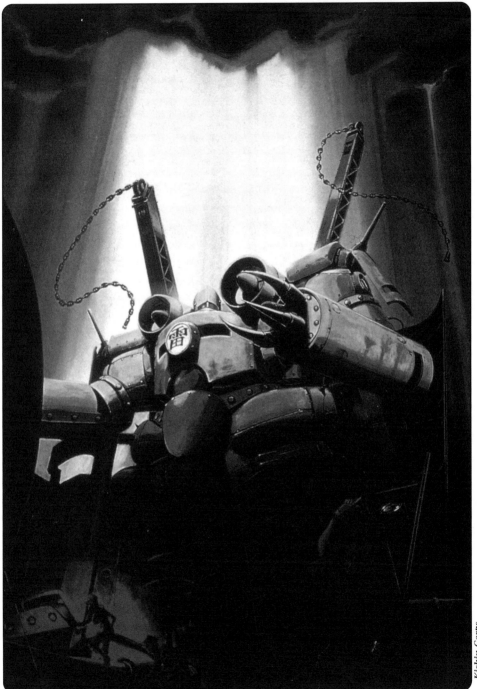

Kishin Corps

*Mission Call for Kishin Thunder. Vol 2: 2
Surprise Attack; 3 The Battle. Vol 3: 4
Kishin vs Panzer Knight Part 1; 5 Kishin vs
Panzer Knight Part 2.*
*ORIGINS: Novels by Masaki Yamada, pub
Chuokoronsha.*
CATEGORIES: SF, A

Another retro-robot story takes the alternative
history of World War Two as its starting point.
Just like its distinguished precursor *Giant Robo*, it
has a spunky orphan boy joining a team fighting
evil. This time the evil is threefold — the Nazis,
those members of the Japanese armed forces who
are working with them, and aliens attacking Earth
at random. Some of the alien technology has been
captured and studied, and although barely under-
stood it is being used to create huge robots.
Despite their origins in alien technology, they still
also make use of the human technology of their
day, and the valves and gears shown cranking and
sparking into action as they power up make for
some fascinating sequences. The story is pure for-
ties Saturday matinée adventure, with wonderful
character stereotypes — the good woman, the evil
beauty, the goofy scientist, the dashing flying ace,
the dastardly general and his obedient subordi-
nates, and many more. Real people crop up, or
rather have their names borrowed; Eva Braun is
flattered by inclusion as a top scientist whose
amorality in the pursuit of knowledge causes
problems for our heroes, and she is also given an
angelically good twin sister, Maria, leading to
even more confusion. Superb mecha action spread
throughout an excellent story, and in particular
some great chase sequences, make up for the at
times oddly slow pacing. (Watch for the
bicycle/car chase and the steam engine
sequences.) ★★★

KISS ME ON THE APPLE OF MY EYE

*JAPANESE CREDITS: Dir: Takuji Endo.
Script: Asami Endo. Chara des & anime dir:
Kazukuro Saeta. Prod: Madhouse for
Margaret Video series. © Ueda, Shueisha.
c40 mins.*
*ORIGINS: Manga by Noriko Ueda, pub
Margaret weekly magazine by Shueisha.*
CATEGORIES: R

Another in the series of romances based on stories
from the bestselling women's manga anthology.
Schoolgirl Ibuki Morisato is ready for love and
dreaming of her first kiss. Then the boy of her
dreams arrives to stay with her family and join

her class at school! A dream come true? Well,
maybe...

KO CENTURY BEAST WARRIORS II, PARTS 1-3
(Eng title for KO SEIKI BEAST SANJYUSHI II;
1 POWER UP DE SURVIVAL WAR TO!, Power Up
for Survival War; 2 PANIC CITY WA LOVE
ROMANCE DEI!?, Panic City is Full of Love and
Romance!?; 3 TRIPLE SORYAKU SEN! YUNI O
OIKAKERO!, Triple Contest! Chase Yuni!)

*JAPANESE CREDITS: Dir: Hiroshi Negishi.
Script: Satoru Akahori. Prod: Animate Film.
© SME, KSS. Each c30 mins.*
ORIGINS: 1992 OAV.
CATEGORIES: SF, C, U

Much spikier, sharper, more manic designs and a
fast-cut cute-punk opening credit sequence lead
into the concluding parts of the *KO Century* story.
V-zhon, V-daan and Akumako are still hot on the
trail of the Beasts and the power of Gaia, and Dr
Password's long scheme is coming to fruition.
Yuni has been developed for a specific purpose,
just like the Beasts, and turns out to have more
than one form. As the Tourmaster's evil minions
attack Meima's home city and pursue the Beasts
into the heart of Gaia itself, only innocence and
courage can save the world. The ending is, of
course, happy, with harmony restored and the
natural order of Gaia prevailing; but *en route* there
is more of the first series' teenage animal may-
hem, including such wonderfully funny seq-
uences as V-daan dressing as a giant beaver, Wan
meeting Meima's mother — and seeing exactly
how she will grow up! — and a mah-jong game
which ends with Badd just seconds away from
becoming a bucket of fried chicken. Wonderful
animation, great music, silliness and style in
bucketloads. ★★★★

LAMUNE & 40 DX 1-3
(Eng title for NG KISHI LAMUNE & 40 DX
WAKUWAKU JIKU, HONO NO DAISOUSASEN, lit
NG Knight Lamune & 40 DX Heart Beat Time-
Space, Big Fire Investigation; 1 ARATA NI
TABIDATE AI NO SENSHITACHI, Start Out
Again, Soldiers of Love; 2 AI NO KISHITACHI
KAKO E, The Soldiers of Love Are Past; 3 AI
NO KISHITACHI EIEN NI, Soldiers of Love Into
Eternity)

*JAPANESE CREDITS: Dir: Satoru Akahori.
Chara des: Takehiko Ito. Prod: Ashi Pro. ©
King Record. Each 30 mins.*

ORIGINS: *1990 TV series; 1991 OAV NG Knight Lamune & 40.*
CATEGORIES: *C, U*

TV series *NG Knight Lamune & 40* started when a ten-year-old game freak fell into the world of the video game *King Sccasher*, Alala, to adventure with Princesses Milk and Cocoa as pilot of the King Scassher robot. Lamuness the Brave, aka ten-year-old Lamune, was hugely popular and the OAV started a new trend for a certain brightness of style, swiftness of pace and silliness of content. The new adventures follow much the same lines. ★★★?

LEGEND OF GALACTIC HEROES VOLS 55-78
(Eng trans for GINGA EIYU DENSETSU)

JAPANESE CREDITS: *Gen dir: Noboru Ishiguro. Series concept: Shimao Kawanaka. Plot: Masatoshi Tahara, Tsutomu Otsuka & Toshihiro Sakai. Mecha concept: Yasumi Tanaka. Art concept: Jin Nagao & Shinichi Tanimura. Mecha anime dir: Hideki Takahashi. Art dir: Jin Nagao. Sound dir: Susumu Akitagawa. Sound prod: Music Capsule. Prod: Masatoshi Tahara. Prod co: Kitty Film Mitaka Studios. © Tanaka, Tokuma, Kitty Enterprise. Each c30 mins.*
ORIGINS: *Yoshiki Tanaka's novel series, pub Tokuma Shobo; 1988 movie; 1988, 1989, 1991 & 1992 OAVs.*
CATEGORIES: *SF, W*

A new series of Tanaka's space opera. Reinhart Von Lohengrimm is unchallenged Emperor and has finally met Yang Wen-Li, the man whose destiny has been so closely linked with his for their entire careers as leaders of opposing armies. Looking back to the innocence and idealism of his youth, this series asks if Reinhart can possibly maintain his ambition to rule justly in the real world, where so many of his old companions and in particular those closest to him are no longer by his side — or is the wish to serve justice simply part of a world of dreams, a return to those bygone days? ★★★★?

LEGEND OF LEMNEAR

JAPANESE CREDITS: *Dir: Kinji Yoshimoto. Chara des: Satoshi Urushibara. © Nihon Cine TV Corp. c45 mins.*
WESTERN CREDITS: *US video release 1996 on US Manga Corps.*
ORIGINS: *Satoshi Urushibara's manga.*
CATEGORIES: *X, DD*

A sword and sorcery (or more properly, lances and lechery) drama about a young girl who goes in search of her missing sister and finds her the tool of an evil tyrant, who is bent on killing her to remove opposition to him. Very prettily drawn, with a predictable story and gratuitous breast shots, but nothing to get excited about. ★★

LEGEND OF THE FOUR KINGS PARTS 9-12
(Eng title for SORYUDEN, lit Dragon Kings Legend, UK ep titles: 9 The Fierce Wind; 10 Narrow Escape; 11 A Revolution of the Heavens; 12 The Four Dragon Kings)

JAPANESE CREDITS: *Dir: Shigeru Ueda & Yoshihiro Yamaguchi. Script: Akinori Endo. Chara des: Shunji Murata. Art dir: Shichiro Kobayashi & Jiro Kono. Prod: Kitty Film. © Tanaka, Kitty, Fuji TV, Kodansha. Each 45 mins.*
WESTERN CREDITS: *UK video release 1995 on Manga Video, dub; US video release 1995 on US Manga Corps, 2 eps to a tape, sub, Eng rewrite Jay Parks.*
ORIGINS: *Novel by Yoshiki Tanaka; 1991 & 1992 OAVs.*
CATEGORIES: *DD, A*

Concludes the adventures of the Ryudo brothers, dragon god avatars striving to lead a normal life in modern Japan. Owaru has been kidnapped by Lady L; as Hajime attempts a rescue he transforms into the White Dragon. In the subsequent chaos she persuades the police to arrest the brothers and manages to get them branded as terrorists. When she and Tamozawa finally capture Hajime and take him to an aircraft carrier for vivisection, the Blue Dragon emerges, and eventually heads for America where he starts to destroy all military facilities. But this isn't the biggest problem; an ancient enemy of the Dragons, the Shiyu, is awake, and the Dragon Kings have to overcome it to save the world from armageddon. A bit of a yawn despite the origin, which is usually a sign of a good story to come. ★☆

MAGICAL PRINCESS MINKY MOMO IN BRIDGE OF DREAMS
(Eng title for MAHO NO PRINCES MINKY MOMO IN YUME NI KAKERU HASHI, lit Magical Princess Minky Momo Bridge Crossing to Dreams)

JAPANESE CREDITS: *Prod: Ashi Pro. © King Record. 40 mins.*
ORIGINS: *1982 TV series; 1985 movie Gigi*

and the Fountain of Youth; 1992 movie.
CATEGORIES: DD, U

The magical Princess remains enduringly popular as she tries to bring dreams and hopes back to mankind in her second incarnation.

MOLDIVER PARTS 1-6

(Ep titles: 1 Metamorforce; 2 Overzone; 3 Longing; 4 Destruction; 5 Intruder; 6 Verity)

JAPANESE CREDITS: Series dir: Hirohide Fujiwara. Dir, original concept & chara des: Hiroyuki Kitazume. Screenplay: 1, 4 & 6 Manabu Nakamura; 2, 3 & 5 Ryoei Tsukimura. Des: Takashi Watanabe. Art dir: Masumi Nishikawa. Music: Kei Wakakusa. Prod: AIC. © Pioneer LDC. Each 30 mins.
WESTERN CREDITS: US & UK video release 1994 on Pioneer.
POINTS OF INTEREST: Note the deliberate use of katakana titles, indicating that these are foreign words, and the initial letter of each episode title plus the second and third of part six...
CATEGORIES: U, R, A

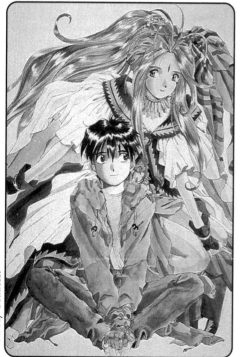

Oh My Goddess!

Also:
SECRET OF MOLDIVER: SECRET ENCYCLOPAEDIA

(Eng trans for SECRET OF MOLDIVER HIMITSU DAIHYAKKA)

CREDITS, POINTS OF INTEREST, CATEGORIES: As above except: 11 mins.

Secret of Moldiver is a curtain-raiser/trailer to the series, presenting snippets of art and settei. Anime has always been fascinated by Western superheroes and Moldiver is the latest reflection of this interest. Hiroshi Ozora, a scatty genius, designs the Mol Unit, which can turn him into superhero Captain Tokyo. Then his sister Mirai, seventeen and no slouch in the intellectual stakes herself, makes a few modifications to render the suit more feminine and fashionable. But the powerful ZIC Corporation and its evil genius head, Dr Machinegal, who masquerades as a nice old professor, are out to steal more and more priceless historic technological artefacts for his private collection, and gain more and more power and influence. Using his android warriors, made in the shape of cute girls and named for famous Western film stars, the Doctor takes on the Moldiver. But all sides reckon without two things — Mirai's secret love for Hiroshi's best friend, and their pesky little brother, who's much, much cleverer than either of them. The gender-shifting comes as a bit of a surprise too, and as for the nude re-materialisation, well... Bright, colourful and fun. ★★★

OH MY GODDESS! 1-5

(Eng trans for AA MEGAMISAMA. Ep titles: 1 Moonlight and Cherry Blossoms; 2 Midsummer Night's Dream; 3 Burning Hearts on the Road; 4 Evergreen Holy Night; 5 For the Love of Goddess)

JAPANESE CREDITS: Dir: Hiroaki Goda. Script: Naoko Hasegawa & Kunihiko Kondo. Chara des: Hidenori Matsubara. Backgrounds: Hiroshi Kato. Music: Takeshi Yasuda. Prod: AIC. © Fujishima, Kodansha, KSS, TBS. Each 30 mins.
WESTERN CREDITS: US video release 1994 on AnimEigo; UK video release 1995 on Anime Projects, trans Shin Kurosawa & Michael House; both sub.
ORIGINS: Manga by Kosuke Fujishima, pub Kodansha, Eng trans pub Dark Horse.
POINTS OF INTEREST: There is a passionate debate among a small group of fans as to whether the correct translation of AA is

'Oh', as used by AnimEigo, or 'Ah'...
CATEGORIES: DD, R

Keiichi is bottom dog in his student dorm and thinks he's too short to get a girlfriend; then one day he misdials for a Chinese takeaway and gets a goddess to go. Belldandy, one of the three sisters who keep the Heavenly Forces in balance and work at the Helping Goddess Office, materialises and answers his wish for a girlfriend just like her by staying. Of course all sorts of problems arise; he gets kicked out of his men-only dorm for having a girl there, and they have to sleep out in an old temple. Then he spends almost all his money on equipping their new home. What on earth is his kid sister going to tell their parents when she arrives and finds him living with a (very) foreign woman? But Belldandy is cute, sweet and waits on him hand and foot, and as time wears on he wants her to stay forever — if only he could work up the courage to hold her hand, or even kiss her. Her elder and younger sisters, Urd and Skuld, turn up to join the household... The compression of a long manga with its well-developed characters into the very short space of five OAVs has led to massive story compression, even before the editing for the Western manga version was done. The intended (Japanese) audience has already read and loved the manga — that's why they're buying the OAVs, after all — and so details of characters and relationships are only sketched in, which to Western eyes makes for very shallow, superficial characterisation. Belldandy comes off worst, looking like a complete doormat, a parody of the ideal of Japanese femininity. However, the OAVs are very pretty indeed, with charming designs — especially the Goddesses' costumes — and background paintings of considerable artistry. Once you accept the shorthand characterisations, there's not much to quibble about here. ★★★

ORGUSS 02, 1 & 2
(Eng title for CHOJIKU SEIKI ORGUSS 02,
lit Super Dimensional Century Orguss 02)

JAPANESE CREDITS: Dir: Fumihiko
Takayama. Screenplay: Mayori Sekijima,
Hiroshi Yamaguchi & Yuji Kishino. Chara
des: Haruhiko Mikimoto. Art dir: Shichiro
Kobayashi. Music: Torsten Rasch. © Orguss
02 Project, Big West. Each 30 mins.
WESTERN CREDITS: US & UK video release
1995 in 3 vols on Manga Video, dub, trans
Raymond Garcia.
ORIGINS: 1980 TV series; original story by
Fumihiko Takayama.
CATEGORIES: SF

For two centuries huge war machines once known as Decimators have lain unused and almost forgotten on the ocean floor and under the earth. Two opposing nations are racing to uncover them and use their devastating potential, and as more of the robots are discovered and reactivated the threat of all-out, worldwide war moves closer and innocent parties are drawn into the conflict. Lean, a young Revillan officer, is working on the routine excavation of one of the machines when an ambush by the opposing Zafrin army forces him to pilot the Decimator in order to survive their attack. He survives but his whole life is changed; he is sent on a mission into enemy territory to try and destroy their Decimators. ★★★?

OZ PARTS 1 & 2

JAPANESE CREDITS: Dir: Katsuhisa
Yamada. Music: Yoichiro Yoshikawa. ©
Izuki. Part 1 35 mins, part 2 30 mins.
ORIGINS: Manga by Natsumi Izuki, based
on the novels by Frank L. Baum.
CATEGORIES: SF

This sure isn't Kansas, Toto. In 1990 a nuclear war killed 60% of mankind and split the USA into six warring territorial factions. Thirty-one years later a legend survives amid the civil strife, hunger, chaos and devastation — the legend of a city where high technology has survived to serve man and war and hunger are unknown — the fabulous city of Oz. Three companions set out to find Oz — the scientist Felicia Epstein, the mercenary Muto and Droid 1019. What they actually find is a military base ruled by a mad scientist with dreams of dominion. Can they stop him? ★★☆?

POPS

JAPANESE CREDITS: Dir: Takuji Endo.
Script: Asami Endo. Chara des & anime dir:
Kazukuro Saeta. Prod: Madhouse for
Margaret Video Series. © Shueisha, Ikuemi.
c40 mins.
ORIGINS: Manga by Aya Ikuemi, pub
Margaret magazine by Shueisha.
CATEGORIES: R

Another of the romantic video series from Shueisha, this is the love story of two high school students, and chronicles all the problems, misunderstandings and pressures they face in trying to combine study and romance.

RAIJIN-OH 3

(Eng title for ZETTAI MUTEKI RAIJIN-O, lit Unrivalled King Raijin; part 3 MINNA GA CHIKYU BOEI-GUMI, lit Everyone is in the Earth Defence Group)

JAPANESE CREDITS: Prod: Kenji Uchida. Prod co: Sunrise. © Toshiba EMI. 30 mins. ORIGINS: 1991 TV series; 1992 OAV. CATEGORIES: SF, U

More adventures of the eleven-year-old Earth Defence Group team, as they fight off alien invaders and their monster henchmen in the mighty robot Raijin-Oh.

REI REI

JAPANESE CREDITS: Dir: Yoshikio Yamamoto. Script: Mitsuru Mochizuki. Created by: Toshimitsu Shimizu. © Toshimitsu Shimizu, Shonen Gahosha, Pink Pineapple. 60 mins. WESTERN CREDITS: US video release 1995 on AD Vision, trans Ichiro Araki & Dwayne Jones; UK video release planned for summer 1996 on Kiseki Films, trans Jonathan Clements. An edited version which is not X-rated is also available in the USA. ORIGINS: Original story by Toshimitsu Shimizu. POINTS OF INTEREST: US release includes bonus art portfolio. CATEGORIES: X, V

Kaguya isn't a normal girl — in fact she isn't a girl at all, she's a powerful entity who can warp time and space, has a weird sense of humour and just loves baring her breasts. Helped by her little manservant, she likes to lend a hand in the affairs of humans who have problems they just can't solve. Somehow, though, her 'help' isn't quite what her victims would have wanted; there's the doctor who spends ages plotting a perfect murder to dispose of an unwanted lover, only to have it foiled, and the guy who doesn't know the girl of his dreams loves another until he gets into her head in an unexpected way. This isn't a plot, it's a silly excuse for erotic fantasy, but it's beautifully drawn and well animated. ★☆?

RUMIKO TAKAHASHI'S RUMIK WORLD — MERMAID'S SCAR

JAPANESE CREDITS: Dir: Morio Asaka. Script: Tatsuhiko Urahata. Chara des &

anime dir: Kumiko Takahashi. Art dir: Hidetoshi Kaneko. Music: Norihiro Tsuri. Prod: Kitty Film. © Takahashi, Shogakukan, Kitty. 50 mins. WESTERN CREDITS: US video release 1995 on Viz Video, dub, trans Toshifumi Yoshida, Eng script by Trish Ledoux. ORIGINS: Manga series by Rumiko Takahashi, pub Shogakukan, Eng trans pub Viz Communications; OAVs every year 1985-87 & 1991. CATEGORIES: H, X

Yuta and Mana, travelling companions and immortals, meet little Masato and his mother Mina. It appears that the two have an unusually close and loving relationship, but all is not as it seems. Childhood and mother-love are not necessarily guarantees of innocence — especially in the quest for a meal of mermaid's flesh. ★★☆?

SINGLES

JAPANESE CREDITS: Dir: Takuji Endo. Script: Asami Endo. Chara des & anime dir: Kazukuro Saeta. Prod: Madhouse for Margaret Video Series. © Shueisha, Fujimura. ORIGINS: Manga by Mari Fujimura, pub Margaret magazine by Shueisha. CATEGORIES: R

Saki is secretly in love with her elder sister's boyfriend, Yo. On leaving college she tries to forget him, but fails, so she joins his social club to at least be near him. She meets another new member, Daichi, and they become friends. When they find themselves making a video together, will her feelings for Yo finally fade away?

SLEEPLESS OEDO

JAPANESE CREDITS: Dir: Takuji Endo. Script: Asami Endo. Chara des & anime dir: Kazukuro Saeta. Prod: Madhouse for Margaret Video Series. © Honda, Shueisha. c40 mins. ORIGINS: Manga by Keiko Honda, pub Margaret magazine by Shueisha. CATEGORIES: R, P

Set in old Tokyo, which was called Edo, this period drama chronicles the adventures of a group of three unlikely friends — the famous courtesan Usugumo, the thief Kikunosuke, and a brilliant young doctor.

TAKAMARU 1-6

JAPANESE CREDITS: Dir: Nao Minda. Anime dir: Takahiro Yoshimatsu. Music: Kohei Tanaka. Prod: Toyo Ashida. © Bandai Visual. Each c27 mins.
CATEGORIES: A, U

Set in the world of the 'Champion Kingdom', an imaginary island whose inhabitants follow a samurai lifestyle, this is a tale of friendship and courage originally intended for pre-teens and young teenagers.

TENCHI MUYO! RYO OH KI 5 & 6

(See last year's Tenchi entry for the various translations of the title; 5 SHINGA-JIN SHURAI, Invasion of the Shinga; 6 TENCHI HITSUYO!, We Need Tenchi!)

JAPANESE CREDITS: Dir: Hiroki Hayashi. Screenplay: Naoko Hasegawa, Masaki Kajishima & Hiroki Hayashi. Chara des & anime dir (5): Masaki Kajishima. Anime dir (6): Yuji Moriyama. Art dir: Takeshi Waki. Sound dir: Yasunori Honda. Music: Seiko Nagaoka. Prod: AIC. © Pioneer LDC. Each 30 mins.
WESTERN CREDITS: UK & US video release 1994 on Pioneer. Trans 5 Mutsuko Erskine, 6 Naomi K. Martin, dialogue polish 5 & 6 Jack Fletcher.
ORIGINS: 1992 OAV.
SPINOFFS: Manga, a popular radio drama series scripted by Naoko Hasegawa, TV series, CDs & merchandise galore.
CATEGORIES: DD, A, C

Kagato, the galactic criminal whom officer Mihoshi was pursuing, arrives on Earth, and boy, is he evil! Grandfather reveals himself to be not human at all, but the lost Jurai Prince whom Aeka was seeking — Tenchi is therefore also a Prince of the Jurai Royal Line, and the tentative romance which has been blossoming between him and Aeka takes on momentum when she realises she has truly lost her half-brother. Then Wasshu, cutest and cleverest pink-haired scientific genius in the galaxy, turns up too, and the scene is set for a titanic battle in space. While everyone is rushing about and getting nowhere, the two youngest members of the family, Sasami and Ryo-Oh-Ki, have the good sense to save the day by transforming into rather less cute but very effective modes. The conclusion of Tenchi's adventures was only temporary; the special featured all the familiar

faces and situations, and of course more OAVs and TV episodes followed. ★★★★

Also:
TENCHI MUYO! RYO OH KI SPECIAL 7: THE NIGHT BEFORE THE CARNIVAL
(Eng trans for TENCHI MUYO! RYO OH KI OMATSURI ZENYA NO YORI)

JAPANESE CREDITS: Dir: Kenichi Yatagai. Screenplay: Yosuke Kuroda. Chara des & story concept: Masaki Kajishima. Art dir: Takeshi Waki. Music: Seiko Nagaoka. Prod: AIC. © AIC, Pioneer. 45 mins
WESTERN CREDITS: US video release 1994; UK video release 1995 both on Pioneer. Trans Eriko Mori, dialogue polish Jack Fletcher.
ORIGINS, SPINOFFS, CATEGORIES: As above.

Despite the defeat of Kagato, Tenchi's troubles are not over. Wasshu's experiments land him in a very embarrassing situation, Ryo-oh-ki clones eat all the family's supply of carrots, and Ryoko and Aeka are still fighting over him. *Tenchi* fans worldwide loved this extra helping of their favourite cute OAV, beautifully produced and holding no surprises. ★★★

TOKYO BABYLON 2

JAPANESE CREDITS: Dir, chara des & anime dir: Kumiko Takahashi. Screenplay: Hiroaki Jinno. Original story: CLAMP. Art dir: Yuji Ikeda. Music: Toshiyuki Honda. Prod: Animate Film. © CLAMP, Shogakukan, MOVIC, SME. c55 mins.
WESTERN CREDITS: UK video release 1994 on Manga Video, dub, Eng rewrite George Roubicek; US video release 1995 on US Manga Corps, dub & sub, trans as above.
ORIGINS: Manga by CLAMP; 1992 OAV.
CATEGORIES: DD, M

Subaru Sumeragi is involved in another psychic mystery in modern Tokyo. This time a beautiful young psychic who can 'read' past events from their setting is trying to help police track down a serial killer when her own mother becomes a victim. Both she and Subaru go into danger as they become the killer's prey in a gripping chase in the Tokyo subway. This is a tense psychological drama in its own right and the psychotic is a genuinely convincing and chilling creation. Although many of the subtleties of the manga are missing and the emphasis of Subaru's major relationship is completely altered, the OAVs reflect CLAMP's visual

style superbly and form an easy introduction to one of their most interesting manga works.
★★★☆

UROTSUKIDOJI III: RETURN OF THE OVERFIEND 1-4

(Eng ep titles: 1 The Birth of the True Chojin; 2 The Secret of Caesar's Palace; 3 The Fall of Caesar's Palace; 4 Passage Into the Unknown)

JAPANESE CREDITS: Dir: Hideki Takayama. Script: 1 Noboru Aikawa; 2 & 3 Hideki Takayama; 4 Gonzo Sasakusa. Chara des: Rikizo Sekime & Shiro Kasami. Monster des: Sumito Loi. Art dir: Kenichi Harada. Music: Masamichi Amano. © Maeda, Westcape Corp. Each 50 mins.
WESTERN CREDITS: UK video release 1994 on Kiseki Films, trans Jonathan Clements; US video release 1994 on Anime 18 using same trans.
ORIGINS: Manga by Toshio Maeda; see also Legend of the Overfiend.
CATEGORIES: X, H, V

Twenty years after Nagumo ravaged the world, Amanojaku learns that Akemi is about to give birth to the true Overfiend, decades earlier than planned. The Overfiend lets Amano know that an evil being, Kyo-O, is about to be born, and demands that he keep this creature away from Osaka Castle. Meanwhile in Tokyo, Caesar is fighting a new menace, a newly evolved order of creatures called the Demon-Beasts, who under the leadership of Buju are fighting his tyrannical rule. His agent Faust (who is really Myunihausen in disguise) plots to unite the child who will become the Kyo-O with a demonic creation of their own. But Caesar is vulnerable through his love for the android he made to replace his dead daughter Alecto. When she and Buju defy him, he exacts a terrible revenge, yet when she is taken by the Demon-Beasts he pursues them relentlessly until she is safe, transforming into a weird man-machine in the process. Although Alecto and Buju are in love, she cannot leave her father; but in the end Caesar learns that she is pregnant by Buju and sees the child as a possible hope for mankind. Meanwhile Himi, the child who will become the Kyo-O, is growing fast, far faster than is natural; grieved by the horror going on around her, her tears unleash a far deadlier horror. Buju comforts her and eventually agrees to go with her to Osaka Castle to meet the Chojin; three of the Demon-Beasts join them, hoping to find some clue to the reason for their own existence. The grosser scenes from this series were cut from the

UK release; but amid what remains, a plot which aspires to epic scope and a number of touches of real humanity can be discerned. Urotsukidoji III is deeply flawed but it has some valid points to make; those with the patience and intelligence to sift its excesses may find themselves surprised.
★★★

USHIO & TORA 5-11

(Eng trans for USHIO TO TORA; 5 & 6 GAMIN-SAMA, TORA MACHI E YUKI PARTS 1 & 2, lit The Gamin Heads, Tora Goes to the City parts 1 & 2; 7 & 8 AYAKASHI NO UMI, lit Strange Sea, parts 1 & 2; 9 & 10 KAZE GURI, lit Crazy Wind parts 1 & 2; 11 USHIO TO TORA COMICAL DEFORMED THEATRE, lit Ushio & Tora Comical Deformed Theatre)

JAPANESE CREDITS: Dir: Kunihiko Yuyama. Script: Kenji Terada, except CD Theatre: Kunihiko Yuyama. Art dir: Kachiyoshi Kanamura. Prod: Pastel, Toho, OB Planning. © Fujita, Shogakukan, Toho Video. Each 30 mins.
WESTERN CREDITS: UK Video release 1995 on Western Connection, sub, trans Jonathan Clements.
ORIGINS: Manga by Kazuhiro Fujita, pub Shogakukan; 1992 OAV.
CATEGORIES: DD, A

Three two-part stories make up the final adventures of the oddly-assorted friends; having spent the first four parts squaring off against each other, in parts five and six Tora helps to rescue Ushio's school chum Mayuko from rampaging ghosts, convinced she is the mystic who shut them beneath a stone a hundred years ago; he also discovers that hamburger is quite good to eat, though no substitute for human. Parts seven and eight see the class at the seaside with Asako's grandparents; she befriends an orphan who reminds her strongly of the younger Ushio, and when the two fall foul of a sea monster it takes all the combined powers of Ushio, Tora and the Spear of Beast to free them. The last adventure features three traditional Japanese weasel-spirits, one of whom has been driven mad by the increasing pressure of Man on his wild habitat; can Ushio and Tora combine their powers to help one of the spirit world, instead of fighting it as they have done in the past, while still preventing humans from being hurt? Lastly, a collection of short spoof stories features the characters in deformed mode. The switch of theme tunes partway through the series serves as an indicator of the changing relationship between Ushio and

Tora, and the use of colour and line to set the mood continues to be artful and excellent. ★★★★

VILLGUST 1 & 2
(Eng title for KORYU DENSETSU VILLGUST, lit Armoured Dragon Legend Villgust; 1 ERABARESHI MONO, Chosen Man; 2 YOMIGAERU DACHI, Revive the Land)

JAPANESE CREDITS: Dir: Satoru Akahori. Chara des: Kosuke Fujishima. Music: Kohei Tanaka. Prod: Animate Film. © Bandai Visual. Each 30 mins.
ORIGINS: Vending machine toys & RPG.
CATEGORIES: DD, A, U

Bandai is credited with originating the gachapon toy machine concept — these are toys in plastic eggs sold for small change from vending machines, and the name comes from the romanisation of the sound of the egg-shaped cases falling from the machine. The cute designs of many of the toys soon spread their influence to video games and card games, then were adapted as manga characters, and finally became this OAV series. Set in a fantasy role-playing world, the series follows the various cute characters on a journey of adventure closely related to the format of a card game/video game. ★★★?

WOLF GUY VOLS 2-6
(2 ONKA, Winter Song; 3 CHI NO MUCHI, Blood Whip; 4 COMPLICATION; 5 EIKETSU, Eternity Apart; 6 REQUIEM)

JAPANESE CREDITS: Dir: Naoyuki Yoshinaga. Script: Toshikazu Fujii. Chara

Ushu & Tora 11

des: Osamu Tsuruyama. Music: Kenji Kawai. Prod: Picture Kobo. © Bandai Visual. Each 27 mins.
ORIGINS: 1992 OAV.

I have no further information.

YS VOLS 1-4
(Eng title for YS TENKU NO SHINDEN, lit YS Palace of the Celestial Gods)

JAPANESE CREDITS: Dir: Takeshi Watanabe. Original idea: Nippon Falcom. Script: Katsuhiko Chiba. Chara des: Hiroshi Nishimura. Prod: Tokyo Kids. © Nippon Falcom, King Records, Kadokawa Shoten, Kadokawa Media Office. Each 30 mins.
ORIGINS: Popular computer game & novels.
CATEGORIES: DD

I have no further information.

ZEGUY 1 & 2
(Eng title for UNKAI NO MEIKYU, lit Labyrinth of the Sky Clouds)

JAPANESE CREDITS: Dir, original story & screenplay: Shigenori Kageyama. Chara des: Aki Tsunaki. Anime dir: Akinobu Takahashi. Music: Soichiro Harada. Prod: KSS. © Kageyama, KSS. Each c40 mins.
WESTERN CREDITS: UK video release 1994 on Manga Video on one tape, dub; US video release 1994 on US Manga Corps, trans William Flanangan, Eng rewrite Jay Parks. Both releases on one tape.
POINTS OF INTEREST: Look out for real historical characters and references, such as Leonardo Da Vinci's flying machine.
CATEGORIES: DD, A, U

Terrible things can happen on a school bus; you can find yourself in a magical kingdom beyond the clouds during a power struggle to overthrow the mad Empress and take control, for instance. A schoolgirl heroine, an insane villainess, a dastardly seducer with his demon cohorts and some magnificently baroque mecha combine in a mythic romp eminently suitable for children of all ages (the UK certificate was PG). A moment of wry amusement for adult fans arises when one of the characters tells our heroine off for using a mildly naughty word, since such are often liberally grafted on to anime by companies looking for a higher UK certificate; but that won't detract from the enjoyment. ★★☆

The New Year opened quietly in the cinema, but the OAV market had plenty to offer to make up for that. The continuation of many popular series, with *Giant Robo* heading the list in January, was backed up by a new production from an old master in the shape of Leiji Matsumoto's war anthology, *The Cockpit*. The distinction between the erotic and the fantastic began to blur, with more titles like *Dragon Pink* joining traditional erotica like *F3* and the beautifully-crafted *End of Summer* on the shelves and attracting the Dungeons and Dragons audience into new areas. What follows is just a brief glimpse of the year's offerings. There is still a great deal of work to be done to collate the vast mass of 1994's release information.

The growing Western interest in anime meant that the number of new titles reaching the West increased. However, the English-speaking market for the most part still displayed a huge ignorance of anime's historical development and breadth of subject matter, with journalists and buyers criticising 'low grade' animation which was in fact simply older material. There was also a widespread general perception of anime as entertainment suitable only for perverts. However, the UK market continued to boom. In the spring, Manga Entertainment extended their interests in the UK market by acquiring *Manga Mania* and other titles when Dark Horse Comics shut down its UK operation. Later in the year, Manga set up a US operation, buying the L.A. Hero company and moving into the biggest English-speaking market in the world. And Pioneer LDC, already strong in the hardware market in the USA and UK, set up its own anime video label in both countries to release Pioneer product in translation. Also in the UK, Crusader Video, Animania and Anime UK Video all produced one tape this year and then ceased operations; Western Connection, launched by East European film importer Sasha Cipkalo, had a larger title list and focused on subtitled output.

MOVIES

DARKSIDE BLUES

JAPANESE CREDITS: Dir: Yoshimichi Furukawa & Michitaka Kikuchi. Script: Mayori Sekijima. Chara des & key animation: Hiroshi Hamazaki. Prod. Toho. © Ashibe, Kikuchi, Tokuma Shoten, Toho. c80 mins.
ORIGINS: Story by Hideyuki Kikuchi & Yuho Ashibe 1985, manga pub Tokuma Shoten in Bonita Comics 1993.
POINTS OF INTEREST: Androgynous hero Darkside is voiced by Natsuki Akira, a star performer from the Takarazuka theatre troupe of male impersonators which was one of the formative influences on the work of the father of modern anime, Osamu Tezuka.
CATEGORIES: SF, H

A cyberpunk vampire legend richly designed and animated, with its roots as firmly in the past of Central Europe as the future of Japan. The map of the world has been changed, countries and boundaries abolished by the Persona Corporation (PC), a company in the grip of the mighty Hogetsu clan which now rules the world. Gren Hogetsu runs PC from his satellite headquarters, looking down on the Earth which his family has carved into nine new 'regions' to simplify their administration. The only area of resistance is a small district in what used to be Shinjuku, Tokyo. Kabuki Town is a wildly anarchic area, the most liberated and most dangerous place on Earth; some call it the 'Tokyo Darkside'. Resistance group Mecia fight the dominance of the Hogetsu from within its maze of alleys, planting bombs and causing disruption in time-honoured terrorist fashion. The Hogetsu clamp down hard to try and stamp out this last pocket of freedom fighters once and for all, sending armies of artificially enhanced cyborg soldiers into Kabuki Town, offering huge rewards, even calling the family psycho, master assassin Enji Hogetsu, back from Africa. As the web of blood, distrust and suspicion is cast ever wider, the Mecia leaders encounter a strange, beautiful young man who materialises from nowhere in a coach and four and calls himself 'Darkside'. A classy vampire romance with style in bucketfuls. ★★★☆?

DORAEMON — NOBITA'S FIRST DIARY
(Eng trans for DORAEMON — NOBITA NO ICHIBAN NIKKI)

JAPANESE CREDITS: Dir: Tsutomu Shibayama. Prod: Shin'ei Doga. © Fujiko-Fuji, Shogakukan, Shin'ei Doga. c50 mins. POINTS OF INTEREST: Opened on a double bill with Slam Dunk in March. ORIGINS: Manga by Fujiko-Fujio, pub Shin'ei Doga; 1979 TV series; movies every year 1984-88, 1991 & 1992. CATEGORIES: U, C

Another *Doraemon* movie. That's all I know about this one!

FATAL FURY THE MOTION PICTURE
(Eng title for GAROH DENSETSU, lit Legend of the Hungry Wolf)

JAPANESE CREDITS: Dir, chara des & anime dir: Masami Obari. Writer: Takashi Yamada. Music: Toshihiko Sahashi. © SNK, Fuji TV, Shochiku, Asatsu Intl. 100 mins. WESTERN CREDITS: US video release 1995 on Viz Video, written by Trish Ledoux. ORIGINS: Neo-Geo console game. CATEGORIES: A, V

The descendant of the ancient family of Gaudeamus, Laocoon scours the world for the legendary Armour of Mars lost by his ancestors during the Crusades. He plans to use its godlike powers to revenge himself and his family on those who have persecuted them. His twin sister, terrified of what the armour may do to him and what he may do to the world, enlists the help of Terry 'Hungry Wolf' Bogard to stop him. All your favourite characters from the game, lots of fight action. ★★☆?

OSAGAWA SUPERBABY

JAPANESE CREDITS: Dir: Junichi Sato. POINTS OF INTEREST: Opened in time for the Christmas/New Year holiday season on a triple bill with Blue Legend Shoot and Sailor Moon S. CATEGORIES: C?

I have no further information on this title.

PONPOKO
(Eng title for HEISEI TANUKI GASSEN PONPOKO, lit Present-Day Great Raccoon War Ponpoko — 'ponpoko' being the sort of noise you make by tapping on a rather fat, full tummy, apparently!)

JAPANESE CREDITS: Dir & writer: Isao Takahata. Prod: Hayao Miyazaki. Prod co: Studio Ghibli. © Nibariki, Tokuma Shoten. c119 mins. ORIGINS: Traditional Japanese folktales. POINTS OF INTEREST: Japan's entry for the Best Foreign Film award at the 1995 Oscars. It didn't get onto the ballot, though. CATEGORIES: DD, U

A gorgeous tale of the incursion of the modern world on ancient Japan. Tanuki — raccoons — are magical creatures according to Japanese lore, shapeshifters with powers over their environment; but not even these ancient skills can combat the increasing pressure of man on the raccoon community. A group of tanuki decide to fight back with all the power at their command, even if it means disguising themselves as the enemy — or their ghosts. As Miyazaki did in *My Neighbour Totoro*, Takahata examines the increasing loss of familiarity of young Japanese with their legends and folklore — like the tanuki lore — and with nature itself, and asks us to consider Japan's huge gains in modern times in balance with such intangible but nevertheless significant losses. A gentle, clever, funny and thoughtful film, much less dark and harrowing than Takahata's *Grave of the Fireflies* but with the same moral intensity wrapped in dazzling production values. ★★★★☆

SAILOR MOON S
(Eng title for BISHOJO SENSHI SAILOR MOON S, lit Pretty Soldier Sailor Moon S)

JAPANESE CREDITS © Toei, Bandai. ORIGINS: Manga by Naoko Takeuchi, pub RunRun magazine by Kodansha; 1992 TV series of same name, continuation of two earlier series, Bishojo Senshi Sailor Moon and Bishojo Senshi Sailor Moon R; 1993 movies. POINTS OF INTEREST: Opened on a triple bill with football movie Youth's Legend Shoot and Osagawa Superbaby just before Christmas. CATEGORIES: U, DD, R

The story of five girls fighting alien invasion with the power of romance and beauty continues with the addition of two more Sailor Senshi, Sailor Uranus and Sailor Neptune. Interestingly, the third TV series and this movie reflect real time — just as a year has passed since the first series, so a year has passed in the story world and heroine Usagi and her friends are a year older at fifteen. A new villain

has arrived — a mad professor with a beautiful but evil assistant, Kaori Night — but the story is the same as ever; Usagi and co struggle to defeat evil, can't do it alone, but with a little help from each other and the dashing Tuxedo Kamen, finally manage to save the world. ★★★?

SLAM DUNK: RED HOT HANAMICHI SAKURAGI
(Eng trans for SLAM DUNK: SAKURAGI HANAMICHI MOETE)

JAPANESE CREDITS: Dir: Hiroshi Kado. Prod: Toei. © T. Inoue, Shueisha, TV Asahi, Dentsu. 48 mins.
ORIGINS: Takehiko Inoue's manga, pub Shueisha & Shonen Jump; 1993 TV series about a high school basketball team.
POINTS OF INTEREST: Opened on a double bill with the annual Doraemon movie in March.
CATEGORIES: N

The series is a huge hit, packed with gorgeous fellas and emotional angst. I haven't seen this one but I can't see it being anything less than a droolfest for those who like men and basketball.

STREET FIGHTER II MOVIE ANIMATED

JAPANESE CREDITS: Dir: Gisaburo Sugii. Script: Gisaburo Sugii & Kenichi Imai. Chara des: Shuko Murase. Art dir: Satoru Matsuoka. Anime dir: Hiroaki Emitsu. Fight dir: Shinichi Shoji. Computer animation: Yasuo Maeda. Prod: Group TAG, AIC, Oh! Production. © Capcom. c90 mins.
WESTERN CREDITS: UK & US video release 1995 on Manga Entertainment, soundtrack redubbed with various existing tracks from American artists.
POINTS OF INTEREST: A number of character names were swapped around in the Western release of the anime to complement the same renaming in the Western release of the game — partly to avoid problems over naming a huge, strong, stupid black boxer 'M. Bison'...
ORIGINS: 1987 video game Street Fighter & 1991 game Street Fighter II, from Capcom.
SPINOFFS: Manga by Masayuki Sakai, Eng trans by Jonathan Clements, pub Manga Publishing (UK), Viz Communications (USA); 'prequel' TV series Street Fighter II V.
CATEGORIES: V, A

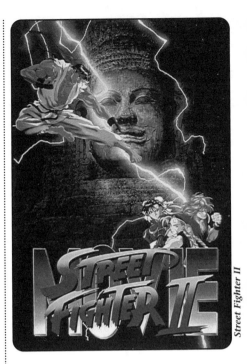

Street Fighter II

Director Sugii is renowned for his meticulous attention to detail, his unique sense of pace and his fidelity to the spirit of his original text; this shows up as strongly in the slugfest that is *Street Fighter II* as it did in the hallucinatory *Night on the Galactic Railroad* or the emotionally overheated *Tale of Genji*. The film is simply a console game transferred to the screen and decked in the framework of a story to provide an excuse for the explosive action scenes, with fights arranged by live-action martial arts specialist Shoji. Major Guile heads the good guys and reluctantly accepts the assistance of Chun Li in tracking down the Shadowlaw organisation; evil Vega (M. Bison in the Western release) is out to dominate the world through corruption and mystical powers. When a politician is assassinated by streetfighter Cammy, who has been brainwashed, a plot emerges to control all the streetfighters and make them agents of evil under Vega's control. Ken, the close friend and former training partner of top streetfighter Ryu, is taken, and his former comrade is determined to free him. There's a well choreographed and very nasty fight between Chun Li and Balrog in which Sugii's own particular style emerges strongly, but for the most part this is a straight take on the game, its purpose — which it achieves admirably — to amuse *SFII* console fans, not film buffs. Technically never less than competent. ★★☆

YOUTH'S LEGEND SHOOT
(Eng title for AOKI DENSETSU SHOOT, lit Blue Legend Shoot)

JAPANESE CREDITS: Dir: Daisuke Nishio. c50 mins.
POINTS OF INTEREST: Opened on a double bill with comedy Osagawa Superbaby and Sailor Moon S in December.
ORIGINS: 1994 TV series.
CATEGORIES: N

The story of three high school students who become pals through their love of football. When they move on to senior high, Toshihiro, Kazuhiro and Kenji are so impressed by the brilliance of soccer club captain Kubo that they join the club and persuade their friend Kazumi to take on the job of team manager too. However, much as they love football, it isn't the only thing in their lives — they're out to have a good time as well. Aimed at a slightly older age-group than the long-running *Captain Tsubasa*. The artwork is pleasant, though not outstanding, but I haven't seen any episodes so I can't rate the action on or off the pitch.

YU YU HAKUSHO: THE TALE OF THE KINGDOM OF SHADOWS

JAPANESE CREDITS: Script: Yoshihiro Togashi. Prod: Studio Pierrot. © Togashi, Shueisha, Fuji TV. 93 mins
ORIGINS: Manga by Yoshihiro Togashi, pub Shueisha in Shonen Jump weekly; 1992 and later TV series; 1993 movie.
POINTS OF INTEREST: 510,000 cels were produced for this film to ensure top quality animation. The story is a new one, not taken from the manga or TV series.
CATEGORIES: H, A

The universe contains two kingdoms, the world of living humans or Ningenkai, and the world of the dead or Reikai. Yusuke can pass between these worlds because although he is dead, he has been appointed to act on behalf of the world of the dead in resolving problems as a sort of ghost detective. A river separates these worlds, and across it souls pass from the living world after their death to be judged by King Enma Dao and sent on to heaven or hell. However, certain ancient scriptures tell of another world, the Meikai, beneath the other two. There is enmity between its King, Yakumo, and Enma Dao, and after a hundred years it flares up once more. Koema, Enma Dao's son, sends to Earth to ask Yusuke and his friends for help. His messenger Botan, a cute girl, has a very soft spot for Yusuke,

and she and her friend Hinageshi persuade him and his friends Kuwabara, Kurama, Hiei, and Hiei's sister Yukina, to help save the world of the dead. However, Yakumo, the cause of the trouble, has a just case too; he wants to save his own world and its people. The stylish and exciting series has won many fans and the movie is highly regarded. ★★★?

OAVS

ARMITAGE III PART 1: ELECTRO BLOOD

JAPANESE CREDITS: General dir & chara des: Hiroyuki Ochi. Dir: Takuya Sato. Screenplay: Chiaki Konaka & Akinori Endo. Des: Atsushi Takeuchi. Anime dir: Kunihiro Abe. Art dir: Norihiro Hiraki. Music: Hiroyuki Namba. Prod AIC. © AIC, Pioneer. 50 mins.
WESTERN CREDITS: US video release 1995 & UK video release 1996 on Pioneer.
POINTS OF INTEREST: Having established themselves in the US and UK with a string of 'softer' titles such as Tenchi Muyo! and Moldiver, this was Pioneer's first direct attack on the hard-SF, action-adventure market. Look out for visual homages to other anime, like the spacecraft from Sol Bianca.
CATEGORIES: SF, X

Mars is inhabited and the planet is being terra-formed to support more immigrants. Cop Ross Sylibus arrives to join the Martian police and walks straight into the murder of singer Kelly McCannon and the shock revelation that she is a 'Third' (ie advanced) robot. A crazed robot-killer, Rene Danclaude, is out to exploit popular anti-robot feeling and wipe out this highly evolved new kind of being. Ross's new partner Naomi Armitage — a tough, spiky, streetwise little bondage-kitten in leather and shades — is more involved in the mystery of the Thirds than he realises at first, but by the end of the episode it emerges that she too is one of the advanced cyborgs and that she is determined to find the answers to her existence. The stylistic influence of *Blade Runner* is still very strong in SF anime and this shows in the design of this OAV; but various homages to its anime antecedents are also there. ★★★

ARMOURED TROOPER VOTOMS 1-4
(Eng trans for SOKOKIHEI VOTOMS)

JAPANESE CREDITS: Dir & story: Ryosuke Takahashi. Dir & storyboard: Takashi Imanishi. Chara des: Norio Shioyama. Mecha des: Kunio Okawara. Des works: Yutaka Izubuchi. Prod: Sunrise. © MOVIC, Youmex, Bandai Visual. Each 30 mins. ORIGINS: Story by Ryosuke Takahashi; 1983 TV series; 1985, 1986 & 1988 OAVs. POINTS OF INTEREST: A supplementary item on the tape, 'Votoms Briefing', fills in the background for those fans too young to have watched the original series. CATEGORIES: SF, W

A return to the battlefield for hero Chirico Cuve, who has been in cryo-sleep with his beloved Fiana for the last thirty-two years, since the end of the fifty-two-episode TV series. Nothing much has changed in their world, and war and corruption still rage. It's time for Chirico to fight again. ★★★☆?

BONDS
(Eng trans for KIZUNA)

JAPANESE CREDITS: Prod: SID. © Daiei, Seiji Biblos. 30 mins. ORIGINS: Based on the manga by Kazuma Kodaka, pub Seiji Biblios. CATEGORIES: X

A shonen ai — boys' love — story about intense emotional and physical attachment between young men, with the strong character development and romantic/dramatic emphasis typical of the genre.

BORGMAN 2 PART 3
(Eng title for CHOSENSHI BORGMAN 2, lit Supersonic Soldier Borgman 2; part 3 Lonely Prologue)

JAPANESE CREDITS: Dir & writer: Yasushi Murayama. Chara des: Michitaka Kikuchi. Mecha des: Takehiro Yamada. Prod: Ashi Pro. © Toho. 30 mins. ORIGINS: 1988 TV series, 1989, 1990 & 1993 OAVs. CATEGORIES: SF, A

Concludes the 1993 series. Will Ken and Sara get together in the end, and will the Yoma really be defeated at last? ★★☆?

CASSHAN: ROBOT HUNTER 4
(Eng title for SHINZO NINGEN CASSHAN SHINWA KARA NO KIKAN, lit Armoured Body

Fighter Casshan: Return from the Myth. Eng ep title The Reviver)

JAPANESE CREDITS: Script: Hiroyuki Fukushima. Chara des & anime dir: Yasuomi Umetsu. Music: Michiru Oshima. Prod: Artmic, Tokyo Kids. © Tatsunoko Pro. 30 mins. WESTERN CREDITS: US video release 1995 on Streamline Pictures, Eng dialogue by Ardwight Chamberlain. ORIGINS: 1973 TV series; 1993 OAV. CATEGORIES: SF

The final battle for the fate of humanity approaches, and Casshan must take on an entire army single-handed as the human resistance forces fall into an elaborate trap. The inevitable conclusion — a confrontation between Casshan and robot overlord Black King — is one he may not survive. What hope is there for the last remnants of humanity? A dramatic, intense and beautifully designed conclusion to the series. ★★★

CATGIRL NUKU-NUKU 2
(Eng title for BANNO BUNKA NEKO MUSUME CHOTTO DAKE NUKU-NUKU 2, lit All Purpose Cultural Cat Daughter Just a Little Nuku-Nuku 2)

JAPANESE CREDITS: Dir: Hidetoshi Shigematsu & Yutaka Takahashi. Chara des: Yuzo Takada. Art dir: Kazuhiro Arai. Music: Hiroshi Matsuda, Beat Club & Vink. Prod: Animate Film. © King Record, KSS. 3 parts, each 30 mins. ORIGINS: Manga by Yuzo Takada, pub Futabasha; 1992 & 1993 OAVs. CATEGORIES: DD, C

A new series of the adventures of the cheerful catgirl who holds her dysfunctional family together with affection and sheer goofiness. Nuku-Nuku is threatened by the arrival of the equally cute Eimi, another android who wants to take over her role — after wiping her out, of course. Plus, to buy Ryunosuke a new bike after she trashed his, she has to work in 'mother' Akiko's restaurant — until it's completely destroyed by heavy artillery — and still contend with the Office Ladies from Hell. ★★★☆

THE COCKPIT

JAPANESE CREDITS: Dir: Yoshiaki Kawajiri, Takashi Imanishi & Ryosuke Takahashi. Prod: Madhouse. © Tokuma

Communications. c75 mins.
WESTERN CREDITS: UK video release 1996
on Kiseki Films, trans Jonathan Clements.
ORIGINS: Based on manga by Leiji
Matsumoto.
CATEGORIES: W

Three tales of World War Two reflect different aspects of aerial and ground warfare. The protagonists are from different nations but all cast in the mould of Matsumoto's heroic outsiders, such as Captain Harlock. Plane freaks will love the mecha design and the direction of the aerial sequences, and there is plenty of drama and human interest in the three short but well-plotted segments. Each story focuses on one of the armed services — army, navy and air force — and the nature of the material is controversial because Matsumoto has chosen to celebrate his fortieth year as a cartoonist both with a view of World War Two from a Japanese viewpoint, and with a romantic slant on undeniably bleak material. Episode one, 'Slipstream', features a Luftwaffe ace, Erhardt Von Rheindars, whose resemblance to Matsumoto's great romantic hero Captain Harlock is entirely intentional. Set to guard a bomber carrying an atom bomb to its destination, he takes the decision to fail in his duty rather than unleash such horror on the world. The segment is directed by Yoshiaki Kawajiri. In episode two, 'Sonic Boom Squadron', director Takashi Imanishi shows the final hours of a young kamikaze flying-bomb pilot whose last mission didn't succeed, as he prepares for his 'second chance' as a hero in the company of a squadron of ordinary servicemen. In episode three, 'Knight of the Iron Dragon', directed by Ryosuke Takahashi, a motorcycle messenger trying desperately to get back to his base in the face of enemy advances gets some unexpected help from a colleague who seems like a deadbeat but turns out to be a true hero. It's also an interesting chance to compare the work of three gifted directors better known in the West for seemingly different themes — Kawajiri for his supernatural horrorfests for Madhouse, Takahashi for supreme mechwar realism, and Imanishi for the romance and drama of mecha represented by *Gundam* — as they pay homage to an older master. A must for any serious collector. ★★★☆

COMPILER 1 & 2

JAPANESE CREDITS: Dir: Michitaka
Kikuchi. Writer & chara des: Kia Asamiya.
Prod: Animate Film. © Asamiya, Kikuchi,
Kodansha. Each 30 mins.
ORIGINS: Manga by Kia Asamiya, pub
Kodansha 1990 in Comic Afternoon; video

Music Clips in Trackdown; CD dramas.
CATEGORIES: SF, A

1997, Earth. A game is about to begin for possession of the planet. Electro-dimension gamers Compiler and Assembler are the players. But a slip-up occurs; when a human is injured, the game stops automatically. Now Compiler and Assembler will be deleted by the 'killer bytes' Bias and Directory — unless Toshi and his friend, smitten by these two electronic cuties, can prevent it. Widely felt to be less fun than the manga and music video. ★★☆?

COSMIC FANTASY

JAPANESE CREDITS: Dir & chara des:
Kazuhiro Ochi. 45 mins.
ORIGINS: A computer RPG for the PC
Engine, des, dir, written & planned by
Kazuhiro Ochi.
CATEGORIES: DD, SF

I know very little about this one. Hero Yuu and his partner Saia, a magician who's also a mean naviga-

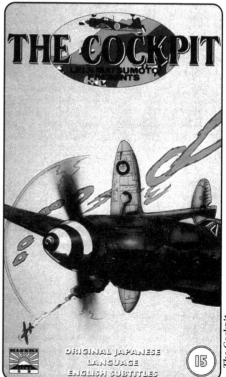

The Cockpit

tor and very cute, are fleeing in Yuu's ship *Algernon* because half the galaxy, and in particular a nasty female pirate called Velga, is on their tail. The bits of artwork I've seen look pretty and nicely executed.

CUTEY HONEY VOLS 1 & 2
(Eng title for SHIN CUTIE HONEY YAMI NO GUNDAN-HEN 1-4, lit New Cutey Honey Dark Group 1-4)

JAPANESE CREDITS: Dir: Yasuchika Nagaoka. Writer: Isao Shiyuza. © Nagai, Dynamic Planning Inc, Toei Video. Vol 1 65 mins, vol 2 60 mins.
WESTERN CREDITS: US video release 1995 on A.D. Vision, trans Ichiro Araki; vol 2 includes bonus art portfolio & answering machine messages & runs 65 mins.
ORIGINS: Manga by Go Nagai; 1973 TV series.
CATEGORIES: X, C

Updating his earlier creation but leaving her most important features — a classy chassis and an ability to change form at will, always with the loss of clothing — Go Nagai inspires new adventures for the one-woman android assault force who was created by Dr Kisaragi to replace his lost daughter. Honey has been in suspended animation in the Kisaragi Research Institute and returns from a decade-long furlough to find that evil master criminal Dolmeck is laying siege to an entire city with his army of shapeshifters. Mayor Light needs help, and all he's got is the elderly lunatic Danbei and his family — that is, until Honey joins forces with them. When she locates and destroys the source of his mutation inducing drugs, that ought to solve the problem; but then there wouldn't be a volume 2... so Dolmeck and his sidekick the Dark Maiden decide to eliminate her, enlisting the help of the elusive Peeping Spider. If you've seen *Kekko Kamen*, Nagai's earlier excursion into fighting crime with sex, you'll know what to expect. This is slapstick action with exposure built in. ★★★

CYBER FORMULA GPX 1-7
(Eng title for SHINSEIKI CYBER FORMULA GPX, lit New Century Cyber Formula GPX 1-7)

JAPANESE CREDITS: Prod: Sunrise. © VAP Video. Each 30 mins.
ORIGINS: 1990 TV show; 1992 & 1993 OAVs.
CATEGORIES: N, A

More motor racing adventures, completed in the eighth episode released in 1995.

DARK BLUE FLEET 1 & 2
(Eng trans for KONHEKI NO SENTAI)

JAPANESE CREDITS: Dir: Takeyuki Kondo. Script: Ryosuke Takahashi. Chara des: Masami Suda. Storyboards: Rei Mano. Music: Yasuji Maigano. Prod: J. C. Staff. © Tokuma Shoten.
ORIGINS: Novel by Yoshio Aramaki, first of a projected 20 novel series.
CATEGORIES: SF, W

It's April 1943; Admiral Isoroku Yamamoto is shot by the American airforce. When he opens his eyes again it's thirty-eight years ago and he is a young man called Isoroku Takano. But he still has his memories, and he is determined to use that advantage to change history. It appears he has fallen into a kind of alternate universe — some things are the same, others not — or has he? The Japanese army is still set on expansion and relations with the USA are worsening. He teams up with an Army officer, Yasaburo Otaka, and they plot to stage a coup against the right-wing government while secretly developing a fleet of supersubmarines armed with the latest in weapons technology. War may still come and still end in Japan's defeat, but not everything will be the same... The meticulous historical research and military hardware made this tense OAV popular with military buffs. Its animation is fairly limited at times but the tension of the plotting and character development make up for a lot. ★★★?

DEVIL HUNTER YOKO 5
(Eng trans for MAMONO HUNTER YOKO 5)

JAPANESE CREDITS: Dir: Junichi Sakata. Writer: Juzo Mutsuki. Chara des: Takeshi Miyao & Yuzo Sato. Art dir: Hidetoshi Kaneko & Masumi Nishikawa. Prod: Madhouse. © NCS, Toho. 50 mins.
WESTERN CREDITS: US video release 1995 on A.D. Vision, trans Ichiro Araki.
ORIGINS: OAVs every year 1991-93.
CATEGORIES: H, A

The final episode in Yoko's demon-hunting adventures (until the second series) comes as she faces a threat too big for even her and Grandma together to handle — the demon Tokima, an old adversary of her family. So they have to call on the help of all 106 preceding generations of demon hunters in the Mano family. It's a shock to see your distant ancestors, even more so when they're all mega-cute and deadly as hell. Tokima already bears the scars of encounters with all of Yoko's ancestors; but each

time he fought them, he vanished into another dimension before his adversary could deliver her killing strike. Will Yoko leave her mark on him only to have him escape again? Or — this time — will he be the one to triumph? ★★★

DIRTY PAIR FLASH 1-5

JAPANESE CREDITS: Dir & script: Tsukasa Sunaga. Chara des & anime dir: Takahiro Kimura. Mecha des: Kazutaka Miyatake. Art dir: Ariaki Okada. Music: Kei Wakakusa. Prod: Sunrise. © Studio Nue, Bandai Visual. Each 30 mins.
ORIGINS: Novels by Haruka Takachiho; appearance in 1983 movie Crushers; 1985 TV series & OAV; 1987 movie; 1987, 88, 90 OAVs.
CATEGORIES: DD, C

The adventures of the most popular and dangerous social workers in the galaxy take a step back in time with this new series. We see Kei and Yuri at seventeen, learn how they came to join 3WA and follow their first case. The redesign of the Pair as skinny, spiky kids with nineties cred has appalled some of their established fans and the lightweight, comic aspects of the script have not appealed to all the old DP-ites. Nevertheless, in the light of the retro trend for making contemporary remakes look 'aged', this deliberate revamp for a new decade is refreshing. ★★☆?

DRAGON KNIGHT 2

JAPANESE CREDITS: Dir: Kaoru Toyo'oka. Script: Akira Hatta. Chara des: Ako Sahara & Akira Kano. Anime dir: Yuma Nakamura. © elf, All Products. 50 mins.
WESTERN CREDITS: US video release 1994 on A.D. Vision.
ORIGINS: Original idea by Dr Pochi; original story by Masato Hiruta (elf); 1991 OAV.
CATEGORIES: X, C, DD

A followup to 1991's adventure; swordsman and master-lecher Takeru finds himself saddled with a knave who's really a wench and a pretty cool pick-pocket and female swordswinger. Together they face magic and mayhem and create much mirth in this fantasy romp. ★★☆?

DRAGON PINK 1

JAPANESE CREDITS: Dir: Wataru Fujii. Prod: AIC. © Iyotoko, Pink Pineapple. 35 mins.

WESTERN CREDITS: US video release 1994 on AD Vision's SoftCel Pictures label. There is an edited 30 minute version which is not X-rated.
ORIGINS: Created by Iyotoko, based on computer RPG.
CATEGORIES: X, DD

A fantasy sex romp that starts when slave girl Pink puts on the cursed Panties of Torajima and literally becomes a sex kitten. The stream of kitty puns on the cover blurb indicate the level of humour. Pink and her boyfriend Santa the swordsman have to fight their way through the Forest of Tajif with the help of elf Pierce and sorceror Bobo, trying to avoid the evil folk who want to skin the cat. ★★?

EIGHT MAN AFTER VOL 2: END RUN

(Eng title for EIGHT MAN AFTER VOLS 3 & 4; US titles: Vol 3 Mr Hallowe'en; Vol 4: Sachiko's Decision, aka EIGHT MAN AFTER PERFECT COLLECTION)

JAPANESE CREDITS: Dir: Sumiyoshi Furuhawa. Screenplay: Yasushi Hirano. Music: Michael Kennedy. Prod: Sanctuary, JC Staff. © Kuwata, Hirai, Act Co. Each 30 mins.
WESTERN CREDITS: US video release 1994 on Streamline Pictures, dub, also released as a compilation of all 4 vols, Eight Man After Perfect Collection, 116 mins; UK video release 1995 on East2West, same version.
ORIGINS: 8 Man manga by Jiro Kuwata & Kazumasa Hirai; 1963 TV series; 1993 OAV.
CATEGORIES: SF, M

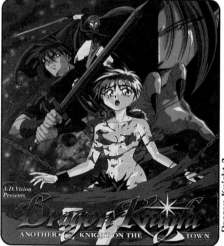

Dragon Knight 2

Further adventures of the robot detective. As Hazuma wrestles with his guilt after his destruction of the drug-crazed football team, sinister criminal Mr Hallowe'en takes off on a crime spree — and kidnaps Hazuma's girlfriend. ★★☆

801 TTS AIRBATS 1 & 2
(Eng title for AOZORA SHOJOTAI, lit Blue Sky Girl Squadron)

JAPANESE CREDITS: Dir: Yuji Moriyama, Osamu Mikasa, Junichi Sakata & Tohru Yoshida. Chara des: Yuji Moriyama. © T. Shimizu, Tokuma Shoten, JVC. Each 30 mins. WESTERN CREDITS: US video release 1995 on A.D. Vision, compiling all 3 eps into one 85 minute story. ORIGINS: Manga by Toshimitsu Shimizu (creator of Rei Rei), pub Tokuma Shoten. SPINOFFS: A successful radio drama series has been produced using the anime voice actors. CATEGORIES: N, C

The 801st Tactical Training Squadron is a womens' aerobatics team to which are assigned the deadbeats, no-hopers or hardened cases that other squadrons just can't cope with. Like Yoko Shimorenjaku, who's an incredibly awful pilot. Or Miyuki Haneda, who has a tendency to slug her commanding officers. So why is their new technician, Takuya Isurugi, assigned to them? Well, he's got a dark and deadly secret... he's an *anime fan*. A true otaku. Where else to send him but down to those crazy females? But he's also pretty cute, and more than one of his new colleagues has her eye on him. How's the poor guy going to survive? Directed and designed by one of the creators of *Project A-Ko*, this OAV combines bright, zappy design and comic mayhem in about equal proportions with truly wonderful depictions of fighter planes and cute, crazy pilots. ★★★

END OF SUMMER 1 & 2

JAPANESE CREDITS: Screenplay: Yuhiro Tomita. Created by: Masato Hiruda. Chara des: Ryunosuke Otonashi. Chara concepts: Masaki Takei. Prod: KSS. © elf, Pink Pineapple, Cinema Paradise, Hero. Each 55 mins. WESTERN CREDITS: US video release 1995 on AD Vision, sub, trans Ichiro Araki & Dwayne Jones. ORIGINS: Based on the computer game Dokyusei, lit 'Classmates'. CATEGORIES: X

The story of teenager Wataru, who sets out to have a perfect summer with Mai, the girl of his dreams, before starting college. During the course of the summer he runs across four other girls, and the different relationships he builds with them and the complications they cause in his relationship with Mai are the subject of these two videos. The animation and design are beautiful, but if onscreen softcore sex bores you then you'll be bored, because there's plenty of it in both episodes. ★★?

EXPLODING FLAME CAMPUS GUARDRESS 1-4

JAPANESE CREDITS: Dir: Toshihiko Nishikubo. Screenplay: Satoru Akahori. Story: Satoru Akahori & Kazushi Hagiwara. Chara des & anime dir: Kazuya Kose. Art dir: Shuichi Hirata. Music: Fumitaka Anzai. Prod: Production I. G. © Shueisha, Victor Entertainment. Each 30 mins. ORIGINS: Manga by Akahori & Hagiwara, pub Shueisha. CATEGORIES: X, C

If you put *NG Knight Lamune & 40*'s creator in a dark room with the guy who dreamed up *Bastard!!*, you might get something like this — so that's exactly what they did. Sex, comedy, action and violence are all elements of this weird, wild high school campus story in which heroine Hasumi Jinno gets drawn into the battle between the Guardians of the gate between the human and demon worlds, and an evil force called 'the Remnants', who plan to fling that gate wide and summon the demons. Saucy, superb artwork and nonstop action. Check your brains at the door, just bring your sense of the ridiculous. ★★★

FINAL FANTASY 1-4
(Ep titles: 1 KASE NO SHO, Wind Chapter; 2 DAN NO SHO, Flame Chapter; 3 TATSU NO SHO, Dragon Chapter; 4 HOSHI NO SHO, Star Chapter.)

JAPANESE CREDITS: Dir: Taro Rin. Screenplay: Satoru Akahori. Chara des & key animation: Yoshinori Kanemori. Art dir: Toshio Kaneko. Prod: Madhouse. © Square, NTT. Each 30 mins. ORIGINS: Computer game, pub Squaresoft. CATEGORIES: DD, A

I have very little information on this title. Set 200 years after the events of the game *Final Fantasy V*, the OAVs are intended to tie in with the gameplay

of *Final Fantasy VI*. The complex backgrounds and designs for which the game is renowned have been very much simplified and the lead characters, headstrong hero Purittsu and cute magic-user heroine Rinarii, have a strong resemblance to Hayao Miyazaki's young heroes, whereas the game characters (designed by Yoshitaka Amano) are very much more adult. The only character to cross over from the game seems to be the giant bird Chocobo. Action sequences are said to be fast and well animated and the art is attractive. ★★☆?

F3: FRANTIC, FRUSTRATED AND FEMALE
(Eng title for F3)

JAPANESE CREDITS: Dir: Masazaku Arai. Planning: Kinya Watanabe. Prod: AIC. © Wan Yan A Gu Da, Pink Pineapple. WESTERN CREDITS: US video release 1995 on AD Vision's SoftCel Pictures label, sub, trans Ichiro Araki. ORIGINS: Created by Wan Yan A Gu Da, Fujimi Publishing. CATEGORIES: X

Another softcore erotic fantasy in which young Hiroe Ogawa is determined to get rid of her frustrations, whatever it takes. I'm told it takes quite a lot — there's a mad scientist in there with some very strange inventions. The artwork I've seen looks pretty and there are a number of male fans who assure me it's 'really well animated'. I expect it's completely harmless. ★★?

GAKUSAVER 2 & 3
(Eng title for RYUSEIKI GAKUSAVER, lit Shooting Star Machine Gakusaver)

JAPANESE CREDITS: Dir: Shinya Sadamitsu. Chara des & art dir: Atsuo Tobe. Supervisor: Akio Sugino. Prod: Production IG. © Tatsunoko, King Record. Each 60 mins. ORIGINS: 1993 OAV. CATEGORIES: C, SF, U

More kids and robots adventure poking fun at the whole giant robot genre. The eight schoolkids pressganged by their teacher into piloting the eight alien mecha which form the giant robot Gakusaver are each very different — a baseball player, a tennis player, a wannabe idol singer, a member of the student council, even a young sumo wrestler. The individual style of the one who takes charge at the time determines the combat style of the robot. And not just the safety of Earth, but good end of year

reports from their teacher, depend on how they respond. ★★☆?

GATCHAMAN VOL 1

JAPANESE CREDITS: Dir: Hiroyuki Fukushima. Concept & scenario: Artmic. Plot: Hirokoku Narushima (Tatsunoko Pro) & Toshimitsu Suzuki (Artmic). Chara des & anime dir: Yasuomi Umetsu. Mecha des: Kiyotoshi Yamane. Art dir: Jiro Kawano. Photography dir: Toshimitsu Nakajo. Music: Maurice White & Bill Meyers (Earth, Wind & Fire). Prod: Tatsunoko. © Tatsunoko, Japan Columbia. 45 mins. ORIGINS: 1972 & subsequent TV series. POINTS OF INTEREST: The original TV series were edited for Western TV release as Battle of the Planets and G-Force. Some episodes have been available on various cheap video labels in the UK and USA. CATEGORIES: SF, A

The adventures of the new, revamped-for-the-nineties *Gatchaman* team as they face the same evil alien warlords as before. Stylish and elegant design manages to incorporate the old costumes and faces into a nineties look without compromising the essential integrity of the original series; Yasuomi Umetsu, a designer of originality and delicacy, had already done a similarly remarkable job on revamping the old *Casshan* characters for a remake. The newly designed Condor Joe is as sexy as ever and has a thoroughly bad attitude, the new Ken is as goody-goody as a team leader should be, and Jun has come off best of all as a thoroughly stylish-looking young woman. The mecha are terrific. ★★★★

GIANT ROBO 4 & 5
(Eng title for GIANT ROBO CHIKYU GA SEISHI SURU HI, lit Giant Robo the Day Earth Stood Still. Western ep titles: 4 The Twilight of the Superhero; 5 The Truth of Bashutarle)

JAPANESE CREDITS: Dir & screenplay: Yasuhiro Imagawa. Des: Makoto Kobayashi. Anime dir: Kazuyoshi Katayama. Art dir: 4 Yusuke Takeda; 5 & 6 Dai Ota. SFX dir: Hideaki Anno. Music: Masamichi Amano. Prod: Mu Film. © Hikari Pro, Amuse Video, Plex, Atlantis. 40 mins. WESTERN CREDITS: US video release 1995, dub, first on US Renditions, then on Manga Video; UK video release 1996, dub, on Manga Video.

*ORIGINS: Manga by Mitsuteru Yokoyama;
1968 live-action TV series; 1992 & 1993
OAVs.*
*POINTS OF INTEREST: Many of the charas
in Giant Robo are 'guest artists' from other
Yokoyama manga.*
CATEGORIES: SF, A, C

Further adventures of young Daisuke and his huge
retro-mecha as they join their friends the Experts of
Justice in the battle against the dastardly plans of
Big Fire for world dominion. In these episodes,
Ginrei finally comes faces to face with her father
and makes a startling discovery about herself. The
truth behind the tragedy of Bashutarle emerges
when Daisuke is lost in the icy wastes of the Hima-
layas. Tesugyu and Ginrei search for him as he drifts
in and out of consciousness and dreams of the past
and the origins of Giant Robo. Funny, involving
and exciting. ★★★★

Also:

GIANT ROBO EXTRA STORY: BAREFOOT GINREI
**(Eng trans for GIANT ROBO GAIDEN HADASHI
NO GINREI, lit Giant Robo Extra Story
Barefoot Ginrei, aka GINREI SPECIAL)**

*JAPANESE CREDITS: Dir: Yasuo Imagawa.
Des: Makoto Kobayashi. Prod: Mu Film. ©
Amuse Video, Bandai Visual. c25 mins.*
*ORIGINS: Spinoff of the Giant Robo OAV
series, itself based on Mitsuteru Yokoyama's
manga.*
*POINTS OF INTEREST: Note that the title is
a pun on Barefoot Gen.*
CATEGORIES: SF, A

The popular cute female agent created enough of a
stir among male fans to get her own OAV series, of
which this is the first. Her renowned fighting cos-
tume — a short-skirted Chinese dress — is stolen;
the OAV asks why and sets out to retrieve it. I
haven't seen it, but friends who have are divided
into two camps: those who think she's incredibly
cute and love it, and those who think *Giant Robo*
was fine but this is a bit pointless. ★★☆?

HOME ROOM AFFAIRS PARTS 1 & 2
**(Eng title for TANIN NO KANKEI 1 & 2; Eng ep
titles: 1 I'll Teach You a Lesson You'll Never
Forget; 2 I Was Born Reckless.)**

*JAPANESE CREDITS: Dir: Osamu Sekita.
Screenplay: Hiroyuki Kawasaki. Chara des:
Minoru Yamazawa. Art dir: Akira Furuya.*

*Music: Hiroyuki Takei. Prod: JC Staff. ©
Arima, Hakusensha, Jam Creation, JC Staff.
Each c45 mins.*
*WESTERN CREDITS: US video release 1995
on Star Anime Enterprises.*
*ORIGINS: Manga by Ichiro Arima, pub
Hakusensha in Young Animal Magazine.*
CATEGORIES: X

Eighteen-year-old Miyako is a girl going off the
rails, and determined to tease novice teacher Tokiro
Ehara mercilessly. But although she seems pretty
wild, and has an unfortunate family background,
she's really a good girl at heart. When her father
confines her to the care of the shy young teacher
she moves into his apartment and gradually they
come to care for each other. The problem with this
slight tale is that it can't decide if it wants to be a
tender romance or soft porn, and its attempts to sit
tantalisingly on the fence can be annoying; but
there's nothing here to offend. ★★☆

HUMMINGBIRDS VOL 2
**(Eng title for IDOL BOETAI HUMMINGBIRD,
lit Idol Defence Band Hummingbird)**

*JAPANESE CREDITS: Dir: Yasushi
Murayama. Anime dir: Kenichiro Katsuro.
Art dir: Torao Arai. Prod: Ashi Pro. © Toho
Video. 50 mins.*
*WESTERN CREDITS: UK video release 1995
on Western Connection, sub, trans
Jonathan Clements.*
*ORIGINS: Story by Taira Yoshioka, who origi-
nated Irresponsible Captain Tyler; 1993 OAV.*
*POINTS OF INTEREST: Launched the careers
of the five voice actresses in the leading roles
to new heights and started a boom in pro-
viding stories stuffed with 'cute' roles for
young actresses which continues to this day.*
CATEGORIES: R, A

Another adventure for the five sisters who combine
a singing career with work as Japan's first line of
aerial defence. A rival duo, the Fever Girls, are chal-
lenging them in the popularity stakes; and the
Fever Girls are trained by a very attractive former
protégé of the girls' own missing father. Can the
sisters stay the number one combat idols? Cute,
pretty, silly and sweet, with some lovely flight anim-
ation. ★★

IRIA: ZEIRAM THE ANIMATION 1-6
**(Ep titles: 1 NUBATAMA, Pitch Black; 2
AKASHIMA, Outrage; 3 OMOKAGE, Visage;**

4 HAHAKIGI Broom Tree; 5 KOWABURI Breath; 6 MAHOROBOA, no trans)

JAPANESE CREDITS: Dir: Tetsuro Amino. Script: 1 & 2 Tetsuro Amino. Scenario: 1 & 2 Naruhisa Arakawa; 3 & 4 Toshihisa Arakawa. Chara des: Ryunosuke Otonashi. Storyboards: 1 & 2 Gen Dojaga; 3 & 4 Tetsuro Amino. Visuals: Keita Amemiya. Music: Yoichiro Yoshikawa. WESTERN CREDITS: Slated for US video release in 1996 on US Manga Corps. ORIGINS: Characters created for the live-action film Zeiram, by Keita Amemiya, UK video release 1995 on Manga Video. CATEGORIES: SF, A

These OAVs form a prequel to the movie in which bounty hunter Iria is pursuing arch-criminal Zeiram. The story begins with the young Iria and her hunky brother Glenn joining their partner Bob to go to the aid of a plundered spaceship and encountering Zeiram there. Glenn is killed — or is he? As his voice guides Iria at significant moments during the rest of the story, we are never sure. She is determined to find the truth about their mission — and why, according to bent official records, it never existed. In the process she runs up against corrupt politicians, cute orphan brats and the constant presence of the genetically engineered master criminal Zeiram. Marvellous artwork, crisp animation, evocative music and an excellent script all contribute to one of the best OAVS of the year. ★★★★

IRON LEAGUERS 1 & 2
(Eng title for SHIPPU IRON LEAGUERS GINKO NO HATA NO SHITA NI, lit Whirlwind Iron Leaguers, Under the Flag of Silver Light)

JAPANESE CREDITS: Dir: Tetsuro Amino. Script: Akihiko Inari & Noboru Sonekawa. Chara des: Tsuneo Ninomiya & Hideyuki Motohashi. Mecha des: Kunio Ogawara. General anime dir: Hideyuki Motohashi. Anime dir: 3 Tetsuya Yanagizawa; 4 Yasuichiro Yamamoto; 5 Hideyuki Motohashi. Art dir: Junichi Higashi. Opening animation & storyboards: Kazuki Sekine. Prod: Sunrise. © Bandai Visual. Each 30 mins. ORIGINS: 1993 TV series. CATEGORIES: C, U

A spinoff of the TV series about robots who play soccer in a future league. I haven't seen it or tracked down anyone who can tell me about it in any detail,

but the artwork in the anime magazines looks bright and fun and it seems to be aimed at kids.

IRRESPONSIBLE CAPTAIN TYLER SPECIAL EDITION 1 & 2
(Eng trans for MUSEKININ KANCHO TYLER TOKUPATSUKAN 1 & 2)

JAPANESE CREDITS: Dir: Koichi Mashita. © Tyler Project. Each 50 mins. ORIGINS: 9 volume comedy novel series The Galaxy's Most Irresponsible Man by Taira Yoshioka; 1960s movie series Irresponsible Man; 26 episode TV & OAV series; 1992 OAV. POINTS OF INTEREST: The homage to the sixties movie series in the title and lead chara Justy Ueki Tyler's name: he was Hitoshi Ueki, and the kanji for Hitoshi can be read as Taira. The first series was made specifically for both TV showing and direct-to-video release. CATEGORIES: SF, C

The war between the Planetary Alliance and Holy Ralgon Empire is over, and Tyler and his crew on the good ship *Soyokaze* are settling into a quiet life; but Wang, the Prime Minister of the Empire, has other ideas. He's developed a startling new weapon and is itching to try it out. How will the galaxy's most laidback commander defuse this crisis? As ever, by complete and endearing inaction. Superb stuff. ★★★☆?

JOJO'S BIZARRE ADVENTURE 3-6
(Eng trans for JOJO NO KIMIYONA BOKEN)

JAPANESE CREDITS: Dir: Hiroyuki Kitakubo © Araki, Shueisha. ORIGINS: Manga by Hirohiko Araki (vols 13-28), pub 1987 Shueisha; 1993 OAV. CATEGORIES: H, V

One of the weirdest manga of the eighties, the *Bizarre Adventure* started in 1890s England and moved across three generations to the USA at the start of World War Two, then into the eighties. Further manga take the story into the future. The rivalry between Dio Brando, whose command of the Stone Masks has given him near-godlike powers, and the current inheritor of the JoJo nickname, is intense and bloody. Based on the tarot and with arcane and magical arts in equal measure, this is a fast-paced adventure story with wild characters and dizzying action. Not for the squeamish but definitely unique in its design and approach to the old adopted-siblings-rivalry theme. ★★★?

KEY THE METAL IDOL 1

*JAPANESE CREDITS: Dir & story: Hiroaki
Sato. Chara des: Kunihiko Tanaka. Anime
dir: Keiichi Ishikura. Prod: Studio Pierrot. ©
Sato, Pony Canyon, Fuji TV, Fuji 8. 25 mins.
ORIGINS: Original work by Hiroshi Sato.
POINTS OF INTEREST: Produced especially
to commemorate Pony Canyon's 10th year in
the OAV business.
CATEGORIES: SF*

The poignant story of a robot girl who wants to be
human. Brought up in a small town by the elderly
scientist who created her, Tokiko Mima is an android
who lives as a normal girl, but being a little
awkward at school is given the nickname 'Key',
meaning strange. Key knows she is different but
not that she can change things. Then her grand-
father dies and she learns that there is a way.
Paying homage to both *Pinocchio* and *Peter Pan*'s
Tinkerbell, she learns that if she can make 30,000
humans adore her, then she herself will become
'real', a human girl. So the obvious thing to do is
set off for Tokyo and try to become a top idol
singer. ★★☆?

KISHIN CORPS 6 & 7
**(Eng title for KISHIN HEIDAN, lit Machine God
Army)**

*JAPANESE CREDITS: Dir: Takaaki Ishiyama.
Chara des & anime dir: Masayuki Goto.
Mecha des: Takeshi Yamazaki & Koji
Watanabe. Art dir: Mitsuki Nakamura.
Music: Kaoru Wada. Prod: Ginga Teikoku. ©
Pioneer LDC. Each 30 mins.
WESTERN CREDITS: US, sub & dub, and
UK, dub, video release 1995 on Pioneer on
single tape, Vol 4. Ep titles: 6 Storming the
Base of the Alien Foe; 7 Youth to the Rescue.
ORIGINS: Novels by Masaki Yamada, pub
Chuokoronsha; 1993 OAV.
CATEGORIES: SF, W*

The conclusion of the retro-mech saga comes as
the Nazis find they have bitten off more than they
can chew by hiding a nest of aliens in their secret
base at Peenemunde. But the US Government now
plans to drop a new kind of bomb onto the base —
which may well have the desired effect of ending
the war, but could also unleash a massive alien
onslaught on mankind. Can the gallant heroes of
the Kishin Corps stop this happening? Some
impressive heavy metal action and eerily evocative
background images create a slow but powerful
climax. ★★★

LORD OF LORDS RYU KNIGHT: ADEU'S LEGEND 1-5

*JAPANESE CREDITS: Dir: Makoto Ikeda (OAV)
& Toshifumi Kawase (TV). Chara des (TV &
OAV): Kazuhiro Soeta. Supervision: Katsumi
Kumazawa (OAV) & Horiyuki Hoshima (TV).
Prod: Sunrise. © Ito, Shueisha, Sunrise, Sotsu
Agency. Each 95 mins
ORIGINS: Original work by Takehiko Ito &
Hajime Yadachi; charas & concept created
by Takehiko Ito; manga by Ito, pub
Shueisha; TV series.
POINTS OF INTEREST: 2 episodes of the TV
series accompany one new OAV episode on
each tape. OAV and TV are produced by dif-
ferent teams with slightly different styles.
CATEGORIES: DD, C*

The start of a planned thirteen-part OAV series of
comedy fantasies set in the magcial world of Earth-
tia, in which young Adeu Warsam, aspiring to
knighthood, finds that fame and glory are not all
they're cracked up to be as he adventures through
a fantasy world with his friends Puffy the mage,
Sarutobi the ninja and Izumi the cleric. Ryu, or
dragon, is the name given to the three huge robots
at the centre of the story, but there is no link with
the *Dragon Knight* OAVs. The Japanese advertising
for the series describes *Adeu* as the 'flushing Holy
Knight in the posterior legend'.

MACROSS PLUS 1

*JAPANESE CREDITS: Dir & mecha des: Shoji
Kawamori. Dir: Shinichiro Watanabe.
Screenplay: Keiko Nobumoto. Chara des:
Masayuki. Art dir: Katsufumi Hariu. Anime
dir: Yuji Moriyama. Music: Yoko Kanno. ©
Big West, Macross Plus Project, Hero Co Ltd.
40 mins.
WESTERN CREDITS: US & UK video release
1995 on Manga Video.
ORIGINS: Original story by Shoji Kawamori
& Studio Nue; 1982 & 1993 TV series; 1984
movie; 1987 OAV Flashback 2012; 1992 OAV.
POINTS OF INTEREST: Advanced computer
graphics were used to create the 'virtual
idol' Sharon Apple and various of the
show's effects.
CATEGORIES: SF, A*

A new twist on the old tale of *Macross*: the girl
singer is a computer generated 'virtual idol' who
comes to self-awareness only in volume three. The
triangle is built of two hotshot pilots, former
friends and now deadly rivals, and one tormented

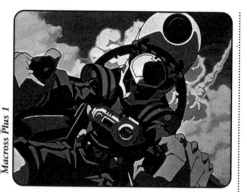

Macross Plus 1

fact no serious anything done, in this softcore romp with high-standard artwork and not much else. ★★?

MAPS: REVIVAL OF THE LEGEND VOLS 1-3
(Eng trans for MAPS DENSETSU NO FUKKATSU)

JAPANESE CREDITS: Dir: Susumu Nishizawa. Screenplay: Masaki Tsuji. Chara des: Masahiko Okura. Art dir: Yukihiro Shibuya. Chief animator: Hideyuki Motobashi. Music: Masahiro Kawasaki. © Hasegawa, Gakken, TMS, KSS. Each 30 mins.
WESTERN CREDITS: US video release 1995 on A. D. Vision, trans Masako Arakawa & Chris Hutts.
ORIGINS: Manga by Yuichi Hasegawa, pub Gakken; 1987 OAV.
CATEGORIES: SF

woman in flight from everything she once loved. A complex, intelligent storyline and a sharp new animation style has catapulted the ancient saga into the modern idiom. The animation is good, the mecha action is superb — Kawamori has lost none of his touch when it comes to flinging giant chunks of metal across the screen — and the relationships, at first appearing shallow and tedious, deepen and draw you in as the series continues. In this first volume, Isamu Dyson, a hotheaded young pilot, is assigned back to a base near his early home to test a new fighter; testing for the opposition is his former friend, now deadly rival, Guld Goa Bowman. And Myung, the woman who forms the third point of the triangle, also returns to its source as programmer/manager of the latest pop sensation, computer-generated 'virtual idol' Sharon Apple. Not just for robot-jocks. ★★★

Gen and his girlfriend don't expect to see an alien and her sixty-storey-high Spirit of Ecstasy spacecraft when they leave the cinema after the movie. Even less do they expect to hear that Gen is the result of generations of genetic programming and is the only person who can locate the long-lost Crystal Maps that will show the way to a priceless alien treasure. And Lipmira isn't the only Hunter on Gen's trail... With danger following and the prize of unimaginable wealth and power beckoning, Gen and Hoshimi decide to go for it and set off on a wild interstellar adventure. Elegantly designed and well-paced. ★★★

MAGICAL TWILIGHT

JAPANESE CREDITS: Dir: Toshiaki Kobayashi. Prod: AIC. © Yuki, Pink Pineapple. 30 mins.
WESTERN CREDITS: US video release 1995 on AD Vision, sub, trans Doc Isaac, includes bonus art portfolio, c35 mins.
ORIGINS: Characters by Yuki (Akane Shinshaken).
CATEGORIES: X.

A harassed student who's already failed his final exams twice and is having nightmares about his own death doesn't need any more trouble. Tsukasa Tachibana gets plenty — he is the test subject for three apprentice witches, each one determined to pass her exams. White witch Chipple is a sweet young thing whose task is to make him love her; sexy Irene is set to catch him through the pleasures of the flesh; and would-be black magician Liv is supposed to murder him, after making him suffer first of course. But there's no serious harm done; in

MARS 1-6

JAPANESE CREDITS: Dir: Junji Nishimura. Script: Seiji Togawa. Chara des & anime dir: Hideyuki Hashimoto. Robot des: Yasuharu Morimoto. Art dir: Mitsuharu Miyamae & Osamu Honda. Music: Kaoru Wada. Prod: KSS, Japan Soft System. © Yokoyama, KSS. Each 30 mins.
ORIGINS: Manga by Mitsuteru Yokoyama; 1982 TV series God Mars: Six Gods In One Body.
POINTS OF INTEREST: Anime dir Hashimoto worked on the original TV series as well.
CATEGORIES: SF

This remake of a classic giant transforming robot show sticks very closely to the story of the original manga, with young Mars and his friends fighting for freedom and justice in their six robots which

together make up the mighty God Mars. In a move likely to appeal to military buffs, the real-life Maritime Self-Defense Force's existing ships, the Aegis cruiser *Kongo* and attack submarine *Nadashio*, make guest appearances. ★★☆?

NATSUKI CRISIS 1 & 2

JAPANESE CREDITS: Dir: Koichi Chiaki. Script: Shurai Sekishima. Chara des & anime dir: Futoshi Fujikawa. Art dir: Koji Ono. Prod: Madhouse. © Tsuruta, King Record. Each 30 mins.
ORIGINS: Manga by Hirohisa Tsuruta, pub in Shueisha's Business Jump.
CATEGORIES: N

A martial arts soap opera set in a private high school in Japan. Natsuki is a karate ace in a school in which martial arts are very much respected and well taught. But another local school has an ever higher martial arts reputation and rivalry between the two is fierce. A girl who transferred to Natsuki's school from its rival is the target of attacks from her former classmates; the student body president authorises spying missions on their 'rivals' and things are generally getting way out of hand. Then there are the romantic complications... Well animated, with superb, fastpaced fight scenes and a wealth of detail, this attractively designed OAV combines battle action with romance and interschool rivalry in a completely believable contemporary setting. ★★★

NEW DOMINION TANK POLICE 1-6
(Eng title for DOMINION CRUSH POLICE)

JAPANESE CREDITS: Dir & chara des: Noboru Furuse. Screenplay: Hiroshi Yamaguchi. Mecha des: Akira Ogura. Anime dir: Shinichi Shimamura & Hisashi Ezura. Art dir: Noboru Yoshida. Music: Yoichiro Yoshikawa. Prod: Sanctuary, J. C. Staff. © Shirow, Soeishinsha, Plex, Bandai. Each 30 mins.
WESTERN CREDITS: US & UK video release 1995 on Manga Video. The UK version picks up the numbering where the previous series left off, so these are parts 7-12; the US version puts 2 eps to a tape, so vol 1 contains eps 1 & 2, vol 2 eps 3 & 4 and vol 3 eps 5 & 6.
ORIGINS: Manga by Masamune Shirow, pub Soeishinsha; 1988 & 1989 Dominion Tank Police OAVs.
CATEGORIES: SF, C

More adventures of the Tank Police, the scourge of Newport City, in the first of a new six-part series. Furuse's sharp character designs bring an interesting edge to the familiar cast such as the voluptuous and deadly Puma Twins. The first episode brings Leona and Bonaparte into direct contact with a gang of drug smugglers and a rogue tank while an official is in the department to monitor the Tank Police's performance and report to the Mayor on whether it's worth keeping the force going. But is he what he seems? Evil forces are at work to try and take over Newport's streets for drug dealers. A rattling start to the new series. Further episodes continued in the style of the first series, with slapstick humour and action in equal measure. In episode four the Pumas even manage to steal Leona's beloved tank Bonaparte! ★★★?

OGRE SLAYER 1 & 2
(Eng trans for ONIKIRIMARU)

JAPANESE CREDITS: Dir: Yoshio Kato. Screenplay: Norifumi Terada. Chara des: Masayuki Goto. Prod: KSS. © Kusunoki, Shogakukan, KSS, TBS. Each 30 mins.
WESTERN CREDITS: US video release 1995 on Viz Video, trans William Flanagan & Yuki Sato, Eng screenplay by Danni Lyons for Animaze.
ORIGINS: Manga by Kei Kusunoki, pub Shogakukan, Eng trans pub (USA) Viz Communications 1995 in Manga Vizion.
CATEGORIES: H, X

A child is born to an ogre — yet he appears human and declares it his destiny to slay all his own kind with the sword born in his hand. He has no name — only the name of his blade, Ogre Slayer. When he has killed every ogre, then he believes he will become human. In these two stories he meets a young girl, bullied and afraid, who believes that the ogres she befriends will stand by her in times of trouble; and a career woman who returns to her hometown to help an old friend in trouble and finds herself embroiled in terrible danger. The animation is pretty limited but the artwork and backgrounds are very nice, creating a convincing image of contemporary Japan. The ogres are superb, bestial and crude, menacing and violent, like mediaeval scroll paintings come to life. The stories are somewhat lacking in pace, though. ★★☆

ORGUSS 02, 3-6
(Eng title for CHOJIKU SEIKI ORGUSS 02, lit Super Dimensional Century Orguss 02: Eng ep titles: 3 Fugitives, 4 Searcher, 5 Destroyer, 6 Those Who Wish For Tomorrow.)

JAPANESE CREDITS: Dir: Fumihiko
Takayama. Screenplay: Mayori Sekijima,
Hiroshi Yamaguchi & Yuji Kishino. Chara
des: Haruhiko Mikimoto. Art dir: Shichiro
Kobayashi. Music: Torsten Rasch. © Orguss
02 Project, Big West. Each 30 mins.
WESTERN CREDITS: US & UK video release
1995 in 3 vols on Manga Video, trans
Raymond Garcia.
ORIGINS: 1980 TV series, original story by
Fumihiko Takayama; 1993 OAV.
CATEGORIES: SF

War has broken out between the nations of Revilla
and Zafrin, and Lean, an officer of Revilla, is on the
run behind enemy lines with a mysterious young
girl who holds the key to a secret. The Zafrin army
secures one of the huge war machines known as
Decimators, and Lean learns that his own Prince
plans to use an even more powerful Decimator to
rule the whole world. Can he be persuaded to
destroy the huge weapons and allow the world to
live in peace? A classic science fiction tale, beauti-
fully designed. ★★★

PEACOCK KING 1 & 2
(Eng trans for KUJAKU-O 1 & 2)

JAPANESE CREDITS: Dir: Taro Rin. Script:
Hajime Inaba & Tatsuhiko Urahata. Chara
des: Ken Koike. Anime dir: Hisashi Abe.
Storyboards: Takuji Endo. Prod: Madhouse.
© Pioneer. Each 45 mins.
ORIGINS: Japanese & Chinese legend; 1988,
1989 & 1991 OAVs.
POINTS OF INTEREST: Pioneer claim this is
the first time the actual mythological
origins of the story have been presented in
anime form, in the early scenes showing the
battle between Kujaku-Oh and Tenja-Oh. A
1988 live-action version featuring martial
arts star Yuen Biao was made as a
Japanese-Hong Kong co-production.
CATEGORIES: H, SH

In the distant past, the god of light, Kujaku-Oh,
defeated the leader of the army of darkness, Tenja-
Oh, ensuring the triumph of good and the survival
of the world. But now, centuries later, the karmic
scales have once again tipped out of balance and
unrest between light and darkness means that the
cosmic war must be fought once again in modern
Japan. Twins Tomoko and Akira have a vital role to
play in this process. They were born to assume the
roles of Tenja-Oh and Kujaku-Oh, and eighteen-
year-old Akira has become a member of the Budd-
hist sect charged with guarding the sacred vessel

MYTHOLOGY

Film and TV writers and designers all over the world
have plundered ancient lore for sources for their stories.
Anime writers and artists are no exception to this rule.
Here are a few examples you will find scattered through-
out anime; a little research will turn up many more.

GREECE

A fertile ground for many stories, Greek myth is used in
anime as the basis for the popular series of TV episodes,
films and OAVs, Saint Seiya. Ancient Greek myths are
also the basis for Yoshikazu Yasuhiko's movie Arion,
while both myth and history, as adapted by Japanese
author Osamu Dazai, provide the basis for the beauti-
fully designed film Run, Melos!

INDIA

The greatest of the Indian myths, the Hindu religious
story cycle the Ramayana, has been made into an
anime film by a Japanese/Indian team. Hindu myth has
also influenced the OAV series Shurato and RG Veda,
while both myth and history are used in the Heroic
Legend of Arslan, and echoes of Hindu gods and writ-
ings show up in Leda: Fantastic Adventure of Yoko.

SCANDINAVIA

Saint Seiya also makes use of the Norse gods of Asgard
on more than one occasion, and OAV Digitial Devil Story
— Goddess Reborn features Loki, the mischief-maker of
Asgard, as a computer-generated bringer of chaos.

CHINA

From Hakujaden, The Legend of the White Serpent, the
first full-length colour anime film released in 1958, to
Rumiko Takahashi's Ranma 1/2, China has provided fer-
tile ground. Look out for Legend of the Four Kings, the
story of the Chinese dragon kings reborn as modern
Japanese brothers, and Akira Toriyama's Dragonball and
Dragonball Z. Chinese history in its earliest days is the
subject of Great Conquest: Romance of Three Kingdoms.

URBAN MYTH

This most recent of mythological cycles has its place
too. An episode of the Patlabor OAV series pays hom-
age to the great myth of the alligator in the city sew-
ers with an albino giant straight out of anyone's night-
mare, and TV series GeGeGe no Kitaro and Ghost Sweep-
er Mikami both have an episode devoted to the legend
of the ghost subway train.

known as the Dragon Grail, whose power can release Tenja-Oh into the world when the time is right. But now a crazed neo-Nazi, Siegfried, is seeking the grail for himself. He plans to use it to become the incarnation of Tenja-Oh, Emperor of Darkness. And this will prevent Akira's twin sister from fulfilling the destiny she was born for. Can he be stopped? ★★★?

PHANTOM QUEST CORP VOLS 1-4
(Eng title for YUUGEN KAISHA — this usually means 'private company' but the particular kanji used are a pun on this company's very special kind of work)

JAPANESE CREDITS: Dir: 1 Koichi Chigira; 2 & 4 Morio Asaka; 3 Takuji Endo. Screenplay: Mami Watanabe, Tatsuhiko Urahata & Tetsu Kimura. Writer & original concept: Juzo Mutsuki. Chara des: Hitoshi Ueda. Opening animation dir: Yoshiaki Kawajiri. Music:

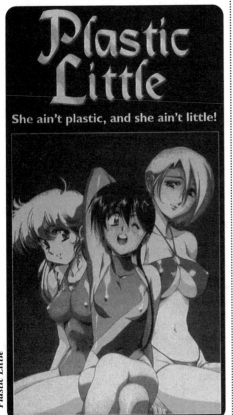

Plastic Little

Junichi Kanezaki. Prod: Madhouse. © Pioneer, AIC. Each 30 mins.
WESTERN CREDITS: US video release 1995 on Pioneer.
POINTS OF INTEREST: File 00 is a trailer cum introductory tape, with interviews, design shots, extracts from the anime and background information, sold separately.
CATEGORIES: H, C, A

The modern world isn't leaving ghosts many places to go. There are more and more people, fewer and fewer churchyards, dark forests and lonely mountains; and now Man has even started messing about with other worlds in his quest for 'scientific knowledge'. The old spirits and demons are getting restless and more and more bizarre phenomena are happening as they intrude on our space just as we're intruding on theirs. For some, this creates opportunity. Ayaka Kisaragi is one of a family of priests who have tended a shrine for generations. But girls only get to be shrine maidens and Ayaka has much bigger ambitions. Running out on the family business, she sets up her own company — a sort of temp agency of dealing with the supernatural. Her oddball staff with their wide range of paranormal talents are called in to deal with jobs as they arise. One day, Ayaka plans to head up the IBM of paranormal investigation and control. However, the Tokyo police have also set up a small section to deal with these cases. Staffed by rejects from 'normal' police work, it has its own agenda — but its head would like to work more closely with the sexy Ayaka. Comedy, romance, and action combine in this funny and entertaining show, with adventures focused round such events as the secret sale of Transylvania's national treasure — Dracula's coffin — to a Japanese investor and a mysterious, life-drinking demon on the loose between dimensions. ★★★

PLASTIC LITTLE

JAPANESE CREDITS: Dir: Kinji Yoshimoto. Writer & chara des: Satoshi Urushibara. © Urushibara, Yoshimoto, MOVIC, Sony Music Entertainment Ltd. 55 mins.
WESTERN CREDITS: UK video release 1995 on Kiseki Films, trans Jonathan Clements; US video release 1995 on A.D. Vision, trans Ichiro Araki & Dwayne Jones.
ORIGINS: Original story by Satoshi Urushibara.
POINTS OF INTEREST: The first OAV to be actively promoted by the Japanese to UK fans on Japanese release; SME sent materials to Anime UK with a request for coverage

prior to the Japanese street date and Kiseki are said to have bought the rights before the Japanese release.
CATEGORIES: SF, A, X

Creator Urushibara and director Yoshimoto said in a 1995 interview that *Plastic Little* was actually only a 'side story' in the vast universe they had created, and that the 'real story' was still to come. It has been one of the most reviled OAVs among politically correct fan groups, nicknamed 'Plastic Nipple' and 'Silicon Little' on account of its creator's fondness for bouncing breasts rendered in lovingly perfect detail. It is also one of the closest and most exact renditions of an artist's painting style in animated form, every frame a near-perfect facsimile of Urushibara's glossy, sensuous art and a glowing tribute to the animators' skills. The story is pretty slight, but why criticise a cream-puff for being light and fluffy? Heroine Teeta has inherited her dad's ship and runs a crew of 'pet shop hunters', picking up exotic creatures in the gas-seas of planet Yietta and selling them on to wealthy collectors. In port for repairs, the crew are loafing around when Teeta runs into Elise, a girl on the run from the authorities, and takes her in. It turns out her scientist father has been killed by a power-mad local commander who wants to use his scientific work as a weapon to gain total power. (Don't they always?) Teeta and her crew determine to help Elise, and the video packs in massive destruction and some exciting fight and chase scenes. Topless sequences earn it its X rating but the sexual content is entirely harmless. If you're freaked out by the idea that teenage boys — the intended audience — find drawings of girls' bodies attractive enough to sell videos, then this isn't for you. Personally, I wasn't in the least offended, and the art is lovely. ★★★

PLEASE SAVE MY EARTH 1-6
(Eng title/trans for BOKU NO CHIKYU O MAMOTTE)

JAPANESE CREDITS: Dir & script: Kazuo Yamazaki. Des: Yuji Ikeda. Anime dir: Takayuki Goto. Music: Hajime Mizoguchi. Prod: Production I. G. © Victor Entertainment, Soeishinsha. Each 30 mins.
ORIGINS: Manga by Saki Hawatori, pub 1987 Hakusensha in Hana To Yume (Flowers & Dreams). To date over 20 compilation volumes have been published.
SPINOFFS: A compilation edition for theatrical release was made & shown in 1995.
CATEGORIES: SF

Alice Sakaguchi is having strange dreams. She's

another person, from another race, a race in which paranormal powers are quite usual — living in a base on the Moon, looking down on planet Earth, which they have sworn to protect. Her whole civilisation has been destroyed by war; only this little base, with its seven crew, survives — for now. They're dying; but they will be reborn as humans on Earth. She'll be Alice Sakaguchi... Alice meets six other teenagers, the reincarnations of her old colleagues, and a series of strange events, mixing this world with the world of the team on the Moon, leaves them all confused and shaken. The Earth is in terrible danger and they must remember how to save it. A classic love triangle replays itself in both incarnations and old and new rivalries and jealousies threaten their mission. This is a dramatic and atmospheric story, varying somewhat from the manga but preserving its delicacy, beauty and intensity. The animation, design and colour balance are all superb and the direction excellent. A high-quality science fantasy romance, not to be missed. ★★★★?

RANMA 1/2 OAV: DESPERATELY SEEKING SHAMPOO
(Includes two Japanese releases: Shampoo's Sudden Switch! The Curse of the Contrary Jewel and Tendo Family Christmas Scramble)

JAPANESE CREDITS: Dir: Junji Nishimura. Screenplay: Ryota Yamaguchi. Chara des: Atsuko Nakajima. Music: Akihisa Matsu'ura. Prod: Kitty Film. © Takahashi, Shogakukan, Kitty, Fuji TV. Each 25 mins.
WESTERN CREDITS: US video release 1994 on Viz Video, dub, trans Toshifumi Yoshida, written by Trish Ledoux.
ORIGINS: Rumiko Takahashi's manga, pub Shogakukan, Eng trans pub Viz Communications; TV series; 1990 OAV; 1991 & 1992 movies.
POINTS OF INTEREST: The US titles are not translations of the Japanese, but puns on contemporary Western movie titles.
CATEGORIES: SF, C, R

Two well designed and animated stories with a lot of charm; I have to confess that the predictability of the *Ranma* setup can wear thin for me at times, but I really enjoyed these two. The first story has one of Ranma's would-be fiancées, Shampoo, choosing an heirloom brooch as a gift from her great-grandmother; but it's a cursed jewel, which when worn upside down reverses the feelings of the wearer towards the one she loves. Worn the right way up it enhances love, but Shampoo puts it on upside down and suddenly hates Ranma. And of course

GAYS & TRANSVESTITES

For the most part anime and manga take a relaxed view of gays, transvestites and transsexuals, though when this accepting attitude goes off the rails it goes right off. However, anime does present a much wider range of positive images than most of Western popular culture, and with far less 'tokenism' — a character's gayness is not his or her sole purpose in the story. Starting with the 1982 TV series *Pataliro! I'm Pataliro!*, anime has presented a wide and largely affirmative range of images.

Samurai Gold probably takes the prize for political incorrectness. Gay bodyguard Okama-san, the 'Gay Blade' (okama is a Japanese word meaning both a sickle and a homosexual), is portrayed in a way that is meant to be humorous, but which many British gays find unfunny to the point of being offensive. On top of this, hero Gold's cross-dressing to avoid his unwanted attentions is also presented with very little sophistication. However, in *Cyber City Oedo 808* the androgynous crossdresser Benten presents a much more positive image, a fast and deadly martial artist whose relationships with both sexes and confidence in himself seem totally unaffected by the style he chooses to adopt. The effect is somewhat marred in the UK dub by the addition of gobbets of profanity to his dialogue, which don't fit with the more sophisticated speech patterns of his Japanese at all.

In the TV series *Genesis Climber Mospeada*, edited and dubbed for the West as part of *Robotech*, the character Yellow Belmont, renamed Yellow Dancer for the edit, is a possibly-bisexual, crossdressing male who is not only one of the principal characters, but one of the most charismatic and likeable in the whole story. In the early part of the OAV series *3 x 3 Eyes*, we learn that hero Yakumo has been raised by a transvestite who took him under his wing when his father vanished; again the image of the character is very positive.

Here is Greenwood, a charming OAV series set in a high school dormitory, recognises the confusion many young people feel about gender and identity. Two of the major male characters are pretty enough to cause the hero considerable astonishment. In the recent OAV series *El Hazard*, the hero is a young man abducted to another world because he looks exactly like a missing Princess, whose presence is vital to peace negotiations; he agrees to help out with a little impersonation, but is at great pains to insist that he isn't a girl. And in Rumiko Takahashi's *Ranma 1/2* there's a girl who has to masquerade as a boy because

of family pressure, whose problems as she has to cope with her own feelings for boys and the attentions of girls are sympathetically and hilariously portrayed. The crossdressing ground was first covered in Ryoko Ikeda's manga and anime series *Rose of Versailles*, in which the only child of a noble French family has to secure her family honour by joining the court of Marie Antoinette masquerading as an officer and a gentleman. She acquits herself with great aplomb until she falls in love with a young revolutionary, threatening both her identity and her position at court.

The tensions and strains that arise in any romantic relationship can tear it apart. In *Wind and Trees Song*, a romance set in a French boys' school at the end of the last century, a love affair between two teenagers ends tragically when one of them can't overcome his feeling that their love is forbidden and wicked, based on his background and religious convictions. And *Love's Wedge* is the story of a teenager whose lover finally can't accept that he has been manipulated and coerced by an older, powerful man of the world, and rejects him.

Ranma can't face that and has to woo and win her even though he doesn't want her. Politically incorrect, but quite funny. The other story shows Christmas at the Tendo household. Santa tells Kasumi to throw a huge party and everyone shows up to give gifts to the ones they love. The preparations get a little fraught, but by the time the special family-and-friends concert is under-way things are set for the best Christmas ever. ★★★

Also:
RANMA 1/2 OAV: LIKE WATER FOR RANMA
(Includes two Japanese releases: Akane vs Ranma! I'll Be the One to Inherit Mother's Recipes and Stormy Weather Comes to School! Growing Up With Miss Hinako)

CREDITS, ORIGINS, POINTS OF INTEREST, CATEGORIES: As above.

Kasumi is ill and Akane has to take over the cooking, helped by a volume of her mother's recipes. Then Ranma's mother shows up, completely unaware of her husband's and son's shape-shifting secret — well, she hasn't seen them for ten years. The equation good woman equals good cook is not an acceptable one in many circles, so some modern thinkers might like to avoid this video (although it's amazing how many people will happily say that the attitudes to women displayed in

Plastic Little are dreadful, yet unblushingly confess to being *Ranma* fans!). In the second OAV, a new teacher decides to bring some discipline to Furinkan High and soon clashes with Ranma. ★★☆?

Also:
RANMA 1/2 OAV: AKANE AND HER SISTERS

CREDITS, ORIGINS, POINTS OF INTEREST, CATEGORIES: As above except: 60 mins.

A terrible shock for the Tendo sisters comes when two girls show up on the doorstep claiming to be Soun Tendo's other daughters, and carrying a document in which he promises to let them take over the dojo. This is an original two-part story not found in the manga. ★★☆?

Also:
RANMA 1/2 OAV: AN AKANE TO REMEMBER PART 1
(Eng trans for RANMA 1/2 SPECIAL YOMIGAERU KIOKU, lit Returning Memory Part 1)

JAPANESE CREDITS: Dir & storyboards: Junji Nishimura. Script: Ryota Yamaguchi. Chara des & general anime dir: Atsuko Nakajima. Anime dir: Fumie Muroi. Art dir: Tomo Muira. Music: Akihisa Matsu'ura. Prod: Studio Dean, Kitty Film. © Takahashi, Shogakukan, Kitty Film, Fuji TV. c30 mins. WESTERN CREDITS: US video release 1995 on Viz Video, dub, trans Toshifumi Yoshida, written by Trish Ledoux, on single tape with part 1 & 4 music videos. ORIGINS, POINTS OF INTEREST: As above. CATEGORIES: SH, C, A

Akane sees a news special about 'monster sightings' in rural Japan. This awakens a vague memory of being rescued in childhood by a boy with a horn whistle, and she sets out alone to see if she really remembers or if it was just a dream. Deep in the forest she meets the boy, Shinnosuke, who lives with his grandfather. Back at the dojo, Soun Tendo insists that Ranma goes to find Akane and bring her home. ★★☆?

SAITAMA BIKER GANG FRONTLINE: FLAG

JAPANESE CREDITS: Chara des: Mutsumi Inomata. Prod: Magic Bus. © VAP Video. 45 mins. CATEGORIES: N, X?

That's all I know apart from the fact that this is a story of modern-day biker gangs; so you can expect loyalty, honour and rumbles.

TALE OF SEVEN CITIES 1 & 2
(Eng trans for SEVEN CITIES MONOGATARI)

JAPANESE CREDITS: Dir: Akinori Nagao. Script: Toruchobu Nobe. Chara des: Tomomi Kobayashi. Prod: Animate. © Sony Music Entertainment. Each 30 mins. ORIGINS: Novel by Yoshiki Tanaka. POINTS OF INTEREST: Chara designer Kobayashi came to the team from the design crew for the SNES game Final Fantasy. CATEGORIES: SF

In 2099 the Earth shifts on its axis, and now rotates at an angle of 90% to the present day equator. After three years of natural disasters and terrible pollution, the Earth's ten billion population is reduced to two million Moon colonists, who return to repopulate the world in seven new cities. The remaining Moon colonists, worried about a threat from the newly colonised Earth, construct a ring of satellite defences that can run automatically for 200 years without any human intervention. Unfortunately, the entire Moon population is then wiped out by a plague. Trapped beneath the ring of defence satellites, the seven cities begin to fight each other... The artwork is atmospheric, gloomy and tense, the name Tanaka guarantees a character-heavy, well-plotted story. ★★★?

TEKKAMAN BLADE 2 VOLS 1-3
(Eng title for UCHU NO KISHI TEKKAMAN BLADE 2, lit Space Knight Tekkaman Blade 2. Ep titles: 1 Virgin Flush; 2 Virgin Blood; 3 Virgin Dream)

JAPANESE CREDITS: Dir: Hideki Tonokatsu. Script: Hiroyuki Kawasaki. Main chara des: Hitoshi Sano. Main mecha des: Yoshinori Sayama & Rei Nakahara. Anime dir: Shigeki Kohara. Mecha anime dir: Yutaka Nakamura. Art dir: Yoshimi Uchino. Sound dir: Hideyuki Tanaka. Prod: Ippei Kuri. Prod co: Sotsu Agency, Tatsunoko Pro. © Tatsunoko, King Record. Each 30 mins. ORIGINS: 1975 & 1991 TV series; original story by Tatsunoko Pro Plot Section. POINTS OF INTEREST: The 1991 TV series has been edited for showing on US TV as Teknoman. CATEGORIES: SF

Further adventures of the alien Tekkaman armour, now used to defend Earth, its wearer and his human friends and allies. D-Boy, the human kidnapped by the alien Radamu in the *Tekkaman Blade* TV series, escaped to help his people fight the aliens. Now he returns to save the Earth once more, although this time he has to team up with several beautiful young girls, the Tekkaman Support Team. Set ten years after the TV series, this OAV sequel capitalises on the nineties 'voice actress boom' ensuring that the protagonist shares the screen with several famous voice actresses, each of whom has also made a tie-in single. Not enough information to rate it, but note the involvement of industry giant Ippei Kuri, who has been involved in many hit TV shows from *Time Bokan* onwards.

TENCHI MUYO! RYO OH KI 8 & 9
(Japanese title also used for English versions. Various trans include 'No Good Tenchi', 'No Time for Tenchi', Heaven and Earth Prince', etc. Eng ep titles: 8 Hello Baby; 9 Sasami and Tsunami)

JAPANESE CREDITS: Dir: Kazuhiro Ozawa. Screenplay: Yosuke Kuroda. Story concept, chara des & anime dir: Masaki Kajishima. Art dir: Takeshi Waki. Music: Seiko Nagaoka. © Pioneer. Each 25 mins. WESTERN CREDITS: US, sub & dub, and UK, dub, release 1995 on Pioneer on one tape. ORIGINS: 1992 & 1993 OAVs. SPINOFFS: Manga, a popular radio drama series scripted by Naoko Hasegawa, TV series, CDs & merchandise galore. CATEGORIES: DD, C, R

Tenchi's further adventures follow exactly the same path as before. The formula has now been tried and tested and it works, so the team keep on repeating

Tenchi Muyo! Ryo Oh Ki

it with infinite charm, talent and resourcefulness. Tenchi is forever both pursued and put-upon by the women in his life; all the characters reveal new facets of themselves in these pretty, light-hearted stories, but nothing changes. Nor would the legions of Western *Tenchi* fans want it to — the series has been a huge hit here. As lightweight as it's light-hearted but very clever in raising its smiles. ★★★

Also:
TENCHI MUYO! MIHOSHI SPECIAL

JAPANESE CREDITS: Dir: Kazuhiro Ozawa. Screenplay: Ryoei Tsukimura. Chara des: Masaki Kajishima. Anime dir: Wataru Abe. Art dir: Chieko Nezaki. Music: Seiko Nagaoka. Prod: AIC. © Pioneer, AIC. WESTERN CREDITS: US video release 1995 on Pioneer, sub & dub. ORIGINS, SPINOFFS, CATEGORIES: As above.

Bubble-brained Galactic Police Officer Mihoshi tells the story of how she and her partner, Kyone, solved the case of the notorious space pirate. All the regular characters are 'persuaded' to join in this reconstruction, with Tenchi as the Investigator, Ryoko as the space pirate and Sasami making her first appearance as Pretty Sammy the Magical Girl. ★★★?

THERE GOES SHURA

JAPANESE CREDITS: Prod: Knack. © Toei. 50 mins. CATEGORIES: X, V?

I have no more information on this yakuza warfare story, but we can infer heavy firepower and buckets of gore from the genre and promotional art.

TIME BOKAN REVIVAL 1

JAPANESE CREDITS: Dir & story: Takao Koyama & Hiroshi Sasagawa. Script: Satoru Akahori. Chara des: Yoshitaka Amano & Kunio Okawara. Music: Masayuki Yamamoto & Masaki Kamiyasa. Prod: Tatsunoko. © Tatsunoko, Victor Entertainment. 30 mins. ORIGINS: 1975 TV series, six subsequent linked series continuing until 1984. CATEGORIES: C!

Pure madness and a homage to *Wacky Races* as well as to its own past and to the creation of the 'Tatsunoko gag anime' of which *Time Bokan* was the first. A race is on — a race to determine who will be

the main character in the next episode. Competing are all seven trios of villains from all seven previous linked series. Oh, and they're all voiced by the same trio of actors... Non-stop slapstick, knockout fun, retro as it should be done. ★★★

TWIN DOLLS I: LEGEND OF THE HEAVENLY BEASTS

JAPANESE CREDITS: Dir: Kan Fukumoto. Original story & script: Ohji Miyako. Chara des: Shin Rin. © Daiei Co. 50 mins. WESTERN CREDITS: US video release 1995 on AD Vision, sub, trans Toru Iwakami. CATEGORIES: X, V

Also:
TWIN DOLLS II: RETURN OF THE HEAVENLY BEASTS

CREDITS, CATEGORIES: As above.

A virtual re-run of everything else in the tits 'n' tentacles genre. Twins Mai and Ai are trained martial artists masquerading as typical high school girls; classroom jealousy gets them entangled with a horned demon who is out to destroy the girls and turn their classmates into an army of sex slaves. The second OAV is — wait for it — about a horned demon who is out to destroy the twins and turn all the girls in the vicinity into an army of sex slaves. I haven't seen this so maybe it's unfair of me to dismiss it, but what the hell — it sounds like rubbish. If you want to exercise your arm, take up tennis.

VILLGUST 3
(Eng title for KORYU DENSETSU VILLGUST, lit Armoured Dragon Legend Villgust)

JAPANESE CREDITS: Dir: Satoru Akahori. Chara des: Kosuke Fujishima. Music: Kohei Tanaka. Prod: Animate Film. © Bandai Visual. 30 mins. ORIGINS: Gachapon (vending machine) toys; 1993 OAV. CATEGORIES: C, U, DD

The final part of the toy-inspired fantasy series.

YOU'RE UNDER ARREST! 1 & 2
(Eng trans for TAIHO SHICHAUZO! 1 And They Met; 2 Tokyo Typhoon Rally)

JAPANESE CREDITS: Dir: Kazuhiro Furuhasi. Chara des: Atsuko Nakajima. ©

Fujishima, Kodansha, Bandai Visual, Marubeni. WESTERN CREDITS: US video release 1995 on AnimEigo, sub, trans Shin Kurokawa. ORIGINS: Manga by Kosuke Fujishima, pub Kodansha. SPINOFFS: Several CDs have not simply featured music from the show but have advanced the story & given extra insight into the characters. POINTS OF INTEREST: Although the manga preceded Oh My Goddess!, the later story was animated first, and the demand for Fujishima's particular style of cute chara drawing led to the release of this very different story as an OAV series. CATEGORIES: N

The adventures of two Tokyo traffic policewomen, one (the gentle Miyuki) an ace driver and mechanic, the other (the very strong Natsumi) a hot-headed motorcyclist, form a charming soap opera whose animation and art are among the most beautiful seen this year. There are action sequences too — the car chase in the rain in part two has rarely been bettered — but the overall emphasis is on gentle humour and relationships. When they first meet, heroines Natsumi and Miyuki don't hit it off, but when they have to chase 'The Fox', a reckless driver in a customised Morris with a penchant for playing games and a seemingly deadly agenda, they have to work together and come to rely on each other. A cute kitten pops up in the story, and there are a whole basketful in part two, where the pursuit of another reckless driver, this time in a yellow Lancia Delta, is intercut with attempts to get a pregnant cat to the animal hospital through one of the worst typhoons to hit Tokyo. A love interest is woven in and there's another subplot about a gossipy colleague. Nothing unusual, nothing heavy, but very nicely done indeed. ★★★?

You're Under Arrest!

The OAV, settled into the maturity of an established medium, was represented this year by 122 new titles. Of these, twenty-five (just over 20%) were 'adult' and five were 'specials' — music videos, or trailer videos for new releases, as in the case of *Gun Smith Cats Chapter 0*. Theatrical releases too had a healthy year. In terms of gross takings, the highest grossing domestic movie was an animation: Studio Ghibli's *Whisper of the Heart*, also known as *If You Listen Carefully*, in seventh position in a chart where the top six slots were held by heavily promoted American blockbusters like *Die Hard With a Vengeance*. Anime occupied four of the top ten slots in the highest grossing domestic release chart. As for sales of OAVs and TV audiences, an interesting anomaly shows in *NewType* magazine's listings for 1995. The top ten best selling animated videos in Japan all came from a single, foreign studio — Disney; yet in the TV ratings chart, the highest scoring foreign animation was *Teenage Mutant Ninja Turtles*, at number twenty-five. I'm not sure whether to write this down to the greater sophistication of the video buying audience, their greater susceptibility to massive promotional spending, or the insularity that seems to categorise TV audiences everywhere.

In America, 1995 saw a resurgence of adapted and dubbed anime on TV. *Tekkaman Blade* became *Teknoman*, *Samurai Troopers* became *Ronin Warriors*, *Dragonball* remained its own sweet self (but with underpants on), and the first serious attempt on the girls' market came in the shape of DIC's version of *Sailor Moon*. The huge success of *Power Rangers*, still the highest selling toy range after three years in the American market, and Saban's willingness to introduce other Japanese titles as evinced by the launch of *Masked Rider* for 1996, was possibly a greater factor than the growing public awareness of anime in persuading American companies to look

again at Japanese animation. This wave has yet to hit the UK, where 1995's biggest TV events as far as anime was concerned were the Channel 4 late night screenings of titles which had already been on general sale for some time, and satellite screenings of a handful of old favourites like *Battle of the Planets*, *G Force* and *Robotech* — hardly the stuff from which cutting edges are forged.

The major event of the year as far as Western involvement in anime production was concerned was the Japanese, UK and US theatrical release of *Ghost in the Shell*, partly financed by Manga Entertainment and much trumpeted in the anime press as the long-awaited 'successor to *Akira*' and latest standard-bearer in the ever-advancing march towards integration of computer and cel animation techniques. The creation of Disney's *Toy Story* entirely in the computer may make this sound a pointless exercise, but there are those who think that using the computer for its own sake is just as futile, and that there will be a place in the industry for the traditional artistry and skill of the cel animator for some time yet. An interesting element of the ballyhoo surrounding the launch of *Ghost in the Shell* (or *GITS*, as it is affectionately known among UK anime fans) was the number of journalists and publicists who thought, quite wrongly, that it was the first US-Japanese, or even Western-Japanese, collaborative effort in anime. The film is remarkable enough in its own right; it has no need of such transparently false trappings.

The year ended with a number of interesting new OAVs and movies in production, and the industry awaiting the next (and possibly the last) masterpiece from Hayao Miyazaki, due in 1997. This summer did see a new Miyazaki release — a six-minute music video called *On Your Marks* for a Chage and Asuka track, directed by the master and given a full-honours theatrical release on a triple bill with *Dragonball Z* and *Slam Dunk*, as well as with *Whisper of the Heart*. Halfway through its ninth decade, anime is alive and well and part of the world's popular cultural mix; and the OAV, now in its second decade, is an important element of that mix.

MOVIES

ANPAN MAN & HAPPY'S BIRTHDAY
(Eng trans for ANPAN MAN TO HAPPY NO TANJOBI)

JAPANESE CREDITS: Dir: Toshio Oga. © *Matsutake, Fuji Distribution. c50 mins.*

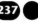

ORIGINS: 1991 TV series; movies.
POINTS OF INTEREST: Double bill release
with another Anpan Man movie, below.
CATEGORIES: C, U

Also:
ANPAN MAN & THE GHOST SHIP
(Eng trans for SORE IKE! ANPAN MAN TO
YUREKANO YATSU KERO, lit Go For It! Anpan
Man & the Ghost Ship)

CREDITS, ORIGINS, CATEGORIES: As above.
POINTS OF INTEREST: Double bill with
movie above.

Anpan Man is a superhero with a beancurd-stuffed bun (anpan) for a head. These cheerful adventures, based on the idea of helping others and being friendly and nice, are moral tales for tinies leavened with comedy, and are very successful at the box office. I don't know enough about these two titles to rate them.

CATLAND BANIPAL WITT
(Eng title for TOTSUZEN! NEKO NO KUNI
BANIPAL WITT, lit Suddenly! Catland Banipal
Witt)

JAPANESE CREDITS: Dir: Takeshi
Nakamura. Script: Takeshi Nakamura &
Chiaki Konaka. Anime dir: Hajime
Hasegawa. Art dir: Shinji Kumara. Music:
Naruaki Mie. Prod: Triangle Staff. ©
Gakken, Banipal Witt Manufacture
Commitments. 90 mins.
ORIGINS: Story by Takeshi Nakamura, pub
Kinema Junpo-sha.
CATEGORIES: A, U

Toriyasu is at that awkward age, scared to grow up, ashamed to be thought childish. He begins to dismiss the power of his imagination, mocking his little sister Miko for her own imagination, and also starts to neglect his pet dog Papadoll. In other words, like many ten-year-old boys, he's a pain in the neck; but when the dog vanishes he is desolate. Late one night three mysterious talking cats show up and take him and Miko in their dimensional travel craft to the world of Banipal Witt. Papadoll has been magicked there and turned into a monster by the evil Princess Bubulina, who is intent on turning everyone in the kingdom into balloons. The cats want his owners to take him back to their own world. The children find that in Banipal Witt they're kittens — and if they stay too long in the catland they'll be changed into cats forever, or even worse, become monsters like Papadoll! This is a

wonderful film for children, and for adults it's the safest trip you'll ever go on, with no hallucinogenic substances required. The design and colours are so psychedelic that you wouldn't be surprised to hear the strains of Sgt Pepper's Lonely Hearts Club Band, and the innocent excitement of the adventure is captivating. ★★★☆?

DIARY OF ANNE [FRANK]
(Eng trans for ANNE NO NIKKI)

JAPANESE CREDITS: Dir: Akinori Nagaoka.
Music: Michael Nyman. Prod: Masaya Araki.
Prod co: Toei. © Toei, Anne Frank
Production. c90 mins.
ORIGINS: The diary of Anne Frank.
POINTS OF INTEREST: Made to commemorate
the fiftieth anniversary of the death of Anne
Frank. Premiered in Amsterdam, her home
town. Anne's diaries have been animated
before, in a 1979 TV special by Nippon
Animation.
CATEGORIES: W, N

This animated version of the moving diary written by a young Jewish girl while in hiding from the Nazis with her family and friends is a superb memorial to her refusal to give up on life. She wrote of the boredom of everyday life in hiding, her dreams and hopes, and the fears of capture which finally came true. Sadly Anne died in a concentration camp only a short while before the end of the war, but her diary survives as a monument to the resilience of the human spirit. ★★★☆?

DRAGONBALL Z — RETURN FUSION GOKU & VEGETA
(Eng trans for DRAGONBALL Z — FUKATSU NO
FUSION GOKU & VEGETA)

JAPANESE CREDITS: Dir: Shigeyasu
Yamauchi. Prod: Toei Doga. © Bird Studio,
Shueisha, Toei. c50 mins.
ORIGINS: Akira Toriyama's manga, pub
Shueisha; 1986 TV series; movies every year
1986-93.
POINTS OF INTEREST: Released in March on
a double bill with the Doraemon movie,
joint 5th highest grossing domestic movie of
1995. The manga series came to an end in
1995 after 42 collected volumes.
CATEGORIES: SH, C

The latest — and as it turned out, almost the last — DBZ movie has the gentle, playful Goku and belligerent, proud Vegeta fusing into one unlikely but

very powerful Super Saiyajin fighter called Gogita to face an immense and terrifying foe too strong for either of them to defeat alone. With *DBZ* veteran Daisuke Nishio fully occupied with *Youth's Legend Shoot* for most of 1994, it fell to Yamauchi to throw Toriyama's beloved characters around the screen for maximum mayhem and comic effect. ★★★?

Also:
DRAGONBALL Z — STRIKE OUT, DRAGON PUNCH! WHO'S WITH GOKU?
(Eng trans for DRAGONBALL Z — RYUHEN, BAFUKETSU! GOKU GA YARU NEBA GAREGA HARU?)

CREDITS, ORIGINS, CATEGORIES: As above except: Dir: Mitsuru Hashimoto.
ORIGINS: As above.
POINTS OF INTEREST: On a triple bill with Slam Dunk and the Miyazaki music short On Your Marks.

Videl has taken up the superhero business herself and joins Gohan, aka Great Saiyaman, on his missions, as Great Saiyaman 2. The pair go to the aid of an old man in trouble and learn from him that a terrible creature is approaching the Earth and will consume it utterly. Only the ancient warrior Tapion, who once saved a planet in the Southern Galaxy from the same threat, can help the world, but he's shut up in a music box. Time to reunite the Dragonballs and free Tapion! But in fact the old man was lying; he had a hidden agenda, since he is himself one of the creators of the threat to Earth. More martial arts fun. ★★★?

FLY, PEGASUS!
(Eng trans for TOBE, PEGASUS!)

JAPANESE CREDITS: Dir: Seiji Okada. Script: Eiji Toda. Prod: EG Film. © Japan Victor.
CATEGORIES: DD?

All I know about this film is that it 'concerns a young girl's dreams'. I haven't seen enough artwork to form a judgement.

GHOST IN THE SHELL
(Eng title for KOKAKU KIDOUTAI, lit Man/Machine Interface)

JAPANESE CREDITS: Dir: Mamoru Oshii. Script: Kazunori Ito. Chara des: Hiroyuki

Ghost in the Shell

Okiura. Mecha des: Shoji Kawamori & Atsushi Takeuchi. Weapon des: Mitsuo Ito. Gun Adviser: Kikuo Irimoto. Choreography: Toshihiko Nishikubo. Music: Kenji Kawai. Prod: Production IG. © Shirow, Kodansha, Bandai Visual, Manga Entertainment. c75 mins.
WESTERN CREDITS: US & UK theatrical release 1995, video release 1996 on Manga Video, trans Taro Yoshida & Paul C. Halbert.
ORIGINS: Manga of the same title by Masamune Shirow, pub Kodansha.
POINTS OF INTEREST: The integration of cel animation with computer techniques makes a quantum leap in this movie and becomes almost imperceptible. This is much more important than the co-production aspect, since Japanese/Western co-productions have been well established for many years.
CATEGORIES: SF

Major Motoko Kusanagi is, like most of her colleagues, an 'enhanced' human, more or less a cyborg, with extensive body and mind 'upgrades' that require regular and expensive maintenance — to the extent where she has begun to question her own humanity and look for a purpose in her existence. In a secret research facility, a programme created for politico-commercial ends has acquired sentience and has also begun to question its destiny. As the ongoing dance of corruption, chicanery and accomodation which passes for politics in the modern world goes on around them, these two remarkable beings move towards their inevitable meeting, and a union which will create a new form of life. The evolutionary metaphors are unmistakable, and beautifully developed, in Oshii's sensuous reworking of Shirow's complex manga. The primary theme of science fiction, first defined in Mary Shelley's *Frankenstein*, is one which acquires increasing interest and importance as we move closer and closer to creating life, not only in the test-tube and insemination dish, but in the com-

puter. We are coming to a point where we will at last be forced to define what life is and what duties it and its creators have to each other and to other forms of life, no matter how they were generated. The question asked about the film most often is 'Is it the next *Akira*?' and the answer is no; but that doesn't make it a failure. The plotting and pacing have their defects, but the visual impact of the film is overwhelming, and very much enhanced by Kenji Kawai's visceral score. The addition of Western music to the end of the film to cover the extra English language production credits doesn't detract from Oshii's work, though a wooden performance from the actress providing Kusanagi's English voice does; but the main problem is one of our own expectations. Many English-speaking viewers still see anime as a one-note song, and judged by *Akira* that song is a hard-driving, dizzying teen-rock rebel anthem; the more orchestrated delicacy of Oshii's work doesn't fail to compete, it just makes another kind of music. ★★★★

GOODBYE TO MOTHER'S PERFUME
(Eng trans for SAYONARA WA O-CHICHI NO NIOI)

JAPANESE CREDITS: © Gakken.
CATEGORIES: N, W

A film made to mark the fiftieth anniversary of the Hiroshima and Nagasaki bombings. A fifteen-year-old apprentice cook tells the story of the war and the Nagasaki massacre as seen through his own adolescent eyes. I don't have enough information to rate this, but it sounds interesting.

JUNKERS, COME HERE!

JAPANESE CREDITS: Dir: Junichi Sato.
Chara des: Ichiro Komatsubara. Planning: Takashi Watanabe. Prod: Gaga. © Gaga Distribution.
CATEGORIES: U

A *Lassie*-type story about a young girl and her devoted canine friend Junkers. That's all I know, so no rating.

KAZU & YASU HERO LEGEND
(Eng trans for KAZU TO YASU HERO DENSETSU)

JAPANESE CREDITS: Script: Kazuki Akane.
Prod: Triangle Staff, T & K Telefilm. ©

Matsutake Distribution, Kazu & Yasu Production.
CATEGORIES: N

The true story of the Miura twins, young Japanese footballers who achieved international success. The elder twin is currently in an Italian league team, the younger in Brazil — both of which countries are also among the most eager audiences for Japanese soccer animation! The art looks competent though I haven't seen the movie. ★★☆?

LEGEND OF CHRYSTANIA
(Eng title for HAJIMARU NO BOKENTACHI CHRYSTANIA NO DENSETSU, lit First Adventurers Legend of Chrystania)

JAPANESE CREDITS: Dir: Ryotaro Nakamura. Script: Ryo Mizuno. Prod: Triangle Staff. © Mizuno, Group SNE, Kadokawa, Marubeni.
ORIGINS: Novel series by Ryo Mizuno, creator of Record of Lodoss War.
SPINOFFS: Games, more novels & merchandising.
POINTS OF INTEREST: Released on a double bill with Slayers.
CATEGORIES: DD, A

In the same universe as *Record of Lodoss War*, but 300 years later on a continent far to the south, an heroic tale unfolds. King Barbas, evil beyond thought, a god deposed and seeking to reclaim his godhead, is out to conquer the world. To do so he must imprison Ashram, the legendary Wandering King, Emperor of Chrystania, in limbo, his soul kept apart from his body. During Barbas' reign of terror, young Rayden's father is murdered and his village burnt, apparently 'by order of the King'.

MASAMUNE SHIROW

A former schoolteacher and fanzine artist, his works are hugely popular in the West. His intelligent, questioning approach, political sophistication, visual inventiveness and boundless curiosity have produced a wide range of works, most of which examine man's relationship with and dependence on technology of various kinds.
RECOMMENDED WORKS: Manga translations by Studio Proteus released by Dark Horse Comics include *Appleseed* and *Dominion Tank Police*, both also available on video in the UK from Manga Video. The manga *Ghost in the Shell* is now available from Dark Horse, and the anime was released in September 1995, with US and UK release on Manga Video.

Rayden sets out armed with the magic blade his father gave him, and accompanied by a small party of friends, to seek the truth behind his father's murder. On the way he meets many strange beings, some trustworthy, others dangerous, and encounters all three of the different kinds of magic practised in Chrystania. Can he and his little band of adventurers survive the great events which are unfolding around their private quest? Elegant *Lodoss*-style art for fantasy with an old-fashioned heroic heart. ★★★?

LUPIN III: GET LOST NOSTRADAMUS

(Eng trans for LUPIN SANSEI KUTABARE NOSTRADAMUS. Kutabare is a fairly rough masculine use of the verb, which could be translated more explicitly than 'get lost')

JAPANESE CREDITS: Dir: Toshiya Ito. Script: Hiroshi Aihara. Anime dir: Kenji Yazaki. Prod: Telecom Animation Film, Lupin III Production Committee. © Monkey Punch, TMS, Toho. c70 mins.
ORIGINS: The Arsène Lupin stories by Maurice Leblanc; manga by Monkey Punch; 1971 & 1977 TV series; 1978, 1985 & 1987 movies.
CATEGORIES: M, A

Rio at Carnival time, and Lupin, Jigen and Fujiko are fleeing from Zenigata after a jewel heist. They board a scheduled passenger flight crowded with civilians, among them the Brazilian soccer team flying to an important international. Then the plane gets hijacked, and the hijackers don't intend to leave anything of value aboard. Lupin has to hide the jewels or lose them, so he picks the most innocent place — inside a little girl's teddy bear. But when the plane lands in Morocco, the hijackers allow the women and children to leave — including little Julia and her bear, now a lot fatter after the richest meal he's ever eaten. It transpires that the hijackers are controlled by a religious cult called Nostradamus which 'predicts' disasters, but in reality triggers them — the original self-fulfilling prophets! The real objective was the Brazilian soccer team, and the chance to pick up a few 'donations' was purely incidental. That's a pity, because Lupin and co have just disguised themselves as members of the Brazilian soccer team... When the sect announces that a 200 storey skyscraper 'will collapse', Lupin decides to get his own back by stealing the Book of Nostradamus, hidden on the 200th floor. And even Zenigata won't be able to find much evidence if the scene of the crime has been reduced to rubble! Pure mayhem, pure magic. ★★★☆?

MACROSS PLUS THE MOVIE EDITION

JAPANESE CREDITS: Dir: Shinichiro Watanabe. Executive dir: Shoji Kawamori. Aerial sequences: Ichiro Itano. Prod: Triangle Staff. © Big West.
ORIGINS: 1982 & 1993 TV series; 1984 movie; 1987 OAV Flashback 2012; 1992 & 1994 OAVs.
POINTS OF INTEREST: Released on a double bill with the Macross 7 movie. A re-edit of the 4 OAV volumes with 20 minutes of extra footage.
CATEGORIES: SF

This high-tech, high-spec SF series starts out all action and no sympathy as a succession of vacuous, arrogant or self-pitying characters parade across the screen. Gradually we begin to see why they are as they are, and what demands their world makes on them. Two former friends who became love rivals are now hotshot pilots in a race to be top gun, with jobs and fortunes riding on who will win. The girl they loved lacked the confidence and courage to rebuild her life and follow her dream, and is leading a secure but unfulfilled and resentful existence as the programmer for a computer singer, an artificial version of the reality she hoped to achieve. Fate brings them all back together again in the place where their friendship fell apart, and as they play out their personal drama a much bigger one goes on behind the scenes. Men greedy for wealth and power bestow sentience and autonomy of action on a hugely powerful computer, and remember too late that no one since Pandora opened her box has ever managed to stuff evil back into it and close the lid. *Macross Plus* is distinguished by superb computer animation, brilliantly integrated, and by some of the best ever depictions of planes performing aerial ballet against skies so glorious that they are a perfect vindication of the traditional skills of the cel animator. Kawamori, creator of the whole saga, said that he wanted to make 'an action story that wasn't a war story' and added that although *Macross Plus* was 'a serious story with a silly plot' (perhaps referring to the almost compulsory *Macross* love triangle), it has some serious messages, though the audience isn't forced to see them. They're worth a look. ★★★☆?

MACROSS 7: THE GALAXY IS CALLING ME

(Eng trans for MACROSS 7 GINGA GA ORE O YONDE IRU)

JAPANESE CREDITS: Dir: Tetsuro Amino. Executive dir: Shoji Kawamori. Chara des:

Haruhiko Mikimoto. Prod: Hal Film Makers Studio. © Big West.
ORIGINS: As above.
POINTS OF INTEREST: Released on a double bill with the movie version of Macross Plus.
CATEGORIES: SF, R

Basara Nekki, lead singer with the group Fire Bomber and reluctant Valkyrie pilot who fires songs at his enemies instead of missiles, hears 'a great voice calling' and follows the call to a wintry planet. He meets a music-mad kid called Pedro, and together they encounter a mystery woman who may or may not be a dangerous enemy. All the regulars of the series show up though Basara is the main character; director Amino promised to keep the tone light-hearted, and delivered. However, Kawamori commented that the theme of *Macross 7* is in fact much 'heavier' and more meaningful than that of *Macross Plus*, which is generally thought of as more serious and accorded more respect by Western fans. The fact that Basara would rather share his music with the enemy than kill them is in gentle and generous contrast to the personally focused rivalries and desires of Isamu and Guld in *Macross Plus*. Light-hearted, maybe, but Kawamori doesn't think it's lightweight, and he should know. ★★★?

MEMORIES

JAPANESE CREDITS: Dir: Katsuhiro Otomo, Tensai 'Genius' Okamoto & Koji Morimoto. Prod: Akira Committee © Otomo, Akira Committee, Kodansha.
ORIGINS: Manga anthology by Katsuhiro Otomo, pub Kodansha, Eng trans pub (UK) 1995 Mandarin Books.
CATEGORIES: SF

An anthology movie consisting of three short stories based on Otomo's eponymous collection. In the original title story 'Her Memories', here entitled 'Magnetic Rose', a rich woman crossed in love builds a space station in the shape of a gigantic rose, and leaves Earth forever. Years later, a three man salvage crew boards the station and finds a wonderland of baroque decor and a last, lingering wish left behind by the former owner, which gives the ending a horrific twist. Okamoto's segment, 'Stink Bomb', plunges an ordinary Japanese worker into industrial espionage and international military pursuit, all because of a simple pharmacy mixup. 'Cannon Fodder', directed by Otomo himself, takes place on an alien world dominated by war, in a small town where the local kids learn that idols can have feet of clay and that 'our side' isn't

always in the right. Extensive use of computer animation and the promise of 'effects that have never been seen before'. ★★★★?

NINKU

JAPANESE CREDITS: Dir: K. Abe. Prod: Studio Pierrot. © Koji Kiriyama, Shueisha, Fuji TV.
ORIGINS: Manga by Koji Kiriyama, pub Shueisha; 1994 TV series.
CATEGORIES: A

Ninku and chums set out on holiday but run out of fuel, so they're forced to stop at a nearby village to ask for help. The villagers have just been robbed, and are delighted to see them, hoping they can help track down the villains; then a group turns up pretending to be... Ninku and friends! The originals decide to play along and see where this imposture is leading...

SAILOR MOON SUPER S: GATHERING OF THE NINE: MIRACLE OF THE HALL OF BLACK DREAMS

JAPANESE CREDITS: Prod: Toei. © Naoko Takeuchi, Kodansha, TV Asahi, Toei.
ORIGINS: Manga by Naoko Takeuchi, pub RunRun magazine by Kodansha; 1992 TV series of same name, continuation of two earlier series, Bishoji Senshi Sailor Moon and Bishojo Senshi Sailor Moon R; 1993 & 1994 movies.
POINTS OF INTEREST: Christmas double bill with the other Sailor Moon film listed below
CATEGORIES: DD, R

Also:

SAILOR MOON SUPER S SIDE STORY: AMI-CHAN'S FIRST LOVE

CREDITS, ORIGINS, CATEGORIES: As above.

The romantic adventure continues and there are even more Sailor Senshi — nine of them must band together in *Miracle of the Hall of Black Dreams*. On Valentine's Day the five original sailor girls and Chibi-Usa, Usagi's daughter, meet to make chocolate for Valentine gifts. Chibi doesn't have a boyfriend and is thinking of giving her chocolate to Tuxedo Kamen, but on the way to buy ingredients she meets a boy and likes him a lot. Unfortunately he's working for Badigan, who plans world con-

quest by replaying the Pied Piper legend. The old friends reunite to save the children. The second film's title is deceptive. With a big exam coming up, Ami wants to come first but there's a boy in her class who might beat her. But the others think she's in love with him! *Sailor Moon* continues to provide a huge slice of Bandai's revenue as it out-earns every other toy range in Japan, its popularity with little girls unshaken by other challengers. ★★☆?

SLAM DUNK: BARKING BASKET MAN
(Eng trans for SLAM DUNK: KOERU BASKET MAN KI)

JAPANESE CREDITS: Dir: Aki Seiji. Prod: Toei. © T. Inoue, Shueisha, TV Asahi, Dentsu, Toei.
ORIGINS: Takehiko Inoue's manga, pub Shueisha & Shonen Jump; 1993 TV series; 1994 movie.
POINTS OF INTEREST: Released on a triple bill with the last of the Dragonball Z movies and Miyazaki's music video On Your Marks.
CATEGORIES: N

Also:
SLAM DUNK: SHOHOKU'S GREATEST THREAT! FIGHT ON, HANAMICHI SAKURAGI

CREDITS, ORIGINS, CATEGORIES: As above

In the first named film, Haruko gets a visit from an old friend, Akane Misusawa. Her brother is captain of his school basketball team and idolises Haruko, dreaming of playing in the same team as him. But he has health problems and the doctors have warned him that if he doesn't give up basketball he'll end up losing the use of his legs. His sister hopes that by arranging a special match for him with the Asegawa team, she can persuade him to give up the sport having realised his dream. The second film has Sakuragi's team challenged by a superteam from another school. The basketball soap with emotional angst and long legs in equal quantities is very popular with fans of both sexes in Japan. ★★★?

SLAYERS

JAPANESE CREDITS: Dir: Kazuo Yamazaki. Prod: J. C. Staff. © Kanzaka, Araizumi, Kadokawa.
ORIGINS: Manga by Hajime Kanzaka & Rui Araizumi, pub Kadokawa; 1994 TV series.

POINTS OF INTEREST: Released on a double bill with Legend of Chrystania.
CATEGORIES: DD, C

It's D & D, Jim, but not as we know it. In a style of broad slapstick comedy that has little in common with the heroic seriousness of *Legend of Chrystania*, the two girl warriors Lina and Naga fight their way across the island of Miploss in search of treasure. After a fierce fight with a huge horde of goblins, the pair are only saved by the appearance of a strange magician who not only saves them, but tells them he knows the secret of eternal life. A sexy, silly slapstick piece with flashing blades and heaving bosoms aplenty but not a bit of serious nastiness in it. Or serious merit, come to that. ★★☆?

2112 AD THE BIRTH OF DORAEMON
(Eng trans for 2112 AD DORAEMON TANJO HEN)

JAPANESE CREDITS: Dir: Yoshizaku Yoneyama. Prod: Shin'ei Doga. © Fujiko-Fujio, Shogakukan, Shin'ei Doga. c50 mins.
ORIGINS: Manga by Fujiko-Fujio, pub Shin'ei Doga; 1979 TV series; movies every year 1984-88, 1991, 1992 & 1994.
POINTS OF INTEREST: Released on a double bill with Dragonball Z: Return Fusion in March, this was the joint 5th highest grossing domestic movie of 1995.
CATEGORIES: C, U

Now it can be told — the origin of the world's favourite earless blue robot cat! Back in the future, the creature who will become the hapless Nobita's friend and mentor first comes into being. How was he chosen for his unique role in trying to reshape history — and his master? It certainly wasn't because of his top-of-the-range, state-of-the-art robotic excellence! ★★☆?

WHISPER OF THE HEART
(Eng title for MIMI O SUMASEBA, lit Prick Up Your Ears, aka IF YOU LISTEN CAREFULLY)

JAPANESE CREDITS: Dir: Yoshifumi Kondo. Script, storyboards & prod: Hayao Miyazaki. Prod co: Studio Ghibli. © Nibariki, THNG, A. Hiragi.
ORIGINS: Shojo manga by Aoi Hiragi, pub Shueisha in Comic Margaret.
POINTS OF INTEREST: On Your Marks, the Miyazaki short for Chage and Asuka, was also shown with this film. Miyazaki directed

a short section of the movie itself, using the opportunity to gain his first experience of computer animation techniques under the guidance of Silicon Graphics technicians. It'll be interesting to see if this experience is used on his next feature film.
CATEGORIES: DD, U

Young Shizuku is led by a cat called Moon to a shop full of wonderful, intriguing things. Old Shiro Nishi, the owner, shares her passion for unusual objects and they become good friends. On meeting his grandson, Seiji Amasawa, she realises he's someone she had labelled as 'not my type' at school without even knowing his name; yet that very name is the one before hers on the withdrawal slip of every single book she's taken out of the school library! So maybe they have something in common after all and her snap judgement on appearances was wrong... Seiji dreams of studying the violin in Italy, and fired by his enthusiasm Shizuku decides to pursue her own dreams of writing. She asks Shiro if she can write a story about his favourite sculpture, a cat called Baron, and he agrees on condition that he can be first to read it. So, encouraged by his faith in her and Seiji's example, she sets out on a fantastic journey — the adventures of Baron and Luisa, his fiancée. The cats live in the land of Ivalade, in a studio occupied by artists descended from magicians, and in the process of writing their story Shizuku learns the importance of both the real world and the world of imagination. Beautifully designed and animated, directed with care and affection by Kondo (formerly chara designer on such Ghibli projects as *Only Yesterday*), this is a film of great charm and quality. ★★★★

OAVS

ARMITAGE III PART 2: FLESH & STONE

JAPANESE CREDITS: Dir & chara des: Hiroyuki Ochi. Script: Chiaki Konaka. Des: Atsushi Takeuchi. Anime dir: Koichi Hashimoto. Art dir: Norihiro Hiraki. Music: Hiroyuki Namba. Prod: AIC. © Pioneer. 25 mins.
WESTERN CREDITS: US video release 1995; UK video release 1996 on Pioneer.
ORIGINS: 1994 OAV.
POINTS OF INTEREST: Having established themselves in the US and UK with a string of 'softer' titles such as Tenchi Muyo! and Moldiver, this was Pioneer's first direct attack on the hard-SF action-adventure

market. Look out for visual homages to other anime, like the spacecraft from *Sol Bianca*.
CATEGORIES: SF, X

Also:
ARMITAGE III PART 3: HEART CORE

JAPANESE CREDITS: As Part 2 except: Anime dir: Kunihiro Abe, Shinya Takahashi & Naoyuki Onda. Art dir: Tokuhiro Hiragi.
WESTERN CREDITS, ORIGINS, CATEGORIES: As above.

Also:
ARMITAGE III PART 4: BIT OF LOVE

JAPANESE CREDITS: As Part 2 except: Anime dir: Kunihiro Abe & Naoyuki Onda. Art dir: Hiroshi Kato.
WESTERN CREDITS: US & UK video release 1996 on Pioneer.
POINTS OF INTEREST: This episode was originally entitled Cold Progression, but this was changed prior to release.
ORIGINS, CATEGORIES: As above.

A closer contender in the 'next *Akira*' stakes than *Ghost in the Shell* in terms of its style and theme, this OAV series is also heavily under the influence of *Blade Runner* in both areas. Set on a future Mars, it features Earth cop Ross Sylibus, who comes trying to escape a tragic incident on Earth, and Martian officer Naomi Armitage, a wild child in leather who is really a highly evolved robot. Mars is in the grip of a political upheaval focused around the role and position of robots in its society, and popular sentiment is being stirred up to burn robots in the streets. When a top singing star is murdered and revealed to have been a 'Third type' robot — like Armitage — the pair set out to track down the murderer, a psychotic hitman named Rene Danclaude. But there's more to the story than meets the eye, and as Danclaude continues his violent rampage Armitage acknowledges that her past and her memories are false and goes in search of the truth about herself and her fellow Thirds. Danclaude himself is only a pawn in the game; there is a much bigger secret behind this than human envy and fear of these ageless, perfect creations. Thirds like Armitage have broken the last barrier between robots and humans, and the end of the story echoes that of *Ghost in the Shell* as we learn that 'natural' and 'artificial' humans can become one species. Some mild nudity and close-up blood-letting make this unsuitable for unsupervised kids and those of a nervous disposition. ★★★

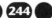

BATTLESKIPPER 1-3
(Eng title for BISHOJO YUGEKITAI BATTLESKIPPER 1-3, lit Beautiful Girls Shooting Group Battleskipper 1-3)

JAPANESE CREDITS: Dir: Takashi Watanabe. Script: Hidemi Kamata. Chara des: 1 & 3 Takashi Kobayashi. Original des: Yoshio Tachiishi. Mecha des: Kimitoshi Yamane. Anime dir: Toshiko Sasaki. Art dir: 1 & 3 Hiroshi Kato; 2 Hitoshi Sato. Music: Kenyu Miyotsu. Prod: Artmic, Tokyo Kids. © Tomy, Victor Entertainment. Each 30 mins.

This is another OAV I have yet to see. To judge from the anime magazines the art is polished and glossy, and the team of six fighting high school girls in skimpy outfits as cute as you'd expect. There seem to be some nuns in there somewhere, too.

BE-BOP HIGH SCHOOL 6

JAPANESE CREDITS: Dir: Toshihiko Ariseki. Scenario: Ko Uemura. Chara des & anime dir: Junichi Hayama. Art dir: Junichi Higashi. Photography dir: Yumiko Kajihara. Music dir: Masafumi Mima. Prod: Toei. © Toei Video. c50 mins. ORIGINS: Manga by Kazuhiro Kiuchi; 1990 & 1993 OAVs. CATEGORIES: N

More high school action but no more information.

BIO HUNTER

JAPANESE CREDITS: Dir & script: Yoshiaki Kawajiri. Dir & storyboards: Yuzo Sato. Chara des & anime dir: Hiroaki Hamazaki. Art dir: Masayoshi Hanno. Music: Masamichi Amano. Prod: Madhouse. © Hosono. 50 mins. ORIGINS: Original work by Fujihiko Hosono. CATEGORIES: X, H

The cover art indicates another demonic-possession epic with humans struggling to defeat dark forces. Though Kawajiri is a favourite director of mine, I haven't yet managed to catch this one; but given the director and the Madhouse reputation for quality, let's risk three stars. ★★★?

BLACK JACK CLINICAL RECORD IV & V
(Eng trans for BLACK JACK CARTE IV & V)

JAPANESE CREDITS: Dir: To Dezaki. Screenplay: To Dezaki & Katsuhiko Kobayashi. Chara des & anime dir: Akio Sugino. Art dir: Kazuo Okada. Sound dir: Etsuji Yamada. Medical dir: Akira Nagai. Medical advisers: Toshitaka Takeshita & Yasumasa Shiratori. Music: Osamu Shoji. Prod: Tezuka Pro. © BJ Production Committee. 50 mins. ORIGINS: Manga by Osamu Tezuka; 1993 OAV. CATEGORIES: N, A

More adventures of the medical maverick who works outside the law and the normal structures of society. Since the death of the 'manga god' in 1989, Tezuka Production has begun to work with young animators on new stories for his classic characters, using the latest technology but preserving the spirit of the master's original work and his commitment to excellence. I'm told these are of the same high standard as 1993's new *Black Jack* stories, so they should deserve a ★★★☆?

BOMBER BIKERS OF SHONAN 10 FROM SAMANTHA
(Eng title for SHONAN BAKUSOZOKU 10 FROM SAMANTHA, lit Wild Explosive Motorbike Gang from Shonan 10 — From Samantha)

JAPANESE CREDITS: Dir: Nobutaka Nishizawa. Screenplay: Higashi Shimizu. Chara des & original work: Satoshi Yoshida. Anime dir: Yoshitaka Yajima & Yoshihiko Umagoshi. Art dir: Nobuzo Gyo. Music: Mitsukazu Hirai. Prod: Toei. © Toei Video. c60 mins. ORIGINS: Original story by Satoshi Yoshida, plot by Nobutaka Nishizawa & Toshihiro Toda; OAVs every year 1986-93. CATEGORIES: N

All I have seen of this is the sleeve art; Samantha is a peaches-and-cream cutie and Eguchi looks very pleased to have her on his bike. Earlier adventures of the biker gang with hearts of gold, honour bright and a leader who does ace embroidery have been endearing and there is no indication that this one's any different.

BONDS 2
(Eng trans for KIZUNA 2)

JAPANESE CREDITS: Dir & concept: Rin Hiro. Script: Miyo Morita. Chara des & general anime dir: Ayako Mihashi. Art dir:

Fumie Ayabe. Photography dir: Tsugio
Ozawa. Prod: SIDO Ltd. © Kodaka, Seiji
Biblos. 30 mins.
ORIGINS: Manga by Kazuma Kodaka, pub
Seiji Biblios; 1994 OAV.
CATEGORIES: R, X

Further romantic adventures of young men.

BOUNTY DOG 1 & 2

JAPANESE CREDITS: Dir: Hiroshi Negishi.
Script: Mayori Sekijima. Chara des:
Hirotoshi Sano. Prod: Zero-G Room. © Zero-
G Room, Starchild, Toho. Each 30 mins.
WESTERN CREDITS: UK video release 1995
on Manga Video.
ORIGINS: Original story by Takehiko Ito; 2
1994 CD drama releases.
CATEGORIES: SF

Hiroshi Negishi, rightly celebrated for his work on
the insane gigglefest *KO Century Beast Warriors*, has
tried his hand at darker, heavier stories before; he
directed the OAV *Judge*. That didn't really come off
either. The problem with *Bounty Dog* is that it can't
make up its mind what it wants to be. Is it hard sci-
ence fiction, romance, mystery or what? The sad
thing is, it looks great. Wonderful designs — many
of which were never used in the anime and ended
up as a bonus extra segment on the end of the
Japanese tape — are matched by a brave use of a
very restricted colour palette, but these and the
attractive characters can't make up for leaden plot-
ting and pace. The animation is very limited, with
a high number of static pans and talking head
shots. The science stinks (two examples: how do
you terraform a planet with no atmosphere, and
why is the Moon's gravity sometimes Earth-nor-
mal?) but I've forgiven worse excesses than this in
a story that thoroughly entertained me. In *Bounty
Dog* three investigators check out a suspected mili-
tary project on the Moon and find it's really an
alien base. Not only are the aliens all clones of
each other and all pretty girls, but the nice clone,
Yayoi, used to nip down to earth for a spot of R &
R and go out with Yoshiyuki, one of Our Heroes in
the investigation team. This of course was before
her untimely death, but luckily there was a spare
nice clone on the moonbase. Just as well, really,
because the nasty clone, Darkness, has a whole
army of nasty clone sisters and the Bounty Dogs
need all the help they can get. Definitely not rec-
ommended, despite the lovely design. One review-
er wrote 'Come back Odin, all is forgiven', and
though I wouldn't go quite that far I can see what
he meant. ★

BOUNTY HUNTER: THE HARD

JAPANESE CREDITS: Dir: Shunji Taiga.
Script: Megumi Hiyoshi. Plot: Masamichi
Fujiwara & Tomoyuki Miyata. Chara des &
anime dir: Masami Suda. Mecha des:
Satoshi Shishido. Mecha anime dir: Makoto
Yamada. Art dir: Noboru Yoshida. Prod: JC
Staff. 45 mins.
ORIGINS: Original work by Tetsuya
Saruwatari.
CATEGORIES: A, X

By all accounts this is a fairly standard action/
adventure story. The artwork doesn't look particu-
larly interesting and I know little about it.

COMPILER FESTA

JAPANESE CREDITS: Dir & script: Michitaka
Kikuchi. Chara des & anime dir: Yasuhiro
Oshima. Art dir: Yoji Nakaza. Sound dir:
Jun Watanabe. Music: Toshiyuki Omori.
Prod: Studio Fantasia. © Asamiya,
Kodansha. 45 mins.
ORIGINS: Manga by Kia Asamiya, pub
Kodansha 1990 in Comic Afternoon; video
Music Clips in Trackdown; CD dramas;
1994 OAV.
CATEGORIES: SF, R

Compiler and Assembler are two computer entity
babes who came to Earth to use it as the console for
a game, met a couple of guys and stuck around. The
manga had great charm and wit, and the music

Bounty Dog

video *Music Clips in Trackdown* was a treat; but the earlier video was a big disappointment — nice art, no action — and I am told this one is the same, despite its lovely art. The plot takes up where the inconclusive ending of *Compiler 2* left off. Compiler has split into two parts, and the albino White Compiler is fighting her other self, Black Compiler, in a duel for world dominion. Toshi and his family have just three days to stop the fighting — or Earth will be destroyed. But Toshi has an even worse dilemma. If Earth is destroyed he'll never get to tell Compiler how he really feels; but if the fighting stops, there'll still be two Compilers around — which one will he choose? ★★?

CUTEY HONEY 5-8
(Eng title for SHIN CUTIE HONEY YAMI NO GUNDAN-HEN 5-8, lit New Cutey Honey Dark Group 5-8)

JAPANESE CREDITS: Dir: Yasushi Nagaoka. Script: 5 & 8 Ko Uemura; 6 & 7 Higashi Shimizu. Chara ideas: Go Nagai. Mecha des: Kunihiro Abe. Anime dir: 5, 6 & 8 Osamu Horiuchi; 7 & 8 Hitoshi Horiwa. Art dir: 5 & 6 Hiroshi kato; 7 Masaru Futoda; 8 Akira Kimura. Photography dir: Hidetoshi Watanabe. Prod: Toei. © Go Nagai, Dynamic Planning, Toei Video. Each 30 mins. WESTERN CREDITS: Vols 5 & 6 1995 US video release from AD Vision, trans Ichiro Arakai, both eps on single tape. ORIGINS: Manga by Go Nagai; 1973 TV series; 1994 OAV. CATEGORIES: SF, X

More adventures of the android superheroine and her friends the wacky Danbei family fighting the forces of evil. Former sidekick Chokei has grown up and he's fallen in love. Unfortunately the object of his desire is on the wrong side of the law and involved with some very nasty creatures. Terrorists and time-tripping samurai are just a couple of the perils Honey encounters in this action-packed, saucy and very daft romp. ★★★

CYBER FORMULA GPX 8
(Eng trans for SHINSEIKI CYBER FORMULA GPX 8, lit New Century Cyber Formula GPX 8)

JAPANESE CREDITS: General dir, story concept, scenario & storyboards: Mitsuo Fukuda. Plot: Sunrise. Chara ideas: Mutsumi Inomata. Chara des & general anime dir: Takahiro Yoshimura. Machine des: Shoji Kawamori. Art dir: Shigemi Ikeda.

Photography dir: Kazuten Hijita. Sound dir: Sadayoshi Fujita. Prod: Sunrise. © Yadachi, Sunrise. ORIGINS: 1990 TV series; OAVs every year 1992-94. CATEGORIES: SF, A

More adventures of Hayato Kazami and friends, depicting the glamorous, dangerous world of motor racing with surprising accuracy and attention to detail. In a tight race for the championship in 2018, Hayato is involved in a serious accident with K.L. Randall and is badly injured. He recovers with the help of his good friend Asuka, but is sidelined for the rest of the season, his championship hopes wrecked. How will he face the future? Kawamori's superb mecha designs contribute to the exciting racetrack action. ★★★?

DARK BLUE FLEET 3-6
(Eng trans for KONHEKI NO SENTAI)

JAPANESE CREDITS: Dir: Takeyuki Kanda. Script: Ryosuke Takahashi. Chara des & anime dir: 3 & 5 Masami Suda; 4 & 6 Shigeki Kurii. Mecha des & anime dir: 3 & 5 Hisashi Emo; 4 & 6 Takashi Tanazawa. Art dir: Hiroaki Sato. Photography dir: Takashi Azubata & Shinichi Sasano. Music: Yasuori Aida. Prod: J. C. Staff. © Aramaki, Tokuma Shoten. Each c48 mins. ORIGINS: Novel by Yoshio Aramaki; 1994 OAV. CATEGORIES: SF, W

The fiftieth anniversary of the end of the Second World War has been extensively referred to in anime, from Matsumoto's *The Cockpit* to *The Diary of Anne*; but this OAV takes a different tack. It sets the war in an alternative reality, one in which Japan is not losing. A script from the master of realistic battle action and superbly researched designs lend weight and reality to a fascinating idea. ★★★?

A DARK KNIGHT'S TALE VOLS 1 & 2
(Eng trans for YAMIYO NO JIDAIGEKI VOLS 1 & 2, lit Period Drama of a Moonless Night Vols 1 & 2)

JAPANESE CREDITS: Dir: Ryosuke Takahashi. Script: 1 Takashi Imanishi & Yoshiyuki Tomino; 2 Ryosuke Takahashi & Takashi Imanishi. Chara des: 1 Kazuhiru Soeta; 2 Yuki Shioyama. Animation: 1 Yuki Shioyama & Yoshihito Hishinuma; 2

Takateru Miwa & Yuki Shioyama. Sound
dir: Yasuo Uragami. Effects: Akihiro
Matsuda. Prod: Sunrise. © Sunrise, NTV,
VAP. Each 45 mins.
ORIGINS: Computer games.
CATEGORIES: DD, X

A game-based dark fantasy from a writer and direc-
tor better known until now for his ability to create
convincing futuristic warfare, aided by Imanishi, a
key *Gundam* team stalwart. The little artwork I've
seen looks suitably fantastic and pseudo-mediaeval.

DEVIL HUNTER YOKO 2 — YOKO'S SITUATION
**(Eng trans for MAMONO HUNTER YOKO 2
YOKO NO JIJO, US aka DEVIL HUNTER YOKO 6)**

*JAPANESE CREDITS: Dir: Akiyuki Shinbo.
Script: Tatsuhiko Urabata. Original story:
Juzo Mutsuku. Chara des & anime dir:
Yoshimitsu Ohashi. Art dir: Hidetoshi
Kaneko & Zosui Nishimura. Photography
dir: Hideo Suzuki. Prod: Madhouse. © Toho.
45 mins
WESTERN CREDITS: US video release 1995
on AD Vision as Devil Hunter Yoko 6.
ORIGINS: OAVs every year 1991-94.
CATEGORIES: H, A*

There's a new girl at Yoko's school. She's called
Ayako and she looks exactly like the young devil
hunter; what's more, she too is a devil hunter,
armed with a magic whip. She even has an assistant
named Azusa, who looks just like Yoko's assistant
Azusa, who's away visiting her family just now.
Ayako is the granddaughter of Chiaki, Yoko's great
aunt, and has the same powers; she's come to town
to prove she's a better demon hunter than her
cousin. A feast of shredded Chinese dresses is prom-
ised as the two demon hunters square up to each
other to see who'll be leaving town. But what about
the real enemy — the demons? ★★☆?

DIRTY PAIR FLASH 2 VOLS 1-5

*JAPANESE CREDITS: Dir: Tomomichi
Mochizuki. Story & screenplay: Haruka
Takachiho. Chara des: Takahiro Kimura.
Mecha des: Kazutaka Miyatake. Anime dir:
Yasuyuki Noda. Photography dir: Toshiyuki
Umeda. Prod: Sunrise. © Takachiho, Nue,
Sunrise. Each 30 mins.
ORIGINS: Based on novels by Haruka
Takachiho; appearance in 1983 movie
Crushers; 1985 TV series & OAV; 1987 movie;*

1987, 1988, 1990 & 1994 OAVs. Original plot
by Sunrise & Toji Gobu.
CATEGORIES: C, A, SF

The younger incarnations of the famous trouble-
makers cum troubleshooters are back for a second
OAV series, this time with a new partner — a trou-
ble consultant named Toma, a computer crime spec-
ialist who is an ace hacker. He's not really their
style; he tends to think before he goes in with all
guns blazing — and the fireworks fly, but they have
to learn to get along with him. Their first adventure
together is set in Walls World, a wacky theme park
planet whose rides and adventures are based on
that exotic fantasyland, late twentieth century
Tokyo. The daffy, slapstick style of the first series
continues. ★★☆?

Also:
DIRTY PAIR FLASH 3 VOL 1

*JAPANESE CREDITS: Dir: Tomomichi
Mochizuki. Original story & screenplay:
Haruka Takachiho. Concept & scenario: Toji
Gobu. Chara des: Takahiro Kimura. Anime
dir & prod: Yusuke Yamamoto. Art dir:
Mitsukoku Nakamura. Prod co: Sunrise. ©
Takachiho, Nue, Sunrise. 30 mins.
ORIGINS, CATEGORIES: As above.*

The first volume of a new series. I haven't seen it
but I hear it's the same mixture as before. ★★☆?

DON'T LOSE, MAKENDO!
(Eng trans for MAKERU NA! MAKENDO)

*JAPANESE CREDITS: Dir, storyboards &
prod: Kazuya Murata. Screenplay: Yasuhiro
Komatsuzaki. Chara des & anime dir:
Sayuri Isseki. Art dir: Riki Nishimura.
Photography dir: Matoaki Ikegami. Music:
Koji Sakuyama. Prod: OLM. © Datem
Polystar. 29 mins.
ORIGINS: Nintendo (Super Famicom)
console game. Concept & charas created by
Ano Shimizu.
CATEGORIES: C, A*

Mai Tsurugino is just another high school girl who
tries to live the life of a normal teenager despite being
a demon hunter. When one of the demon good guys,
Officer Doro, asks her to join his team and help him
keep his less well-meaning brethren in check, she
refuses; but when he enlists her kid sister Hikari
instead, she's forced to help out as any responsible
big sister would. And the trio need each other, plus
all the outside help they can get, when they confront

their first foe. A mad scientist (helpfully named Dr Mad) has operated on a juvenile delinquent to turn him into a superweapon for use in the conquest of the human and demon world. Since Rei Kamiyoji wasn't a nice boy to start with, it's no surprise that he resorts to violence, and the Doctor descends summarily to Hell. Keeping him there is Mai and Hikari's problem — and what do they do about Rei, a superweapon with the manners and morals of a delinquent teenage boy on the loose? The artwork is cute and silly, the plot has the depth we normally expect of videogame transfers. ★★☆?

DRAGON PINK 2 & 3

JAPANESE CREDITS: Dir: Hitoshi Takai. Prod: AIC. © Pink Pineapple, AIC. Each 35 mins.
WESTERN CREDITS: US release 1995 on AD Vision, trans. Doc Issaac, on 2 separate tapes; each is also available as an edited, non-X-rated 30 mins version.
ORIGINS: Created by Itoyoko, based on computer RPG; 1994 OAV.
CATEGORIES: DD, X

More softcore sex adventures of the slavegirl who's also a catgirl and her friends. Part Two sees the gang on the trail of a monster, and Pink is monster bait; but they're also using her jewelry to pay their bill at the inn, and when that runs out they have to leave her as a security deposit. Can they nabble the monster and get its treasure in time to get Pink out of hock? Part three shows our heroes fallen on hard times and needing Pierce's magic to bail them out — magic she augments from an unexpected source. ★★?

EAR OF THE YELLOW DRAGON 1 & 2
(Eng trans for ORYU NO MIMI 1 & 2)

JAPANESE CREDITS: Dir: Kunihiko Yuyama. Script: Kenji Terada. Chara des & storyboard: Masayuki Goto. Anime dir: Yutaka Oka, Eiji Hirayama, Kazuo Takigawa & Akio Uchino. Art dir: Katsuyoshi Kanemura & Junichiro Nishimura. Backgrounds: M.A.T. & Noriyoshi Inoue. Sound dir: Masafumi Mima. Prod: OLM. © Osawa, Shueisha, VAP. Each 27 mins.
ORIGINS: Manga by Arimasa Osawa, pub Shueisha in Young Jump magazine.
CATEGORIES: DD?

I know almost nothing about this one, but with big names like Yuyama and Masayuki Goto heading the team it ought to be worth looking at. A young guy has a pierced ear — in Japan that's a sign that you're 'different'. But he becomes even more different when he removes his earring, because then he can use his superpowers.

801 TTS AIRBATS 3
(Eng title for AOZORA SHOJOTAI 801 TTS DEFCON 3, lit Blue Sky Girl Squad 801 TTS Defcon 3)

JAPANESE CREDITS: Dir, chara des & storyboards: Yuji Moriyama. Script: Ryoichi Yagi. Anime dir: Toshiharu Murata. Art dir: Yoji Nakaza. Photography dir: Akihiko Takahashi. Prod: Studio Fantasia. © Shimizu, Tokuma Shoten, JVC. 30 mins.
WESTERN CREDITS: US video release 1995 on AD Vision, on one tape with 2 earlier eps.
ORIGINS: Manga by Toshimitsu Shimizu (creator of Rei Rei), pub Tokuma Shoten; 1994 OAV.
SPINOFFS: A successful radio drama series has been produced using the anime voice actors.
CATEGORIES: C, A

Getting assigned to a squadron of ace display fliers is a great job for a mechanic, isn't it? Especially when the pilots in question are all gorgeous females, hmmm? Well, not if it's this squadron, as young mechanic Takuya quickly found out in the first two episodes. The comic (and romantic) adventures continue. ★★★☆

ELEMENTALORS
(Eng trans for SEIREITSUKAI, which could be translated Druid Master, Spirit Messenger or even Speaker for the Dead!)

JAPANESE CREDITS: General dir: Katsuhito Akiyama. Dir: Hiroaki Goda. Screenplay: Takeshi Okazaki. Chara des & storyboards: Hidenori Matsubara. Anime dir: Hiroyuki Kitauri, Naoyuki Onda, Nobuyuki Kitajima & Keiji Hashimoto. Art dir: Tatsuya Kushida & Norihiro Hirajo. Photography dir: Hitoshi Sato. Music: Masanori Sasaji. Prod: AIC. © Sony Music Entertainment. 50 mins.
ORIGINS: Original work, plot & scenario by Takeshi Okazaki, based on his manga.
POINTS OF INTEREST: The manga artist has decided that this will be his last work and he plans to retire. He is not yet 30.
CATEGORIES: SF

This is another title I haven't seen but the art looks good. OAVs are getting glossier all the time. The story starts in ancient times, when all of Earth's elements housed intelligent spirits — trees, fire, water, rocks and so on. The spirits battled each other to conquer their enemies and multiply themselves. Many new spirits, called 'elementalors', were generated and battles continued to rage between them. Move forward to the present day, where a young Japanese high school student is a reincarnated elementalor. He only finds out about his past when an ancient enemy seeks him out and tries to kill him.

EL HAZARD: THE MYSTERIOUS WORLD 1-6
(Eng title for SHINPI NO SEKAI EL HAZARD 1-6, lit El Hazard: The Magnificent World)

JAPANESE CREDITS: Dir: Hiroki Hayashi. Script & plot: Ryoei Tsukimura. Chara des & general anime dir: Kazuto Nakazawa. Des works: Koji Watanabe. Art dir: Nobuhito Sue. Photography dir: Hitoshi Sato. Music: Seiko Nagaoka. Prod: AIC. © Pioneer. Part 1 45 mins, parts 2-6 30 mins.
WESTERN CREDITS: US video release 1995 on Pioneer on 3 tapes.
SPINOFFS: A TV series has also commenced screening in Japan.
POINTS OF INTEREST: The successful partnership of Hiroki Hayashi & Ryoei Tsukimura continues from their work on Tenchi Muyo!
CATEGORIES: DD, R, A

This is a 'fantasy adventure romantic action movie', set in a world which acknowledges influences from the *Arabian Nights* and Edgar Rice Burroughs' Martian stories in about equal quantities. There are also overtones of *The Prisoner of Zenda* and H. Rider Haggard's romances in this tale of high adventure, honour, love and deception. The production is a deluxe job: lovely designs, gorgeous saturated colours and a sweeping orchestral music track combining to give an impression of richness and exoticism. The story starts in a Japanese high school where ace student Makoto and his arch rival Jinnai, Jinnai's kid sister and their chain-smoking, mountaineering teacher are swept into another dimension where they encounter all kinds of dangers and adventures. Jinnai aligns himself with the bad guys, Queen Diva and her insectoid Bagrom forces; Makoto is perforce on the side of good because he's a dead ringer for Queen Lune Venus' sister. He is persuaded to impersonate the missing Princess for an important meeting — which somehow turns into a longterm commit-

ment to help out until the real Princess can be found. As the little team travels round the marvellous world, always hoping to find the way back to their own dimension, they encounter priestesses, assassins, loyal servants and faithless lovers, the whole fabulous spectrum of fantasy characters. In the end the greatest danger comes from the least expected quarter — from one in whom the Queen had placed her entire trust. My personal favourite of Pioneer's 1995 releases and one whose UK début will hopefully not be delayed too long. ★★★★

EMBLEM TAKE 2

JAPANESE CREDITS: Dir: Tetsuo Imazawa. Script: Ko Uemura. Plot: Naoko Takahashi. Chara des & anime dir: Hideyuki Motohashi. Art dir: Nobuzo Gyo. Photography dir: Yoshiyuki Tashiro. Prod: Toei Video. © Toei, Kodansha. 50 mins. ORIGINS: Manga by Kazuo Kiuchi & Jun Watanabe, pub Kodansha. CATEGORIES: M, X

Yakuza minion Susumu is in deep trouble, alone on enemy turf, a sitting target for their bullets. Then he's sucked into a timewarp and emerges ten years in the past. The usual response is to try to get back to the future, but Susumu realises that reliving a decade with full foreknowledge and memory will have advantages for him. He's ten years younger, stronger and sharper, but with ten years' extra experience of yakuza politics, battles, alliances and doublecrosses that haven't even happened yet stored in his mind. He knows who'll come out on top, who's a non-starter, and who'll be sleeping with the fishes. He can even get his own back on his sworn enemy, Ehara — in advance. A violent gangland tale with a time-travel twist. ★★★?

FAIRY PRINCESS RAIN 1
(Eng title for YOSEI HIME RAIN 1 OTAKARA KOKETARA MENA KOKETA, lit Fairy Princess Rain 1, Everything's Gone Wrong Since I Failed to Get the Treasure)

JAPANESE CREDITS: Dir & storyboards: Ryotaro Daichi. Screenplay: Hitoshi Yamazaki. Chara des & anime dir: Toshihide Sotodate. Des works: Kenji Yamazaki. Art dir: Kenichi Harada. Photography dir: Akio Saito. Sound dir: Kazuya Tanaka (B-Line). Music: Harukichi Yamamoto. Prod: Dangun Picture. © KSS. 30 mins. CATEGORIES: DD, C

Fairy Princess Rain

This comedy-fantasy-adventure is, in my opinion, the best thing KSS have done this year. It's a linguistic duffer's nightmare because the characters talk several dialects and respond to stress by spraying dialogue as hard and fast as machine-gun ammo, but the action is so graphically funny that you don't really need to understand a word to know what's going on. It's packed with sight gags which will have you helpless with laughter if you know your anime, and are still funny for novices. Take the ultracool Mr Zenshuin's hair; even if you don't have a soft spot for all the hoary jests about anime hairgel, you'll still smile every time the improbable blue quiff slides forward and is repositioned with a weary flick of the head. Take the way Go's backpack turns into a hang-glider when he falls off tall buildings. Take it from me, you'll enjoy this one. Go Takarada is a typical teenage layabout until he finds an ancient grimoire full of instructions for treasure hunting. Then, out of nowhere, a fairy Princess pops into his life on a quest for the magic artefacts that will save her world. Suddenly life is not so dull in the sleepy little town of Kamakura — and that's before the naughty rival fairy shows up, and before Go's identical-triplet sisters and the local big businessman start complicating matters over the plans to build a huge amusement park with a Salamander whiteknuckle ride! You can't describe this universe of nutty delights; you can only experience it. Its artwork may look just like any other highgrade cute fantasy anime, and heaven knows 1995 has enough of those, but it's unique. And fabulous. ★★★★

GALAXY FRAULEIN YUNA 1 & 2
(Eng title for GINGA NO OJOSAMA DENSETSU YUNA KANISHIMI NO SIREN, lit Legend of Galaxy Lady Yuna, Sad Siren 1 & 2)

JAPANESE CREDITS: Dir: Yorifusa Yamaguchi. Script: Satoru Akahori & Masahsi Noro. Chara des & general anime dir: Katsumi Shimazaki. Mecha des: Kunihiro Abe. Anime dir: Ryoichi Oki. Art dir: Masaru Sato. Photography dir: Toyomitsu Nakajo & Katsuyuki Otaki. Mecha des dir: Makoto Yamada. Prod: Animate Film. © Red, Hudson, Toho, Starchild, MOVIC. Each 30 mins.
ORIGINS: Computer game; original story by Mika Akitada.
CATEGORIES: DD, C

Long ago, the Queen of Light fought the Queen of Darkness and lost the battle. All the remaining goodness of Light was concentrated in one of the few Lightside android survivors, Elna, whose duty it was to carry the Light forward for the next battle. In the present day, a beauty contest is being organised as a cover to find the next Queen of Light. A young human girl named Yuna wins, and now, as Saviour of the Light, has to fight the Queen of Darkness and her forces. Yuna has three android doubles, which she can use for land, sea and air combat or can link with the help of Elna into the mighty El-Line robot. 'The last word in bishojo anime' says the advertising. Well, it's got really cute designs, really cute girls, and a game-based fantasy scenario. What it hasn't got, from everything I've been able to discover, is any substance. But it certainly is cute. ★★?

GATCHAMAN VOLS 2 & 3

JAPANESE CREDITS: Dir: Hiroyuki Fukushima. Concept & scenario: Artmic. Plot: Hirokoku Narushima (Tatsunoko Pro) & Toshimitsu Suzuki (Artmic). Chara des & anime dir: Yasuomi Umetsu. Mecha des: Kiyotoshi Yamane. Art dir: Jiro Kawano. Photography dir: Toshimitsu Nakajo. Music: Maurice White & Bill Meyers. Prod: Tatsunoko. © Tatsunoko, Japan Columbia. Each 45 mins.
ORIGINS: 1972 & subsequent TV series; 1994 OAV.
POINTS OF INTEREST: The original TV series were edited for Western TV release as Battle of the Planets and G-Force. Some episodes have been available on various cheap video labels in the UK and USA.
CATEGORIES: SF, A

The adventures of the new, revamped-for-the-nineties *Gatchaman* team continue. Stylish and ele-

gant design manages to incorporate the old costumes and faces into a nineties look without compromising the essential integrity of the original series; Yasuomi Umetsu, a designer of originality and delicacy, had already done a similarly remarkable job on revamping the old *Casshan* characters for a remake. The concepts — love of justice, defence of the weak, devoted friendship in spite of rivalry and courage in the face of evil — are also presented as they were back in the seventies, as ideals worth saving in a tarnished world. Remakes of classics like *Gatchaman* not only take us back to the roots of character development, drama and storytelling which were so strong in anime TV series of the seventies and early eighties, but also remind us that these elements are essential in any title of lasting merit, regardless of how much flash and dash a production team can plaster over the surface. However much the idea of aliens in funny clothes fighting good guys in skin-tight suits might have dated, those elements are as strong in the new *Gatchaman* as they were in the old. Respect them. ★★★★

GHOSTS AT SCHOOL 1-3
(Eng trans for GAKKO NO YUREI; 1 WATASHI NO GAKKO NO YUREI, Ghost at My School; 2 ONGAKUSHITSU NI YUREI GA IRU!, There's a Ghost in the Music Room; 3 MY BIRTHDAY)

JAPANESE CREDITS: Dir: Norio Kashima. Script: Masatoshi Kumura. Chara des & anime dir: Kenichi Ishimaru. Art: Studio Uni. Prod: Naoko Takahashi & Katsuaki Takemoto. Prod co: Aubeck. © Toei.
Each 16 mins.
CATEGORIES: H, N

I have very little information on this title. From the cover art it seems they are ghost stories set in a present day school, and the voice actors are credited, but not assigned character names.

GIANT ROBO 6
(Eng title for GIANT ROBO CHIKYU GA SEISHI SURU HI 6, lit Giant Robo the Day Earth Stood Still 6. Western ep title: Conflict in the Snow Mountains)

JAPANESE CREDITS: Dir & script: Yasuhiro Imagawa. Chara des: Toshiyuki Kuboka, Akihiko Yamashita & Masami Kosone. General anime dir: Kazuyoshi Katayama. Anime dir: Akihiko Yamashita & Keiichi Sato. Art dir: Masaru Futoda. Photography dir: Yoshiaki Yasuhara. Music: Masamichi

Amano. Prod: Phoenix Entertainment. © Yokoyama, Hikari Pro, Amuse Video, Plex, Atlantis. 45 mins
WESTERN CREDITS: US video release 1995; UK video release 1996 both on Manga Video.
ORIGINS: Manga by Mitsuteru Yokoyama; concept story by Yasuhiro Imagawa & Yasuhito Yamamoto; 1968 live-action TV series; OAVs every year 1992-94.
SPINOFFS: Extra stories, 1994 & below.
CATEGORIES: SF, A

The last chapter of the adventure sees Big Fire trying to absorb all Earth's energy with a fiendish device. High in the Himalayas, Daisuke and Ginrei in Giant Robo try to stop the detonation and save the world. Stylish, action-packed story. ★★★★

Also:
GIANT ROBO EXTRA STORY: GINREI'S BLUE EYES
(Eng trans for GIANT ROBO GAIDEN AOI HITOMI NO GINREI)

JAPANESE CREDITS: Dir & storyboards: Takeshi Mori. Script: Michiko Yokote. Chara des: Keiichi Sato, Akihiko Yamashita & Toshiyuki Kubooka. Anime dir: Keiichi Sato. Art dir: Toru Koga. Photography dir:

Giant Robo

Yoshiaki Yasuhara. Music: Masamichi Amano. Prod: Phoenix Entertainment. © A Pro, Amuse, Plex, Atlantis. 30 mins.
ORIGINS: Manga by Mitsuteru Yokoyama; 1994 OAV Giant Robo Extra Story: Barefoot Ginrei, itself a spinoff of the Giant Robo OAVs.
CATEGORIES: SF, A

Also:
GIANT ROBO EXTRA STORY: IRON ARM GINREI
(Eng trans for GIANT ROBO GAIDEN TETSUWAN GINREI)

JAPANESE CREDITS: Dir & anime dir: Umanosuke Ida. Screenplay: Michiko Yokote. Music: Masamichi Amano. Prod: Phoenix Entertainment. © A Pro, Amuse, Plex, Atlantis. 30 mins.
ORIGINS, CATEGORIES: As above.
POINTS OF INTEREST: As with the first Ginrei OAV, note the punning reference to an earlier anime classic — Tezuka's Tetsuwan Atom — in the title.

More adventures of the heroine of *Giant Robo* take her to exotic locations and give her the chance to wear interesting new costumes. The first OAV puts her in the desert, tracking down the evil Chandara with the help of local tribesmen, and was trailered as guaranteeing 'at least one bathing scene'. Hmmm. ★★☆?

GOLDEN BOY 1-3
(Eng title for GOLDEN BOY SASURAI NO OBENKYO BOY 1-3, lit Golden Boy Hippy Study Boy 1-3)

JAPANESE CREDITS: Dir & prod: Hiroyuki Kitakubo. Dir & original work: Tatsuya Egawa. Chara des: Toshihiro Kawamoto. Anime dir: Yasuhito Kikuchi, Masa Honda & Michiyo Suzuki. Art dir: Tatsuya Kushida & Yuji Ikehata. Photography dir: Hideo Okazaki. Music: Joyo Katayanagi. Prod: APPP. © KSS, TBS. Each 30 mins.
ORIGINS: Tatsuya Egawa's manga.
CATEGORIES: N, R

Actually the categories should include fantasy because this is (im)pure teen male wish fulfilment. A twenty-five-year-old student is stressed and taking a year out of his studies after graduating in law from prestigious and pressured Tokyo University. To make ends meet, he takes a menial job as an office janitor and finds he can combine work with

his two favourite hobbies — computers and women — because everyone in the company from the high-powered boss down is female and gorgeous. In next to no time all his skills are in great demand from his new colleagues. Body design makes *Plastic Little* look restrained, stories are repetitive, probably on the grounds that nobody will watch this for the story. ★★?

GUN SMITH CATS CHAPTER 1: THE NEUTRAL ZONE

JAPANESE CREDITS: Dir & storyboards: Takeshi Mori. Script: Atsuji Kanako. Original charas & concept: Kenichi Sonoda. Chara des & general anime dir: Tokuhiro Matsubara. Anime dir: Toshimitsu Kobayashi. Art dir: Kazuo Nagai (Studio Kazemasa). Gun des: Keiyu Fukuda. Gun des dir: Hidetoshi Yoshida. Car des dir: Koji Sugiura. Backgrounds: Studio Kazemasa. Opening animation: Hidenori Matsubara. Music: Peter Arthkin. Prod: OLM. © Sonoda, Kodansha, TBS, VAP. 30 mins.
WESTERN CREDITS: UK & US video release 1996 on AD Vision.
ORIGINS: Kenichi Sonoda's manga, pub 1991 Kodansha in Comic Afternoon, Eng trans by Studio Proteus, pub 1995 Dark Horse Comics.
POINTS OF INTEREST: The team made research trips to Chicago and Los Angeles before starting work on the animation, and the sound effects and music were produced there. The guns and cars, as usual in Sonoda's work, are very accurately rendered. Later episodes of the manga feature guest appearances by Bean Bandit, hero of Sonoda's earlier OAV Riding Bean. The same team made an introductory music video with interview footage, clips and an 'investigation' of the making of the video, entitled Gun Smith Cats Chapter 0.
CATEGORIES: M, X

Rally Vincent, gun dealer and bounty hunter, her seventeen-year-old Lolita sidekick and bomb expert 'Minnie' May Hopkins and their informer Becky Farrah are so admired that the five collected volumes of their manga adventures have sold over 250,000 copies each. In this first of three anime volumes, a suspected drug dealer named Washington turns out to be up to his neck in an even deadlier game — international arms dealing. The police want Rally's help, but she doesn't want to get involved. However, a small dispute regarding how many guns she owns and what licences

she does or doesn't have persuades her to change her mind. Before long, Rally has been set up by Washington to take the blame for killing the policeman in charge of the case — while he gets away scot-free. A dramatic, gripping manga has become a tense, exciting and beautifully rendered animation with one of the punchiest and most stylish credit sequences seen on a TV screen for many years. This is terrific entertainment. ★★★★

THE HAKKENDEN NEW CHAPTER VOL 7
(Eng trans for HAKKENDEN SHIN SHO 7, lit The Eight Dogs Legend New Chapter 7)

JAPANESE CREDITS: Dir & storyboards: Yukiro Okamoto. Script: Hidemi Kamata. Original chara des: Atsushi Yamagata. Chara des & anime dir: Jun Okuda. Art dir: Hiroshi Kato. Photography dir: Hitoshi Sato. Music: Takashi Kudo. Prod: AIC. © Pioneer. 30 mins
ORIGINS: 98 volume Edo period novel by Bakin Kyokutei; 1990, 1991 & 1993 OAVs.
CATEGORIES: SH, P

Continues the story of the eight Dog Warriors. The art looks beautiful, and slightly softer than the earlier episodes.

THE HEROIC LEGEND OF ARSLAN 5 & 6
(Eng title for ARSLAN SENKI SEIMAKOEI VOLS 1 & 2, lit Arslan Battles Vols 1 & 2)

JAPANESE CREDITS: Dir & storyboards: Mamoru Hamazu. Script: Megumi Sugihara. Chara des: Sachiko Kamimura. Anime dir: 1 Satoshi Nakamura; 2 Masatsu Shino. Art dir: 1 Tatsuya Kushida; 2 Chieko Nezaki. Animal dir: Satono Kikuchi. Photography dir: Masayuki Otaki. Music: Kyohiro Tome. Prod: Animate Film, J. C. Staff. © Tanaka, Kadokawa, MOVIC, Sony Music Entertainment. Each 29 mins.
WESTERN CREDITS: US video release 1996 on US Manga Corps, numbered in sequence with the first OAV series.
ORIGINS: Novel by Yoshiki Tanaka; created by Haruki Kadokawa, Hiroshi Inagaki & Yutaka Takahashi; 1991 & 1992 movies; 1993 OAV.
CATEGORIES: DD

The battle to free the kingdom of Parse continues, with Prince Arslan, now at the head of a much larg-

er army, having escaped terrible dangers in the last series but now facing even greater peril as he and his band of faithful companions lead their troops against the invading armies of Lusitania. Heroic fantasy action loosely based on Persian myth and history, beautifully designed and stuffed with pretty boys. ★★★

HUMMINGBIRDS 95 1 & 2
(Eng title for IDOL BOETAI HUMMINGBIRD 95: 1 KAZE NO UTA, and 2 YUME NO BASHO E; lit Idol Defence Band Hummingbird 95: 1 Song of the Wind, and 2 To the Place of Dreams)

JAPANESE CREDITS: Dir & storyboards: Yasu Murayama. Plot: Masamichi Fujiwara. Script: 1 Yasu Murayama; 2 Yasu Murayama & Ritsuko Hayasaka. Chara des & anime dir: Masahide Yanagizawa. Mecha des & dir: Kazutaka Miyabu (Studio Nue). Art dir: Yoshimi Umino. Prod: Ashi Pro. © T. Yoshioka, Ashi Pro, Toho. Each 30 mins.
ORIGINS: Story by Taira Yoshioka, who originated Irresponsible Captain Tyler; 1993 OAV.
SPINOFFS: A music video, Hummingbirds Final Concert, showcased the 5 voice actresses who play the sisters and, in the words of NewType magazine, 'kicked off the nineties

Gun Smith Cats Chapter 1

voice actress anime boom!'
CATEGORIES: A, C

Young singing star and airforce pilot Satsuki and her sisters are still determined to be the top pilots in the privatised defence force; their main rivals, the Fever Girls, have become Satsuki's good friends and their handsome trainer, Mr Kato, is her secret love. What will happen to her romance, and what about the All-Japan Pilot Contest? Romantic adventure comedy whose silly plot is supported by excellent design and some terrific flight sequences. ★★☆?

HYPERDOLLS VOLS 1 & 2
(Eng title for RAKUSHO! HYPERDOLL VOLS 1 & 2)

JAPANESE CREDITS: Dir: 1 Go Seki; 2 Makoto Moriwaki. Concept & screenplay: Ryo Motohira. Chara des & anime dir: Satoru Nakamura. Art dir: Kazuhiro Arai. Photography dir: Takashi Azubata. Music: Takayuki Negishi. Prod: Triangle Staff. © Pioneer LDC. Each 40 mins.
ORIGINS: Manga by Noboyuki Ito, pub Tokuma Shoten in Monthly Captain Comic.
CATEGORIES: SF, A

Mica and Mew are a two-woman alien team charged with defending planet Earth. They are, of course, disguised as seventeen-year-old Japanese schoolgirls to preserve their secret identities. Cool, calm, collected Mica and hotheaded, impatient Mew work with the help of their controller — a magnificently weird alien head who materialises out of any flat surface, from a floor to a pizza — and two school friends, a girl, and a boy who is helplessly in lust with both of them. The design and animation are very nice, the story has possibilities, but these first two volumes, while pleasant and entertaining, just didn't pack enough punch to stand out from the crowd of cute alien/magical girls who seem to have invaded Japan this year. Enjoyable but not outstanding. ★★☆

ICZELION 1 & 2
(Eng title for ICZER GIRL ICZELION 1 & 2)

JAPANESE CREDITS: Dir & original story: Toshihiro Hirano. Chara des: Toshihiro Hirano & Masanori Nishii. Mecha des: Takashi Hashimoto. Anime dir: Masanori Nishii, Takashi Hashimoto & Takafumi Nishii. Art dir: Hiroshi Kato. Des works: Yasuhiro Morimoto. Music: Tatsumi Yano & Kenji Kawai. Prod: AIC. © Hirano, Jimusho,

KSS. Each 30 mins.
WESTERN CREDITS: US video release 1995 on single tape from AD Vision.
ORIGINS: 1993 radio drama; spinoff story from Hirano's 1985 OAV Iczer-One & 1989 audiobook; 1990 OAV Iczer-Three.
CATEGORIES: A, SF

Nagisa Kai is just an ordinary girl, who dreams of becoming a professional wrestler, but she's descended from Nagisa Kano, who partnered Iczer-1 to save the Earth from the alien Cthulhu. This genetic inheritance makes her a natural choice to join the team of girls piloting the alien Iczelion body armour, a form-fitting body armour with incredible powers. When the Earth is threatened again by more icky tentacled things from space, Nagisa has to come to grips with the problems of learning to handle alien technology before she can kick alien ass. Somewhat more serious than the action-comedy Iczer-3, this still misses the geniune frisson of Iczer-1. ★★☆?

IDOL PROJECT 1: STARLAND FESTIVAL

JAPANESE CREDITS: Dir: Yasushi Nagaoka. Script: T. Amano. Chara des & storyboards: Noritaka Suzuki. Art dir: Yukiko Iijima. Music: Kanji Saito. Prod & © KSS. 29 mins.
ORIGINS: Pasocon computer game.
SPINOFFS: More OAVs, CD soundtrack & drama discs are to be released.
CATEGORIES: DD, C

Teenage girls all over Japan share the dream of fourteen-year-old heroine Mimu Emilton; they want to be an idol. Idols are manufactured entertainment figures (think Kylie or Take That, though they don't have to be singers) who are groomed for stardom and have short but intense careers, adored by legions of fans who will be faithful until the next craze comes along. The game on which this OAV is based challenged players to make their character the top idol, and that's exactly what Mimu hopes to achieve by entering and winning the audition to choose the newest Excellent Idol at the Starland Festival. A catalogue of comic mishaps seem set to prevent her even reaching the audition, but in fact all these events are ways of testing her suitability and giving her the skills she needs — kindness, smiles, rhythm, relaxation and so on. Everyone she meets seems bent on giving her wise bits of advice like 'Follow your dream' and 'Always keep a calm heart'. When she finally gets to the audition after a hard day spent rescuing lost kids, crawling from under wrecked sound stages, and fending off attacks

SPORT

There are a huge number of anime covering sports of various kinds. Here are just a few of them.

1 GOLF

There's actually a monthly manga called *Better Golf Comics*, in which big names and fictional characters collaborate to give you hints and tips, plus stories of golfing endeavour both real and fictional. One of the biggest names in manga and anime, Fujiko-Fujio, created *Progolfer Saru*, an animated series about a golfer who means to become the biggest name in his sport. It has about as much relationship to the real world of non-supernatural golf tournaments as *Enter the Dragon* does to the real world of martial arts tournaments, but golfers and non-golfers alike enjoyed it immensely.

2 TENNIS

Along with golf, this is one of the major sports for students and young urban professionals. *Aim for the Ace!* tells the story of a girl who, while not the most talented or athletic of players, has the potential to become one of the greats of the sport, and of her romance with the coach who believes in her.

3 FOOTBALL

Top of the youth league is Captain Tsubasa, whose TV and movie adventures were thrilling Japanese soccer fans long before Gary Lineker hit Tokyo. The sport is increasingly popular and newer contenders have moved onto the Captain's turf, but he remains a much loved character.

4 BASEBALL

A host of series and specials about real and professional baseball testify to Japan's love for the number one foreign sport. One of the best is *Touch*, based on Mitsuru Adachi's manga, the story of twin brothers who play school baseball and of how the younger survives when his brighter, more popular twin dies tragically.

5 WRESTLING

Both men's and women's wrestling are crowd-pullers in Japan. Kenichi Sonoda produced chara designs for *Wanna-Be's*, the story of a would-be champion girls tag wrestling team, while *Kinnikuman* spoofs the whole men's scene in a comic show for children. The Dirty Pair are a spoof on a real-life wrestling team, the Beauty Pair.

by hordes of ninja crows, the other Idols are the only audience left, but even they don't hear her sing a note, since they're all kidnapped by space aliens just as she opens her mouth, and whisked away in a starship with the sacred Golden Microphone. Yes, it really is as silly and saccharine as it sounds, but it's wildly enjoyable, with one of the most infectious ending themes around. Lovely animation, hypercute design and bright, clear, cheerful colours create an overwhelmingly insidious atmosphere of perkiness. ★★★★

IRON LEAGUERS 3-5
(Eng title for SHIPPU IRON LEAGUERS GINKO NO HATA NO SHITA NI, lit Whirlwind Iron Leaguers, Under the Flag of Silver Light)

JAPANESE CREDITS: Dir: Tetsuro Amino. Script: Akihiko Inari & Noboru Sonekawa. Chara des: Tsuneo Ninomiya & Hideyuki Motohashi. Mecha des: Kunio Ogawara. General anime dir: Hideyuki Motohashi. Anime dir: 3 Tetsuya Yanagizawa; 4 Yasuichiro Yamamoto; 5 Hideyuki Motohashi. Art dir: Junichi Higashi. Opening animation & storyboards: Kazuki Sekine. Prod: Sunrise. © Bandai Visual. Each 30 mins. ORIGINS: 1993 TV series; 1994 OAV. CATEGORIES: C, U

More adventures of the robot football team, made originally for children.

IRRESPONSIBLE CAPTAIN TYLER NEW SERIES 1-4
(Eng trans for MUSEKININ KANCHO TYLER NEW SERIES 1-4)

JAPANESE CREDITS: Dir: Naoyuki Yoshinaga. Script: 1 & 4 Kei Yamaki; 2 Naoto Kimura; 3 Asami Watanabe. Chara des & general anime dir: Masaaki Konan. Chara ideas: Tomohiro Hirata. Mecha des: Tomo Shigeta. Anime dir: Teysuya Yanagizawa. Art dir: 1 & 2 Hitoshi Sato; 3 & 4 Hiroshi Kato. Photography dir: Masahide Okino. Music: Toshiyuki Watanabe. Prod: Studio Dean. © Tyler Project. Each 30 mins. ORIGINS: Original story by Taira Yoshioka. CATEGORIES: SF, C

Justy Ueki Tyler, laziest and least motivated captain in the spacefleet, and his crew are back again to solve problems and bring galactic peace (well, sort of) through good nature, misunderstanding, luck

or total inaction. One of the most popular series among Western fans. ★★★?

KEY THE METAL IDOL 2-7

JAPANESE CREDITS: Dir, original story, script & storyboards: Hiroshi Sato. Original chara ideas: Kunihiko Tanaka. Chara des: Keiichi Ishikura. Anime dir: 2 & 5 Toshimitsu Kobayashi; 3 Yoshiyuki Kishi; 6 & 7 Keiichi Ishikura & Shiho Takeuchi; 7 also Satono Kikuchi. Art dir: Yukihiro Shibuya. Photograhpy dir: Toshimitsu Nakajo & Shinichi Sasano. Music: Tamiya Terashima. Prod: Studio Pierrot. © Sato, Pony Canyon, Fuji Eight. Each 25 mins. ORIGINS: Original work by Hiroshi Sato; 1994 OAV. CATEGORIES: SF, R

Key can only become human if she makes 30,000 human beings love her. She decides to become a 'metal idol' and heads for the bright lights to seek stardom as an idol singer. The artwork is delicate and pretty and the story corny, sweet with mawkish overtones. *Idol Project*, a title which goes over the same ground, seems to do so less portentously. ★★★?

LEGEND OF GALACTIC HEROES VOLS 79-86
(Eng trans for GINGA EIYU DENSETSU 79-86)

JAPANESE CREDITS: General dir: Noboru Ishiguro. Series concept: Shimao Kawanaka. Plot: Masatoshi Tahara, Tsutomu Otsuka & Toshihiro Sakai. Mecha anime dir: Hideki Takahashi. Mecha concept: Yasumi Tanaka. Art dir: Jin Nagao. Art concept: Jin Nagao & Shinichi Tanimura. Sound dir: Susumu Akitagawa. Sound prod: Music Capsule. Prod: Kitty Film Mitaka Studios. © Tanaka, Tokuma, Kitty Enterprise. ORIGINS: Yoshiki Tanaka's novel series, pub Tokuma Shobo; 1988 & 1993 movies; OAVs in 1988, 1989 & 1991-93. CATEGORIES: SF, W

Further episodes of Reinhart Von Lohengrimm's conquest of the galaxy and Yang Wen-Li's opposition to his efforts as a general of the enemy Free Alliance, at least until it surrenders to Reinhart through a brilliant stroke of strategy, aided by the political weakness and cowardice of Yang's political superiors. Reinhart is now unchallenged Emperor, founder of the Reinhart Dynasty, but the story's not over yet. In his boyhood he dreamed of right-

ing wrongs and correcting injustices, but has power corrupted him, as his beloved sister Annerose and closest friend Siegfried Kircheis feared it might? A magnificent treat for fans of character development, strategy, military gaming, and huge space battles, this is a treasure of a series. ★★★★

LITTLE RED HOOD CHA-CHA: POPPY HAS COME
(Eng trans for AKAZUKIN CHA-CHA: POPPY-KUN GA YATTEKITA)

JAPANESE CREDITS: Dir, chara des & storyboards: Yuji Moriyama. Script: Ryoichi Yagi. Anime dir: Toshiharu Murata. Art dir: Yoji Nakaza. Photography dir: Akihiko Takahashi. Prod: Studio Fantasia. © King Records. 30 mins. ORIGINS: Manga by Min Sugihara, pub Shueisha, in Ribbon Serial Comic; 1994 TV series. CATEGORIES: DD, U

Latest in the long line of 'magical girls' TV shows aimed at pre-teens, this is the story of a little magician and her animal and human friends. This is the first of a planned three-part series and brings the friends into opposition with the students of nearby Momiji College, and in particular the super-powered spy in schoolgirl's clothing, Poppy. ★★☆?

LORD OF LORDS RYU KNIGHT: ADEU'S LEGEND 6-13
(Eng trans for HAOTAIKEI RYU KNIGHT ADEU'S LEGEND 6-13)

JAPANESE CREDITS: Dir: Makoto Ikeda. Script: 6 Kenichi Kanemaki; 7 & 11 Akemi Moide; 8 Katsuhiko Chiba; 9, 10, 12 & 13 Katsuyuki Sumizawa. Chara ideas: Takehiko Ito & Taku Koide. Mecha des: Kazuhiro Nakazawa. Anime dir: 7, 10, 11 & 12 Yuriko Chiba; 8 Atsushi Suita; 9 Seiyoshi Nishimura; 6 & 13 Kazuhiro Soeta, Tetsuya Yanagisawa & Yoshihito Hishinuma. Mecha anime dir: 7 kazumi Sato; 13 Keiko Han. Music: Toshihiko Sahashi & Kiechi Oku. Prod: Sunrise. © Ito, Shueisha, Sunrise, Sotsu Agency. Each 95 mins. ORIGINS: Original work by Takehiko Ito & Hajime Yadachi; charas & concept created by Takehiko Ito; manga by Ito, pub Shueisha; TV series; 1994 OAV. POINTS OF INTEREST: Industry veteran Tsukasa Dokite, one of the earliest designers of the Dirty Pair, storyboarded and

produced episode 6.
CATEGORIES: DD

Also:
LORD OF LORDS RYU KNIGHT: ADEU'S LEGEND 2 VOL 1
(Eng trans of title as above)

JAPANESE CREDITS: Dir: Makoto Ikeda. Script: Katsuyuki Sumizawa. Chara ideas: Takehiko Ito & Taku Koide. Chara des: Kazuhiro Soeta. Mecha des: Kazuhiro Nakazawa. Anime dir: Atsushi Suita. Art dir: Hiroshi Kato. Photography dir: Hiroshi Tsuchigi. Storyboards & prod: Tsukasa Dokite. Prod co: Sunrise © Ito, Shueisha, Sunrise, Sotsu Agency. 95 mins ORIGINS, CATEGORIES: As above.

I have no further information.

MACROSS PLUS 2-4

JAPANESE CREDITS: Dir, storyboards & mecha des: Shoji Kawamori. Dir & storyboards: Shinichiro Watanabe. Script: Keiko Nobumoto. Chara des: Masayuki. Anime dir: 2 Wase Ezo; 3 Yuji Moriyama; 4 Yasuhiro Seo. Mecha anime dir: Ichiro Itano. Art dir: Katsufumi Hariu. Photography dir: Akihiko Takahashi & Takashi Azubata. Music: Yoko Kanno. Prod: Triangle Staff. © Bandai Visual, Macross Project. Each c40 mins. WESTERN CREDITS: US & UK video release of vols 2 & 3 1995 on Manga Video. Announcement for release date of vol 4 is still awaited as of May 1996. ORIGINS: 1982 & 1993 TV series; 1984 & 1995 movies; 1987 OAV Flashback 2012; 1992 & 1994 OAVs. CATEGORIES: SF

The rivalry between Guld Goa Bowman and Isamu Dyson is as strong as their former friendship. When Myung is in danger, both men rush to help her, yet when they are in their prototype fighters they do their utmost to kill each other. Myung wants to forget the past, but dinner with two old friends awakens sad memories of the days when she was herself a singer, and she leaves the restaurant in tears. She is hiding behind virtual singer Sharon Apple, yet hates her music and all she stands for. But Sharon now has an agenda of her own — secret developments have enabled her to become sentient, autonomous, and virtually uncontrollable. Myung leaves for Earth and the last volume shows the cele-

brations for the thirtieth anniversary of the human-Zentraedi armistice in full swing, forming a perfect cover for Sharon as she takes over the military, the city and even the mighty SDF-1 battle fortress itself. As the celebration concert plays, Isamu and Guld must put aside their rivalry to save Myung and the rest of mankind. Technically stunning, with wonderful computer animation successfully integrated into the whole, the most striking feature of this remarkable series remains those wonderful skies and the aerial ballets fought in them. Director Kawamori said that he had made 'an action story, but not a war story. *Macross Plus* is a serious story with a silly plot. The serious messages are there, but you aren't forced to see them.' With our own armistice celebrations just behind us — volume four appeared in the fiftieth anniversary year of the ending of the war in the Pacific — and our own increasing flight from nature towards increased dependence on technology, maybe we should start looking for those messages. ★★★☆

Also:
MACROSS 7 ENCORE 1 & 2

JAPANESE CREDITS: Dir: Tetsuro Amino. Script: 1 Yuhiro Tomita; 2 Shikichi Ohashi. Chara original des: Haruhiko Mikimoto. Anime charas: Kenichiro Kei. Mecha des: Kazutake Miyatake & Shoji Kawamori. Anime dir: 1 Yuki Iwai; 2 Kazumi Sato. Prod: Ashi Pro. © Macross Project, Big West. 60 mins, 2 stories on one tape. ORIGINS: As above. SPINOFFS: Macross 7 Trash, a manga side story by Haruhiko Mikimoto, pub Kadokawa in Shonen Ace magazine, 1994. CATEGORIES: SF, R

Filling in some of the background to the popular series, and making some shock revelations, this mini-OAV series gives us details of the Zentraedi childhood of Fire Bomber's drummer Bihida, and goes over some of lead singer Mylene's childhood memories. Most shocking of all, it reveals that lead singer Basara Nekki is the love child of Ray Loverock, the band's guitarist. The construction of the *Macross 7* saga now spans TV, video, movies and comics and is rapidly heading towards a whole new development of the *Macross* saga in fascinating directions which no one watching the early episodes of the TV series would have expected. ★★★?

MAPS: REVIVAL OF THE LEGEND VOL 4
(Eng trans for MAPS DENSETSU NO FUKKATSU VOL 4)

JAPANESE CREDITS: Dir & prod:
Susumu Nishigawa. Script: Masaki Tsuji.
Chara des & opening animation des:
Masahiko Okura. Anime dir: Hideyuki
Motohashi. Art dir: Yukihiro Shibuya.
Music: Masahiro Kawasaki. Opening
animation: Yasushi Nagaoka. Prod co: TMS,
KSS. © Hasegawa, Gakken, Japan Soft
System, TMS, KSS. 30 mins.
WESTERN CREDITS: US video release 1995
on AD Vision, trans Masako Arakawa &
Christ Hutts, on one tape with vol 3.
ORIGINS: Manga by Yuichi Hasegawa, pub
Gakken; 1987 & 1994 OAVs.
CATEGORIES: SF, A

Gen and his girlfriend Hoshimi have been helping the alien Lipmira to search the galaxy for a great treasure known as the Flowing Light. Since Gen is the key to the location of this prize they've been hotly pursued by other interested parties. In the final volume Lipmira must confront a dark shadow from her past, and Gen will face an alien menace such as he never imagined. ★★★?

MEGAMI PARADISE
(Eng trans for MEGAMI TENGOKU 1 & 2,
lit Goddess Paradise 1 & 2)

JAPANESE CREDITS: Dir & storyboards vol
2: Katsuhiko Nishijima. Plot: Koji Shimana
& Masaki Sawato. Chara des & anime dir:
Noriyasu Yamauchi. Chara ideas: Akihiro
Yoshimi. Concept: Mayori Sekima. Art dir:
Yoji Nakaza. Storyboards vol 1: Ko
Matsuzono. Prod: Animate Film. ©
Kodansha, JVC. Each 30 mins.
WESTERN CREDITS: US video release 1996
on A.D. Vision
ORIGINS: Original story by Akihiro Yoshimi,
Suya Miya & Media Works.
CATEGORIES: DD, A

The Megami Paradise is an enclave of light and goodness in a corrupt universe, shielded from its evil influences by the purifying Astrostar. But the evil followers of the Dark Goddess seek to possess this beautiful land. Lilith is to become the new Mother Goddess, but the Dark Goddess' forces are out to kidnap her and the Astrostar. Can her friend Lulubell, with the help of Stasia, Juliana and the powers of Good, keep the Megami Paradise safe and ensure that Lilith is not sacrificed? Incredibly cute female chara designs and lovely artwork make this an OAV which has caused at least one young man of my acquaintance to go completely daft. On his wildly enthusiastic report, with my pinch of salt added, it rates a ★★★?

MIGHTY SPACE MINERS 1 & 2
(Eng title for OIRA UCHU NO TANKO-FU,
lit I'm a Space Miner)

JAPANESE CREDITS: Dir: Umanosuke Iida.
Script: Ritsuko Hayasaka & Tsutomu Iida.
Chara des & anime dir: Toshihiro
Kawamoto. Mecha des: Isamu Imagake &
Muchos Mecanihos. Mecha anime dir:
Katsutoahi Tunoda. Art dir: Junichi
Taniguchi. Music: Kenji Kawai. Prod:
Triangle Staff. © KSS. Each 30 mins.
WESTERN CREDITS: US video release 1995
on AD Vision, both eps on one tape.
ORIGINS: Original work by Horceman
Lunchfield.
CATEGORIES: SF, A

In 2060, deep in space on a remote asteroid colony, a military satellite malfunction triggers a disaster. Many of the colonists are killed. Those who are left are a special breed — Mighty Space Miners, clever enough and brave enough to survive the harshest of environments and mine the minerals Earth needs in the depths of space. The story, a gripping hard-science adventure, is told by a young boy survivor and based on the most up-to-date research on real conditions in space. ★★★?

MIYUKI-CHAN IN WONDERLAND 1 & 2
(Eng trans for FUSHIGI NO KUNI NO
MIYUKI-CHAN)

JAPANESE CREDITS: Script: Nanase Okawa
(CLAMP). Chara des & anime dir: Tetsuro
Aoki. Anime dir: Shin Koga. Art dir:
Katsushi Aoki. Photography dir: Hiroshi
Nerikawa. Music: Toshihisa Honda. Prod:
Animate Film. © CLAMP, Sony Music
Entertainment. Each 30 mins
ORIGINS: Original story by CLAMP, manga
in Genki comic.
CATEGORIES: DD, C

CLAMP are riding high with their hit TV series *Magic Knight Rayearth*, which demonstrated that the mistresses of elemental magic and emotion, creators of *RG Veda*, *Tokyo Babylon* and *X* could be cute and cuddlesome with the best of them. This is another cute tale, and rather racier than *Rayearth*, though still with a charming innocence and playfulness about it. Miyuki is a typical high school girl, always daydreaming and always late. Waking up late for school one day, she rushes down the street and falls down a rabbit hole, where after a sparring session with Tweedledum and Tweedledee she is

seduced by the Mad Hatter and the Cheshire Cat and pursued by the Queen of Hearts in bondage gear. Just when things get really dangerous she wakes up with a start: she's safe in bed, it was all a dream; but she's late for school and when she rushes down the street she notices a rabbit hole... In volume two, the Jabberwocky pulls her through her dressing table mirror to a world where she has an erotic encounter with some flower fairies and sees a rather revealing chess game. But this is another dream, a daydream this time; she wakes with a start in front of her mirror, and realises she's late again. As she gets up and rushes out of the room, her reflection, unchanged, gives us a cheeky little smile. Oh, by the way, every being she encounters in these strange dreamworlds is female. A beautifully animated piece, and if the story is slight it's not too hard to forgive. ★★★?

NINKU: HEADSTONE OF A KNIFE
(Eng trans for NINKU KNIFE NO BOHYO)

JAPANESE CREDITS: Dir & storyboards: Noriyuki Abe. Script: Hiroshi Hashimoto. Chara des: Mari Kitayama & Tetsuya Nishio. Anime dir: Tetsuya Nishio. Art dir: Sai Nagasaki. Photography dir: Toshiyuki Fukushima. Sound dir: Kan Mizumoto. Prod: Yomiuri Kokoku-sha, Studio Pierrot. © Kiriyama, Pony Canyon. 35 mins. ORIGINS: Manga by Mitsutsugu Kiriyama; 1994 TV series; 1995 movie. CATEGORIES: A

Ninku and his friends have been enjoying a peaceful life in their home village since the end of the TV series' adventures, and four years have passed. Then a gang of pirates threaten the tranquillity of the neighbourhood and they have to go back into action. ★★☆?

OGRE SLAYER 3 & 4
(Eng trans for ONIKIRIMARU 3 & 4)

JAPANESE CREDITS: Dir: Yoshio Kato. Screenplay: Norifumi Terada. Chara des & general anime dir: Masayuki Goto. Art dir: Katsuyoshi Kanemura. Photography dir: Hiroko Takahashi. Music: Kazuhiko Sotoyama. Prod: Pastel, OB Planning. © Kusonoki, Shogakukan, KSS, TBS. Each 30 mins. ORIGINS: Manga by Kei Kusonoki, pub Shogakukan, Eng trans pub (USA) Viz Communications in Manga Vizion; 1994 OAV. CATEGORIES: H, X

More adventures of the ogre who wants to become human, and believes he will achieve his aim when he has slain every one of his own kind. The ogres are the best thing in it, gross and openly amoral; the backgrounds are attractively and realistically drawn, and the animation, while limited, is adequate. But despite buckets of gore and severed limbs, the horror never really convinces. ★★

PRINCESS MINERVA

JAPANESE CREDITS: Dir & storyboards: Mihiro Yamaguchi. Script: Hideki Sonoda. Chara des & general anime dir: Tokuhiro Matsubara. Chara original ideas: Run Ishida. Anime dir: Hanchi Rei & Hokukan Sen. Art dir: Masayoshi Kanemura. Prod: Pastel. © Maisaka, Ishida, Red, Toho, Group Tack. 45 mins. WESTERN CREDITS: US video release 1995 on AD Vision, UK video release 1996 on AD Vision UK, same version. ORIGINS: PC Engine Super CD-ROM Duo game; original work by Ko Maisaka & Run Ishida. CATEGORIES: DD, A

Minerva, Princess of the small kingdom of Wisler, has a spare-time secret identity as a crusading superheroine. Unfortunately Wisler is so sleepy there's not much going on, so when a contest for female warriors is announced she's delighted, and fighting females begin to descend on the kingdom from all over. Then the evil sorceress Dynastar tries to kidnap Minerva, but ends up grabbing her faithful body-

Princess Minerva

guard Blue Morris by mistake! Can the warrior girls defeat evil, rescue Blue Morris and save the day? Will the kingdom survive the attempt? Thoroughly silly but very cute and prettily done. ★★☆?

RANMA 1/2 OAV: AN AKANE TO REMEMBER PART 2
(Eng trans for RANMA 1/2 SPECIAL YOMIGAERU KIOKU, lit Ranma 1/2 Returning Memory Part 2)

JAPANESE CREDITS: Dir & storyboards: Junji Nishimura. Script: Ryota Yamaguchi. Chara des & general anime dir: Atsuko Nakajima. Anime dir: Fumie Muroi. Art dir: Tomo Muira. Music: Akihisa Matsu'ura. Prod: Studio Dean, Kitty Film. © Takahashi, Shogakukan, Kitty Film, Fuji TV. 30 mins WESTERN CREDITS: US video release 1995 on Viz Video, trans Toshifumi Yoshida, written by Trish Ledoux, on single tape with part 1 and 4 music videos. ORIGINS: Rumiko Takahashi's manga, pub Shogakukan, Eng trans pub Viz Communications; TV series; 1990 & 1994 OAVs; 1991 & 1992 movies. CATEGORIES: SH, C, A

Takahashi's magic martial arts high school romance continues and the formula shows no signs of losing its appeal to its legions of fans worldwide. Akane has found the boy she remembers from her childhood, Shinnosuke, living deep in a strange forest populated by giant creatures. It's the water in these parts that makes ordinary animals grow to giant size and makes Akane's cooking taste great: the water of life. And without it, Shinnosuke will die. Ranma and friends must join forces to get the water away from its guardian, a ferocious dragon. Kitty Film always turn out a quality product and the design and animation is of the usual high standard. ★★★?

Also:
RANMA 1/2 SUPER VOLS 1 & 2
(Eng title for RANMA 1/2 SUPER JA'AKI NO ONI, lit Ranma 1/2 Evil Ogre)

JAPANESE CREDITS: Dir & storyboards vol 2: Junji Nishimura. Script: Ryota Yamaguchi. Chara des & general anime dir: Atsuko Nakajima. Anime dir: Yuka Kodo. Art dir: Tomo Miura. Storyboards vol 1 & prod: Nakaro Shirohata. Prod co: Studio Dean, Kitty Film. © Takahashi, Shogakukan, Kitty Film, Fuji TV. Each 30 mins. WESTERN CREDITS: US video release 1996

CLAMP

Not an artist but a collective, this group of friends started out in dojinshi — fanzines — and have become an important creative team, with recent successes, including the TV series *Magic Knight Rayearth* and *Miyuki-chan in Wonderland*, representing a departure from their darker themes of malevolent magic such as *X* and *Tokyo Babylon*.
RECOMMENDED WORKS: *X* translated in *Animerica* magazine. Look for *Tokyo Babylon* on Manga Video in the UK and US Manga Corps in the US. *Rayearth* is said to be slated for a US TV release.

on Viz Video, trans Toshifumi Yoshida, written by Trish Ledoux. ORIGINS, CATEGORIES: As above.

Look, you know what happens. Ranma gets wet and changes sex. Other people get wet and change sex or species. Girls and boys pine for Ranma, boys pine for Akane, Ranma and Akane are horrid to each other but really care for each other. There are lots of fights. The cause of the chaos this time is a little red devil who's chasing after Akane's sister Kasumi, but as always with *Ranma 1/2* the cause is incidental. This mixture-as-before will not disappoint its fans. ★★★?

RUIN EXPLORERS FAM & IRLIE 1-3
(Eng title for HIKYO TANTEI FAM & IRLIE 1-3, lit Mysterious Land Adventure Fam & Irlie 1-3)

JAPANESE CREDITS: Dir, script & storyboards 1: Takeshi Mori. Storyboards 2 & 3: Hiroyuki Nishimura. Chara des: Toshihisa Amatani. Anime dir: 1-3 Toshihisa Amatani & Yoshiaki Yanagida; 3 Takuya Saito. Art dir: Takashi Miyano & Takashi Nakamura. Photography dir: Akio Saito. Music: Masamichi Amano. Prod: Animate Film & Ado Asai. © Tanaka, RPG Magazine. Each 30 mins. ORIGINS: Original work by Kunihiko Yuyama; charas created for RPG Magazine. CATEGORIES: DD, A

The elf Fam and her human friend Irlie are on a quest for treasure. In a dark inn they meet a traveller who claims to be a great mage and to know the location of a huge treasure, in a castle deep in the desert. Can he get them there and can they get the treasure away? Flashing blades, heaving bosoms, the usual D & D female fighter stuff. ★★☆?

SAINT MICHAEL'S SCHOOL STORY 2
(Eng trans for SAINT MICHAEL GAKUEN HYORYU-KI 2)

JAPANESE CREDITS: Dir: Yorifusa Yamaguchi. Script: Yu Yamamoto. Plot: Dr Pochi. Anime dir: Mitsuru Takanashi. Art dir: Noboru Yoshida. Photography dir: Katsuyuki Otaki. Prod: OL Production. © Pem Entertainment. 45 mins.
ORIGINS: 1990 OAV.
CATEGORIES: H, X

More adventures at the girls' school where horror and demonic possession are on the curriculum.

SHADOW SKILL

JAPANESE CREDITS: Dir: Hiroshi Negishi & Gatake Okada. Script: Masayori Sekijima. Chara des: Toshinari Yamashita. Anime dir: Toshio Murata. Art dir: Torao Arai. Sound dir: Kazuhiro Watanabe. Music: Satomi Tezuka & Tsutomo Ohira. Prod: Zero-G Room. © Shadow Skill Project, DR. 45 mins
ORIGINS: Original manga by Gatake Okada.
CATEGORIES: SF, DD

A style strongly reminiscent of Negishi's spiky, silly-punk *KO Century Beast Warriors 2* is in evidence in the artwork for this OAV. It's a future-ninja conflict kind of story with game-style action and humour. The art looks good but I don't know enough to rate it.

THE SIGN OF OTAKU 1 & 2
(Eng trans for OTAKU NO SEIZA; note that this is a play on the word 'sign' as either 'distinguishing mark' or 'constellation', which is the closest translation for the Japanese word)

JAPANESE CREDITS: Dir & storyboards: Junji Nishimura. Screenplay: Seishi Togawa. Chara des: Toru Kose. Art dir: Kazuhiro Arai. Prod: Kotobuki Pro. © Eguchi, Moto Planning, KSS. Each 30 mins
ORIGINS: RPG by Hisashi Eguchi & Hiroshi Motomiya.
POINTS OF INTEREST: In the deadline-obsessed manga industry Eguchi is something of a legend. He has never yet completed a manga series and is rumoured never to have turned in a piece of work on time. He was also chara designer on the anime of Otomo's Roujin Z.
CATEGORIES: C, DD

The purpose of the game was to prevent the 'otaku-nisation' of the human race. The anime is a wild slapstick parody in which a new idol group, the Aurora Girls, are out to exterminate civilisation by spreading the 'otaku disease', a deadly virus that transforms ordinary people into hardcore fans. Packed with anime parodies, including affectionate homages to Gainax's earlier *Otaku No Video* — see the interviews with the characters at the end of the tape! ★★★?

SM GIRLS SABRE MARIONETTE R ACTS 1-3

JAPANESE CREDITS: Dir: Koji Masunari. Script: 1 & 2 Masaharu Amiya; 3 Sumio Uetake. Chara des: Kodai Iwata. Chara original ideas: Yoshitsune Izuna & Kazuichiro Tanuma. Mecha des: Takahiro Kishida. Anime dir: 1 & 2 Eiji Suganama; 3 Takuya Saito. Art dir: Minoru Nishida. Music: Toshiyuki Omori. Prod: Animate Film, Zero-G Room. © Bandai Visual. Each 30 mins.
ORIGINS: Manga by Satoru Akahori & Hiroshi Negishi.
CATEGORIES: DD, A

I have no further information.

SUPER ATRAGON 1
(Eng title for SHIN KAITEI GUNKAN 1 METSUBO ENO ZERO HOUR, lit New Oceanfloor Warship 1 — Zero Hour to Fall)

JAPANESE CREDITS: Dir & storyboards: Kazuyoshi Katayama. Script: Nobuaki Kishima. Chara des: Yoshikazu Yasuhiko. Mecha des: Makoto Kobayashi. Chara general dir: Masami Kosone. Mecha general dir: Noriaki Tetsura. Art dir: Akira Kotani. Photography dir: Yoshiaki Yasuhara. Music: Masamichi Amano. Prod: Tetsuhisa Yamada. © Toho. 50 mins.
WESTERN CREDITS: UK & US video release 1996 on AD Vision.
ORIGINS: Novel Kaitei Gunkan by Shunro Oshikawa.
POINT OF INTEREST: A live-action film of the novel was made in 1963 and released in the West as Atragon.
CATEGORIES: SF, A

With names like Yasuhiko and Kobayashi on board, this is one cruise worth joining; a four-part series is planned. The story starts in 1940 as two super-submarines disappear while engaged in a fierce

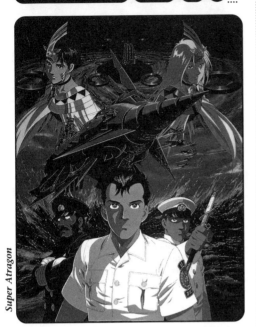

Super Atragon

Further adventures of the alien Tekkaman armour, now used to defend Earth, its wearer Blade and his human friends and allies. Not enough information to rate it, but note the involvement of industry giant Ippei Kuri, who has been involved in many hit TV shows.

TENCHI MUYO! RYO OH KI 10-13
(This title also used for Western release; the first phrase translates in a number of ways, some of which are 'Good For Nothing Tenchi', 'No Time For Tenchi', and 'Heaven and Earth Are Futile'. Ryo Oh Ki is used as a proper name. Eng ep titles: 10 I Love Tenchi; 11 The Advent of the Goddess; 12 Zero Ryoko; 13 The Royal Family Has Come)

JAPANESE CREDITS: Dir: Kenichi Yatagai. Story concept, chara des & general anime dir: Masaki Kajishima. Plot: Taro Maki & Ryo Miura. Screenplay: Yosuke Kuroda. Des works: Atsushi Takeuchi. Anime dir: 10 Yo Nishio, Akio Kawamura & Esaku Inoue; 11 Fumio Matsumoto; 12 Hiromi Araoka; 13 Yo Nishio & Naoyuki Onda. Art dir: Kenji Waki. Photography dir: Hitoshi Sato. Music: Seiko Nagaoka. Prod: AIC, Oniro, Doom, Triangle Staff. © AIC, Pioneer. Each 30 mins.
WESTERN CREDITS: US video release 1995 on Pioneer LDCA, 2 eps to a tape.
ORIGINS: OAVs every year 1992-94.
SPINOFFS: Manga (Eng trans, pub Viz Communications, due in the USA during 1996), a popular radio drama series scripted by Naoko Hasegawa, TV series, CDs & merchandise galore.
CATEGORIES: DD, C

battle. Fifty years later, a young man joins a United Nations mission to investigate mysterious disturbances at the North and South poles. Their ship comes under attack and they are rescued by one of these long-vanished vessels, a huge submarine with a distinctive screw-like bow. Friend or foe, it holds a secret that will change his life and could change the whole world. High quality design and artwork and the promise of an action-packed, suspenseful ongoing story. ★★★?

TEKKAMAN BLADE 2 VOLS 4-6
(Eng title for UCHU NO KISHI TEKKAMAN BLADE 2, lit Space Knight Tekkaman Blade 2; Ep titles: 4 Dead Boy; 5 Dirty Night; 6 Dangerous Boys)

JAPANESE CREDITS: Dir: Hideki Tonokatsu. Script: Hiroyuki Kawasaki. Main chara des: Hitoshi Sano. Main mecha des: Yoshinori Sayama & Rei Nakahara. Anime dir: Shigeki Kohara. Mecha anime dir: Yutaka Nakamura. Art dir: Yoshimi Uchino. Sound dir: Hideyuki Tanaka. Prod: Ippei Kuri. Prod co: Sotsu Agency, Tatsunoko Pro. © Tatsunoko, King Record. Each 30 mins.
ORIGINS: 1975 & 1991 TV series; original story by Tatsunoko Pro Plot Section; 1994 OAV.
CATEGORIES: SF

Four more comic adventures of the boy who's in demand with a bevy of alien babes and the cutest, fluffiest starship ever to nibble on a carrot and say 'mya!'. *Tenchi Muyo!* is rapidly acquiring the same cult status as *Ranma 1/2* in the West, and like *Ranma 1/2* it consists mainly of variations on the same theme, but played with verve and beautifully animated and designed. Episode ten sees Tenchi hurting Ryo Oh Ki's feelings, with strange results when an alien creature kept in Washu's laboratory steps in. Episodes eleven and twelve make up a single story in which alien Queen Tomiki sends one of her superscientists to Earth to kidnap Washu and assassinate Tenchi. His assassin assumes Ryoko's form and takes her hostage. Can the Masaki household save Ryoko? The final episode of this second OAV series sees the rest of the royal family of planet Jurai arrive on Earth. Princesses Ayeka and Sasami are already there,

living in the Masaki home, which is only fair as Grandpa Masaki is really a Jurai Prince, which makes Tenchi a Jurai Prince too. The family want to take someone back with them — but who? ★★★

Also:

TENCHI MUYO! TENCHI AND FRIENDS SPECIAL: PRETTY SAMMY THE MAGICAL GIRL

(Eng title for TENCHI MUYO! RYO OH KI MAHO SHOJO PRETTY SAMMY, lit Magical Girl Pretty Sammy)

JAPANESE CREDITS: Dir: Kazuyuki Hirokawa. Script: Yosuke Kuroda. Story Concept: Hiroki Hayashi. Chara des & anime dir: Yoshitaka Kono. Art dir: Masaru Sato. Music: Seiko Nagaoka. Prod: AIC. © AIC, Pioneer. 45 mins WESTERN CREDITS: US video release 1995 on Pioneer LDCA. ORIGINS, SPINOFFS: As above. CATEGORIES: DD, C

A 'side story' with its roots in last year's Mihoshi special, this moves the characters into another universe, in which Sasami Kawai is a cheerful schoolgirl who is approached by Tsunami, Queen of the magic kingdom of Juraihelm, to help make Earth a better place. She bestows magical powers on Sasami, but Pretty Sammy isn't the only magical girl around. She has a rival, Pixy Misa, and their encounters plus Sasami's scatterbrained mother, her big brother Tenchi and the two girls who are constantly fighting over him, make life very difficult, even for a girl with magical powers! A charming homage to the long tradition of 'magical girls'. ★★★

THERE GOES SHURA 2

(Eng trans for SHURA GA YUKU 2)

JAPANESE CREDITS: Dir: Masamune Ochiai. Anime dir: Teruo Kogure. Art dir: Aiko Kamada. Photography dir: Yosuke Moriguchi. Sound dir: Hideyuki Tanaka. Prod: Knack Film. © Toei Video. 50 mins. ORIGINS: Comic strip by Masato Yamaguchi; original story by Yu Kawabe; 1994 OAV. CATEGORIES: X

A yakuza tale animated and designed in a fairly stylised, blocky fashion. It looks interesting but I haven't seen it and so can't rate it.

3 x 3 EYES PART 2, 1 & 2

(Eng title for SAZAN EYES SEIMA DENSETSU, lit 3 x 3 Eyes Holy Devil Legend; 1 MATSURIN NO SHO, Book of Deification, 2 KAGI NO SHO, Book of the Key)

JAPANESE CREDITS: Dir: Kazuhisa Takeuchi. Script: Yuzo Takada & Kazuhisa Takeuchi. Chara des & anime dir: Tetsuya Kumatani. Art Dir: 1 Hiroshi Kato; 2 Yusuke Takeda. Photography dir: Hidetoshi Watanabe. Music: Kaoru Wada. Prod: Taback, Studio Junior. © Takada, Kodansha, Bandai Visual, King Record. Each c45 mins. ORIGINS: Original story by Yuzo Takada; manga by Yuzo Takada, pub Kodansha in Young Weekly, Eng trans pub Dark Horse Comics; 1991 & 1992 OAVs. CATEGORIES: H, A

The end of the first OAV series saw Yakumo separated from Pai in Hong Kong. Returning to Tokyo as a vagabond in search of her, Yakumo finds that she is living as a normal schoolgirl. She has completely lost her memory of her past and believes herself to be the daughter of two dollmakers who were killed in a car crash in Hong Kong. Seeing Yakumo, and a vision of her former servant Takuji, who used to live in her staff when she was an immortal Tibetan being, she becomes so upset that she faints. Taking her home, Yakumo meets her 'grandparents' and finds a house full of dolls. These are really spirit guardians placed there by the powerful dark magician Benares and his master to prevent Pai recovering her powers; only in her dreams does Pai remember her people and what was done to them. But seeing Yakumo again triggers her old memories; when these surface the dolls try to kill both him and Pai. Her life as a normal human — the life she has been seeking so desperately ever since she left Tibet — is destroyed as completely as Yakumo's, and together they set off on a quest to regain their humanity. Dazzling artwork and tense, atmospheric plotting were features of the first series and continue here. A treat for horror fans who like a story under the gore. ★★★☆?

UROTSUKIDOJI IV: PARTS 1-3

(Eng title for CHOJIN DENSETSU UROTSUKIDOJI INFERNAL ROAD, lit Legend of the Overfiend: The Wandering Kid: Infernal Road, aka LEGEND OF THE OVERFIEND IV. Ep titles: 1 HIMITSU NO KAEN, The Secret Garden; 2 KAMI E NAGAI MICHI, The Long Road to Divinity; 3 TABI, HATSURU TOKORO, Quest's End)

JAPANESE CREDITS: Dir: Hideki Takayama. Screenplay: Noboru Aikawa. Chara des: Aki

Tsunaki. Anime dir: Shigenori Kageyama.
Music: Masamichi Amano. Prod: Madhouse.
© Maeda, Westcape Corp, Studio Take-off.
Each c40 mins.
WESTERN CREDITS: UK video release 1996
on Kiseki.
ORIGINS: Manga by Toshio Maeda; 1993
OAV, see also Legend of the Overfiend .
CATEGORIES: X, V, H

The 'infernal road' of the title is the journey of the
Kyo-O Himi and the Makemono to Osaka to con-
front the Chojin. On the way they encounter a
strange village which has been created by the
psionic powers of Eruth, a young boy whose mind
has been warped by the Chojin. Adults are the
slaves of children in this village and puberty signi-
fies the end of freedom. Two children in love
resolve to escape and are caught and tortured;
Amanojaku takes pity on them and helps them to
escape, but when they reach the edge of the mists
surrounding the village, they die. Meanwhile
Eruth, convinced that drinking Himi's blood will
bring back his long-dead twin brother, sets out to
destroy her. Chojin has destroyed the minds of the
children and killed Eruth's brother simply to try
and stop Himi reaching Osaka. Old friends return
as Faust/Munchausen rises from the dead, joins
forces with Princess Yoen, who appeared briefly as
an infant in *Urotsukidoji I part three* and has now
grown up, and decides to steal the Kyo-O's powers
for himself. The Makemono are killed off one by
one defending Himi from his attacks, until she and
Chojin finally meet. Chojin drinks a drop of her
blood and the world is once again destroyed. But
the Kyo-O's power is far more terrible than that of
the Chojin; Amanojaku awakes and discovers to
his terror that he is back in 1980s Osaka, ready to
start the whole cycle again. The last section of the
saga sandwiches flashes of brilliance between grat-
uitous sex and violence and useless subplots;
much of the more orgiastic violence is unlikely to
survive the British certification process but Ameri-
can viewers will be able to form their own opin-
ions. The scenes involving the children show their
disturbing cruelty to each other and hatred for the
adult world. Echoes of Maeda's obsession with the
theme of doomed lovers show up in episode two,
which is virtually a remake of the Buju-Alecto
sequences in *Urotsukidoji III part two*. The death of
the doomed lovers is accompanied by a splendid
pastiche of Wagner's *Tristan und Isolde*. The grand
finale of the journey is triggered by Himi's first
menstruation. The end of the huge saga indicates
that both man and the natural order tend towards
chaos, and that between the cruel self-centredness
of the child and the blundering, hormone-driven
excesses of the adult there is little hope for the

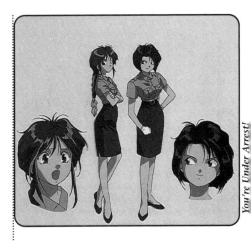

You're Under Arrest!

higher virtues. The dragging out of its central story
over so many blind alleys, dead ends and useless
subplots indicates that film-makers everywhere in
the world will milk a cash cow long after it's dead
on its feet. ★★

YAMATO TAKERU: AFTER WAR

JAPANESE CREDITS: Dir & script: Hideharu
Iuchi. Chara & mecha des: Takahiro
Kishida. Anime dir: 1 Takahiro Kishida; 2
Koji Osaka. Art dir: Kazuo Ebizawa. Music:
Satomi Tezuka & Vink. Prod: Zero-G Room.
© TBS. 47 mins.
ORIGINS: 1994 TV series.
POINTS OF INTEREST: The unbroadcast last
3 episodes of the TV series were released to
form a 'bridge' with the new OAV series.
CATEGORIES: DD, A.

After a period of danger and adventure when he
was just a kid, Takeru is now sixteen years old, and
his village has enjoyed peace and plenty for three
years. Then a metoerite lands nearby, and brings
with it a demonic fortress from planet Izumo, comp-
lete with demonic inhabitants. Takeru, his friends
and his giant robot have to save their world again.
A naïve, almost childish style of animation has
great charm. ★★☆?

YAMATO 2520 1 & 2

JAPANESE CREDITS: General dir, plot,
original work, script & prod: Yoshinobu
Nishizaki. General dir: Takeshi Shiraji. Dir:
Toshio Sotoda. Script: Yasushi Hirano &
Eichi Yamamoto. Yamato original des: Leiji
Matsumoto. Original chara des: Toshiyuki

Kuboka & Hiroyuki Kitazume. Chara des: 1
Toshiyuki Kuboka; 2 Aki Tsunaki & Nobuaki
Nagano. Mecha des: Makoto Kobayashi,
Atsushi Takeuchi & Keiji Hashimoto. Future
concept des: Syd Mead. General anime dir:
Kazuhiko Udagawa. Art dir: Yusuke Takeda.
Sound dir: Kentaro Hada. Prod co: Studio
Take Off © Westcape, Bandai Visual. Each
50 mins.
ORIGINS: Based on the Space Cruiser
Yamato concept & 1974 TV series, original
story by Yoshinobu Nishizaki; 1983 movie
Final Yamato.
CATEGORIES: SF

Much trumpeted, long delayed, the work of this
stellar team finally commenced release early in
1995. Once again a youthful team must save the
oppressed Earth using the revamped, Syd Mead-
styled Yamato.

YOU'RE UNDER ARREST! 3 & 4
(Eng trans for TAIHO SHICHAUZO 3 & 4)

JAPANESE CREDITS: Dir: Kazuhiro
Furuhashi. Script: Michiru Shimada. Chara
des: Atsuko Nakajima. Prod: Studio Dean. ©
Fujishima, Kodansha, Bandai Visual,
Marubeni. Each 30 mins.
WESTERN CREDITS: US video release on
AnimEigo, sub, in 1996.
ORIGINS: Manga by Kosuke Fujishima, pub
Kodansha; 1994 OAV.
SPINOFFS: Several CDs have not simply
featured music from the show but have
advanced the story and given extra insight
into the characters.
CATEGORIES: N, A

More adventures of the two Tokyo traffic police-
women. I haven't seen these yet but the first two
volumes were beautifully animated, light-hearted
and fluffy. ★★★?

1996

The year began with many changes in the anime
industry. Andy Frain, the man who created
Manga Video and guided the company through
headline-grabbing notoriety to its expansion into
the US market and Japanese co-production, left the
company late in 1995. Former sales director Mike
Preece took over as UK Managing Director, but con-
trol shifted to the US with the appointment of
Manga Entertainment Inc's Chicago-based chair-
man Marvin Gleischer as head of the group world-
wide. Manga, through their links with Polygram,
joined Orion Home Video and Streamline Pictures
in bringing anime to the mainstream US market at
price points as low as $9.98 and moved prices in
the traditionally higher-spending fan market down
as smaller companies responded. Japanese-owned
label Pioneer consolidated a successful year in the
UK and US markets with plans for more title
launches and a distribution deal for Australasia.
International distributor Capital City tied up an
exclusive distribution deal with Viz for their anime,
manga and related products. US video label AD
Vision has become the latest entrant into the UK
market with the establishment in the spring of
1996 of AD Vision UK. Greater mainstream pene-
tration in the US and the rapid growth of the exist-
ing video market in Europe, Australasia and South
America have demonstrated that anime is increas-
ingly a world phenomenon with a world audience.
Sailor Moon has even made it onto satellite TV in
Poland.

There is much to come in 1996. I'm finishing this
book in the early weeks of the year, already wishing
I had more time to write, to make more exhaustive
checks on what is already written and to include
some of the titles that have been omitted. We've
still only scratched the surface of all there is to say
about anime. But we have to go to press sometime,
and my editor would rather it was sometime this
century. The rest of this story will have to wait for
other books — mine, or maybe yours?

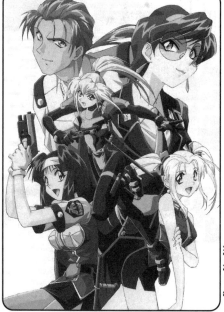

Burn-Up W

Researchers should be aware that there is very little published material on anime in English outside the fan circuit. A rash of articles and theses on anime and manga has appeared, but unfortunately many of these are written with no detailed knowledge of anime, manga or Japan; at best they are speculation, at worst regurgitation of UK video packagers' press releases.

Sadly, the nature of fan publishing means that many of the items listed below under 'Fanzines and Convention Publications' are now next to impossible to obtain, though an Internet appeal may help to produce some back issues, or at least some photocopies. Readers should also bear in mind that any source is only as good as its author's state of knowledge at the time; nothing is set in stone, and simply because an author has a massive and well-deserved reputation, this should not be taken as an indication that every line of his or her work is absolutely and 100% correct. I come from the fan community and my debt of love and gratitude to my fellow fans is immense; but we aren't always right!

Similar caution should be applied to non-specialist books, even when written by authors with immense expertise in other fields. For example, a book by two rightly admired experts on Western SF art recently described a painting done for an anime movie poster as a piece of manga art; such a mistake is easily explained and excused by the slipshod use of the word 'manga' by British writers, but it is a mistake nonetheless, and creates further confusion in an area which has quite enough already. Any source, fan or pro, should be checked and cross-checked as far as possible.

A knowledge of French or Italian will be helpful to any serious student of anime and manga, since there is useful material in both these languages; a knowledge of Cantonese will unlock the anime and manga material published in Hong Kong (in such magazines as *A-Club*, available in Chinese bookstores). If you read Japanese, I'm flattered that you have read this far, but wonder why you bothered and advise you to go and buy some Japanese books on anime instead.

The two major specialist outlets in the UK for anime and manga material are the Sheffield Space Centre and Forbidden Planet London, both of which carry most UK and US books and zines and can order other material. In the USA there is a much larger range of suppliers; I know and can personally recommend the excellent Nikaku Animart and Kimono My House in California, and Anime Crash in New York City. In France, Tonkam, Samourai and Kaze can supply a wide range of publications, including their own translated manga lines, and Italy and Spain also have a number of specialist retailers.

BOOKS

Anime! A Beginner's Guide to Japanese Animation
Helen McCarthy, pub Titan 1993.
ISBN 1 85286 492 3.

Cartoonia Anime: Guida al Cinema di Animazione Giapponese
Baridcordi et al, pub Granata Press 1991.
ISBN 88 7248 14 0. Italian language.

The Complete Anime Guide Japanese Animation Video Directory and Resource Guide
Trish Ledoux & Doug Ranney, pub Tiger Mountain Press 1995, edited Fred Patten; covers Japanese animation available in the USA, fandom, sources, etc.
ISBN 0-9649542-3-0.

Kaboom! Explosive Animation from America and Japan
various, pub Museum of Contemporary Art, Sydney, Australia.
ISBN 1 875 632 32 8.

Manga
catalogue for the exhibition 'Manga, Comic

Strip Books from Japan', Pomeroy Purdey
Gallery, London, Oct-Nov 1991; edited Adam
Lowe, inc essays by McCarthy, Gravett, pub
Lowe Culture 1991.
ISBN 1 873184 02 6.

Manga Manga Manga, A Celebration of Japanese Animation at the ICA
Helen McCarthy, pub Island World
Communications, 1992.
ISBN 0 9520434 0 8.

Manga! Manga! The World of Japanese Comics
Frederik L. Schodt, pub Kodansha 1983, 1987.
ISBN 0 87011 752 1.

Il Mondo Dei Manga
Thierry Groensteen, trans Carlotti &
Fornaroli, pub Granata Press 1991.
*ISBN 88 7248 013 2. Italian language.
French version also available,
Le Monde du Manga.*

MAGAZINES

JAPANESE LANGUAGE

The essential information sources are *Anime V*, *Newtype* and *Animage*. It is fashionable among certain wannabe-cool otaku to slam *Newtype* as 'more gloss than content'; would that many English-language publications without its gloss had half its content in terms of sheer raw information! *Anime V* concentrates on video, the other two have more general coverage. *Animedia* is probably the most lightweight of the Japanese magazines. *B-Club* is Bandai's own magazine, so obviously it focuses more on merchandised anime, but is still invaluable. Anyone interested in studying the dojinshi phenomenon should look at *Fanroad*, *Out* and *Comic Box*. There are a multitude of weekly and monthly manga digests aimed at different sectors of the market; the best bet is to go into a Japanese bookshop and ask for help or browse till you find what you want. My first book included a few suggestions for Japanese and other shops where such goods could be found.

ENGLISH LANGUAGE

Animag, irregular, ceased publishing, pub Eclipse, San Francisco, CA, USA, 1987-92.

A very useful source and well worth the difficulty of tracking down back issues, this zine followed *Animezine's* lead in attempting to emulate the best of the Japanese magazines for an English-speaking audience.

Animenominous, wildly irregular, pub Jeff Thompson, NY, USA, 1990-.

Virtually unpronounceable and very hard to find, the five issues of this zine published to date contain some wonderful extended articles packed with useful information on particular shows.

Animerica, monthly, pub Viz Communications, San Francisco, CA USA, 1993-.

Like *Manga Mania*, this contains primarily translated manga, though most are original and not reprints of material already seen elsewhere; every issue also includes at least one interview or feature, plus very useful news and review sections. Sometimes unfairly accused of being heavily biased towards the products of its parent company, Shogakukan, it provides a good coverage of the US scene and Japanese news and is an important source for the work of Rumiko Takahashi and other Shogakukan authors.

Anime UK Magazine 1-17, bimonthly, pub Anime UK Ltd, London, UK, 1991-95.
Anime UK Magazine (new series) 1-4, monthly, pub Anime UK Limited (1-3), Ashdown Publishing Ltd (4), 1995.
Anime FX Magazine 5-12, ceased publishing, monthly, pub Ashdown Publishing, West Sussex, UK, 1995-96.

The UK's first dedicated anime and manga magazine, its staffers and freelancers have produced a superb body of work over five years; as the magazine's co-founder and editor I am immensely indebted to them all. AUK and AFX covered news, new releases, older material, authors, artists and other industry figures, manga, music and books and fan activity worldwide, with regular convention and fanzine reviews. The magazine was widely regarded by many commentators as the most influential English language periodical in the field and many of its innovations were also taken up by other magazines. Strong visual focus was always a major feature, with glossy paper and full colour covers from the beginning, and full colour interiors for the last eight issues.

Animezine, ceased publishing, Minstrel Press, NJ, USA, 1986.

This superb zine was the first American attempt at an *'Animage-style'* professional magazine devoted to anime, and a seminal influence on English language anime publishing in the USA and UK. Under the guidance of Robert Fenelon and Beverley Headley, a team of gifted and dedicated otaku produced a zine which still can stand on its merits against any other title.

Manga Mania, monthly, pub Manga Publishing, London, UK, 1993-.

The bulk of its page count consists of manga translation reprints, but it also includes useful features and news columns. Regular contributors include *AUK/AFX* and *Animerica* staffers and columnists.

Mangazine, bimonthly, pub Antarctic Press, San Antonio, TX, USA, 1985-.

Starting life as an outlet for 'American manga', which continued as a major part of the zine until 1995, *Mangazine* later introduced anime information translated from Japanese magazines and has developed into one of the most useful and reliable sources of anime information in English, essential to any serious researcher.

Protoculture Addicts, bimonthly, pub Ianus Publications, Montreal, Canada, 1985-.

Founded as a fanzine for *Robotech* otaku, it has gradually broadened its scope and moved into the professional publishing arena. Its coverage of new and current material is always good, and with its editorial team's interest in games and gaming it is particularly strong on mecha and related topics.

V-Max, bimonthly, pub R. Talsorian Games, CA, USA, 1991-.

Started life as a group fanzine with high production and editorial values, which it has maintained into its professional incarnation. Superb on older series and TV shows, with a strong editorial stance on issues affecting the industry.

FRENCH LANGUAGE

Animeland, bimonthly, pub Association Animarte, Paris, France, 1991-.

The best European zine, a well presented and meticulously researched semi-prozine which combines superb coverage of the anime and manga scene in France with Japanese news and information.

Tsunami, bimonthly, pub Tonkam, Paris, France, 1992-.

An excellent publication with a strong emphasis on Japanese rock music and pop culture mixed with anime and manga coverage.

ITALIAN LANGUAGE

Kappa Magazine, monthly, pub Edizioni Star Comics srl, PG, Italy.
Mangazine, monthly, pub Granata Press, Bologna, Italy.

Two translated manga anthologies with detailed and useful feature articles on aspects of anime, manga and live-action shows in Japan, as well as news and reviews of Italian releases. The manga translations are usually less edited and censored than American versions — for example, the *Ghost in the Shell* translation in *Kappa* included pages missing completely from the US edition.

INFORMATION FROM WESTERN COMPANIES

The companies involved in the distribution of anime in the West provide press and trade information of varying utility. Among the companies whose materials have proved very useful to me I must single out AnimEigo, whose liner notes and press releases are most helpful; Central Park Media, who provided excellent information not only on their own labels but on distributed ones; and Streamline, where Fred Patten has been a constant source of help. In the UK, Manga Video's partial list of production credits has been very useful, and Western Connection's leaflets and sleeves provided some director name translations I failed to find elsewhere or which were my only cross-check for another source.

FANZINES AND CONVENTION PUBLICATIONS

Convention books and press handouts have been of immense value in checking synopses and a wide range of facts. The following convention publications have been used:

American conventions: Publications from Anime-Con, Anime America, Anime Expo, Baycon and Capricorn, dating from 1987 to 1995.

British conventions: Anime Day 1991/94, the
ConTanimeTed series from 1992/95.

The following publications have been referred to
continuously and have supplied much useful infor-
mation:

Anime Janai, 1986/94
Anime APA (Amateur Press Association), extracts
kindly supplied by Douglas Orlowski.

Fifteen Years of US Anime Fandom, Cartoon Fantasy
Organisation, 1992, pub Anime UK 1993/4.
Chronology of the development of US fandom by
Fred Patten.

J.A.M.M.! (Japanese Animation and Manga
Magazine), 1992-.
English language fanzine produced in Belgium by a
multilingual team, a superb example of the depth
and intelligence to which the best fanzine research
and writing aspires.

The Rose, 1987-.
Quarterly newsletter of international fan club
Anime Hasshin, kindly supplied by Lorraine Savage.

I would like to extend my thanks to the many
authors, translators and researchers, fan and prof-
essional, whose work has been so useful to me in
compiling this book.

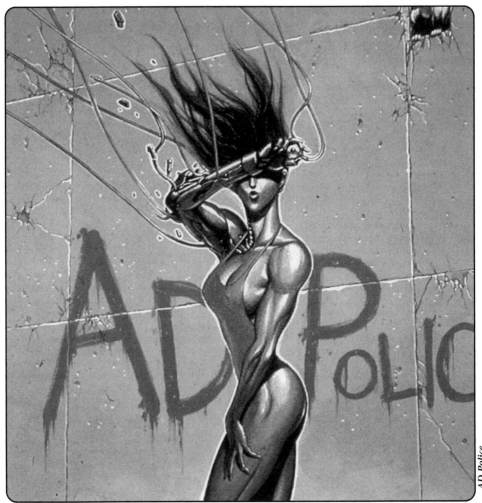

AD Police

TITLE INDEX

Note on layout

There is method in this madness. The idea of this index is to list the titles you are most likely to know a work by, and cross-reference them to the place where you can find that work listed. This has been complicated by the prevalence of variant translations and alternative titles, and by the habit of releasing items under their Japanese titles, a generic series title, or different titles altogether. However, bear with me while I try and make things clear.

The listing is in Roman alphabetical order, so Japanese titles in romaji are listed as English words. Each entry in the book is listed with its year and page number. Where there is a series of movies or OAVs, the entries are listed in chronological order under a sub-heading. Where the Japanese titles for a series begin in the same way as their English counterparts, (Angel Cop, for example), you will also find them listed in chronological order under a sub-heading. Otherwise, all Japanese titles are listed alphabetically. Where a variant title is listed I have cross-referred you to the title under which it is listed in the book. You can then check the relevant page to find all the variants I could list for the main title in one place.

In choosing the title to list as the major entry, I have usually opted for that currently known in the UK, or where no UK title exists the current US title; if no English language release has been made I have chosen the most usual translated Japanese title. I have listed titles separately only when they were distinctive enough and well known enough to make that worthwhile. (A remarkable number of items are subtitled Tanjo Hen or Kanketsuhen — Birth or Final Chapter!) The same applies to alternate titles. I apologise to everyone whose preferred title has been passed over as the main listing in favour of one less evocative to them; many of my own favourites have been treated in this way in an effort to be consistent.

3x3 Eyes see 'Three'
8 Man After see 'Eight'
801 TTS Airbats see 'Eight'
1982 Zoku Otaku No Video see Otaku No Video
1985 Otaku No Video see Otaku No Video
1999 Tokyo Wars see Patlabor The Movie
2112 AD The Birth of Doraemon see Doraemon

A Aa Megamisama 1-5 see Oh My Goddess! 1-5
Ace o Nerae! Final Stage Vols 4-6 see Aim for the Ace! Final Stage Vols 4-6
Ace o Nerae! Final Stage Vols 1-3 see Aim for the Ace! Final Stage Vols 1-3
Ace o Nerae! II Stage V see Aim for the Ace! II Stage Five
Ace o Nerae! II Stage IV see Aim for the Ace! II Stage Four
Ace o Nerae! II Stage I see Aim for the Ace! II Stage One
Ace o Nerae! II Stage III see Aim for the Ace! II Stage Three
Ace o Nerae! II Stage II see Aim for the Ace! II Stage Two
Across the Sea of Stars see Legend of Galactic Heroes: Across the Sea of Stars

Adesugata Maho No Sannin Musume see Three Little Witches
Adeu's Legend see Lord of Lords Ryu Knight: Adeu's Legend
AD Police OAVs
 AD Police File 1: The Phantom Woman (1990) 125
 AD Police File 2: The Ripper (1990) 126
 AD Police File 3: The Man Who Bites His Tongue (1990) 126
 AD Police File 1: Voomer Madness see AD Police File 1: The Phantom Woman
 AD Police File 2: The Paradise Loop see AD Police File 2: The Ripper
 AD Police File 3: I Want Medicine see AD Police File 3: The Man Who Bites His Tongue
Adventure Duo 1-3 (1993) 194
Adventure! Iczer-3 see Iczer-3
Adventure Kid see Adventure Duo 1-3
Affair of Nolandia see Dirty Pair: Affair on Nolandia
Affair on Nolandia see Dirty Pair: Affair on Nolandia
A-Girl (1993) 194
Ai City see Love City
Aim for the Ace! OAVs
 Aim for the Ace! II Stage One (1988) 80
 Aim for the Ace! II Stage Two (1988) 80
 Aim for the Ace! II Stage Three (1988) 80
 Aim for the Ace! II Stage Four (1988) 80
 Aim for the Ace! II Stage Five (1988) 80
 Aim for the Ace! Final Stage Vols 1-3 (1989) 104
 Aim for the Ace! Final Stage Vols 4-6 (1990) 126
Aim for the Top! GunBuster see GunBuster
Ai No Kusabi see Love's Wedge
Ai No Wakusei Lezeria see The Humanoid
Ai Oboete Imasuka see Macross: Do You Remember Love?
Akai Hayate 1-4 see Akai Hayate Vols 1 & 2
Akai Hayate Vols 1 & 2 (1992) 168
Akai Kiba Blue Sonnet see Blue Sonnet Vol 2
Akai Kiba Blue Sonnet Shirei-01 Tsuisekisha see Blue Sonnet Vol 1
Akai Kiba Blue Sonnet Shirei-03 Challenger see Blue Sonnet Challenger
Akai Kiba Blue Sonnet Shirei-02 Stratagem see Blue Sonnet Stratagem
Akai Kodan Zillion Utahime Yakoku — Burning Night see Zillion — Burning Night
Akazukin Cha-Cha: Poppy-kun Ga Yattekita see Little Red Hood Cha-Cha: Poppy Has Come
Akira (1988) 74
A-Ko the Vs OAVs
 A-Ko the Vs: Battle 1, Grey Side (1990) 126
 A-Ko the Vs: Battle 2, Blue Side (1990) 126
Ambassador Magma 1-13 (1993) 194
Ambassador Magma Vols 1-6 see Ambassador Magma 1-13
The Ambition of Gofar see Salamander Advanced Saga: The Ambition of Gofar
Ami-Chan's First Love see Sailor Moon Super S Side Story: Ami-chan's First Love
Amon Saga (1986) 45
Ancient Memory see Cyber City Oedo 808 File-1 Virtual Death
Angel Cop OAVs (Eng titles)
 Angel Cop 1 Special Security Force (1989) 104
 Angel Cop 2 The Disfigured City (1989) 105
 Angel Cop 3 The Death Warrant (1990) 127
Angel Cop OAVs (Jap titles)
 Angel Cop 1 Tokushu Koan see Angel Cop 1 Special Security Force
 Angel Cop 2 Henbou Toshi see Angel Cop 2 The Disfigured City
 Angel Cop 3 Massatsu Shirei see Angel Cop 3 The Death Warrant
Angel's Egg (1985) 31
Ankoku No Judge see Judge
Anne No Nikki see Diary of Anne [Frank]
Anpan Man movies (Eng titles)
 Anpan Man & Happy's Birthday (1995) 236
 Anpan Man & the Ghost Ship (1995) 237
Anpan Man movies (Jap titles)
 Anpan Man To Happy No Tanjobi see Anpan Man & Happy's Birthday
 Sore Ike! Anpan Man To Yurekano Yatsu Kero see Anpan Man & the Ghost Ship
Aoki Densetsu Shoot see Youth's Legend Shoot
Aoki Ryusei SPT Layzner Act III see Blue Comet SPT Layzner Act III
Aozora Shojotai see 801 TTS Airbats 1 & 2
Aozora Shojotai 801 TTS Defcon 3 see 801 TTS Airbats 3
A-Plus for the Fashion Boy (1993) 195
Appleland Story OAVs (Eng titles)
 Appleland Story (1992) 169
 Appleland Story 2 (1993) 195
Appleland Story OAVs (Jap titles)